Oil Paintings in Public Ownership in Norfolk

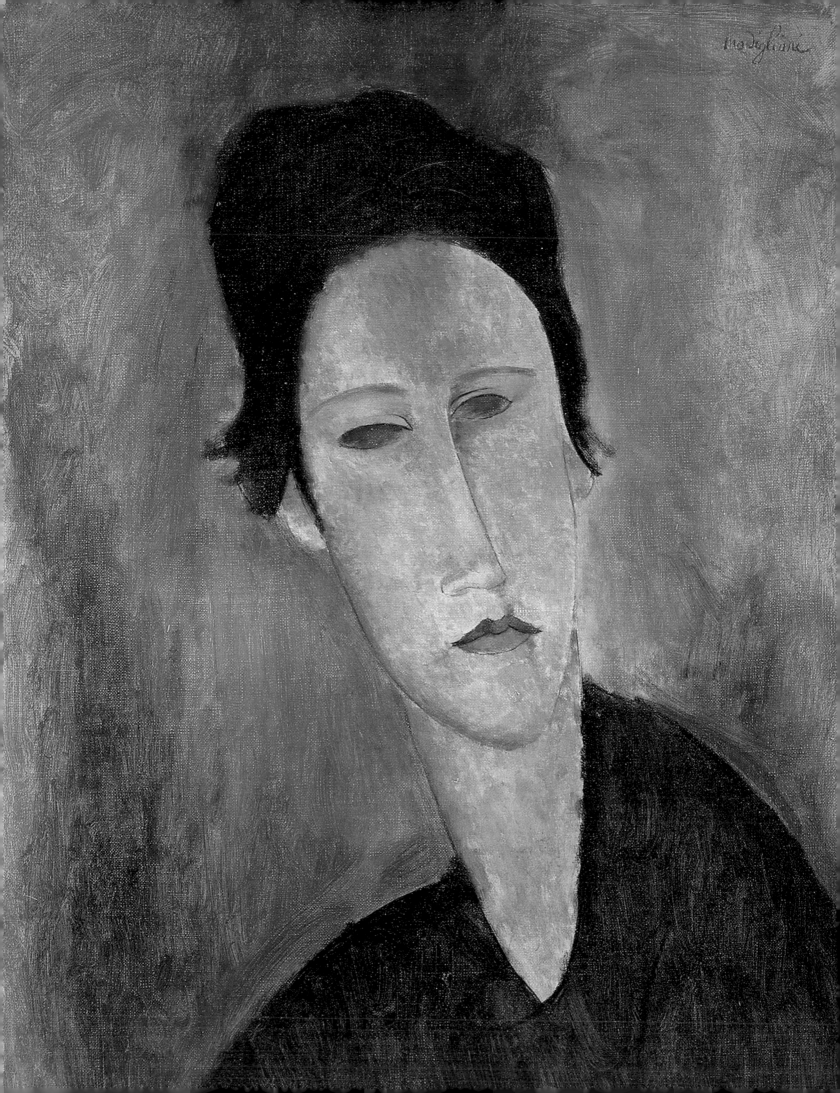

Oil Paintings in Public Ownership in Norfolk

The Public Catalogue Foundation

Andrew Ellis, Director
Sonia Roe, Editor
Sarah Norcross-Robinson, Norfolk Coordinator
Graham Portlock, Norfolk Photographer

ISBN 1-904931-20-0 (hardback)
ISBN 1-904931-21-9 (paperback)

Norfolk photography: Graham Portlock

Designed by Jeffery Design, London

Distributed by the Public Catalogue Foundation, St Vincent House, 30 Orange Street, London, WC2H 7HH
Telephone 020 7747 5936

Printed and bound in the UK by Butler & Tanner Ltd, Frome, Somerset

Cover image:

Miles Edmund 1810–1858
Boats on the Medway, a Calm (detail), c.1845
Norwich Castle Museum and Art Gallery (see p.120)

Image opposite title page:

Modigliani, Amedeo 1884–1920
Head of a Woman (Anna Zborowska) 1918–1919 (detail)
Sainsbury Centre for Visual Arts, University of East Anglia (see p. 264)

Back cover images (from top to bottom):

Keymer, Matthew 1764–1816
Lord Horatio Nelson (1758–1805)
The Norfolk Nelson Museum (see p.46)

Sandys, Frederick 1829–1904
Autumn 1860
Norwich Castle Museum and Art Gallery (see p.184)

Green, Anthony b.1939
My Mother Alone in Her Dining Room 1975–1976
Sainsbury Centre for Visual Arts, University of East Anglia (see p. 256)

Contents

Wymondham

* These collections are managed by Norfolk Museums and Archaeology Service

Following page: Beechey, William, 1753–1839, *Horatio, Viscount Nelson* (1758–1805), 1801, Norwich Civic Portrait Collection, (p.234)

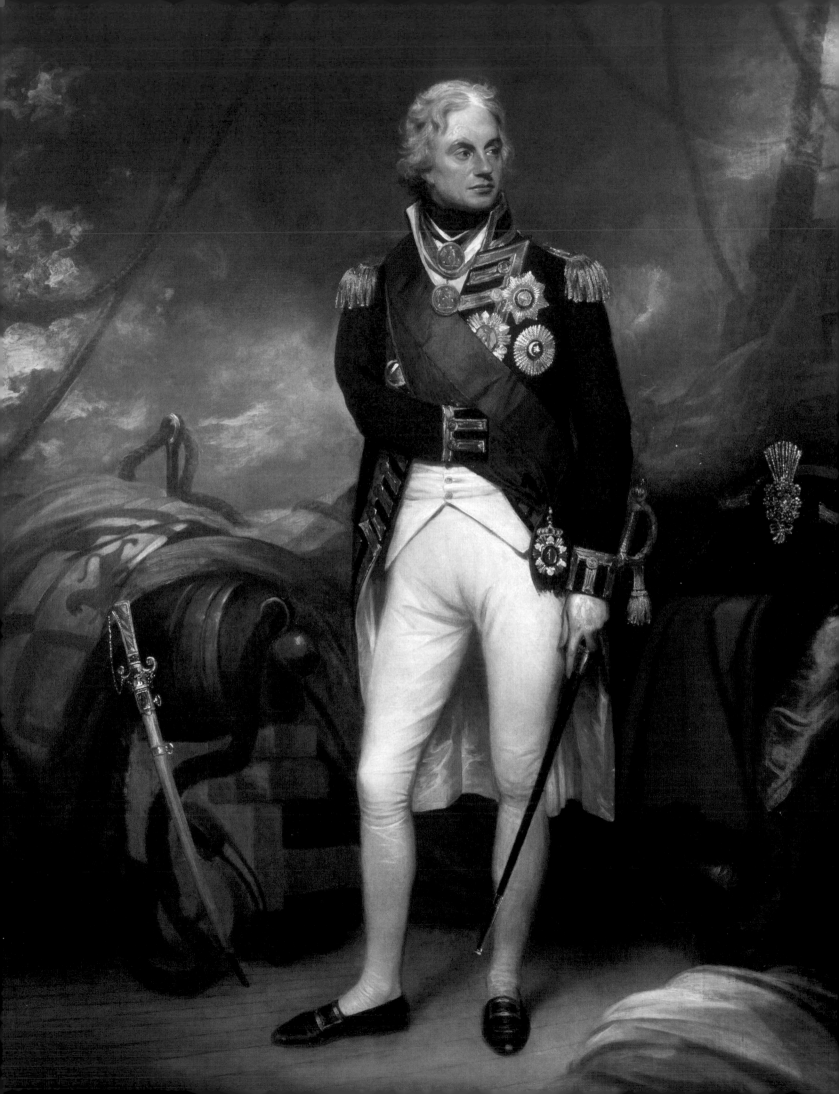

Foreword

Those who fear that they may 'have followed too much the devices and desires of their own hearts' can console themselves with thoughts of Norfolk. From draining swamps to raising to heaven the finest assemblage of churches known to man; from building glorious houses to the creation of fine art collections, Norfolk allows us to believe we may steer by a satisfyingly broad compass.

Our Norfolk catalogue illustrates for those who still need informing or reminding, that our regional collections can be very rich indeed. In fact, the county almost symbolizes what the Public Catalogue Foundation bears witness to: private generosity and public neglect. In 1926, the presentation of the collection of the Indian Prince Frederick Duleep Singh to Thetford caused such public excitement that a three-day public holiday was declared to allow the public to visit. Consisting mainly of portraits, 30 years later not a single painting was on display and even today only a few can be seen. It is painfully evident to me that there is profound public interest in portraiture. Yet, undermined by a disdain for our past and the 'boring portraits of old councillors' we so often assign enjoyable art to rot unseen in the stacks.

Norfolk, though, is richly blessed. Duleep Singh apart, the Sainsbury family have given the University of East Anglia not just a rich collection of paintings but the gallery in which to display them. The Colman family have been open-handed benefactors of Norwich Castle Museum and Art Gallery from 1898 to the present day, and without Sir Timothy Colman's support and encouragement, this catalogue might never have appeared. The Norwich collection – comprising a strong holding of the Norwich School of Artists – is of international quality.

This catalogue, in fairness, counts but few of Norfolk's blessings. Norwich Castle contains not just 1,200 oil paintings but some 10,000 watercolours and drawings. Being told this at a very early stage in the creation of the Public Catalogue Foundation led me to understand that if the project were to succeed it had to limit its scope. It is our hope that this series will inspire others to undertake the parallel work for watercolours, drawings and sculpture. However, it is not a hope so much as an intention to get all the Public Catalogue Foundation's work on to the Internet – as soon as we can find someone to fund it. Please don't hesitate to call.

As usual my great appreciation goes to the collections for their enormous help with this catalogue. In particular, we are indebted to Andrew Moore and his colleagues at the Norwich Castle Museum and Art Gallery. Andrew, who is also one of our Advisors, has given this project enormous support and wise advice. I am also aware that our own team has put many long hours into this particular catalogue. Sonia Roe, Nickie Murfitt and our coordinator on the ground, Sarah Norcross-Robinson, deserve the greatest of praise.

Norfolk County Council, Sir Timothy Colman and Richard Jewson at Archant were early and enthusiastic supporters of this volume whilst Hiscox PLC has again given valuable support as with so many of our previous volumes. But in the end, this catalogue was made possible by the generosity and labours of one man, Sir Nico Bacon. I would like to express my sincere thanks for his invaluable contribution.

Fred Hohler, Chairman

The Public Catalogue Foundation

The United Kingdom holds in its galleries and civic buildings arguably the greatest publicly owned collection of oil paintings in the world. However, an alarming four in five of these paintings are not on view. Whilst many galleries make strenuous efforts to display their collections, too many paintings across the country are held in storage, usually because there are insufficient funds and space to show them. Furthermore, very few galleries have created a complete photographic record of their paintings, let alone a comprehensive illustrated catalogue of their collections. In short, what is publicly owned is not publicly accessible.

The Public Catalogue Foundation, a registered charity, has three aims. First, it intends to create a complete record of the nation's collection of oil, tempera and acrylic paintings in public ownership. Second, it intends to make this accessible to the public through a series of affordable catalogues and, after a suitable delay, through a free Internet website. Finally, it aims to raise funds through the sale of catalogues in gallery shops for the conservation and restoration of oil paintings in these collections and for gallery education.

The initial focus of the project is on collections outside London. Highlighting the richness and diversity of collections outside the capital should bring major benefits to regional collections around the country. The benefits also include a revenue stream for conservation, restoration, gallery education and the digitisation of collections' paintings, thereby allowing them to put the images on the Internet if they so desire. These substantial benefits to galleries around the country come at no financial cost to the collections themselves.

The project should be of enormous benefit and inspiration to students of art and to members of the general public with an interest in art. It will also provide a major source of material for scholarly research into art history.

Financial Supporters

The Public Catalogue Foundation would like to express its profound appreciation to the following organisations and individuals who have made the publication of this catalogue possible.

Donations of £5,000 or more

Archant Ltd
Hiscox plc

Norfolk County Council

Donations of £1,000 or more

John Alston, CBE
The Bacon Charitable Trust
The Timothy Colman Charitable Trust
David Gurney

Lady Hind Trust
MLA East of England
The Pennycress Trust
P. F. Charitable Trust

Other Donations

Sir J. C. C. Blofeld, QC
The Marquess of Cholmondeley
The Viscount Coke
Great Yarmouth Borough Council

Sir John Guinness
The J. & D. Hambro Charitable Trust
Paul King, OBE
The Reverend Mark Wathen

National Supporters

The Bulldog Trust
The John S. Cohen Foundation
Hiscox plc
The Manifold Trust

The Monument Trust
P. F. Charitable Trust
Stavros S. Niarchos Foundation
Garfield Weston Foundation

National Sponsor

Christie's

Acknowledgements

The Public Catalogue Foundation would like to thank the individual artists and copyright holders for their permission to reproduce for free the paintings in this catalogue. Exhaustive efforts have been made to locate the copyright owners of all the images included within this catalogue and to meet their requirements. Copyright credit lines for copyright owners who have been traced are listed in the Further Information section.

The Public Catalogue Foundation would like to express its great appreciation to the following organisations for their great assistance in the preparation of this catalogue:

Bridgeman Art Library
Flowers East
Marlborough Fine Art
National Association of Decorative and Fine Art Societies (NADFAS)
National Gallery, London
National Portrait Gallery, London
Royal Academy of Arts, London
Tate

The participating collections included in the catalogue would like to express their appreciation to the many individuals who have contributed so generously to the county's collections and those who continue to do so. They would also like to express their thanks to the following organisations which have so generously enabled them to acquire paintings featured in this catalogue:

The Hilda Bacon Bequest Fund
The Paul Bassham Trust
The Beecheno Bequest Fund
The Broadbent Bequest Fund
The Doyle Bequest Fund
East Anglia Art Foundation (East Anglia Art Fund)
East Anglian Art Society
Eastern Arts Association
The Esmée Fairbairn Charitable Trust
The Friends of the Norwich Museums
The J. Paul Getty Charitable Trust
The Gulbenkian Foundation
The Headley Trust
MLA/ V & A Purchase Grant Fund
The Museums and Galleries Commission
National Art Collections Fund (The Art Fund)
National Heritage Memorial Fund
Norfolk Contemporary Arts Society
The P. F. Charitable Trust
The Pilgrim Trust
The Robert and Lisa Sainsbury Charitable Fund
The Walker Bequest Fund
The Wolfson Foundation

Catalogue Scope and Organisation

Medium and Support

The principal focus of this series is oil paintings. However, tempera and acrylic are also included as well as mixed media, where oil is the predominant constituent. Paintings on all forms of support (e.g. canvas, panel, etc.) are included as long as the support is portable. The principal exclusions are miniatures, hatchments or other purely heraldic paintings and wall paintings *in situ*.

Public Ownership

Public ownership has been taken to mean any paintings that are directly owned by the public purse, made accessible to the public by means of public subsidy or generally perceived to be in public ownership. The term 'public' refers to both central government and local government. Paintings held by national museums, local authority museums, English Heritage and independent museums, where there is at least some form of public subsidy, are included. Paintings held in civic buildings such as local government offices, town halls, guildhalls, public libraries, universities, hospitals, crematoria, fire stations and police stations are also included. Paintings held in central government buildings as part of the Government Art Collection and MoD collections are not included in the county-by-county series but should be included later in the series on a national basis.

Geographical Boundaries of Catalogues

The geographical boundary of each county is the 'ceremonial county' boundary. This county definition includes all unitary authorities. Counties that have a particularly large number of paintings are divided between two or more catalogues on a geographical basis.

Criteria for Inclusion

As long as paintings meet the requirements above, all paintings are included irrespective of their condition and perceived quality. However, painting reproductions can only be included with the agreement of the participating collections and, where appropriate, the relevant copyright owner. It is rare that a collection forbids the inclusion of its paintings. Where this is the case and it is possible to obtain a list of paintings, this list is given in the Paintings Without Reproductions section. Where copyright consent is refused, the paintings are also listed in the Paintings Without Reproductions section. All paintings in collections' stacks and stores are included, as well as those on display. Paintings which have been lent to other institutions, whether for short-term exhibition or long-term loan, are listed under the owner collection. In addition, paintings on long-term loan are also included under the borrowing institution when they are likely to remain there for at least another five years from the date of publication of this catalogue. Information relating to owners and borrowers is listed in the Further Information section.

Layout

Collections are grouped together under their home town. These locations are listed in alphabetical order. In some cases collections that are spread over a number of locations are included under a single owner collection. A number of collections, principally the larger ones, are preceded by curatorial forewords. Within each collection paintings are listed in order of artist surname. Where there is more than one painting by the same artist, the paintings are listed chronologically, according to their execution date.

The few paintings that are not accompanied by photographs are listed in the Paintings Without Reproductions section.

There is additional reference material in the Further Information section at the back of the catalogue. This gives the full names of artists, titles and media if it has not been possible to include these in full in the main section. It also provides acquisition credit lines and information about loans in and out, as well as copyright and photographic credits for each painting. Finally, there is an index of artists' surnames.

Key to Painting Information

Almost all paintings are reproduced in the catalogue. Where this is not the case they are listed in the Paintings Without Reproductions section. Where paintings are missing or have been stolen, the best possible photograph on record has been reproduced. In some cases this may be black and white. Paintings that have been stolen are highlighted with a red border. Some paintings are shown with conservation tissue attached to parts of the painting surface.

Adam, Patrick William 1854–1929
Interior, Rutland Lodge: Vista through Open Doors 1920
oil on canvas 67.3 × 45.7
LEEAG.PA.1925.0671.LACF ✻

Artist name This is shown as surname first. Where the artist is listed on the Getty Union List of Artist Names (ULAN), ULAN's preferred presentation of the name is always given. In a number of cases the name may not be a firm attribution and this is made clear. Where the artist name is not known, a school may be given instead. Where the school is not known, the painter name is listed as *unknown artist*. If the artist name is too long for the space, as much of the name is given as possible followed by (…). This indicates the full name is given at the rear of the catalogue in the Further Information section.

Painting title A painting followed by *(?)* indicates that the title is in doubt. Where the alternative title to the painting is considered to be better known than the original, the alternative title is given in parentheses. Where the collection has not given a painting a title, the publisher does so instead and marks this with an asterisk. If the title is too long for the space, as much of the title is given as possible followed by *(…)* and the full title is given in the Further Information section.

Medium and support Where the precise material used in the support is known, this is given.

Artist dates Where known, the years of birth and death of the artist are given. In some cases one or both dates may not be known with certainty, and this is marked. No date indicates that even an approximate date is not known. Where only the period in which the artist was active is known, these dates are given and preceded with the word *active*.

Execution date In some cases the precise year of execution may not be known for certain. Instead an approximate date will be given or no date at all.

Dimensions All measurements refer to the unframed painting and are given in cm with up to one decimal point. In all cases the height is shown before the width. Where the painting has been measured in its frame, the dimensions are estimates and are marked with (E). If the painting is circular, the single dimension is the diameter. If the painting is oval, the dimensions are height and width.

Collection inventory number In the case of paintings owned by museums, this number will always be the accession number. In all other cases it will be a unique inventory number of the owner institution. (P) indicates that a painting is a private loan. Details can be found in the Further Information section. The ✻ symbol indicates that the reproduction is based on a Bridgeman Art Library transparency (go to www.bridgeman.co.uk) or that the Bridgeman administers the copyright for that artist.

Facing page: Mellon, Campbell A., 1876–1955, *Late Afternoon, August 1926* (detail), Great Yarmouth Museums, (p. 32)

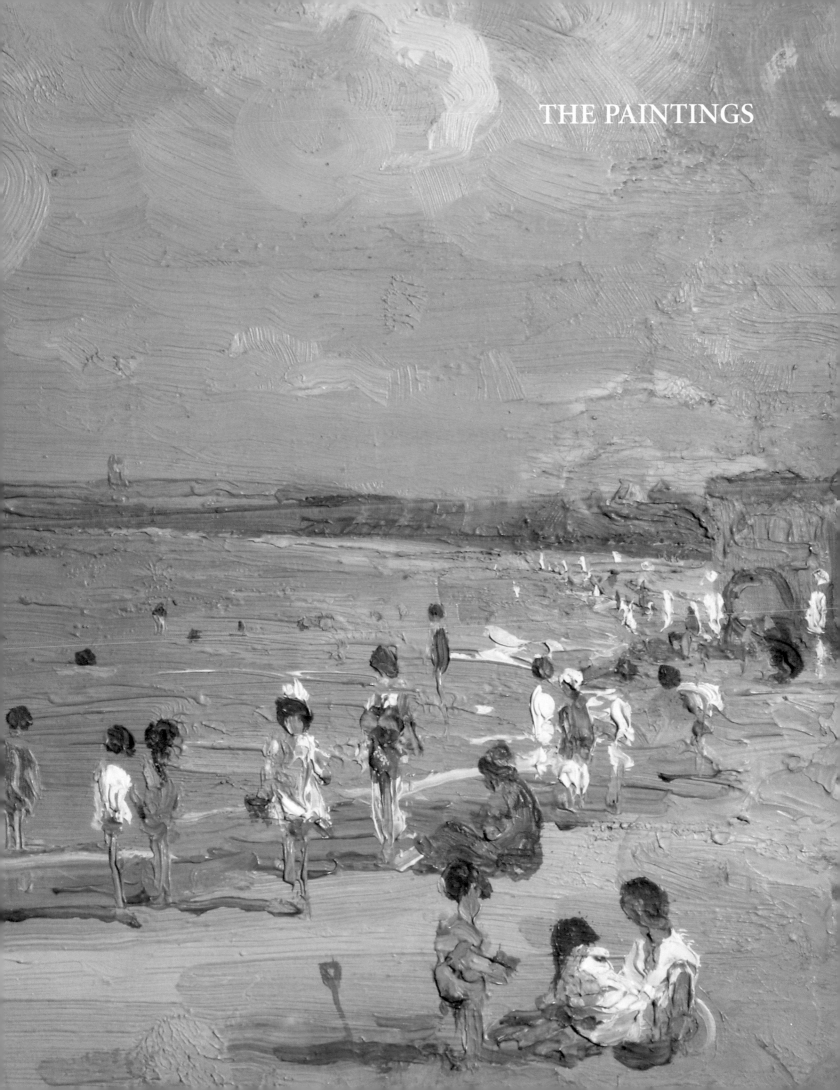

Aylsham Town Council

Little, Ida (attributed to) b.1873
B. B. Sapwell
oil on canvas 60 x 50 (E)
ATC1

Little, Ida (attributed to) b.1873
Frederick Little
oil on canvas 67 x 53 (E)
ATC2

Bressingham Steam Museum

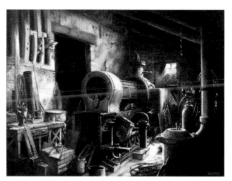

Weston, David b.1935
Narrow Gauge Locomotive No.1643, 'Bronllwyd', under Restoration at Bressingham
1968
oil on canvas 36 x 46
5

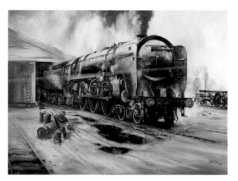

Weston, David b.1935
Britannia Class Locomotive No.70013, 'Oliver Cromwell' 1969
oil on canvas 76 x 100
1

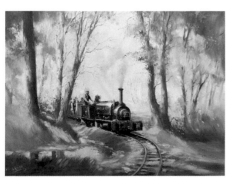

Weston, David b.1935
Narrow Gauge Locomotive No.1643, 'Bronllwyd', Being Driven by Alan Bloom 1969
oil on canvas 61 x 81
3

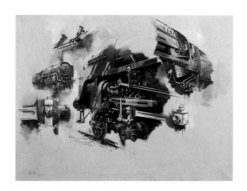

Weston, David b.1935
Sketches of Engineering Detail on Britannia Class Locomotive No.70013, 'Oliver Cromwell'
1970
oil on canvas 76 x 100
2

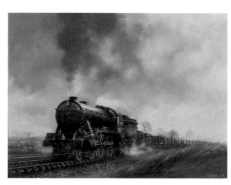

Weston, David b.1935
LNER Gresley K3 Class Locomotive No.164
1976
oil on canvas 35 x 45
4

Costessey Parish Council

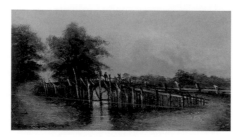

Beaty, Charles active 1878–1956
Costessey Stick Bridge 1878
oil on board 20 x 37
CPC6

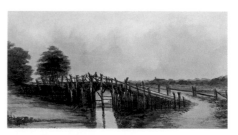

Beaty, Charles active 1878–1956
Costessey Stick Bridge 1956
oil on board 20 x 38
CPC5

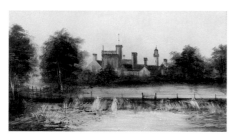

Beaty, Charles active 1878–1956
The Weir and Costessey Hall 1956
oil on board 20 x 38 (E)
CPC4

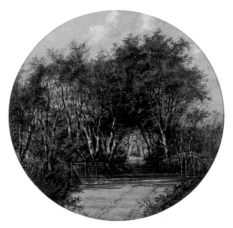

Freeman, William Philip Barnes 1813–1897
Costessey Stick Bridge (a pair)
oil on paper 30
CPC8

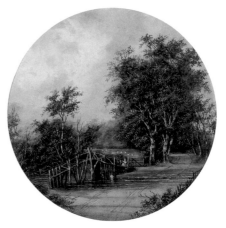

Freeman, William Philip Barnes 1813–1897
Costessey Stick Bridge, Longloather Lane (a pair)
oil on paper 30
CPC7

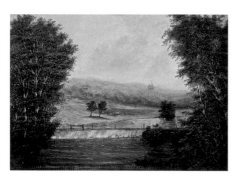

Freeman, William Philip Barnes 1813–1897
Costessey Weir with View of Costessey Hall
oil on board 48 x 65
CPC3

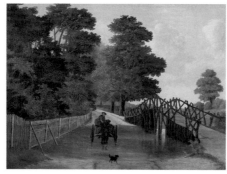

Littlewood, Edward active 1863–1898
Costessey Stick Bridge and Ford with Pony and Trap Crossing
oil on canvas 50 x 68
CPC2

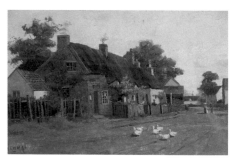

Newman, William A. active 1885–1895
The Street, Old Costessey
oil on board 14 x 23
CPC9

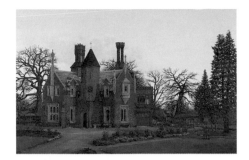

Turner, Cyril Boyland
One of the Costessey Lodges
oil on canvas 60 x 90
CPC1

Cromer Museum

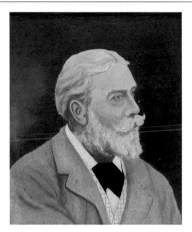

Church, Herbert S. d. after 1912
Lord Battersea (1843–1907)
oil on canvas 23 x 19
CRRMU:2002.11

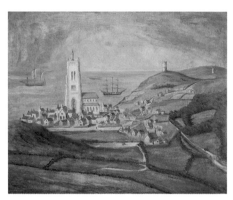

Rogers, Ellis
Cromer
oil on canvas 25 x 30
CRRMU:1981.80.1522

Cromer Town Council

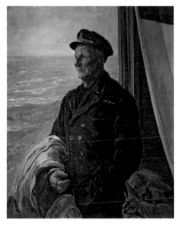

Dugdale, Thomas Cantrell (copy of)
1880–1952
Henry Blogg (1876–1954), Coxswain of the Cromer Lifeboat 1943
oil on canvas 123.2 x 99.1
CTC 1

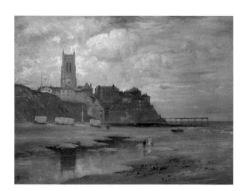

Western, Charles active 1884–1900
View of Cromer from the Beach 1899
oil 61 x 68.6 (E)
CTC 2

North Norfolk District Council

Baldwin, Peter b.1941
Beeston Hill 2000
oil on canvas stretched on MDF board
84 x 69
1

The RNLI Henry Blogg Museum

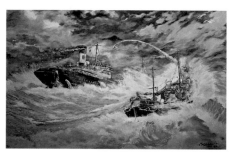

Childs, Ernest Alfred b.1947
Rescue of the 'François Tixier' 1990
oil on board 133 x 194
CR.2002.4

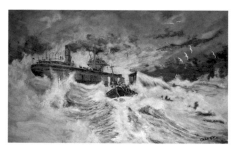

Childs, Ernest Alfred b.1947
RNLB 'Henry Blogg' Attending a Steamer in Distress 1995
oil on board 125 x 180
CR.2002.5

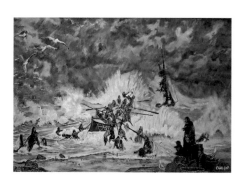

Childs, Ernest Alfred b.1947
Rescue of the Barge 'Sepoy'
oil on board 167 x 305
CR.2002.6

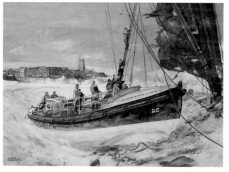

Cole, C. L.
The Coxswain Henry Blogg Driving the Cromer Lifeboat onto the Deck of the Barge 'Sepoy', December 1933 (…)
oil on board 54 x 69
CR.2002.3

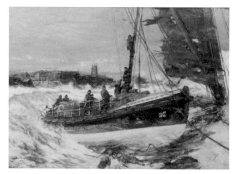

Dixon, Charles 1872–1934
The Coxswain Henry Blogg Driving the Cromer Lifeboat onto the Deck of the Barge 'Sepoy', December 1933 1934
oil on canvas 102 x 127
ART.2004.54

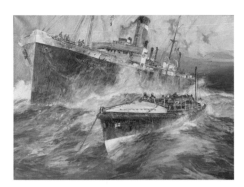

Dixon, Charles 1872–1934
The Cromer Lifeboat alongside the Italian Steamer 'Monte Nevoso', October 1932
oil on canvas 102 x 127
ART.2004.58

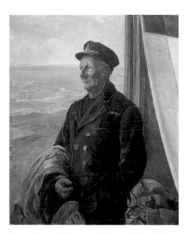

Dugdale, Thomas Cantrell 1880–1952
Henry Blogg (1876–1954), Coxswain of the Cromer Lifeboat 1942
oil on canvas 147 x 122
ART.2004.53

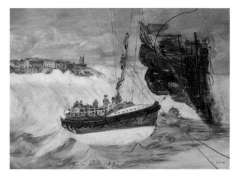

Gladden, I.
Cromer Lifeboat Receiving Two Men from the 'Sepoy' (after Charles Dixon)
oil on hardboard 45 x 52
CR.2002.43

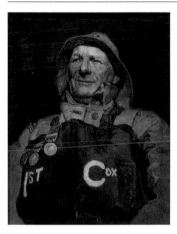

Hodgson, Margaret L. active 1912–1941
Head and Shoulders of Henry Blogg (1876–1954) c.1940–1941
oil on canvas 58 x 48
ART.2004.36

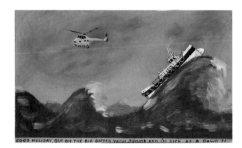

Hunt, Kenny
'Good holiday, but on the big dipper with junior and I'm sick as a dawg!!'
oil on hardboard 19 x 31
CR.2002.66

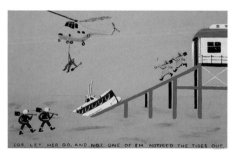

Hunt, Kenny
SOS let her go, and not one of em' noticed the tides out'
oil on hardboard 23 x 35
CR.2002.67

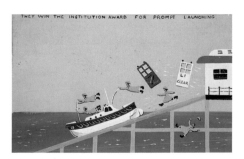

Hunt, Kenny
'They win the institution award for prompt launching'
oil on hardboard 21 x 35
CR.2002.65

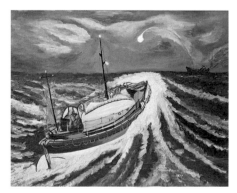

Johnson, Philip M.
Answering an SOS 1977
oil on board 52 x 62
CR.2002.44

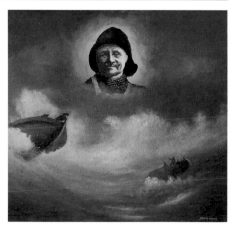

Mann, John J. b.1903
*Sea Rescue**
mixed media 61 x 61
CR.2002.45

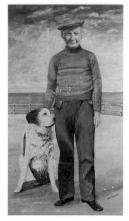

Tyrell, A. W.
Henry Blogg (1876–1954) and Dog
oil on hardboard 69 x 43
CR.2002.42

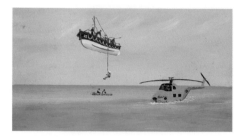

unknown artist
*Sea Rescue**
oil on hardboard 20 x 34
CR.2002.64

Dereham Town Council

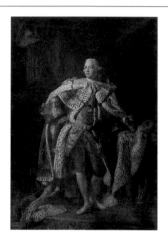

Ramsay, Allan 1713–1784
George III (1738–1820)
oil on canvas
1

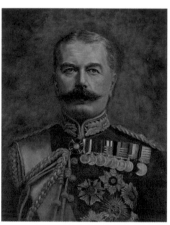

unknown artist
Lord Kitchener (1850–1916)
oil 60 x 45 (E)
2

Gressenhall Farm and Workhouse: The Museum of Norfolk Life

Bowles
Father's Daub c.1899–1900
oil on canvas 30.4 x 50.7
GRSRM : 1994.8.2

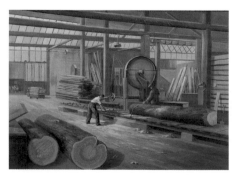

Cocks, Fred
Hobbies Saw Mill 1950–1959
oil on canvas 57.2 x 75
GRSRM : 1978.77

Cooper, J.
This House to Let
oil on paper & wood 36.3 x 30.9
GRSRM : 1981.154

Locke, J. active 1870–1900
Horses Pulling a Plough
oil on canvas 51 x 76
GRSRM : 1976.27

Nursey, Perry 1799–1867
Norfolk Sheep (recto) 1840
oil
GRSRM : NN414

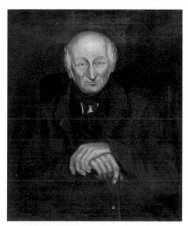

Nursey, Perry 1799–1867
Norfolk Sheep (verso) 1840
oil
GRSRM : NN414

unknown artist
Scragg's Cow 1831
oil on canvas 73.5 x 88
GRSRM : Scragg

unknown artist 19th C
Delivery Cart of William Buckenham
oil on canvas 30.5 x 38
GRSRM : 1968.780

unknown artist
Jeremiah William King
oil on canvas 76 x 63
GRSRM : 1999.65

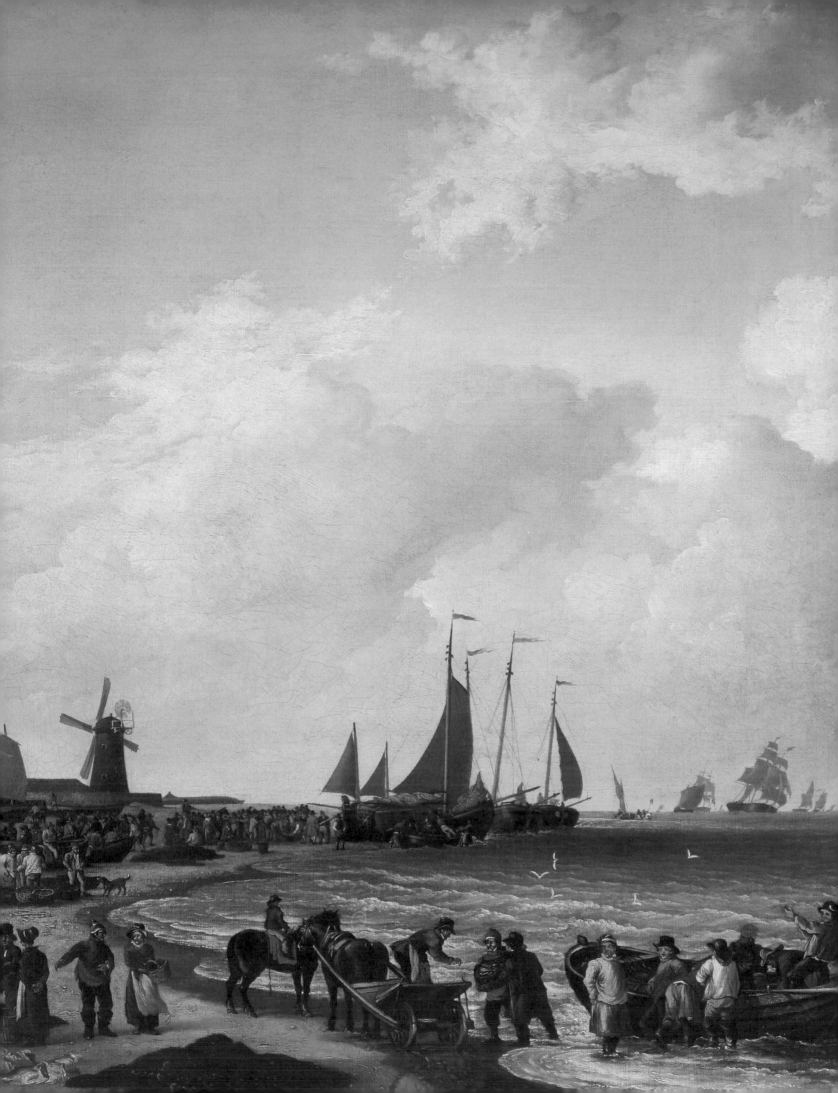

Diss Town Council

Boxall, William 1800–1879
Thomas Lombe Taylor 1857
oil on canvas 142 x 112
DTC2

Bunbury, Harry
Rear Admiral A. H. Taylor 1964
oil on canvas 122 x 91
DTC1

100th Bomb Group Memorial Museum

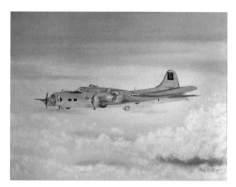

Catchpole, Glyn b.1932
B17 Flying Fortress 398945 1983
oil on canvas board 48 x 61 (E)
TA 1111

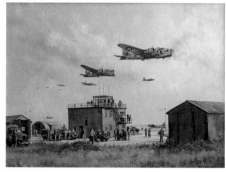

Crowfoot, Joe b.1946
Thorpe Abbots' Control Tower, World War Two
1994
acrylic on board 44 x 61
TA 1526

Howlett, Dennis
*Storm Clouds over the Old USAAF Control
Tower* 1986
acrylic on board 12.5 x 17.5
TA 2165

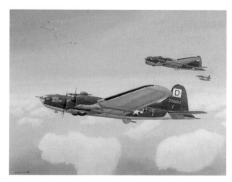

Leigh, Ronald b.1961
*B17s x 4 (230062) Flying Fortress, 100th Bomb
Group* 1994
acrylic on board 31 x 41
TA 1033

Powers
John Bennett 1946
oil on canvas 51 x 41
TA 00392

Facing page: Ladbrooke, Robert, 1770–1842, *The Mackerel Market on Yarmouth Beach* (detail), 1810, Great Yarmouth Museums, (p.29)

unknown artist
Female Figure 1943–1945
oil on board 91 x 57
TA 1271/1

unknown artist
Female Figure 1943–1945
oil on board 87 x 83
TA 1271/2

Fakenham Town Council

Riviere, J. S.
Sir Lawrence Jones, Bt
oil on canvas 102 x 80 (E)
FTC1

Great Yarmouth Magistrates Court

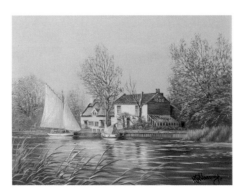

Hastings, Keith William b.1948
Ferry Inn at Horning
oil on canvas 29 x 33 (E)
4

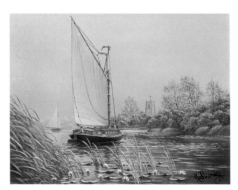

Hastings, Keith William b.1948
Wherry Hathor near Ranworth
oil on canvas 29 x 33 (E)
3

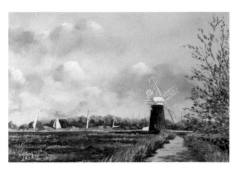

Leckie, Brian
Horsey Mill 1993
oil on canvas 29 x 33 (E)
5

Great Yarmouth Museums

Today Great Yarmouth is known as a popular seaside resort, but in the nineteenth century its herring fishing and commercial industries were more important. It is therefore not surprising that the maritime heritage of Great Yarmouth is featured most prominently in the fine art collection at the museums within the Borough.

Great Yarmouth Museums' art collection comprises that owned by the Borough and County Councils. The joint collection is managed by Norfolk Museums and Archaeology Service. Subject matter is mostly topographical, marine and portraiture, which dates from the late eighteenth century to the present. The majority of the collections date from the early to mid-nineteenth century. This period witnessed the town's major development and rise in prosperity as the largest herring fishing port in the world. Much of Yarmouth's wealth, until the mid-twentieth century, was derived from fishing and export of cured herring in particular.

Great Yarmouth Museums' art collections are displayed to the public at Time and Tide Museum of Great Yarmouth Life, the Elizabethan House Museum and the Great Yarmouth Borough Council Town Hall. The Tolhouse Museum previously housed the County Borough's collection until April 1941 when it was bombed and much of the collection destroyed. The art collection was partly re-established with the assistance of the War Damages Fund. Today the Tolhouse Museum, Great Yarmouth, does not display or store any oil paintings.

The significant collection of marine pictures reflects Yarmouth's unique position on the East Coast as a seaside holiday destination, North Sea offshore base and international trading port. The fishing boats that plied the North Sea and the fishermen unloading their catches on the beach attracted many artists to Great Yarmouth. They also found a wealth of subjects along the quaysides and in the town among the gates and towers of the mediaeval town walls, the unique narrow rows, and the historic Market Place. The collection includes

works by notable Norwich School artists, including George Vincent (1796–1831), Alfred Stannard (1806–1889), Robert Ladbrooke (1770–1842) and William Joy (1803–1867). Many examples of Norwich School Artists' work featuring Great Yarmouth illustrate the realism in their observations of both work and leisure in the town. Local scenes also illustrate how important Great Yarmouth's coastline was as an inspiration to artists such as John Constable and J. M. W. Turner.

Many of the beach scenes in the Collection fall within a national trend embracing contemporary views of seaside resorts, such as Hastings and Brighton. Great Yarmouth differed from such places in that at the beginning of the nineteenth century the town was a thriving industrial centre and fishing port as well as an emerging middle-class seaside resort. Yarmouth Beach and Jetty were particularly popular subjects with locally-based artists in the nineteenth century.

James Steward, Museums Officer

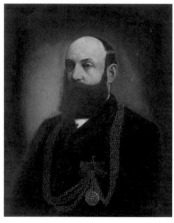

Abbott, Edwin active 1879–1899
John William Budds Johnson, Mayor of Yarmouth (1899), Founder of Johnson's Overalls Ltd 1899
oil on canvas 50 x 40
GRYEH : 1972.136

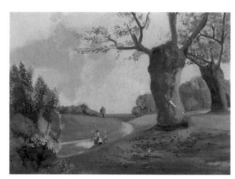

Allen, Elsie active 19th C
Country Scene
oil on canvas 30 x 41
GRYEH : T13

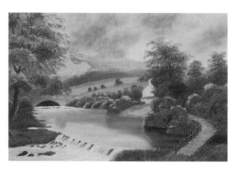

Allen, H. L.
Countryside Scene
oil on canvas 39 x 60
GRYEH : 2005.14

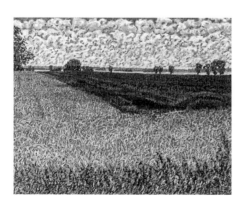

Amies, Anthony 1945–2000
Burnt Stubble
oil on hessian 77.4 x 92.3
GRYEH : 2001.15.14

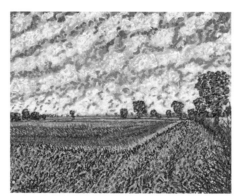

Amies, Anthony 1945–2000
Burnt Stubble
oil on hessian 50.5 x 61
GRYEH : 2001.15.30

Amies, Anthony 1945–2000
Cliff Top and Seascape
oil on hessian 77.2 x 92.5
GRYEH : 2001.15.2

Amies, Anthony 1945–2000
Cliffs
oil on hessian 77.4 x 92.7
GRYEH : 2001.15.9

Amies, Anthony 1945–2000
Hill Trees Sussex
oil on hessian 42.4 x 46.9
GRYEH : 2001.15.21

Amies, Anthony 1945–2000
Landscape
oil on hessian 76.3 x 60.9
GRYEH : 2001.15.15

Amies, Anthony 1945–2000
Landscape
oil on board 82.9 x 65.9
GRYEH : 2001.15.16

Amies, Anthony 1945–2000
Landscape
oil on board 83.9 x 45.9
GRYEH : 2001.15.17

Amies, Anthony 1945–2000
Landscape
oil on board 72.4 x 46.6
GRYEH : 2001.15.18

Amies, Anthony 1945–2000
Landscape
oil on board 71.1 x 51.1
GRYEH : 2001.15.19

Amies, Anthony 1945–2000
Landscape
oil on hessian 40.5 x 45.8
GRYEH : 2001.15.22

Amies, Anthony 1945–2000
Landscape
oil on hessian 40.5 x 40.8
GRYEH : 2001.15.23

Amies, Anthony 1945–2000
Landscape
oil on hessian 48.5 x 46
GRYEH : 2001.15.24

Amies, Anthony 1945–2000
Landscape
oil on hessian 38.3 x 43
GRYEH : 2001.15.25

Amies, Anthony 1945–2000
Landscape
oil on hessian 71.5 x 61
GRYEH : 2001.15.27

Amies, Anthony 1945–2000
Landscape
oil on hessian 61 x 50.5
GRYEH : 2001.15.28

Amies, Anthony 1945–2000
Landscape
oil on hessian 50.6 x 60.6
GRYEH : 2001.15.29

Amies, Anthony 1945–2000
Landscape
oil on hessian 46 x 61
GRYEH : 2001.15.31

Amies, Anthony 1945–2000
Landscape
oil on hessian 40.8 x 45.7
GRYEH : 2001.15.32

Amies, Anthony 1945–2000
Northants
oil on hessian 45.8 x 40.5
GRYEH : 2001.15.33

Amies, Anthony 1945–2000
Seascape
oil on hessian 76 x 91.5
GRYEH : 2001.15.1

Amies, Anthony 1945–2000
Seascape
oil on hessian 70.9 x 71
GRYEH : 2001.15.3

Amies, Anthony 1945–2000
Seascape
oil on hessian 60.6 x 61
GRYEH : 2001.15.4

Amies, Anthony 1945–2000
Seascape
oil on hessian 65.8 x 45.7
GRYEH : 2001.15.5

Amies, Anthony 1945–2000
Seascape
oil on hessian 60.9 x 48.3
GRYEH : 2001.15.6

Amies, Anthony 1945–2000
Seascape
oil on hessian 40.5 x 35.2
GRYEH : 2001.15.8

Amies, Anthony 1945–2000
Seascape
oil on hessian 46 x 51.3
GRYEH : TEMP.37

Amies, Anthony 1945–2000
Seascape with Cliffs
oil on hessian 61 x 70.5
GRYEH : 2001.15.11

Amies, Anthony 1945–2000
Seascape with Cliffs
oil on hessian 114 x 125.5
GRYEH : 2005.68

Amies, Anthony 1945–2000
Shadow of a Tree
oil on hessian 42.3 x 47.2
GRYEH : 2001.15.26

Amies, Anthony 1945–2000
Suffolk Landscape
oil on hessian 73.9 x 83.8
GRYEH : 2001.15.13

Amies, Anthony 1945–2000
Sussex Landscape
oil on hessian 52 x 62.2
GRYEH : 2001.15.20

Anthony, Philip
Cutty Sark
oil on canvas 47 x 62
GRYEH : 1971.28

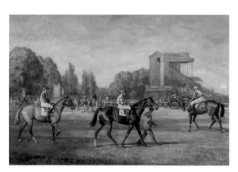

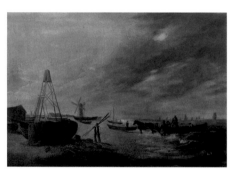

Austin, William Frederick 1833–1899
View from Thorpe Gardens
oil on canvas 35 x 66
GRYEH : 2005.5

Bacon, Marjorie May b.1902
Racehorses Parading 1949
oil on board 50 x 75
GRYEH : 1997.16

Baines, Henry 1823–1894
Yarmouth North Beach
oil on canvas 40 x 61
GRYEH : 1960.65

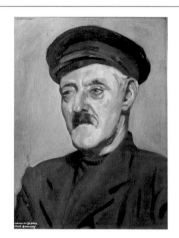

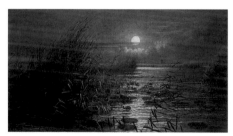

Baldry, George W. active c.1865–1917
Portrait of Unknown Sitter 1878
oil on canvas 142 x 112
GRYEH : 2005.66

Barkway, Arthur active 1964–1970
Portrait of a Yarmouth Skipper
oil on board 50.5 x 38
GRYEH : 1979.39

Batchelder, Stephen John 1849–1932
*South Walsham Broad by Moonlight (The
Long Ripple Washing in the Reeds)* 1882–1929
oil on canvas 46 x 94.5
GRYEH : 1958.46

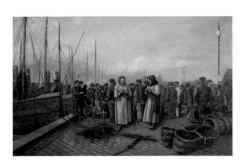

Batchelder, Stephen John 1849 1932
A Slack Day at the Quay 1920
oil on canvas 60.8 x 90.8
GRYEH : 1958.39

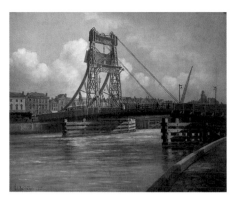

Batchelder, Stephen John 1849–1932
The Temporary Bridge 1928
oil on canvas 50.8 x 61
GRYEH : 1958.30

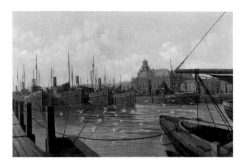

Batchelder, Stephen John 1849–1932
Hush'd is the Voice of Labour 1929
oil on canvas 60.2 x 90.5
GRYEH : 1958.37

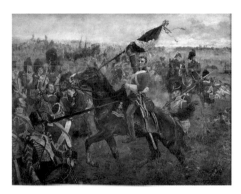

Beadle, James Prinsep 1863–1947
The Captive Eagle
oil on canvas 187 x 243
CP5

Beaty, Charles active 1878–1956
Steam Vessels at Sea 1883
oil on board 22.5 x 33.5
GRYEH : 1958.48

Beaty, Charles active 1878–1956
Fishing Boat with Net at Sea 1886
oil on canvas 20 x 36
GRYEH : 1965.19

Beaty, Charles active 1878–1956
Sailing Smacks at Sea 1886
oil on canvas 20 x 36
GRYEH : 1965.22

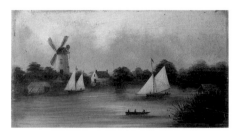

Beaty, Charles active 1878–1956
Broadland Scene 1887
oil on board 20 x 36
GRYEH : 1965.20

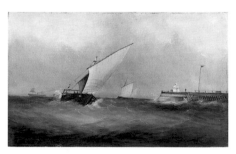

Beaty, Charles active 1878–1956
Yarmouth Fishing Boat Coming into Harbour
1887
oil on board 38 x 60.8
GRYEH : 1964.36

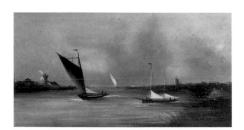

Beaty, Charles active 1878–1956
Three Yachts and a Wherry on a Broad
oil on canvas 21.5 x 36
GRYEH : 1965.18

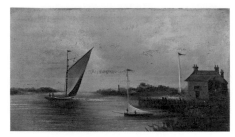

Beaty, Charles active 1878–1956
Wherry and Yacht on a Broad
oil on board 20 x 36
GRYEH : 1965.16

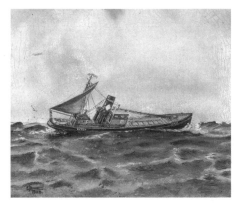

Beckett, E. J.
'YH 627' 1928
oil on canvas 25.4 x 30.5
GRYEH : 1976.43

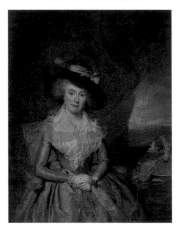

Beechey, William 1753–1839
Elizabeth Taylor (née Barnby) (1746–1827)
1786
oil on canvas 29.5 x 25
GRYEH : 1961.261

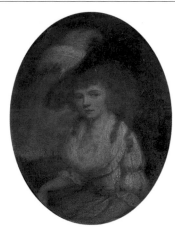

Beechey, William (attributed to) 1753–1839
Miss Elizabeth Taylor (d.1816), Daughter of William Taylor
oil on copper 26 x 22.5
GRYEH : 1961.262

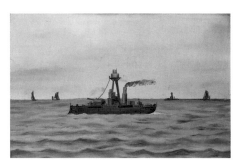

Bennett, M. G. active 1914–1918
'HMS Sir John Moore' 1914–1918
oil on board 19 x 27
GRYEH : 1979.15.2

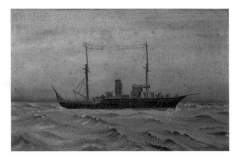

Bennett, M. G. active 1914–1918
'HMS Alecto' c.1917
oil on board 14 x 22
GRYEH : 1979.15.1

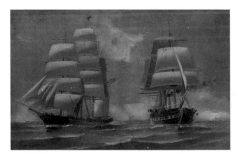

Bourne, J.
Man o'War and Ship Flying the Flag of the United States of America
oil on canvas 37 x 59
GRYEH : 2005.17

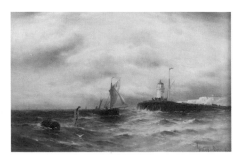

Breanski, Gustave de c.1856–1898
Sailing Vessel Entering Harbour
oil on canvas 59.5 x 90.5
GRYEH : 1970.258

Facing page: Chedgey, David, b.1940, *Private View at the Alibi* (detail), City of Norwich Collection, (p.79)

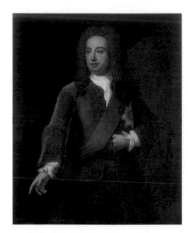

British (English) School 18th C
Sir Robert Walpole (1676–1745)
oil on canvas 124 x 100
GRYEH : 2005.63

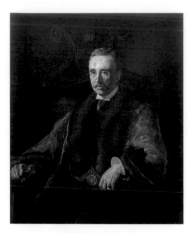

British (English) School
Edward William Worlledge 1908
oil on canvas 110.5 x 91
CP13

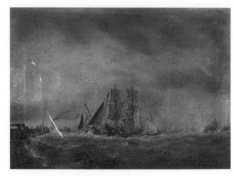

British (English) School
Great Yarmouth Harbour Scene
oil on canvas 29 x 39
GRYEH : 2004.168

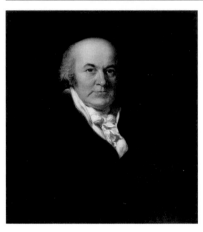

British (English) School
Sir Edmund Lacon
oil on canvas 75 x 61
CP11

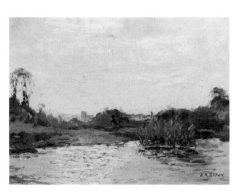

Brown, Agnes Augusta 1847–1932
Broadland Sunset
oil on canvas 29 x 39
GRYEH : 1962.7

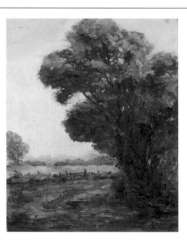

Brown, Agnes Augusta 1847–1932
The Sentinel
oil on canvas 50.5 x 40.3
GRYEH : 1962.13

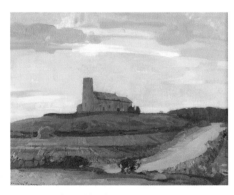

Brown, John Alfred Arnesby 1866–1955
Haddiscoe Church
oil on canvas 39 x 49.5
GRYEH : 1958.5

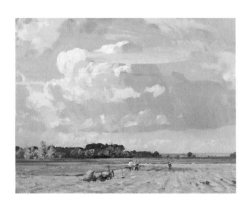

Brown, John Alfred Arnesby 1866–1955
Hay-Cutting on the Norfolk Marshes
oil on canvas 41 x 51
GRYEH : 1958.4

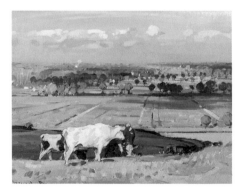

Brown, John Alfred Arnesby 1866–1955
Marshes at Bramerton
oil on canvas 38 x 50.5
GRYEH : 1958.7

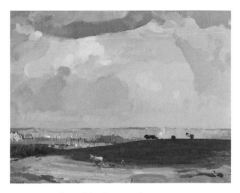

Brown, John Alfred Arnesby 1866–1955
Panoramic View of Nottingham
oil on canvas 36 x 46
GRYEH : 1958.6

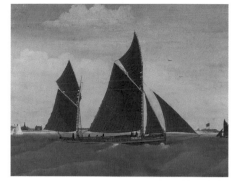

Browne, F. J. active 1884–1894
Sailing Drifter YH 1063 'Lewis and Katie'
1892
oil on cardboard 36.1 x 45.4
GRYEH : 1967.593

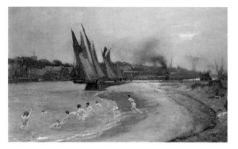

Bundy, Edgar 1862–1922
Boys Bathing at Sandy Hook, Great Yarmouth
1909
oil on canvas 40 x 60
GRYEH : 1956.179

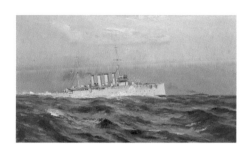

Burgess, Arthur James Wetherall
1879–1957
'HMS Yarmouth'
oil on canvas 35 x 60
GRYEH : 1964.37

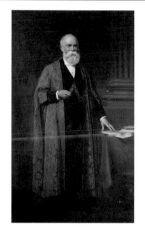

Burgess, John Bagnold 1830–1897
Charles Cory Aldred, Mayor of Great Yarmouth
oil on canvas 227 x 130
CP10

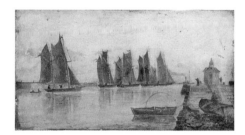

Bussey, F. J.
*Fishing Trawlers Going to Sea, Gorleston,
Suffolk* 1902
oil on canvas 25.5 x 45.8
GRYEH : 1961.44

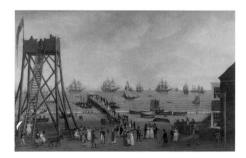

Butcher, John 1736–1806
Yarmouth Jetty
oil on canvas 57 x 87 (E)
CP4

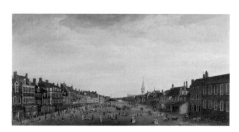

Butcher, John 1736–1806
Yarmouth Market
oil on canvas 59 x 114 (E)
CP2

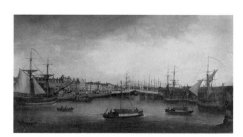

Butcher, John 1736–1806
Yarmouth Quay
oil on canvas 83 x 147 (E)
CP3

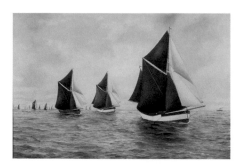

Chappell, Reuben 1870–1940
Barges Racing
oil on canvas 51 x 76
GRYEH : 2005.121

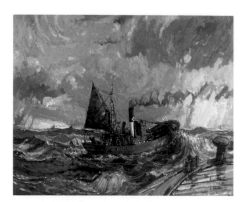

Chatten, Geoffrey b.1952
YH 89 'Lydia Eva'
oil on canvas 80 x 121
GRYEH : 2004.28

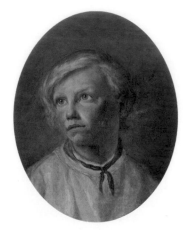

Chevalier, Thomas
Hospital Schoolboy, Great Yarmouth, 1840
c.1840
oil on paper 44.5 x 35
GRYEH : 1963.211 (P)

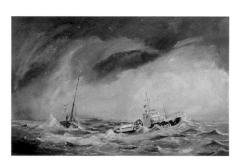

Clifford, John
Rescue by 'The Kharmi'
oil on canvas
GRYEH : 1973.48

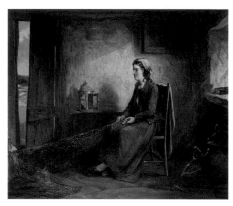

Collins, William (attributed to) 1788–1847
Girl Mending Nets
oil on canvas 45 x 60
GRYEH : 1968.473

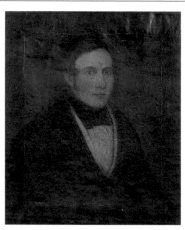

Combes
Self Portrait 1870
oil on canvas 64 x 53
GRYEH : 1970.298

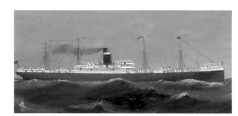

Crane, H. b.1922
'SS Ionian'
oil on panel 15 x 31
GRYEH : 1977.151

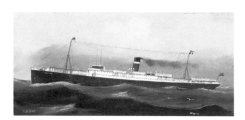

Crane, H. b.1922
'SS Sicilian'
oil on panel 15.2 x 29.7
GRYEH : 1977.150

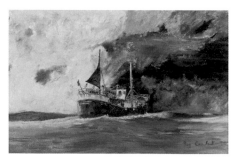

Crowfoot, Reginald active 1970–1995
Sea Area Dogger 1970
oil on board 40 x 70
GRYEH : T14

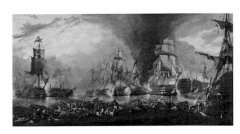

Daniel, T. B. F.
*Lord Nelson's Victory over the Combined Fleets
of France and Spain off Cape Trafalgar, 21
October 1805* 1812
oil on canvas 162 x 300
CP12

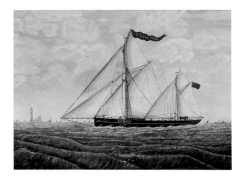

Dobson
Sailing Drifter 'Gorleston YH 840'
oil on canvas 51 x 66
GRYEH : 1968.700

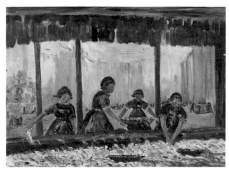

Filbee, N.
Scots Fisher Girls at Yarmouth
oil on board 30 x 41
GRYEH : 1973.107

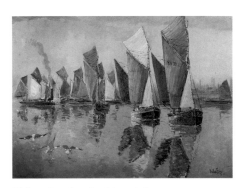

Fisher, Rowland 1885–1969
Fishing Smacks 1960
oil on canvas 89 x 119
GRYEH : 1968.484z1

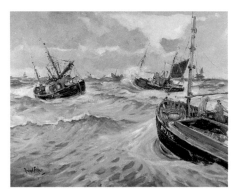

Fisher, Rowland 1885–1969
Scots Fishing Boats 1960
oil on canvas 100 x 125
GRYEH : 2003.292

Fisher, Rowland 1885–1969
Trawlers 1961
oil on board 75.5 x 100
GRYEH : 1968.484

Fisher, Rowland 1885–1969
Cargo Vessel Entering Yarmouth Haven
oil on board 49.2 x 59.2
GRYEH : 1968.265

Fisher, Rowland 1885–1969
Drifters
oil on canvas 100 x 126
GRYEH : 1968.403

Fisher, Rowland 1885–1969
Fish Market
oil on canvas 75 x 95
GRYEH : 1956.320z1

Fisher, Rowland 1885–1969
Haven Bridge, Great Yarmouth
oil on canvas 45 x 60.5
GRYEH : 1963.209

Fisher, Rowland 1885–1969
Hay Wagon
oil on canvas 39 x 75
GRYEH : 2005.67

Fisher, Rowland 1885–1969
Lowestoft Harbour
oil on board 38 x 48
GRYEH : 1969.9

Fisher, Rowland 1885–1969
Market in Brittany
oil on canvas 44 x 59
GRYEH : 1956.320

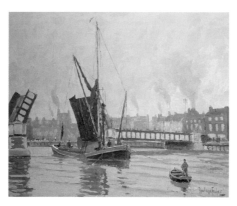

Fisher, Rowland 1885–1969
Sailing Barge Passing through Haven Bridge
oil on board 50.2 x 59.5
GRYEH : 1963.210

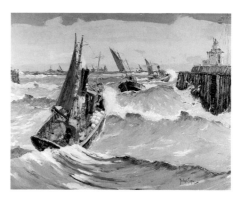

Fisher, Rowland 1885–1969
Steam Drifters Heading out in Rough Sea
oil on canvas 100 x 127
GRYEH : 2005.93

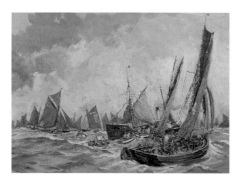

Fisher, Rowland 1885–1969
Trawlers
oil on canvas 62.8 x 75.4
GRYEH : 1956.319

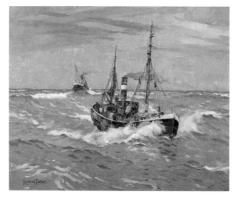

Fisher, Rowland 1885–1969
Trawlers
oil on canvas 63 x 75
GRYEH : 2005.83

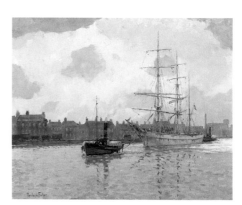

Fisher, Rowland 1885–1969
Yarmouth River
oil on canvas 49 x 60
GRYEH : 2005.75

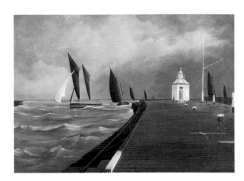

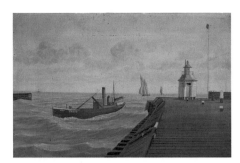

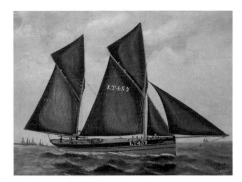

Gouge, Mark 1869–1955
*Dutch Pier at Gorleston with Sailing Vessels
Entering Harbour*
oil on canvas 30.6 x 41
GRYEH : 1978.44

Gouge, Mark 1869–1955
*Dutch Pier at Gorleston with Steam Drifter
'Eight YH 500' Entering Harbour*
oil on canvas 30.8 x 45.5
GRYEH : 1978.45

Gregory, John 1841–1917
'LT 457' 1895
oil on board 48 x 63
GRYEH : M2000.1

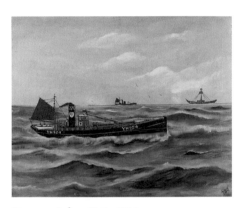

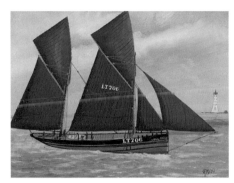

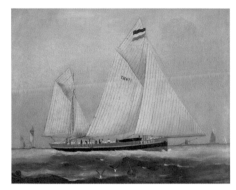

Gregory, John 1841–1917
Steam Drifter 'Sweet Pea YH 924' 1913
oil on canvas 53.5 x 68.5
GRYEH : 1977.10

Gregory, John 1841–1917
Sailing Drifter, 'Renown LT 706'
oil on board 45 x 60
GRYEH : 2005.10

R. R. H. active 19th C
'Guiding Star YH 470'
oil on canvas 38 x 56
GRYEH : 1972.407

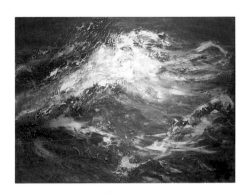

Hambling, Maggi b.1945
Big Sea, May 2005
oil on canvas 91.4 x 121.9
GRYEH : 2006.32

Harrison, Charles Harmony 1842–1902
Country Lane 1892
oil on canvas 60 x 50
GRYEH : 2005.118

Harrison, Charles Harmony (attributed to)
1842–1902
Riverside Scene with Cattle 1899
oil on canvas 52.5 x 84
GRYEH : 2005.11

Heins, John Theodore Sr 1697–1756
John Ives Senior as a Boy (1718/1719–1793)
1728
oil on canvas 126 x 102
GRYEH : 1997.34

Hodds, Dennis Roy 1933–1987
Maldon from the Estuary 1973–1977
oil on board 40.6 x 50.8
GRYEH : 1992.26

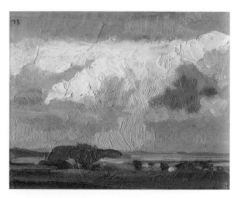

Holzer, Henry active 1958–1973
Mounting Clouds over the Marshes 1973
oil on board 9 x 13.2
GRYEH : 1974.55

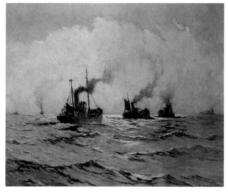

Jarvis, William Howard
Approaching Smith's Knoll
oil on canvas 50 x 60.2
GRYEH : 1963.206

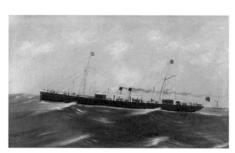

Jensen, Alfred 1859–1935
'SS Norwich' c.1891
oil on canvas 54 x 87.6
GRYEH : 1963.189

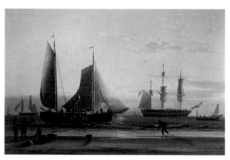

Joy, William 1803–1867
Dutch Schuyts on the Beach
oil on canvas 88 x 130.2
GRYEH : 1956.331

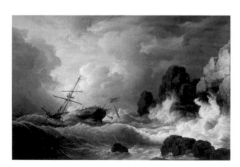

Joy, William 1803–1867
Shipwreck
oil on canvas 61.3 x 91.6
GRYEH : 1963.207

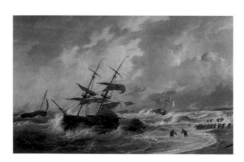

Joy, William 1803–1867
Vessels Stranded on Yarmouth Beach
oil on canvas 70 x 110
GRYEH : 1967.778

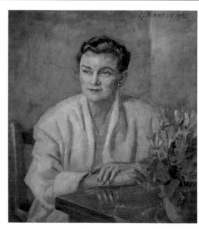

Kennedy, Cedric J. 1898–1968
Woman with a Bowl of Cyclamen 1956
oil on canvas 76 x 64
GRYEH : 2005.12

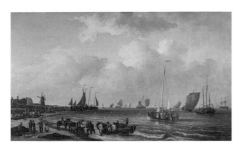

Ladbrooke, Robert 1770–1842
The Mackerel Market on Yarmouth Beach
1810
oil on canvas 84 x 145
GRYEH : 1963.208

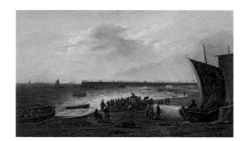

Ladbrooke, Robert 1770–1842
Yarmouth Beach c.1810
oil on canvas 42 x 71
GRYEH : 1956.176

Lewis, Tobias c.1888–1916
A Breezy Day c.1910
oil on paper on wood 24.5 x 34
GRYEH : 1998.8

Lewis, Tobias c.1888–1916
Reverend Forbes Phillips, Vicar of Gorleston
oil on canvas 61 x 51
GRYEH : 1956.336

Longsdale, W.
Edward Pitt Yovell
oil on canvas 180 x 128
CP7

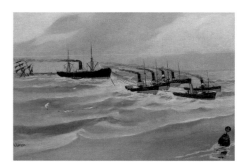

Luck, Kenneth 1874–1936 & **Mowle, Claude**
1871–1950
'SS Adriatico' 1912
oil on cardboard 38.1 x 55.9
GRYEH . 1976.40.1

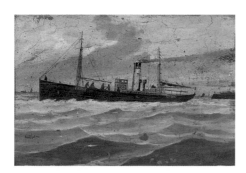

Luck, Kenneth 1874–1936 & **Mowle, Claude**
1871–1950
Steam Drifter 'Girl Winifred YH 997' 1912
oil on cardboard 38 x 53
GRYEH : 1972.408

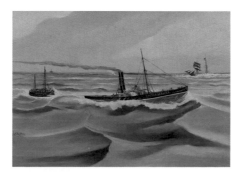

Luck, Kenneth 1874–1936 & **Mowle, Claude**
1871–1950
*Steam Tug 'United Service' Towing the Caister
Lifeboat 'Covent Garden'* 1912
oil on board 37.8 x 52.7
GRYEH : 1976.40.2

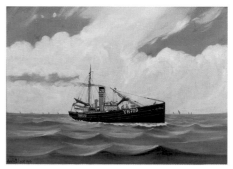

Luck, Kenneth 1874–1936 & **Mowle, Claude**
1871–1950
Steam Drifter 'Archimedes YH 720' 1913
oil on board 63 x 78
GRYEH : 2005.16.7

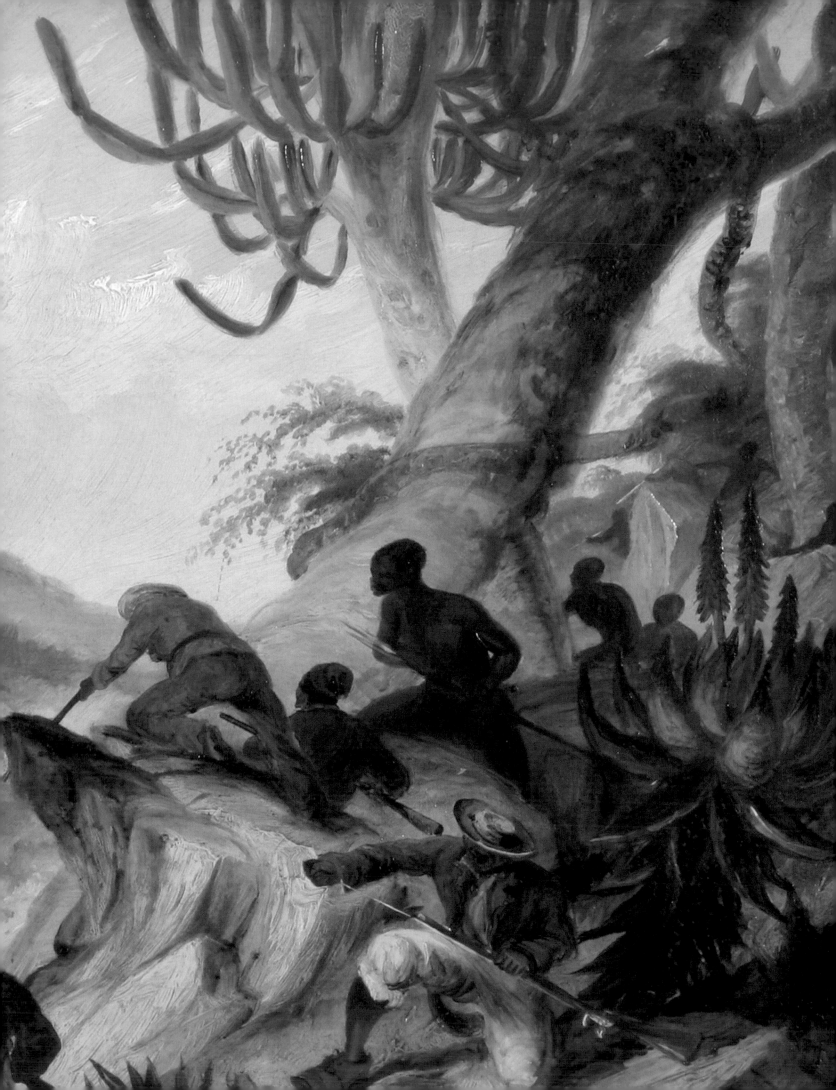

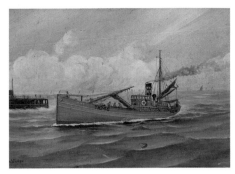

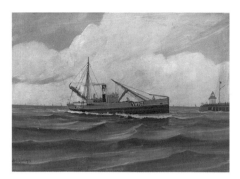

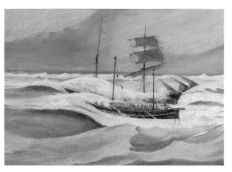

Luck, Kenneth 1874–1936 & **Mowle, Claude**
1871–1950
Steam Drifter 'YH 246' 1913
oil on board 38 x 53
GRYEH : 1972.409

Luck, Kenneth 1874–1936 & **Mowle, Claude**
1871–1950
'Piscator YH 403'
oil on board 39 x 54
GRYEH : 2005.13

Luck, Kenneth 1874–1936 & **Mowle, Claude**
1871–1950
Rescue of the Crew, Schooner 'Falke'
oil on board 40 x 56
GRYEH : 1968.695

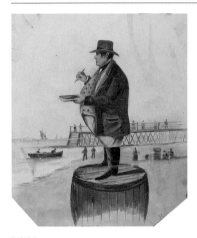

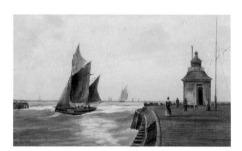

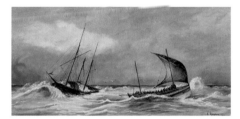

W. M.
Billy Mann
oil on paper 35 x 25.5
GRYEH : 1964.11

Marjoram, William 1859–1928
Harbour Mouth, Gorleston 1898
oil on board 23 x 37
GRYEH : 1964.73 (P)

Marjoram, William 1859–1928
Great Yarmouth Lifeboat 'Mark Lane' 1902
oil on board 42.2 x 73
GRYEH : 2004.169

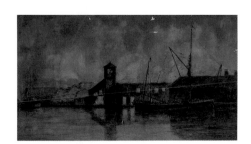

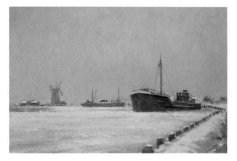

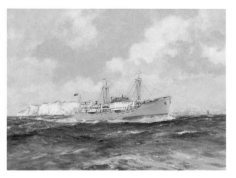

Marjoram, William 1859–1928
Fire at Jewsons' Timber Yard, Great Yarmouth
oil on board 44 x 68
GRYEH : 2004.162

Mason, Frank Henry 1876–1965
'Acclivity' on the Yare
oil on canvas 43 x 64
GRYEH : 2005.123

Mason, Frank Henry 1876–1965
'Georgina V. Everard' Passing Beachy Head
oil on canvas 45 x 63
GRYEH : 2005.8

Facing page: Baines, Thomas, 1820–1875, *Kaffirs and Rebel Hottentots Attacking a Wagon Train* (detail), 1854, King's Lynn Museums, (p. 55)

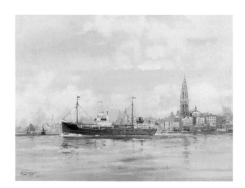

Mason, Frank Henry 1876–1965
'Saga City'
oil on canvas 49 x 64
GRYEH : 1969.416

Matthews
Harry Andrews, Yarmouth Violin Maker
c.1960
oil on board 61 x 50.5
GRYEH : 2005.77

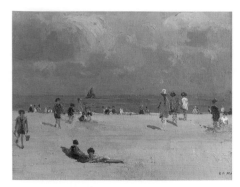

Mellon, Campbell A. 1876–1955
Late Afternoon, June 1927 1927
oil on board 22.8 x 30.5
GRYEH : 1961.76

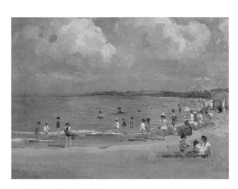

Mellon, Campbell A. 1876–1955
Late Afternoon, August 1926
oil on board 22.8 x 30.5
GRYEH : 1961.75

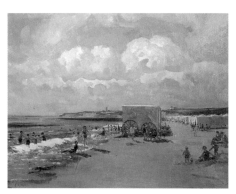

Mellon, Campbell A. 1876–1955
The Holiday Season
oil on canvas 49 x 60
GRYEH : 1961.74

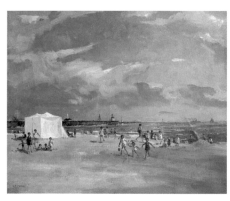

Mellon, Campbell A. 1876–1955
The South Wind, Gorleston
oil on canvas 51 x 61
GRYEH : 1956.130

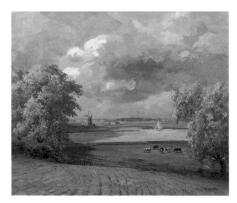

Mellon, Campbell A. 1876–1955
Willows, Burgh Castle
oil on canvas 49 x 60
GRYEH : 1961.79

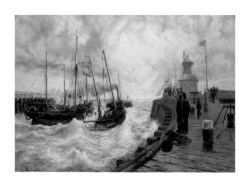

Miller, A. active 1880–1900
*Fishing Vessels Being Towed out of Yarmouth
Harbour by Steam Vessel* 1896
oil on canvas 60 x 106
GRYEH : 1956.244

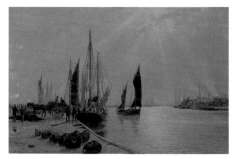

Miller-Marshall, T. active 1878–1925
Fish Wharf, Great Yarmouth 1896
oil on board 49.6 x 75.3
GRYEH : 1956.249

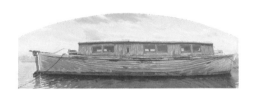

Moody, N.
House Boat c.1978
acrylic on hardboard 27.5 x 79
GRYEH : 1981.42

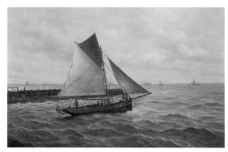

Moore, John of Ipswich 1820–1902
'Yarmouth Wolder' Leaving the Harbour 1892
oil on canvas 59.8 x 90.3
GRYEH : 1963.191

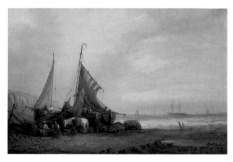

Moore, John of Ipswich 1820–1902
Boats on the Shore
oil on canvas 35 x 50
GRYEH : 2005.122

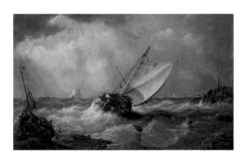

Moore, John of Ipswich 1820–1902
Rough Sea
oil on canvas 50 x 82
GRYEH : 1956.343

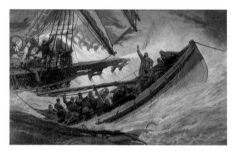

Nash, Joseph the younger 1835–1922
Lifeboat 'James Pearce' Rescuing Crew from a Shipwreck 1865–1878
oil on canvas 128 x 226
GRYEH : 1956.350

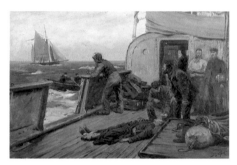

Nash, Joseph the younger 1835–1922
Casualty at Sea
oil on board 44.9 x 62.6
GRYEH : 1964.44

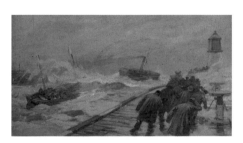

Nash, Joseph the younger 1835–1922
Lifeboat Being Towed out of Yarmouth Harbour
oil on board 47.1 x 62.4
GRYEH : 1964.43

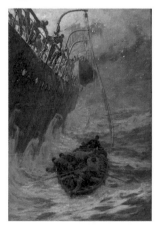

Nash, Joseph the younger 1835–1922
Sea Rescue
oil on board 50 x 34.5
GRYEH : 1964.28

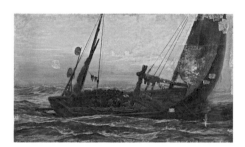

Nash, Joseph the younger 1835–1922
Sunday Afternoon at Sea
oil on canvas 110 x 187
GRYEH : 1956.351

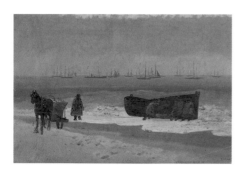

Nash, Joseph the younger 1835–1922
Yarmouth Beach
oil on paper 38.1 x 54.7
GRYEH : 1964.42

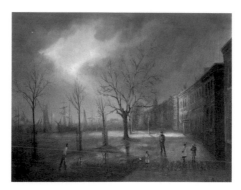

Palmer, Guy active 1900–1901
South Quay, Great Yarmouth, Looking North
1900
oil on canvas 44.5 x 60
GRYEH : 1956.183

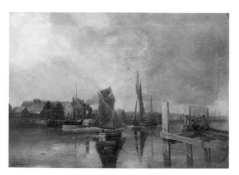

Palmer, Guy active 1900–1901
Towing out 1901
oil on canvas 55.5 x 76
GRYEH : 1956.322

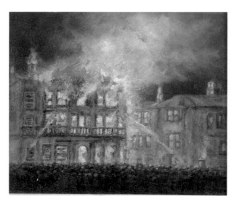

Palmer, Guy active 1900–1901
Goodes Hotel Fire
oil on canvas 18 x 23
GRYEH : 2005.103

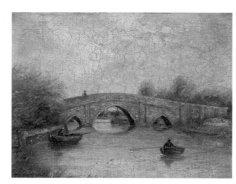

Palmer, Guy active 1900–1901
Potter Heigham Bridge
oil on canvas 22 x 29.5
GRYEH : 1963.76

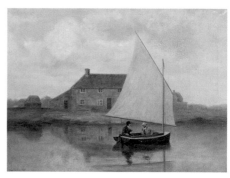

Palmer, Guy active 1900–1901
Two Men in a Dinghy
oil on canvas 44 x 60
GRYEH : 2005.65

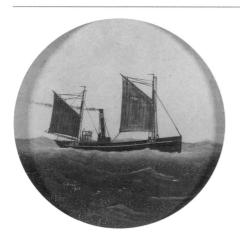

Race, George 1872–1957
'SS Never Can Tell' 1906
oil on board 21
GRYEH : 1967.294 (P)

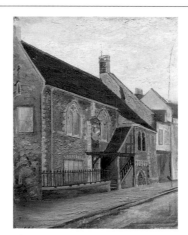

Ramsey, G. active 1856–1888
The Tolhouse c.1867
oil on canvas 22.8 x 17.9
GRYEH : 1965.31

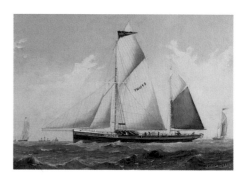

Ramsey, G. active 1856–1888
'Nell Morgan YH 1048' 1886
oil on board 40 x 56
GRYEH : 1986.35.3

Ramsey, G. active 1856–1888
The Tolhouse 1887
oil on canvas 38.4 x 28
GRYEH : 1962.25

Ramsey, G. active 1856–1888
The Fishermen's Hospital 1888
oil on canvas 23 x 18
GRYEH : 1961.214

Ramsey, G. active 1856–1888
The Tolhouse 1888
oil on canvas 23 x 18
GRYEH : 1961.213

Ramsey, G. active 1856–1888
The Tolhouse
oil on canvas 22 x 16
GRYEH : 1962.2522

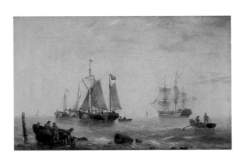

Redmore, Henry 1820–1887
Great Yarmouth Shipping Scene
oil on canvas 25 x 40
GRYEH : 2005.84

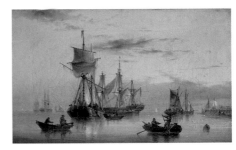

Redmore, Henry 1820–1887
Vessels at Sea
oil on canvas 25 x 40
GRYEH : 2005.85

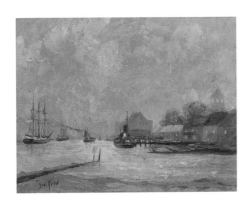

Reed, William Sidney
Darby's Hard 1937
oil on canvas 22.7 x 28.5
GRYEH : 1971.200

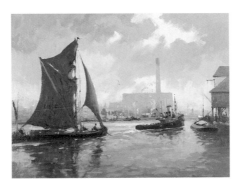

Reed, William Sidney
Power on the River
oil on board 41 x 62
GRYEH : 1985.60.1 (P)

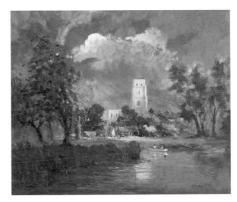

Reed, William Sidney
Storm over Beccles
oil on board 50 x 58
GRYEH : 1985.60.2 (P)

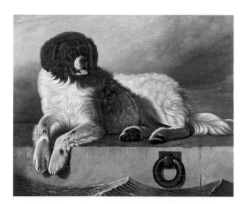

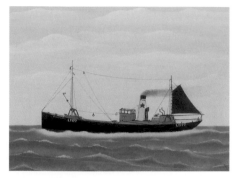

Reed, William Sidney
The Return of the Prodigal Son
oil on canvas 84 x 64
GRYEH : 1978.51

Ruggles, William Henry active 1833–1846
*A Distinguished Member of the Humane
Society*
oil on canvas 79 x 97
GRYEH : 1968.694

Saunders, John
'Kindred Star LT 177'
oil on board 33.7 x 43.8
GRYEH : 1976.27

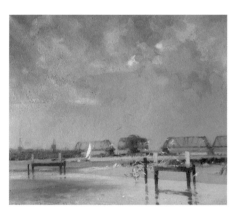

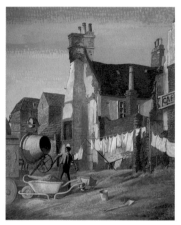

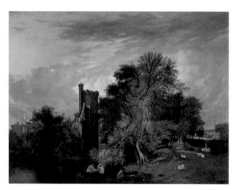

Seago, Edward Brian 1910–1974
Swing Bridge over Breydon
oil on canvas 50 x 60
GRYEH : 1956.177

Spencer, Noël 1900–1986
Row Demolition, Yarmouth
tempera on canvas 42 x 35
GRYEH : 1963.117

Stannard, Alfred 1806–1889
Caister Castle c.1832
oil on canvas 101.4 x 127.5
GRYEH : 1956.250

Stannard, Alfred 1806–1889
Burgh Castle c.1845
oil on canvas 52 x 78
GRYEH : 1956.133

Stannard, Alfred 1806–1889
Yarmouth Beach 1847
oil on canvas 102 x 127.9
GRYEH : 1999.7

Stannard, Alfred 1806–1889
Yarmouth Beach 1847
oil on canvas 45 x 62
GRYEH : 2005.119

Stannard, Joseph 1797–1830
Yarmouth Jetty c.1820–1830
oil on canvas 63.3 x 76.5
GRYEH : 1956.134 (P)

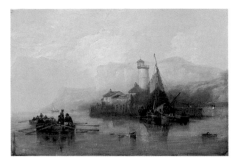

Stannard, Joseph 1797–1830
Tetley Water
oil on mahogany panel 42 x 60.5
GRYEH : 2004.166

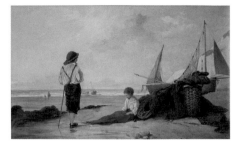

Stannard, Joseph (attributed to) 1797–1830
Beach Scene
oil on canvas 26 x 43
GRYEH : 2005.86

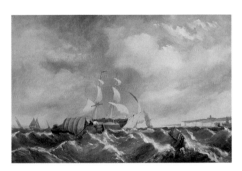

Stannard, Joseph (attributed to) 1797–1830
Shipping off Gorleston
oil on canvas 40 x 60
GRYEH : 1959.89

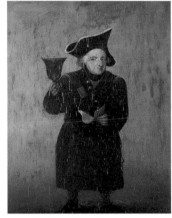

Swanborough
*Josiah Curtis, Bellman of Great
Yarmouth* c.1806
oil on panel 38.5 x 31.5
GRYEH : 1956.178

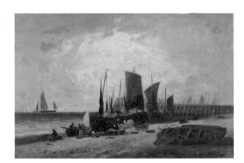

Syer, John 1815–1885
Yarmouth Jetty
oil on board 37.3 x 54.7
GRYEH : 1963.188

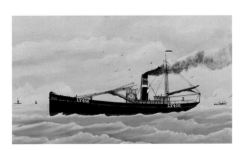

Tench, Ernest George 1885–1942
'Clara and Alice LT 456' 1909
oil on card 45 x 76.5
GRYEH : 1982.1

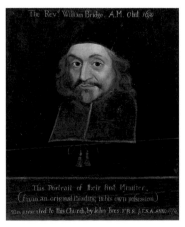

unknown artist
*Reverend William Bridge, First Minister of the
Unitarian Church in Great Yarmouth (copy of
17th C original by unknown artist)* 1774
oil on canvas & wood 44 x 36.5
GRYEH : 2002.76

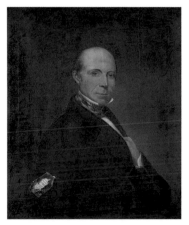

unknown artist
William North Burroughs 1846
oil on canvas 74.8 x 62
GRYEH : 1956.325

unknown artist
Great Yarmouth Suspension Bridge c.1860
oil on wood 52 x 88
GRYEH : 1956.108

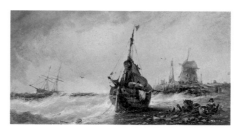

unknown artist late 19th C
Coastal Scene
oil on canvas on wood 28 x 44.5
GRYEH : 2002.48

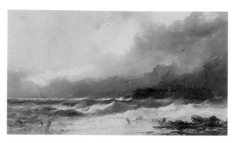

unknown artist late 19th C
Jetty at Great Yarmouth
oil on canvas on wood 28.3 x 42
GRYEH : 2002.49

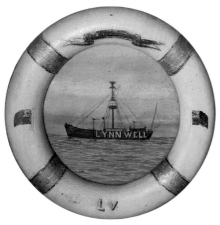

unknown artist
Lynn Well Lightship 1900–1925
oil on board 15
GRYEH : 1971.91 (P)

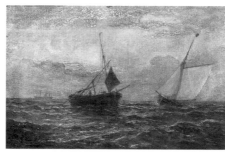

unknown artist
Sailing Luggers c.1900
oil on canvas 35 x 45
GRYEH : 2005.18

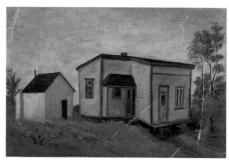

unknown artist
*Arthur Victor Buck's Accommodation in
Australia* before 1917
oil on canvas 20 x 30.5
GRYEH : 1987.30.28)

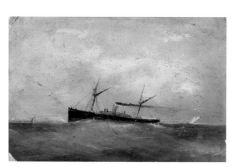

unknown artist
Steamer in Rough Sea c.1920
oil on board 100 x 127
GRYEH : 1958.24

unknown artist
Abstract
oil on canvas 91 x 121
GRYEH : 2005.79

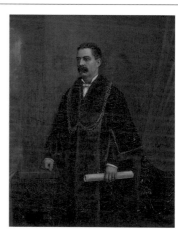

unknown artist
Alderman T. Burton Steward
oil on canvas 50 x 39
GRYEH : 2005.78

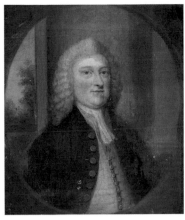

unknown artist
Anthony Taylor (1722–1795), Mayor of Yarmouth (1771)
oil on canvas 32 x 26
GRYEH : 1961.259

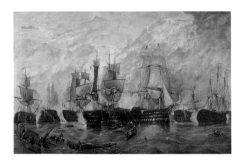

unknown artist
Battle of Trafalgar, 21st October 1805
oil on canvas 86.4 x 128.3
GRYEH : 2005.76

unknown artist
Bowl of Apples
oil on canvas 38.5 x 46
GRYEH : 2005.9

unknown artist
Burgh Castle Water Frolic
oil on board 17.4 x 56.4
GRYEH : 1973.196

unknown artist
Burgh Castle Water Frolic, Sunset Scene
oil on board 17.4 x 56.4
GRYEH : 1973.196.1

unknown artist
Caister Castle
oil on canvas 49 x 74.5
GRYEH : 2005.74

unknown artist
Captain Benjamin West
oil on canvas 75 x 62.5
GRYEH : 1956.324

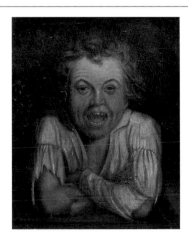

unknown artist
Character
oil on canvas 22 x 19.5
GRYEH : 2005.104

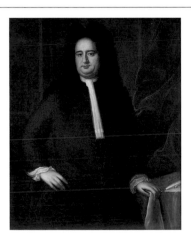

unknown artist
George England Esq., a Member of Parliament in Great Yarmouth
oil on canvas 127 x 100
GRYEH : 1956.340

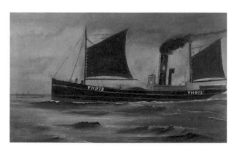

unknown artist
'Internos YH 973'
oil on canvas 30.5 x 51
GRYEH : 1977.253

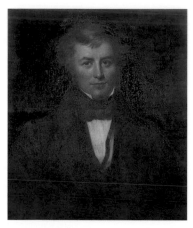

unknown artist
Isaac Preston
oil on canvas 75 x 63
GRYEH : 2005.73

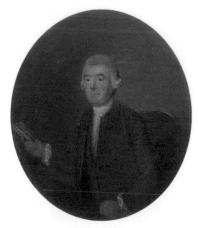

unknown artist
John Ives
oil on board 15.8 x 13
GRYEH : 1961.189

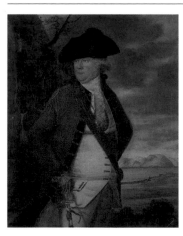

unknown artist
John Worship (1744–1805)
oil on canvas 124 x 100
GRYEH : 1961.263

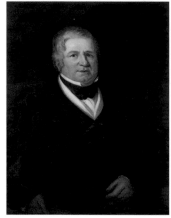

unknown artist
Joseph Grout, Founder of Grout and Co.,
Partner (1807–1852)
oil on paper on wood 91 x 70
GRYEH : 2003.178

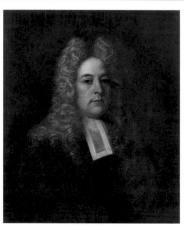

unknown artist
Portrait of a Clergyman Wearing a Wig
oil on canvas 74.8 x 62
GRYEH : 2005.64

unknown artist
Portrait of a Gentleman
oil on canvas 75 x 63
GRYEH : 1956.339

unknown artist
Portrait of a Gentleman
oil on canvas 34.5 x 29
GRYEH : 2005.69

unknown artist
Portrait of a Man in a Black Bow Tie
oil on canvas 61.5 x 52
GRYEH : 2005.72

Facing page: Wimhurst, Juliet, b.1940, *Strange Event in Chapelfield* (detail), 1998, City of Norwich Collection, (p.80)

unknown artist
Portrait of a Mayor
oil on canvas 77.7 x 63.3
GRYEH : 1956.326

unknown artist
Portrait of a Woman
oil on canvas 34.5 x 29
GRYEH : 2005.70

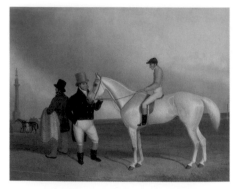

unknown artist
Racing Scene
oil on paper on wood 47 x 59
GRYEH : 2003.173

unknown artist
Religious Scene
oil on glass
GRYEH : 1963.118

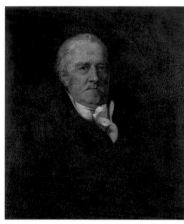

unknown artist
Robert Warmington
oil on canvas 74.8 x 62
GRYEH : 2005.80

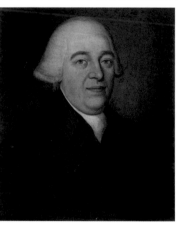

unknown artist
Samuel Tolver, Town Clerk (1822–1848)
oil on canvas 55 x 45.5
GRYEH : 1970.347

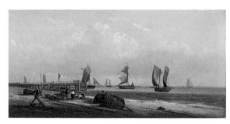

unknown artist
Shipping at Yarmouth Jetty
oil on canvas 30 x 59
GRYEH : 2005.82

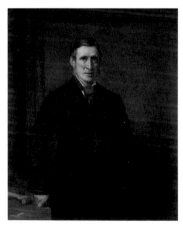

unknown artist
Sir James Paget
oil on canvas 127 x 100
GRYEH : 2005.71

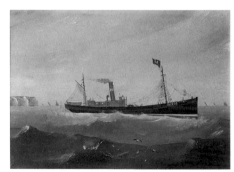

unknown artist
'SN 208'
oil on canvas 19 x 27
GRYEH : 1968.703

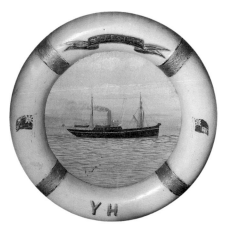

unknown artist
'SS Argus'
oil on board 13.5
GRYEH : 1970.348.2

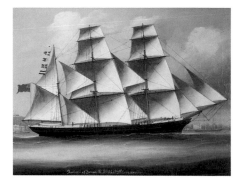

unknown artist
The Barque 'Frederica' of Yarmouth
oil on canvas 41.9 x 54.6
GRYEH : 1956.334

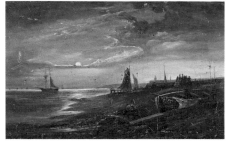

unknown artist
The Harbour's Mouth (Beach by Moonlight)
oil on board 30.2 x 48.6
GRYEH : 1965.32

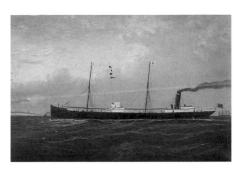

unknown artist
The 'Rich'
oil on canvas 46 x 65
GRYEH : 2005.81

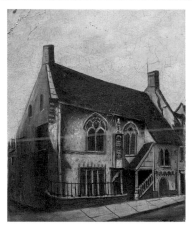

unknown artist
The Tolhouse
oil on board 30 x 25
GRYEH : 1966.40

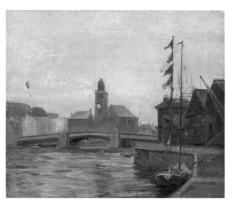

unknown artist
Town Hall and Haven Bridge, Great Yarmouth
oil on canvas 31 x 36
GRYEH : 2005.7

unknown artist
Vessels at Sea
oil on pine panel 23 x 28.7
GRYEH : 1981.106.3

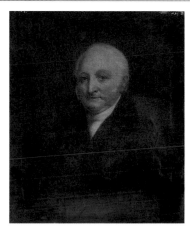

unknown artist
William Steward
oil on canvas 76 x 63.8
GRYEH : 1970.121

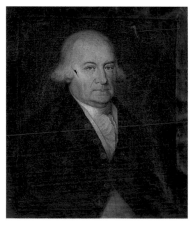

unknown artist
William Taylor (1755–1816)
oil on canvas 66 x 56
GRYEH : 1961.260

unknown artist
Woodland Scene with Swans
oil on board 61 x 24
GRYEH : 2005.19

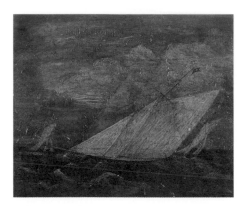

unknown artist
Yachts at Sea
oil on pine panel 23.1 x 28.8
GRYEH : 1981.106.2

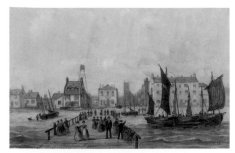

unknown artist
Yarmouth Front from the Jetty
oil on board 24.4 x 37.6
GRYEH : 1971.128

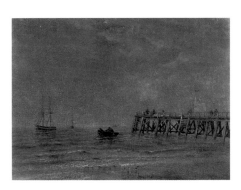

unknown artist
Yarmouth Jetty
oil on canvas 22.9 x 30.4
GRYEH : 1962.152

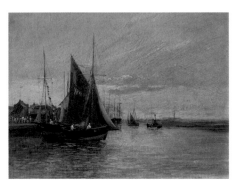

unknown artist
'YH 11' Leaving North Quay
oil 15 x 20
GRYEH : 2004.19

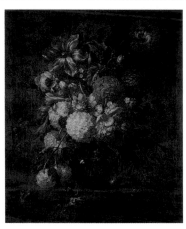

Verbruggen, Gaspar Peeter de II 1664–1730
Flower Piece
oil on canvas 81 x 69
GRYEH : 1966.45

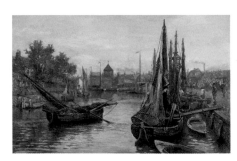

Verey, Arthur 1840–1915
Shrimpers on the Bure 1888
oil on canvas 78 x 112.5 (E)
GRYEH : 1956.338

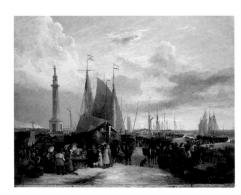

Vincent, George 1796–1831
Dutch Fair on Yarmouth Beach 1821
oil on canvas 67.3 x 102.5
GRYEH : 1956.136

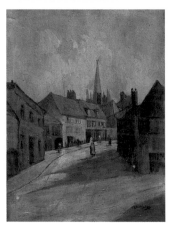

Watling, M.
Fullers Hill 1927
oil on board 21 x 15.5
GRYEH : 1963.199

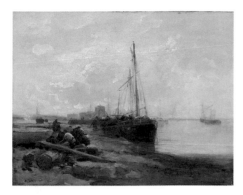

Webb, James c.1825–1895
River Scene
oil on canvas 31 x 39
GRYEH : 2005.6

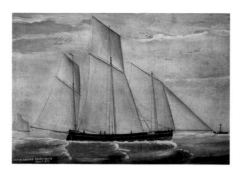

Westgate, W. H.
Dairymaid 'YH 181' 1852
oil on canvas 50 x 73
GRYEH : 1986.35.2

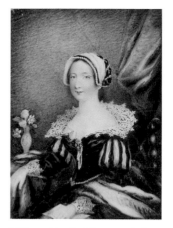

Wilson, Frederick Francis b.1901
Lady Jane Grey
oil on paper 14.9 x 10.6
GRYEH : 1960.81

Wilson, Geoffrey b.1920
Country Lane 1963
oil on board 24.1 x 34.5
GRYEH : 1963.113

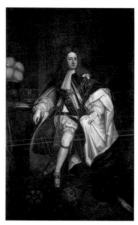

Worsdale, James c.1692–1767
George I (1660–1727)
oil on canvas 232 x 144
CP6

Great Yarmouth Port Authority

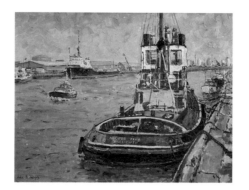

Applegate, John Stephen b.1935
Tug 'Hector Read'
oil on canvas 35.6 x 45.7
26

Chatten, Geoffrey b.1952
Great Yarmouth South Pier
oil on canvas 50.8 x 76.2
17

Fisher, Rowland 1885–1969
The Harbour Entrance 1908
oil on canvas 61 x 73.7
12

Goodall, Thomas Frederick
1856/1857–1944
View of Great Yarmouth
oil on canvas 45.7 x 96.5
13

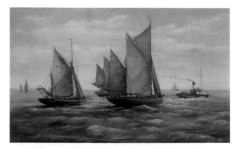

Lionel, Percy active 1890–1904
Fishing Smacks
oil on canvas 48.3 x 76.2
15

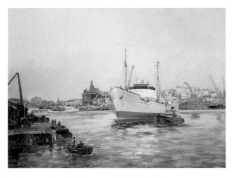

Mason, Frank Henry 1876–1965
'M. V. Speciality' Dry Docking at Great Yarmouth
oil on canvas 61 x 76.2
14

The Norfolk Nelson Museum

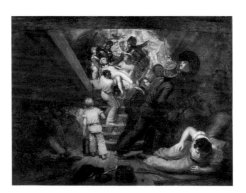

Drummond, Samuel 1765–1844
The Death of Nelson 1806
oil on canvas 133 x 160
BB:192

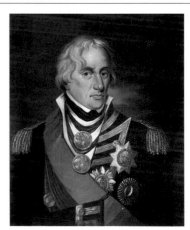

Keymer, Matthew 1764–1816
Lord Horatio Nelson (1758–1805)
oil on canvas 59.3 x 49.7
GYC.CP1

Royal Air Force
Air Defence Radar
Museum

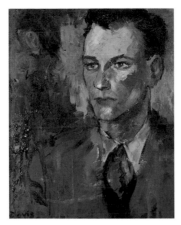

Davis
Squadron Leader H. G. Donald RAFVR 1942
oil on canvas 51 x 41 (E)
NEDAD 1998.147

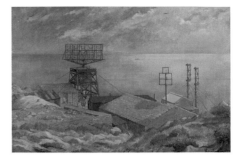

Rawlinson, William Thomas 1912–1993
A 'CHL' (Chain Home Low) Radar Station
1945
oil on canvas 50.8 x 76.2
IWM ART ld 5731

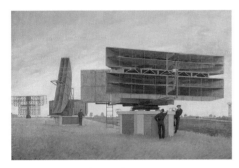

Rawlinson, William Thomas 1912–1993
*A 'Final' GCI (Grand Controlled Interception)
Radar Station* 1946
oil on canvas 50.8 x 76.2
IWM ART ld 5836

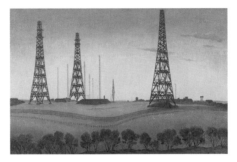

Rawlinson, William Thomas 1912–1993
*A 'Type CH' (Chain Home) Radar Station on
the West Coast* 1946
oil on canvas 50.8 x 76.2
IWM ART ld 5838

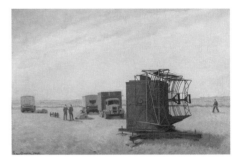

Rawlinson, William Thomas 1912–1993
A 'Type 11' Radar Station 1946
oil on canvas 50.8 x 76.2
IWM ART ld 5837

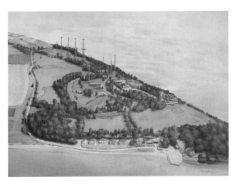

Thompson, Charles John b.1931
Radar Station, Bawdsey, Suffolk 2003
oil on canvas 91.5 x 152.5 (E)
NEDAD 2005.303

King's Lynn Arts Centre

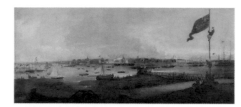

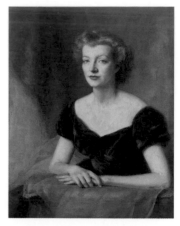

British (English) School
Regatta c.1840
oil on canvas 48 x 106.7
KLAC 1

Devas, Anthony 1911–1958
Ruth, Lady Fermoy (1908–1993) 1954
oil on canvas 91 x 71
KLAC 2 🐝

King's Lynn Corn Exchange

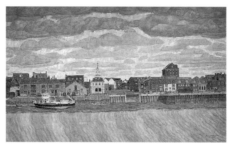

McComb, Leonard b.1930
View of King's Lynn from across the Great Ouse 2000
oil on canvas 142 x 229
AFS 1 (P)

King's Lynn Custom House

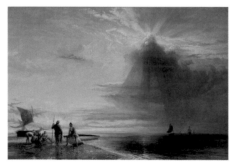

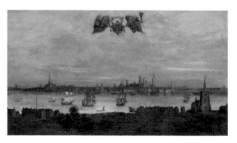

Baines, Henry 1823–1894
Sunset, Low Tide in the Wash
oil on canvas 72 x 105
KILLM : 1945.301.1

Bell, Henry 1647–1711
Prospect of Lynn from the West 1706
oil on canvas 66 x 107
KILLM : 1994.1237

King's Lynn Museums

The King's Lynn Museum was founded in 1844 by members of the Lynn Conversazione and Society of Arts. It was the second time it had been founded in Norfolk. The Museum's first home was Welwick House in South Lynn, and in 1854 it moved to the Athenaeum, now the site of the Post Office in Baxter's Plain. A further move happened in 1904 when the Museum arrived in the current Lynn Museum building, a Victorian non-conformist Baptist Chapel.

The King's Lynn Museums have significant collections of fine art, the majority of which have strong local associations. Art work by three local artists, Thomas Baines, Henry Baines, and Walter Dexter predominates, but there are also works by Henry Bell (1647–1711), James Sillett (1764–1840), Edward Edwards (1766–1849), William Taylor (1800–1861), George Laidman (1872–1954) and others (these paintings are not necessarily in oils and therefore do not feature in this catalogue).

Thomas Baines achieved fame as an explorer and prolific artist in southern Africa and Australia from the 1840s to the 1870s. Born in King's Lynn, John Thomas Baines was the eldest son of a master mariner. His first job was painting liveries on stage coaches. At the age of 22, Thomas travelled to Durban, South Africa, to visit an aunt. There he established himself as a portrait painter.

Thomas' adventurous spirit soon led him away from Durban into the less well-known parts of southern Africa. Everywhere he went he sketched and painted the peoples and lands he saw, including the natural fauna and flora. He recorded scenes during the wars with the African tribes of 1846 and went on his first expedition into the African interior in 1848. In 1850 Thomas went on a scientific expedition to map the location of Lake Ngam.

Thomas returned to England in 1853 and his war sketches were published. His reputation as an artist led to the Royal Geographical Society sending him on Augustus Gregory's expedition to northern Australia in 1854. His conduct, energy, and judgement were commended.

In 1858 Thomas returned to Africa as the artist and store-keeper on David Livingstone's Zambesi expedition. During the journey he painted a portrait on a piece of canvas from the expedition stores. Thomas was accused of stealing and dismissed from the expedition. Although he always denied any impropriety, this disgrace damaged his reputation.

Thomas lectured widely in England in the 1860s, finally returning to Zimbabwe in 1869 to search for gold. On losing his financial backing in 1870, he was forced to live out a meagre existence as an artist in Durban. In 1875, he was preparing another expedition to the gold fields when a suffered a bout of dysentry and died on 8th May. Oil paintings and drawings created during Baines' travels in southern Africa, as well as views of Lynn, reside in the Lynn Museum collections.

Another local artist represented in the Collection is Henry Baines, who was the younger brother of Thomas, and spent much of his life in the town, recording the historic buildings and scenes around the river and the docks in large oil paintings and sketches.

Henry served two years of an apprenticeship at sea, and went on to study art at the British Institution Life School in London. It was there he formed a friendship with the artist Edwin Landseer.

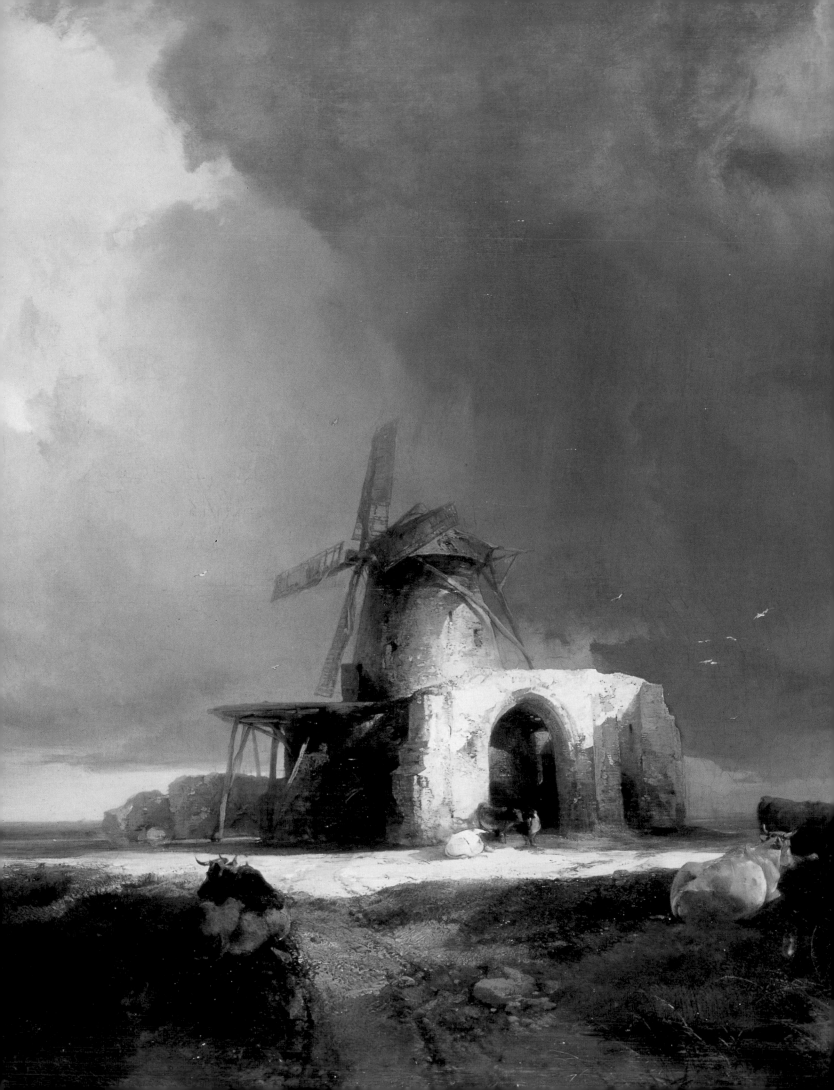

Following travels and further art training in Europe, Henry returned to King's Lynn in 1855 and set up his own Art Academy in Union Street. His own pictures consisted mainly of landscapes, topographical views, and coastal scenes. These works often included ships or fishing in or around Lynn. He was a prolific draughtsman and nearly 1,000 of his detailed sketches, watercolours, and oil paintings are now in the Museums' collections.

In his later years Henry Baines continued to travel and his sketches are known to include views of Antwerp, Edinburgh and various parts of East Anglia. He was an excellent copyist, imitating the styles of Rembrandt, Reynolds, Etty, Rubens and Hogarth.

Walter Dexter was born in Wellingborough and grew up in Lynn, where he was taught painting by Henry Baines. He studied at the Birmingham Municipal School of Art and the Royal Society of Artists in Birmingham. He visited the Low Countries and was influenced by the Pre-Raphaelites.

From the early 1900s Dexter concentrated on local landscapes, including the waterfront of King's Lynn. He exhibited at the Royal Academy and became a member of the Royal Society of British Artists.

Dexter illustrated a series of books and also designed posters and publicity material for companies such as the King's Lynn Docks and the Midland and Great Northern Railway. The first major exhibition of his work was held during the King's Lynn Festival of 1951. Dexter died in 1958 after being hit by a motorcycle in Lynn's Saturday Market Place.

Tim Thorpe, Curator

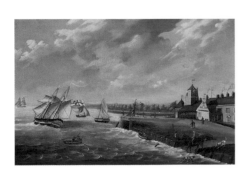

Ayre, John
The Pilot Office c.1740
oil on canvas 68.6 x 100.2
KILLM : 2004.72

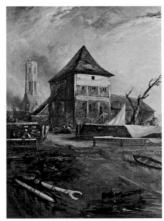

Baines, Henry 1823–1894
Old Oil Mill, King's Lynn 1840
oil on canvas 90 x 67
KILLM : 1965.96

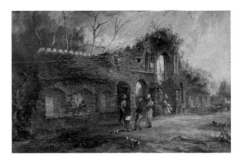

Baines, Henry 1823–1894
Gateway in the Walks 1843–1894
oil on canvas 36.5 x 52
KILLM : 1999.160

Facing page: Bright, Henry, 1814–1873, *Remains of St Benedict's Abbey on the Norfolk Marshes, Thunderstorm Clearing Off* (detail), 1847, Norwich Castle Museum and Art Gallery, (p.98)

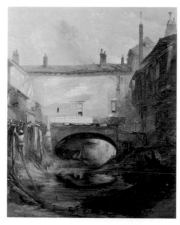

Baines, Henry 1823–1894
Inside the High Bridge, Purfleet, King's Lynn
1855
oil on canvas 35.5 x 30.5
KILLM : 2004.3

Baines, Henry 1823–1894
Kettle Mill, King's Lynn 1855
oil on canvas 35.5 x 30.5
KILLM : 2004.4

Baines, Henry 1823–1894
Quayside with St Margaret's 1855–1865
oil on canvas 84 x 64.5
KILLM : 1994.1173

Baines, Henry 1823–1894
Greenland Fishery Yard from the Rear 1857
oil on canvas 56.5 x 45.5
KILLM : 1958.11.76.1

Baines, Henry 1823–1894
Union Baptist Chapel, King's Lynn 1859
oil on canvas 48 x 40.5
KILLM : 2003.24

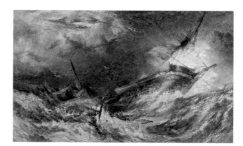

Baines, Henry 1823–1894
Wreck of 'The Glory' 1860
oil on canvas 65 x 104.5
KILLM : 1922.1617

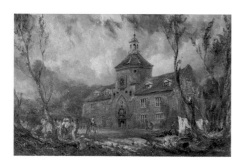

Baines, Henry 1823–1894
St James' Workhouse c.1860
oil on canvas 30 x 45
KILLM : 2005.64

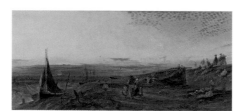

Baines, Henry 1823–1894
Sunset, North End 1862
oil on canvas 41 x 90
KILLM : 1975.438

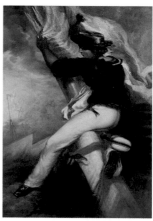

Baines, Henry 1823–1894
'The colours of old England he nail'd to the mast' 1864
oil on canvas 61 x 43.2
KILLM : 1970.25

Baines, Henry 1823–1894
Hut at Gray's Coal Yard on the Sea Bank 1865
oil on canvas 30 x 43
KILLM : 1994.1301

Baines, Henry 1823–1894
Dragging the Net 1880
oil on canvas 35.5 x 66.5
KILLM : 1994.1246

Baines, Henry 1823–1894
The 'Margaret of Christiana' (wrecked at Hunstanton, 1886) 1886
oil on canvas 33.5 x 48
KILLM : 1994.1251

Baines, Henry 1823–1894
Clifton House Tower
oil on canvas 57.5 x 41.5
KILLM : 1965.1

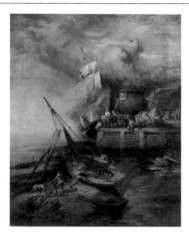

Baines, Henry 1823–1894
Common Staithe Quay
oil on canvas 62 x 51.5
KILLM : 1994.1299

Baines, Henry 1823–1894
Country Scene
oil on paper 92 x 80
KILLM : 1991.756

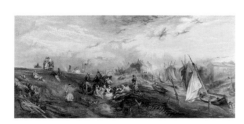

Baines, Henry 1823–1894
Fisher Fleet Looking East
oil on canvas 44 x 92
KILLM : 1994.1298

Baines, Henry 1823–1894
Friar's Gate (Carmelite Arch)
oil on canvas 36.5 x 53.5
KILLM : 1994.1250

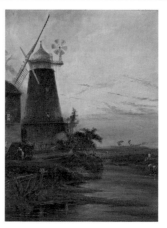

Baines, Henry 1823–1894
Gaywood Mill
oil on canvas 84 x 63.5
KILLM : 1994.1249

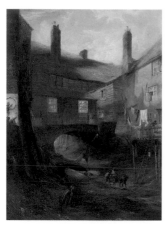

Baines, Henry 1823–1894
High Bridge, Purfleet
oil on canvas 91 x 68
KILLM : 1994.1174

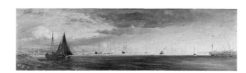

Baines, Henry 1823–1894
King's Lynn from West Lynn, 1892
oil on canvas 21 x 76
KILLM : 1994.1155

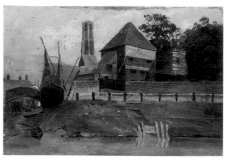

Baines, Henry 1823–1894
Millfleet with Greyfriars Tower and Tar Office
oil on paper 13 x 18.5
KILLM : 2001.146

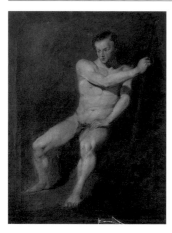

Baines, Henry 1823–1894
Nude Man
oil on canvas 58 x 45
KILLM : 1994.1160

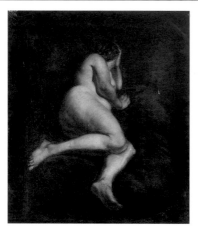

Baines, Henry 1823–1894
Nude Woman
oil on canvas 49 x 42
KILLM : 1994.1159

Baines, Henry 1823–1894
Rainbow over Ely
oil on canvas 19 x 69.9
KILLM : 1994.1158

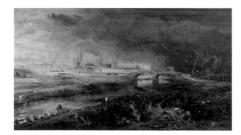

Baines, Henry 1823–1894
Rainbow over Ely
oil on canvas 56 x 95
KILLM : 1994.1247

Baines, Henry 1823–1894
Ship on Seascape
oil on paper 19 x 82
KILLM : 1991.755

Baines, Henry 1823–1894
The Old Cut Bridge
oil on canvas 28 x 47
KILLM : 1903.1174

Baines, Thomas 1820–1875
Hogsback 1851–1852
oil on board 22 x 27.5
KILLM : 1994.1244

Baines, Thomas 1820–1875
Bloemfontein 1852
oil on canvas 38 x 61
KILLM : 1994.1245

Baines, Thomas 1820–1875
Scenery and Events in South Africa 1852
oil on paper 65 x 51.5
KILLM : 1854.971

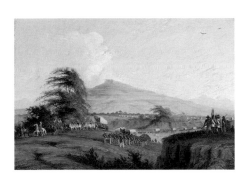

Baines, Thomas 1820–1875
*Forces under the Command of Lieutenant
General Cathcart Crossing the Orange River to
Attack Moshesh, 1852* 1854
oil on canvas 31.5 x 44
KILLM : 1980.9

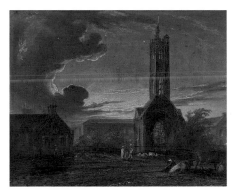

Baines, Thomas 1820–1875
Greyfriars Tower 1854
oil on canvas 21 x 26
KILLM : 1932.19

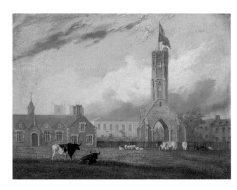

Baines, Thomas 1820–1875
Greyfriars Tower 1854
oil on millboard & card 43 x 49.5
KILLM : 1999.161

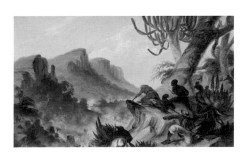

Baines, Thomas 1820–1875
*Kaffirs and Rebel Hottentots Attacking a
Wagon Train* 1854
oil on canvas 38 x 61
KILLM : 1994.1243

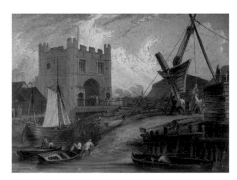

Baines, Thomas 1820–1875
South Gates, Lynn 1854
oil on canvas 26.5 x 36
KILLM : 1994.1300

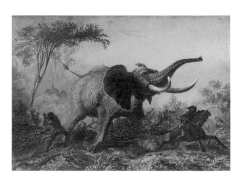

Baines, Thomas 1820–1875
Elephant Hunting with the Sword, Abyssinia
1867
oil on canvas 45.5 x 66
KILLM : 1975.443

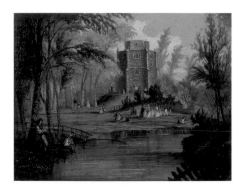

Baines, Thomas 1820–1875
Red Mount
oil on board 20 x 27
KILLM : 2005.65

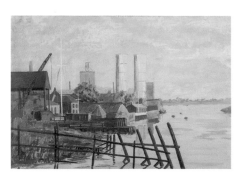

Bocking, William
King's Lynn and River Great Ouse Facing South 1965
oil on board 53.5 x 75
KILLM : 2002.104.1

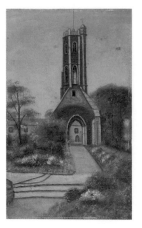

Borrmann, Thomas active 1900–1910
Greyfriars Tower 1900–1910
oil on board 31.5 x 19
KILLM : 1968.36.2

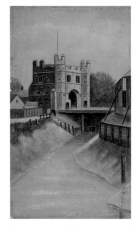

Borrmann, Thomas active 1900–1910
South Gates 1900–1910
oil on board 32 x 19
KILLM : 1968.36.1

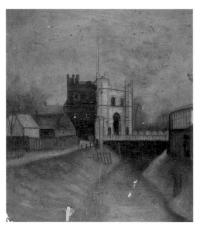

Borrmann, Thomas active 1900–1910
South Gates 1900–1910
oil on board 35 x 30
KILLM : 2000.133

Borrmann, Thomas active 1900–1910
Gateway in the Walks 1910
oil on board 40.5 x 53
KILLM : 2003.40.2

Borrmann, Thomas active 1900–1910
Greyfriars Tower 1910
oil on board 53 x 40.5
KILLM : 2003.40.1

Borrmann, Thomas active 1900–1910
South Gates 1910
oil on board 53 x 40.5
KILLM : 2003.40.3

Borrmann, Thomas active 1900–1910
Lynn Scene, Fisher Fleet
oil on board 30 x 45
KILLM : 1973.155

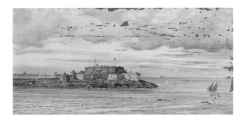

Brett, John 1830–1902
Castle Cornet, Guernsey
oil on canvas 18 x 36
KILLM : 1994.130

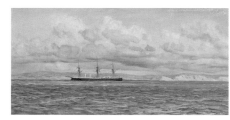

Brett, John 1830–1902
'HMS Northumberland'
oil on canvas 18 x 35
KILLM : 1994.1156

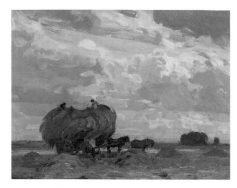

Brown, John Alfred Arnesby 1866–1955
The Hayfield 1910
oil on canvas 36 x 46
KILLM : 1994.129

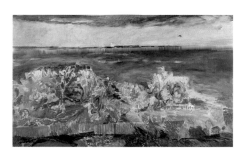

Camp, Jeffery b.1923
Black North Sea 1959
oil on board 76 x 122
KILLM : 1994.1303

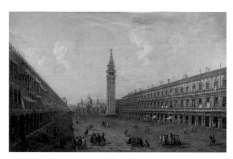

Canaletto (school of) 1697–1768
St Mark's, Venice
oil on canvas 80 x 125
KILLM : 1994.1242

Closterman, John (after) 1660–1711
Charles Turner, Mayor of Lynn (1694–1706)
c.1700
oil on canvas 119 x 101
KILLM : 2005.70

Closterman, John (after) 1660–1711
Charles Turner, Mayor of Lynn (1694–1706)
oil on canvas 127 x 102
KILLM : 1980.262.2

Closterman, John (after) 1660–1711
Sir John Turner
oil on canvas 73 x 61
KILLM : 1980.262.1

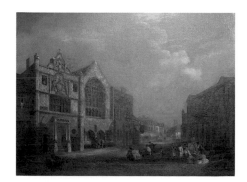

Cotman, John Sell 1782–1842
Town Hall, King's Lynn 1820
oil on canvas 75.5 x 102
KILLM : 1982.113

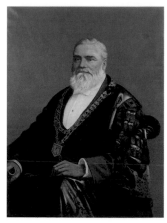

Dante, M.
Frederick Savage 1897
oil on canvas 102 x 76
KILLM : 1965.14

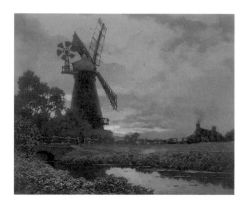

Dexter, Walter 1876–1958
Gaywood Mill 1920
oil on canvas 25.5 x 36.5
KILLM : 1980.266

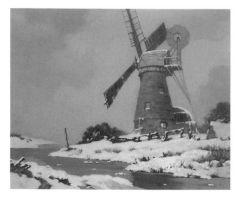

Dexter, Walter 1876–1958
A Winter Afternoon 1922
oil on canvas 25.5 x 30.5
KILLM : 1980.266.2

Dexter, Walter 1876–1958
Helen Dexter, the Artist's Wife c.1925
oil on canvas 55 x 39
KILLM : 1966.4

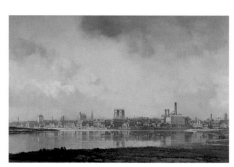

Dexter, Walter 1876–1958
Lynn from the South West 1930–1933
oil on canvas 61.5 x 91
KILLM : 1994.1241

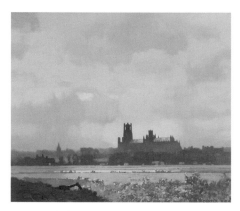

Dexter, Walter 1876–1958
Ely from Middle Fen 1935
oil on canvas 24.5 x 29
KILLM : 1969.90

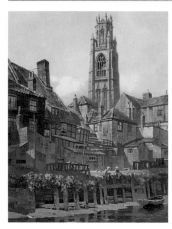

Dexter, Walter 1876–1958
Boston Stump
oil on canvas 46 x 36
KILLM : 1992.801

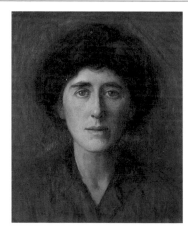

Dexter, Walter 1876–1958
Helen Dexter, the Artist's Wife
oil on canvas 30.5 x 26
KILLM : 1966.30

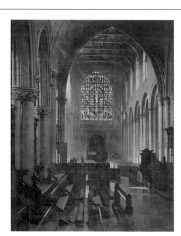

Dexter, Walter 1876–1958
Interior of St Margaret's Church
oil on canvas 51 x 41
KILLM : 1967.113

Dexter, Walter 1876–1958
Landscape Near King's Lynn (possibly East Winch)
oil on canvas 45 x 59
KILLM : 1970.102

Dexter, Walter 1876–1958
Landscape Studies
oil on board 13 x 21.5
KILLM : 1991.490

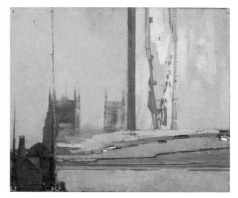

Dexter, Walter 1876–1958
Marsh Landscapes, St Margaret's Church, King's Lynn
oil on canvas 24 x 29
KILLM : 1977.260.317

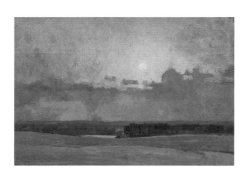

Dexter, Walter 1876–1958
Moonlit Landscape
oil on card 21 x 29
KILLM : 1977.260.320

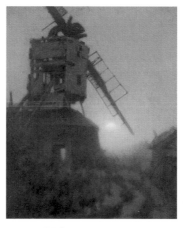

Dexter, Walter 1876–1958
Moonrise
oil on canvas 38 x 33
KILLM : 1994.1239

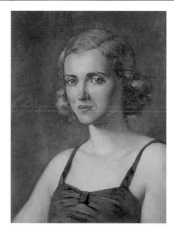

Dexter, Walter 1876–1958
Mrs Chadwick
oil on canvas 49.5 x 39
KILLM : 1967.31

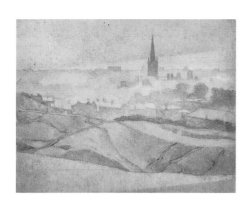

Dexter, Walter 1876–1958
Norwich from Mousehold
oil on hardboard 18 x 22
KILLM : 1991.489.1

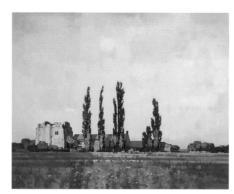

Dexter, Walter 1876–1958
Pentney Priory
oil on canvas 41 x 51
KILLM : 1972.74

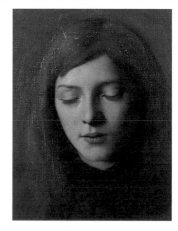

Dexter, Walter 1876–1958
Portrait of a Lynn Fishergirl
oil on canvas 26 x 20
KILLM : 1975.439

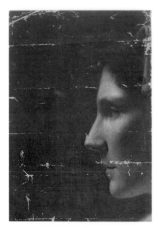

Dexter, Walter 1876–1958
Portrait of a Woman
oil on paper 32 x 19.5
KILLM : 1977.260.1

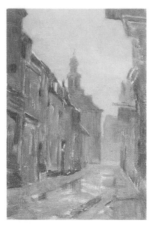

Dexter, Walter 1876–1958
Purfleet Street, King's Lynn
oil on board 25 x 18 (E)
KILLM : 1977.260.315

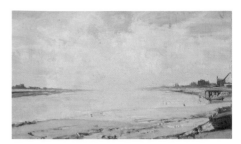

Dexter, Walter 1876–1958
River Great Ouse
oil on board 10 x 17
KILLM : 1977.260.316

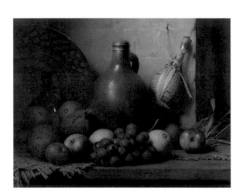

Dexter, Walter 1876–1958
Still Life
oil on canvas 35 x 46
KILLM : 1994.1238

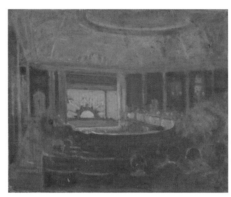

Dexter, Walter 1876–1958
Theatre Scene
oil on canvas
KILLM : 1966.30.3

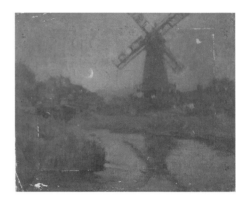

Dexter, Walter 1876–1958
Windmill by Moonlight
oil on canvas 25 x 30
KILLM : 1977.260.319

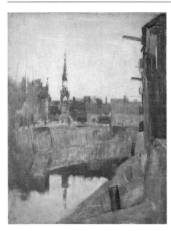

Dexter, Walter 1876–1958
Wisbech
oil on canvas 30 x 23
KILLM : 1966.30.2

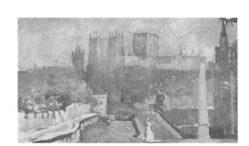

Dexter, Walter 1876–1958
York Minster and Walls
oil on card 12 x 21
KILLM : 1977.260.321

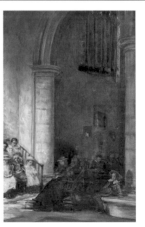

Gemmath, Mary
The Sunday School, Heacham
oil on canvas 52 x 33.5
KILLM : 1973.44

Facing page: Seago, Edward Brian, 1910–1974, *The Dark Canal, Venice* (detail), 1940, Norwich Castle Museum and Art Gallery, (p.185)

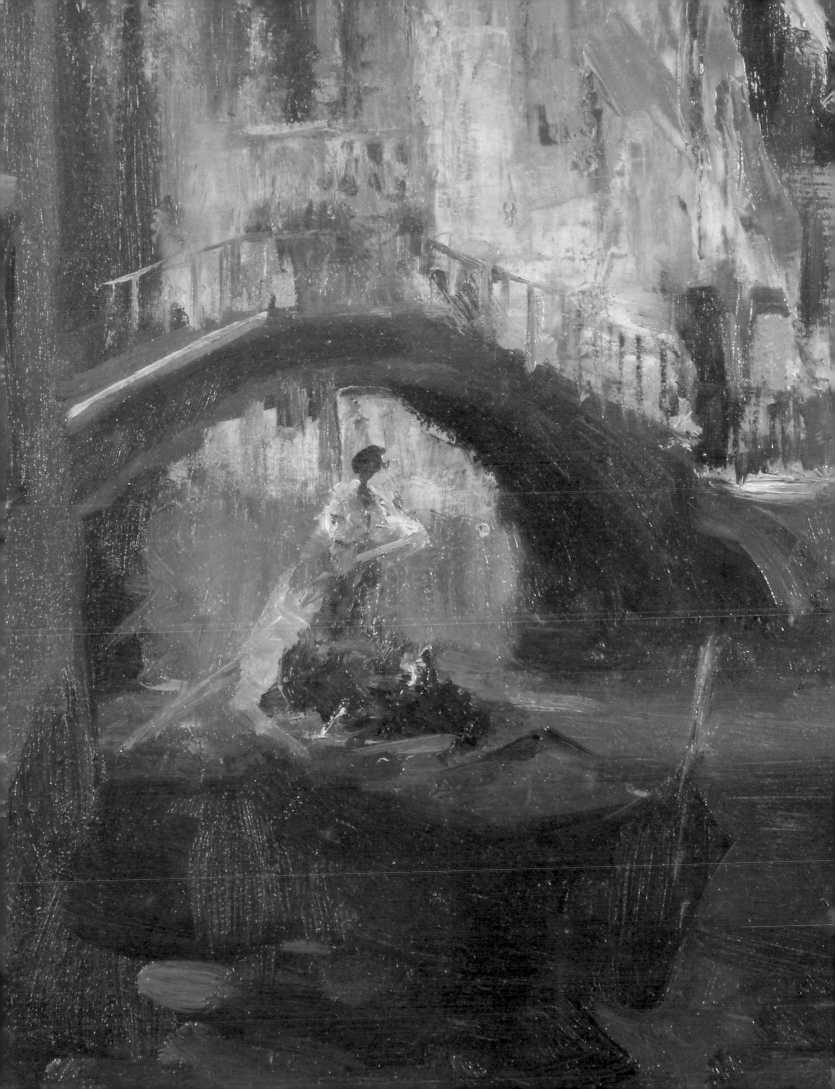

Gosling, Edward
Ruskin School, Heacham 1920
oil on canvas 33 x 43
KILLM : 1996.145

Green, George Colman b.1877
Downham Market 1912
oil on canvas 44 x 87
KILLM : 1994.1302

Hinton, Brian active 1955–c.1970
Mr Johnson at the Lathe, Savages 1955
oil on board 95.5 x 111
KILLM : 1991.1034

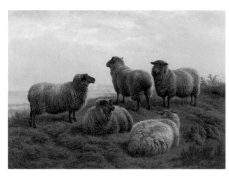

Jones, Charles 1836–1892
Sheep on a Hillside 1876
oil on canvas 36 x 51
KILLM : 1999.455

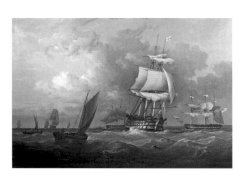

Joy, William 1803–1867
'HMS Victory' Entering Portsmouth, 1844
oil on canvas 88 x 131
KILLM : 1985.174

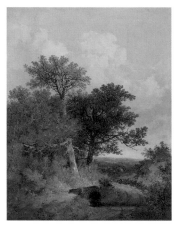

Ladbrooke, John Berney 1803–1879
A Bridge 1874
oil on canvas 61 x 48
KILLM : 1994.1168

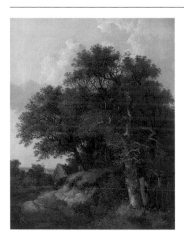

Ladbrooke, John Berney 1803–1879
Cottage and Trees
oil on canvas 61 x 48.5
KILLM : 1994.1167

Lane, Samuel 1780–1859
William Swatman c.1820
oil on canvas 22 x 17
KILLM : 2005.66

Lane, Samuel 1780–1859
Frederick Lane
oil on panel 29.8 x 24.8
KILLM : 1994.126 : F

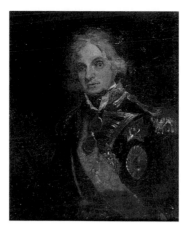

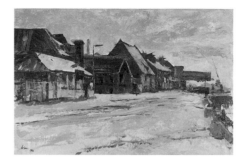

Lane, Samuel 1780–1859
Henry Self
oil on board 22 x 17
KILLM : 2001.257

Lane, Samuel 1780–1859
Horatio Nelson (1758–1805)
oil on wood 20.5 x 17
KILLM : 1999.440

Lefevre, Geoffrey
South Quay No.2 1966
oil on board 61 x 91.4
KILLM : 1969.44

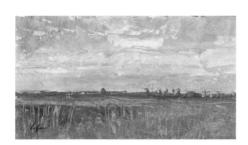

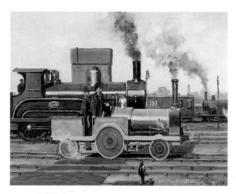

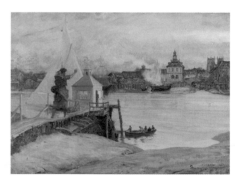

Lefevre, Geoffrey
Evening on the Marsh
oil on board 30.5 x 46.8
KILLM : 1985.175.1

Lilley (Reverend), Ivan active 1979–1980
Gazelle 1980
oil on board 35.5 x 45.5
KILLM : 1980.187

Macbeth, Robert Walker 1848–1910
Too Late for the Ferry 1882
oil on canvas 47.5 x 65
KILLM : 1994.1236

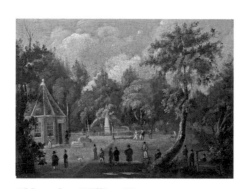

Nurse, Charles Baxter active 1895–1915
H. J. Hillen
oil on canvas 77 x 64
KILLM : 1994.1164

Oldmeadow, William H.
Ressley Spring 1818
oil on canvas 30 x 40
KILLM : 2005.68

Pickford, William
Kettle Mills
oil on canvas 71 x 91.5
KILLM : 1994.128.1

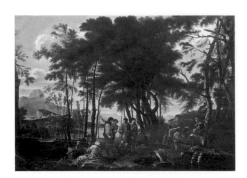

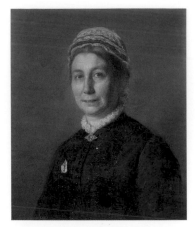

Pickford, William
Kettle Mills
oil on canvas 47 x 65
KILLM : 1994.128.2

Rosa, Salvator (after) 1615–1673
Wood of the Philosophers 1800–1830
oil on canvas 120 x 150
KILLM : 2000.372

Schmitt, Guido Philipp 1834–1922
Sarah Ingleby 1884
oil on canvas 61 x 51
KILLM : 1994.1163

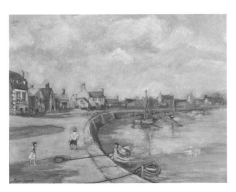

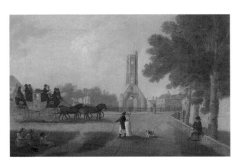

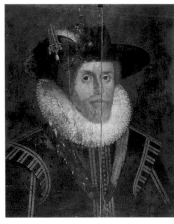

Serjeant, G.
The Quay, Wells
oil on canvas 35 x 44
KILLM : 1988.69.1

Sillett, James 1764–1840
Norwich Stagecoach at King's Lynn 1813
oil on canvas 34.5 x 58.5
KILLM : 2002.2

Somer, Paulus van I 1576–1621
James I (1566–1625)
oil on wood 73 x 58
KILLM : 2000.388

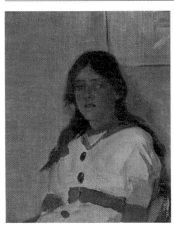

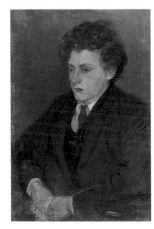

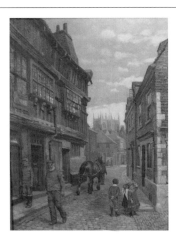

Southgate, Frank 1872–1916
Elaine Auger
oil on canvas 27 x 22
KILLM : 1996.143

Southgate, Frank 1872–1916
Gordon Lowerison
oil on canvas 62 x 40
KILLM : 1996.144

Tamlin, J. H. P. active 1903–1911
Greenland Fishery 1911
oil on canvas 61 x 46
KILLM : 1911.1465

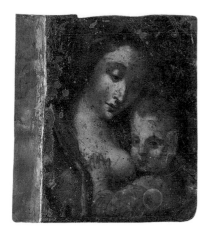

unknown artist 17th C
Mother and Child
oil on copper 14 x 12.5
KILLM : 1978.294

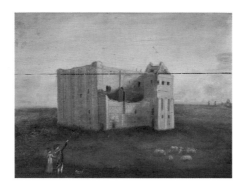

unknown artist
Castle Rising 1740–1830
oil on wood 53 x 69
KILLM : 1994.1157

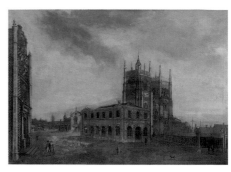

unknown artist
St Margaret's and Saturday Market Place 1800
oil on canvas 46.5 x 63
KILLM : 1994.1233

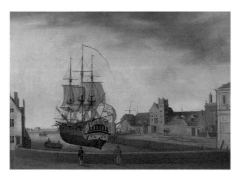

unknown artist
The Purfleet 1800
oil on canvas 60 x 80
KILLM : 1977.190

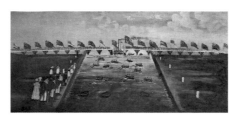

unknown artist
*A View of the Procession on the Opening
of the New Eaubrink Cut in the County of
Norfolk* 1800–1820
oil on canvas 66 x 127
KILLM : 2004.73

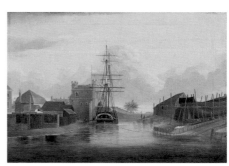

unknown artist
The Friar's Fleet Boatyard and South Gates
1800–1820
oil on canvas 38 x 53
KILLM : 2004.7

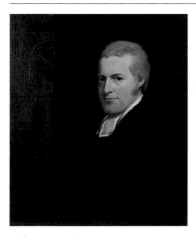

unknown artist
Reverend Edward Edwards c.1800
oil on canvas 77 x 64
KILLM : 1994.1232

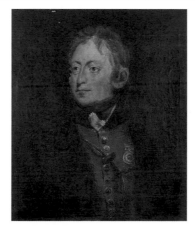

unknown artist
Captain Manby (1765–1854) 1820
oil on board 97.8 x 85
KILLM : 2004.71

unknown artist
An Enormous Sheep 1850
oil on canvas 49 x 65
KILLM : 1967.34

unknown artist
A Market Square (possibly Wymondham)
oil on wood 38 x 46
KILLM : 1994.127

unknown artist
Burnham Thorpe Church
oil on canvas 29 x 38
KILLM : 1962.81

unknown artist
Captain Manby (1765–1854)
oil on canvas 45.5 x 35.5
KILLM : 1994.1230

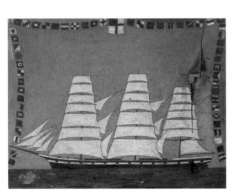

unknown artist
Clipper
oil on canvas 49.5 x 57.5
KILLM : 1970.46

unknown artist
Elizabeth Cooper (1718–1739)
oil on wood 11 x 9.5
KILLM : 2005.69

unknown artist
Francis John Lake
oil on canvas 61 x 51
KILLM : 1983.55

unknown artist
Greyfriars
oil on canvas 37 x 53.5
KILLM : 2000.132

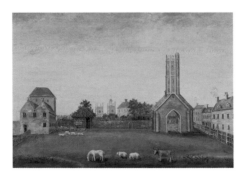

unknown artist
Greyfriars Tower
oil on wood 51 x 71
KILLM : 1994.1234

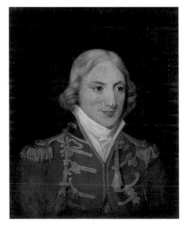

unknown artist
Horatio Nelson (1758–1805)
oil on canvas 46.5 x 36
KILLM : 1994.1231

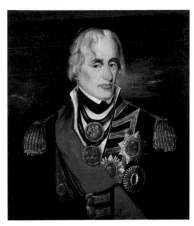

unknown artist
Horatio Nelson (1758–1805) (copy of Matthew Keymer)
oil on canvas 60.5 x 53
KILLM : 1994.1229

unknown artist
John Pinn, Local Character
oil on canvas 51 x 39
KILLM : 2000.134

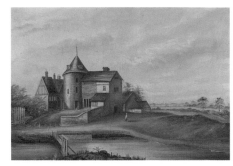

unknown artist
Kettle Mills
oil on canvas 49.5 x 70
KILLM : 1994.1235

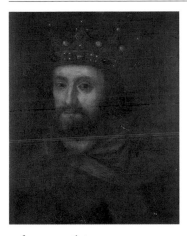

unknown artist
King John (1167–1216)
oil on canvas 58 x 46.5
KILLM : 1978.216

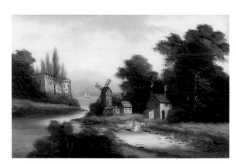

unknown artist
Landscape with Windmill
oil on glass 40.5 x 61
KILLM : 1985.99.7

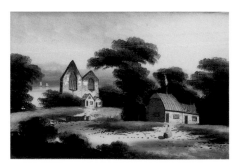

unknown artist
Landscape, Cottage and Chapel
oil on glass 40.5 x 61
KILLM : 1985.99.6

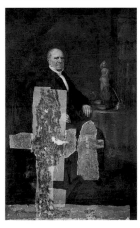

unknown artist
Mr Weston Jarvis
oil on canvas 240 x 146
KILLM : 1844.1695A

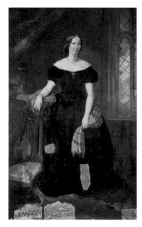

unknown artist
Lady Weston Jarvis
oil on canvas 235 x 145
KILLM : 1844.1695B

unknown artist
Portrait of a Man
oil on canvas 74 x 65.5
KILLM : 1994.1171

unknown artist
Portrait of a Man
oil on canvas 74 x 56
KILLM : 1994.1172

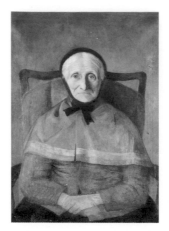

unknown artist
Portrait of an Old Woman
oil on canvas 65 x 46
KILLM : 1977.321

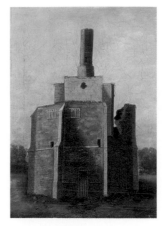

unknown artist
Red Mount
oil on canvas 61 x 51
KILLM : 1994.1161

unknown artist
Red Mount
oil on canvas 50.5 x 61
KILLM : 2005.91

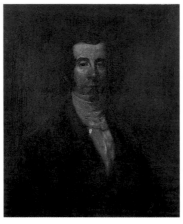

unknown artist
Roger Le Strange
oil on canvas 77 x 64
KILLM : 1981.76

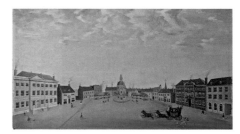

unknown artist
Tuesday Market
oil on canvas 74.9 x 127
KILLM :2005.67

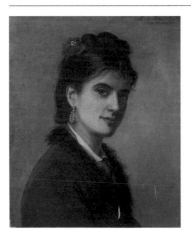

Weiler, Lina van b.1857
Mrs Laurence Oliphant 1872
oil on canvas 46 x 38
KILLM : 1969.84

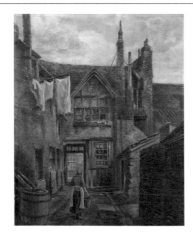

White, J. T.
Greenland Fishery Yard from the Rear 1917
oil on canvas 50.5 x 40.5
KILLM : 1994.1162

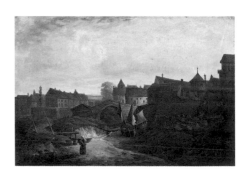

Winearls, S.
Fisher Fleet Looking East 1869
oil on canvas 51 x 73
KILLM : 1994.1165

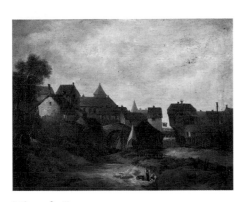

Winearls, S.
Fisher Fleet Looking West 1869
oil on canvas 48 x 60
KILLM : 1994.1166

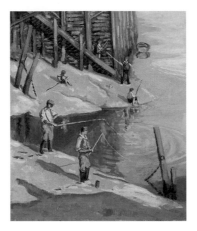

Winter, Alexander Charles b.1887
Fisher Fleet
oil on canvas 56.5 x 46
KILLM : 1994.1169

King's Lynn Town Hall

King's Lynn was granted its first royal charter by King John in 1204, becoming a 'free borough forever'. The charter gave the burgesses the right to have a 'gild merchant', a role assumed by the Trinity Guild whose members were to dominate the economic and political life of medieval Lynn.

The present Trinity Guildhall dates from the first half of the fifteenth century. The Town Council held its meetings in its hall and following the suppression of the Guild was granted the building by King Edward VI in 1548. It was later extended by the addition of the Assembly and Card Rooms in the 1760s, the Gaol House in 1784 and the Municipal Building in 1895.

The Collection principally encompasses portraits of mayors, monarchs and members of parliament which form an important decorative element in the historic suite of rooms. There are also portraits of the novelist and diarist Fanny Burney and the naval officer and explorer George Vancouver, both born in King's Lynn.

One of the most striking portraits is that of Sir Robert Walpole hanging in the Assembly Room. He is depicted in the robes of the Order of the Garter, an honour he received in 1726. Walpole, regarded as our first Prime Minister, represented King's Lynn in Parliament from 1702 until 1742. He built nearby Houghton Hall and formed an important collection of old masters, later sold to Catherine the Great of Russia.

The Collection contains eight portraits by Samuel Lane. Samuel was born in Lynn, the son of the Collector of Customs, but an accident in childhood resulted in deafness and difficulty with speech. He studied under Joseph Farrington and later under Sir Thomas Lawrence, who employed him as a chief assistant. Lane first exhibited at the Royal Academy in 1804 and was a constant contributor for over 50 years. Lane's first contributions to the Collection were copies of the portraits of George III by Reynolds and of Norfolk's hero, Lord Nelson by Hoppner. His finest painting in the Town Hall is the prime version of the portrait of Lord George Cavendish Bentinck, racehorse owner and member of parliament for the borough.

David Pitcher, Assistant Custodian

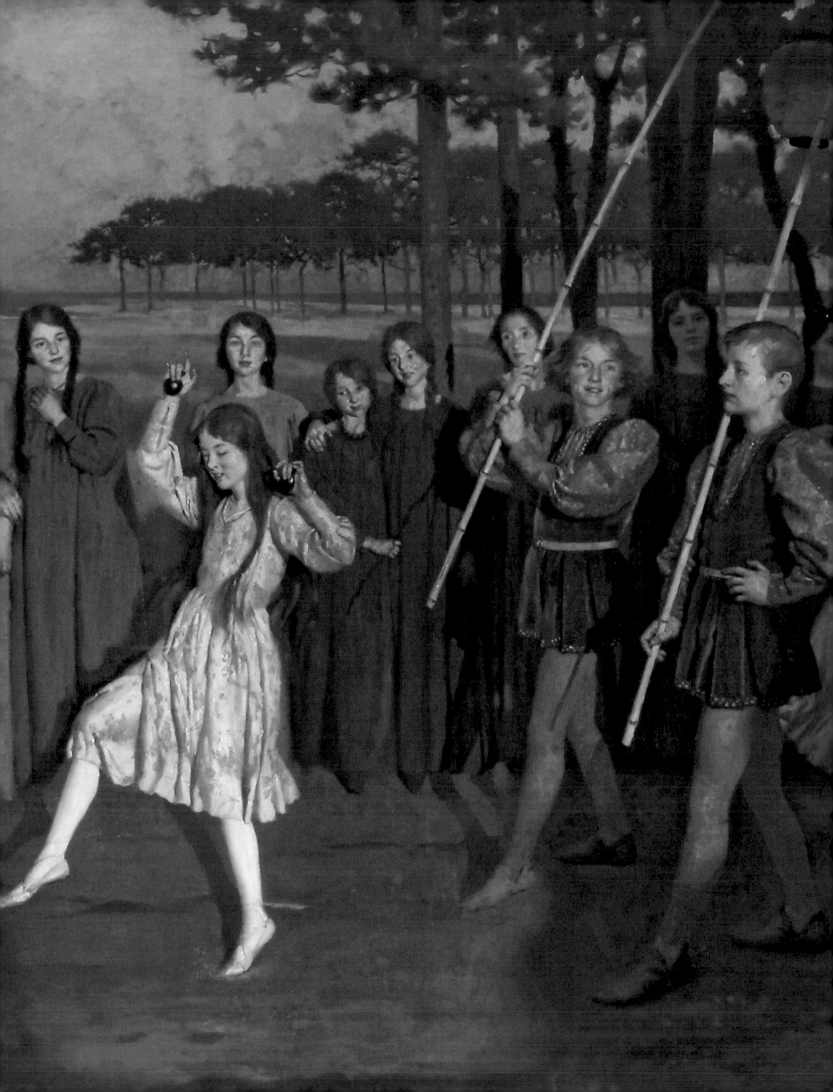

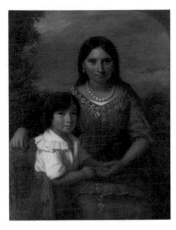

American School
Pocahontas and Her Son Thomas Rolfe c.1800
oil on canvas 105 x 81.3
KLTH 45

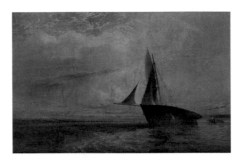

Baines, Henry 1823–1894
Fishing Smack on the Shore
oil on canvas 67.7 x 102.2
KILLM : 2005.4

Beresford, Frank Ernest 1881–1967
King George VI (1895–1952) 1937
oil on canvas 99.6 x 74.7 (E)
KLTH 42

Beresford, Frank Ernest 1881–1967
Queen Elizabeth (1900–2002) 1937
oil on canvas 99.7 x 74.6 (E)
KLTH 43

British (English) School
William Atkins, Mayor (1619–1620) c.1619
oil on panel 78.4 x 58.8
KLTH 1

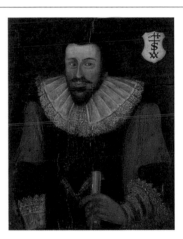

British (English) School
Thomas Snelling, Mayor (1622–1623) c.1622
oil on canvas laid on panel 65.4 x 52
KLTH 2

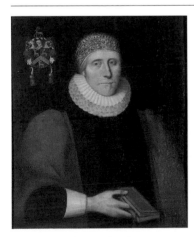

British (English) School
Joshua Green, Mayor (1627 & 1637) c.1630
oil on canvas laid on panel 76.7 x 63.7
KLTH 3

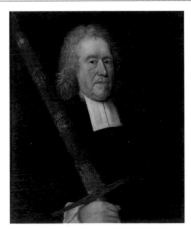

British (English) School early 18th C
A Cleric Holding the King John Sword
oil on canvas 76.5 x 63.6
KLTH 14

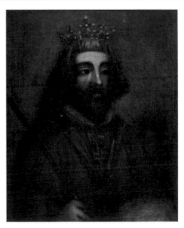

British (English) School late 18th C
Henry IV (1367–1413)
oil on canvas 75.5 x 62.5
KLTH 15

Facing page: Gotch, Thomas Cooper, 1854–1931, *Golden Youth* (detail), Norwich Assembly House, (p.87)

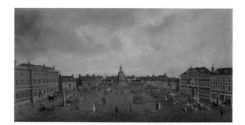

British (English) School
Tuesday Market Place, King's Lynn c.1805
oil on canvas 75 x 144.2
KLTH 20

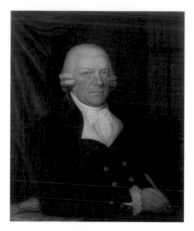

British (English) School late 19th C
Robert Whincop
oil on canvas 74 x 61
KLTH 19

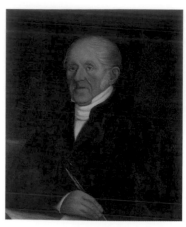

British (English) School
Portrait of a Gentleman
oil on canvas 76 x 63
KLTH 21

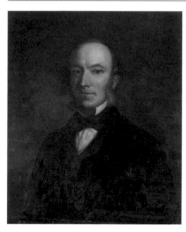

British (English) School
Sir Lewis Jarvis
oil on canvas 76 x 63.2
KLTH 22

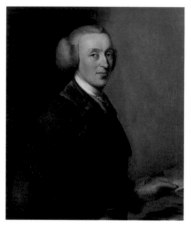

Cotes, Francis (circle of) 1726–1770
Portrait of a Gentleman
oil on canvas 77 x 64
KLTH 29

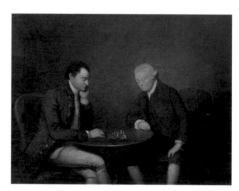

Devis, Arthur (circle of) 1712–1787
Two Men Playing Chess
oil on canvas 36.6 x 46.7
KLTH 36

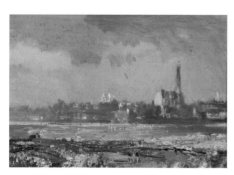

Dexter, Walter 1876–1958
Sketch of King's Lynn over the Harbour
oil on card 12.1 x 17.1 (E)
KLTH 16

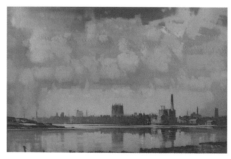

Dexter, Walter 1876–1958
View of King's Lynn over the Harbour
oil on canvas 59.5 x 90.7
KLTH 24

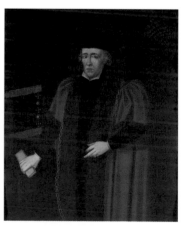

Ferrour, John b.1654 or earlier
*Sir Thomas White (1492–1567), Lord Mayor
of London and Founder of St John's College,
Oxford* 1681
oil on canvas 128.3 x 105.3
KLTH 4

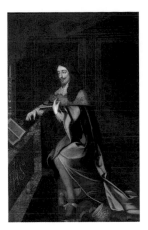

Ferrour, John b.1654 or earlier
King Charles I (1600–1649) 1690
oil on canvas 236.5 x 150
KLTH 5

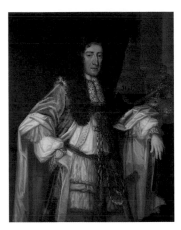

Ferrour, John b.1654 or earlier
King William III (1650–1702) 1690
oil on canvas 126.6 x 102.7
KLTH 6

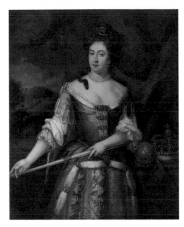

Ferrour, John b.1654 or earlier
Queen Mary II (1662–1694) 1690
oil on canvas 125.7 x 102.8
KLTH 7

Ginnett, Louis 1875–1946
Sir William H. B. Ffolkes, Bt (1847–1912)
(after Oswald Hornby Joseph Birley)
oil on canvas 123 x 100.5
KLTH 31

Hoare, William c.1707–1792
Thomas Somersby, Mayor (1743–1744)
oil on canvas 126 x 102
KLTH 10

Hodgson, David 1798–1864
A View of the Guildhall, King's Lynn
oil on canvas 53.3 x 76
KLTH 32

Hoskins, John I c.1595–1665
Sir Hamon Le Strange of Hunstanton
(1583–1654) 1617
oil on panel 56.7 x 43.7
LS 1 (P)

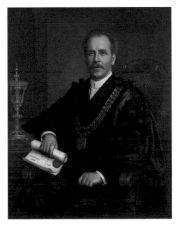

Hudson, Benjamin active 1850–1894
William S. V. Miles, Mayor 1894
oil on canvas 110.5 x 90
KLTH 23

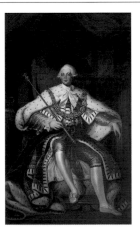

Lane, Samuel 1780–1859
King George III (1738–1820) (after Joshua
Reynolds) 1804
oil on canvas 237.5 x 146.5 (E)
KLTH 11

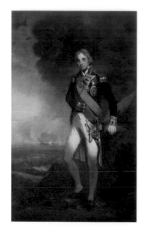

Lane, Samuel 1780–1859
Horatio, Lord Nelson (1758–1805) (after John Hoppner) 1806–1807
oil on canvas 238 x 146 (E)
KLTH 12

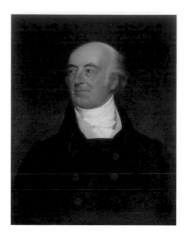

Lane, Samuel 1780–1859
Thomas William Coke, 1st Earl of Leicester c.1820
oil on canvas 78 x 61.6 (E)
KILLM : 2005.62

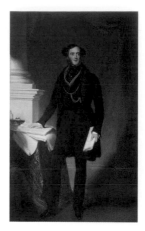

Lane, Samuel 1780–1859
Lord George Bentinck (1802–1848), MP for King's Lynn (1828) 1834
oil on canvas 235.7 x 146.5 (E)
KLTH 13

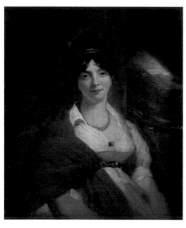

Lane, Samuel 1780–1859
Elizabeth Swatman
oil on canvas 76 x 63.2 (E)
KLTH 40

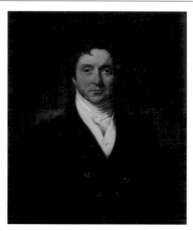

Lane, Samuel 1780–1859
John Prescott Blencowe, Mayor (1825)
oil on canvas 76.5 x 63.3
KLTH 30

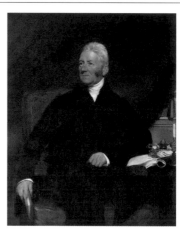

Lane, Samuel 1780–1859
The Reverend Robert E. Hankinson
oil on canvas 125 x 99.8 (E)
KLTH 17

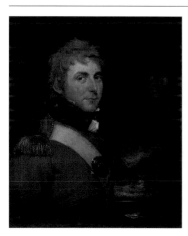

Lane, Samuel 1780–1859
William Swatman, Mayor (1813)
oil on canvas 76 x 63 (E)
KLTH 39

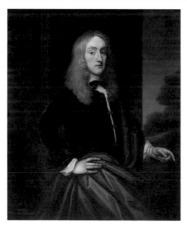

Lely, Peter (attributed to) 1618–1680
Horatio, 1st Viscount Townshend (1630–1657)
oil on canvas 124 x 98.7 (E)
KLTH 38

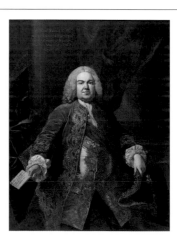

Loo, Louis Michel van (after) 1707–1771
Sir Benjamin Keene (1697–1757), British Minister to Spain
oil on canvas 147.6 x 114.5
KLTH 9

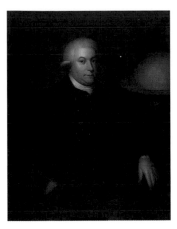

Morris, William Bright 1844–1912
Captain George Vancouver, RN (1757–1798)
oil on canvas 111.5 x 86.2
KLTH 34

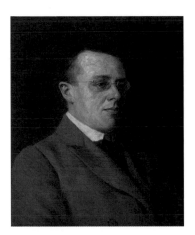

Nurse, Charles Baxter active 1895–1915
Christopher Thomas Page 1911
oil on canvas 61 x 50.8
KLTH 44

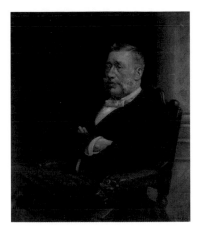

Nurse, Charles Baxter active 1895–1915
Thomas Edward Bagge (1838–1908) 1912
oil on canvas 101 x 85.5
KLTH 27

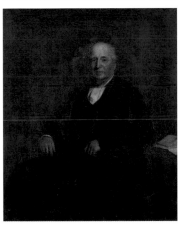

Pearce, Stephen 1819 1904
William Seppings, Mayor (1848) 1869
oil on canvas 127.8 x 102.6
KLTH 25

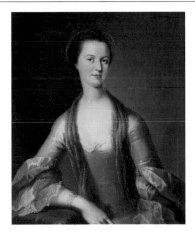

Pickering, Henry active 1740–c.1771
Portrait of a Lady
oil on canvas 77 x 64.2
KLTH 28

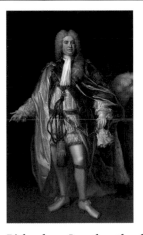

Richardson, Jonathan the elder 1665–1745
Sir Robert Walpole, KG (1676–1745)
after 1726
oil on canvas 229.5 x 141 (E)
KLTH 8

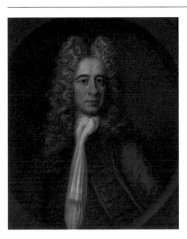

Richardson, Jonathan the elder 1665–1745
Roger Le Strange
oil on canvas 74.5 x 61.5 (E)
LS 2 (P)

Riviere, Hugh Goldwin 1869–1956
Sir Somerville Gurney
oil on canvas 126 x 102.6
KLTH 26

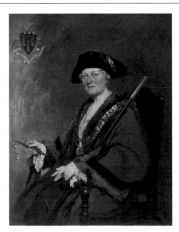

Roe, Fred 1864 1947
*Florence Ada Coxon, First Woman Mayor
(1925)* 1925
oil on canvas 127 x 102
KLTH 35

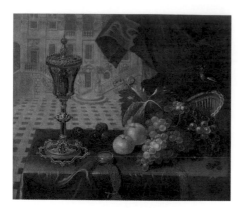

Roestraten, Pieter Gerritsz. van
1629/1630–1700
Still Life with King John Cup c.1700
oil on canvas 60.5 x 74 (E)
KILLM : 1994.1253

Shewring, Colin 1924–1995
Saturday Market Place, King's Lynn
oil on canvas 152 x 91
KLTH 47

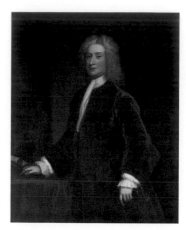

Vanderbank, John (circle of) c.1694–1739
Portrait of a Gentleman (said to be Horace Walpole)
oil on canvas 127.2 x 102
KLTH 18

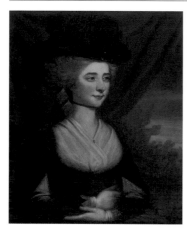

Veresmith, Emil active 1891–1924
Fanny Burney (1752–1840)
oil on canvas 76.5 x 63.7
KLTH 37

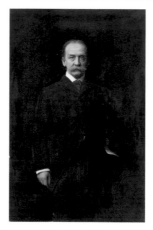

Watson, George Spencer 1869–1934
Thomas Gibson Bowles, MP (1841–1922)
1901
oil on canvas 142 x 91.7
KLTH 33

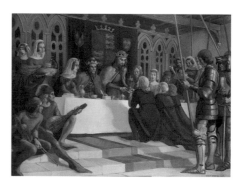

Whitmore, Robert 1908–1993
King John of France Presenting His Cup to the Mayor of Lynn, Robert Braunche, 1349 1939
oil on canvas 91.6 x 122
KLTH 41

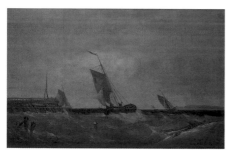

Wilson, John James II (attributed to)
1818–1875
Fishing Smacks on a Rough Sea
oil on canvas 61 x 91.4
KILLM : 2005.5

Broadland District Council

Applegate, John Stephen b.1935
Norwich Cathedral
oil on board 30.5 x 40.4
1

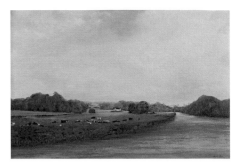

Moss, Brian
A Broadland Scene
oil on board 60 x 86
4

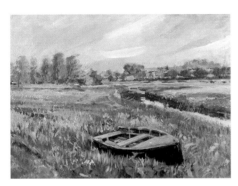

unknown artist
Landscape with Boat
oil on canvas 70 x 90 (E)
3

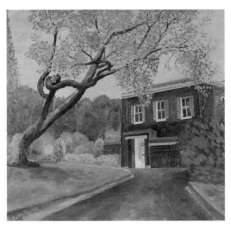

E. W.
Thorpe Lodge, Yarmouth Road, Thorpe St Andrew's
oil on board 44 x 46 (E)
2

City of Norwich Aviation Museum

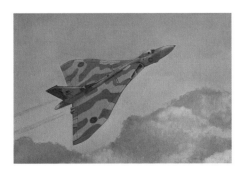

Barrington, Peter b.1928
Avro Vulcan B, Mk 2 XM612 Arriving at Norwich Airport on Its Last Flight, Being Delivered (…)
oil on board 50 x 60 (E)
CNAM.2000.761

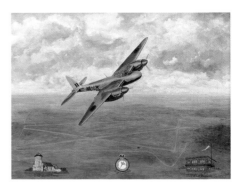

Best, Edward
De Havilland Mosquito AS-H of 515 Squadron Flying over Little Snoring 2004
oil 45 x 60 (E)
CNAM.2005.186

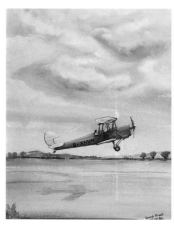

Frost, David active 1980–1981
De Havilland Tiger Moth, G-AHHM 1980
oil on canvas 80 x 50 (E)
CNAM.2003.292

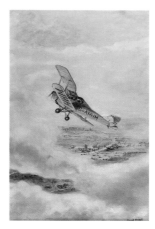

Frost, David active 1980–1981
De Havilland Tiger Moth, G-AHHM 1980
oil on canvas 45 x 30 (E)
CNAM.2003.293

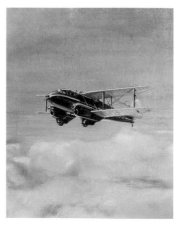

Frost, David active 1980–1981
De Havilland Dragon Rapide in Flight 1980?
oil on canvas 50 x 40 (E)
CNAM.2003.290

Frost, David active 1980–1981
World War One Dogfight, Nieuport 17 1981
oil on canvas 80 x 50 (E)
CNAM.2003.291

Godfrey, C.
Dresden, 1945
oil on board 60 x 45 (E)
CNAM.1996.104

Matthews, Leslie 1926–2004
100 Group Sets out to Confound 1997
oil on canvas 60 x 90 (E)
CNAM.2001.688

Smith, Ray
Avro Lancaster Tanker with 3 Gloster Meteor Fighters, 1950, 245 Squadron Royal Air Force, Based at Horsham St Faith 1996
oil on board 56 x 80 (E)
CNAM.1996.81

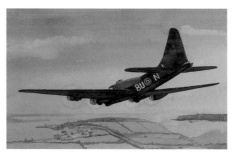

unknown artist
Boeing B-17 Fortress, 214 Squadron, 100 Group, Peter Knights
oil on canvas 28 x 45 (E)
CNAM.2002.906

City of Norwich Collection

Chedgey, David b.1940
Private View at the Alibi (panel 1 of 4)
acrylic on board 60 x 60
CH6

Chedgey, David b.1940
Private View at the Alibi (panel 2 of 4)
acrylic on board 60 x 60
CH6

Chedgey, David b.1940
Private View at the Alibi (panel 3 of 4)
acrylic on board 60 x 60
CH6

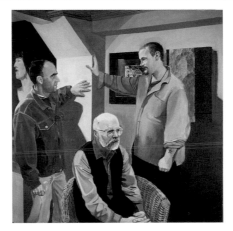

Chedgey, David b.1940
Private View at the Alibi (panel 4 of 4)
acrylic on board 60 x 60
CH6

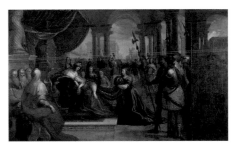

Italian School 17th C
King Ahasuerus and Queen Esther
oil on canvas 162.5 x 264.4
CH13

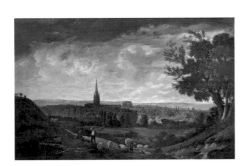

Ladbrooke, Henry 1800–1869
View of Norwich from Mousehold Heath
oil on canvas 160 x 217
CH1

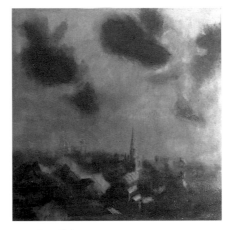

Mutch, Gil b.1955
Seeing Norwich 1991
oil on canvas 120 x 120
CH4

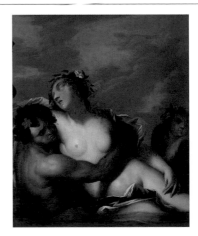

Pellegrini, Giovanni Antonio 1675–1741
Nymph and Satyrs (Galatea)
oil on canvas 137 x 108
CH10

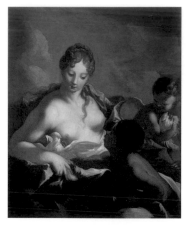

Pellegrini, Giovanni Antonio 1675–1741
Venus Seated with Winged Cupid and a Young Faun
121.5 x 101
CH12

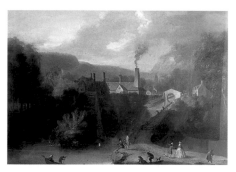

unknown artist
Landscape by a Canal c.1730
oil on wood 63 x 87
CH3

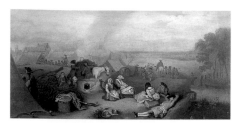

unknown artist
Travellers Resting c.1750
oil on wood 46 x 91
CH2

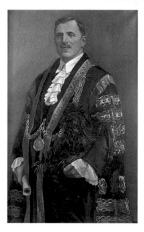

unknown artist
Herbert Edward Whitard 1928
oil on canvas 89 x 60
CH7

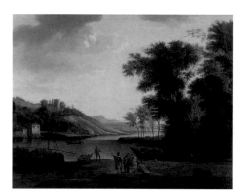

unknown artist
Classical Scene
oil on canvas 108 x 137
CH11

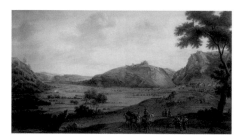

unknown artist
Mountain Landscape
oil on canvas 102.2 x 179
CH9

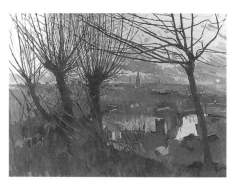

unknown artist
Norwich from Mousehold
oil on canvas 89 x 119
CH8

Wimhurst, Juliet b.1940
Strange Event in Chapelfield 1998
oil on canvas 196 x 226
CH5

Facing page: Beechey, William, 1753–1839, *Mr and Mrs John Custance of Norwich and Their Daughter Frances* (detail), c.1786,
Norwich Castle Museum and Art Gallery, (p.96)

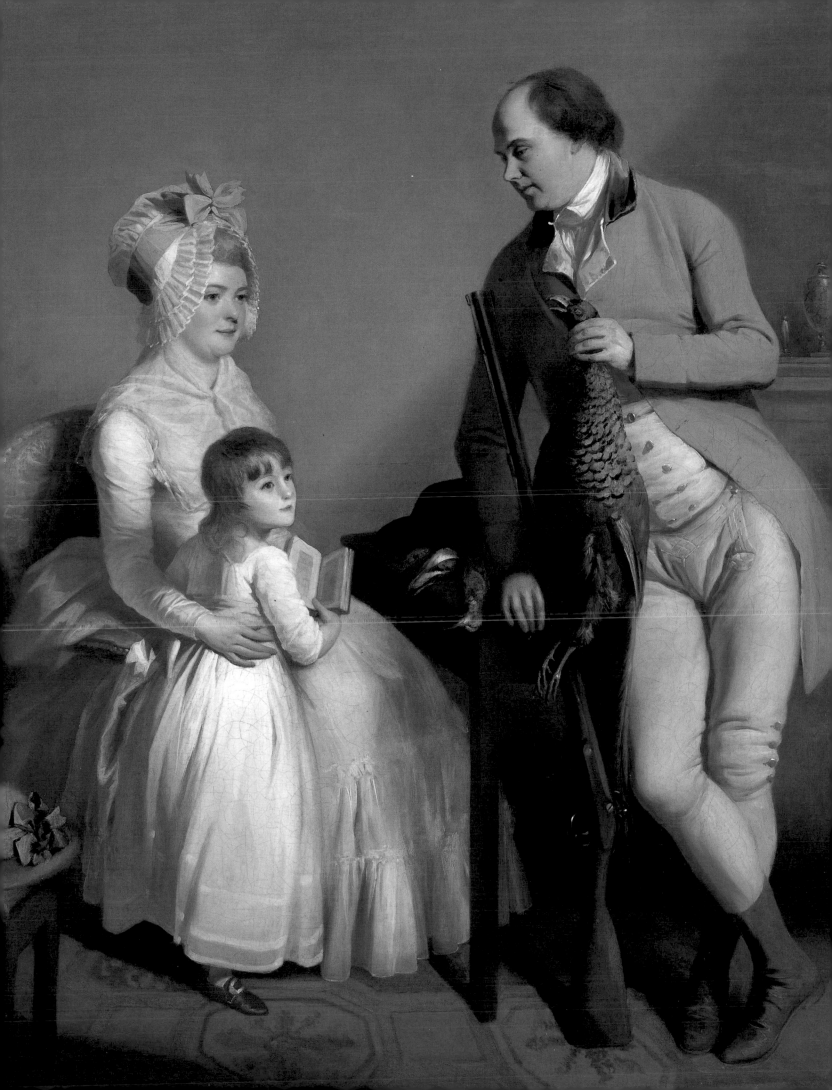

Norfolk and Norwich University Hospital

The Norfolk and Norwich University Hospital possesses one of the largest collections of medical portraits of any UK hospital outside London. This Collection is largely the creation of Charles Williams, a surgeon at the former Norfolk and Norwich Hospital from 1869 to 1906, who decided to mark the Hospital's centenary in 1871 by assembling a collection of portraits of members of the Hospital's consultant medical staff since its foundation. This collection was personally funded by Williams who either persuaded his friends to donate their paintings, purchased them himself, or paid for copies to be made of others' originals. His efforts were lauded in *The Lancet* and by 1890, when he compiled a catalogue, Williams had amassed 37 portraits (not all oils), covering all bar eight of the medical staff from the period 1771 to 1871. The most notable portrait in the Collection post-dates Williams' efforts though; the Hospital marked the retirement of its preeminent surgeon, William Cadge, in 1890 by commissioning a portrait painted by Sir Hubert von Herkomer.

David Wraight, Hospital Arts Assistant

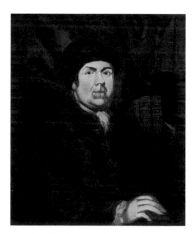

Bardwell, Thomas (copy of) 1704–1767
Benjamin Gooch (1708–1776) c.1900
oil on canvas 77 x 63
NWHHA : 1995.5.1

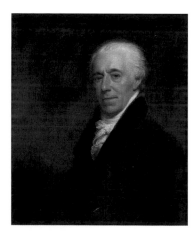

Beechey, William 1753–1839
Philip Meadows Martineau (1752–1829),
Assistant Surgeon & Surgeon (1778–1828)
c.1825
oil on canvas 76.3 x 63
NWHHA : 1995.28.1

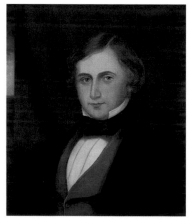

Benski (copy of)
Arthur Tawke (1817–1884), Consultant
Physician (1847–1851)
oil on canvas 57 x 47
NWHHA : 1995.4.1

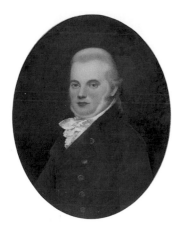

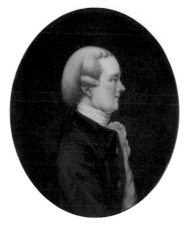

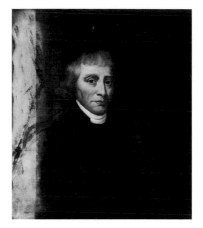

Brewer, Julian Cedric c.1830–1903
*Edward Colman (d.1812), Assistant Surgeon
(1790–1812) (copy of original miniature by
unknown artist)* c.1870
oil on card 19 x 14
NWHHA : 1995.19.1

Brewer, Julian Cedric c.1830–1903
William Donne (1746–1804) c.1870
oil on canvas 24 x 19
NWHHA : 1995.18.1

Bush-Brown, Margaret Lesley 1857–1944
*John Murray (1720–1792), Physician
(1771–1790) (copy of a portrait by an
unknown artist)*
oil on canvas 76 x 64
NWHHA : 1995.3.1

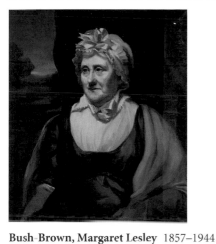

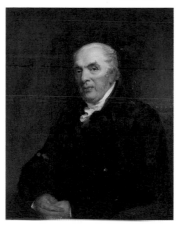

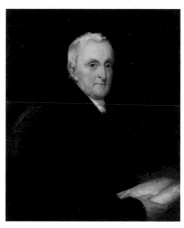

Bush-Brown, Margaret Lesley 1857–1944
Mary Boyles
oil on canvas 76 x 64
NWHHA : 1999.785.1

Clover, Joseph 1779–1853
Edward Rigby (1747–1821) c.1819
oil on canvas 91 x 71
NWHHA : 1995.20.1

Clover, Joseph (copy of) 1779–1853
Robert Fellowes
oil on canvas 75 x 62
NWHHA : 1995.2.1

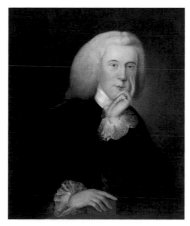

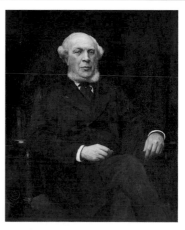

Frere, Amy Hanbury active 1902–1958
*Sir Thomas Browne (1605–1682) (copy of an
original by an unknown artist)* 1905
oil on canvas 71 x 58
NWHHA : 1995.14.1

Heins, John Theodore Jr (copy after)
1732–1771
John Manning (1730–1806) c.1871
oil on canvas 75 x 62
NWHHA : 1995.1.1

Herkomer, Hubert von 1849–1914
William Cadge (1822–1903) 1890
oil on canvas 123 x 98
NWHHA : 1995.23.1

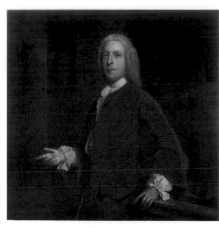

Highmore, Joseph (copy of) 1692–1780
William Fellowes of Shotesham (1706–1775)
oil on canvas 114 x 114
NWHHA : 1995.22.1

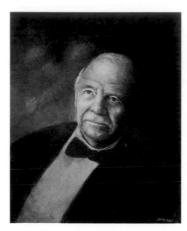

Mann, John J. b.1903
Mr McKee c.1990
oil on canvas 70 x 50
NWHHA : 1995.9.1

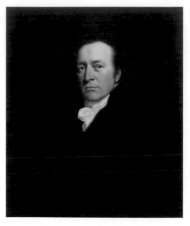

Opie, John 1761–1807
*James Alderson (1742–1825), Surgeon
(1772–1793), Physician (1793–1821)* 1798
oil on canvas 76 x 63
NWHHA : 1995.6.1

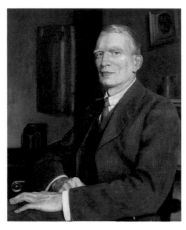

Sage, Faith K. active 1918–c.1950
*Athelstan Jasper Blaxland (1880–1963),
Consultant Surgeon (1909–1946)* c.1950
oil on canvas 76 x 63
NWHHA : 1995.8.1

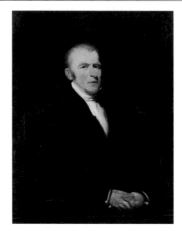

Smith, Henry active 1828–1844
*William Dalrymple (1772–1847), Assistant
Surgeon & Surgeon (1812–1839)* c.1840
oil on canvas 102 x 75
NWHHA : 1995.21.1

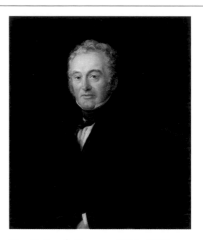

Strutt, Jacob George 1790–1864
Warner Wright (1775–1845) c.1840
oil on canvas 76 x 63
NWHHA : 1995.7.1

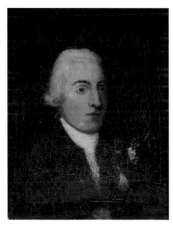

unknown artist
Jonathan Matchett, Physician (1773–1777)
c.1775
oil on canvas 36 x 31
NWHHA : 1995.223.1

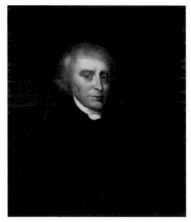

unknown artist
John Murray (1720–1792), Physician
before 1871
oil on canvas 76 x 63
NWHHA : 1999.784.1

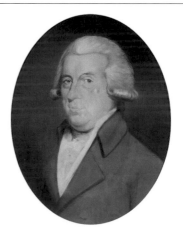

unknown artist
*John Beevor, MD (1726–1815), Physician
(1771–1793)*
oil on paper 47 x 30
NWHHA : 1995.29.1

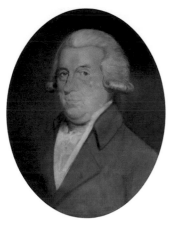

unknown artist
*John Beevor, MD (1726–1815), Physician
(1771–1793)*
oil on canvas 60 x 45
NWHHA : 1995.160.1

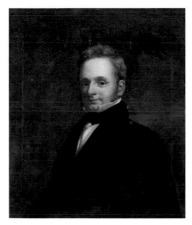

Ventnor, Arthur Dale 1829–1884
John Green Crosse (1790–1850) c.1850
oil on canvas 76 x 63
NWHHA : 1995.24.1

Norfolk and Waveney Mental Health Partnership

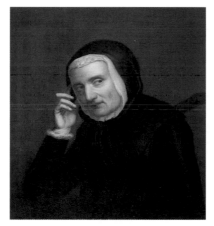

unknown artist late 19th C
Mary Chapman (1647–1724)
oil on canvas 80.5 x 71 (E)
B/P/10

Norfolk County Council

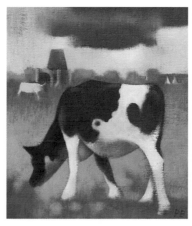

Baldwin, Peter b.1941
St Benet's Abbey with Cow 1993
oil on canvas 42 x 36
NCC1

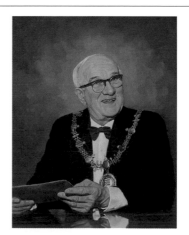

unknown artist
Charles Denny
oil on canvas 37 x 30
DTC4

unknown artist
Henry Denny
oil on canvas 40 x 30
DTC3

Norfolk Record Office

unknown artist
Possibly Alderman Herbert Edward Witard, JP (1874–1954), Chairman of Norwich Mental Hospital (…) c.1948
oil on canvas 59.4 x 48.8 (E)
ACC 2003/88

unknown artist early 20th C
A View of Tombland Alley from Tombland, Norwich
oil on canvas board 40.2 x 30.4
N/MC 23/7

Norwich Assembly House

Clover, Joseph 1779–1853
Augustin Noverre (1729–1805)
oil on canvas 77 x 63 (E)
NAH 3

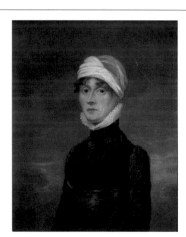

Crome, John 1768–1821
Woman in a Turban
oil on canvas 25 x 19 (E)
NAH 8

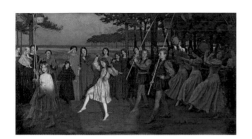

Gotch, Thomas Cooper 1854–1931
Golden Youth
oil on canvas 122 x 213 (E)
NAH 1 (P)

Lamb, Henry 1883–1960
H. J. Sexton 1951
102 x 84 (E)
NAH 7

Messel, Oliver 1904–1978
Lilies
oil on board
NAH 9

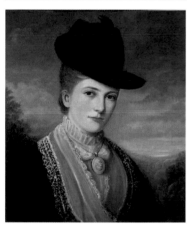

unknown artist 19th C
A Member of the Noverre Family
61 x 51 (E)
NAH 6

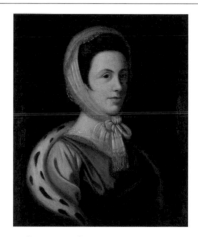

unknown artist
Mary Noverre (wife of Augustin Noverre)
61 x 51 (E)
NAH 5

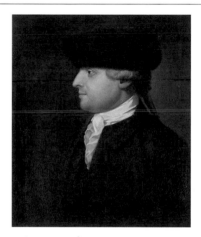

unknown artist
Augustin Noverre (1729–1805)
61 x 51 (E)
NAH 4

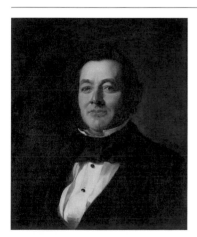

unknown artist
Frank Noverre (1806–1878)
oil on canvas 61 x 51 (E)
NAH 2

Norwich Castle Museum and Art Gallery

The fine art collections in Norwich Castle Museum and Art Gallery comprise approximately 1,200 oil paintings and 10,000 watercolours and drawings representing almost 900 artists, as well as 8,500 prints.

The earliest collection of paintings to be acquired by the Norwich Museum was in 1841 when Captain William Manby, the inventor of early effective life saving equipment at sea, presented a unique collection of seascapes, originally commissioned by him to illustrate and promote his invention. Manby, who lived at Great Yarmouth, was the patron of William Joy and set him upon his career as a successful marine artist. The gift includes works by other notable marine painters of the day, including two by F. T. L. Francia, the only oil paintings known by this internationally recognized watercolourist.

It was not until 1894 when the Norwich Museum moved to Norwich Castle that an art gallery was incorporated in the Museum for the first time. The nucleus of the fine art collection was the gift of paintings collected by the East Anglian Art Society, which had been formed in 1876. Its collection of about 80 Norwich School paintings and watercolours was given to the Castle Museum for the new art gallery in 1894. In 1898 Jeremiah James Colman, the Norwich mustard manufacturer, bequeathed 20 major Norwich School paintings to the Norwich Museum. Colman had been collecting Norwich School paintings since the 1850s under the guidance of James Reeve, FGS (1833–1920), Curator of Norwich Museum from 1851 to 1910, and it was Reeve who selected the paintings that formed the bequest. It was through Reeve's discernment and knowledge that the Museum's Norwich School collection was formed.

The Museum owes its greatest debt to the bequest in 1946 of Russell James Colman, the son of J. J. Colman. Not only did R. J. Colman bequeath thousands of Norwich School paintings, watercolours and drawings, including many major works by Cotman and Crome, he also provided for the construction of two galleries in which to exhibit them.

In the intervening years, the Museum has acquired numerous items through gift, bequest and purchase. It has also relied extensively on the Museums & Galleries Commission/Victoria & Albert Museum Purchase Grant Fund, the National Art Collections Fund, the Friends of the Norwich Museums and private sponsorship for assistance with purchases. At every stage, new acquisitions have enhanced the collection. Most recently the East Anglia Art Foundation has added its support to the acquisition of works of art for the collection, notably with the acquisition of The Adeane Collection, Zoffany's *A Family Picture: Henry and Mary Styleman* and *The Supper at Emmaus* by Cornelis Engelsz.

Undoutedly, the most represented School within the Collection is the Nowich School. In 1803 John Crome and Robert Ladbrooke founded the Norwich Society of Artists. It began as a club where local artists could meet once a fortnight to talk about art and exchange ideas. In 1805 it held its first exhibition. Exhibitions were then held annually until 1833, except for a break in 1826–1827. It was the first society of artists to be formed outside London, and the artists connected with it became known nationally as the Norwich School.

The Norwich Castle Collection of works by these artists covers three generations of some 50 artists who form the nucleus of the School.

The two leading members of the School were John Crome (1768–1821) and John Sell Cotman (1782–1842), both of whom have international reputations in their own right. Cotman, a more prolific and deeply successful artist in watercolour, is represented at Norwich with the largest collection of his oil paintings in existence, 32 in total. John Crome was the more popular artist in his lifetime and was grouped with Constable and Turner as one of the three foremost British landscape painters. Crome's reputation has been marred by the numerous paintings wrongly ascribed to him. However, over the last 40 or so years, researchers on the Norwich School have identified a group of 20 paintings in the Norwich collection which stylistically and historically can be firmly attributed to him. They include the magnificent *Norwich River: Afternoon*, regarded as his finest work, which was acquired in 1994 with the assistance of the National Heritage Memorial Fund, Museums and Galleries Commission/Victoria & Albert Museum Purchase Grant Fund, National Art Collections Fund, Friends of the Norwich Museums and private funds. Crome rarely left Norwich, and most of his paintings are beautiful evocations of the Norwich river and countryside around the city. As such they stand as touchstones to the British sense of place in the early nineteenth century.

The Norwich artists were linked by friendship, family and master-pupil relationships, and the collections reflect the influences they had on each other. Although they are considered a school of landscape painters, their subject matter was diverse. Norfolk was the common link, although several of them produced paintings of their travels around Britain and abroad. Their work gives a rich and unique picture of the county: busy river scenes, heathland, agriculture, cottages, wooded lanes, cityscapes, churches, the coastline, beaches, seascapes and shipwrecks. Many of the works can be identified with exhibits with the Norwich Society of Artists or in London at the Royal Academy, British Institution, etc. The women of the School, Emily and Eloise Harriet Stannard and Emily Crome were still life artists, as was James Sillett who also painted miniatures. The highly prolific Henry Bright, who was equally proficient in oil and watercolour, is well represented in the collection. An important later artist, who had his roots in the Norwich School, was Frederick Sandys, the 'Norwich Pre-Raphaelite', who Rossetti called 'the greatest of living draughtsmen'. As well as seven oils by him, the collection includes a series of magnificent chalk portraits in the Pre-Raphaelite manner.

The Museum's collection of British and European School paintings of the eighteenth and nineteenth centuries aims to place the Norwich School in context and to represent the development of British painting. The rich cultural heritage of the area has enabled the Museum to acquire many fine works with a Norfolk or East Anglian provenance. An early example is the miniature of a Mayor of Norwich by Nicholas Hilliard. Another example is a more recent acquisition of a painting by William Hogarth, *Francis Matthew Schutz in His Bed*.

A large-scale acquisition in 2000 was *A Family Picture: Henry and Mary Styleman* (1780–1783), by Johann Zoffany, Sawrey Gilpin and Joseph Farington. Other British School paintings include works by John Wootton and Henry Walton depicting Norfolk families. Local hero Horatio Nelson is also

featured in paintings by Samuel Drummond and Eyre Crowe. Landscapes by Thomas Gainsborough and Richard Wilson demonstrate the influence of these artists on John Crome. Later artists represented include David Roberts and G. F. Watts all with important works presented by donors who recognized their significance for the permanent collection.

The city of Norwich has been, and still is, the centre of a flourishing community of artists and many of them have progressed to achieve national status. The most notable twentieth century practitioners are Sir Arnesby Brown, Sir Alfred Munnings and Edward Seago. All three artists are well represented with oil paintings and watercolours, in particular Munnings with over 30 works (16 of which are oils and therefore appear in this catalogue). These include three major early works, which are considered amongst his best horse paintings.

The Dutch and Flemish School comprises over 60 works, the earliest of which is the remarkable *Ashwellthorpe Triptych* of c.1519 by the Master of the Legend of the Magdalen. It depicts the Seven Sorrows of Mary in the centre panel and portraits of the donors, Christopher and Catherine Knyvett, with their name-saints painted on the wing panels. It is the earliest known Flemish commission by a regional family, and was purchased in 1983 with the help of Victoria & Albert Museum Purchase Grant Fund and grants from the NACF and a group of local benefactors.

The seventeenth century Dutch landscape painters had a profound influence on the work of John Crome and his followers. This is demonstrated in a collection carefully constructed to include individual works by artists of influence such as Meindert Hobbema and Jan van Goyen. The collection has attracted many gifts and bequests, including figurative works by Pieter Brueghel and Jan Siberechts, a key painting by Abraham Begeyn and an impressive work by Tobias Verhaecht, *The Tower of Babel*. A flower piece attributed to Andries Danielsz. and a *Still Life* by Heda were both accepted by the Government in lieu of capital transfer tax and allocated to Norwich Castle. The Collection was again enhanced through the 'acceptance in lieu' arrangement with the capital taxes office in 1991 by the Patteson Collection of 40 Dutch and Flemish paintings formerly in the collection of John Patteson, Mayor of Norwich. These include nine fine works by Peter Tillemans, notably *The Artist's Studio* which shows both the artist and the commissioner, the celebrated antiquarian Cox Macro, in the studio. This unique holding stands for the 'imaginary temple in honour of Tillemans' that Cox Macro wished to preserve for posterity. Others (for example by Abraham Hondius, Salomon Rombouts and Jan Frans van Bloemen) represent the cultural heritage upon which the Norwich School was founded. The most recent acquisition in this category is *The Supper at Emmaus* by Cornelis Engelsz., notable for its long association with an East Anglian private collection.

The small but significant modern collection covers the different movements in art from Impressionism to Surrealism, notably including works by Alfred Sisley, George Clausen, Gwen John, W. R. Sickert and T. F. Goodall. The 1993 acquisition of the bequest from Lady Adeane to the Tate in East Anglia Foundation (now named the East Anglia Art Fund) of 15 modern works has greatly enhanced the Museum's holdings of the modern movement: these include oils by Picabia, Louis Marcoussis and Max Ernst. Paintings by Magritte

and Vlaminck from the original bequest were accepted in lieu of tax by HM Government and allocated to Norwich Castle. Together these augmented the Museum's existing works by Modernist and Surrealist artists: notably, David Bomberg and Roland Penrose. Of all the collections this probably has the most significant gaps, but the Museum actively attempts to fill these with occasional purchases, such as a sketch by Edouard Vuillard, and by alerting collectors to the Museum's interest in this field.

In common with the historical collection, the Museum's contemporary art collection has a bias towards artists connected with the region. For example, Michael Andrews, Pop artist Colin Self and Mary Potter are represented, as well as artists who have taught at Norwich Art School and whose work is included in major contemporary collections, notably works by Edward Middleditch and John Wonnacott. It has been augmented by the collection of the Norfolk Contemporary Art Society which is deposited with Norwich Castle and which includes important early work by Allen Jones and Terry Frost. The Society (established in 1955 and until recently the only regional contemporary art society to form in emulation of the London example) has also assisted with the purchase of major acquisitions, among them paintings by Bridget Riley and Howard Hodgkin (the latter being two watercolours and therefore not included in the current publication). In 2005, the society presented Zara Schofield's *Veiled, Orange and Green* in celebration of its 50th anniversary. The Museum continues to aquire work through the Contemporary Art Society.

Andrew Moore, Keeper of Art and Senior Curator

Adolphe, Joseph Anton 1729–c.1765
Philip Meadows (1679–1752) 1763
oil on canvas 127 x 103.7
NWHCM : 1990.227 : F

Andrews, Michael 1928–1995
Lowestoft Promenade 1958
oil on canvas board 22.8 x 27.8
NWHCM : L1980.4 : F

Andrews, Michael 1928–1995
The Lord Mayor's Reception in Norwich Castle Keep (…) 1966–1969
oil & screened photograph on canvas
213.3 x 213.3
NWHCM : 1968.820 : F

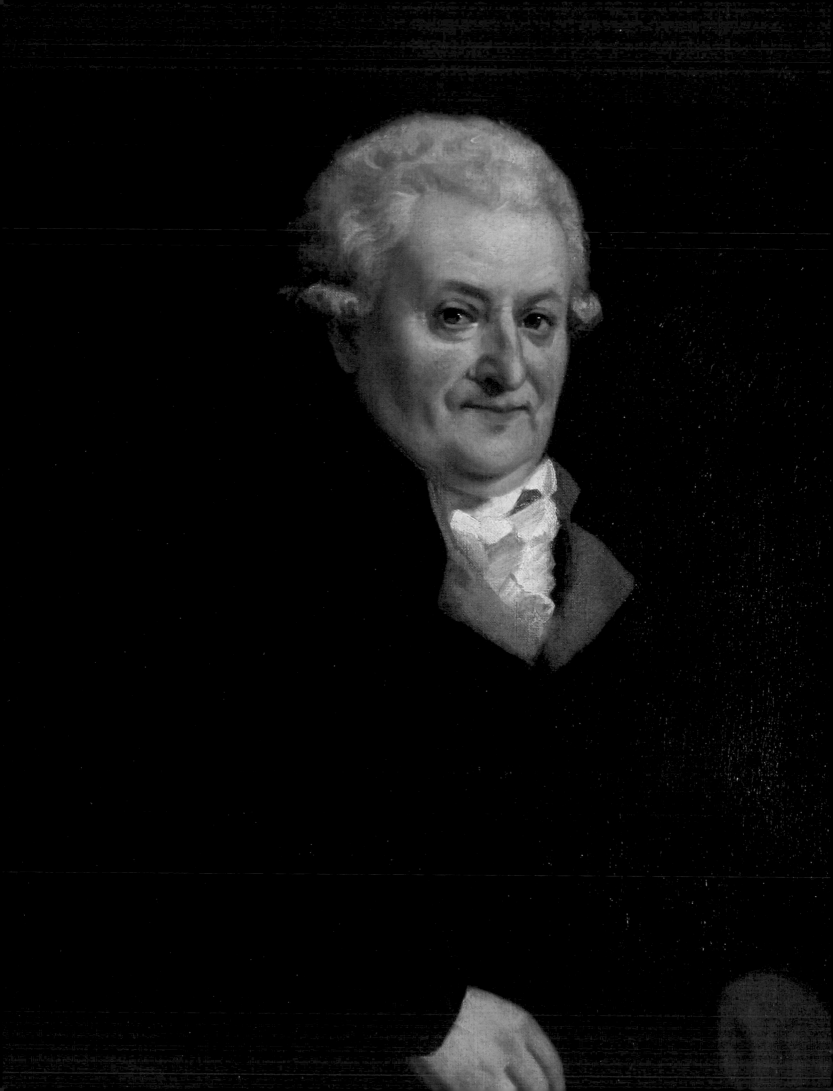

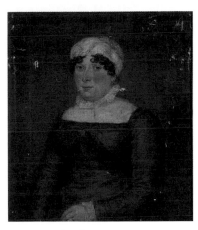

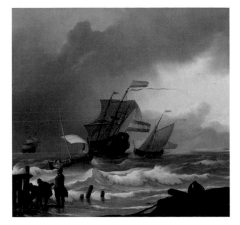

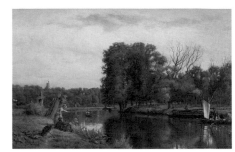

Arrowsmith, Thomas 1772–c.1829
Mrs Derry 1814
oil on canvas 35.5 x 30.7
NWHCM : 1940.83.1 : F

Backhuysen, Ludolf I 1630–1708
The Coming Squall
oil on canvas 54.7 x 58.6 (E)
NWHCM : 1894.7.1 : F

Bagge-Scott, Robert 1849–1925
On the River Yare 1883
oil on canvas 48.2 x 73.6
NWHCM : 1951.235.1224 : F

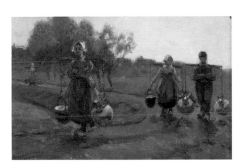

Bagge-Scott, Robert 1849–1925
Goin' a' Milking, South Holland 1888
oil on board 15.2 x 22.9
NWHCM : 1951.235.1225 : F

Bagge-Scott, Robert 1849 1925
The Wind and the Willows 1888
oil on canvas 25.7 x 35.6
NWHCM : 1951.235.1226 : F

Bagge-Scott, Robert 1849–1925
Keulsche Aaks, Dordt 1889
oil on canvas 30.8 x 51
NWHCM : 1928.97 : F

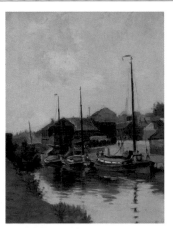

Bagge-Scott, Robert 1849–1925
Wroxham Bridge 1898
oil on paper 25.4 x 38.8
NWHCM : 1926.64.2 : F

Bagge-Scott, Robert 1849–1925
On a Dutch Dyke 1899
black & white oil on cardboard 71.8 x 53.5
NWHCM : 1951.235.1228 : F

Bagge-Scott, Robert 1849–1925
By the Riverside 1900
oil on millboard 35.5 x 24
NWHCM : 1901.6 : F

Facing page: Clover, Joseph, 1779–1853, *Augustin Noverre (1729–1805)* (detail), Norwich Assembly House, (p.86)

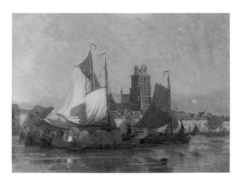

Bagge-Scott, Robert 1849–1925
'Twas Calm at Dordt 1923
oil on canvas 52 x 71
NWHCM : 1924.1 : F

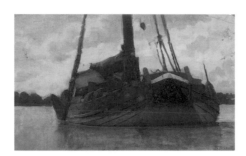

Bagge-Scott, Robert 1849–1925
Dutch Boat
oil on paper 24.6 x 39.4
NWHCM : 1926.64.1 : F

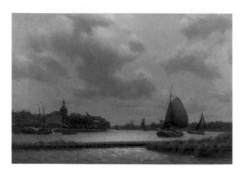

Bagge-Scott, Robert 1849–1925
The Merwede at Dordrecht
oil on canvas 50.8 x 73.6
NWHCM : 1914.18 : F

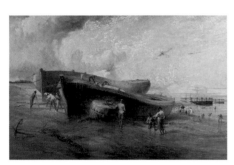

Baines, Henry 1823–1894
Ballast Boats at King's Lynn 1865
oil on canvas 50.8 x 76.6
NWHCM : 1947.93 : F

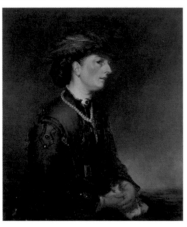

Baines, Henry 1823–1894
Mrs Henry Baines
oil on canvas 47.6 x 34.3
NWHCM : 1947.92 : F

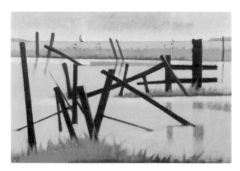

Baldwin, Peter b.1941
Havergate Island
oil on canvas 45.8 x 66.7
NWHCM : 1995.96.1 : F

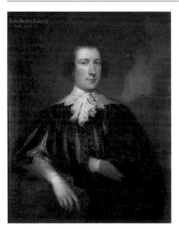

Bardwell, Thomas 1704–1767
John Buxton of Channonz (1717–1782) 1750
oil on canvas 90.2 x 69.8
NWHCM : 1963.268.23 : F

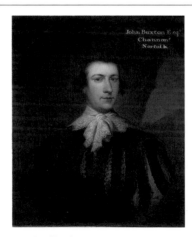

Bardwell, Thomas 1704–1767
John Buxton of Channonz (1717–1782)
c.1750
oil on canvas 76 x 63
NWHCM : 1949.107.2 : F

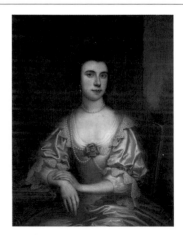

Bardwell, Thomas 1704–1767
Anne Buxton (1721–1771) 1751
oil on canvas 90.2 x 68.6
NWHCM : 1963.268.26 : F

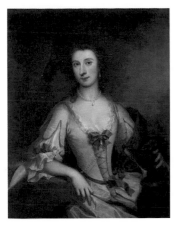

Bardwell, Thomas 1704–1767
Isabella Buxton 1751
oil on canvas 89 x 68.6
NWHCM : 1963.268.27 : F

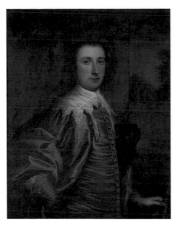

Bardwell, Thomas 1704–1767
Leonard Buxton (1719–1788) 1751
oil on canvas 89 x 69.8
NWHCM : 1963.268.25 : F

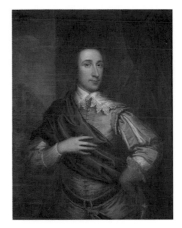

Bardwell, Thomas 1704–1767
Robert Buxton (1710–1750) 1751
oil on canvas 99 x 69.8
NWHCM : 1963.268.22 : F

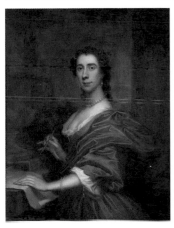

Bardwell, Thomas 1704–1767
Sarah Buxton 1751
oil on canvas 89 x 69.8
NWHCM : 1963.268.24 : F

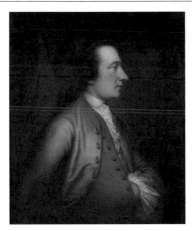

Bardwell, Thomas 1704–1767
John Buxton of Channonz (1717–1782)
oil on canvas 75 x 64.6
NWHCM : 1963.268.21 : F

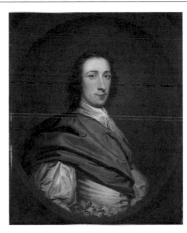

Bardwell, Thomas 1704–1767
Robert Buxton (1710–1750)
oil on canvas 76 x 63.2
NWHCM : 1949.107.7 : F

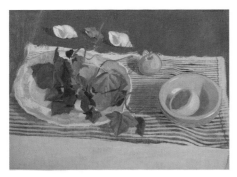

Barker, Ruth b.1925
Still Life with Ivy and Lemon 1953
oil on hardboard 46.2 x 61.1
NWHCM : 1990.225.6 : F

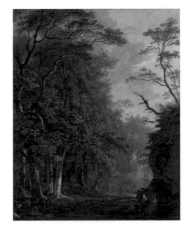

Barret, George 1728/1732–1784
The Drive, Norbury Park 1775
oil on canvas 126 x 115
NWHCM : 1976.369.21 : F

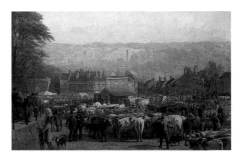

Barwell, Frederick Bacon 1831–1922
The Hill at Norwich on Market Day 1871
oil on canvas 98.8 x 152.2
NWHCM : 1921.7 : F

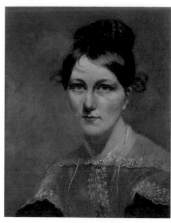

Barwell, John 1798–1876
Study of a Head 1836
oil on oak panel 42.7 x 35.2
NWHCM : 1894.75.12 : F

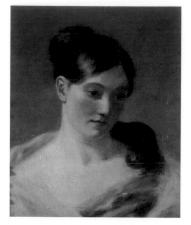

Barwell, John 1798–1876
Miss Julia Smith
oil on oak panel 42.5 x 35.5
NWHCM : 1918.77 : F

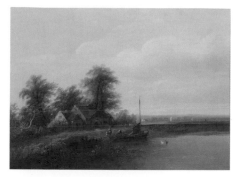

Beattie, A. active 1850–1856
Cantley Dyke, River Yare 1856
oil on canvas 38.2 x 51
NWHCM : 1971.55.143 : F

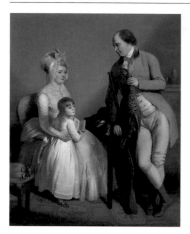

Beechey, William 1753–1839
*Mr and Mrs John Custance of Norwich and
Their Daughter Frances* c.1786
oil on canvas 68.8 x 55.1
NWHCM : 1990.232 : F

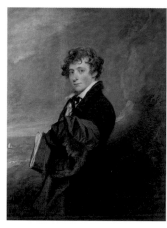

Beechey, William 1753–1839
Joseph Stannard (1797–1830) 1824
oil on oak panel 56 x 43
NWHCM : 1951.235.1384 : F

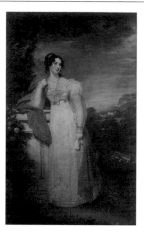

Beechey, William 1753–1839
*Elizabeth, Lady Buxton, née Cholmeley
(d.1884)* 1825
oil on canvas 238.8 x 147.3
NWHCM : 1963.268.29 : F

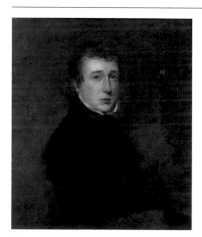

Beechey, William 1753–1839
Alfred Stannard (1806–1889), Aged 19 c.1825
oil on canvas mounted on oak panel
41.6 x 35.4
NWHCM : 1951.235.1383 : F

Begeyn, Abraham 1637/1638–1697
Plant Study with Goat
oil on canvas 35.5 x 31.1
NWHCM : 1957.390 : F

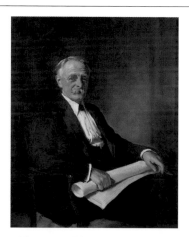

Birley, Oswald Hornby Joseph 1880–1952
Russell James Colman (1861–1946) 1930
oil on canvas 128 x 102.5
NWHCM : 1951.235.1386 : F

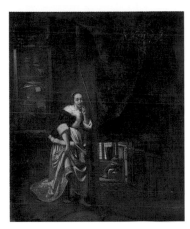

Bisschop, Cornelis 1630–1674
The Listening Maid
oil on canvas 76.8 x 62.8
NWHCM : 1894.7.3 : F

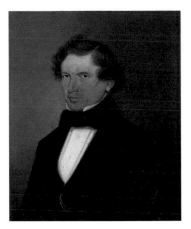

Blazeby, William (attributed to)
active 1833–1848
Portrait of an Unknown Man
oil on canvas 26.4 x 22.6
NWHCM : L1972.4 : F

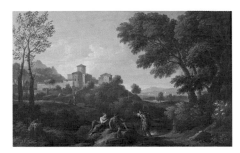

Bloemen, Jan Frans van 1662–1749
Southern Landscape with Figures
oil on canvas 48.3 x 76.3
NWHCM : 1991.1.12 : F

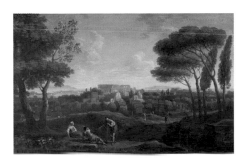

Bloemen, Jan Frans van 1662–1749
Southern Landscape with Figures
oil on canvas 48.3 x 76.3
NWHCM : 1991.1.13 : F

Blow, Sandra b.1925
*Painting: Black, White and Brown, Concrete
and Sawdust* 1961
oil & mixed media on hardboard 121.4 x 114
NWHCM : 1965.29 : F

Bomberg, David 1890–1957
Flowers 1946
oil on canvas 91.5 x 61
NWHCM : 1981.398.2 : F

Bomberg, David 1890–1957
Ronda, Summer 1954
oil on canvas 71 x 91.5
NWHCM : 1981.398.1 : F

Bonington, Richard Parkes 1802–1828
Sea Coast, the Dunes
oil on paper laid on canvas 31.7 x 46.8
NWHCM : 1951.203 : F

Both, Jan (attributed to) c.1618–1652
*A Southern Landscape with Muleteers on a
Roadway*
oil on canvas 52.2 x 65.6
NWHCM : 1991.1.2 : F

Bourdon, Sébastien (copy of) 1616–1671
Moses Striking the Rock
oil on canvas 57.2 x 70.5
NWHCM : 1949.133 : F

Bradley, John 1786–1843
Sir Robert Seppings (1767–1840) 1822
oil on canvas 81.5 x 63
NWHCM : 1985.343 : F

Bratby, John Randall 1928–1992
The Purple Globe Artichoke Flower
oil on canvas 142 x 81
NWHCM : 1966.39 : F ✻

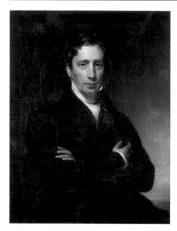

Briggs, Henry Perronet 1791/1793–1844
Sir John Jacob Buxton, 2nd Bt (1788–1842)
oil on canvas 88.9 x 68.5
NWHCM : 1963.268.28 : F

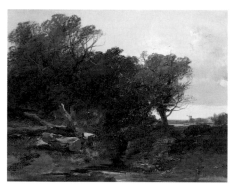

Bright, Henry 1814–1873
Grove Scene 1847
oil on canvas 40.2 x 50.8
NWHCM : 1951.235.2 : F

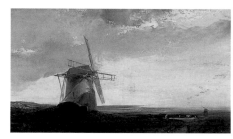

Bright, Henry 1814–1873
Marsh Mill 1847
oil on canvas 25.6 x 46
NWHCM : 1951.235.3 : F

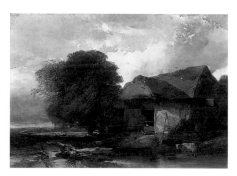

Bright, Henry 1814–1873
Old Barn, Suffolk 1847
oil on canvas 38.3 x 53.5
NWHCM : 1951.235.4 : F

Bright, Henry 1814–1873
Remains of St Benedict's Abbey on the Norfolk Marshes, Thunderstorm Clearing Off 1847
oil on canvas 80.3 x 132.9
NWHCM : 1947.172.1 : F

Bright, Henry 1814–1873
The Mill c.1848
oil on canvas 32 x 54.8
NWHCM : 1948.65.1 : F

Bright, Henry 1814–1873
Shore Scene near Leyden, Holland 1852
oil on canvas 61 x 109.6
NWHCM : 1993.100.1 : F

Bright, Henry 1814–1873
Orford Castle, Suffolk 1856
oil on canvas 104.8 x 168.7
NWHCM : 1935.132 : F

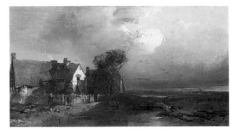

Bright, Henry 1814–1873
Effect after Rain
oil on canvas 25.5 x 46.1
NWHCM : 1894.75.2 : F

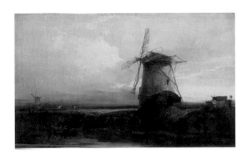

Bright, Henry 1814–1873
Marsh Mill
oil on canvas 36 x 57.7
NWHCM : 1993.100.2 : F

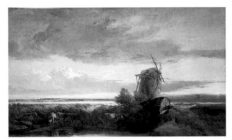

Bright, Henry 1814–1873
Mills on the Fens
oil on canvas 91.2 x 152.6
NWHCM : 1947.172.2 : F

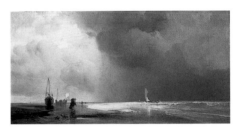

Bright, Henry 1814–1873
North Beach, Great Yarmouth
oil on canvas 41.1 x 79.2
NWHCM : 1929.88 : F

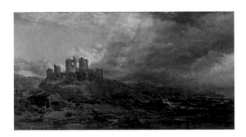

Bright, Henry 1814–1873
Seascape (Dunstanburgh Castle)
oil on canvas 61.4 x 109.7
NWHCM : 1949.186 : F

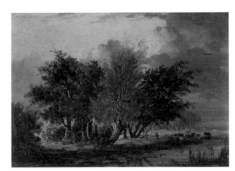

Bright, Henry 1814–1873
Trees by River with Cattle
oil on panel 12.7 x 17.8
NWHCM : 1982.101.2 : F

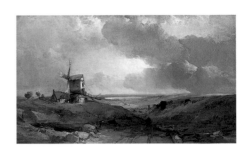

Bright, Henry 1814–1873
Windmill at Sheringham
oil on canvas 80.5 x 133
NWHCM : 1903.53 : F

Brown, John Alfred Arnesby 1866–1955
Myra Plater, Sister of the Artist c.1892
oil on canvas 61 x 50.5
NWHCM : 1989.81.1 : F

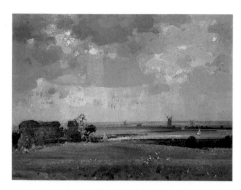

Brown, John Alfred Arnesby 1866–1955
The Marshes from Burgh Castle c.1919
oil on canvas 65.4 x 85.4
NWHCM : 1956.1 : F

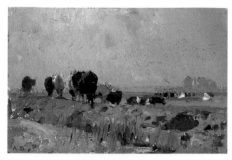

Brown, John Alfred Arnesby 1866–1955
Cattle on the Marshes c.1921
oil on panel 15.9 x 23.5
NWHCM : 1948.99 : F

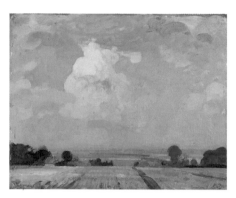

Brown, John Alfred Arnesby 1866–1955
The Cloud (September) c.1930
oil on panel 21.5 x 26.7
NWHCM : 1949.129.4 : F

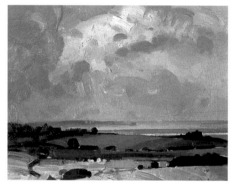

Brown, John Alfred Arnesby 1866–1955
Sketch for 'The Estuary, Gathering Clouds'
1931
oil on panel 20.9 x 26.7
NWHCM : 1949.129.3 : F

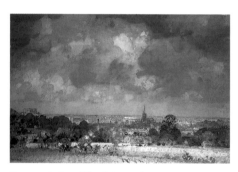

Brown, John Alfred Arnesby 1866–1955
View of Norwich from the Bungay Road
1934–1935
oil on canvas 75 x 111
NWHCM : 1945.1 : F

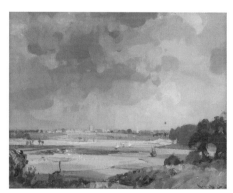

Brown, John Alfred Arnesby 1866–1955
Blythsburgh (Beccles across the Marshes)
oil on canvas 35.8 x 46.1
NWHCM : 1949.129.1 : F

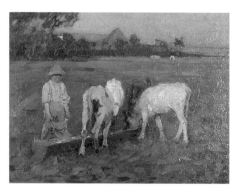

Brown, John Alfred Arnesby 1866–1955
Calves
oil on canvas 35.9 x 45.7
NWHCM : 1949.129.2 : F

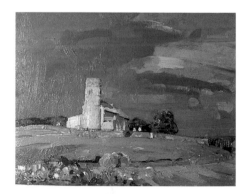

Brown, John Alfred Arnesby 1866–1955
Haddiscoe Church, Norfolk
oil on panel 21.6 x 26.9
NWHCM : 1949.129.5 : F

Facing page: Dufour, Bernard, b.1922, *Composition* (detail), 1957, Sainsbury Centre for Visual Arts, The University of East Anglia, (p.255)

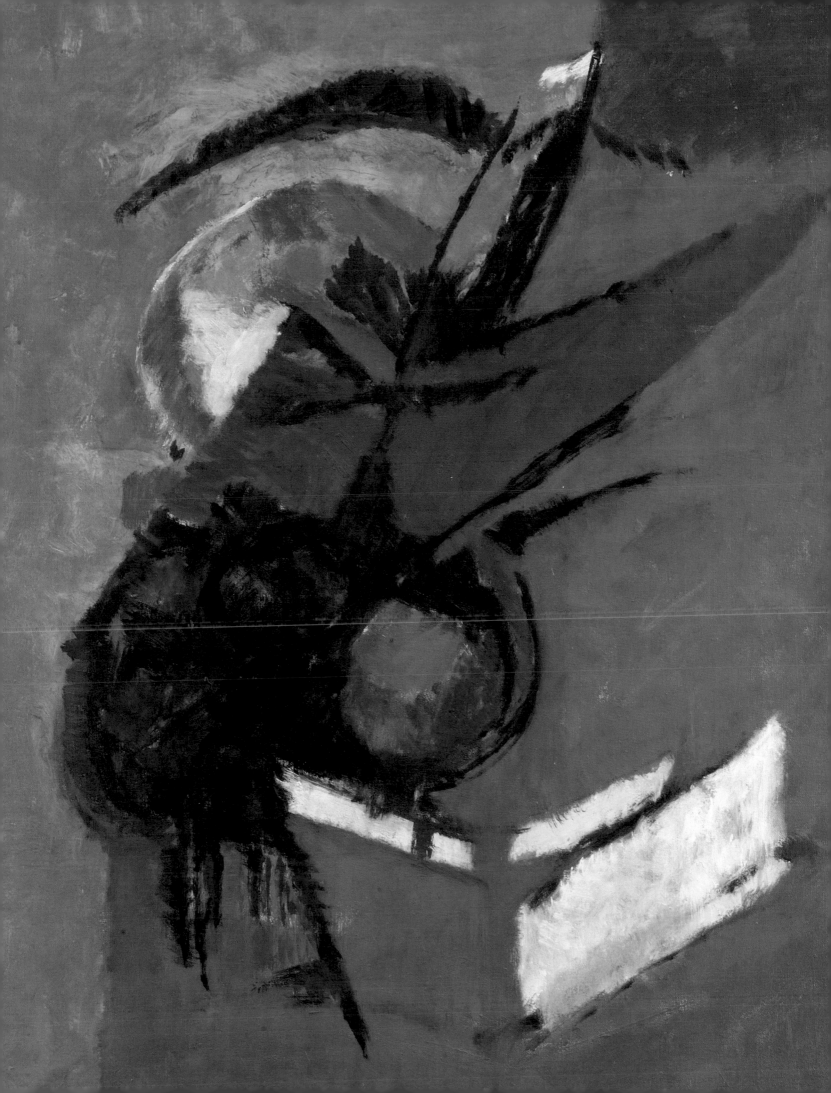

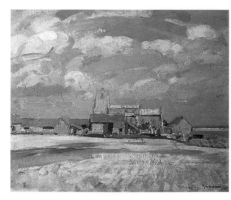

Brown, John Alfred Arnesby 1866–1955
Morston Church, Norfolk
oil on panel 21 x 26
NWHCM : 1949.129.6 : F

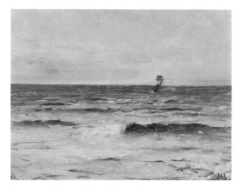

Brown, John Alfred Arnesby 1866–1955
Seascape with Yacht
oil on board 26.2 x 34.1
NWHCM : 1989.81.2 : F

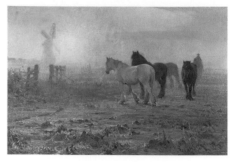

Brown, John Alfred Arnesby 1866–1955
The Coming Day
oil on canvas 121.3 x 177.5
NWHCM : 1947.99 : F

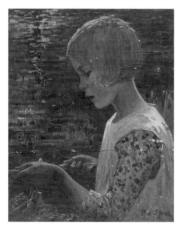

Brown, Mia Arnesby 1865–1931
Girl Fishing c.1918
oil on canvas 49.5 x 40.4
NWHCM : 1989.81.4 : F

Brown, Mia Arnesby 1865–1931
Sleeping Girl 1931
oil on canvas 36 x 30.5
NWHCM : 1989.81.3 : F

Brown, Mia Arnesby 1865–1931
Thomas South Mack as a Small Boy
oil on canvas 50.2 x 40.6
NWHCM : 1981.294 : F

Browne, Joseph 1720–1800
St Peter's Denial 1795
oil on board 96 x 266.4
NWHCM : L1980.3.1 : F

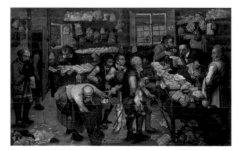

Brueghel, Pieter the younger
1564/1565–1637/1638
The Rent Collectors 1618
oil on mahogany panel 54 x 84.9
NWHCM : 1975.272 : F

Brundrit, Reginald Grange 1883–1960
Trees
oil on canvas 24 x 34.3
NWHCM : 1949.129.17 : F

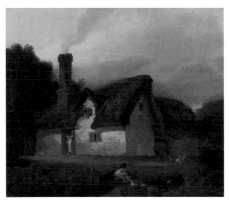

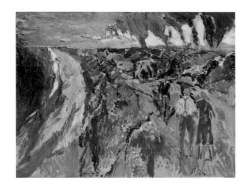

Butler, Thomas (after) c.1730–c.1760
*The Godolphin Arabian (inn sign from 86
Magdalen Street, Norwich)*
oil on board 67.6 x 81
NWHCM : 1921.55 : F

Callcott, Augustus Wall 1779–1844
Cottage Scene
oil on canvas 57.2 x 65
NWHCM : 1943.88.12 : F

Camp, Jeffery b.1923
Golden Cliff Top 1959
oil on hardboard 48.2 x 63.5
NWHCM : 1960.30 : F

Carpenter, Margaret Sarah 1793–1872
James Stark (1794–1859)
oil on canvas 76.5 x 63.8
NWHCM : 1949.204 : F

Carr, David 1915–1968
Machine Drawing
oil on canvas 91.2 x 61
NWHCM : L1969.26 : F

Carter, William 1863–1939
Juliet Dudley Edenborough (1916–1937)
oil on canvas 65.4 x 50.2
NWHCM : 1950.79.1 : F

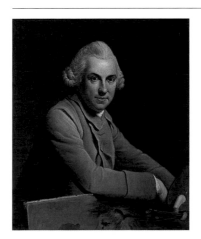

Catton, Charles the younger 1756–1819
Charles Catton, RA (1728–1798) 1773
oil on canvas 75 x 61
NWHCM : 1920.2 : F

Chalkley, Brian b.1948
Con-Cast 2/84 1984
oil on primed paper 105 x 135
NWHCM : 1985.92 : F

Chance, Ian b.1940
Landscape Device c.1973
acrylic resin on canvas 101.6 x 101.6
NWHCM : 1973.382 : F

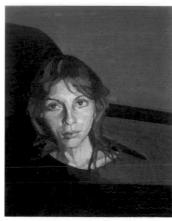

Chaudhuri, Jayanta b.1958
Study for 'Night Portrait', 1980–1981
oil on hardboard 34.1 x 27.5
NWHCM : 1981.295 : F

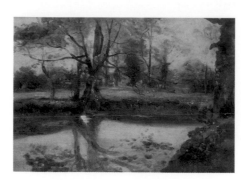

Churchyard, Thomas 1798–1865
Landscape with Trees by a Pool
oil on panel 23.5 x 34.3
NWHCM : 1943.88.5 : F

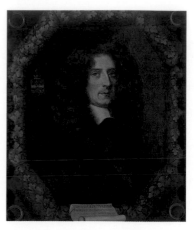

Churchyard, William John d.1930
Copy of a Portrait of Sir John Pettus, Bt, 1670
1889
oil on canvas 61.8 x 51.2
NWHCM : 1948.150 : F

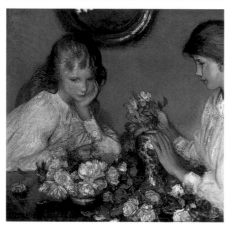

Clausen, George 1852–1944
Children and Roses 1899
oil on canvas 64 x 76.7 (E)
NWHCM : L1992.1 : F (P)

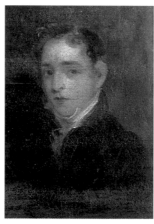

Clint, George 1770–1854
John Berney Crome (1794–1842)
oil on oak panel 18.5 x 13.4 (E)
NWHCM : 1951.235.1391 : F

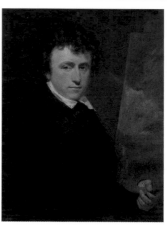

Clint, George 1770–1854
Joseph Stannard (1797–1830)
oil on mahogany panel 30.5 x 23.7
NWHCM : 1894.72.1 : F

Clint, George 1770–1854
William Henry Crome (1806–1867)
oil on millboard 30.5 x 25.4
NWHCM : 1951.235.1392 : F

Clough, Prunella 1919–1999
Man Entering a Boiler House 1957
oil on canvas 91.2 x 60.5
NWHCM : 1957.46 : F

Clover, Joseph 1779–1853
Anna Mann (née Wade) (1751–1830) c.1800
oil on canvas 76.2 x 63.5
NWHCM : 1965.81.1 : F

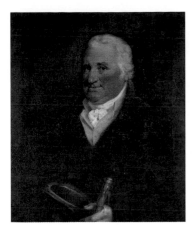

Clover, Joseph 1779–1853
William Mann (1738–1812) c.1800
oil on canvas 76.2 x 63.5
NWHCM : 1965.81.2 : F

Clover, Joseph 1779–1853
The Harvesters c.1806
oil on canvas 62 x 51.9
NWHCM : 1976.501 : F

Clover, Joseph 1779–1853
Barnabas Leman, Mayor of Norwich (1813 &
1818) c.1819
oil on canvas 53.2 x 35.4
NWHCM : 1970.312 : F

Clover, Joseph 1779–1853
The Harvey Family of Norwich c.1820
oil on canvas 102.8 x 126.5
NWHCM : 1985.435 : F

Clover, Joseph 1779–1853
Whitlingham Church, Norwich 1822
oil on millboard 28.3 x 35.3
NWHCM : 1939.141.9 : F

Clover, Joseph 1779–1853
Mrs Withington 1829
oil on mahogany panel 42 x 30.9
NWHCM : 1961.304 : F

Clover, Joseph 1779–1853
Interior with Figures 1830
oil on prepared board 25 x 20
NWHCM : 1939.141.19.12 : F

Clover, Joseph 1779–1853
Landscape with Village in a Dale c.1832
oil on prepared board 29.2 x 35.5
NWHCM : 1939.141.18 : F

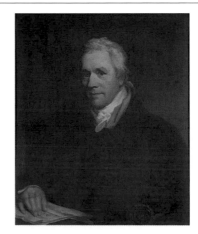

Clover, Joseph 1779–1853
Alderman John Browne
oil on canvas 76.8 x 66.1
NWHCM : 1894.75.29 : F

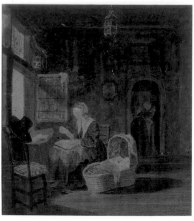

Clover, Joseph 1779–1853
An Interior (after Gerrit Dou)
oil on card 14 x 13.8
NWHCM : 1939.141.19.9 : F

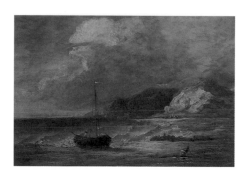

Clover, Joseph 1779–1853
Beach and Fishing Boats, Rugged Cliffs Beyond
oil on oak panel 17.8 x 25.4
NWHCM : 1939.141.13 : F

Clover, Joseph 1779–1853
Corner of a Walled Garden with Washing on Line
oil on panel 41 x 23.5
NWHCM : 1939.141.14 : F

Clover, Joseph 1779–1853
Couple in a Garden
oil on millboard 19 x 16.2
NWHCM : 1939.141.4 : F

Clover, Joseph 1779–1853
Couple with a Child in a Garden
oil on board 12.1 x 10.5
NWHCM : 1939.141.5B : F

Clover, Joseph 1779–1853
Diana
oil on card 8 x 11.3
NWHCM : 1939.141.19.3 : F

Clover, Joseph 1779–1853
Diana and Actaeon (after Titian)
oil on panel 29.1 x 35.1
NWHCM : 1939.141.19.2 : F

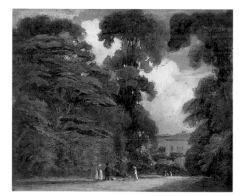

Clover, Joseph 1779–1853
Drive of Country House, with Trees and Figures
oil on paper laid on cardboard 13.7 x 18.5
NWHCM : 1939.141.15 : F

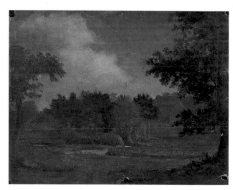

Clover, Joseph 1779–1853
Landscape with Farm Buildings (recto)
oil on paper 27.5 x 35.8
NWHCM : 1939.141.19.17A : F

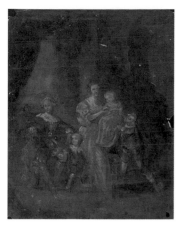

Clover, Joseph 1779–1853
Family Group (verso)
oil on paper 35.8 x 27.5
NWHCM : 1939.141.19.17B : F

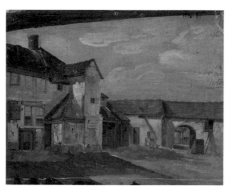

Clover, Joseph 1779–1853
Farm Buildings
oil on canvas board 15.2 x 20.3
NWHCM : 1939.141.16 : F

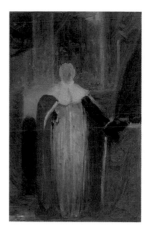

Clover, Joseph 1779–1853
Figure in Mayoral Robes
oil on card 18.9 x 14
NWHCM : 1939.141.19.1 : F

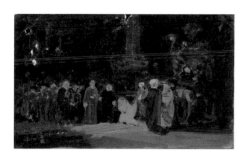

Clover, Joseph 1779–1853
Figures in an Interior
oil on card 8.5 x 13.2
NWHCM : 1939.141.19.4 : F

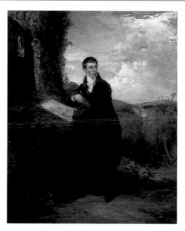

Clover, Joseph 1779–1853
George Vincent (1796–1832)
oil on canvas 77 x 63.5
NWHCM : 1899.4.16 : F

Clover, Joseph 1779–1853
Hilly Wooded Landscape (recto)
oil on card 26.5 x 32.8 (E)
NWHCM : 1939.141.19.11A : F

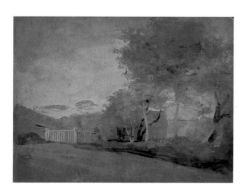

Clover, Joseph 1779–1853
Wooded Landscape with Farm Buildings (verso)
oil on card 26.5 x 32.8 (E)
NWHCM : 1939.141.19.11B : F

Clover, Joseph 1779–1853
Horatio Bolingbroke (1798–1879)
oil on canvas 76.2 x 63.5
NWHCM : 1961.103 : F

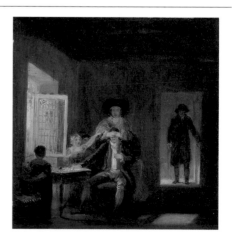

Clover, Joseph 1779–1853
Interior with Couple and Children Playing
oil on millboard 22.3 x 20.1
NWHCM : 1939.141.6 : F

Clover, Joseph 1779–1853
Interior with Figures
oil on panel 12.7 x 18.8
NWHCM : 1939.141.19.7 : F

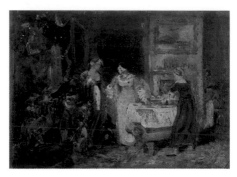

Clover, Joseph 1779–1853
Interior with Women and Children at a Table
oil on blue paper 20.3 x 27.5
NWHCM : 1939.141.19.13 : F

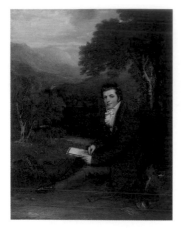

Clover, Joseph 1779–1853
James Stark (1794–1859)
oil on canvas 76.5 x 57
NWHCM : 1921.16 : F

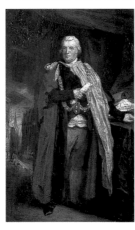

Clover, Joseph 1779–1853
John Herring, Mayor of Norwich (1799) (after John Opie)
oil on oak panel 25.4 x 16.4
NWHCM : 1939.141.7 : F

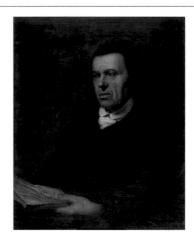

Clover, Joseph 1779–1853
Joseph Clover, Farrier (1725–1811), Grandfather of the Artist
oil on canvas 75.6 x 63.5
NWHCM : 1939.141.1 : F

Clover, Joseph 1779–1853
Landscape with Birches and Pond
oil on paper laid on cardboard 35.5 x 27.6
NWHCM : 1939.141.12 : F

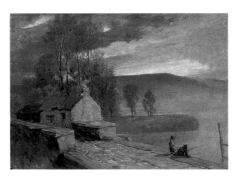

Clover, Joseph 1779–1853
Landscape with Bridge and Cottage
oil on canvas 27.9 x 38.1
NWHCM : 1939.141.11 : F

Clover, Joseph 1779–1853
Landscape with Castle
oil on millboard 24.1 x 29.2
NWHCM : 1939.141.10 : F

Clover, Joseph 1779–1853
Landscape with Church and Houses, Pines in Foreground
oil on canvas 25.7 x 20.6
NWHCM : 1939.141.8 : F

Clover, Joseph 1779–1853
Landscape with Cottage (recto)
oil on paper 34.6 x 23.2
NWHCM : 1939.141.19.15A : F

Clover, Joseph 1779–1853
Two Studies of Women (verso)
oil on paper 23.2 x 34.6
NWHCM : 1939.141.19.15B : F

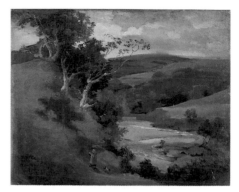

Clover, Joseph 1779–1853
Landscape with River in Hilly Country
oil on card 26.3 x 32.5
NWHCM : 1939.141.17 : F

Clover, Joseph 1779–1853
Man, Woman and Baby in a Bedroom
oil on board 15.2 x 13.5
NWHCM : 1939.141.5A : F

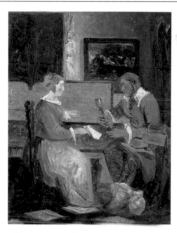

Clover, Joseph 1779–1853
Man and Woman in an Interior Playing Music
oil on board 15.2 x 12
NWHCM : 1939.141.5C : F

Clover, Joseph 1779–1853
Mother and Child
oil on panel 20.5 x 15.7
NWHCM : 1939.141.19.8 : F

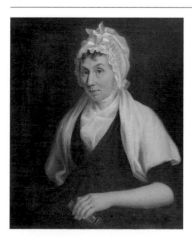

Clover, Joseph 1779–1853
Mrs Martha Farrow (née Suckling)
oil on canvas 77.4 x 64.2
NWHCM : 1978.89 : F

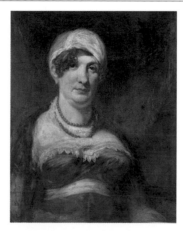

Clover, Joseph 1779–1853
Mrs Nathaniel Bolingbroke (née Mary Yallop)
(1760–1833)
oil on canvas 77 x 63.7
NWHCM : 1970.497.84 : F

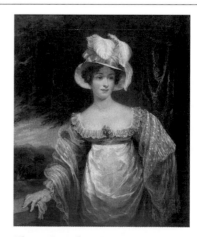

Clover, Joseph 1779–1853
Portrait of a Lady with Ostrich Plume Hat
oil on canvas 53.3 x 43.5
NWHCM : 1939.141.3 : F

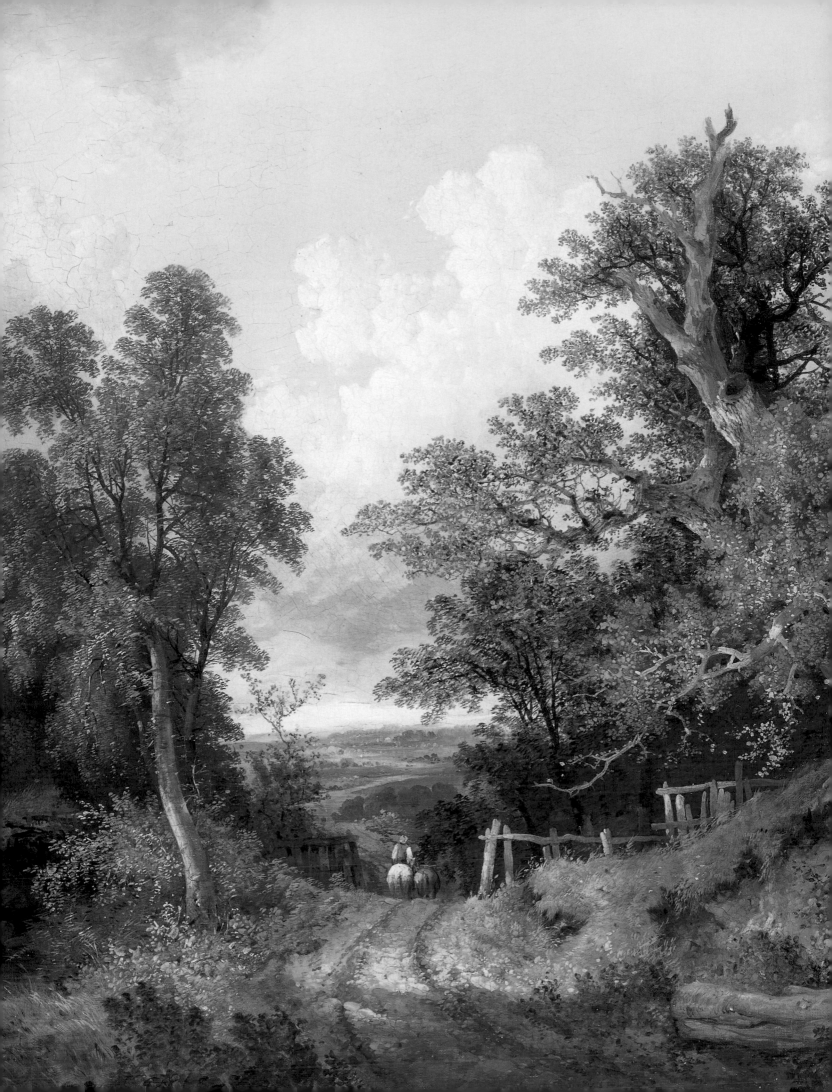

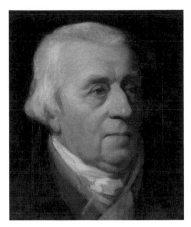

Clover, Joseph 1779–1853
Richard Cumberland, the Poet (1732–1811)
oil on canvas 35.6 x 30.5
NWHCM : 1939.141.2 : F

Clover, Joseph 1779–1853
River Landscape with Rocks in the Foreground
oil on brown paper 24.8 x 31.5
NWHCM : 1939.141.19.14 : F

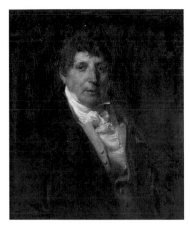

Clover, Joseph 1779–1853
Sir John Harrison Yallop, Kt (1763–1835)
oil on canvas 76.2 x 64
NWHCM : 1970.497.85 : F

Clover, Joseph 1779–1853
Three Figures Seated in a Landscape
oil on card 14 x 9.5
NWHCM : 1939.141.19.5 : F

Clover, Joseph 1779–1853
Three Interiors with Figures
oil on card 14 x 9.5
NWHCM : 1939.141.19.6 : F

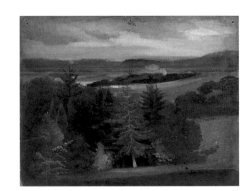

Clover, Joseph 1779–1853
Wooded Landscape
oil on card 26.2 x 32.5
NWHCM : 1939.141.19.10 : F

Clover, Joseph 1779–1853
Wooded Landscape (recto)
oil on paper 26.2 x 32.6 (E)
NWHCM : 1939.141.19.16A : F

Clover, Joseph 1779–1853
Sketch of Girls in a Landscape (verso)
oil on paper 26.2 x 32.6 (E)
NWHCM : 1939.141.19.16B : F

Clover, Joseph (attributed to) 1779–1853
Landscape
oil on prepared board 37.8 x 27.6
NWHCM : 1951.235.99 : F

Facing page: Ladbrooke, John Berney, 1803–1879, *Lane Scene* (detail), 1874, Norwich Castle Museum and Art Gallery, (p.154)

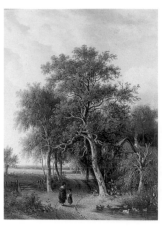

Coates, M. L.
Stoke Mill near Norwich
oil on canvas 35.8 x 53.8
NWHCM : 1940.28 : F

Coker, Peter 1926–2004
Pig's Head 1955
oil on canvas 63.2 x 75.8
NWHCM : 1984.319.1 : F

Colkett, Samuel David 1806–1863
Landscape 1846
oil on mahogany panel 44.5 x 34.2
NWHCM : 1924.36 : F

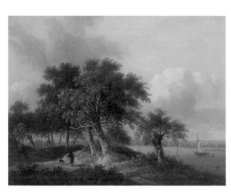

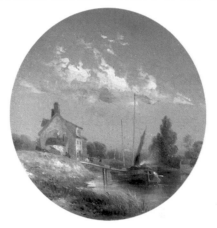

Colkett, Samuel David 1806–1863
River Scene 1850
oil on canvas 35.7 x 46.1
NWHCM : 1944.20.4 : F

Colkett, Samuel David 1806–1863
River Scene near Norwich 1851
oil on mahogany panel 20.7
NWHCM : 1973.138.2 : F

Colkett, Samuel David 1806–1863
On the River Yare 1852
oil on mahogany panel 19.2 x 28
NWHCM : 1951.235.32 : F

Colkett, Samuel David 1806–1863
Landscape 1853
oil on canvas 35.9 x 45.7
NWHCM : 1939.14 : F

Colkett, Samuel David 1806–1863
River Scene near Norwich 1853
oil on mahogany panel 20.7
NWHCM : 1973.138.1 : F

Colkett, Samuel David 1806–1863
River Scene near Cambridge 1858
oil on canvas 40.8 x 50.5
NWHCM : 1971.55.141 : F

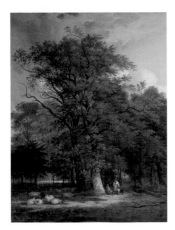

Colkett, Samuel David 1806–1863
Queen's College Grove, Cambridge 1860
oil on canvas 61.5 x 45.4
NWHCM : 1900.29 : F

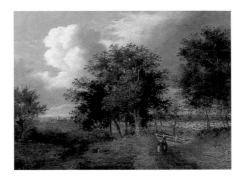

Colkett, Samuel David 1806–1863
*Landscape with Church in Distance and Figure
in a Red Shawl*
oil on oak panel 29.2 x 39.5
NWHCM : 1940.118.11 : F

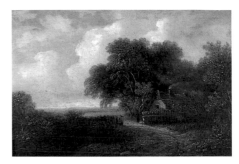

Colkett, Samuel David 1806–1863
Landscape with Cottage
oil on mahogany panel 18.5 x 27.6
NWHCM : 1951.235.30 : F

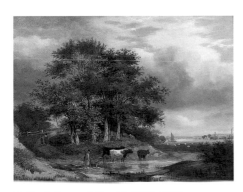

Colkett, Samuel David 1806–1863
*Landscape with Cows in a Pool by a Clump of
Trees*
oil on oak panel 28.9 x 39.6
NWHCM : 1940.118.10 : F

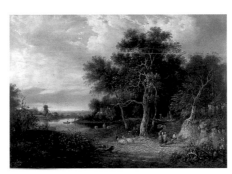

Colkett, Samuel David 1806–1863
*Landscape with River and Mill, Sheep in
Foreground*
oil on canvas 61.5 x 87
NWHCM : 1951.235.31 : F

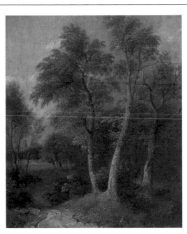

Colkett, Samuel David 1806–1863
Lane Scene
oil on panel 33 x 27.3
NWHCM : 1933.46.1 : F

Collins, Cecil 1908–1989
Landscape: Autumn 1958
oil on hardboard 91.5 x 122
NWHCM : 2001.285.1 : F

Collins, Cecil 1908–1989
Landscape: Dawn 1959
oil on hardboard 92 x 122
NWHCM : 2005.285.2 : F

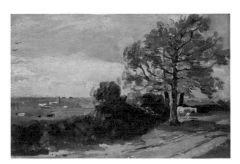

Constable, John (after) 1776–1837
At East Bergholt
oil on canvas 15 x 22.9
NWHCM : 1940.46.1 : F

Constable, John (after) 1776–1837
Brighton
oil on canvas 12.1 x 31.1
NWHCM : 1940.46.2 : F

Constable, John (after) 1776–1837
Cloudy Landscape
oil on canvas 23.5 x 30
NWHCM : 1940.46.3 : F

Constable, John (after) 1776–1837
The Glebe Farm
oil on canvas 61 x 77.5
NWHCM : 1948.216 : F

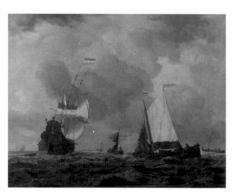

Coopse, Pieter d. after 1677
A Dutch Man of War and Vessels in a Breeze
1675
oil on canvas 50.2 x 65.1
NWHCM : 1973.161.1 : F

Coppin, Mrs Daniel c.1768–1812
The Cottage Door (after Thomas Gainsborough) c.1808
oil on canvas 58.4 x 47
NWHCM : 1894.72.2 : F

Corden, William II c.1820–1900
James Stark (1794–1859)
oil on canvas 59.7 x 49.5
NWHCM : 1906.52 : F

Cotman, Frederick George 1850–1920
From Shade to Sunshine 1880
oil on millboard 36.3 x 22
NWHCM : 1951.235.34 : F

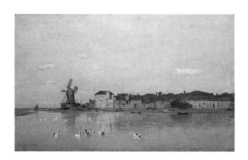

Cotman, Frederick George 1850–1920
A Flood Tide at Cley-next-the-Sea, Norfolk
1885
oil on canvas 43.4 x 69.5
NWHCM : 1942.82 : F

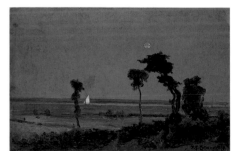

Cotman, Frederick George 1850–1920
Moonlight River Scene 1899
oil on card 21.5 x 32
NWHCM : 1975.474.44 : F

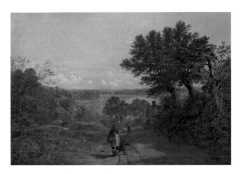

Cotman, John Joseph 1814–1878
Station Road, Brundall 1850
oil on canvas 45.9 x 63.2
NWHCM : 1970.480.3 : F

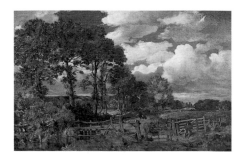

Cotman, John Joseph 1814–1878
Road on the Trowse Meadows, Norfolk c.1860
oil on canvas 33.2 x 51.2
NWHCM : 1951.235.39 : F

Cotman, John Joseph 1814–1878
Lane near Carrow, Norwich
oil on canvas 38.7 x 56.5
NWHCM : 1951.235.38 : F

Cotman, John Joseph 1814–1878
Postwick Grove, Norwich
oil on canvas 50.8 x 76.2
NWHCM : 1945.97 : F

Cotman, John Joseph 1814–1878
River at Postwick near Norwich
oil on canvas 30.5 x 101.7
NWHCM : 1940.120 : F

Cotman, John Joseph 1814 1878
Roughton Heath, Cromer
oil on canvas 34.4 x 50.8
NWHCM : 1907.50 : F

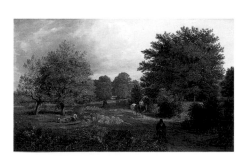

Cotman, John Joseph 1814–1878
Whitlingham Lane, Norwich
oil on canvas 48 x 76.8
NWHCM : 1951.235.37 : F

Cotman, John Joseph 1814–1878
Whitlingham Woods near Norwich
oil on canvas 46.1 x 35.5
NWHCM : 1951.235.36 : F

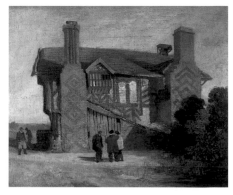

Cotman, John Sell 1782–1842
Moreton Hall, Cheshire c.1807–1808
oil on canvas 62.3 x 75.5
NWHCM : 1951.235.116 : F

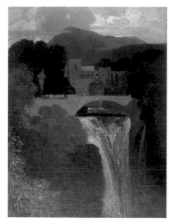

Cotman, John Sell 1782–1842
The Waterfall c.1807–1808
oil on canvas 57.3 x 43.2
NWHCM : 1951.235.118 : F

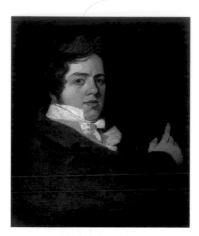

Cotman, John Sell 1782–1842
Portrait of a Young Man c.1807–1809
oil on canvas 61.2 x 50.8
NWHCM : 1951.235.91 : F

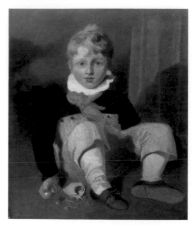

Cotman, John Sell 1782–1842
Boy at Marbles (Henry Cotman) 1808
oil on canvas 76.2 x 63.5
NWHCM : L1983.5 : F (P)

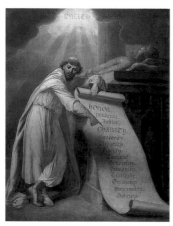

Cotman, John Sell 1782–1842
St James of Compostela 1808
oil on canvas 94.9 x 74
NWHCM : 1951.235.93 : F

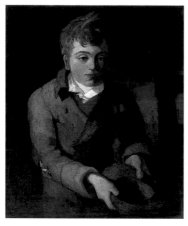

Cotman, John Sell 1782–1842
The Beggar Boy 1808
oil on millboard 72.7 x 61.5
NWHCM : 1951.235.92 : F

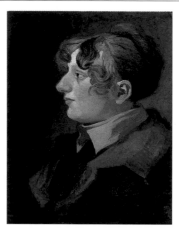

Cotman, John Sell 1782–1842
Mrs John Sell Cotman c.1808–1809
oil on millboard 54.6 x 40
NWHCM : 1952.195 : F

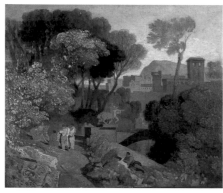

Cotman, John Sell 1782–1842
The Judgement of Midas c.1808–1809
oil on canvas 60.8 x 73.7
NWHCM : 1951.235.117 : F

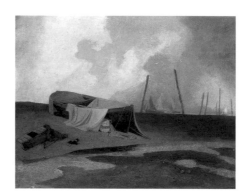

Cotman, John Sell 1782–1842
Boats on Cromer Beach c.1808–1810
oil on mahogany panel 37 x 46.7
NWHCM : 1951.235.96 : F

Cotman, John Sell 1782–1842
Old Houses at Gorleston c.1815–1823
oil on canvas 45.5 x 35.3
NWHCM : 1899.4.8 : F

Cotman, John Sell 1782–1842
Sea View (Fishing Boats) c.1820
oil on canvas 63.2 x 76
NWHCM : 1899.4.7 : F

Cotman, John Sell 1782–1842
After a Storm 1820s
oil on canvas 63.2 x 75.6
NWHCM : 1951.235.103 : F

Cotman, John Sell 1782–1842
*Dutch Boats off Yarmouth, Prizes during the
War* c.1823–1824
oil on mahogany panel 43.5 x 63.5
NWHCM : 1951.235.115 : F

Cotman, John Sell 1782–1842
*View from Yarmouth Bridge, Looking towards
Breydon, Just after Sunset* c.1823–1825
oil on millboard 44.5 x 63.4
NWHCM : 1951.235.114 : F

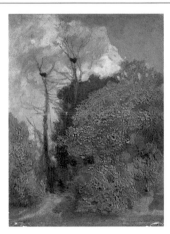

Cotman, John Sell 1782–1842
In the Bishop's Garden c.1824–1825
oil on millboard 25.6 x 18.9
NWHCM : 1951.235.107 : F

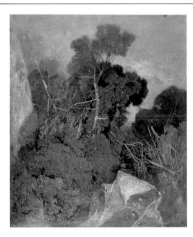

Cotman, John Sell 1782–1842
Silver Birches c.1824–1828
oil on canvas 76.2 x 62.7
NWHCM : 1951.235.119 : F

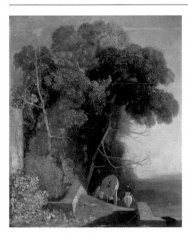

Cotman, John Sell 1782–1842
The Baggage Wagon c.1824–1828
oil on panel 43 x 35.2
NWHCM : 1899.4.5 : F

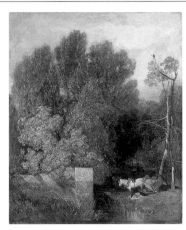

Cotman, John Sell 1782–1842
The Mishap c.1824–1828
oil on panel 43 x 35.4
NWHCM : 1899.4.6 : F

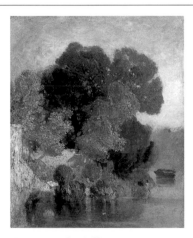

Cotman, John Sell 1782–1842
The Silent Stream, Normandy c.1824–1828
oil on canvas 40.2 x 33.5
NWHCM : 1951.235.120 : F

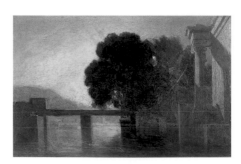

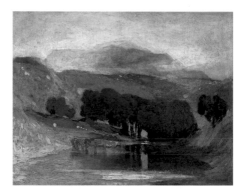

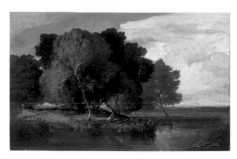

Cotman, John Sell 1782–1842
Palace of Prince Beauharnais c.1827–1830
oil on panel 28 x 43
NWHCM : 1951.235.108 : F

Cotman, John Sell 1782–1842
Cader Idris c.1828–1833
oil on oak panel 24.4 x 31.6
NWHCM : 1941.103 : F

Cotman, John Sell 1782–1842
Alder Carr, Norwich c.1830s
oil on mahogany panel 33.5 x 52.2
NWHCM : 1951.235.106 : F

Cotman, John Sell 1782–1842
An Ecclesiastic 1836
oil on mahogany panel 44.7 x 33.9
NWHCM : 1951.235.110 : F

Cotman, John Sell 1782–1842
The Monk 1836
oil on mahogany panel 44.8 x 34
NWHCM : 1951.235.111 : F

Cotman, John Sell 1782–1842
Henley-on-Thames, Boys Fishing c.1837–1839
oil on mahogany panel 35.1 x 43.3
NWHCM : 1951.235.121 : F

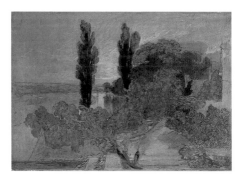

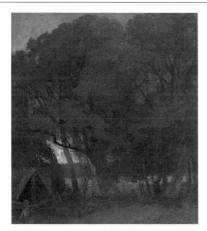

Cotman, John Sell 1782–1842
Alder Carr, Norwich c.1839–1842
oil on mahogany panel 35.1 x 45.7
NWHCM : 1951.235.113 : F

Cotman, John Sell 1782–1842
From My Father's House at Thorpe 1842
oil on canvas 68.4 x 94
NWHCM : 1894.75.1 : F

Cotman, John Sell 1782–1842
Boat House and Trees
oil on millboard 42 x 35.6
NWHCM : 1951.235.102 : F

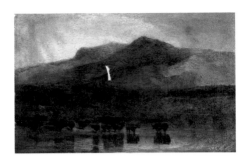

Cotman, John Sell 1782–1842
Capel Curig, Cader Idris
oil on mahogany panel 28 x 43.2
NWHCM : 1951.235.101 : F

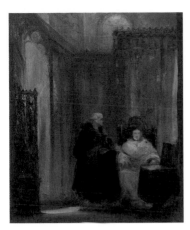

Cotman, John Sell 1782–1842
Ecclesiastics in a Vestry (Interior of Church in Normandy)
oil on millboard 26.1 x 21.6
NWHCM : 1951.235.112 : F

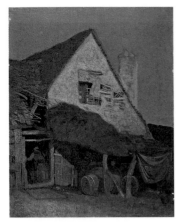

Cotman, John Sell 1782–1842
Gable End of Old Houses, St Albans (after Francis Stevens)
oil on millboard 42.8 x 32.9
NWHCM : 1951.235.100 : F

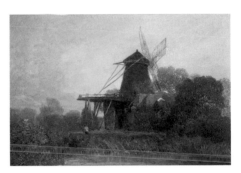

Cotman, John Sell 1782–1842
St Benet's Abbey, Norfolk
oil on mahogany panel 43.5 x 63.5
NWHCM : 1951.235.109 : F

Cotman, John Sell (attributed to)
1782–1842
Sketch of Church Interior 1842
oil on card 40 x 25.1
NWHCM : 1949.47 : F

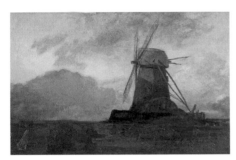

Cotman, John Sell (attributed to)
1782–1842
Lincolnshire Draining Mill
oil on canvas 35.5 x 54.3
NWHCM : 1951.235.98 : F

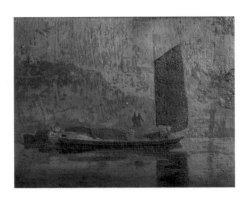

Cotman, John Sell (attributed to)
1782–1842
River Scene (A Norfolk Wherry)
oil on millboard 17.5 x 22.1
NWHCM : 1951.235.97 : F

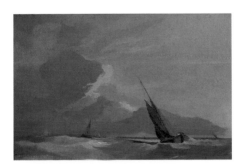

Cotman, John Sell (attributed to)
1782–1842
Seascape
oil on oak panel 33 x 48.2
NWHCM : 1951.235.105 : F

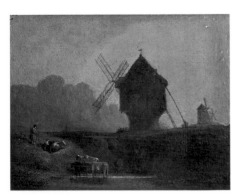

Cotman, John Sell (attributed to)
1782–1842
The Mills
oil on mahogany panel 23.9 x 29.8
NWHCM : 1945.93 : F

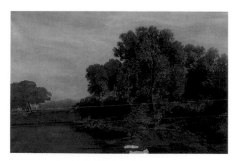

Cotman, John Sell (attributed to)
1782–1842
Unfinished Landscape
oil on canvas 79.4 x 120.7
NWHCM : 1937.117 : F

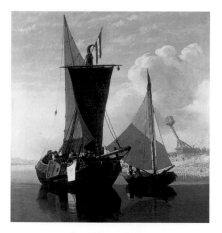

Cotman, Miles Edmund 1810–1858
Boats on the Medway, a Calm c.1845
oil on canvas 55.3 x 50.2
NWHCM : 1899.4.12 : F

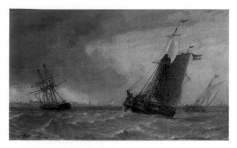

Cotman, Miles Edmund 1810–1858
Dutch Shipping in Stormy Weather
oil on oak panel 14.2 x 22.5
NWHCM : 1951.235.630 : F

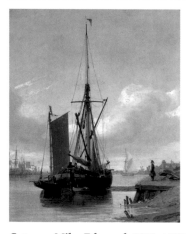

Cotman, Miles Edmund 1810–1858
Gorleston Harbour
oil on mahogany panel 32.4 x 27.8
NWHCM : 1951.235.626 : F

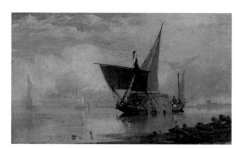

Cotman, Miles Edmund 1810–1858
Hay Barge off Yarmouth
oil on millboard 13.4 x 21.9
NWHCM : 1951.235.629 : F

Cotman, Miles Edmund 1810–1858
Mapledurham Mill
oil on canvas 34.9 x 50.8
NWHCM : 1951.235.624 : F

Cotman, Miles Edmund 1810–1858
Near the Coast (The Wave)
oil on paper laid on mahogany panel
33.5 x 51.3
NWHCM : 1951.235.634 : F

Cotman, Miles Edmund 1810–1858
The Mouth of the Yare
oil on mahogany panel 31.5 x 44.4
NWHCM : 1894.75.20 : F

Cotman, Miles Edmund 1810–1858
The Whitlingham Road
oil on panel 31.7 x 44.4
NWHCM : 1978.357 : F

Facing page: Messel, Oliver, 1904–1978, *Lilies* (detail), Norwich Assembly House, (p.87)

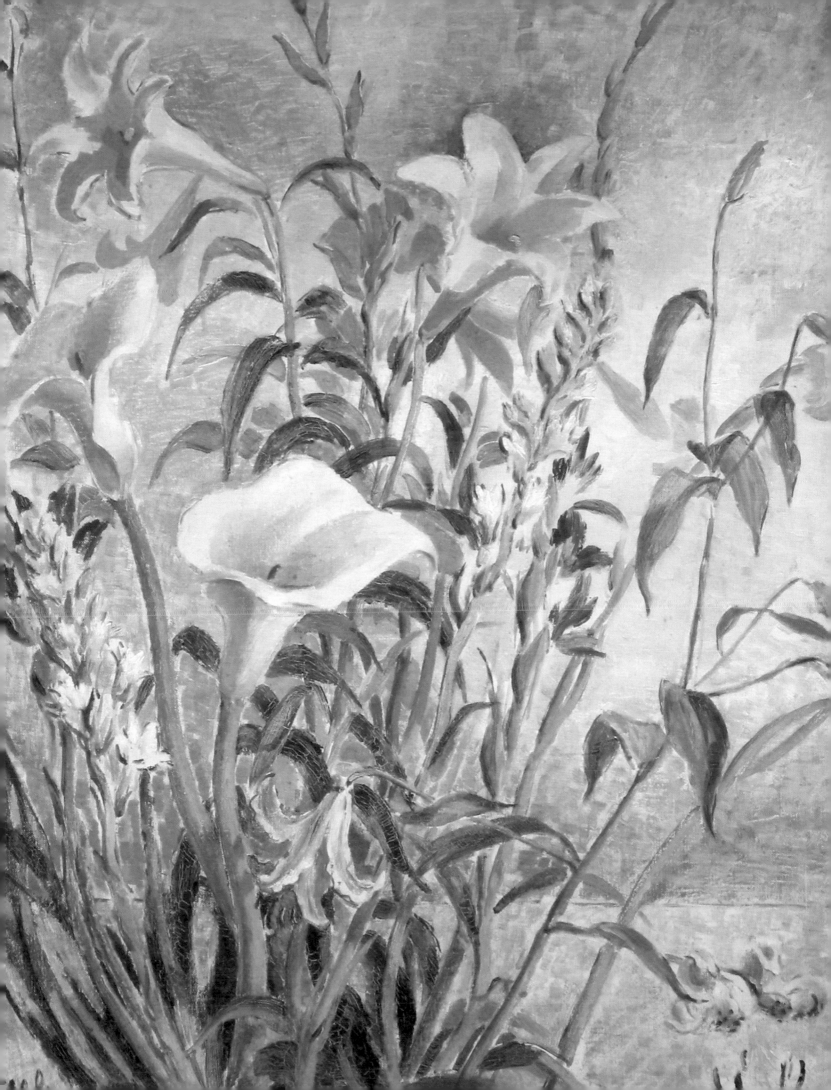

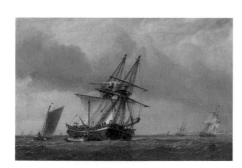

Cotman, Miles Edmund 1810–1858
Unloading Timber
oil on canvas 34.6 x 51.1
NWHCM : 1951.235.627 : F

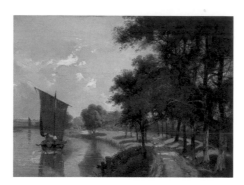

Cotman, Miles Edmund 1810–1858
Whitlingham, Lane Scene with River on Left
oil on oak panel 24.4 x 33.3
NWHCM : 1951.235.633 : F

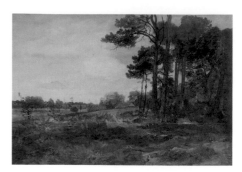

Cotman, Miles Edmund 1810–1858
Whitlingham Looking towards Thorpe
oil on canvas 34.3 x 50.8
NWHCM : 1951.235.632 : F

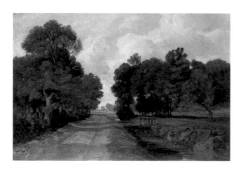

Cotman, Miles Edmund 1810–1858
Whitlingham, Norfolk
oil on canvas 34.5 x 50.9
NWHCM : 1951.235.631 : F

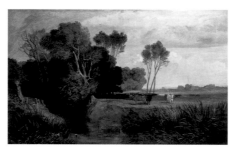

Cotman, Miles Edmund 1810–1858
Wooded Landscape with Cattle
oil on canvas 75.8 x 121.3
NWHCM : 1951.235.623 : F

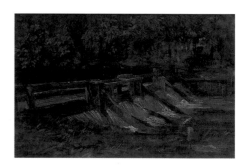

Cotman, Miles Edmund 1810–1858
Woodland and Water (The Weir)
oil on millboard 18.4 x 29.4
NWHCM : 1951.235.622 : F

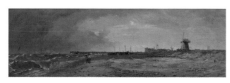

Cotman, Miles Edmund 1810–1858
Yarmouth Beach and Jetty
oil on canvas 36.8 x 112.7
NWHCM : 1934.134.1 : F

Cotman, Miles Edmund 1810–1858
*Yarmouth Beach with the Nelson Monument
in Distance*
oil on mahogany panel 17 x 24.3
NWHCM : 1951.235.628 : F

Cotman, Miles Edmund (attributed to)
1810–1858
Breydon
oil on canvas 34.3 x 44.5
NWHCM : 1942.83 : F

Cotman, Miles Edmund (attributed to)
1810–1858
Farm Buildings and Pond
oil on mahogany panel 23.8 x 32.7
NWHCM : 1952.59.1 : F

Creffield, Dennis b.1931
Within a Budding Grove I 1980
oil on canvas 91.5 x 101.5 (E)
NWHCM : 2002.110.6 : F

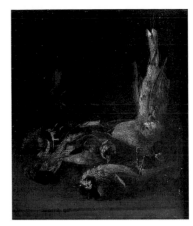

Crome, Emily 1801–1840
Dead Birds 1815
oil on oak panel 23.6 x 20.3
NWHCM : 1972.536 : F

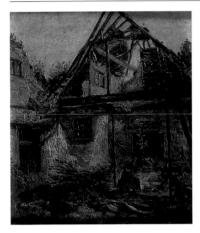

Crome, Emily 1801–1840
An Interior
oil on millboard 15.5 x 12.7
NWHCM : 1951.235.703 : F

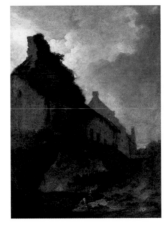

Crome, John 1768–1821
Carrow Abbey, Norwich 1805
oil on canvas 133.7 x 99
NWHCM : 1951.235.705 : F

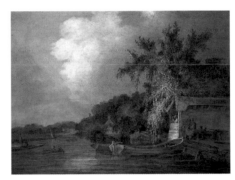

Crome, John 1768–1821
The Yare at Thorpe, Norwich c.1806
oil on mahogany panel 42.3 x 57.7
NWHCM : 1951.235.707 : F

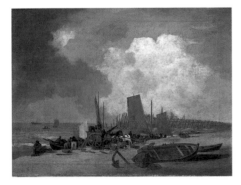

Crome, John 1768–1821
Yarmouth Jetty c.1807–1819
oil on canvas 44.5 x 57.5
NWHCM : 1899.4.1 : F

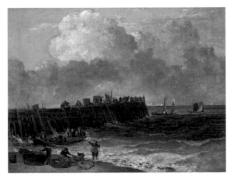

Crome, John 1768–1821
Yarmouth Jetty c.1810–1814
oil on canvas 44.8 x 58.3
NWHCM : 1945.92 : F

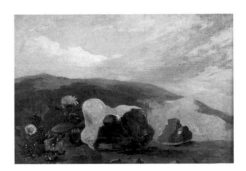

Crome, John 1768–1821
Study of Flints c.1811
oil on canvas 21.8 x 31.8
NWHCM : 1951.235.718 : F

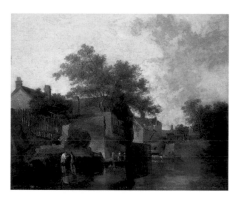

Crome, John 1768–1821
New Mills: Men Wading c.1812
oil on pine panel 29.8 x 35.7
NWHCM : 1970.531 : F

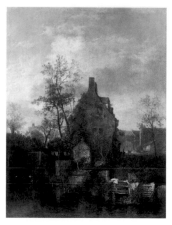

Crome, John 1768–1821
St Martin's Gate, Norwich c.1812–1813
oil on panel 50.7 x 38.3
NWHCM : 1955.170 : F

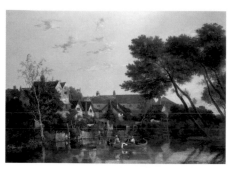

Crome, John 1768–1821
Norwich River: Afternoon c.1812–1819
oil on canvas 71 x 99.5
NWHCM : 1994.189 : F

Crome, John 1768–1821
Dock Leaves c.1813
oil on canvas laid on panel 16.8 x 35.4
NWHCM : 1951.235.716 : F

Crome, John 1768–1821
Study of a Burdock c.1813
oil on panel 54.5 x 41.3
NWHCM : 1899.4.4 : F

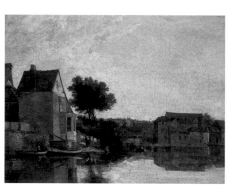

Crome, John 1768–1821
Back of the New Mills c.1814–1817
oil on canvas 41.3 x 54
NWHCM : 1899.4.2 : F

Crome, John 1768–1821
Postwick Grove c.1814–1817
oil on millboard 48.9 x 40.6
NWHCM : 1951.235.728 : F

Crome, John 1768–1821
Boulevard des Italiens, Paris 1815
oil on canvas 54.5 x 87.3
NWHCM : 1935.1.1 : F (P)

Crome, John 1768–1821
Road with Pollards c.1815
oil on canvas 75.8 x 101.7
NWHCM : 1951.235.722 : F

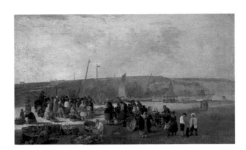

Crome, John 1768–1821
The Fish Market, Boulogne 1820
oil on canvas 52.7 x 86.2
NWHCM : 1935.1.2 : F

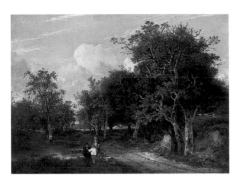

Crome, John 1768–1821
Grove Scene c.1820
oil on canvas 47.6 x 65.1
NWHCM : 1951.235.727 : F

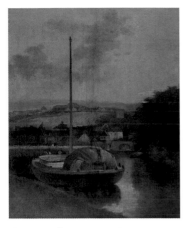

Crome, John 1768–1821
A View on the Wensum
oil on panel 50.8 x 39.4
NWHCM : 1894.75.24 : F

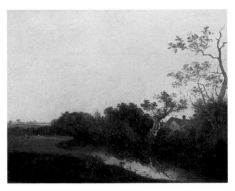

Crome, John 1768–1821
At Honingham, Norfolk
oil on canvas laid on panel 36.4 x 45.2
NWHCM : 1951.235.719 : F

Crome, John 1768–1821
*Bruges River, Ostend in the Distance -
Moonlight*
oil on canvas 64.1 x 79.4
NWHCM : 1899.4.3 : F

Crome, John 1768–1821
View of Kirstead Church, Norfolk
oil on canvas 24.8 x 31.2
NWHCM : 1951.235.710 : F

Crome, John (after) 1768–1821
On the Wensum, above New Mills, Norwich
oil on panel 38 x 51
NWHCM : 1940.118.3 : F

Crome, John (after) 1768–1821
Study of a Burdock
oil on panel 43.1 x 32.5
NWHCM : 1976.158 : F

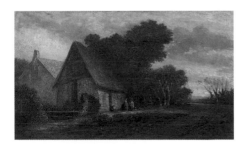

Crome, John (after) 1768–1821
The Old Lazar House, Norwich
oil on canvas 24.8 x 42.5
NWHCM : 1951.235.715 : F

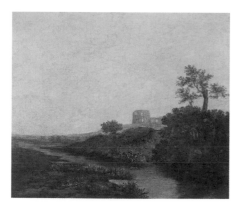

Crome, John (attributed to) 1768–1821
A Castle in Ruins, Morning
oil on canvas 30.4 x 35.5
NWHCM : 1930.152 : F

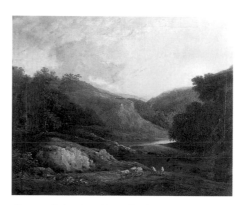

Crome, John (attributed to) 1768–1821
A River Scene, Welsh Hills
oil on canvas 63.7 x 76.8
NWHCM : 1951.235.721 : F

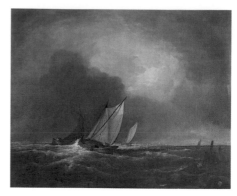

Crome, John (attributed to) 1768–1821
Dutch Boats off Yarmouth
oil on canvas 63.5 x 78.7
NWHCM : 1940.118.2 : F

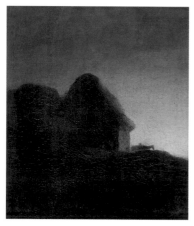

Crome, John (attributed to) 1768–1821
Early Dawn
oil on paper laid on canvas 34.6 x 29.8
NWHCM : 1951.235.706 : F

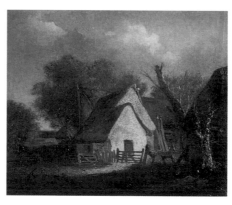

Crome, John (attributed to) 1768–1821
Farmyard near Trowse
oil on millboard 22.6 x 27.3
NWHCM : 1951.235.723 : F

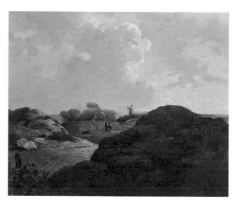

Crome, John (attributed to) 1768–1821
Heath Scene
oil on oak panel 27.9 x 35.3
NWHCM : 1939.26 : F

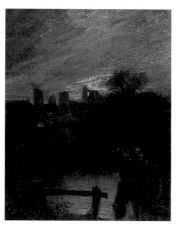

Crome, John (attributed to) 1768–1821
Horse Watering
oil on millboard 35.8 x 27.3
NWHCM : 1951.235.717 : F

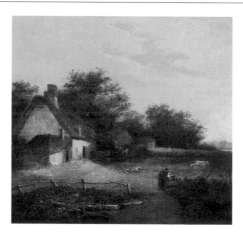

Crome, John (attributed to) 1768–1821
Landscape with Cottage and Trees with Cattle and Figure
oil on canvas laid on panel 27 x 29.2
NWHCM : 1951.235.713 : F

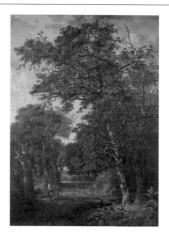

Crome, John (attributed to) 1768–1821
Marlingford Grove
oil on canvas 95.9 x 70.5
NWHCM : 1940.118.1 : F

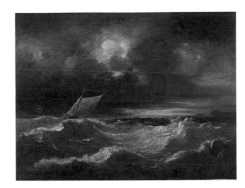

Crome, John (attributed to) 1768–1821
Seascape
oil on canvas 54 x 68.5
NWHCM : 1951.235.720 : F

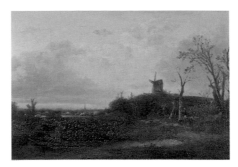

Crome, John (attributed to) 1768–1821
Sprowston Mill, Norwich
oil on oak panel 38.1 x 50.2
NWHCM : 1951.235.726 : F

Crome, John (attributed to) 1768–1821
Study of Foliage
oil on cardboard 24.8 x 32.4
NWHCM : 1951.235.708 : F

Crome, John (attributed to) 1768–1821
Study of Foliage
oil on cardboard 27.2 x 34.8
NWHCM : 1951.235.709 : F

Crome, John (attributed to) 1768–1821
The Cow Tower, Norwich
oil on canvas 48.2 x 63.5
NWHCM : 1951.235.704 : F

Crome, John (attributed to) 1768–1821
The Mill
oil on canvas 101.6 x 127
NWHCM : 1949.130 : F

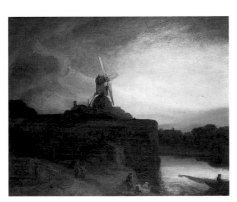

Crome, John (attributed to) 1768–1821
The Mill (after Rembrandt van Rijn)
oil on deal panel 82.3 x 100
NWHCM : 1951.235.728A : F

Crome, John (attributed to) 1768–1821
The Temple of Venus, Baiae
oil on canvas 43.5 x 70.5
NWHCM : 1951.235.711 : F

Crome, John (attributed to) 1768–1821
The Three Cranes' Inn Sign
oil on panel 79.7 x 89.5
NWHCM : 1936.6 : F

Crome, John (attributed to) 1768–1821
View of Norwich
oil on canvas 35.9 x 46.1
NWHCM : 1941.68 : F

Crome, John (imitator of) 1768–1821
Mill on Mousehold
oil on canvas 37.2 x 30.4
NWHCM : 1949.131 : F

Crome, John Berney 1794–1842
Rouen c.1822–1823
oil on canvas 73.5 x 101.8
NWHCM : 1935.131 : F

Crome, John Berney 1794–1842
Moonlight Scene 1823
oil on canvas 35.7 x 58.7
NWHCM : 1942.50 : F

Crome, John Berney 1794–1842
Amsterdam late 1820s
oil on canvas 71.5 x 98.4
NWHCM : 1982.277 : F

Crome, John Berney 1794–1842
View near Bury St Edmunds, Suffolk 1832
oil on canvas 113 x 94
NWHCM : 1895.11 : F

Crome, John Berney 1794–1842
River Scene by Moonlight 1834
oil on canvas 29.9 x 44.5
NWHCM : 1951.235.760 : F

Crome, John Berney 1794–1842
Great Gale at Yarmouth on Ash Wednesday
1836
oil on canvas 53.5 x 86.8
NWHCM : 1951.235.762 : F

Crome, John Berney 1794–1842
The Removal of Old Yarmouth Bridge 1837
oil on canvas 76.2 x 102.9
NWHCM : 2002.135.5 : F

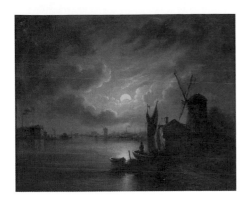

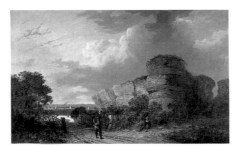

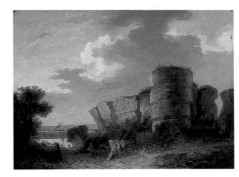

Crome, John Berney 1794–1842
Breydon, Moonlight
oil on canvas 25.6 x 30.9
NWHCM : 1969.301.1 : F

Crome, John Berney 1794–1842
Burgh Castle near Yarmouth
oil on canvas 53.6 x 87.7
NWHCM : 1899.4.14 : F

Crome, John Berney 1794–1842
Burgh Castle near Yarmouth
oil on mahogany panel 25.1 x 34.1
NWHCM : 1973.138.4 : F

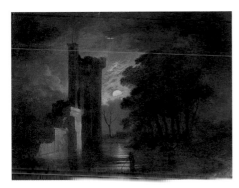

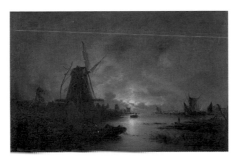

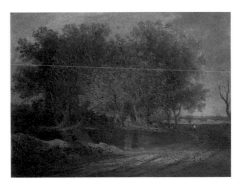

Crome, John Berney 1794–1842
Caister Castle, Moonlight
oil on mahogany panel 25.3 x 34.2
NWHCM : 1973.138.3 : F

Crome, John Berney 1794–1842
Fishing Boats on the Scheldt
oil on canvas 61.2 x 90.5
NWHCM : 1940.118.8 : F

Crome, John Berney 1794–1842
Landscape
oil on millboard 17.7 x 27.7
NWHCM : 1951.235.756 : F

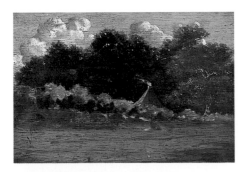

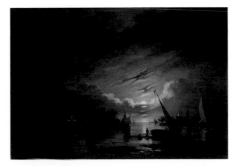

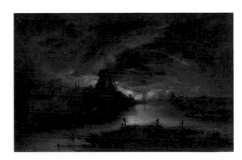

Crome, John Berney 1794–1842
Landscape with Trees and Cottage at Felbrigg
oil on oak panel 11.1 x 16.5
NWHCM : 1951.235.759 : F

Crome, John Berney 1794–1842
Moonlight
oil on canvas 36.2 x 51.8
NWHCM : 1934.120.6 : F

Crome, John Berney 1794–1842
Moonlight on the Yare
oil on canvas 68 x 103.2
NWHCM : 1941.62 : F

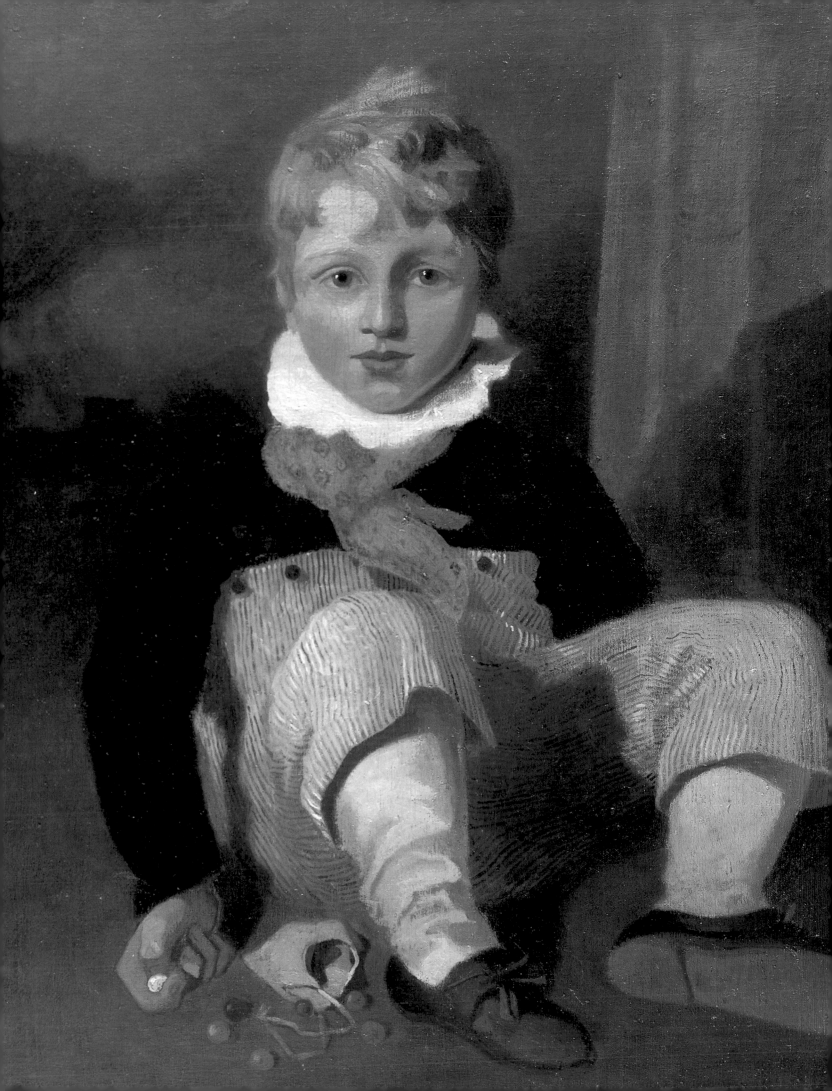

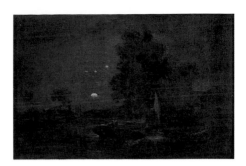

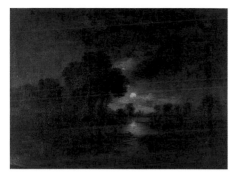

Crome, John Berney 1794–1842
Moonlight Scene, Carrow
oil on oak panel 18.9 x 27.8
NWHCM : 1951.235.758 : F

Crome, John Berney 1794–1842
Moonlight Scene near Dereham
oil on canvas 44.9 x 60.3
NWHCM : 1951.235.761 : F

Crome, John Berney 1794–1842
River Scene in Holland
oil on canvas 87.3 x 114.7
NWHCM : 1934.70 : F

Crome, John Berney 1794–1842
Yarmouth Jetty, Moonlight Scene
oil on oak panel 15.7 x 19.4
NWHCM · 1951.235.757 : F

Crome, John Berney (attributed to)
1794–1842
Holl's Lane, Heigham, Norwich
oil on canvas 59.1 x 79.2
NWHCM : 1951.235.754 : F

Crome, Vivian 1842–c.1926
The White Dog 1883
oil on canvas 29.5 x 39.7
NWHCM : 1970.188 : F

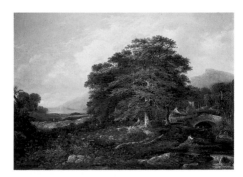

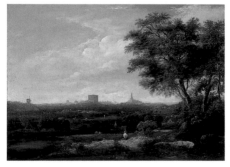

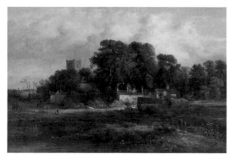

Crome, William Henry 1806–1873
Landscape with Bridge and Man Fishing 1843
oil on panel 68 x 94.3
NWHCM : 1951.235.768 : F

Crome, William Henry 1806–1873
*Landscape with Norwich Castle and Cathedral
in the Distance* 1843/1863
oil on oak panel 65.8 x 91.5
NWHCM : 1951.235.769 : F

Crome, William Henry 1806–1873
Lewisham Church and Village 1844
oil on canvas 61.7 x 92.3
NWHCM : 1951.235.767 : F

Facing page: Cotman, John Sell, 1782–1842, *Boy at Marbles (Henry Cotman)* (detail), 1808, Norwich Castle Museum and Art Gallery, (p.116)

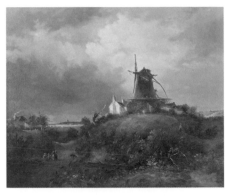

Crome, William Henry 1806–1873
Scene with Mill 1864
oil on canvas 63.5 x 76.5
NWHCM : 1942.51 : F

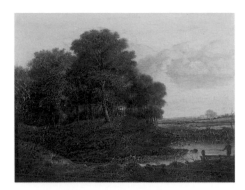

Crome, William Henry 1806–1873
*A Grove of Trees near a Stream with a Man
Fishing from a Boat*
oil on mahogany panel 45 x 53.2
NWHCM : 1951.235.765 : F

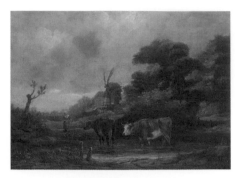

Crome, William Henry 1806–1873
Landscape with Cattle
oil on canvas 25.4 x 35.7
NWHCM : 1969.301.7 : F

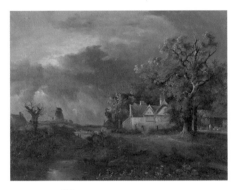

Crome, William Henry 1806–1873
Landscape with Farmhouse and Mill
oil on canvas 35.4 x 45.7
NWHCM : 1970.480.4 : F

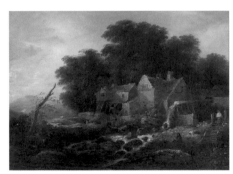

Crome, William Henry 1806–1873
The Old Watermill, Ivybridge, South Devon
oil on canvas 69.5 x 95
NWHCM : 1938.154 : F

Crome, William Henry 1806–1873
*Wooded Stream with Anglers and Man on a
White Horse*
oil on oak panel 47 x 64.8
NWHCM : 1951.235.766 : F

Crotch, William 1775–1847
Windsor Castle 1832
oil on canvas 71 x 91.2
NWHCM : 2005.584.1 : F

Crotch, William 1775–1847
Lane near Budleigh Salterton, Devon 1833
oil on card 25.4 x 22.2
NWHCM : L1976.9.4 : F

Crotch, William 1775–1847
Landscape c.1835
oil on canvas 76.5 x 64.2
NWHCM : 1945.96 : F

Crotch, William 1775–1847
Landscape (after Jacques d'Arthois) c.1835
oil on canvas 58.6 x 42.3
NWHCM : L1976.9.1 : F

Crotch, William 1775–1847
Landscape with Ruins 1837
oil on canvas 20.3 x 29.2
NWHCM : L1976.9.2 : F

Crotch, William 1775–1847
Sheep and Cows (after Augustus Wall Callcott)
oil on canvas 29.8 x 45.1
NWHCM : L1976.9.3 : F

Crowe, Eyre 1824–1910
Nelson's Last Farewell to England c.1888
oil on canvas 162.5 x 247.7
NWHCM : 1905.48 : F

Culbert, Bill b.1935
Transcend 1965
oil on canvas 101.7 x 127
NWHCM : 1965.296 : F

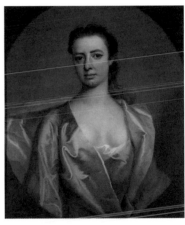

Dahl, Michael I 1656/1659–1743
Elizabeth Buxton 1722
oil on canvas 73.6 x 60.9
NWHCM : 1963.268.20 : F

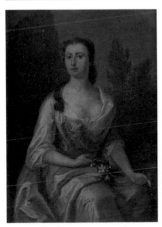

Dahl, Michael I 1656/1659–1743
Ann Gooch, Mrs John Buxton (1691–1749)
oil on canvas 27.9 x 20.3
NWHCM : 1949.107.8 : F

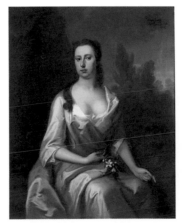

Dahl, Michael I (attributed to)
1656/1659–1743
Ann Gooch, Mrs John Buxton (1691–1749)
1709
oil on canvas 123.2 x 100.3
NWHCM : 1963.268.8 : F

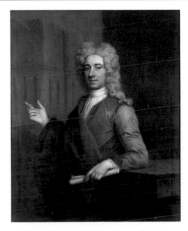

Dahl, Michael I (attributed to)
1656/1659–1743
John Buxton (1684–1731) c.1720
oil on canvas 124.4 x 99
NWHCM : 1963.268.7 : F

Daniell, (Miss)
Yarmouth Old Jetty
oil on papier mâché lid 8.6
NWHCM : 1964.438 : F

Daniell, Edward Thomas 1804–1842
Ruins in Rome c.1830
oil on millboard 18.4 x 25.2
NWHCM : 1951.235.771 : F

Daniell, Edward Thomas 1804–1842
A View of St Malo c.1838
oil on canvas 38.3 x 101.9
NWHCM : 1894.75.15 : F

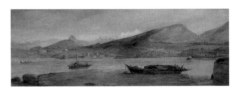

Daniell, Edward Thomas 1804–1842
Sketch for a Picture of the Mountains of Savoy from Geneva c.1839
oil on canvas 37.1 x 101.5
NWHCM : 1894.75.16 : F

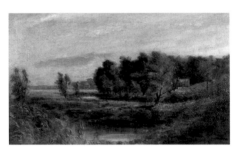

Daniell, Edward Thomas 1804–1842
Back River, Norwich (View at Hellesdon)
oil on canvas 30.4 x 52.1
NWHCM : 1951.235.772 : F

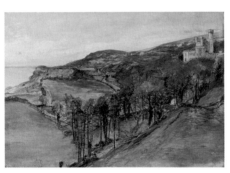

Daniell, Edward Thomas 1804–1842
Mount Edgecombe, Devonshire
oil on paper laid on cardboard 36.8 x 51.8
NWHCM : 1951.235.770 : F

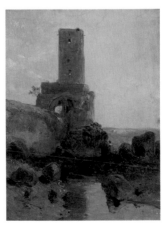

Daniell, Edward Thomas 1804–1842
Ruins of a Claudian Aqueduct in the Campagna di Roma
oil on millboard 20.2 x 15.3
NWHCM : 1951.235.773 : F

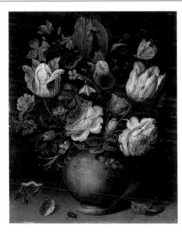

Danielsz., Andries (attributed to)
c.1580–c.1640
Floral Study with Insects in the Foreground
oil on copper 25.9 x 20.7
NWHCM : 1987.309 : F

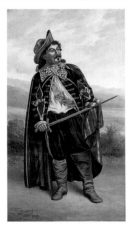

Darby, Alfred William active 1875–1902
Cavalier 1902
oil on canvas 96.2 x 53.9
NWHCM : 1987.100.5 : F

Daubigny, Charles-François 1817–1878
Cattle at a Stream, Evening
oil on panel 19 x 33.7
NWHCM : 1949.136 : F

Davis, John Philip 1784–1862
Captain George William Manby (1765–1854)
1818
oil on canvas 124.5 x 100.5
NWHCM : 1831.80.1 : F

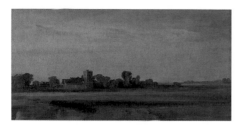

De Wint, Peter 1784–1849
Bray-on-Thames
oil on paper laid on millboard 21.3 x 41.2
NWHCM : 1949.129.9 : F

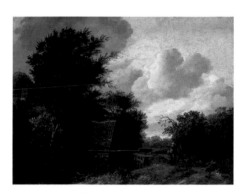

Decker, Cornelis Gerritsz. d.1678
A Sluice, Wooded Landscape with Figures on a Path
oil on oak panel 40.1 x 52
NWHCM : 1991.1.6 : F

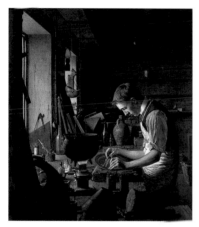

Dexter, Walter 1876–1958
A Workshop 1901
oil on canvas 68.1 x 60.2
NWHCM : 1901.56 : F

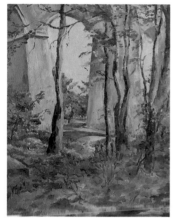

Dexter, Walter 1876–1958
An Arch in a Wood
oil on canvas board 42.5 x 32.4
NWHCM : 2005.439 : F

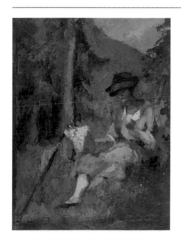

Dexter, Walter 1876–1958
Sketch of Seated Woman in a Blue Hat
oil on canvas board 43.1 x 32.4
NWHCM : 2005.440 : F

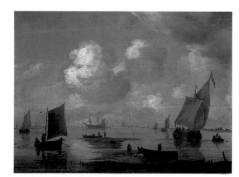

Diest, Willem van (attributed to)
1610–1673
Estuary Scene with Shipping, Figures in the Foreground
oil on oak panel 47.6 x 63.5
NWHCM : 1991.1.29 : F

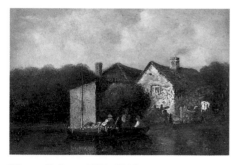

Dixon, Robert 1780–1815
River Scene with Sailing Boat and Cottage
1813
oil on panel 10.3 x 14.9
NWHCM : 1945.136 : F

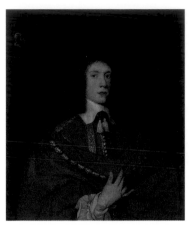

Dobson, William (attributed to) 1611–1646
Robert Buxton (1633–1662)
oil on canvas 89.5 x 77.2
NWHCM : 1963.268.14 : F

Donthorne, William John 1799–1859
Norwich Cathedral (South Aisle) c.1816
oil on panel 59.7 x 51.1
NWHCM : 1938.157.2 : F

Donthorne, William John 1799–1859
St Andrew's Hall, Norwich c.1817
oil on panel 77.5 x 66
NWHCM : 1938.157.1 : F

Doyle, Honor Camilla 1888–1944
Lock 75, Cassiobury Canal
oil on canvas 45.6 x 68.3
NWHCM : 1944.109.14.1 : F

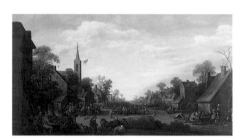

Droochsloot, Joost Cornelisz. 1586–1666
Village Scene 1644
oil on oak panel 63 x 106.7
NWHCM : 1967.342 : F

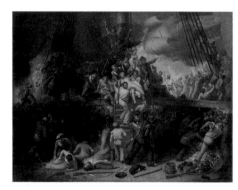

Drummond, Samuel 1765–1844
The Death of Nelson c.1824
oil on canvas 71.1 x 76.2 (E)
NWHCM : 1973.418 : F

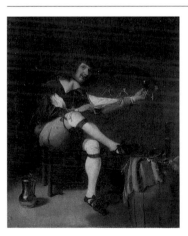

Ducq, Johan le (school of) 1629–1676/1677
The Tippler
oil on panel 30.5 x 25
NWHCM : 2005.446 : F

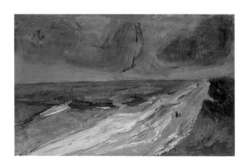

Duguid, John 1906–1961
Happisburgh Beach 1958
oil on hardboard 76 x 118
NWHCM : 2002.24 : F

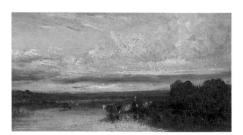

Dupré, Jules 1811–1889
Landscape with Cattle Watering
oil on panel 12.7 x 24.1
NWHCM : 1949.135 : F

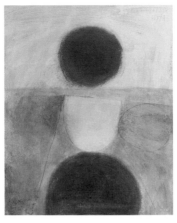

Durrant, Roy Turner 1925–1998
Inscape: Autumn at Alderworth 1971
acrylic on millboard 54.2 x 42.8
NWHCM : 1973.95 : F

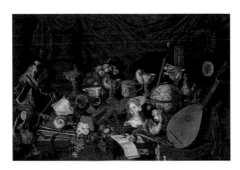

Dutch School
The Yarmouth Collection c.1665
oil on canvas 165 x 246.5
NWHCM : 1947.170 : F

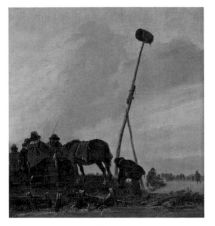

Dutch School 17th C
Group of Men and a Horse near a Frozen River
oil on board 31.2 x 29.2
NWHCM : 1973.161.2 : F

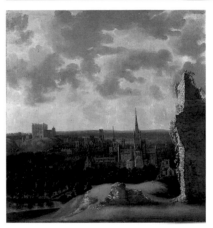

Dutch School
View of Norwich c.1707
oil on deal panel 133.7 x 125.1
NWHCM : 1967.341 : F

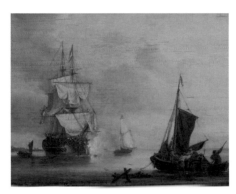

Dutch School
Shipping Scene c.1800
oil on panel 23.8 x 28.5
NWHCM : 1955.172 : F

Edwards, Edwin 1823–1879
Westleton Common, Suffolk
oil on panel 25.7 x 37.7
NWHCM : 1925.96 : F

Elliott, Edward 1851–1916
Miss Catherine Maud Nichols (1847–1923)
c.1893
oil on canvas 91.9 x 71.5
NWHCM : 1923.75 : F

Elliott, Edward 1851–1916
George Clayton Eaton (1834–1900) (painted from a photograph) 1900
oil on canvas 62.8 x 47.5
NWHCM : 2002.135.4 : F

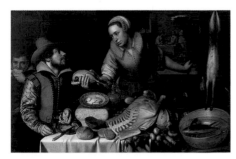

Engelsz., Cornelis 1574/1575–1650
The Supper at Emmaus 1612
oil on canvas 102.2 x 153.7
NWHCM : 2004.767 : F

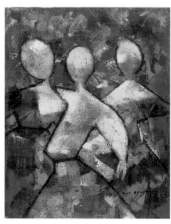

Ernst, Max 1891–1976
A Sunny Afternoon in 1913 1957
oil on canvas 25.5 x 20.3
NWHCM : L1993.3.4 : F

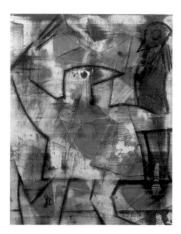

Ernst, Max 1891–1976
The Bird School Sign c.1957
oil on panel 35 x 26.9
NWHCM : L1993.3.5 : F

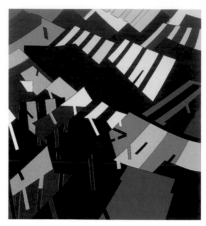

Fidler, Martin b.1950
Norwich Market in the Rain 1985
acrylic on board 34.1 x 29.9
NWHCM : 1985.219.2 : F

Fidler, Martin b.1950
Norwich Market in the Sun 1985
acrylic on board 30 x 34
NWHCM : 1985.219.1 : F

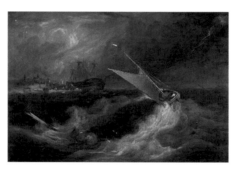

Fielding, Anthony V. C. (attributed to)
1787–1855
Sailing Boat in a Storm
oil on canvas 53.5 x 76.8
NWHCM : 1943.88.7 : F

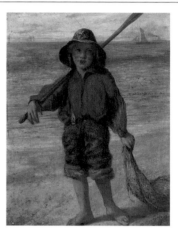

Finnie, John 1829–1907
A Member of the Naval Reserve 1862
oil on canvas 20.3 x 14.9
NWHCM : 1896.25.389 : F

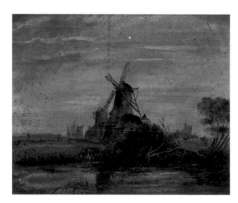

Fitzpatrick, (Colour Sergeant)
Windmill
oil on panel 27.5 x 33
NWHCM : 1926.130.2 : F

Flemish School
*Triptych: The Adoration with St Peter and St
Barbara and Donors* 1505–1520
oil on panel
54.3 x 16.8; 54.3 x 36.5; 54.3 x 16.8
NWHCM : 1948.117 : F

Flemish School mid-16th C
Head of Christ
oil on oak panel 61 x 17.1
NWHCM : 1945.95 : F

Flemish School early 17th C
Vanity
oil on oak panels 117 x 179
NWHCM : 1925.130 : F

Flemish School 17th C
The Virgin and Child with St Catherine
oil on canvas 101 x 85.5 (E)
NWHCM : 2005.441 : F

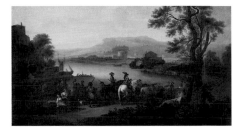

Flemish School late 17th/early 18th C
Landscape with Figures
oil on canvas 81.2 x 145.5
NWHCM : 1969.182 : F

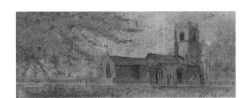

Fletcher, Alexandrina
*St Andrew's Church, Burlingham, 7th June
1894* 1894
oil on canvas 14.6 x 35
NWHCM : 1971.414.4 : F

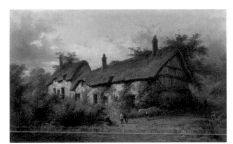

Foley, Henry John 1818–1874
Anne Hathaway's Cottage, Stratford-on-Avon
oil on canvas 55 x 90.5 (E)
NWHCM : 1933.117 : F

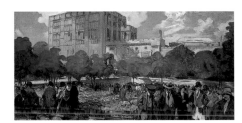

Fouqueray, Dominique Charles 1871–1956
Norwich Castle with Cattle Market 1920s
oil on canvas 50.4 x 99.3
NWHCM : 1991.29 : F

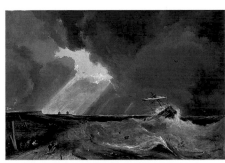

Francia, François-Thomas-Louis
1772–1839
*Saving the Crew and Passengers from the Brig
'Providence', Wrecked off (…)* 1815
oil on canvas 49.2 x 71.2
NWHCM : 2003.12.1 : F

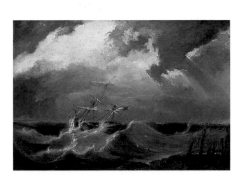

Francia, François-Thomas-Louis
1772–1839
*Saving the Crew of the Brig 'Leipzig', Wrecked
on Yarmouth Bar, on 7th December 1815* 1815
oil on canvas 49.2 x 71.2
NWHCM : 2003.12.2 : F

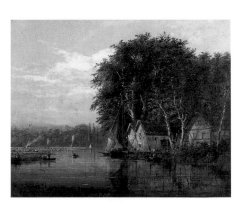

Freeman, William Philip Barnes 1813–1897
The River at Thorpe Reach, Norwich 1878
oil on canvas 40.8 x 50.9
NWHCM : 1969.301.3 : F

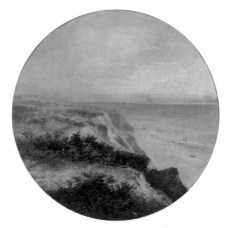

Freeman, William Philip Barnes 1813–1897
Cromer from the East, Evening 1880
oil on millboard 31
NWHCM : 1963.65 : F

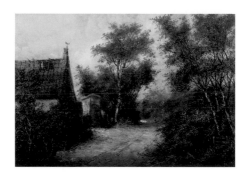

Freeman, William Philip Barnes 1813–1897
Landscape
oil on cardboard 27.9 x 39.9
NWHCM : 1933.70.2 : F

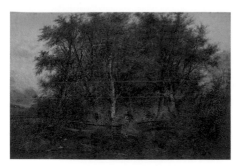

Freeman, William Philip Barnes 1813–1897
Landscape at Costessey
oil on millboard 30 x 44.6
NWHCM : 1951.235.978 : F

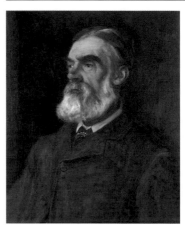

Frere, Amy Hanbury active 1902–1958
The Late J. H. Gurney (after William Carter)
oil on canvas 59.7 x 49.5
NWHCM : 1923.170 : F

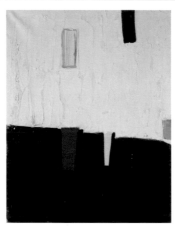

Frost, Terry 1915–2003
October Red Wedge 1957
oil on canvas 111.6 x 86.2
NWHCM : 1962.199 : F

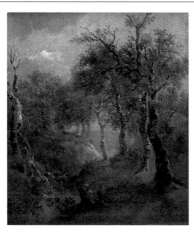

Gainsborough, Thomas 1727–1788
Autumn Landscape c.1746–1747
oil on canvas 38.6 x 33.4
NWHCM : 1951.131 : F

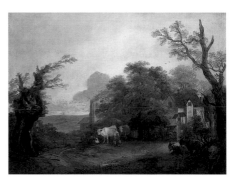

Gainsborough, Thomas 1727–1788
Farmyard with Milkmaid, Cows and Donkeys
c.1755
oil on canvas 94 x 124.7
NWHCM : L1975.10 : F (P)

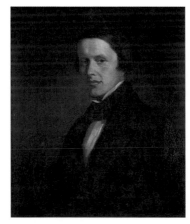

Gallon, Robert Samuel Ennis
active 1830–1868
John Ayris (1830–1902)
oil 75 x 62.2
NWHCM : 1952.98 : F (P)

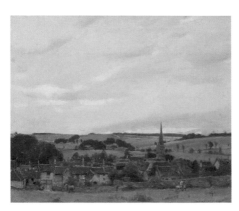

Garstin, Norman 1847–1926
Burford, Oxfordshire
oil on canvas 50.1 x 60.2
NWHCM : 1980.456 : F

Facing page: Charles Maussion, b.1923, *Family Portrait* (detail), 1978, Sainsbury Centre for Visual Arts,
The University of East Anglia, (p.262)

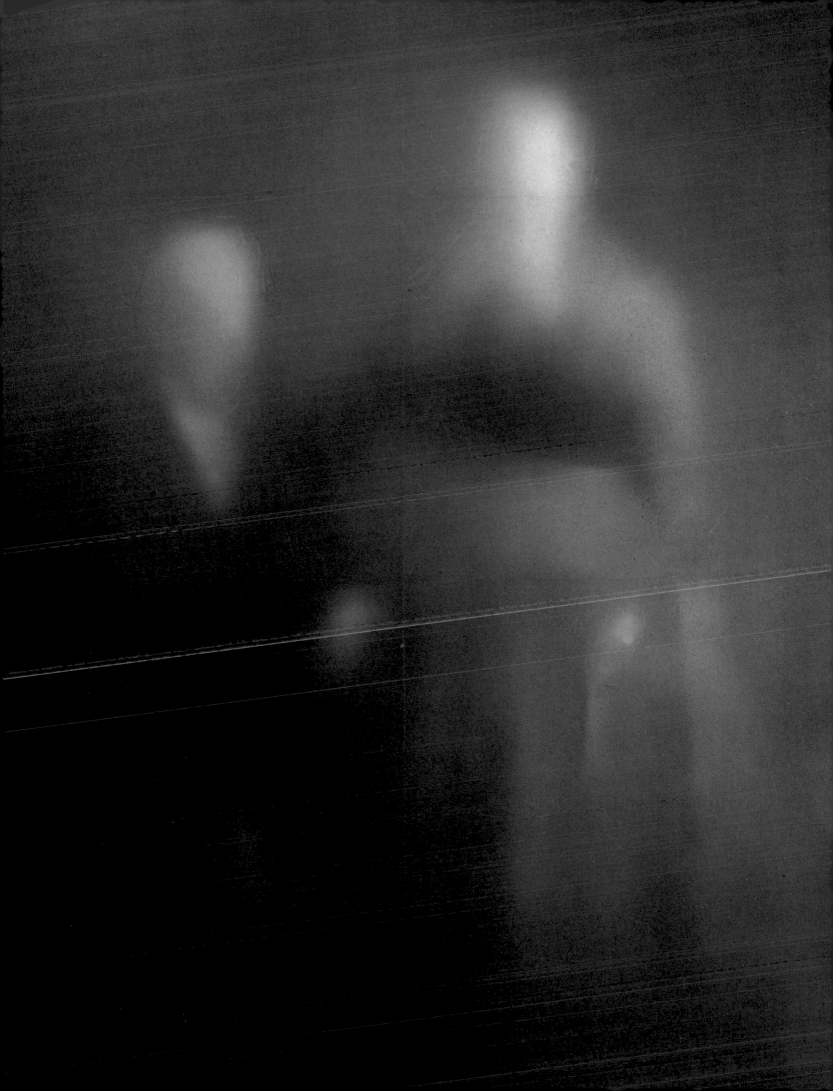

Geldart, Joseph 1808–1882
Old Trowse Bridge, Norwich
oil on millboard 23.5 x 36.8
NWHCM : 1951.235.983 : F

George, Patrick b.1923
Natalie Dower 1960–1961
oil on canvas 122 x 106.7
NWHCM : 1962.22 : F

Gill, William 1826–1869
Bridge over a Stream
oil on panel 12.7 x 9.9
NWHCM : 1946.189.5 : F

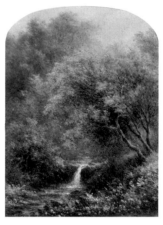

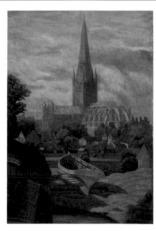

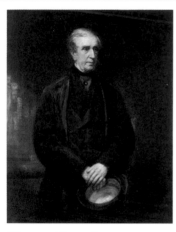

Gill, William 1826–1869
Rocky Stream with Small Waterfall
oil on panel 13.3 x 9.9
NWHCM : 1946.189.5A : F

Ginner, Charles 1878–1952
Norwich Cathedral from Pull's Ferry
oil on canvas 80 x 54.8
NWHCM : 2004.45 : F

Glasgow, Alexander c.1840–1894
The Reverend T. J. Batcheler (1794–1874)
1869
oil on canvas 123 x 98.7
NWHCM : 1946.88.12 : F

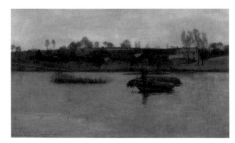

Goodall, Thomas Frederick
1856/1857–1944
Rockland Broad, Norfolk 1883
oil on canvas 91.8 x 153.2
NWHCM : 1948.147 : F

Goyen, Jan van 1596–1656
A River Estuary 1639
oil on oak panel 38.5 x 62.4
NWHCM : 1958.223 : F

Graham, George 1881–1949
Shipping Scene
oil on canvas 25.5 x 35.6
NWHCM : 1949.129.14 : F

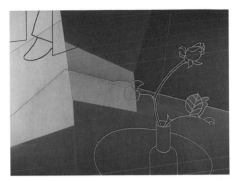

Graham, J. active 1853
The Philosopher's Breakfast
oil on canvas 118 x 81.2 (E)
NWHCM : 2005.442 : F (P)

Grant, Francis 1803–1878
John Henry Gurney (1819–1890) c.1861
oil on canvas 127.9 x 102.1
NWHCM : 1861 : F

Greaves, Derrick b.1927
Entering a Room with Difficulty 1979
acrylic on canvas 137.2 x 181.7
NWHCM : 1984.287 : F

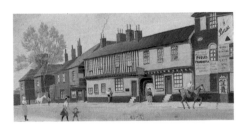

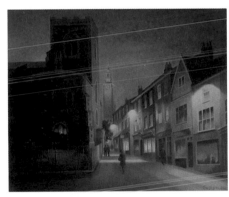

Green, George Colman b.1877
Heydon's House, King Street, Norwich
oil on board 22.6 x 45.1
NWHCM : 2005.443 : F

Greiffenhagen, Maurice 1862–1931
Sir Henry Rider Haggard (1856–1925) 1897
oil on canvas 211 x 132
NWHCM : 1925.92 : F

Griffiths, Tom 1901–1990
St Gregory's Alley, Norwich 1974
oil on board 50.6 x 61
NWHCM : 1986.54 : F

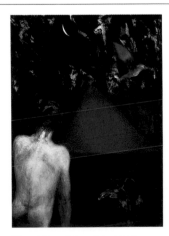

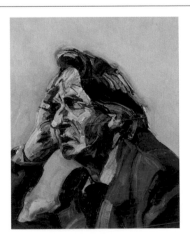

Gross, Anthony 1905–1984
Undulating Valley 1957
oil on canvas 64.7 x 92.1
NWHCM : 1959.221 : F

Hambling, Maggi b.1945
Sleepwalker 1978
oil on canvas 129 x 97
NWHCM : 2002.110.7 : F

Hambling, Maggi b.1945
*Preparatory Study for 'The Head of a Warder
at the National Gallery'* 1981
oil on canvas 50.8 x 40.7
NWHCM : 2003.11 : F

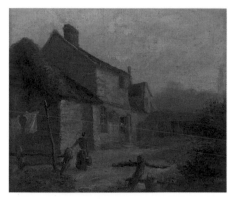

Harcourt, Bosworth 1836–1914
At Costessey, Norfolk
oil on canvas 21.9 x 27.3
NWHCM : 1914.46.2 : F

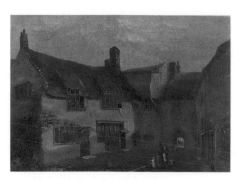

Harcourt, Bosworth 1836–1914
St Swithin's Alley, Norwich
oil on canvas 23.8 x 34.9
NWHCM : 1914.46.1 : F

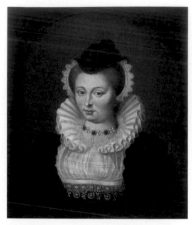

Harding, George Perfect (style of)
1781–1853
Portrait of a Lady
oil on mahogany panel 19.7 x 15.5
NWHCM : 1991.1.7 : F

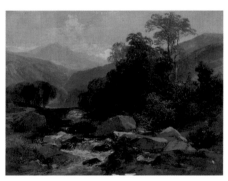

Harding, James Duffield 1798–1863
In the Welch Hills 1850
oil on mahogany panel 22.9 x 30.5
NWHCM : 1973.315 : F

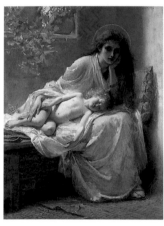

Havers, Alice 1850–1890
'But Mary kept all these things and pondered them in her heart' 1888
oil on canvas 122.2 x 91.9
NWHCM : 1895.28 : F

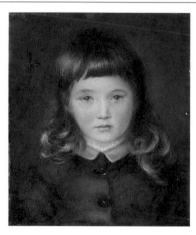

Hawkins, M. A. (attributed to)
Portrait of a Young Girl 1877
oil on canvas 35.2 x 30.3
NWHCM : 2005.584.4 : F

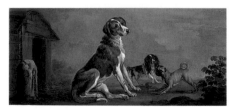

Hayman, Francis c.1708–1776
A Hound, a Spaniel and a Pug (A Portrait of a Mastiff) 1734
oil on canvas 45.2 x 100.1
NWHCM : 1991.1.8 : F

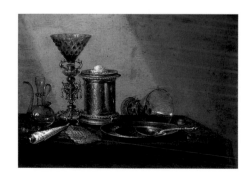

Heda, Willem Claesz. 1594–1680
Still Life with an Upturned Roemer 1638
oil on oak panel 35.3 x 49.7
NWHCM : 1998.68 : F

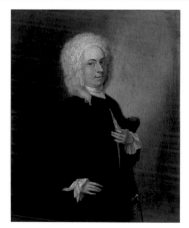

Heins, John Theodore Sr 1697–1756
Self Portrait 1726
oil on copper 15.9 x 12.7
NWHCM : 1974.462 : F

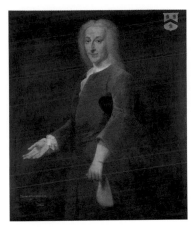

Heins, John Theodore Sr 1697–1756
Thomas Harwood, Mayor of Norwich (1728)
c.1728
oil on canvas 127 x 101.5
NWHCM : 1924.121 : F

Heins, John Theodore Sr 1697–1756
The Death of Thomas Guy 1737
oil on canvas 33.1 x 26
NWHCM : 1981.476.2 : F

Heins, John Theodore Sr 1697–1756
Thomas Guy Counting His Money 1737
oil on canvas 33.1 x 26
NWHCM : 1981.476.1 : F

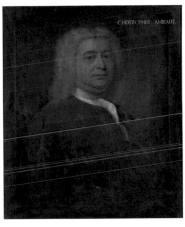

Heins, John Theodore Sr 1697–1756
Christopher Amiraut 1739
oil on canvas 76 x 63.5
NWHCM : 1926.11 : F

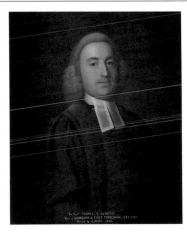

Heins, John Theodore Sr 1697–1756
The Reverend Thomas Roger Duquesne 1750
oil on canvas 76 x 63.2
NWHCM : 1946.15 : F

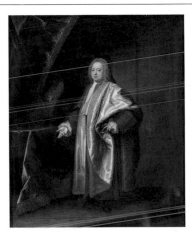

Heins, John Theodore Sr 1697–1756
Thomas Hurnard, Mayor of Norwich (1752)
1754
oil on canvas 76.1 x 64
NWHCM : 1974.461 : F

Henderson, Nigel 1917–1985
Willy Call-Up 1979
photomontage, oil & added collage elements
mounted on blockboard 40.6 x 51.1
NWHCM : 1984.288 : F

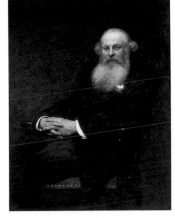

Herkomer, Hubert von 1849–1914
Jeremiah James Colman, MP
oil on canvas 143.5 x 112.7
NWHCM : 1951.235.1395 : F

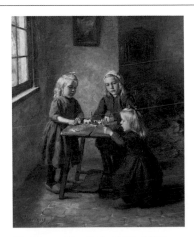

Heyligers, Hendrik 1877–1967
Three Children Playing with a Toy Farm
oil on canvas 64.1 x 54.6
NWHCM : 1938.132.1 : F

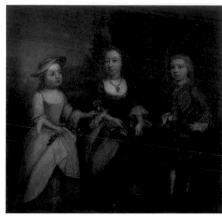

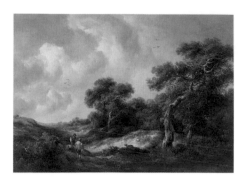

Highmore, Joseph (attributed to)
1692–1780
Portrait of Three Children c.1730
oil on canvas 122.5 x 127
NWHCM : 1953.134.1 : F

Hilder, Richard 1813–1852
Landscape with Figures
oil on panel 25.4 x 35.5
NWHCM : 1943.88.1 : F

Hilton, William I 1752–1822
Nathaniel Bolingbroke (1757–1840), Mayor of Norwich (1819–1820)
oil on canvas 76.8 x 64.1
NWHCM : 1939.140.4 : F

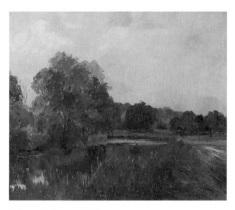

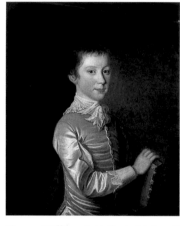

Hines, Edward Sidney 1906–1975
Toward Stratford St Mary 1962
oil on canvas 38.1 x 45.8
NWHCM : 1980.29 : F

Hitchens, Ivon 1893–1979
Red Spring 1955
oil on canvas 51.4 x 105.4
NWHCM : 1956.281 : F

Hoare, William (attributed to) c.1707–1792
John Plampin, Aged 11 1766
oil on canvas 75 x 60.9
NWHCM : 1944.34 : F

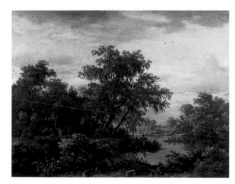

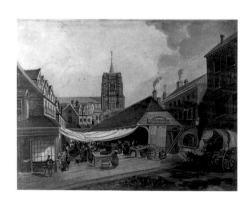

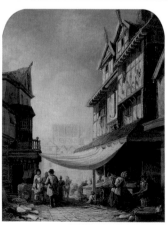

Hobbema, Meindert 1638–1709
The Anglers
oil on panel 52.7 x 68.6
NWHCM : 1955.171 : F

Hodgson, Charles (attributed to)
1769–1856
The Old Fish Market, Norwich c.1821
oil on canvas 31.4 x 40
NWHCM : 1937.10 : F

Hodgson, David 1798–1864
The Old Fish Market, Norwich 1830
oil on canvas 60.9 x 45.7
NWHCM : 1900.13.3 : F

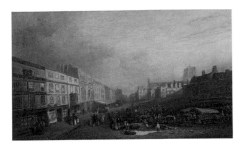

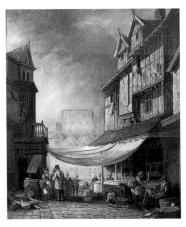

Hodgson, David 1798–1864
Market Place, Norwich 1842
oil on canvas 48.2 x 78.5
NWHCM : 2005.444 : F

Hodgson, David 1798–1864
Norwich Fish Market 1849
oil on canvas 76.8 x 63.2
NWHCM : 1923.62 : F

Hodgson, David 1798–1864
Old Post Office Court, Norwich 1860
oil on canvas 20 x 15.5
NWHCM : 1951.235.988 : F

Hodgson, David 1798–1864
Sir Benjamin Wrench's Court, Norwich 1860
oil on canvas 20 x 15.1
NWHCM : 1951.235.989 : F

Hodgson, David 1798–1864
Cowgate, Norwich 1860–1864
oil on canvas 23 x 30.7
NWHCM : 1938.28 : F

Hodgson, David 1798–1864
Norwich Castle 1861
oil on canvas 30.2 x 35.6
NWHCM : 1923.63 : F

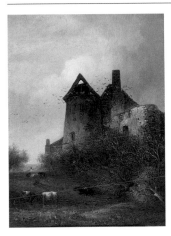

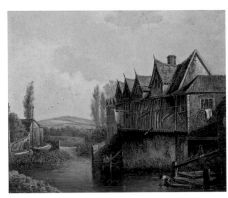

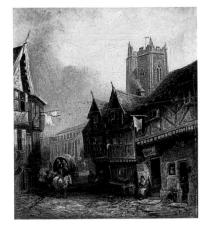

Hodgson, David 1798–1864
Sandling's Ferry, Norwich 1861
oil on canvas 40.8 x 30.6
NWHCM : 1894.75.3 : F

Hodgson, David 1798–1864
A View from Whitefriars Bridge, Norwich
1863
oil on canvas 49.3 x 59.6
NWHCM : 1900.13.2 : F

Hodgson, David 1798–1864
St Laurence Church, Norwich 1863
oil on canvas 46 x 39.7
NWHCM : 1946.140 : F

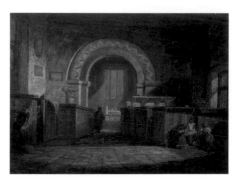

Hodgson, David 1798–1864
Interior of a Church near Ely
oil on canvas 31.2 x 41.3
NWHCM : 1923.64 : F

Hodgson, David 1798–1864
King Street Gates, Norwich
oil on millboard 18.1 x 22.9
NWHCM : 1951.235.986 : F

Hodgson, David 1798–1864
Norwich Castle
oil on canvas 84 x 71.1
NWHCM : 1938.27 : F

Hodgson, David 1798–1864
Norwich Cathedral from Cowgate
oil on canvas 84 x 66.3
NWHCM : 1940.118.13 : F

Hodgson, David 1798–1864
Old Fish Market, Norwich
oil on canvas 70.9 x 91.2
NWHCM : 1951.235.987 : F

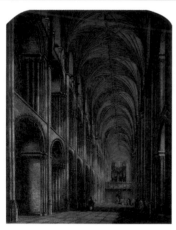

Hodgson, David 1798–1864
The Nave of Norwich Cathedral, Looking East
oil on canvas 91.5 x 71.2
NWHCM : 1895.13.1 : F

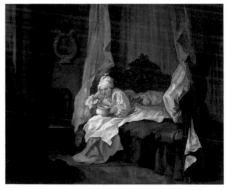

Hogarth, William 1697–1764
Francis Matthew Schutz in His Bed
c.1755–1760
oil on canvas 63 x 75.5
NWHCM : 1990.130 : F

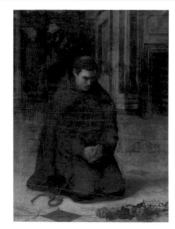

Holland, Philip Sidney 1855–1891
The Monk's Repentance ('Divided') 1880
oil on canvas 149.8 x 109.9
NWHCM : 1896.33 : F

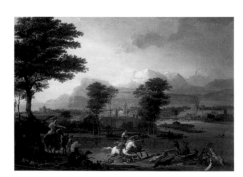

Hondius, Abraham c.1625–1691
The Stag Hunt c.1675
oil on canvas 109.2 x 155.3
NWHCM : 1991.1.9 : F

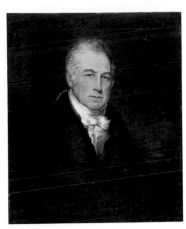

Housego, Henry c.1795–1858
The Reverend Francis Howes (1776–1844)
oil on canvas 75.7 x 63.8
NWHCM : 1984.103 : F

Howlin, John b.1941
I'll Remember April No.1 1962
acrylic on canvas 152.4 x 183
NWHCM : 1976.40 : F

Hoyland, John b.1934
Painting 20.2.70 1970
acrylic on canvas 213.4 x 101.9
NWHCM : 1972.216 : F ✳

Hübner, Louis 1694–1769
Still Life of Game 1752
oil on canvas 101.6 x 126.2
NWHCM : 1975.55 : F

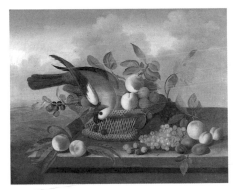

Hübner, Louis 1694–1769
*A Parakeet Perched on a Basket of Mixed Fruit,
Including Peaches, Grapes, Cherries and Plums*
oil on canvas 70.7 x 88.6
NWHCM : 1973.383 : F

Hughes, Patrick b.1939
An Artist Wields a Painter's Brush 1974
gloss paint on hardboard 88.5 x 119
NWHCM : 2002.110.2 : F

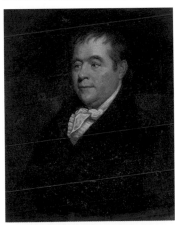

Humphry, Ozias (attributed to) 1742–1810
*Portrait of a Man (previously believed to be
John Crome)*
oil on canvas 24.5 x 19.1
NWHCM : 1932.26 : F

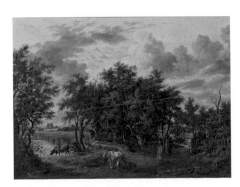

Hunt, Samuel Valentine 1803–1893
Cottage at the Edge of a Forest
oil on panel 52.5 x 72
NWHCM : 1972.212 : F

Hunt, Samuel Valentine 1803–1893
The Open Gate (after James Stark)
oil on oak panel 20.6 x 15.5
NWHCM : 1900.13.1 : F

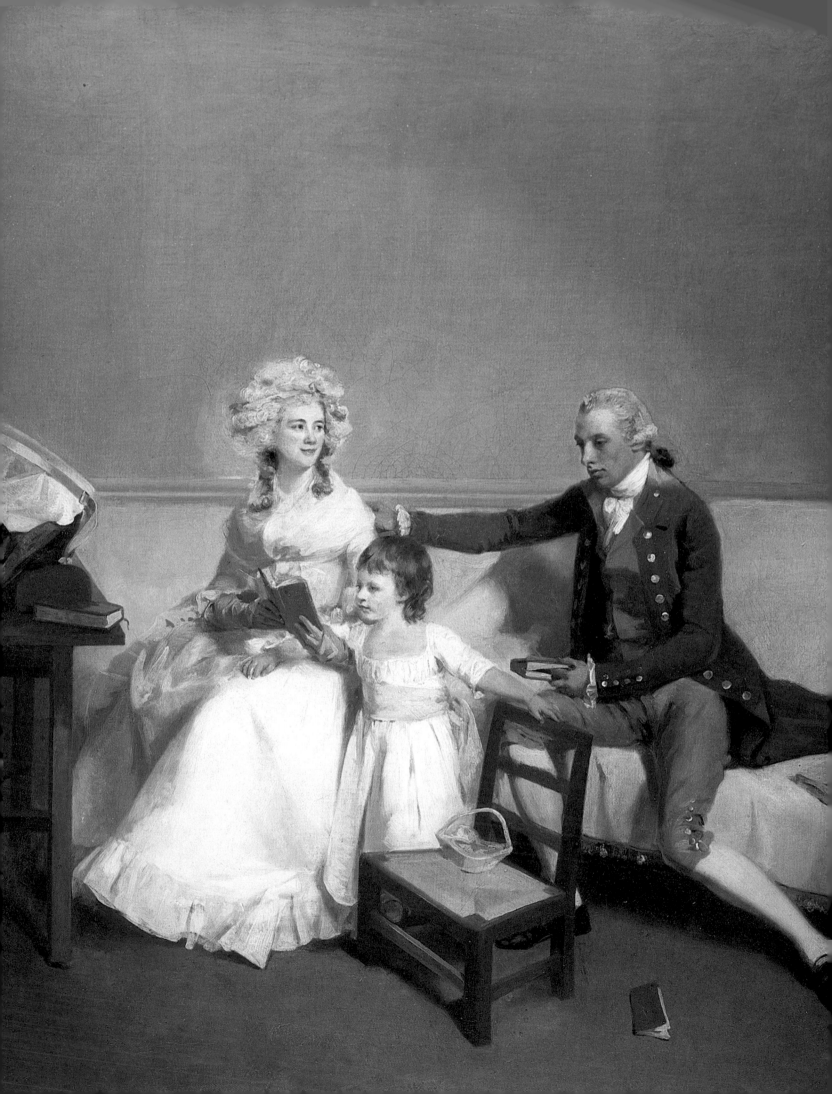

Hurlstone, Frederick Yeates 1800–1869
Robert and Elizabeth Buxton 1834
oil on canvas 83.8 x 113
NWHCM : 1963.268.30 : F

Ibbetson, Julius Caesar 1759–1817
Peasants in a Welsh Landscape
oil on canvas 49.8 x 63.5
NWHCM : 1971.594 : F

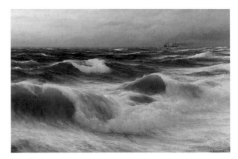

James, David 1834–1892
Seascape, Storm Breakers 1892
oil on canvas 39.5 x 49.9 (E)
NWHCM : 1938.132.13 : F

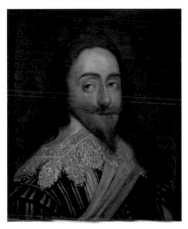

**Janssens van Ceulen, Cornelis
(attributed to)** 1593–1661
Charles I (1600–1649)
oil on panel 31 x 26.3
NWHCM : 1949.107.1 : F

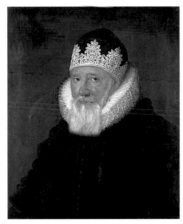

**Janssens van Ceulen, Cornelis
(attributed to)** 1593–1661
Sir Henry Spelman (c.1564–1641)
oil on canvas 76 x 63
NWHCM : 1976.369.28 : F

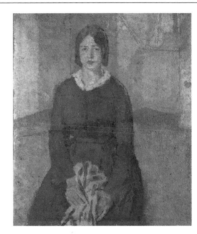

John, Gwen 1876–1939
Girl in a Blue Dress Holding a Piece of Sewing
oil on canvas 46.3 x 38.4
NWHCM : 1961.258 : F

Jones, Allen b.1937
Thinking about Women 1961–1962
oil on canvas 152 x 151.8
NWHCM : L1967.7 : F

Jones, William (attributed to)
active 1764–1775
Still Life with a Loaf of Bread, Wine and Plums
oil on oak panel 28.4 x 37.7
NWHCM : 1991.1.10 : F

Joy, John Cantiloe 1806–1859
Yarmouth Jetty, Boat Returning from Wreck
oil on oak panel 25.4 x 30.8
NWHCM : 1951.235.1000 : F

Facing page: Walton, Henry, 1746-1813, *Sir Robert and Lady Buxton and Their Daughter Anne* c.1786, Norwich Castle Museum and Art Gallery, (p.226)

Joy, William 1803–1867
Lifeboat Going to a Vessel in Distress c.1832
oil on canvas 102 x 127.9
NWHCM : 2003.12.6 : F

Joy, William 1803–1867
*Saving a Crew near Yarmouth Pier (to
illustrate Captain Manby's invention for saving
lives from wrecks)* c.1832
oil on canvas 76.6 x 109.5
NWHCM : 2003.12.4 : F

Joy, William 1803–1867
Boat Going to a Vessel in Distress
oil on canvas 65.3 x 91.2
NWHCM : 2003.12.3 : F

Joy, William 1803–1867
Seascape
oil on panel 13.3 x 17.2
NWHCM : 1932.58 : F

Kettle, Tilly 1735–1786
Muhammad Ali Khan, the Nawab of Arcot
oil on canvas 109.2 x 88.9
NWHCM : 1939.144 : F

King, Elizabeth Thompson
active 1880–1901
Seven Character Studies of Country Folk 1882
oil on board 30.3 x 46
NWHCM : 2005.445 : F

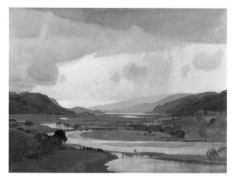

Knight, Charles Parsons 1829–1897
*Summer Flood, North Wales (The Valley of the
Mawddach near Dolgelly)*
oil on board 75 x 101
NWHCM : 1955.168A : F

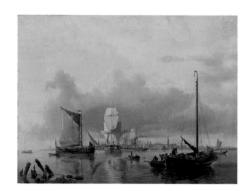

Koekkoek, Johannes Hermanus 1778–1851
View on the Scheldt
oil on canvas 41.5 x 54
NWHCM : 1894.7.2 : F

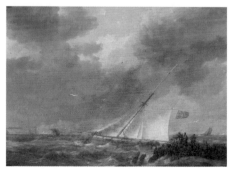

**Koekkoek, Johannes Hermanus
(attributed to)** 1778–1851
Sea Piece
oil on panel 21 x 28.3
NWHCM : 1971.55.144 : F

Ladbrooke, Frederick 1812–1865
Landscape
oil on canvas 27.8 x 38
NWHCM : 1934.120.3 : F

Ladbrooke, Frederick 1812–1865
Landscape with Mountains
oil on canvas 61.8 x 83.7
NWHCM : 1934.120.1 : F

Ladbrooke, Frederick 1812–1865
Mountainous Landscape and Rocky Stream
oil on canvas 30.6 x 40.6
NWHCM : 1934.120.4 : F

Ladbrooke, Frederick 1812–1865
River and Distant View, Woman Driving Cattle
oil on oak panel 25.7 x 38.1
NWHCM : 1934.120.5 : F

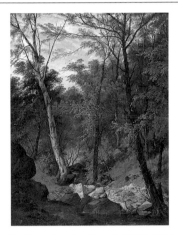

Ladbrooke, Frederick 1812–1865
Study of Trees
oil on canvas 61.3 x 46
NWHCM : 1934.120.2 : F

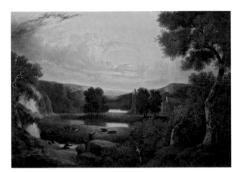

Ladbrooke, Henry 1800–1869
Bolton Abbey 1841
oil on canvas 91.5 x 129.5
NWHCM : 1951.235.1008 : F

Ladbrooke, Henry 1800–1869
*Head of a Bloodhound (after Edwin Henry
Landseer)*
oil on canvas 50.8 x 61
NWHCM : 1841.31 : F

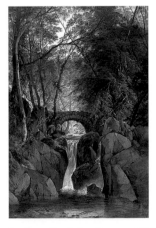

Ladbrooke, John Berney 1803–1879
The Waterfall 1852–1854
oil on canvas 48.2 x 33
NWHCM : 1944.20.3 : F

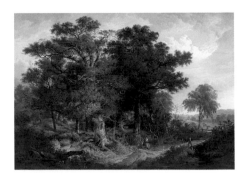

Ladbrooke, John Berney 1803–1879
Water Lane, Autumn 1864
oil on canvas 76.5 x 101.7
NWHCM : 1940.27 : F

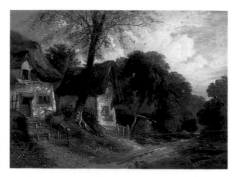

Ladbrooke, John Berney 1803–1879
Thatched Cottages by a Woodland Track 1867
oil on canvas 17.5 x 25.6
NWHCM : 1951.235.1011 : F

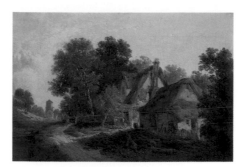

Ladbrooke, John Berney 1803–1879
Thatched Farm Buildings by a Woodland Path
1867
oil on canvas 17.5 x 25.4
NWHCM : 1951.235.1010 : F

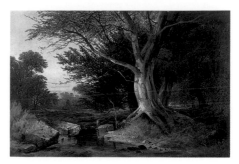

Ladbrooke, John Berney 1803–1879
Beech Tree by a Rocky Stream 1869
oil on canvas 35.5 x 53.3
NWHCM : 1951.235.1012 : F

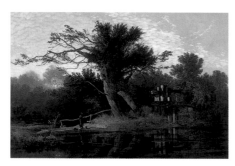

Ladbrooke, John Berney 1803–1879
The Sluice Gate 1869
oil on canvas 50.8 x 76.5
NWHCM : 1951.235.1013 : F

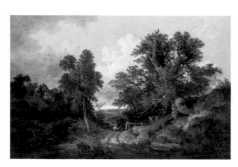

Ladbrooke, John Berney 1803–1879
Lane Scene 1874
oil on canvas 61 x 91.8
NWHCM : 1916.67 : F

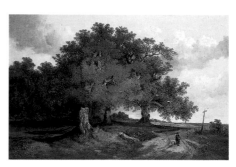

Ladbrooke, John Berney 1803–1879
Pollard Oaks 1874
oil on canvas 50.5 x 76
NWHCM : 1894.75.6 : F

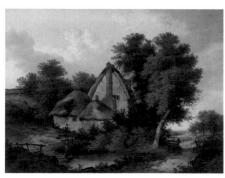

Ladbrooke, John Berney 1803–1879
*Landscape with Thatched Cottage and Pond in
Foreground* 1878
oil on canvas 69 x 91.9
NWHCM : 1963.279 : F

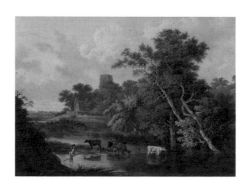

Ladbrooke, John Berney 1803–1879
Cows in a Woodland Pool
oil on millboard 22.1 x 30
NWHCM : 1951.235.1009 : F

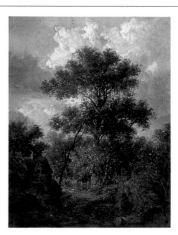

Ladbrooke, John Berney 1803–1879
Landscape with Woodland Path and Cottage
oil on canvas 30.5 x 23
NWHCM : 1941.78 : F

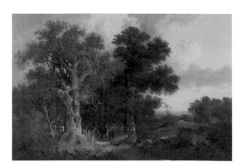

Ladbrooke, John Berney 1803–1879
The Great Oak
oil on canvas 59.7 x 90.2
NWHCM : 1939.62 : F

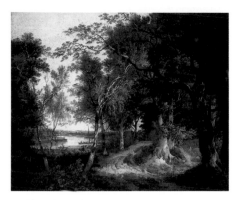

Ladbrooke, John Berney 1803–1879
Woodland Landscape
oil on canvas 63.4 x 76.5
NWHCM : 1940.189 : F

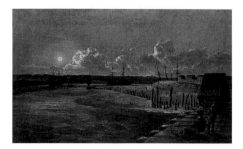

Ladbrooke, Robert 1770–1842
Yarmouth Harbour, Moonlight c.1813
oil on canvas 61.5 x 97.4
NWHCM : 1951.235.1016 : F

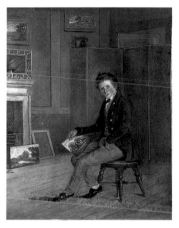

Ladbrooke, Robert 1770–1842
Joseph Stannard as a Youth c.1816
oil on paper laid on canvas 41.9 x 33.3
NWHCM : 1951.235.1017 : F

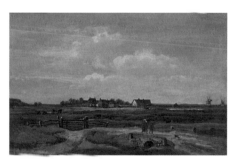

Ladbrooke, Robert 1770–1842
Landscape 1820s
oil on deal panel 21.3 x 32.8
NWHCM : 1951.235.1019 : F

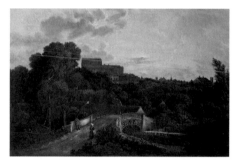

Ladbrooke, Robert 1770–1842
Foundry Bridge, Norwich c.1822–1833
oil on canvas 66.7 x 98.4
NWHCM : 1938.26 : F

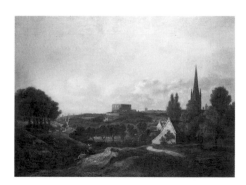

Ladbrooke, Robert 1770–1842
A View of Norwich Castle and Cathedral
after 1822
oil on canvas 74.4 x 99.4
NWHCM : 1981.475 : F

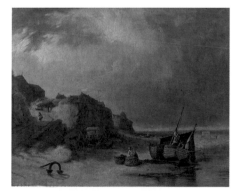

Ladbrooke, Robert 1770–1842
Beach Scene, Mundesley
oil on canvas 51.1 x 63.8
NWHCM : 1951.235.1021 : F

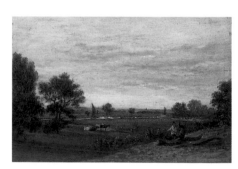

Ladbrooke, Robert 1770–1842
Landscape, River Yare from Postwick
oil on panel 21.6 x 33
NWHCM : 1926.114 : F

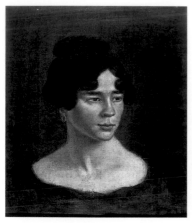

Ladbrooke, Robert 1770–1842
Portrait of a Young Woman
oil on canvas 41 x 35.9
NWHCM : 1946.33 : F

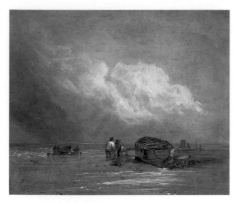

Ladbrooke, Robert (attributed to)
1770–1842
Fishermen on Beach with Boats
oil on oak panel 30.4 x 36.4
NWHCM : 1971.55.145 : F

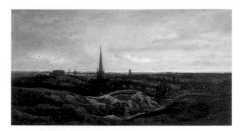

Ladbrooke, Robert (attributed to)
1770–1842
Norwich from Mousehold
oil on panel 21.9 x 43.1
NWHCM : 1951.235.1018 : F

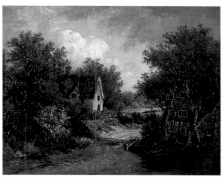

Ladbrooke, Robert (attributed to)
1770–1842
Road Scene with Thatched Cottage
oil on mahogany panel 21.7 x 29.1
NWHCM : 1951.235.1020 : F

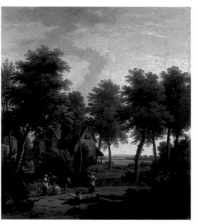

Lambert, George c.1700–1765
Pastoral Scene with a Peasant Family 1753
oil on canvas 48 x 42.4
NWHCM : 1976.369.20 : F

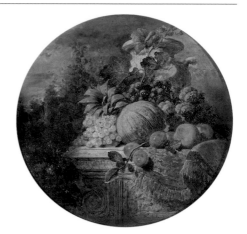

Lance, George 1802–1864
Still Life of Fruit
oil on panel 30.2
NWHCM : 1938.132.26 : F

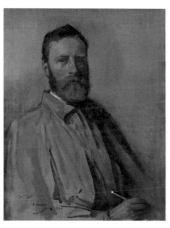

Lavery, John 1856–1941
Arthur Heseltine 1900
oil on canvas 46 x 36.1
NWHCM : 1914.94 : F

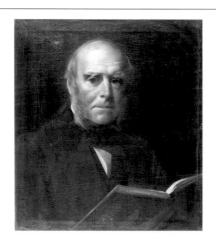

Lawrence, Samuel (attributed to)
1817–1884
William Bodham Donne, DL (1807–1882)
oil on canvas 64.8 x 55.8
NWHCM : 1944.110 : F

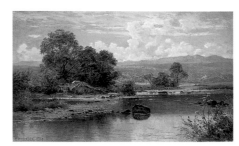

Leader, Benjamin Williams 1831–1923
A Sunny Morning on the Llugwy, North Wales
1888
oil on canvas 46.3 x 76.5
NWHCM : 1974.276 : F

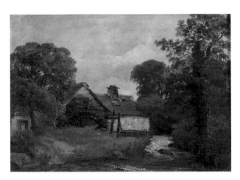

Lee, Frederick Richard 1798–1879
Mill on the Ogwen River, North Wales c.1857
oil on millboard 25 x 35.1
NWHCM : 1943.88.6 : F

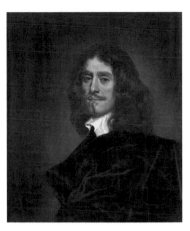

Lely, Peter 1618–1680
Sir John Holland of Quidenham (c.1603–1701)
c.1650
oil on canvas 76.3 x 64
NWHCM : 1949.107.4 : F

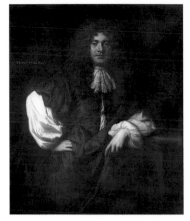

Lely, Peter (attributed to) 1618–1680
Sir Thomas Fitch, Bt (1637–1688)
oil on canvas 126.2 x 102.4
NWHCM : 1904.40.1 : F

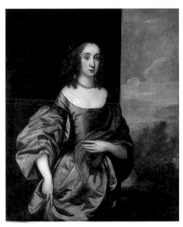

Lely, Peter (school of) 1618–1680
Hannah Wilton (d.1709) c.1660
oil on canvas 127 x 104
NWHCM : 1963.268.15 : F

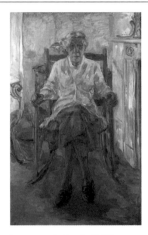

Lessore, John b.1939
Helen Lessore (1908–1994) 1984
oil on hardboard 122.4 x 77.3
NWHCM : 1985.215 : F

Linnell, John 1792–1882
The Reverend Edward Thomas Daniell
(1804–1842) 1836
oil on panel 77.1 x 56.5
NWHCM : 1901.41 : F

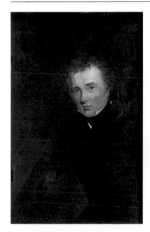

Linnell, John 1792–1882
The Reverend Edward Thomas Daniell
(1804–1842) c.1840
oil on mahogany panel 26.5 x 18.1
NWHCM : 1951.235.1396 : F

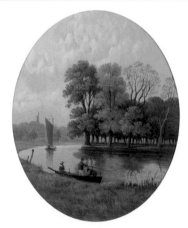

Littlewood, Edward active 1863–1898
Aldercar, near Norwich
oil on cardboard 26.5 x 21.5
NWHCM : 1968.819.2 : F

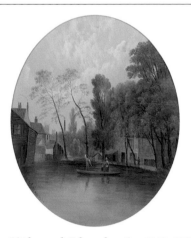

Littlewood, Edward active 1863–1898
Piggins Ferry, Back River, Norwich
oil on cardboard 27.5 x 21.5
NWHCM : 1968.819.1 : F

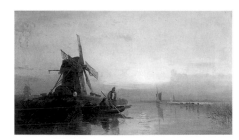

Lound, Thomas 1802–1861
Sunrise on the Yare 1853
oil on canvas 25.8 x 45.7
NWHCM : 1933.162 : F

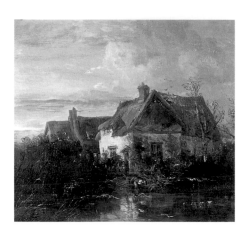

Lound, Thomas 1802–1861
At Lakenham
oil on panel 33.6 x 37.5
NWHCM : 1951.235.1054 : F

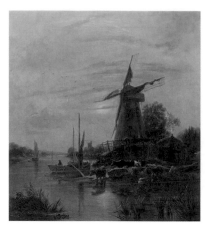

Lound, Thomas 1802–1861
Evening Composition (Mill at Sunset)
oil on canvas 53.7 x 48.2
NWHCM : 1947.177 : F

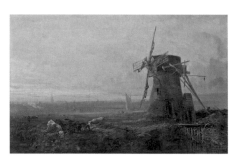

Lound, Thomas 1802–1861
Marsh Mill
oil on canvas 23.8 x 36.8
NWHCM : 1951.235.1056 : F

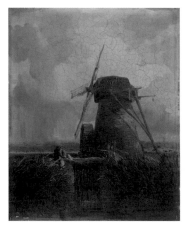

Lound, Thomas 1802–1861
Marsh Mill, Norfolk (Mill at Reedham)
oil on oak panel 24.1 x 19.8
NWHCM : 1894.75.22 : F

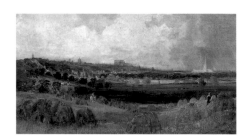

Lound, Thomas 1802–1861
Norwich from Crown Point
oil on millboard 26.7 x 46.7
NWHCM : 1957.357 : F

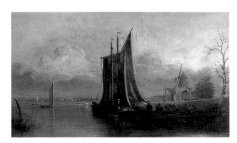

Lound, Thomas 1802–1861
St Benet's Abbey, Norfolk
oil on canvas 33 x 55.8
NWHCM : 1933.163 : F

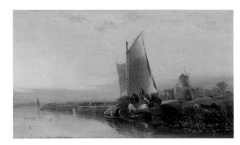

Lound, Thomas 1802–1861
St Benet's Abbey, Norfolk
oil on canvas 46.1 x 76.2
NWHCM : 1951.235.1055 : F

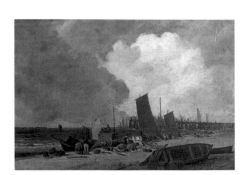

Lound, Thomas 1802–1861
Yarmouth Beach and Jetty (after John Crome)
oil on canvas 43.8 x 61.4
NWHCM : 1934.134.2 : F

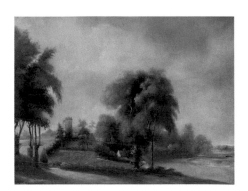

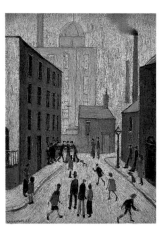

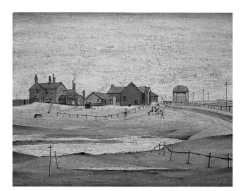

Lovell, J. Frederic d.1931
Old Lakenham, Norwich
oil on canvas 30.4 x 40.6
NWHCM : 1931.179 : F

Lowry, Laurence Stephen 1887–1976
Industrial Scene 1953
oil on canvas board 34.7 x 24.6
NWHCM : L1971.14 : F (P)

Lowry, Laurence Stephen 1887–1976
Landscape with Farm Buildings 1954
oil on canvas board 40.4 x 50.2
NWHCM : 1955.206 : F

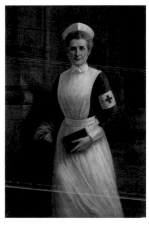

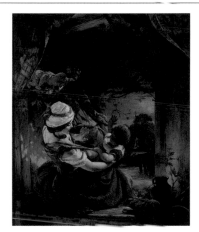

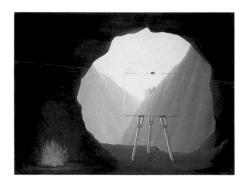

Lynde, Raymond active 1890–1919
Nurse Edith Cavell (1865–1915)
oil on canvas 152.5 x 101.5
NWHCM : 2005.447 : F (P)

Maclise, Daniel 1806–1870
Cottage Group
oil on canvas 59.7 x 49.5
NWHCM : 1938.132.2 : F

Magritte, René 1898–1967
La condition humaine 1935
oil on canvas 54 x 73
NWHCM : 1995.88.2 : F

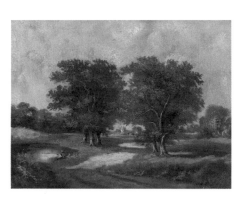

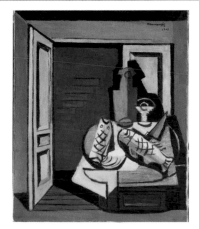

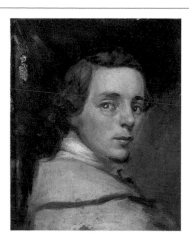

Mallett, Robert 1867–1950
In a Wood, Taverham
oil on canvas 35.6 x 45.8
NWHCM : 1990.229 : F

Marcoussis, Louis 1883–1941
The Open Door 1928
oil on canvas 60.7 x 49.6
NWHCM : L1993.3.7 : F

Marsham, Edward active 1844–1854
Self Portrait
oil on canvas 16.5 x 14
NWHCM : 1932.71 : F

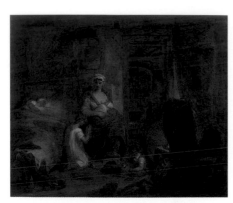

Martin, William 1753–1836 or after
Interior of an English Cottage with Children Going to Bed c.1827
oil on canvas 64.4 x 77.1
NWHCM : 1981.272.1 : F

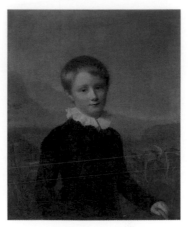

Massot, Firmin 1766–1849
Henry Reeve, Aged 9 (1813–1895) c.1822
oil on canvas 44.8 x 25.4
NWHCM : 1964.275 : F

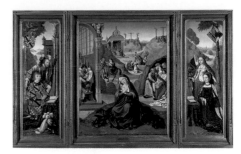

Master of the Legend of the Magdalen
c.1483–c.1530
The Seven Sorrows of Mary (…) c.1519
oil on panel
83.8 x 26.7; 83.8 x 64.2; 83.8 x 26.7
NWHCM : 1983.46 : F

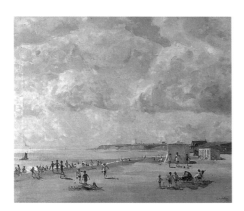

Mellon, Campbell A. 1876–1955
The Summer Sea (Gorleston Sands)
oil on canvas 50.8 x 60.8
NWHCM : 1956.79 : F

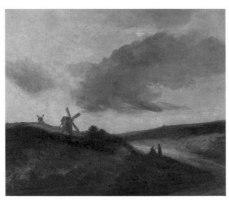

Michel, Georges 1763–1843
Windmills on Heath
oil on canvas 45.5 x 54
NWHCM : 1950.81 : F

Middleditch, Edward 1923–1987
Two Roses, Black and White c.1966
oil on canvas 130.8 x 169.8
NWHCM : 1966.745 : F

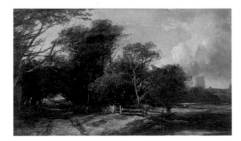

Middleton, John 1827–1856
Landscape 1847
oil on millboard 14.3 x 25.4
NWHCM : 1938.81 : F

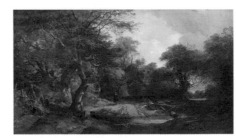

Middleton, John 1827–1856
Cantley Beck near Ketteringham, Norfolk
1848
oil on canvas 50.8 x 87.1
NWHCM : 1951.235.1129 : F

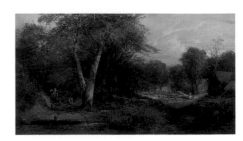

Middleton, John 1827–1856
Gunton Park 1849
oil on canvas 60.9 x 109.2
NWHCM : 1951.235.1130 : F

Facing page: Seago, Edward Brian, 1910–1974, *The East Window* (detail), Norwich Castle Museum and Art Gallery, (p.186)

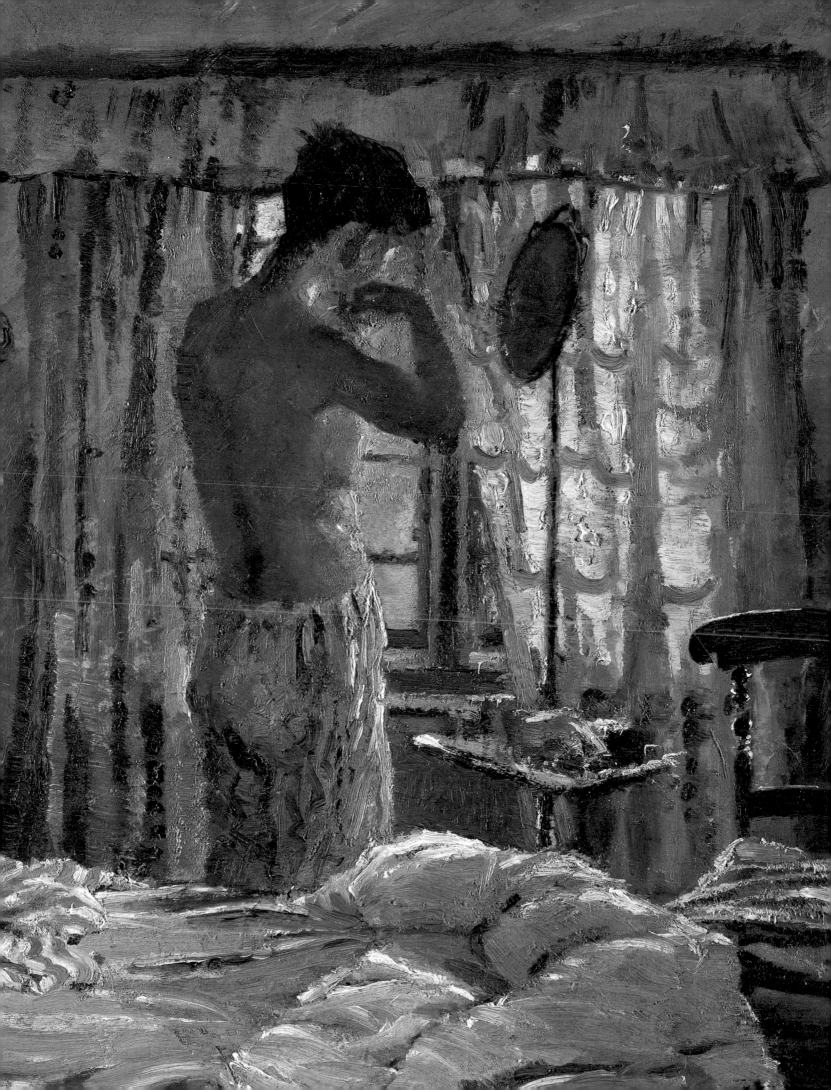

Middleton, John 1827–1856
Sunshine and Shade 1854
oil on canvas 53.5 x 77.2
NWHCM : 1894.75.23 : F

Middleton, John 1827–1856
A Fine Day in February (Hellesdon)
oil on millboard 17.8 x 27.9
NWHCM : 1951.235.1132 : F

Middleton, John 1827–1856
A Fine Day in February (Hellesdon)
oil on canvas 24.8 x 34.9
NWHCM : 1951.235.1133 : F

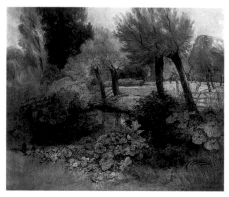

Middleton, John 1827–1856
Landscape with Pollards
oil on canvas 51.2 x 61.3
NWHCM : 1938.67 : F

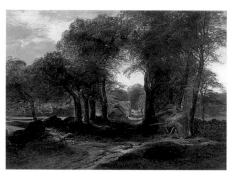

Middleton, John 1827–1856
Near Ivybridge, South Devon
oil on canvas 38.1 x 53.3
NWHCM : 1951.235.1135 : F

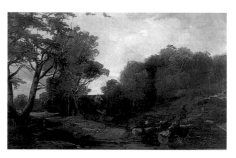

Middleton, John 1827–1856
Road Scene
oil on canvas 33.7 x 55.2
NWHCM : 1951.235.1134 : F

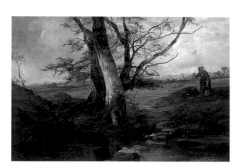

Middleton, John 1827–1856
Stepping Stones
oil on oak panel 25.4 x 36.5
NWHCM : 1951.235.1131 : F

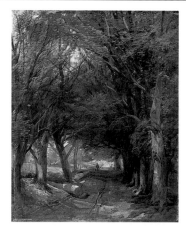

Middleton, John 1827–1856
The Avenue, Gunton Park, Norfolk
oil on canvas 25.7 x 20.7
NWHCM : 1963.486 : F

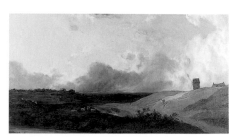

Middleton, John (attributed to) 1827–1856
View of Mousehold
oil on canvas 61 x 106.8
NWHCM : 1941.20 : F

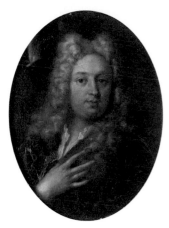

**Mieris, Frans van the younger
(attributed to)** 1689–1763
The Reverend Dr Cox Macro (1683–1767)
oil on copper 11.1 x 8.5
NWHCM : 1991.1.38 : F

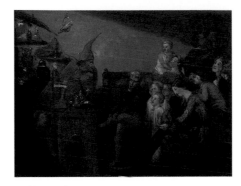

Millais, John Everett 1829–1896
The Conjuror c.1847
oil on canvas 35.2 x 45.5
NWHCM : 1938.132.21 : F

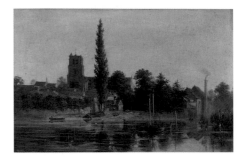

Minns, Edwin 1852–1915
Beccles 1878
oil on canvas 35.3 x 53.3
NWHCM : 1929.102 : F

Mommers, Hendrick (attributed to)
1623–1693
Cowherd with Cattle on a Path beneath a Cliff
oil on oak panel 29.4 x 26.9
NWHCM : 1991.1.1 : F

Morris, Cedric Lockwood 1889–1982
Solva 1934
oil on canvas 60.4 x 73.4
NWHCM : 1990.225.4 : F

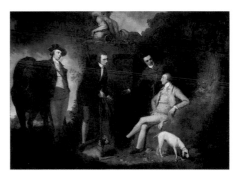

Mortimer, John Hamilton 1740–1779
*A Shooting Party at Cavenham Park, Bury St
Edmunds, Sir Simon le Blanc and Nephews*
oil on canvas 120.7 x 168.3
NWHCM : 1950.181 : F

Moucheron, Frederick de (attributed to)
1633–1686
Extensive Southern Landscape
oil on canvas 34.5 x 46.9
NWHCM : 1991.1.11 : F

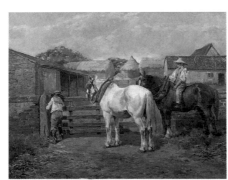

Munnings, Alfred James 1878–1959
The Farmyard 1896
oil on canvas 71 x 91.2
NWHCM : 1986.57 : F

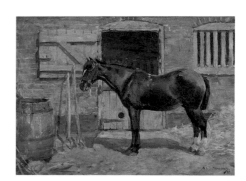

Munnings, Alfred James 1878–1959
Study of a Pony 1897
oil on canvas 33 x 43.2
NWHCM : 1961.40.2 : F

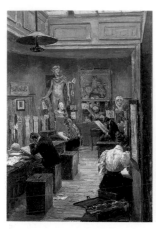

Munnings, Alfred James 1878–1959
The Painting Room, Norwich School of Art
1897
oil on canvas 66 x 45.7
NWHCM : L2001.4.1 : F

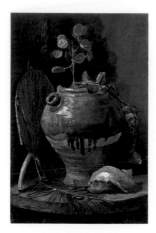

Munnings, Alfred James 1878–1959
Still Life c.1897
oil on canvas 53.7 x 35.5
NWHCM : L2001.4.3 : F

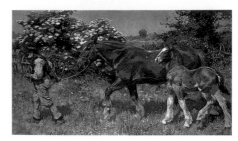

Munnings, Alfred James 1878–1959
Sunny June 1901
oil on canvas 76.5 x 128
NWHCM : 1902.35 : F

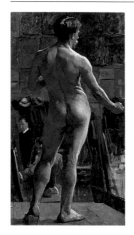

Munnings, Alfred James 1878–1959
First Study in Oils from Life at Julien's Atelier
1902
oil on canvas 81.2 x 45.2
NWHCM : L2001.4.2 : F

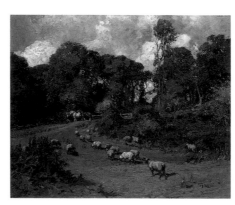

Munnings, Alfred James 1878–1959
Crostwick Common 1904
oil on canvas 63.6 x 76.5
NWHCM : 1932.90 : F

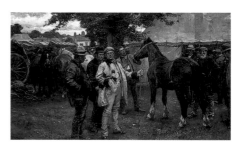

Munnings, Alfred James 1878–1959
The Horse Fair (A Suffolk Fair) 1904
oil on canvas 76.8 x 128
NWHCM : 1937.8 : F

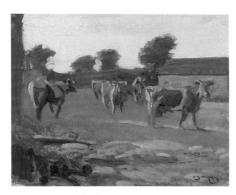

Munnings, Alfred James 1878–1959
Sketch of Cows c.1905
oil on canvas 35.4 x 45.5
NWHCM : 1925.105 : F

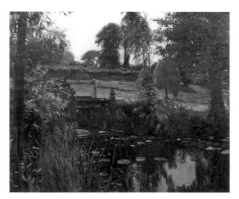

Munnings, Alfred James 1878–1959
Mendham, the Mill Pool near the Artist's Home
1909
oil on canvas 63.5 x 76.2
NWHCM : 1951.88 : F

Munnings, Alfred James 1878–1959
Gravel Pit in Suffolk c.1911
oil on canvas 125.7 x 183
NWHCM : 1928.108 : F

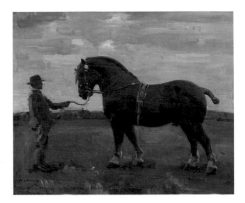

Munnings, Alfred James 1878–1959
'Mendham Ensign', Suffolk Stallion 1914
oil on canvas 50.8 x 61
NWHCM : 1961.40.1 : F

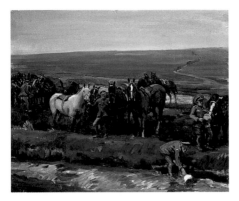

Munnings, Alfred James 1878–1959
Watering Horses, Canadian Troops in France, 1917 1918
oil on canvas 50.8 x 61.2
NWHCM : 1928.107 : F

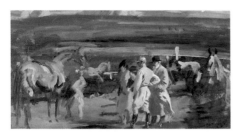

Munnings, Alfred James 1878–1959
Study for 'In the Paddock, Cheltenham' c.1944–1946
oil on panel 29.6 x 56.9
NWHCM : 1951.205 : F

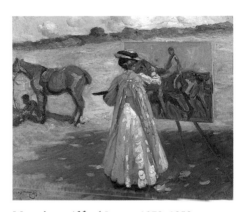

Munnings, Alfred James 1878 –1959
Laura Knight Painting
oil on canvas 51 x 61
NWHCM : 1985.170 : F

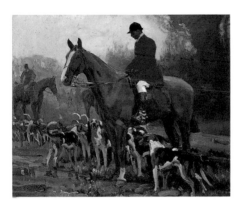

Munnings, Alfred James 1878 –1959
The Huntsman and Hounds
oil on canvas 63.8 x 76.7
NWHCM : 1971.413 : F

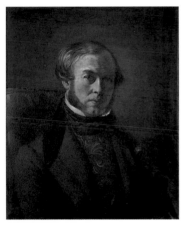

Muzin, C. P.
John Husfeld 1838
oil on canvas 67.8 x 56.4
NWHCM : 2005.448 : F

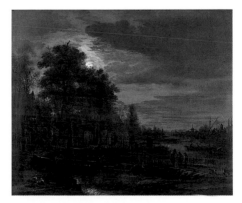

Neer, Aert van der 1603–1677
Moonlit Landscape with a River
oil on canvas 82.7 x 98.2
NWHCM : 1967.23 : F

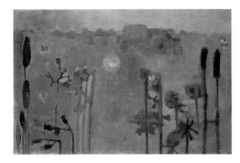

Newcomb, Mary b.1922
Moths and Men with Hay, August 1960
oil on hardboard 60.2 x 90.7
NWHCM : 2000.2.1 : F

Newcomb, Mary b.1922
Mendham Marsh 1964
oil on hardboard 60.5 x 90.5
NWHCM : 2000.2.2 : F

Newcomb, Mary b.1922
Burdock and Us with Burrs 1972
oil on hardboard 30 x 35.5
NWHCM : 2002.25.3 : F

Newcomb, Mary b.1922
The Fête 1976
oil on hardboard 61 x 58.5
NWHCM : 1978.128 : F

Newcomb, Mary b.1922
Suffolk Clun-Cross Ewe with Two Lambs 1983
oil on canvas 76.2 x 92
NWHCM : L2004.3.1 : F (P)

Newcomb, Mary b.1922
Suffolk Ewe Sitting down 1992
oil on canvas 91.7 x 102.2
NWHCM : L2004.3.2 : F (P)

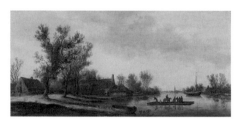

Neyn, Pieter de (attributed to) 1597–1639
River Landscape with Ferry Boat and Cottage
oil on oak panel 29.5 x 57.8
NWHCM : 1991.1.30 : F

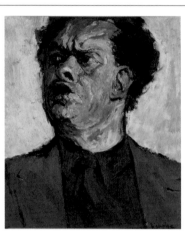

Nicholls, Guy b.1926
Dylan Thomas (1914–1953)
oil on canvas 61 x 50.8
NWHCM : 1966.41 : F

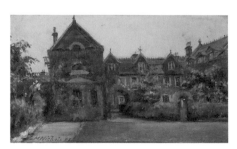

Nichols, Catherine Maude 1847–1923
Bethel Hospital, Norwich
oil on millboard 13.3 x 24.1
NWHCM : 1940.75.8 : F

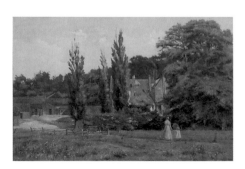

Nichols, Catherine Maude 1847–1923
Earlham, Norwich
oil on canvas 75 x 110.5
NWHCM : 1903.57.1 : F

Nichols, Catherine Maude 1847–1923
Early in the Year
oil on canvas 20 x 30.2
NWHCM : 1934.134.17 : F

Nichols, Catherine Maude 1847–1923
George Borrow (after John Thomas Borrow)
oil on canvas 80 x 67.3
NWHCM : 2005.449 : F

Nichols, Catherine Maude 1847–1923
Lime Pit Cottages, Ipswich Road, Norwich
oil on canvas 43 x 79.8
NWHCM : 1917.1 : F

Nichols, Catherine Maude 1847–1923
On Norwich River
oil on panel 27.3 x 32.1
NWHCM : 1952.125 : F

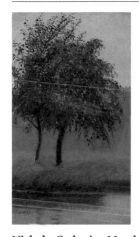

Nichols, Catherine Maude 1847–1923
River and Trees
oil on millboard 24.1 x 12.7
NWHCM : 1940.75.3 : F

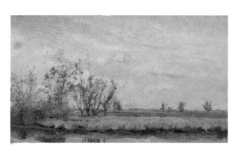

Nichols, Catherine Maude 1847–1923
River Scene
oil on millboard 13.3 x 23.5
NWHCM : 1940.75.7 : F

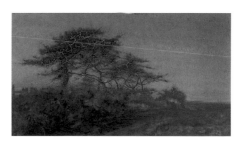

Nichols, Catherine Maude 1847–1923
Somerleyton, Evening
oil on canvas 35.2 x 56.5
NWHCM : 1940.75.2 : F

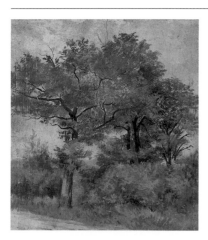

Nichols, Catherine Maude 1847–1923
The Roadside
oil on cardboard 31.5 x 27.8
NWHCM : 1934.12.1 : F

Nichols, Catherine Maude 1847–1923
Trees in Meadow
oil on canvas 27.3 x 22.3
NWHCM : 1940.75.6 : F

Nichols, Catherine Maude 1847–1923
Trees in Spring
oil on millboard 22.2 x 12.1
NWHCM : 1940.75.5 : F

Nichols, Catherine Maude 1847–1923
Waterloo Bridge, London
oil on millboard 24.1 x 13.3
NWHCM : 1940.75.4 : F

Ninham, Henry 1793–1874
Jesus Chapel, Norwich Cathedral 1840
oil on mahogany panel 11.8 x 9.5
NWHCM : 1951.235.1180 : F

Ninham, Henry 1793–1874
The Devil's Tower, Carrow, Norwich 1840
oil on panel 18.5 x 14.3
NWHCM : 1951.235.1183 : F

Ninham, Henry 1793–1874
*View through the Archway of the Cow Tower,
Norwich, Showing the Dean Meadow* 1840
oil on panel 22.2 x 15.9
NWHCM : 1951.235.1184 : F

Ninham, Henry 1793–1874
Whitefriars, Norwich 1840
oil on millboard 18.3 x 14.3
NWHCM : 1951.235.1185 : F

Ninham, Henry 1793–1874
St Stephen's Back Street, Norwich 1843
oil on millboard 17.8 x 22.8
NWHCM : 1951.235.1189 : F

Ninham, Henry 1793–1874
Market Cross, Wymondham 1865
oil on board 18.5 x 15.1
NWHCM : 1971.55.142 : F

Ninham, Henry 1793–1874
Cromer Church
oil on millboard 40.6 x 30.5
NWHCM : 1969.301.2 : F

Ninham, Henry 1793–1874
Fuller's House, St Martin's, Norwich
oil on panel 29.5 x 40.6
NWHCM : 1951.235.1188 : F

Ninham, Henry 1793–1874
Gateway and Cattle
oil on millboard 21.6 x 16.5
NWHCM : 1894.75.9 : F

Ninham, Henry 1793–1874
Gateway Norwich (Entrance to the Bishop's Palace)
oil on paper laid on millboard 20 x 14.9
NWHCM : 1951.235.1186 : F

Ninham, Henry 1793–1874
Interior of Strangers' Hall, Norwich
oil on mahogany panel 31.4 x 39.4
NWHCM : 1946.141 : F

Ninham, Henry 1793–1874
Near Mousehold, Norwich (Sheds behind Cavalry Barracks)
oil on millboard 15.2 x 18.4
NWHCM : 1951.235.1181 : F

Ninham, Henry 1793–1874
Norwich Scene with Whitefriars Bridge
oil on millboard 24.1 x 31.8
NWHCM : 1961.428 : F

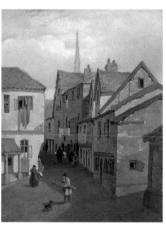

Ninham, Henry 1793–1874
Old Houses, Elm Hill, Norwich
oil on millboard 22.6 x 17.7
NWHCM : 1937.9.2 : F

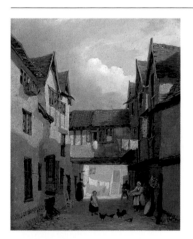

Ninham, Henry 1793–1874
Old Houses near St Benedict's Church, Norwich
oil on millboard 22.6 x 17.7
NWHCM : 1937.9.1 : F

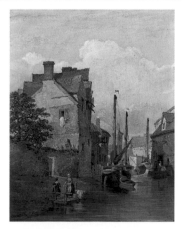

Ninham, Henry 1793–1874
The River Wensum, Norwich
oil on mahogany panel 25.5 x 20.2
NWHCM : 1951.235.1187 : F

Ninham, Henry (attributed to) 1793–1874
Farm at Great Ormesby, Norfolk
oil on canvas 29.2 x 53.3
NWHCM : 1945.94 : F

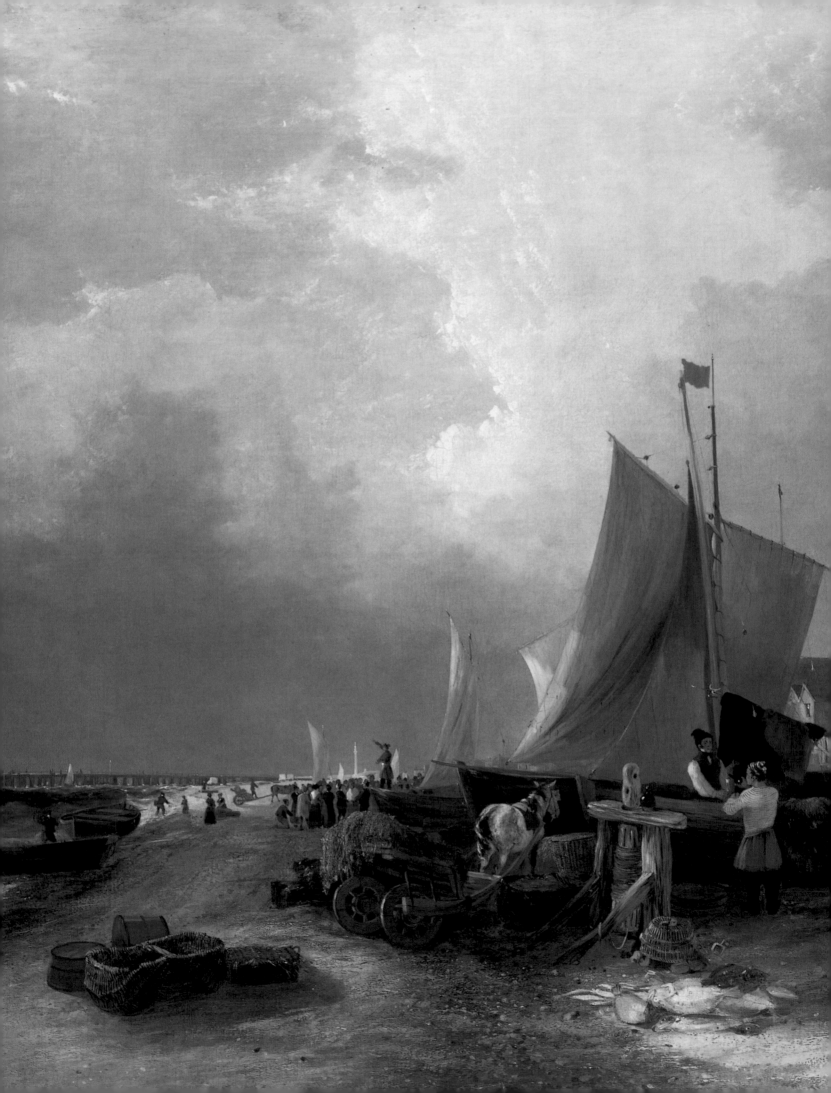

Ninham, John 1754–1817
Beach Scene
oil on canvas 35 x 50.5
NWHCM : 1951.235.1191 : F

Noiles, Arthur
Philip Barnes (1792?–1874), Secretary, Vice-President and President of the Norwich Society of Artists 1870
oil on canvas 139.8 x 109.8
NWHCM : 1973.27 : F

Nursey, Claude Lorraine Richard Wilson
1816–1873
Officers of the 1st City of Norwich Rifle Volunteers, with Their Captain (…) 1862
oil on canvas 65 x 108.5
NWHCM : 1988.165 : F

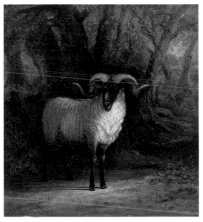

Nursey, Perry 1799–1867
The Norfolk Sheep: A Portrait 1846
oil on millboard 32.4 x 29.9
NWHCM : 1976.159 : F

Oakes, John Wright 1820–1887
Moonlight, Near Cemmaes, Anglesea c.1871
oil on millboard 18.8 x 23.9
NWHCM : 1896.25.405 : F

Oakes, John Wright 1820–1887
Glen Sannox (Arran)
oil on canvas 112 x 143
NWHCM : 1896.25.407 : F

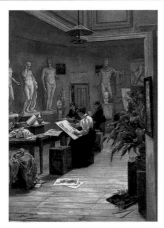

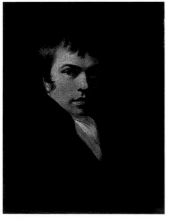

Offord, Gertrude Elizabeth 1860–1903
Still Life with Water Lilies 1882
oil on board 50.8 x 60.9
NWHCM : 2005.450 : F

Offord, Gertrude Elizabeth 1860–1903
The Art Class c.1897
oil on canvas 76 x 56
NWHCM : 2002.23 : F

Opie, John 1761–1807
John Crome (1768–1821) c.1798
oil on canvas 55.8 x 43.2
NWHCM : 1899.4.15 : F

Facing page: Vincent, George, 1796–1831, *The Fish Auction, Yarmouth* (detail), 1827, Norwich Castle Museum and Art Gallery, (p. 223)

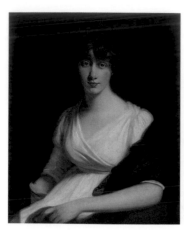

Opie, John 1761–1807
Mary Gay (the future Mrs Girdlestone)
(c.1780–1853) c.1799
oil on canvas 76.2 x 63.5
NWHCM : 1935.134 : F

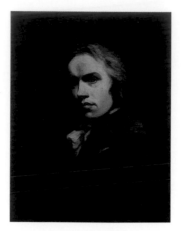

Opie, John 1761–1807
Self Portrait c.1799
oil on canvas 71 x 54
NWHCM : 1910.54 : F

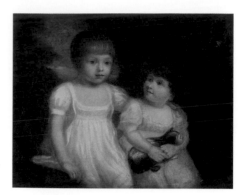

Opie, John 1761–1807
The Noverre Children c.1805
oil on canvas 71 x 83.8
NWHCM : 1958.264 : F

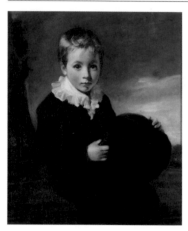

Opie, John 1761–1807
Master William Buckle Frost (1798–1875)
c.1805–1806
oil on canvas 76 x 63.5
NWHCM : 1963.270 : F

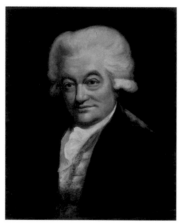

Opie, John 1761–1807
Crisp Molineux (1730–1792)
oil on canvas 61.6 x 51.1
NWHCM : 1979.368.1 : F

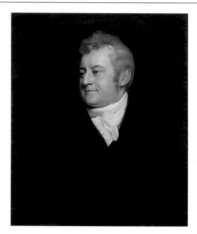

Opie, John (after) 1761–1807
Dr Frank Sayers (1763–1817), at the Age of
37 c.1852–1853
oil on canvas 76.5 x 63.7
NWHCM : 1945.33 : F

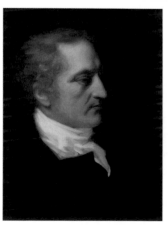

Opie, John (after) 1761–1807
Thomas Harvey of Catton
oil on canvas 58.5 x 45
NWHCM : 1959.161 : F

Pacheco, Ana Maria b.1943
A Little Spell in Six Lessons (lid of box
containing a series of six drypoint etchings)
1989
oil on lid of sycamore box 19.5 x 19.5
NWHCM : 1992.182.3a : F

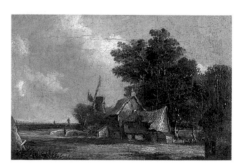

Paul, Joseph 1804–1887
Cottage and Mill
oil on canvas 18.4 x 26.1
NWHCM : 1929.148.2 : F

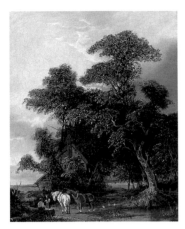

Paul, Joseph 1804–1887
Cottage Landscape with Figures and Horses by a Pond
oil on canvas 56 x 43
NWHCM : 1989.41 : F

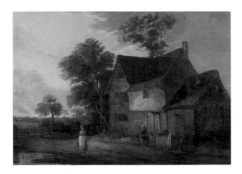

Paul, Joseph 1804–1887
Farm Buildings
oil on canvas 92.5 x 128.1
NWHCM : 1951.235.1192 : F

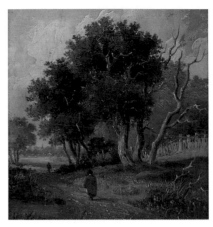

Paul, Joseph 1804–1887
Landscape
oil on oak panel 16.6 x 16
NWHCM : 1940.36.6 : F

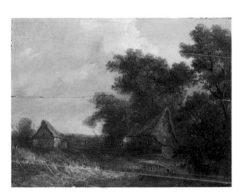

Paul, Joseph 1804–1887
Landscape with Cottage
oil on mahogany panel 27.3 x 35.4
NWHCM : 1929.148.1 : F

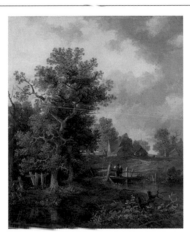

Paul, Joseph 1804–1887
Landscape with Farm Buildings
oil on canvas 75.2 x 63.1
NWHCM : 1951.235.1193 : F

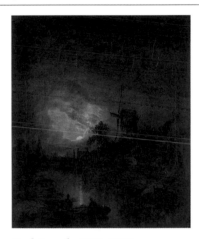

Paul, Joseph 1804–1887
Moonlight Scene
oil on canvas 76.4 x 63.5
NWHCM : 1948.48.1 : F

Paul, Joseph 1804–1887
Moonlight with Shipping and Mill
oil on canvas 70.8 x 90.7
NWHCM : 1948.48.2 : F

Paul, Joseph 1804–1887
Poringland Oak (after John Crome)
oil on canvas 126.7 x 101.6
NWHCM : 1943.88.11 : F

Paul, Joseph 1804–1887
Pull's Ferry, Norwich
oil on canvas 71.5 x 91.4
NWHCM : 1943.88.9 : F

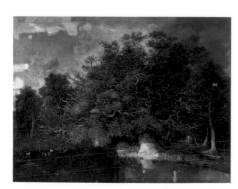

Paul, Joseph 1804–1887
Trees and Pool
oil on canvas 64.8 x 108
NWHCM : 1943.88.10 : F

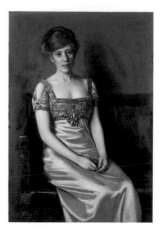

Peacock, Ralph 1868–1946
Mrs Maud Isobel Buxton
oil on canvas 121.9 x 87.6
NWHCM : 1963.268.31 : F

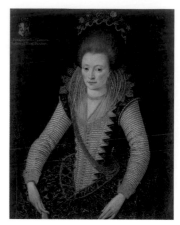

Peake, Robert I c.1551–1619
Elizabeth D'Oyley, Aged 16 c.1608
oil on panel 88.9 x 69.9
NWHCM : 1963.268.4 : F

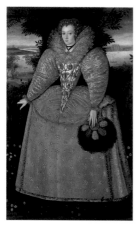

Peake, Robert I (attributed to) c.1551–1619
Elizabeth Buxton, née Kemp c.1588–1590
oil on canvas 175.4 x 106
NWHCM : 1963.268.13 : F

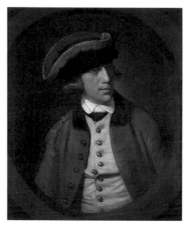

Penny, Edward 1714–1791
Captain Matthew Pepper Manby
oil on canvas 76 x 63
NWHCM : 1831.80.2 : F

Penrose, Roland 1900–1984
Cryptic Coincidence II 1950s
oil on canvas 76.1 x 101.6
NWHCM : L1998.2 : F

Péri, Lucien 1880–1948
Mont Notre Dame, 15 April 1916 (Wartime Scene) 1916
oil & watercolour on card 23 x 30.5
NWHCM : 1925.98.15 : F

Phillips, Tom b.1937
The Castle, Norwich… the Splendour Falls 1971–1972
acrylic on canvas 61 x 50.8
NWHCM : 1972.215.5 : F

Picabia, Francis 1879–1953
Le colibri c.1928–1930
oil on canvas 38 x 85
NWHCM : L1993.3.13 : F

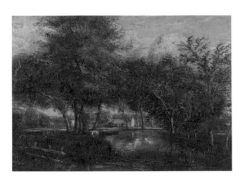

Pigg, James Woolmer 1850–1910
Back River, Heigham, Norwich 1876
oil on canvas 25.4 x 37.2
NWHCM : 1894.75.10 : F

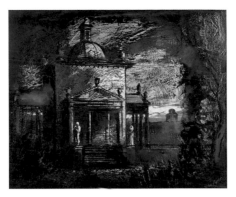

Piper, John 1903–1992
Castle Howard: Temple and Mausoleum 1944
oil on canvas laid on deal panel 63.4 x 76.2
NWHCM : 1950.74 : F

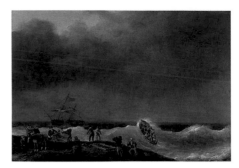

Pocock, Nicholas 1740–1821
Saving a Crew at Corton, Norfolk 1815
oil on canvas 43.3 x 60.9
NWHCM : 2003.12.13 : F

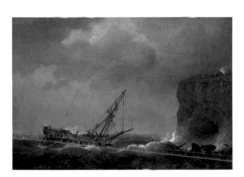

Pocock, Nicholas 1740–1821
Vessel in Distress, Yarmouth 1815
oil on canvas 43.2 x 61.2
NWHCM : 2003.12.12 : F

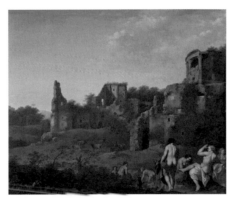

Poelenburgh, Cornelis van 1594/1595–1667
Landscape with Roman Ruins
oil on oak panel 39.4 x 48
NWHCM : 1957.295 : F

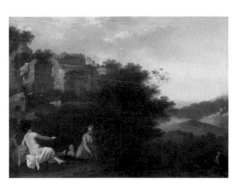

Poelenburgh, Cornelis van 1594/1595–1667
Nymphs Bathing in a Southern Landscape
oil on panel 18.2 x 24.6
NWHCM : 1991.1.32 : F

Potter, Mary 1900–1981
The Mere 1958
oil on canvas 50.5 x 76.2
NWHCM : 1962.153 : F

Potter, Mary 1900–1981
Orchard 1973
oil on canvas 55.5 x 76
NWHCM : 2002.25.4 : F

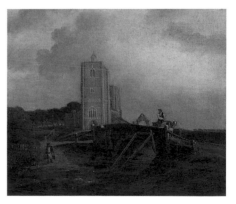

Preston, Thomas (attributed to)
active 1826–1850
Wymondham Abbey from the West 1828
oil on canvas 30.7 x 36
NWHCM : 1957.78 : F

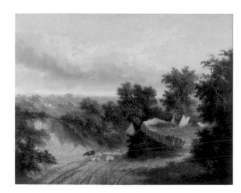

Priest, Alfred 1810–1850
Road by the Churchyard 1834
oil on canvas 71.1 x 91.4
NWHCM : 1940.118.12 : F

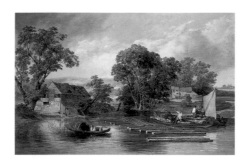

Priest, Alfred 1810–1850
Scene at Taverham, Norfolk (Taverham Paper Mill) 1839
oil on canvas 87.1 x 133.4
NWHCM : 1969.302 : F

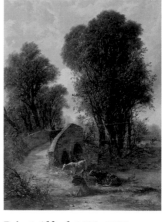

Priest, Alfred 1810–1850
Godstowe Bridge, Oxford 1844
oil on canvas 76.5 x 55
NWHCM : 1951.235.1196 : F

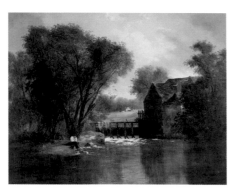

Priest, Alfred 1810–1850
Iffley Mill, Oxford 1844
oil on canvas 71.3 x 91.7
NWHCM : 1894.75.4 : F

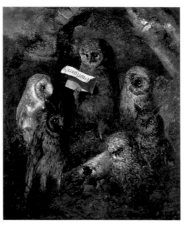

Priest, Alfred 1810–1850
Owlegarchy 1848
oil on canvas 77 x 63.7
NWHCM : 1894.75.5 : F

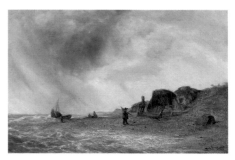

Priest, Alfred 1810–1850
Beach Scene 1849
oil on canvas 39.8 x 61.3
NWHCM : 1971.55.140 : F

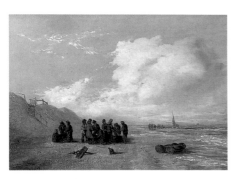

Priest, Alfred 1810–1850
Beach Scene with Fishermen and Fishing Baskets in the Foreground 1849
oil on canvas 39.4 x 57.2
NWHCM : 1951.235.1199 : F

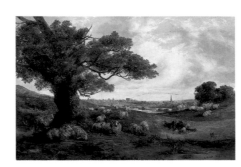

Priest, Alfred 1810–1850
Norwich from the South-East 1849
oil on canvas 68.3 x 103
NWHCM : 1950.80 : F

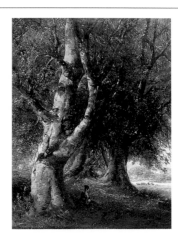

Priest, Alfred 1810–1850
Beech Trees, Grazing Cattle to Right
oil on millboard 40.7 x 30.4
NWHCM : 1951.235.1198 : F

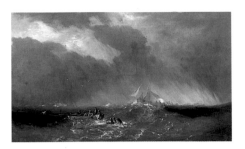

Priest, Alfred 1810–1850
Fishing Boats in a Storm
oil on canvas 50.8 x 86.3
NWHCM : 1951.235.1195 : F

Priest, Alfred 1810–1850
*Landscape with Stream Passing through Trees,
Pond in Foreground*
oil on millboard 8.9 x 14
NWHCM : 1951.235.1197(5) : F

Priest, Alfred 1810–1850
River Scene with Overhanging Trees
oil on millboard 8.9 x 14
NWHCM : 1951.235.1197(1) : F

Priest, Alfred 1810–1850
*River Scene with Tree to the Right and Wooden
Palings on the Left*
oil on millboard 8.7 x 13.8
NWHCM : 1951.235.1197(4) : F

Priest, Alfred 1810–1850
*River Scene with Trees and House with Red
Roof and Felled Trunk*
oil on millboard 8.7 x 14
NWHCM : 1951.235.1197(2) : F

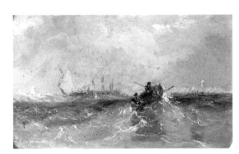

Priest, Alfred 1810–1850
*Rough Sea with Rowing Boat and Two Figures,
Sailing Vessels in the Background*
oil on millboard 8.7 x 14
NWHCM : 1951.235.1197(3) : F

Priest, Alfred 1810–1850
*Thorpe River, Norwich (View through an Arch
of Whitlingham Church)*
oil on oak panel 28.1 x 22.3
NWHCM : 1951.235.1194 : F

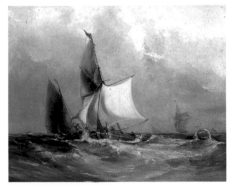

Priest, Alfred (attributed to) 1810–1850
Fishing Boat in a Storm
oil on canvas 40.6 x 50.8
NWHCM : 1952.59.2 : F

Redpath, Anne 1895–1965
Spanish Village
oil on panel 50.8 x 76.2
NWHCM : 1962.154 : F ✱

Reeve, James 1833–1920
Ruins at Whitlingham 1863
oil on canvas 25.4 x 30.4
NWHCM : 1951.235.1202 : F

Reeve, James 1833–1920
Trowse Old Hall 1863
oil on canvas 18.8 x 25.2
NWHCM : 1951.235.1201 : F

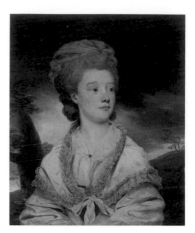

Reinagle, Philip 1749–1833
Elizabeth Patteson, née Staniforth (1760–1838)
c.1781
oil on canvas 76.1 x 63.3
NWHCM : L1984.15.2 : F (P)

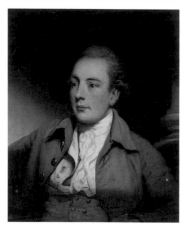

Reinagle, Philip 1749–1833
John Patteson (1755–1833) c.1781
oil on canvas 76.4 x 63.6
NWHCM : 1984.15.1 : F (P)

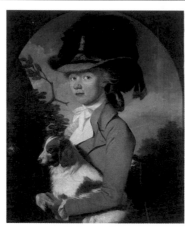

Reinagle, Philip 1749–1833
*Mrs John Patteson, née Elizabeth Staniforth
(1760–1838)*
oil on canvas 76.6 x 63.7
NWHCM : 1991.1.14 : F

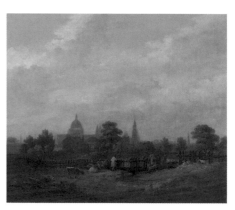

Reinagle, Ramsay Richard 1775–1862
A View of London with St Paul's
oil on canvas 43.2 x 52.7
NWHCM : 1978.418 : F

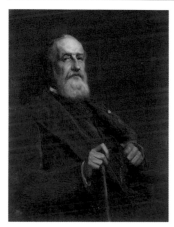

Richmond, William Blake 1842–1921
Lieutenant Colonel Charles Edward Bignold
oil on canvas 88.9 x 68.5
NWHCM : 1951.9 : F

Richmond, William Blake 1842–1921
Phaeton and the Horses of the Sun
oil on canvas 108.6 x 165.1
NWHCM : 1924.38 : F

Riley, Bridget b.1931
Edge of Day 1981
oil on linen 175 x 151.3
NWHCM : 1985.91 : F

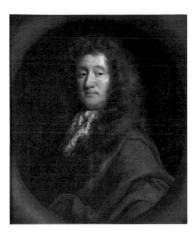

Riley, John 1646–1691
Thomas Marsham of Stratton Strawless c.1680
oil on canvas 75.7 x 63
NWHCM : 1949.107.3 : F

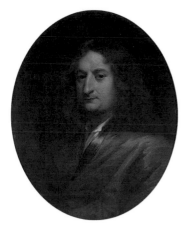

Riley, John 1646–1691
Joseph Cox
oil on canvas 67.1 x 55
NWHCM : 1991.1.3 : F

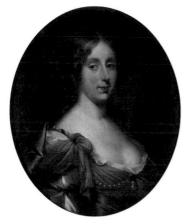

Riley, John 1646–1691
Mrs Joseph Cox, née Elizabeth Macro (d.1682)
oil on canvas 67.1 x 54.6
NWHCM : 1991.1.4 : F

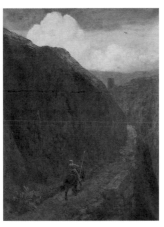

Riviere, Briton 1840–1920
Childe Roland to the Dark Tower Came 1917
oil on canvas 126.4 x 93.5
NWHCM : 1932.25 : F

Riviere, Briton 1840–1920
Two Boys with a Birdcage
oil on canvas 30.9 x 23
NWHCM : 1976.207.116 : F

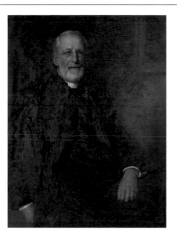

Riviere, Hugh Goldwin 1869–1956
Canon Sydney Pelham 1916
oil on canvas 116.8 x 87.6
NWHCM : 1941.102 : F

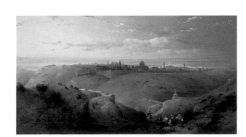

Roberts, David 1796–1864
*Jerusalem from the Mount of Olives with
Pilgrims Entering from the River Jordan* 1842
oil on canvas 84.1 x 153
NWHCM : 1918.12 : F

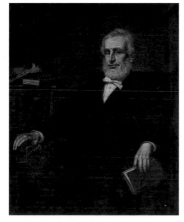

Roberts, Herbert Harrington
1837–after 1920
The Reverend John Gunn, FGS (1801–1890)
oil on canvas 124.4 x 99.7
NWHCM : 2005.451 : F

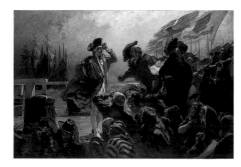

Roe, Fred 1864–1947
The Return of the Hero (Lord Nelson) c.1909
oil on canvas 125.2 x 183.6
NWHCM : 1928.76 : F

Rombouts, Salomon c.1652–c.1702
A Village Fair with a Mummer in the Foreground
oil on canvas 75.5 x 63
NWHCM : 1991.1.15 : F

Romeyn, Willem (attributed to)
c.1624–1694
A Shepherdess with Sheep beneath the Walls of Rome, Other Figures and Buildings Beyond
oil on panel 46 x 61.9
NWHCM : 1991.1.34 : F

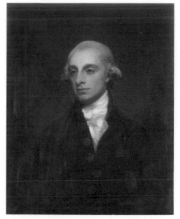

Romney, George 1734–1802
Sir Robert John Buxton, 1st Bt 1785
oil on canvas 89.8 x 69.4
NWHCM : 1963.268.10 : F

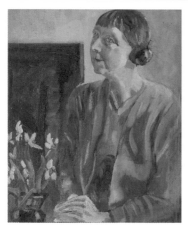

Roscoe, Theodora active 1929–1962
Camilla Doyle
oil on canvas board 30.2 x 25
NWHCM : 1951.46 : F

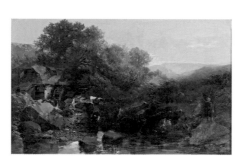

Rose, William S. 1810–1873
Morning in the Highlands
oil on canvas 39.1 x 61.3
NWHCM : 1951.235.1 : F

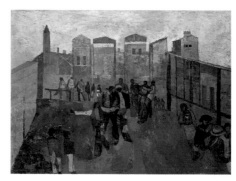

Rosoman, Leonard Henry b.1913
Figures in a Square 1958
oil on canvas 76 x 101.7
NWHCM : L1999.1 : F

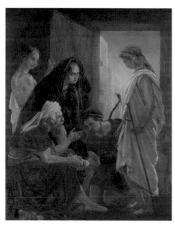

Rossetti, Dante Gabriel 1828–1882
Tobias in the House of His Father and Mother
oil on mahogany panel 53.3 x 42.9
NWHCM : 1938.132.24 : F

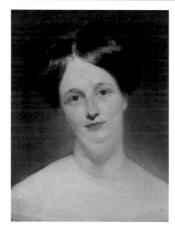

Rothwell, Richard 1800–1868
Mrs Barwell
oil on panel 42.3 x 32.4
NWHCM : 1918.76 : F

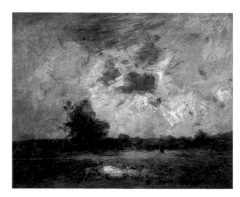

Rousseau, Théodore 1812–1867
Landscape c.1842
oil on canvas 37.2 x 45.7
NWHCM : 1949.134 : F

Facing page: Marcoussis, Louis, 1883–1941, *The Open Door* (detail), 1928, Norwich Castle Museum and Art Gallery, (p.159)

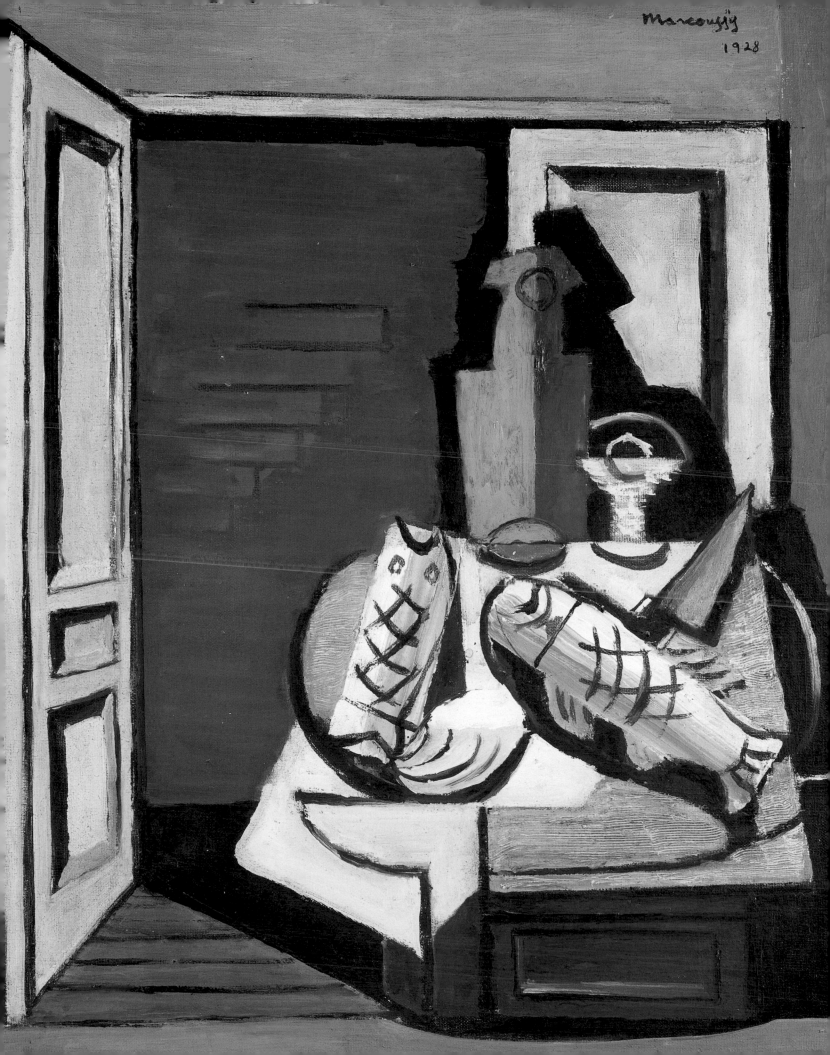

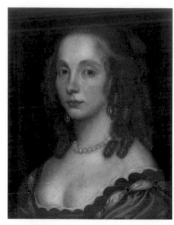

Russel, Anthony (attributed to)
c.1660–1743
Mrs Soame
oil on oak panel 39.5 x 31.6
NWHCM : 1991.1.39 : F

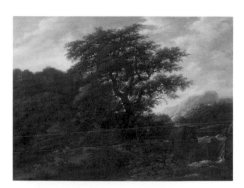

Ruysdael, Jacob Salomonsz. van
1629/1630–1681
Landscape
oil on canvas 83.2 x 109.8
NWHCM : 1986.55 : F

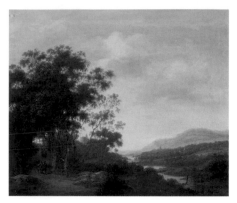

Saftleven, Herman the younger (circle of)
1609–1685
An Extensive River Landscape with Figures on a Road, a Wood to the Left
oil on canvas 50 x 58.2
NWHCM : 1991.1.17 : F

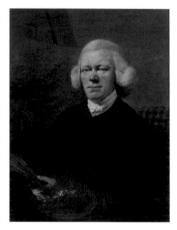

Sanders, John 1750–1825/1826
Joseph Browne (1720–1800) 1779
oil on canvas 91.9 x 71.1
NWHCM : L1980.3.2 : F

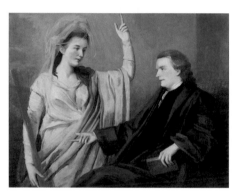

Sanders, John 1750–1825/1826
The Reverend John Walker and His Wife 1780
oil on canvas 102.7 x 127.5
NWHCM : 1982.364 : F

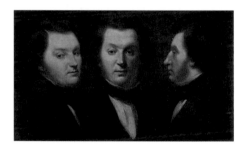

Sandys, Anthony 1806–1883
Three Portraits of the Artist 1838
oil on canvas 25.8 x 38.1
NWHCM : 1951.235.1203 : F

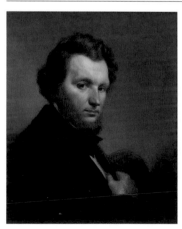

Sandys, Anthony 1806–1883
Self Portrait 1850
oil on canvas 30.2 x 24.8
NWHCM : 1909.41.1 : F

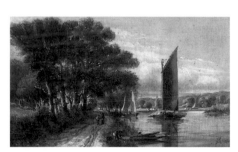

Sandys, Anthony 1806–1883
Whitlingham Reach, near Norwich 1860
oil on panel 14.7 x 24.6
NWHCM : 1951.235.1205 : F

Sandys, Anthony 1806–1883
Henry Ninham (1796–1874)
oil on canvas 30.8 x 25.7
NWHCM : 1947.149.1 : F

Sandys, Anthony 1806–1883
Meditation
oil on canvas 30.8 x 25.7
NWHCM : 1931.169 : F

Sandys, Anthony 1806–1883
On the River Yare
oil on oak panel 12.7 x 17.5
NWHCM : 1951.235.1204 : F

Sandys, Anthony 1806–1883
Portrait of a Man
oil on canvas 31 x 25.5
NWHCM : 1939.15 : F

Sandys, Anthony 1806–1883
Richard Roper Boardman (Underchamberlain to Norwich Corporation, 1834)
oil on canvas 76.2 x 63.4
NWHCM : 1894.75.13 : F

Sandys, Anthony 1806–1883
The Girl in the Hat
oil on panel 30.4 x 25.4
NWHCM : 1968.505 : F

Sandys, Anthony 1806–1883
The Mill
oil on canvas 30.5 x 45.9
NWHCM : 1911.96 : F

Sandys, Anthony (attributed to) 1806–1883
The Sand Pit
oil on board 30.8 x 45.7
NWHCM : 1950.82 : F

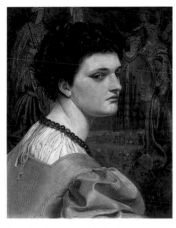

Sandys, Emma 1843–1877
Portrait Study of a Lady in a Yellow Dress
c.1870
oil on panel 37 x 29.5
NWHCM : 1951.235.1208 : F

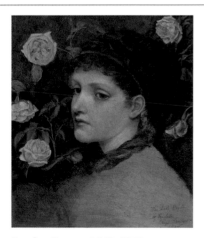

Sandys, Emma 1843–1877
Study of a Head 1877
oil on canvas 30.4 x 25.4
NWHCM : 1894.75.14 : F

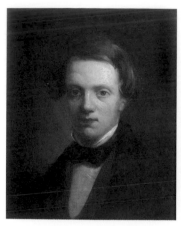

Sandys, Frederick 1829–1904
Self Portrait, When 19 Years of Age 1848
oil on canvas 29.2 x 24.2
NWHCM : 1909.41.2 : F

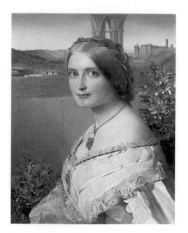

Sandys, Frederick 1829–1904
Adelaide Mary, Mrs Philip Bedingfeld 1859
oil on oak panel 42.6 x 33.8
NWHCM : 1942.26.2 : F

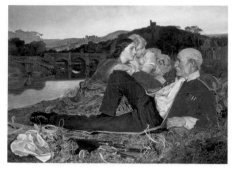

Sandys, Frederick 1829–1904
Autumn 1860
oil on canvas 79.6 x 108.7
NWHCM : 1951.235.1209 : F

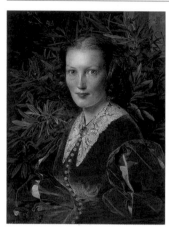

Sandys, Frederick 1829–1904
Hannah Louisa, Mrs William Clabburn 1860
oil on mahogany panel 44.8 x 34
NWHCM : 1951.235.1211 : F

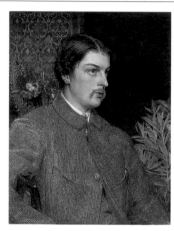

Sandys, Frederick 1829–1904
Philip Bedingfeld, LLD, JP 1860
oil on mahogany panel 47.2 x 37.8
NWHCM : 1942.26.1 : F

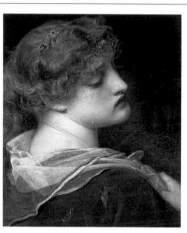

Sandys, Frederick 1829–1904
Mary Magdalene (Tears, Idle Tears) 1862
oil on canvas 29.2 x 24.8
NWHCM : 1951.235.1210 : F

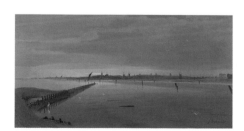

Sandys, Frederick 1829–1904
Breydon Water 1871
oil on board 33.1 x 62.5
NWHCM : 1951.235.1212 : F

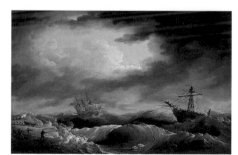

Sartorius, Francis II c.1777–c.1808
*A Stranded Vessel: The Snipe Gun-Brig
Grounded at Great Yarmouth in 1807 with the
Loss of 67 Lives* 1807
oil on canvas 50.5 x 76.1
NWHCM : 2003.12.15 : F

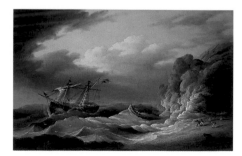

Sartorius, Francis II c.1777–c.1808
Saving a Crew at Anholt 1808
oil on canvas 50.5 x 76.5
NWHCM : 2003.12.14 : F

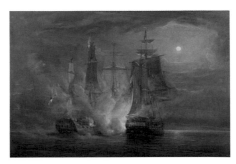

Schetky, John Christian 1778–1874
'HMS Amelia' and the French Frigate
'Arethuse' in Action, 1813 1852
oil on canvas 60.8 x 91.4
NWHCM : 1902.15.2 : F

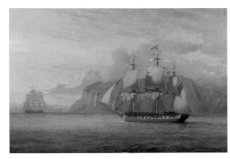

Schetky, John Christian 1778–1874
'HMS Amelia' Chasing the French Frigate
'Arethuse', 1813 1852
oil on canvas 60.7 x 91.4
NWHCM : 1902.15.1 : F

Schofield, Zara b.1981
Veiled (Orange and Green) 2005
oil, wax & resin on canvas 201 x 158
NWHCM : 2005.462 : F

Schott, Cecil (attributed to) active 1887
John Gurney (after George Frederick Watts)
oil on canvas 66 x 53.3
NWHCM : 1894.36 : F

Scully, Sean b.1945
26.7.74, No.3/4 1974
acrylic on canvas 122 x 121.5
NWHCM : 2002.110.1 : F

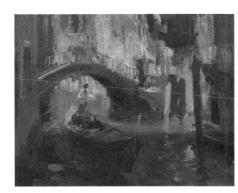

Seago, Edward Brian 1910–1974
The Dark Canal, Venice 1940
oil on panel 21.7 x 26.6
NWHCM : 1977.481.2 : F

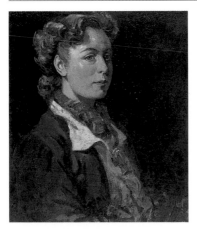

Seago, Edward Brian 1910–1974
Miss Rosamund Le Hunte-Cooper c.1946
oil on canvas 61.3 x 51.1
NWHCM : 1977.481.7 : F

Seago, Edward Brian 1910–1974
Sunset, Yarmouth 1948
oil on canvas board 21.7 x 27.3
NWHCM : 1977.481.4 : F

Seago, Edward Brian 1910–1974
A Stubble Field near Ludham 1950
oil on hardboard 30.1 x 40.6
NWHCM : 1978.185 : F

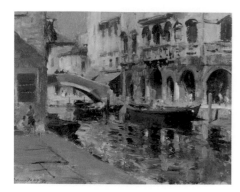

Seago, Edward Brian 1910–1974
La Vena Canal, Chioggia 1950
oil on hardboard 30.5 x 40.6
NWHCM : 1977.481.5 : F

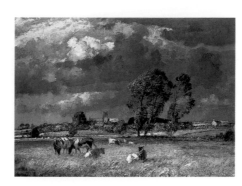

Seago, Edward Brian 1910–1974
A Norfolk Village, Aldeby
oil on canvas 75.9 x 101.5
NWHCM : 1977.481.1 : F

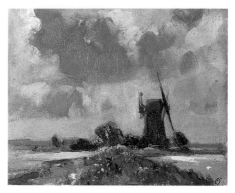

Seago, Edward Brian 1910–1974
Drainage Mill on the Bure
oil on board 22.8 x 26.7
NWHCM : 1977.481.10 : F

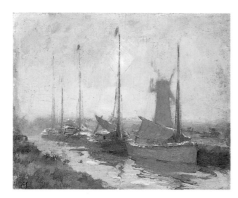

Seago, Edward Brian 1910–1974
Evening Haze, Thurne Dyke
oil on canvas board 21.6 x 26.7
NWHCM : 1977.481.3 : F

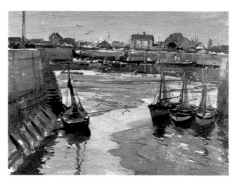

Seago, Edward Brian 1910–1974
Fishing Boats on the Mud, Honfleur
oil on canvas 45.7 x 60.7
NWHCM : 1977.481.6 : F

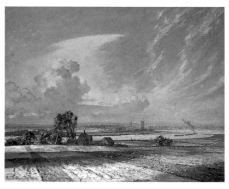

Seago, Edward Brian 1910–1974
The Anvil Cloud
oil on canvas 101.6 x 127
NWHCM : 1944.82 : F

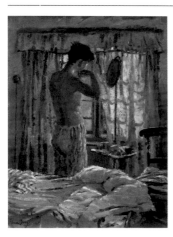

Seago, Edward Brian 1910–1974
The East Window
oil on hardboard 48.8 x 37
NWHCM : 1944.83 : F

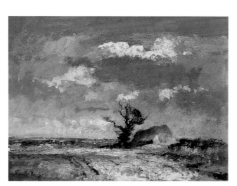

Seago, Edward Brian 1910–1974
The Haystack
oil on hardboard 50.7 x 66.3
NWHCM : 1976.77 : F

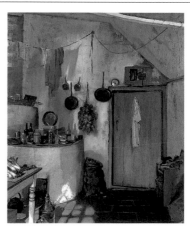

Seago, Edward Brian 1910–1974
The White Kitchen
oil on canvas 76.5 x 63.5
NWHCM : 1956.246 : F

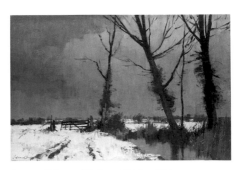

Seago, Edward Brian 1910–1974
Winter Landscape, Norfolk
oil on hardboard 49.5 x 75
NWHCM : 1963.253 : F

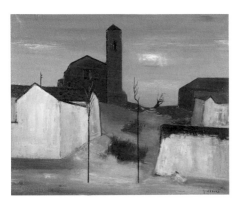

Sebire, Gaston 1920–2001
Environs de Madrid
oil on canvas 59.7 x 73
NWHCM : 1964.27 : F

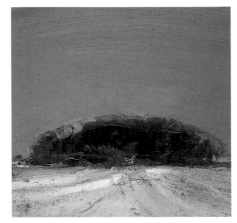

Self, Colin b.1941
Large Harvest Field with Two Hay Bales at Happisburgh, Norfolk 1984
oil (with some straw in paint) on hardboard 70.5 x 82.1
NWHCM : 1998.505.9 : F

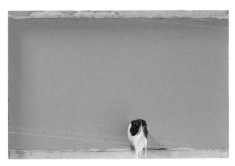

Self, Colin b.1941
Norfolk Landscape with Cow, 14th September 1984
mixed media, oil & model toy 14.8 x 22.2
NWHCM : 1998.505.8 : F

Sewell, Benjamin 1774–1849
Norwich Castle
oil on canvas 75 x 119.3
NWHCM : 1923.92 : F

Sewell, Benjamin 1774–1849
Norwich Cathedral
oil on canvas 73.7 x 104
NWHCM : 1891.52 : F

Sewell, Benjamin 1774–1849
Norwich Cathedral
oil on canvas 74.3 x 106
NWHCM : 1891.53 : F

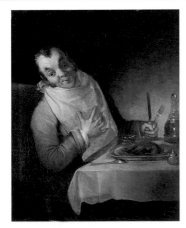

Sharp, Michael William 1777–1840
Man Eating 1813
oil on mahogany panel 25.4 x 21.6
NWHCM : 1969.181 : F

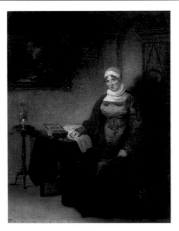

Sharp, Michael William 1777–1840
Mrs John Crome Seated at a Table by an Open Work Box 1813–1814
oil on panel 43.5 x 34
NWHCM : 1935.86 : F

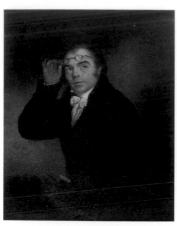

Sharp, Michael William 1777–1840
John Crome (1768–1821) c.1813
oil on oak panel 30.2 x 25.4
NWHCM : 1951.235.1229 : F

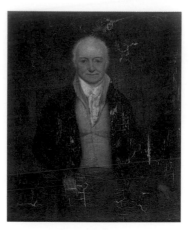

Sharp, Michael William 1777–1840
Samuel Marsh 1820
oil on oak panel 30.2 x 24.1
NWHCM : 1951.235.1230 : F

Sherrington, James Norton d.1848
Road with Pollards (after John Crome)
oil on canvas 78.8 x 112.4
NWHCM : 1974.60 : F

Shiels, William 1785–1857
Possibly William Loades Rix (c.1777–1855)
1832
oil on canvas 76.2 x 63.2
NWHCM : 1977.32.1 : F

Short, Obadiah 1803–1886
Footbridge with Woman Crossing 1874
oil on mahogany panel 26 x 37.5
NWHCM : 1894.75.7 : F

Short, Obadiah 1803–1886
Road Scene 1876
oil on canvas 28.3 x 43.5
NWHCM : 1927.68.49 : F

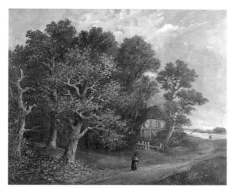

Short, Obadiah 1803–1886
Wooded Landscape with Cottage and Woman
1876
oil on canvas 35 x 43.8
NWHCM : 1932.59.14 : F

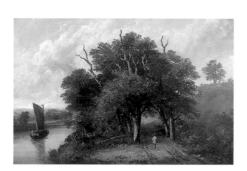

Short, Obadiah 1803–1886
*Landscape with Tree-Lined Road, River and
Barge* 1880
oil on canvas 33 x 48.3
NWHCM : 1932.59.13 : F

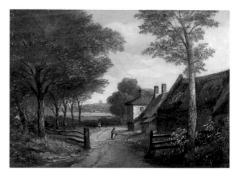

Short, Obadiah 1803–1886
At the Farm Gate
oil on canvas 22.4 x 30.5
NWHCM : 1983.18 : F

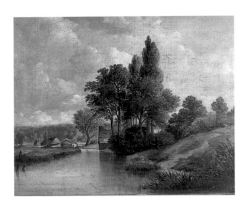

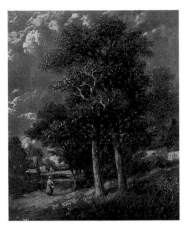

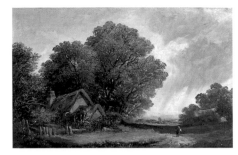

Short, Obadiah 1803–1886
River Scene with Cottage and Trees
oil on canvas 29.2 x 36.9
NWHCM : 1951.235.1232 : F

Short, Obadiah 1803–1886
Road Scene
oil on mahogany panel 23.5 x 20.8
NWHCM : 1894.75.8 : F

Short, Obadiah 1803–1886
Road Scene with Cottage
oil on canvas 28.9 x 44.5
NWHCM : 1951.235.1231 : F

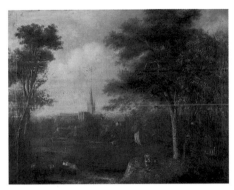

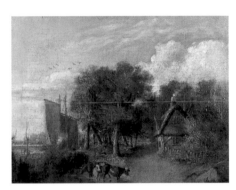

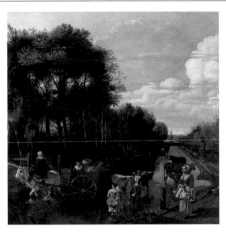

Short, Obadiah 1803–1886
View of Norwich
oil on canvas 49.5 x 64.9
NWHCM : 1940.14 : F

Short, Obadiah (attributed to) 1803–1886
Landscape
oil on canvas 29.9 x 38
NWHCM : 1940.36.4 : F

Siberechts, Jan 1627–c.1703
Landscape with Road, Cart and Figures
oil on canvas 104 x 104
NWHCM : 1949.137 : F

Sickert, Walter Richard 1860–1942
The Red Shop (The October Sun) c.1888
oil on panel 26.7 x 35.6
NWHCM : 1949.129 : F

Sickert, Walter Richard 1860–1942
Auberville c.1919
oil on canvas 49.9 x 60.8
NWHCM : 1961.506 : F

Sillett, James 1764–1840
Self Portrait 1803
oil on canvas 33.1 x 25.6
NWHCM : 2005.452 : F

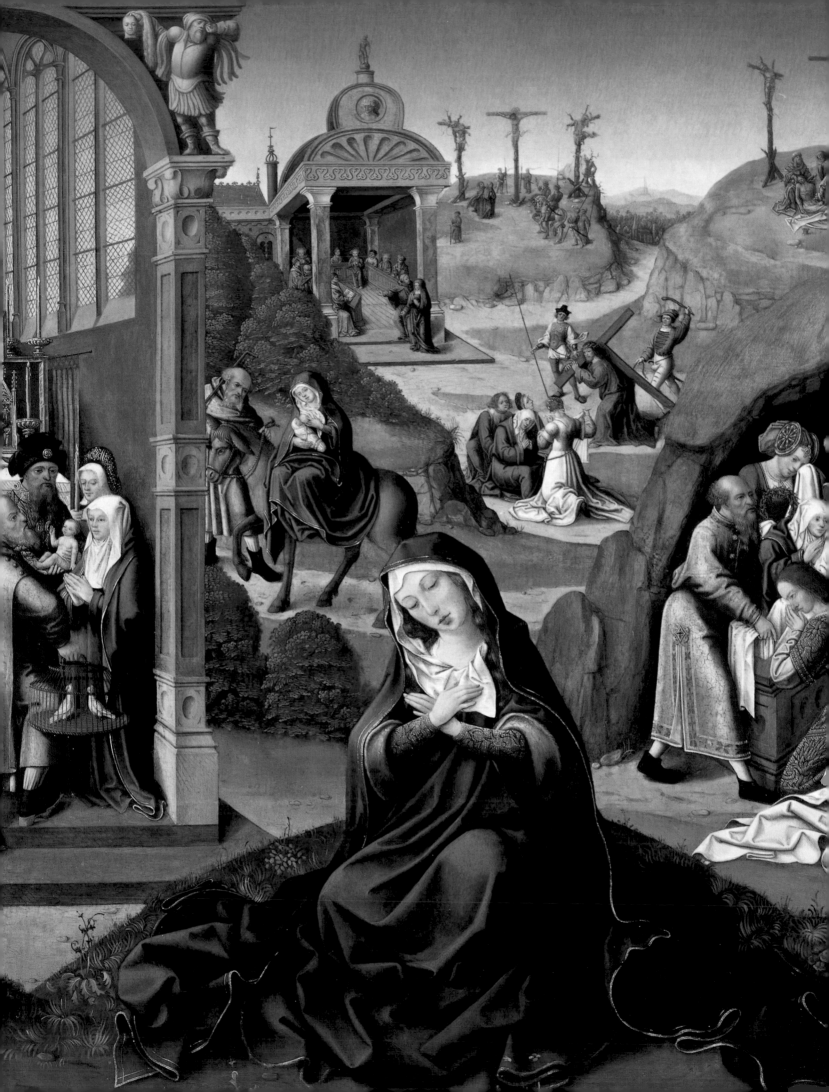

Sillett, James 1764–1840
The Winfarthing Oak 1812
oil on canvas 45.4 x 60.4
NWHCM : 1947.89 : F

Sillett, James 1764–1840
Thorpe Gardens Public House, Norwich 1818
oil on canvas 45.7 x 65.7
NWHCM : 1941.104 : F

Sillett, James 1764–1840
Flowers and Fruit 1827
oil on canvas 60.4 x 50
NWHCM : 1894.75.11 : F

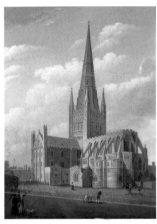

Sillett, James 1764–1840
Norwich Cathedral 1832
oil on oak panel 42.6 x 32.3
NWHCM : 1951.235.1233 : F

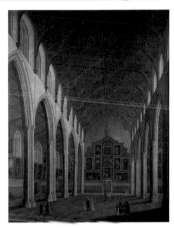

Sillett, James 1764–1840
Interior of St Andrew's Hall, Norwich 1837
oil on canvas 91.8 x 71.2
NWHCM : 1934.53 : F

Sillett, James 1764–1840
*Three-Panel Screen with Six Flower Pieces
(recto)* 1838
oil on paper laid on canvas on both sides
168 x 183 (E)
NWHCM : 1994.148 : F

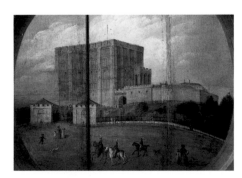

Sillett, James 1764–1840
*Three-Panel Screen with a View of Norwich
Castle (verso)* 1838
oil on paper laid on canvas on both sides
168 x 183 (E)
NWHCM : 1994.148 : F

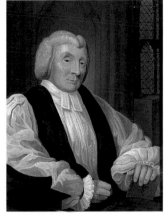

Sillett, James 1764–1840
*Henry Bathurst DD, Bishop of Norwich
(1744–1837)*
oil on canvas 42.9 x 32.9
NWHCM : 1983.219 : F

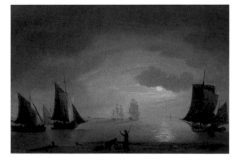

Sillett, James 1764–1840
Seascape in Moonlight
oil on canvas 45.5 x 68.7
NWHCM : 1955.168.1 : F

Facing page: Master of the Legend of the Magdalen, c.1483–c.1530, *The Seven Sorrows of Mary (The Ashwellthorpe Triptych)* (detail), c.1519,
Norwich Castle Museum and Art Gallery, (p.160)

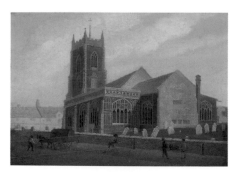

Sillett, James 1764–1840
St Michael Coslany Church, Norwich
oil on canvas 18.1 x 26
NWHCM : 1951.235.1234 : F

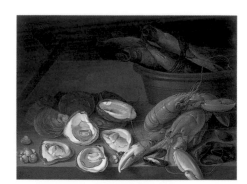

Sillett, James 1764–1840
Still Life of Lobsters, etc.
oil on canvas 45.9 x 61.1
NWHCM : 1944.5 : F

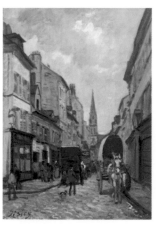

Sisley, Alfred 1839–1899
A Street Scene (La grande rue à Argenteuil)
1872
oil on canvas 65.4 x 46.2
NWHCM : 1945.90 : F

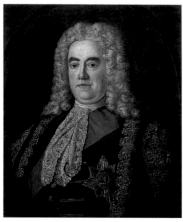

Slaughter, Stephen 1697–1765
Sir Robert Walpole, 1st Lord Orford
(1676–1745) 1742
oil on canvas 77 x 64
NWHCM : 1996.90 : F

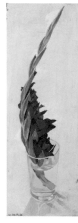

Smith, Ivy b.1945
Gladioli in a Glass (preparatory study for 'The
Smith Family Golden Wedding') 1985
oil on hardboard 45.9 x 16.5
NWHCM : 1986.271.1 : F

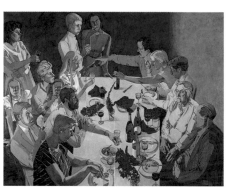

Smith, Ivy b.1945
The Smith Family Golden Wedding 1986
oil on canvas 198 x 251.5
NWHCM : 1986.270 : F

Smith, Miller c.1854–1937
St Helen's Hospital, Norwich c.1893
oil on canvas 35.6 x 45.4
NWHCM : 1956.164.2 : F

Smith, Miller c.1854–1937
Costessey, Norfolk
oil on canvas 76.5 x 51
NWHCM : 1956.164.1 : F

Smythe, Thomas 1825–1907
Carriers' Cart, Winter
oil on mahogany panel 25.3 x 38
NWHCM : 1971.55.146 : F

Smythe, Thomas 1825–1907
Carting Timber, Winter
oil on panel 30 x 54.5
NWHCM : 1969.301.6 : F

Smythe, Thomas 1825–1907
Crossing the Brook, Scene near Ipswich
oil on panel 25 x 38
NWHCM : 1969.301.5 : F

Smythe, Thomas 1825–1907
Crossing the Common, Scene near Ipswich
oil on panel 25 x 37.9
NWHCM : 1969.301.4 : F

Smythe, Thomas 1825–1907
The Rabbit Catcher and His Horse, Winter
oil on mahogany panel 25 x 38.1
NWHCM : 1971.55.147 : F

Solomon, Abraham 1824–1862
Portrait of Lady with a Letter
oil on canvas 29.2 x 24.8
NWHCM : 1938.132.23 : F

Somerville, Margaret active c.1927–1929
Happy's Days by the Sea c.1927
oil on cardboard 13 x 15.5
NWHCM : 1985.113.31 : F

Somerville, Peggy 1918–1975
Spring Time 1930
oil on cardboard 25.4 x 30.4
NWHCM : 1985.113.32 : F

Somerville, Peggy 1918–1975
Gipsies, Tring 1937
oil on paper 32 x 27.3
NWHCM : 1985.113.47 : F

Somerville, Peggy 1918–1975
Wiggington, Near Tring c.1940
oil on plywood 25.6 x 33
NWHCM : 1985.113.11 : F

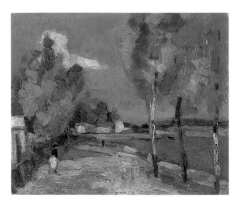

Somerville, Peggy 1918–1975
Beside the Deben 1949
oil on canvas 25.5 x 30.7
NWHCM : 1985.113.7 : F

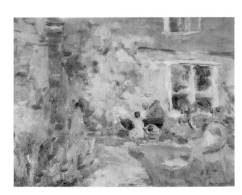

Somerville, Peggy 1918–1975
Newbourne Hall 1951
oil on canvas 45.7 x 61
NWHCM : 1985.113.4 : F

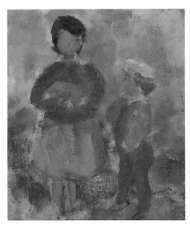

Somerville, Peggy 1918–1975
John and Charlotte 1952–1953
oil on canvas 36.8 x 30.5
NWHCM : 1985.113.1 : F

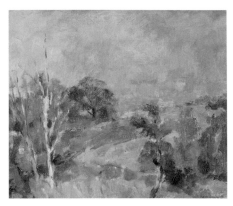

Somerville, Peggy 1918–1975
Winter, Newbourne 1958
oil on canvas 47.8 x 56.6
NWHCM : 1985.113.6 : F

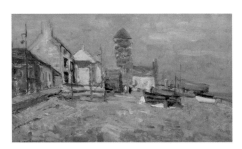

Somerville, Peggy 1918–1975
Summer, Aldeburgh c.1960
oil on plywood panel 46 x 78.5
NWHCM : 1985.113.5 : F

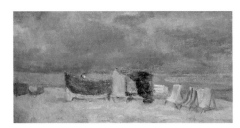

Somerville, Peggy 1918–1975
Aldeburgh, Coast Scene 1962/1964
oil on hardboard 39.3 x 69.6
NWHCM : 1985.113.8 : F

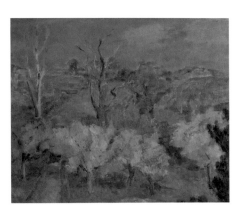

Somerville, Peggy 1918–1975
Spring, The Orchard, Newbourne
oil on canvas 63.5 x 76.3
NWHCM : 1985.113.10 : F

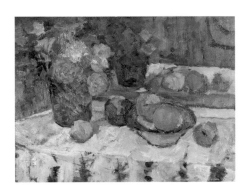

Somerville, Peggy 1918–1975
Still Life with Flowers and Mirror
oil on canvas 45.5 x 60.9
NWHCM : 1985.113.9 : F

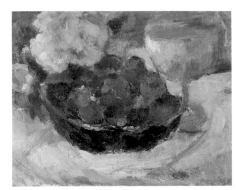

Somerville, Peggy 1918–1975
Strawberries
oil on canvas 28.5 x 35.9
NWHCM : 1985.113.2 : F

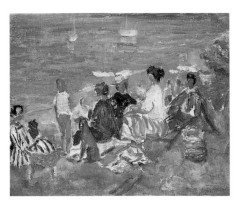

Somerville, Peggy 1918–1975
Summer
oil on canvas 47.6 x 57
NWHCM : 1985.113.3 : F

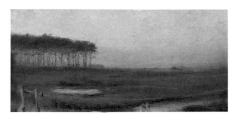

Sothern, Arthur active 1893–1900
Aldborough, Norfolk
oil on board 16.5 x 34.3
NWHCM : 2005.453 : F

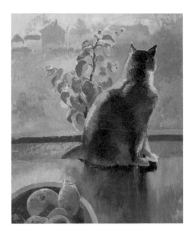

Spencer, Vera 1901–1989
Jock
oil on board 54 x 42.5
NWHCM : 1987.308 : F

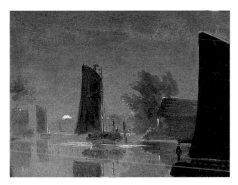

Stannard, Alfred 1806–1889
Moonlight Scene near Carrow 1824
oil on paper laid on canvas 16.1 x 21.7
NWHCM : 1951.235.1236 : F

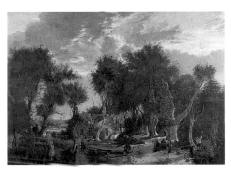

Stannard, Alfred 1806–1889
Scene in Crown Point Wood with Woodcutters
1829
oil on mahogany panel 60 x 81.5
NWHCM : 1926.18 : F

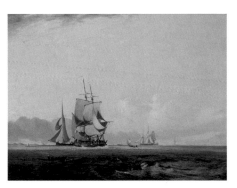

Stannard, Alfred 1806–1889
Vessels in Full Sail 1838
oil on mahogany panel 37.2 x 49.1
NWHCM : 1951.235.1268 : F

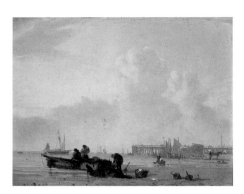

Stannard, Alfred 1806–1889
Yarmouth Jetty 1841
oil on mahogany panel 32.1 x 40.8
NWHCM : 1951.235.1238 : F

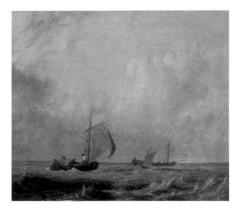

Stannard, Alfred 1806–1889
Seascape c.1841–1845
oil on mahogany panel 30.2 x 35.5
NWHCM : 1940.36.1 : F

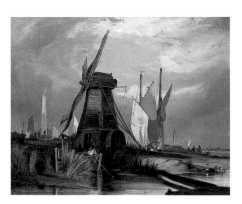

Stannard, Alfred 1806–1889
On the River Yare 1846
oil on canvas 65 x 80
NWHCM : 1951.235.1241 : F

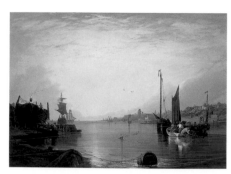

Stannard, Alfred 1806–1889
Gorleston Harbour 1848
oil on canvas 81.2 x 112.4
NWHCM : 1951.235.1239 : F

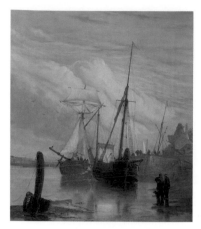

Stannard, Alfred 1806–1889
On the River Deben 1849
oil on canvas 63 x 52.7
NWHCM : 1983.47 : F

Stannard, Alfred 1806–1889
Caister Castle, near Great Yarmouth 1851
oil on canvas 57 x 76.4
NWHCM : 1951.235.1246 : F

Stannard, Alfred 1806–1889
River Scene with Mill 1855
oil on canvas 24.8 x 30.6
NWHCM : 1894.75.28 : F

Stannard, Alfred 1806–1889
Yarmouth Beach 1857
oil on canvas 65.8 x 101.6
NWHCM : 1951.235.1243 : F

Stannard, Alfred 1806–1889
Seascape 1867
oil on canvas 12.4 x 22
NWHCM : 1928.8 : F

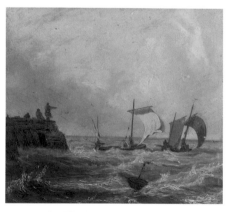

Stannard, Alfred 1806–1889
Seascape 1868
oil on oak panel 16.1 x 17.8
NWHCM : 1940.36.2 : F

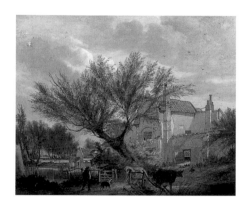

Stannard, Alfred 1806–1889
Trowse Hall near Norwich 1872
oil on canvas 63 x 75.9
NWHCM : 1943.55.2 : F

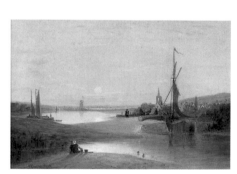

Stannard, Alfred 1806–1889
River Scene with Lock 1873
oil on canvas 23.2 x 34.6
NWHCM : 1951.235.1244 : F

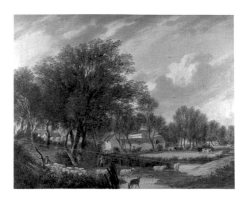

Stannard, Alfred 1806–1889
Trowse Old Hall, near Norwich 1876
oil on canvas 61.7 x 76.8
NWHCM : 1951.235.1245 : F

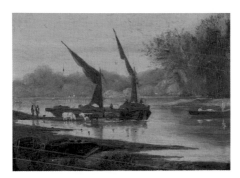

Stannard, Alfred 1806–1889
Barges on the Thames
oil on millboard 13.2 x 17.6
NWHCM : 1951.235.1242 : F

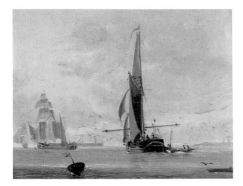

Stannard, Alfred 1806–1889
Sea Piece
oil on oak panel 17.7 x 23.5
NWHCM : 1951.235.1237 : F

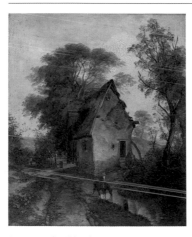

Stannard, Alfred George 1828–1885
A Road Scene 1855/1858
oil on panel 30.5 x 25.1
NWHCM : 1895.13.2 : F

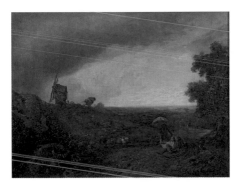

Stannard, Alfred George 1828–1885
A View of Gresham near Cromer 1856
oil on canvas 53.7 x 68.8
NWHCM : 1951.235.1251 : F

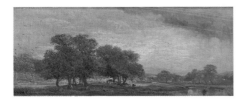

Stannard, Alfred George 1828–1885
Meadows near Norwich
oil on oak panel 13.7 x 35.1
NWHCM : 1951.235.1254 : F

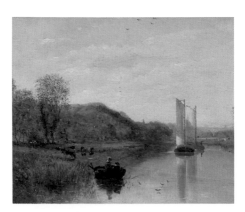

Stannard, Alfred George 1828–1885
On the Yare at Whitlingham
oil on oak panel 19.8 x 26
NWHCM : 1951.235.1253 : F

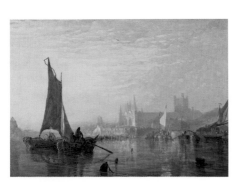

Stannard, Alfred George 1828–1885
River Scene with Peterborough Cathedral in the Distance
oil on canvas 48.3 x 66
NWHCM : 1951.235.1252 : F

Stannard, Anna Maria active 1852–1869
Winter Scene
oil on millboard 14 x 17.2
NWHCM : 1951.235.1250 : F

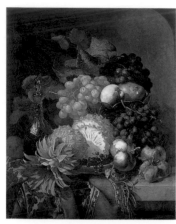

Stannard, Eloise Harriet 1829–1915
*Fruit: Grapes, Peaches, Plums and Pineapple
with a Carafe of Red Wine* 1872
oil on canvas 71.7 x 58.8
NWHCM : 1951.235.1255 : F

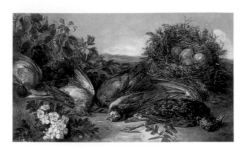

Stannard, Eloise Harriet 1829–1915
Dying Birds, Illustration for a Poem 1874
oil on canvas 23.1 x 38.2
NWHCM : 1962.198 : F

Stannard, Eloise Harriet 1829–1915
Still Life, Black Grapes 1881
oil on canvas 39.4 x 36.2
NWHCM : 1894.75.17 : F

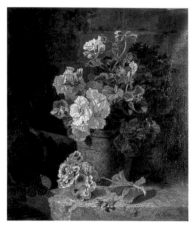

Stannard, Eloise Harriet 1829–1915
Still Life, Pelargoniums 1881
oil on canvas 42 x 36.9
NWHCM : 1894.75.18 : F

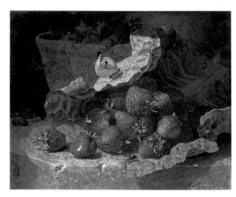

Stannard, Eloise Harriet 1829–1915
*Strawberries in a Cabbage Leaf on a Table with
a Flower Pot Behind* 1881
oil on canvas 23.4 x 28.5
NWHCM : 1951.235.1257 : F

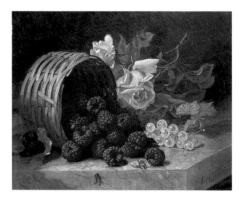

Stannard, Eloise Harriet 1829–1915
*Overturned Basket with Raspberries, White
Currants and Roses* 1882
oil on canvas 23 x 28.1
NWHCM : 1951.235.1257A : F

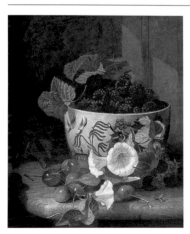

Stannard, Eloise Harriet 1829–1915
*Still Life of Raspberries in a Willow Pattern
Bowl, with Cherries and Bindweed* 1890
oil on canvas 33 x 27.8
NWHCM : 1989.82.1 : F

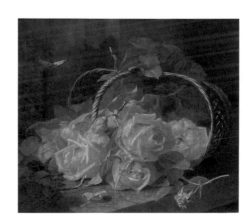

Stannard, Eloise Harriet 1829–1915
*Still Life of Yellow Roses in an Upturned
Basket* 1890
oil on canvas 30.2 x 35.5
NWHCM : 1989.82.2 : F

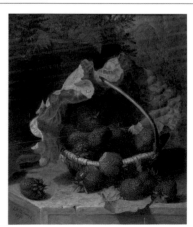

Stannard, Eloise Harriet 1829–1915
*Still Life of Strawberries on a Cabbage Leaf in
a Basket* 1891
oil on canvas 33 x 28
NWHCM : 1989.82.3 : F

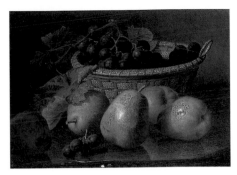

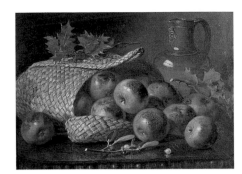

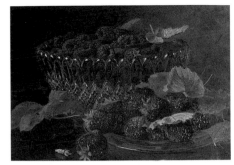

Stannard, Eloise Harriet 1829–1915
Duchess Pears with Black Grapes in a Basket 1895
oil on canvas 29.2 x 39.5
NWHCM : 1933.116.1 : F

Stannard, Eloise Harriet 1829–1915
Ribston Pippins in a Rush Basket with Mistletoe Sprig 1895
oil on canvas 30.6 x 41.1
NWHCM : 1933.116.2 : F

Stannard, Eloise Harriet 1829–1915
Strawberries and Raspberries in a Glass Bowl 1896
oil on canvas 28 x 35.6
NWHCM : 1951.235.1256 : F

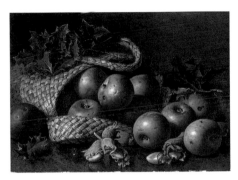

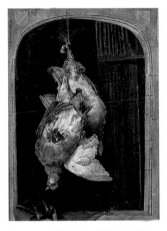

Stannard, Eloise Harriet 1829–1915
Apples in an Overturned Basket
oil on canvas 28 x 38
NWHCM : 1998.67 : F

Stannard, Emily 1803–1885
Dead Game and a Gun 1835
oil on mahogany panel 22.8 x 30.5
NWHCM : 1951.235.1258 : F

Stannard, Emily 1803–1885
Dead Game 1837
oil on mahogany panel 42.4 x 31.1
NWHCM : 1951.235.1259 : F

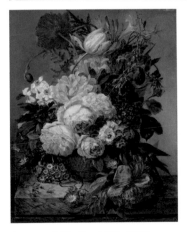

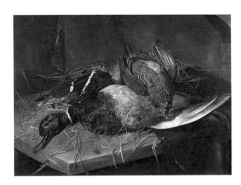

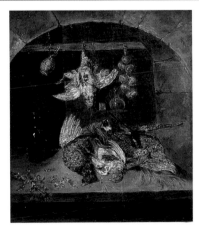

Stannard, Emily 1803–1885
Flowers 1840s
oil on canvas 51 x 40.5
NWHCM : 1894.72.3 : F

Stannard, Emily 1803–1885
Group of Dead Game Birds 1844
oil on panel 44.7 x 60.5
NWHCM : 1894.68 : F

Stannard, Emily 1803–1885
Still Life of Dead Game with a Flagon and a String of Onions 1847
oil on panel 27.3 x 25 (E)
NWHCM : 1951.235.1262 : F

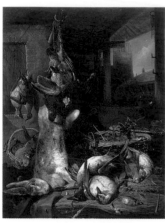

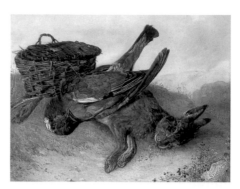

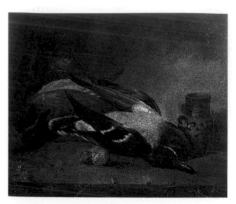

Stannard, Emily 1803–1885
Still Life of Dead Ducks, a Hare with a Basket and a Sprig of Holly 1853
oil on canvas 91.6 x 70.7
NWHCM : 1951.235.1261 : F

Stannard, Emily 1803–1885
Still Life of Hamper with Dead Wood Pigeon and Leveret
oil on oak panel 23.5 x 31.8
NWHCM : 1951.235.1260 : F

Stannard, Emily 1803–1885
Study of Wild Duck
oil on millboard 30.5 x 35.5
NWHCM : 1940.36.5 : F

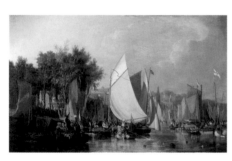

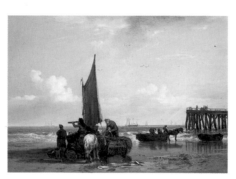

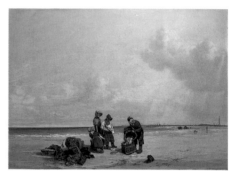

Stannard, Joseph 1797–1830
Thorpe Water Frolic, Afternoon 1824
oil on canvas 109.8 x 175.8
NWHCM : 1894.35 : F

Stannard, Joseph 1797–1830
Yarmouth Beach and Jetty 1828
oil on mahogany panel 52.2 x 74
NWHCM : 1951.235.1267 : F

Stannard, Joseph 1797–1830
Yarmouth Sands 1829
oil on mahogany panel 75.2 x 102.8
NWHCM : 1935.87 : F

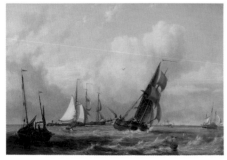

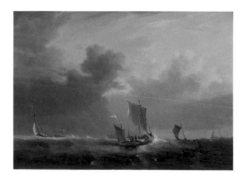

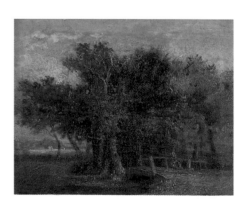

Stannard, Joseph 1797–1830
A Fresh Breeze
oil on mahogany panel 52 x 78.9
NWHCM : 1894.75.19 : F

Stannard, Joseph 1797–1830
Fishing Boats
oil on oak panel 30.8 x 45
NWHCM : 1951.235.1270 : F

Stannard, Joseph 1797–1830
Landscape
oil on oak panel 12.4 x 15.2
NWHCM : 1951.235.1264 : F

Facing page: Tillemans, Peter, 1684–1734, *The Artist's Studio* (detail), c.1716, Norwich Castle Museum and Art Gallery, (p.207)

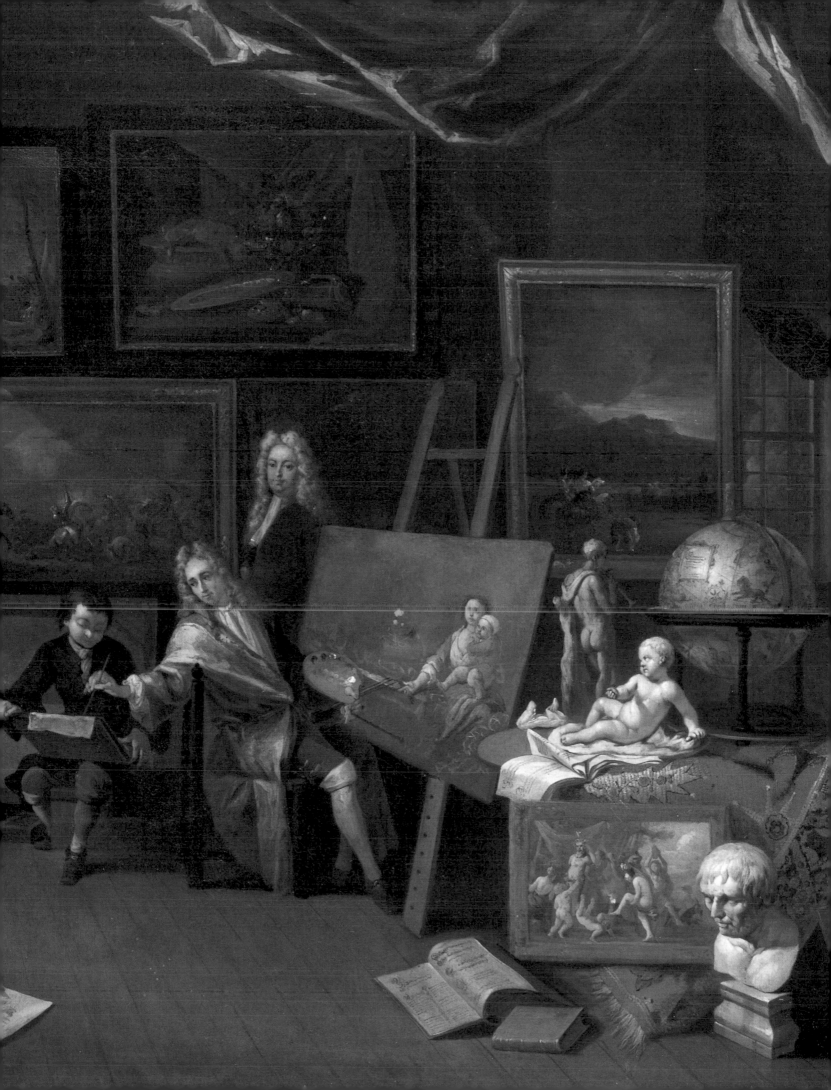

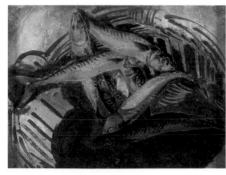

Stannard, Joseph 1797–1830
*Still Life with a Group of Eight Mackerel in a
Broken Basket: A Study on Yarmouth Beach*
oil on panel 10.2 x 14
NWHCM : 1951.235.1269 : F

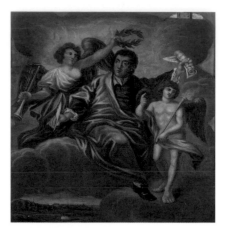

Stannard, Joseph 1797–1830
The Apotheosis of Dr Beckwith
oil on panel 121.9 x 121.9
NWHCM : 1957.81 : F

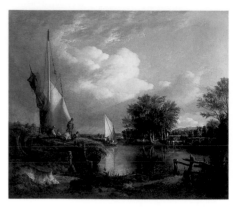

Stannard, Joseph 1797–1830
The River at Thorpe
oil on canvas 97.7 x 111.6
NWHCM : 1951.235.1263 : F

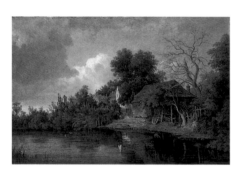

Stannard, Joseph 1797–1830
Thorpe, near Norwich
oil on canvas 45.8 x 66.2
NWHCM : 1951.235.1266 : F

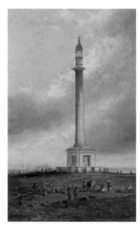

Stannard, Joseph (attributed to) 1797–1830
Nelson's Column at Great Yarmouth
oil on oak panel 29.6 x 19.3
NWHCM : 1963.64 : F

Stark, Arthur James 1831–1902
Dartmoor Ponies
oil on canvas 36.8 x 52.7
NWHCM : 1902.65 : F

Stark, Arthur James 1831–1902
James Stark
oil on panel 20 x 17.5
NWHCM : 1968.335 : F

Stark, Arthur James 1831–1902
Near Bettws-y-Coed, North Wales
oil on canvas 64.1 x 91.8
NWHCM : 1927.151 : F

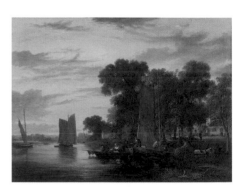

Stark, James 1794–1859
View on the Yare near Thorpe Church
c.1825–1828
oil on mahogany mounted on oak panel
42.5 x 55.9
NWHCM : 1955.173 : F

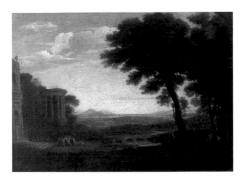

Stark, James 1794–1859
Landscape (after Claude Lorrain) 1826
oil on millboard 28.6 x 38.1
NWHCM : 1951.235.1293 : F

Stark, James 1794–1859
*An Interior of an Old Bakehouse, Bank Street,
Norwich* 1830
oil on oak panel 14.6 x 21.9
NWHCM : 1951.235.1298 : F

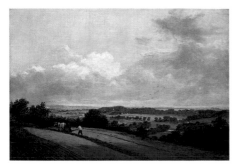

Stark, James 1794–1859
Whitlingham from Old Thorpe Grove c.1830
oil on canvas 43.5 x 61
NWHCM : 1951.235.1299 : F

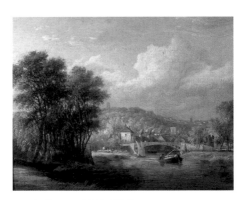

Stark, James 1794–1859
Carrow Bridge, Norwich c.1834
oil on panel 26.3 x 32.5
NWHCM : 1951.235.1294 : F

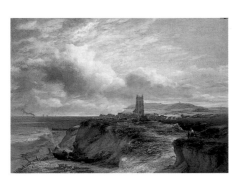

Stark, James 1794–1859
Cromer c.1837
oil on deal panel 60.8 x 85.8
NWHCM : 1975.688 : F

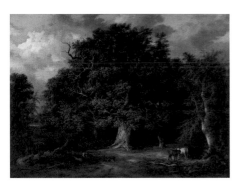

Stark, James 1794–1859
The Forest Oak 1843
oil on canvas 85.1 x 114.9
NWHCM : 1899.4.9 : F

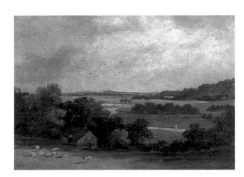

Stark, James 1794–1859
Whitlingham from Old Thorpe Grove 1845
oil on panel 25.6 x 36.9
NWHCM : 1951.235.1307 : F

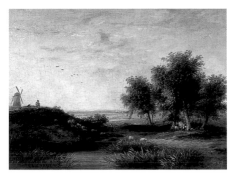

Stark, James 1794–1859
A Dyke Head
oil on mahogany panel 29.8 x 41.8
NWHCM : 1951.235.1302 : F

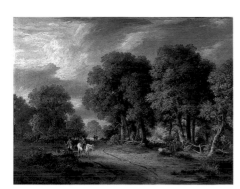

Stark, James 1794–1859
*A View through Trees with a Horseman and
Other Figures, Cattle and Sheep*
oil on mahogany panel 42.5 x 56.2
NWHCM : 1951.235.1304 : F

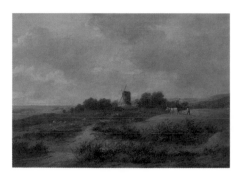

Stark, James 1794–1859
Buckenham Common, Norfolk
oil on mahogany panel 34.9 x 49.5
NWHCM : 1951.235.1303 : F

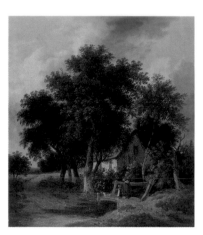

Stark, James 1794–1859
Footbridge over a Stream, with Woman, Child and Dog
oil on oak panel 44.5 x 39.4
NWHCM : 1951.235.1292 : F

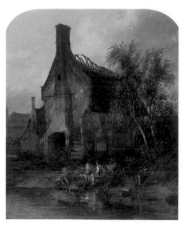

Stark, James 1794–1859
Gable End of Cottage
oil on mahogany panel 38 x 30.4
NWHCM : 1951.235.1296 : F

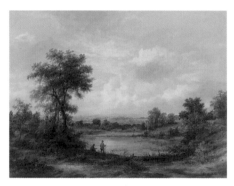

Stark, James 1794–1859
Lake Scene, with Two Men Fishing
oil on canvas 46.4 x 61.6
NWHCM : 1951.235.1309 : F

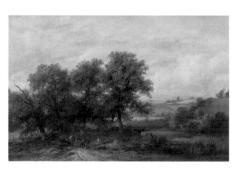

Stark, James 1794–1859
Landscape with Road Winding through Trees with Figures
oil on canvas 40 x 60.9
NWHCM : 1951.235.1305 : F

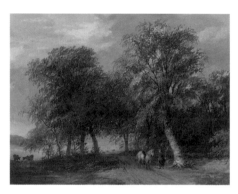

Stark, James 1794–1859
Lane Scene, with Horseman Talking to Woman
oil on canvas 28 x 37.7
NWHCM : 1951.235.1306 : F

Stark, James 1794–1859
Marlborough Forest
oil on canvas 47 x 62.2
NWHCM : 1951.235.1308 : F

Stark, James 1794–1859
Penning the Flock
oil on thick card laid on mahogany panel 23.5 x 29.6
NWHCM : 1933.46.2 : F

Stark, James 1794–1859
River Scene, Cattle in Foreground
oil on canvas 27 x 34
NWHCM : 1951.235.1295 : F

Stark, James 1794–1859
River Scene with Men Fishing from a Boat
oil on panel 22.3 x 20.8
NWHCM : 1977.241 : F

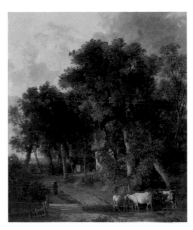

Stark, James 1794–1859
Road Scene at Intwood
oil on mahogany panel 50.8 x 41.3
NWHCM : 1900.13.4 : F

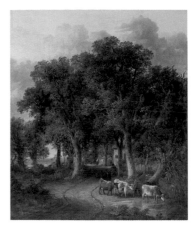

Stark, James 1794–1859
Road Scene at Intwood
oil on mahogany panel 49.9 x 40.6
NWHCM : 1940.118.7 : F

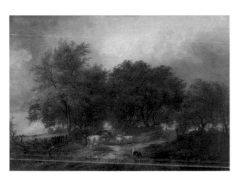

Stark, James 1794–1859
Rustic Scene
oil on canvas 51.1 x 71.8
NWHCM : 1944.20.1 : F

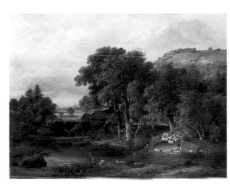

Stark, James 1794–1859
Sheep Washing
oil on mahogany panel 61.7 x 81.4
NWHCM : 1951.235.1301 : F

Stark, James 1794–1859
Sheep Washing
oil on canvas 63.7 x 77
NWHCM : 1957.169 : F

Stark, James 1794–1859
The Bathers
oil on millboard 12.7 x 16.5
NWHCM : 1899.4.11 : F

Stark, James 1794–1859
The Edge of a Wood
oil on mahogany panel 51.3 x 71.4
NWHCM : 1951.235.1297 : F

Stark, James 1794–1859
The Forest Gate
oil on mahogany panel 51.4 x 76.2
NWHCM : 1899.4.10 : F

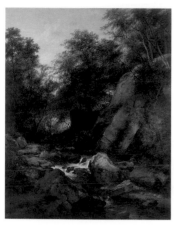

Stark, James 1794–1859
The Strid, Bolton Abbey
oil on canvas 127.3 x 100.7
NWHCM : 1921.89 : F

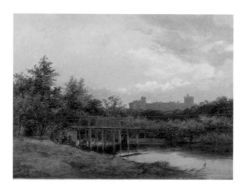

Stark, James 1794–1859
Windsor Castle
oil on canvas 45.8 x 61
NWHCM : 1894.75.21 : F

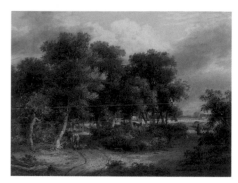

Stark, James 1794–1859
Wood Scene
oil on panel 30.8 x 41
NWHCM : 1939.60 : F

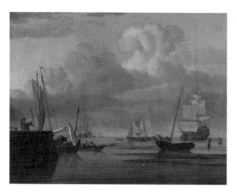

Storck, Abraham (circle of) 1644–1708
Shipping in an Estuary with a Jetty to the Left
oil on canvas 40.9 x 52.7
NWHCM : 1991.1.18 : F

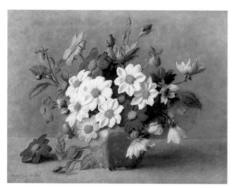

Stubbs, Joseph Woodhouse 1862–1953
Dahlias and Rosebuds
oil on canvas 50 x 64.5
NWHCM : 1985.93.1 : F

Sutherland, Graham Vivian 1903–1980
A Path in the Woods 1958
oil on canvas 25.4 x 20.2
NWHCM : 1958.403 : F

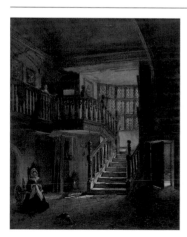

Swarbreck, Samuel Dukinfield c.1799–1863
Interior of Strangers' Hall, Norwich c.1856
oil on board 40.8 x 32.4
NWHCM : 1983.218 : F

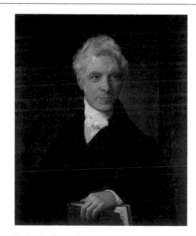

Tait, Robert Scott c.1816–1897
*Edward Taylor (1784–1863), Founder of the
Norwich Festival*
oil on canvas 76.7 x 63.4
NWHCM : 1990.129 : F

Tidman, Brüer b.1939
The Dressing Room 1987
acrylic on canvas 183 x 152.5
NWHCM : 1994.149.1 : F

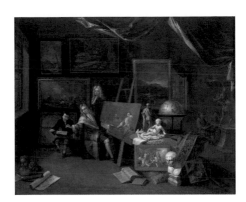

Tillemans, Peter 1684–1734
The Artist's Studio c.1716
oil on canvas 68.3 x 84
NWHCM : 1989.86 : F

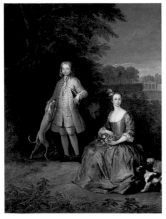

Tillemans, Peter 1684–1734
*Master Edward and Miss Mary Macro, the
Children of the Reverend Dr Cox Macro*
c.1733
oil on canvas 117.2 x 88.1
NWHCM : 1991.1.21 : F

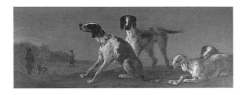

Tillemans, Peter 1684–1734
Four Hounds with Gentlemen Shooting 1734
oil on canvas 45.5 x 111.1
NWHCM : 1991.1.24 : F

Tillemans, Peter 1684–1734
Four Hounds with Huntsmen to the Right
1734
oil on canvas 46.1 x 110
NWHCM : 1991.1.41 : F

Tillemans, Peter 1684–1734
Horse with Groom and Hounds 1734
oil on canvas 134.5 x 167.3
NWHCM : 1991.1.26 : F

Tillemans, Peter 1684–1734
*Three Hounds with Sportsman, a Hunt to the
Left* 1734
oil on canvas 47.7 x 110.5
NWHCM : 1991.1.25 : F

Tillemans, Peter 1684–1734
*A Hunting Piece: Going-a-Hunting with Lord
Biron's Pack of Hounds*
oil on canvas 46.5 x 67.7
NWHCM : 1991.1.22 : F

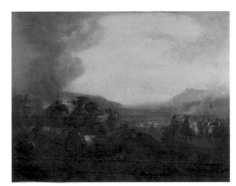

Tillemans, Peter 1684–1734
Battle Scene
oil on canvas 85 x 109.8
NWHCM : 1991.1.20 : F

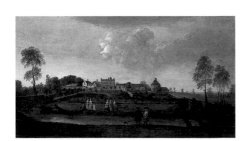

Tillemans, Peter 1684–1734
Little Haugh Hall, Suffolk
oil on canvas 85.8 x 152.2
NWHCM : 1991.1.23 : F

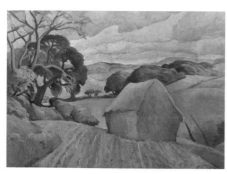

Tuck, Horace Walter 1876–1951
Landscape near Sheringham, Norfolk 1936
oil on canvas 48.2 x 66
NWHCM : 1995.95.6 : F

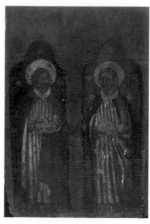

unknown artist 15th C
Two Saints
oil on panel 45.8 x 35.5
NWHCM : 1974.127 : StP

unknown artist
St Catherine (panel 1 of 3 from a chancel screen) 1500–1555
oil on wood 124.6 x 29.3
NWHCM : L1968.12 : StP

unknown artist
St Appolonia (panel 2 of 3 from a chancel screen) 1500–1555
oil on wood 119.7 x 28.5
NWHCM : L1968.12 : StP

unknown artist
St Mary Magdalene (panel 3 of 3 from a chancel screen) 1500–1555
oil on wood 113.7 x 27.2
NWHCM : L1968.12 : StP

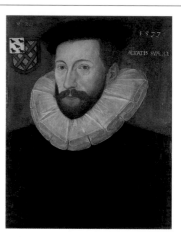

unknown artist
Mr Bill, Dean of Westminster 1577
oil on oak panel 47.7 x 37.5
NWHCM : 1831.94 : F

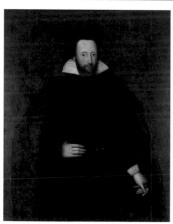

unknown artist
Robert Buxton c.1580
oil on canvas 120.7 x 97.8
NWHCM : 1963.268.2 : F

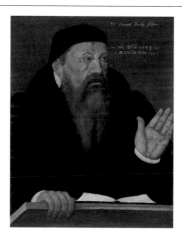

unknown artist
Henry Birde, Aged 60 1583
oil on panel 68.5 x 53.3
NWHCM : 1935.130 : F

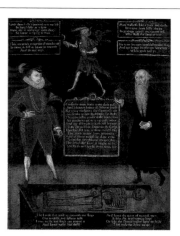

unknown artist
Memento Mori c.1590–1610
oil on panel 56.6 x 43.2
NWHCM : 1953.134.2 : F

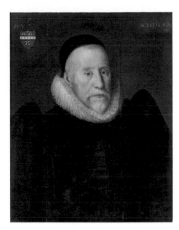

unknown artist
Anthony Meres of Lincoln (1539–1616) 1615
oil on panel 70 x 53.7
NWHCM : 1946.88.1 : F

unknown artist
The Ages of Man c.1620–1630
oil on canvas 125 x 249
NWHCM : 1927.96 : F

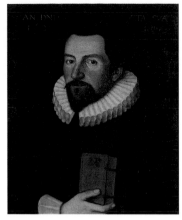

unknown artist
Portrait of an Unknown Man 1625
oil on canvas 62.2 x 48.2
NWHCM : 1963.268.1 : F

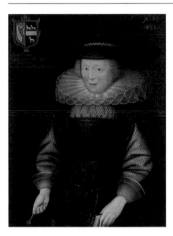

unknown artist
Mrs Thomas Conyers 1632
oil on canvas 88.5 x 65.8
NWHCM : 1963.268.12 : F

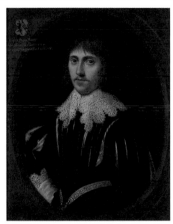

unknown artist
John Buxton (1608–1660) c.1635
oil on canvas 82.2 x 64.5
NWHCM : 1963.268.5 : F

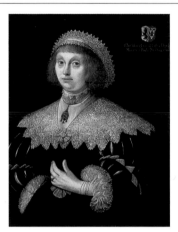

unknown artist
*Margaret Conyers (Mrs John Buxton of
Tibenham) (1611–1687)* c.1640
oil on canvas 85.4 x 65.3
NWHCM : 1963.268.6 : F

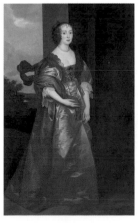

unknown artist
*Anne Murray, Viscountess Bayning
(1619–c.1678)* c.1642
oil on canvas 202.8 x 127.5
NWHCM : 1938.98 : F

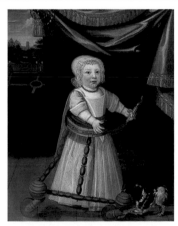

unknown artist
Boy with Coral c.1650–1660
oil on canvas 108.5 x 84
NWHCM : 1949.138.1 : F

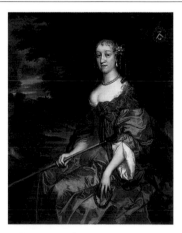

unknown artist
Jane Palmer (1632–1701) c.1650–1665
oil on canvas 127.5 x 103
NWHCM : 1946.88.7 : F

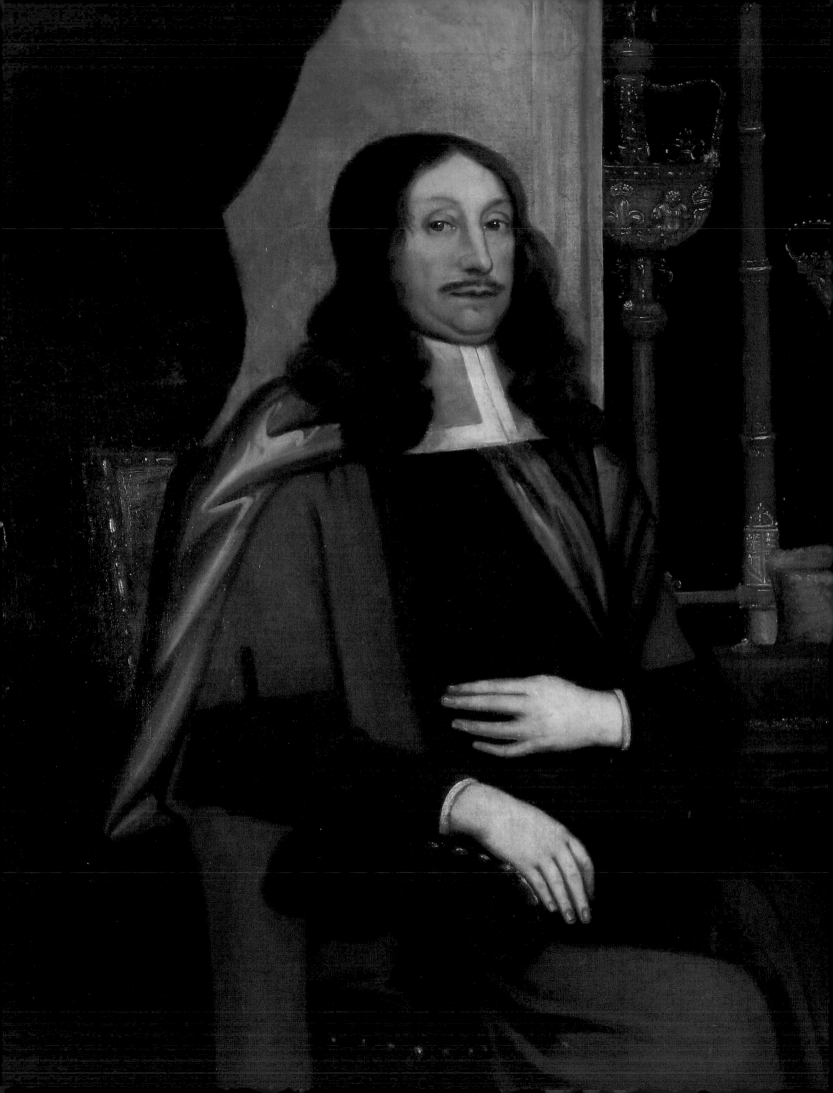

unknown artist
Jehosophat Davy, Sheriff of Norwich (1667), Mayor (1678) c.1670
oil on canvas 114.1 x 96
NWHCM : 1959.117 : F

unknown artist
William Skutt 1680
oil on canvas 91.8 x 71.1
NWHCM : 1944.7 : F

unknown artist
Sir Neville Catelyn 1688
oil on canvas 76.4 x 63.8
NWHCM : 1963.268.18 : F

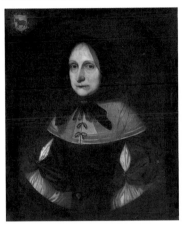

unknown artist 17th C
The Wife of Bishop Sparrow (1621–1697)
oil on canvas 73.8 x 61
NWHCM : 1831.63.2 : F

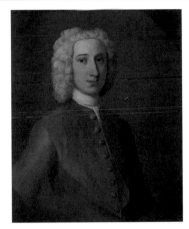

unknown artist
Robert Buxton (d.1735) c.1735
oil on canvas 73.6 x 60.3
NWHCM : 1963.268.19 : F

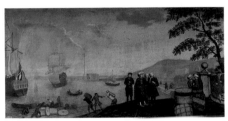

unknown artist
Harbour and Men Loading Cargo 1750–1799
oil on wood 61 x 120.5
NWHCM : 2004.746 : S

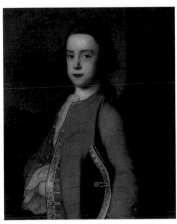

unknown artist
Thomas John Batcheler of Horstead Hall (1737–1789), Norfolk, Aged 16 1753
oil on canvas 72.5 x 59.5
NWHCM : 1946.88.10 : F

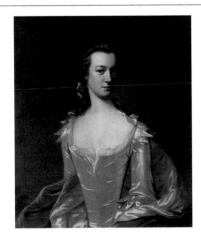

unknown artist
Mrs Margaret Tryon c.1757
oil on 63.5 x 76.2
NWHCM : 1950.40.1 : F

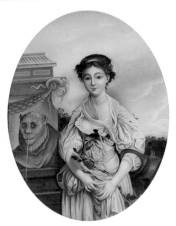

unknown artist
Portrait of a Lady with a Broken Pitcher 1770–1799
oil on board & glass 35 x 26
NWHCM : 1974.102.79 : S

Facing page: unknown artist, *Unknown Mayor of Norwich* (detail), c.1680, Norwich Civic Portrait Collection, (p.246)

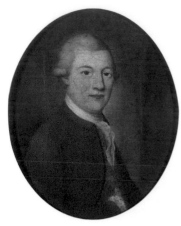

unknown artist
*Robert Harvey (1730?–1816), Mayor of
Norwich, 1770 & 1800* c.1770
oil on canvas 35 x 29.6
NWHCM : 1982.365 : F

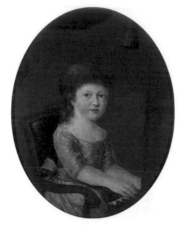

unknown artist
Master William Crotch (1775–1847) 1778
oil on canvas 68 x 51.9
NWHCM : L1976.9.5 : F

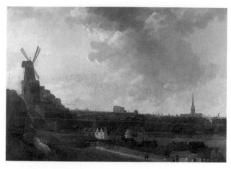

unknown artist
A Panoramic View of Norwich c.1780
oil on canvas 69.2 x 92
NWHCM : 1975.54 : F

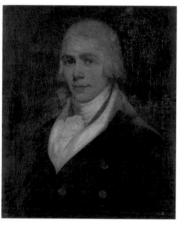

unknown artist
Captain Horatio Nelson, RN, 1781 1781
oil on canvas 59.7 x 49.5
NWHCM : 1865.35 : F

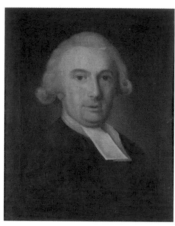

unknown artist
Robert Forby (1759–1825) c.1800
oil on canvas 53.2 x 42.9
NWHCM : 1858.70.2 : F

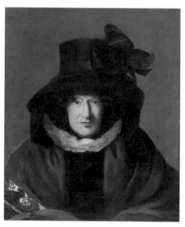

unknown artist
*Portrait of a Woman (formerly believed to be
Elizabeth Fry)* c.1818
oil on canvas 61 x 51.3
NWHCM : 1944.58 : F

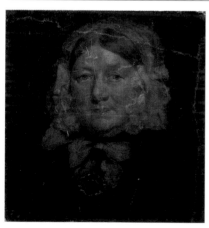

unknown artist
Sarah Coaks, Wife of Richard Coaks 1853
oil on canvas stuck to card 36.7 x 35.7
NWHCM : 1953.128 : F

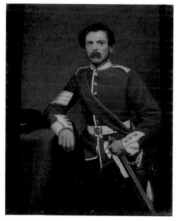

unknown artist
Paymaster Frederick Jackson (1830–1912)
1853–1867
oil on panel 12.7 x 10.2
NWHCM : 1937.2 : S

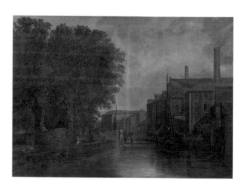

unknown artist
*View of Carrow Works and the River Wensum,
Norwich* c.1870
oil on canvas 86.5 x 112
NWHCM : 1942.19 : F

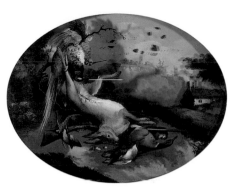

unknown artist
Hare and Game Birds with Gun c.1900
oil on metal & glass 18 x 22
NWHCM : 1982.197.1 : S

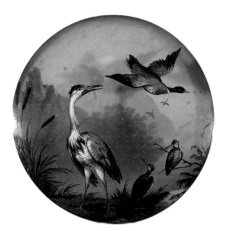

unknown artist
Heron with Mallard and Birds c.1900
oil on board & glass 15.5
NWHCM : 1982.197.2 : F

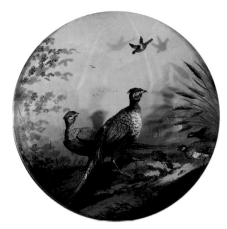

unknown artist
Pheasants c.1900
oil on board & glass 15.5 (E)
NWHCM : 1982.197.3 : S

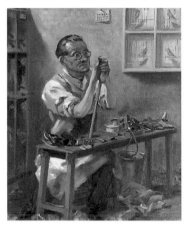

unknown artist
Turnshoe Maker 1950–1959
oil on canvas 61.1 x 51.3
NWHCM : 1985.235 : F

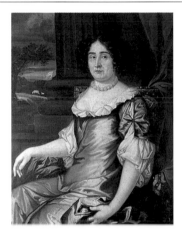

unknown artist
A Lady in a Satin Dress
oil on canvas 110.5 x 85.1
NWHCM : 1949.138.2 : F

unknown artist
Angel Playing a Guitar (painted panel of a rood screen)
oil on panel 81 x 28.5
NWHCM : 2005.674.1 : F

unknown artist
Angel Playing a Harp (painted panel of a rood screen)
oil on panel 82 x 28.5
NWHCM : 2005.674.2 : F

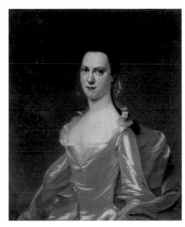

unknown artist
Anne Batcheler (1734–1808)
oil on canvas 74 x 61
NWHCM : 1946.88.9 : F

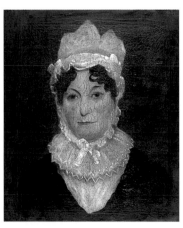

unknown artist
Arabella Baker (1793–1881)
oil on canvas 59.5 x 49.2 (E)
NWHCM : 2001.22.3 : F

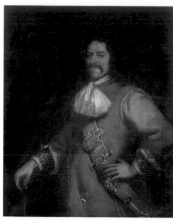

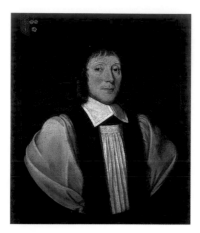

unknown artist
Augustine Briggs (1617–1684), Mayor of Norwich (1670)
oil on canvas 113 x 92.7
NWHCM : 1953.33 : F

unknown artist
Bishop Anthony Sparrow (1620–1685)
oil on canvas 73.6 x 61.5
NWHCM : 1831.63.1 : F

unknown artist
Boy with Sheep, Master Thomas John Batcheler (1737–1789)
oil on canvas 127.2 x 101.2
NWHCM : 1946.88.4 : F

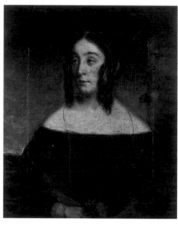

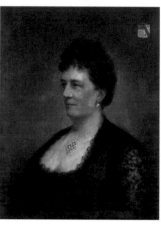

unknown artist
Carisbrooke Castle
oil on metal 11.8 x 15.7
NWHCM : 1975.474.47 : F

unknown artist
Caroline Bilham
oil on canvas 30.5 x 25.5
NWHCM : 1963.487 : F

unknown artist
Catherine Jane Magnay
oil on canvas 75 x 58.4
NWHCM : 1946.88.13 : F

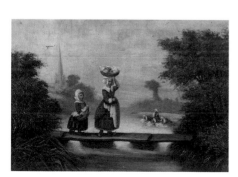

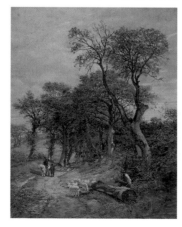

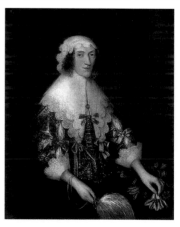

unknown artist
Children in Dutch Costume Crossing a Stream
oil on canvas 28.2 x 40.5
NWHCM : 2005.454 : F

unknown artist
Country Lane
oil on canvas 43.4 x 33.2
NWHCM : 1952.59.2a : F

unknown artist
Dame Elizabeth Pettus (d.1653)
oil on canvas 101.4 x 81.7
NWHCM : 1946.88.2 : F

unknown artist
Devil's Tower, Norwich
oil on card 17.9 x 14.2
NWHCM : 1979.371 : F

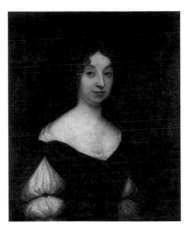

unknown artist
Elizabeth Gooch (Mrs Robert Buxton)
(1664–1730)
oil on canvas 75 x 62.2
NWHCM : 1963.268.17 : F

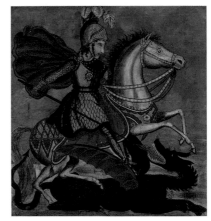

unknown artist
George and Dragon (inn sign from Norwich)
oil on board 50.2 x 47.6
NWHCM : TNO 224 : B

unknown artist
House on the Marsh
oil on canvas 59.7 x 44.5
NWHCM : 1940.119 : F

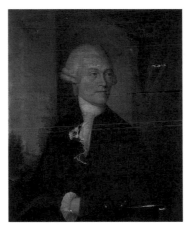

unknown artist
I, Smith
oil on canvas 76.2 x 63.6
NWHCM : 2005.584.3 : F

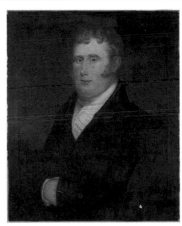

unknown artist
James Watson, Sheriff of Norwich (1847–1848)
oil on canvas 76 x 63.5
NWHCM : 1947.174 : F

unknown artist
John Bull Laden with Taxes
oil on canvas 59.3 x 97.3
NWHCM : 1958.64 : F

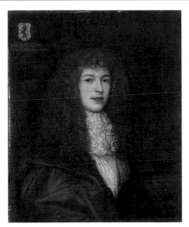

unknown artist
John Buxton (1657–1682)
oil on canvas 76.2 x 60.9
NWHCM : 1949.107.6 : F

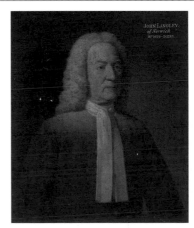

unknown artist
John Langley of Norwich (1679–1755)
oil on canvas 74.5 x 63.5
NWHCM : 1926.10 : F

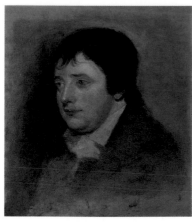

unknown artist
John Ninham (1754–1817)
oil on panel 40.5 x 37
NWHCM : 1947.149.2 : F

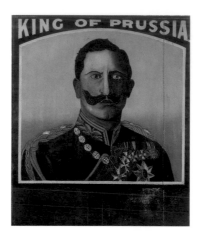

unknown artist
King of Prussia (inn sign from Ipswich Road, Norwich)
oil on board 99.2 x 83.9
NWHCM : TNO 221 : B

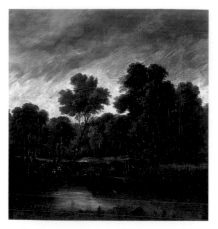

unknown artist
Landscape
oil on canvas 35 x 34.9
NWHCM : 1934.52 : F

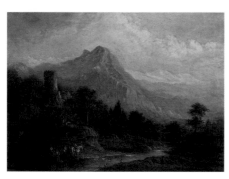

unknown artist
Landscape
oil on canvas 45.5 x 60.7
NWHCM : 1946.88.14 : F

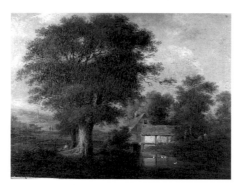

unknown artist
Landscape
oil on panel 22.2 x 29.8
NWHCM : 1949.129.11 : F

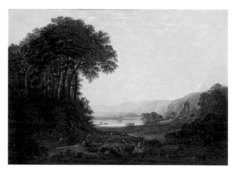

unknown artist
Landscape with Lake, Mountains and Ruined Castle
oil on canvas 96.5 x 137.1
NWHCM : 1954.18 : F

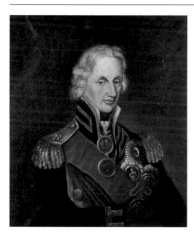

unknown artist
Lord Nelson (1758–1805)
oil on canvas 61 x 53.5
NWHCM : 1846.9 : F

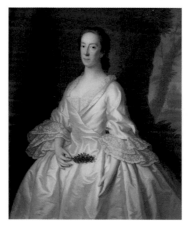

unknown artist
Mary Pettus (1701–1764)
oil on canvas 130.2 x 104.4
NWHCM : 1946.88.6 : F

unknown artist
Meriden Heath near Coventry
oil on canvas 43.8 x 59.7
NWHCM : 1949.1 : F

unknown artist
Mrs Butcher
oil on canvas 76.5 x 64.5
NWHCM : 1956.224.2 : F

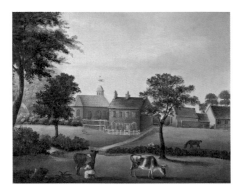

unknown artist
Naïve Painting of a Farmhouse with
Outbuildings and Farm Animals in Foreground
oil on canvas 50.3 x 62.5
NWHCM : 1985.152.51 : F

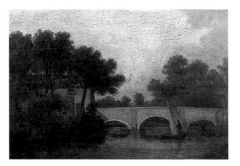

unknown artist
Old Trowse Bridge, Norwich
oil on oak panel 25.8 x 39.2
NWHCM : 1951.235.714 : F

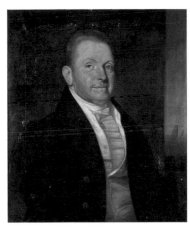

unknown artist
Possibly Francis Bell Rix
oil on canvas 77.2 x 64.5
NWHCM : 1977.32.2 : F

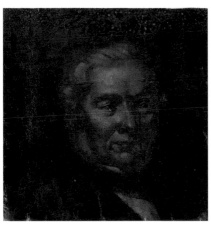

unknown artist
Richard Coaks, Sheriff of Norwich
(1840–1841), Mayor of Norwich (1852–1853)
oil on canvas 37.3 x 35.5
NWHCM : 1953.127 : F

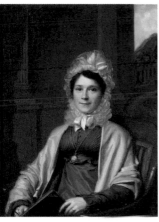

unknown artist
Richenda Cunningham, née Gurney
(1782–1855)
oil on canvas 35.5 x 28.5
NWHCM : 1982.366.1 : F

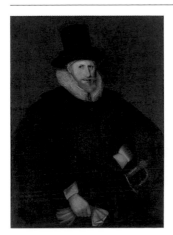

unknown artist
Robert Buxton (1558–1610)
oil on canvas 112 x 80.8
NWHCM : 1963.268.3 : F

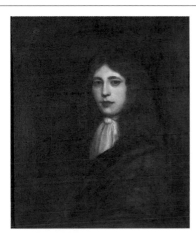

unknown artist
Robert Buxton (1659–1691)
oil on canvas 73.6 x 62.2
NWHCM : 1963.268.16 : F

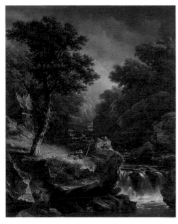

unknown artist
Rocks and Waterfall
oil on canvas 127.6 x 102.2
NWHCM : 1951.235.725 : F

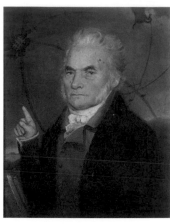

unknown artist
*Samson Arnold Mackey, the Self-Taught
Astronomer of Norwich (1765–1843)*
oil on canvas 31.7 x 26.2
NWHCM : 1868.14.2 : F

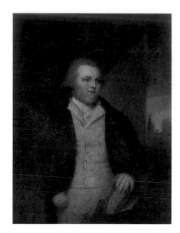

unknown artist
Samuel Fitch
oil on canvas 51 x 39.3
NWHCM : 1904.40.2 : F

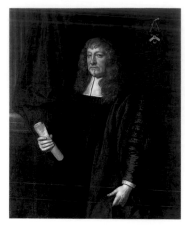

unknown artist
Sir Geoffrey Palmer (1598–1670)
oil on canvas 127.4 x 103
NWHCM : 1946.88.8 : F

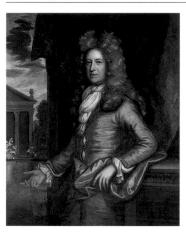

unknown artist
*Sir Horatio Pettus, 4th Bt of Rackheath
(d.1731)*
oil on canvas 125.5 x 102.5
NWHCM : 1946.88.5 : F

unknown artist
Sir Thomas Browne (1605–1682)
oil on oak panel 31.7 x 24.3
NWHCM : 1995.55 : F

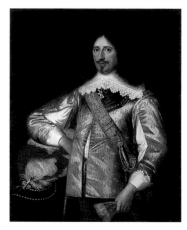

unknown artist
Sir Thomas Pettus (d.1654)
oil on canvas 101.5 x 82
NWHCM : 1946.88.3 : F

unknown artist
The Bittern
oil on canvas 67.2 x 78.8
NWHCM : 1949.132 : F

unknown artist
The Reverend Francis Cunningham
oil on canvas 35.5 x 28.5
NWHCM : 1982.366.2 : F

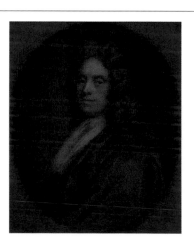

unknown artist
*The Reverend John Horne, Chaplain to Mary
of Orange*
oil on canvas 75 x 62.2
NWHCM : 1949.107.5 : F

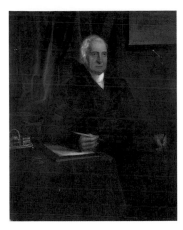

unknown artist
The Reverend William Kirby (1759–1850)
oil on canvas 140.3 x 127.5 (E)
NWHCM : 1878.15 : F

unknown artist
The Star Inn, Haymarket, Norwich
oil on canvas 46.5 x 61.3
NWHCM : 1960.155 : F

unknown artist
The Woodcutters
oil on canvas 35.5 x 30.4
NWHCM : 1952.59.1a : F

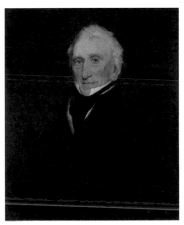

unknown artist
Thomas Horatio Batcheler (1763–1844)
oil on canvas 77.2 x 63.5
NWHCM : 1946.88.11 : F

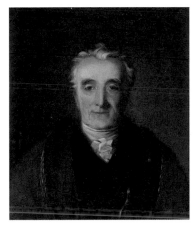

unknown artist
Thomas Osborn Springfield (1782–1858)
oil on canvas 36 x 30.8
NWHCM : 1923.131 : F

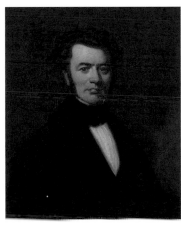

unknown artist
W. Butcher, Sheriff of Norwich, 1870
oil on canvas 76.5 x 63.5
NWHCM : 1956.224.1 : F

unknown artist
William Baker (d.1808)
oil on copper plate 25.5 x 20.7
NWHCM : 2001.22.2 : F

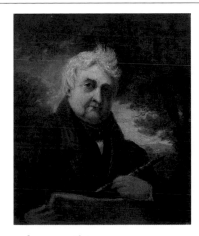

unknown artist
William Crotch (1775–1847)
oil on board 35.6 x 30.5
NWHCM : L1976.9.6 : F

unknown artist
William Crotch (1775–1847)
oil on canvas 91.5 x 71
NWHCM : 1940.47 : F

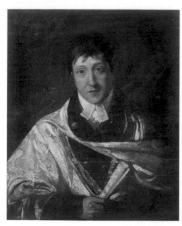

unknown artist
William Crotch (1775–1847)
oil on canvas 76 x 64
NWHCM : 2005.584.2 : F

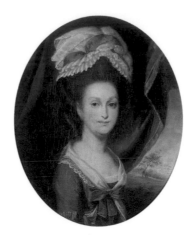

Vandergucht, Benjamin 1753–1794
Sophy Coates 1774
oil on oval canvas 41.3 x 33
NWHCM : 1940.29 : F

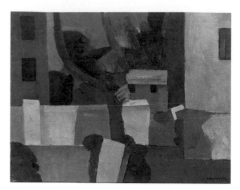

Vaughan, John Keith 1912–1977
Untitled 1955
oil on canvas 35.8 x 45.7
NWHCM : 2002.25.1 : F

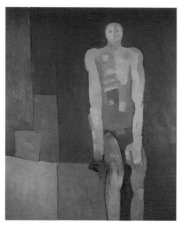

Vaughan, John Keith 1912–1977
Figure in a Red Room
oil on softboard 121.1 x 99.8
NWHCM : 1960.29 : F

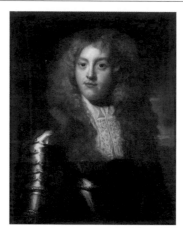

Vautier, D.
Sir Henry Bedingfeld of Oxburgh 1663
oil on canvas 75.5 x 60.2
NWHCM : 1949.107.9 : F

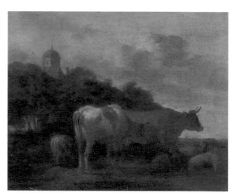

Velde, Adriaen van de (attributed to)
1636–1672
Cattle in a Field, a Village beyond a Wood
oil on oak panel 23.2 x 28.9
NWHCM : 1991.1.5 : F

Velde, Adriaen van de (attributed to)
1636–1672
Landscape with Cattle
oil on oak panel 22.6 x 28.7
NWHCM : 1991.1.31 : F

Ventnor, Arthur Dale 1829–1884
Mr C. B. Dennes
oil on canvas 61 x 51
NWHCM : 1977.142.1 : F

Ventnor, Arthur Dale 1829–1884
Mrs C. B. Dennes
oil on canvas 61 x 50.8
NWHCM : 1977.142.2 : F

Facing page: Latter, Jim, b.1945, *Triptych* (detail), 1980, Sainsbury Centre for Visual Arts, University of East Anglia, (p.259)

Ventnor, Arthur George active 1890–1926
A Quaint Corner c.1896
oil on canvas 34.5 x 44.3
NWHCM : 1896.48 : F

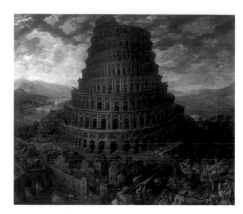

Verhaecht, Tobias c.1560–1631
The Tower of Babel
oil on canvas 198.2 x 232.2
NWHCM : 1949.28 : F

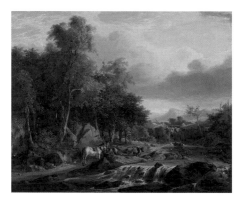

Vickers, Alfred 1786–1868
A Farmstead with Cattle 1857
oil on panel 23 x 31.4
NWHCM : 1943.88.3 : F

Vickers, Alfred 1786–1868
The Watering Place
oil on panel 24 x 30.6
NWHCM : 1943.88.2 : F

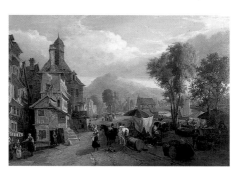

Vincent, George 1796–1831
Rouen c.1817
oil on canvas 63.4 x 91.7
NWHCM : 1952.1 : F

Vincent, George 1796–1831
View in Glen Sharrah near Inverary 1823
oil on canvas 63.5 x 76.8
NWHCM : 1919.39 : F

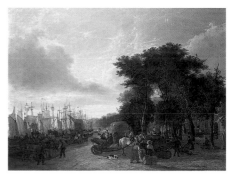

Vincent, George 1796–1831
Yarmouth Quay 1823
oil on canvas 77.2 x 103
NWHCM : 1951.235.1359 : F

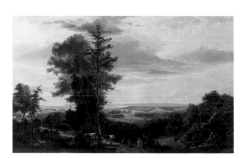

Vincent, George 1796–1831
*A Distant View of Pevensey Bay, the Landing
Place of King William the Conqueror* 1824
oil on canvas 146 x 233.7
NWHCM : 1945.17 : F

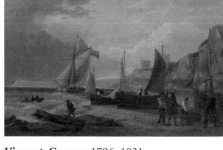

Vincent, George 1796–1831
Pevensey Bay 1824
oil on paper laid on millboard 20.6 x 27.5
NWHCM : 1951.235.1357 : F

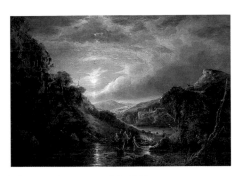

Vincent, George 1796–1831
Entrance to Loch Katrine, Moonlight,
Highlanders Spearing Salmon 1825
oil on canvas 76.2 x 101.6
NWHCM : 1951.235.1362 : F

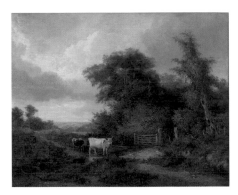

Vincent, George 1796–1831
Rustic Scene 1826
oil on panel 53 x 63.8
NWHCM : 1944.20.2 : F

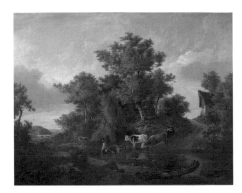

Vincent, George 1796–1831
The Travelling Pedlar c.1826
oil on canvas 88.4 x 112
NWHCM : 1940.118.5 : F

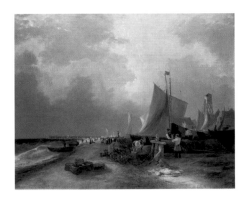

Vincent, George 1796–1831
The Fish Auction, Yarmouth 1827
oil on canvas 102.5 x 128.3
NWHCM : 1927.120 : F

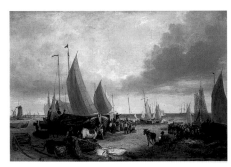

Vincent, George 1796–1831
The Fish Auction, Yarmouth Beach 1828
oil on canvas 64 x 92.4
NWHCM : 1940.118.4 : F

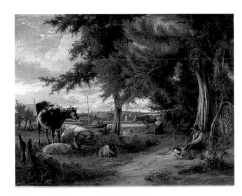

Vincent, George 1796–1831
Pastoral Scene 1828
oil on mahogany panel 66.1 x 84.5
NWHCM : 1951.235.1361 : F

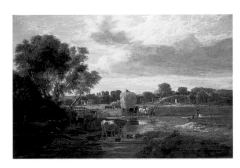

Vincent, George 1796–1831
Trowse Meadows, near Norwich 1828
oil on canvas 72.9 x 109.4
NWHCM : 1899.4.13 : F

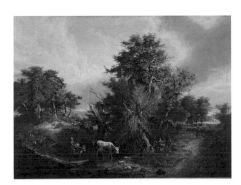

Vincent, George 1796–1831
Valley of the Yare, near Bramerton 1828
oil on canvas 76.2 x 104.5
NWHCM : 1940.118.6 : F

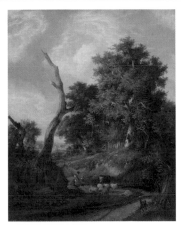

Vincent, George 1796–1831
The Blasted Oak 1830
oil on canvas 76.1 x 63.1
NWHCM : 1968.649 : F

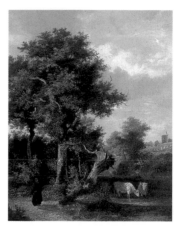

Vincent, George 1796–1831
A Shady Pool
oil on oak panel 30.4 x 25.4
NWHCM : 1933.46 : F

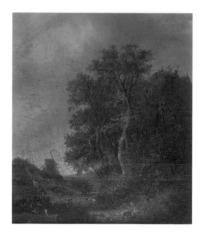

Vincent, George 1796–1831
Lane Scene
oil on oak panel 24.8 x 20.3
NWHCM : 1951.235.1355 : F

Vincent, George 1796–1831
On the River Yare
oil on canvas 87 x 112.7
NWHCM : 1951.235.1354 : F

Vincent, George 1796–1831
Postwick Grove
oil on panel 38.4 x 32.4
NWHCM : 1951.235.1356 : F

Vincent, George 1796–1831
Road Scene with Cattle
oil on oak panel 42.2 x 34.9
NWHCM : 1951.235.1353 : F

Vincent, George 1796–1831
Road Scene with Cottage
oil on panel 29.8 x 38.1
NWHCM : 1894.75.89 : F

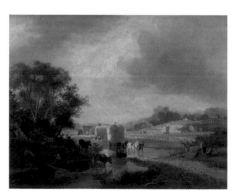

Vincent, George 1796–1831
Trowse Hythe, near Norwich
oil on canvas 31.8 x 41.3
NWHCM : 1939.27 : F

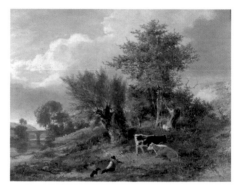

Vincent, George 1796–1831
View near Norwich
oil on mahogany panel 26.7 x 34.6
NWHCM : 1951.235.1358 : F

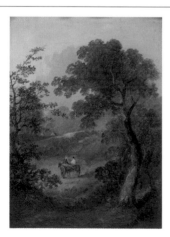

Vincent, George (attributed to) 1796–1831
Landscape with Cart
oil on panel 25.4 x 18.1
NWHCM : 1968.650 : F

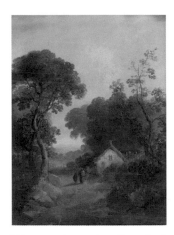

Vincent, George (attributed to) 1796–1831
Landscape with Figures and Cottage
oil on panel 25.4 x 18.1
NWHCM : 1968.651 : F

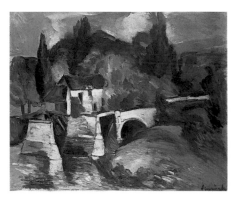

Vlaminck, Maurice de 1876–1958
Les Andelys c.1911
oil on canvas 59.8 x 72.7
NWHCM : 1996.155 : F

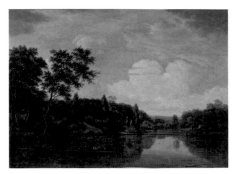

Vroom, Hendrick Cornelisz. (attributed to)
1566–1640
Ferry Boat on a River, Trees on a Hill to the Left
oil on canvas 65 x 84.4
NWHCM : 1991.1.16 : F

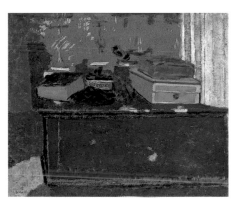

Vuillard, Jean Edouard 1868–1940
L'encrier bleu sur la cheminée c.1900
oil on brown paper laid on panel 33.6 x 40.6
NWHCM : 1997.712 : F

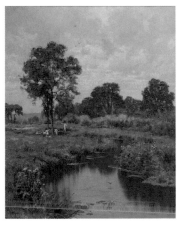

Waite, Edward Wilkins 1854–1924
An August Afternoon, Woolhampton
c.1898–1899
oil on canvas 53.5 x 43.5
NWHCM : 1938.132.22 : F

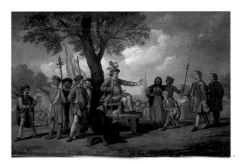

Wale, Samuel 1721–1786
Robert Kett Receives the Earl of Warwick's Herald, 1549 c.1746
oil on canvas 52.6 x 77.5
NWHCM : 1976.254 : F

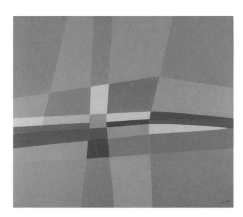

Wales, Marjorie active 1979–1982
Gulf of Corinth (from sketches made in 1979)
1982
oil on canvas 68.8 x 81.2
NWHCM : 1990.179.4 : F

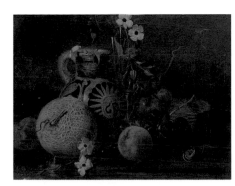

Walker, James William 1831–1898
Still Life of Fruit c.1861
oil on canvas 28 x 38.2
NWHCM : 1896.25.436 : F

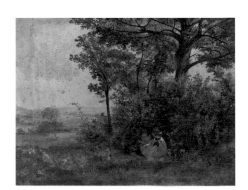

Walker, James William 1831–1898
Under the Trees 1864
oil on millboard 15.2 x 20.2
NWHCM : 1896.25.433 : F

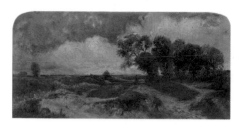

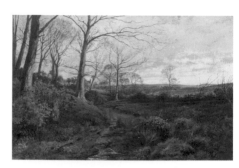

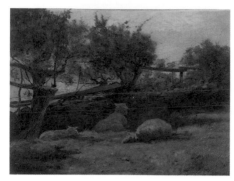

Walker, James William 1831–1898
A Sandy Lane 1870
oil on canvas 19.4 x 38.5
NWHCM : 1896.25.432 : F

Walker, James William 1831–1898
December, near Rivington, Lancashire
oil on canvas 47.2 x 70.2
NWHCM : 1896.25.434 : F

Walker, James William 1831–1898
Père, mère et fils
oil on canvas 24.4 x 32
NWHCM : 1896.25.435 : F

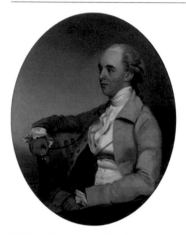

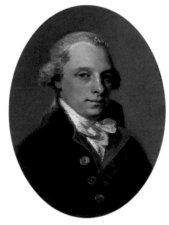

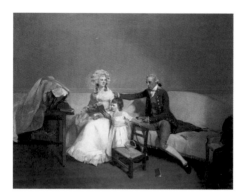

Walton, Henry 1746–1813
*John Custance (1749–1822), of Weston House,
Norfolk* c.1782
oil on canvas 53.5 x 40.5
NWHCM : 2005.12 : F

Walton, Henry 1746–1813
Sir Robert Buxton, 1st Bt (1753–1839)
c.1785–1790
oil on copper 23.5 x 18
NWHCM : 1949.107.10 : F

Walton, Henry 1746–1813
*Sir Robert and Lady Buxton and Their
Daughter Anne* c.1786
oil on canvas 73.6 x 92.5
NWHCM : 1963.268.9 : F

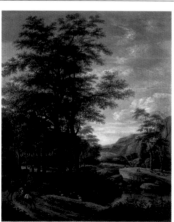

Walton, Henry 1746–1813
Edmund Gillingwater (1735–1813)
oil on wood panel 22.8 x 18.5
NWHCM : 1858.70.1 : F

Warhol, Andy 1928–1987
Pom 1976
acrylic on screened canvas 81.2 x 65.9
NWHCM : L1993.3.11 : F

Waterloo, Anthonie c.1610–1690
*Landscape with Horsemen on a Path Entering
a Wood, Figures Waiting for a Ferry, Cattle and
Sheep Beyond*
oil on canvas 73.1 x 54.6
NWHCM : 1991.1.33 : F

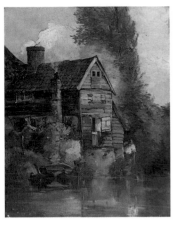

Watson, Charles John 1846–1927
Old Cottage, Trowse Hythe, Norwich 1870
oil on panel 41.7 x 32.4
NWHCM : 1894.75.26 : F

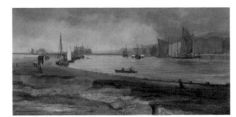

Watson, Charles John 1846–1927
Dirty Weather near the Mouth of the Yare
1873
oil on canvas 63.5 x 128.3
NWHCM : 1874.75.27 : F

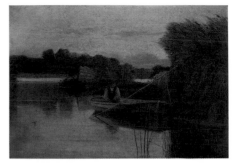

Watson, Charles John 1846–1927
Shades of Evening, Barton Broad, Norfolk
c.1876
oil on canvas 47 x 65.4
NWHCM : 1894.75.25 : F

Watson, Charles John 1846–1927
Minna Bolingbroke, Wife of the Artist
oil on canvas board 33 x 20.3
NWHCM : 1972.387.2 : F

Watts, George Frederick 1817–1904
Study for 'The Court of Death' c.1868–1870
oil on canvas 65.5 x 45
NWHCM : 1907.35.1 : F

Watts, George Frederick 1817–1904
The Curse of Cain c.1868–1872
oil on canvas 66.1 x 34.2
NWHCM : 1907.35.2 : F

Watts, George Frederick 1817–1904
Study for 'Britomart' 1878
oil on canvas 64.6 x 45.7
NWHCM : 1907.35.3 : F

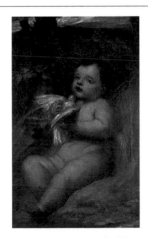

Watts, George Frederick 1817–1904
The Outcast: Goodwill
oil on canvas 96.9 x 59.1
NWHCM : 1907.44 : F

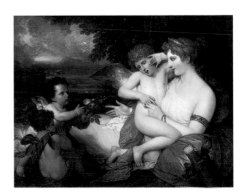

West, Benjamin 1738–1820
Venus Comforting Cupid Stung by a Bee 1813
oil on canvas 102 x 129.5
NWHCM : 1916.85 : F

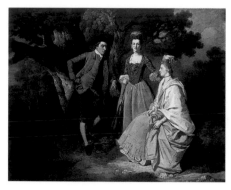

Wheatley, Francis 1747–1801
*Edward and Priscilla Wakefield with Mrs
Wakefield's Sister, Catherine Bell* c.1774
oil on canvas 91.5 x 115
NWHCM : 1985.90 : F

Wilkins, William the elder 1751–1815
South-East View of Norwich Castle 1785
oil on canvas 73.5 x 153
NWHCM : 2005.456 : F

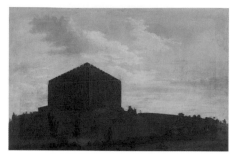

Wilkins, William the elder 1751–1815
Norwich Castle 1787
oil on canvas 75 x 112.5
NWHCM : 2005.455 : F

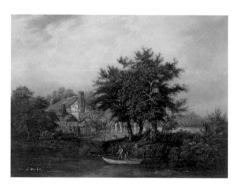

Williams, Edward 1782–1855
River Bank with Cottage
oil on oak panel 45.7 x 60.3
NWHCM : 1953.116 : F

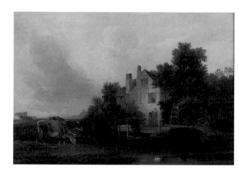

Williams, Edward 1782–1855
The Mill
oil on mahogany panel 35.4 x 51
NWHCM : 1943.88.4 : F

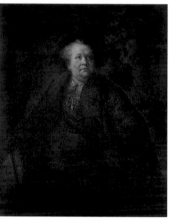

Wilson, Benjamin 1721–1788
Edward Macro (d.1766)
oil on canvas 127.3 x 101.4
NWHCM : 1991.1.35 : F

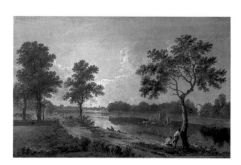

Wilson, Richard 1713/1714–1782
The Thames at Twickenham c.1760–1763
oil on canvas 59.7 x 91.5
NWHCM : 1955.174 : F

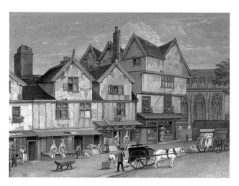

Winter, Cornelius Jansen Walter 1817–1891
The Butcheries, Norwich 1870
oil on panel 29.8 x 40
NWHCM : 1938.29 : F

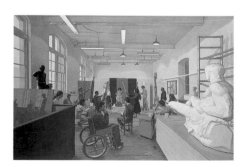

Wonnacott, John b.1940
The Life Room 1977–1980
oil on canvas 173 x 259
NWHCM : 1981.92 : F

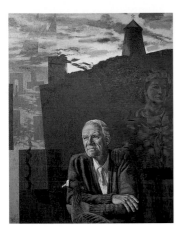

Wood, Tom b.1955
Timothy Colman 1990–1991
oil on board 155.5 x 121
NWHCM : 1992.119 : F

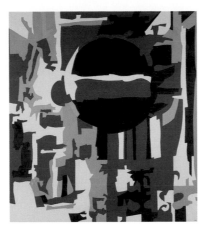

Woods, Michael b.1933
Sign 1968
oil on hardboard 136 x 121.6
NWHCM : 1968.919 : F

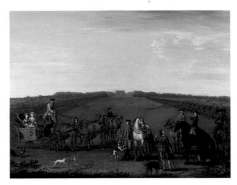

Wootton, John c.1682–1765
The Beauchamp-Proctor Family and Friends at Langley Park, Norfolk 1749
oil on canvas 152.7 x 199.7
NWHCM : 1993.3 : F

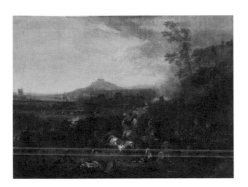

Wouwerman, Philips 1619–1668
A Cavalry Skirmish in a Mountainous Landscape
oil on canvas 46.4 x 61
NWHCM : 1991.1.36 : F

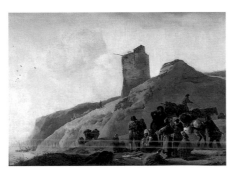

Wouwerman, Philips 1619–1668
The Seashore at Scheveningen
oil on canvas 52.7 x 71.1
NWHCM : 1956.10 : F

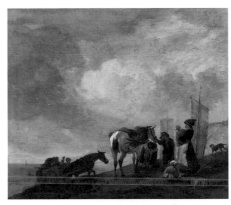

Wouwerman, Philips (follower of)
1619–1668
Figures on a Shore, a Mother with a Child, a Grey Horse, a Cart Beyond
oil on oak panel 41.3 x 49.3
NWHCM : 1991.1.37 : F

Wyndham, Richard 1896–1948
A Dinka Herdsman 1937
oil on canvas 76.1 x 50.4
NWHCM : L1993.3.12 : F

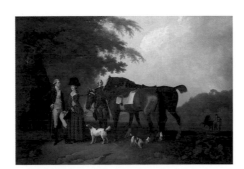

Zoffany, Johan 1733–1810, **Gilpin, Sawrey** 1733–1807 & **Farington, Joseph** 1747–1821
A Family Picture: Henry and Mary Styleman 1780–1783
oil on canvas 182.2 x 259
NWHCM : 2001.43 : F

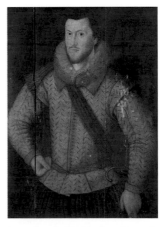

Zuccaro, Federico (attributed to)
c.1541–1609
Thomas Flowerdewe, Aged 26 1603
oil on panels 91.5 x 67.3
NWHCM : 1917.61 : F

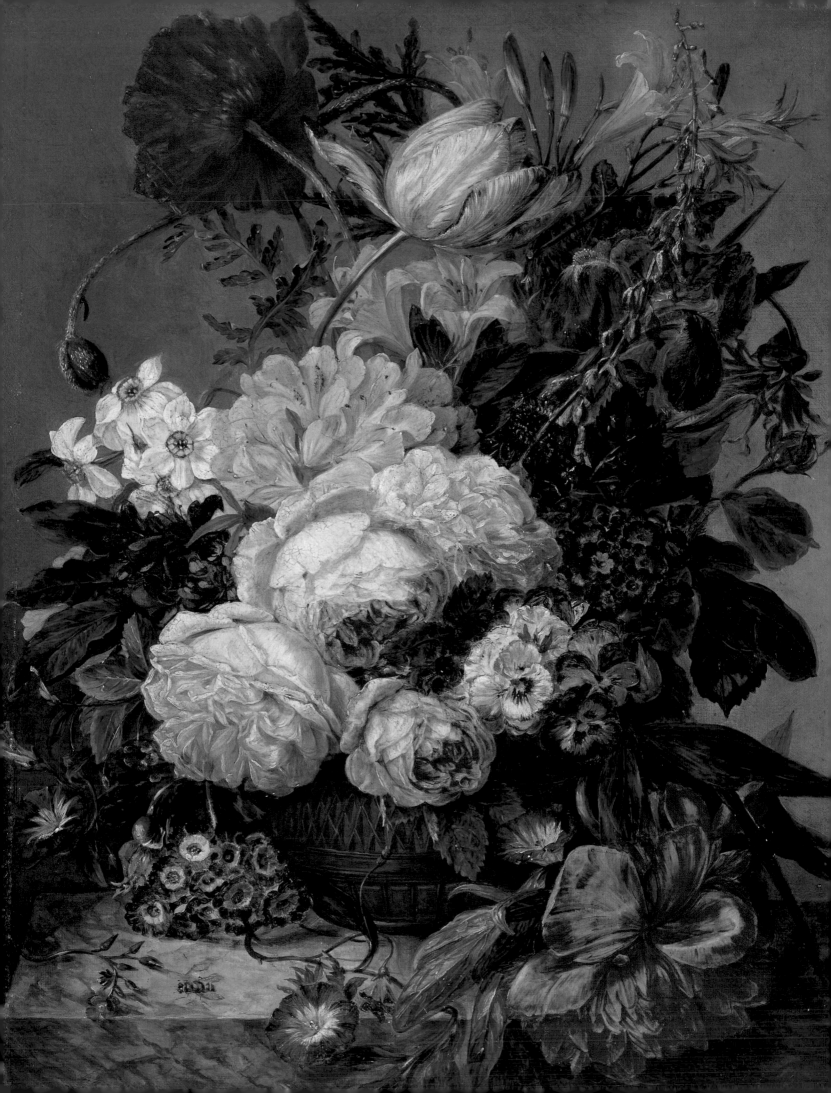

Norwich Civic Portrait Collection

The Norwich Civic Portrait Collection encompasses an important number of portraits of mayors of Norwich, local members of parliament and civic and other dignitaries from the late sixteenth century to the twentieth century. Since at least 1936, the Collection has been recognised for its strengths: '… no other municipality in the country possesses a collection of portraits … with so long a tradition behind it, and of such a generally good level of quality …'.[1]

The earliest group numbers just over 30 portraits painted before 1715. They are all of similar style and size, dominated by four colours: red, black, white and gold. They were painted to be hung in the Mayor's Court Chamber in the Guildhall, the seat of civic government, and were closely hung one above the other on all four walls.

At that time Norwich was the second city in the United Kingdom. Much of its wealth was founded on the textile industry. The portraits of the three earliest mayors represented – *Robert Jannys* (1517 & 1524), *John Marsham* (1518), and *Augustine Steward* (1534, 1546, 1556) – are painted in an archaistic style, probably in the late sixteenth or very early seventeenth century. It is significant that they were also civic benefactors, in particular contributing towards the rebuilding of the Guildhall which was completed in 1537. It therefore seems probable that the tradition for civic portraits was begun in order to commemorate the generosity of benefactors. This is confirmed by the inclusion of portraits of London donors such as *Alan Percy* (1560), *Sir Thomas White* (1567) and *Mrs Joanna Smith* (1594), one of the few women represented in the Collection. The portrait of *Sir Peter Reade* (1646) is accompanied by a separate painted panel recording his gifts to the city and it is possible that similar memorial panels existed for other portraits.

The unknown artists of the earliest Norwich portraits were artisans employed by the Council to undertake a variety of decorative work for the City. The Chamberlain's accounts for the Guildhall show that in addition to working on various buildings and bridges, the painters were also required to paint anything from water tankards to the ducking stool. One payment of 37s. to George Trewe in 1637–1638 was for 'writing the guift and names of many benefactors and frames', but none of the payments can be identified with any of the civic portraits.

The first full-length portraits on canvas in the Collection were presented by the Guild of St George in 1705, when it commissioned local artist, Thomas Starling, to paint the portraits of Queen Anne and Prince George. This ancient religious guild, which after the Reformation became virtually a social club, gave extensively to city charity. Its pageantry centred around the spectacular Guild Day procession and feast held at St Andrew's Hall which accompanied the inauguration of the new mayor.

By 1731 the Guild was in debt, and the city took over much of its pageantry and customs. It is probably significant that this coincided with the commissioning of the first full-length civic portrait of a mayor (*Robert Marsh*, 1731), which was presented by the Grocers' Company of which he was a member. Presumably the city wished to continue the tradition of memorialising

[1] Henry Hake, *Report of the City Committee to the Council on the Subject of the Preservation of Civic Portraits*, 2 January 1936

Facing page: Stannard, Emily, 1803–1885, *Flowers* (detail), 1840s, Norwich Castle Museum and Art Gallery, (p.199)

its leading citizens, and there can be no doubt that the portraits were connected with the mayor-making festivities: 'On Monday a fine picture of Timothy Balderstone was put up at the Guild Hall and on Tuesday the said gentleman was sworn mayor for the year ensuing'.[2] Initially some of the portraits were taken to St Andrew's Hall to decorate the walls during the feast-making, and eventually it became their permanent home.

Of the 84 full-length paintings acquired by the city from 1705 to 1934, the Corporation itself commissioned only eight. These were of officers of the Council, benefactors and the local hero, *Lord Nelson* (1801). The majority of the rest were acquired by public subscription and it is known, for example, that over 300 citizens subscribed to the portrait of *Crisp Brown* (1817). Others were given by trade companies, militia or private individuals or presented by the sitter.

Initially a single artist secured all the full-length commissions. German émigré, John Theodore Heins, received every commission from 1732 until 1746, followed by Thomas Bardwell who later had to compete with other local or visiting artists such as Charles Stoppelaer and Joseph Anton Adolphe from Austria. The early portraits followed a pattern in which the sitters are shown in poses derived from classical sculptures, usually in toga-like mayoral robes, surrounded by civic symbols.

This pattern was broken in a spectacular way in 1783 with the portrait by Thomas Gainsborough of Sir Harbord Harbord, MP for Norwich. It is believed that Harbord persuaded his constituents to commission the portrait, which was then presented to the Corporation. It heralded a series of some of the most attractive portraits in the Civic Collection.

Two London-based artists, William Beechey and John Opie, shared the commissions over the following 20 years. Both artists visited Norwich to work, and met and married Norwich women. During this time the Corporation requested Lord Nelson to sit for his portrait to celebrate his triumph at the Battle of the Nile in 1798. Nelson was allowed to select the artist and chose his friend Beechey. As a memento of the sitting he gave Beechey his hat, which is shown in the portrait. It is now in the collection of Norwich Castle.

It is evident that the social status of the sitter influenced the choice of artist. For example in 1804 two of the leading portrait painters of the day, John Hoppner and Thomas Lawrence, were commissioned to paint respectively portraits of the statesman William Windham and Charles Harvey, Recorder of Norwich and a member of a wealthy Norfolk family. Conversely, when it came to select an artist for the next portrait of local banker *Thomas Back* (1809), the young Norwich artist Joseph Clover was chosen.

By this time the style of portraits had changed. Gone were the elegant poses. The sitters are now shown in a more business-like stance, often holding documents and sometimes seated. One portrait that stands out is *Robert Hawkes* (1822) by Benjamin Robert Haydon, in which the mayor is shown walking in procession in the Guildhall. When offered one hundred pounds to go to Norwich to paint the portrait he replied '… I am not very fond of painting portraits; but a mayor is a mayor, … I'll go; moreover, I am just at this moment confoundedly in need of money …'.[3] Sadly, it was considered a failure, and the Corporation reverted to tried and tested artists such as Thomas Phillips and Samuel Lane of King's Lynn.

[2] *Norwich Mercury*, 26 June 1736
[3] George Borrow, *Lavengro*, 1851

Soon after this phase the standard of the portraits declined, although some notable artists such as James Jebusa Shannon and Hubert von Herkomer were commissioned. The sombreness of the men's dress and the uninspired backgrounds in several are typical of much Victorian portraiture. There are one or two exceptions, such as the portrait of *Jacob Henry Tillett* (1859) by the Norwich Pre-Raphaelite Frederick Sandys, and that of *Ernest Blyth* (1910) by William Orpen.

The whole tradition of portraiture had changed following the advent of photography in the late 1830s and from that date the paintings never quite matched the glory of the former portraits. Nevertheless, the Collection demonstrates the development of portraiture over four centuries, and is a unique record of the city's colourful civic past.

Norma Watt, Assistant Keeper of Art

Adolphe, Joseph Anton 1729–c.1765
Benjamin Hancock, Mayor of Norwich (1763) 1764
oil on canvas 244.5 x 153.2
NWHCM : Civic Portrait 44 : F

Adolphe, Joseph Anton 1729–c.1765
Elisha de Hague, Sr (1717–1792), Town Clerk of Norwich 1764
oil on canvas 243.8 x 182
NWHCM : Civic Portrait 97 : F

Bardwell, Thomas 1704–1767
William Crowe (d.1778), Mayor of Norwich (1747) 1746
oil on canvas 228.6 x 147.3
NWHCM : Civic Portrait 40 : F

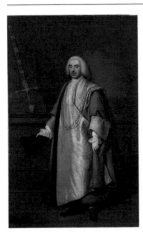

Bardwell, Thomas 1704–1767
John Gay (d.1787), Mayor of Norwich (1754) 1754–1755
oil on canvas 244 x 150
NWHCM : Civic Portrait 56 : F

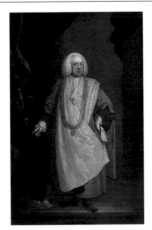

Bardwell, Thomas 1704–1767
John Goodman (d.c.1779), Mayor of Norwich (1757) 1757
oil on canvas 243.2 x 152.7
NWHCM : Civic Portrait 53 : F

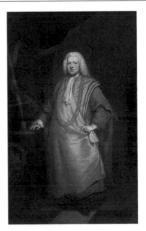

Bardwell, Thomas 1704–1767
John Press (1696/1697–1773), Mayor of Norwich (1753) 1759
oil on canvas 241 x 152.5
NWHCM : Civic Portrait 39 : F

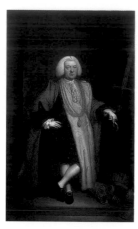

Bardwell, Thomas 1704–1767
Sir Thomas Churchman (1702–1781), Mayor of Norwich (1761) 1761
oil on canvas 240 x 148.5
NWHCM : Civic Portrait 1 : F

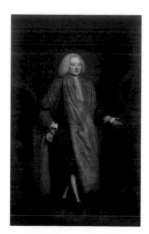

Bardwell, Thomas 1704–1767
Robert Rogers, Mayor of Norwich (1758) 1762
oil on canvas 243 x 152
NWHCM : Civic Portrait 32 : F

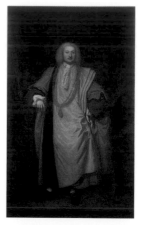

Bardwell, Thomas 1704–1767
Jermy Harcourt (1708/1709–1768), Mayor of Norwich (1762) 1763
oil on canvas 233.7 x 144.8
NWHCM : Civic Portrait 29 : F

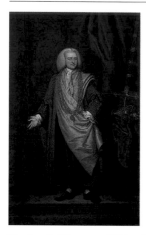

Bardwell, Thomas 1704–1767
John Dersley, Mayor of Norwich (1764) 1766
oil on canvas 242.1 x 151.6
NWHCM : Civic Portrait 26 : F

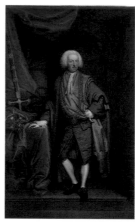

Bardwell, Thomas 1704–1767
James Poole (d.1780), Mayor of Norwich (1765) 1767
oil on canvas 241.7 x 149.5
NWHCM : Civic Portrait 41 : F

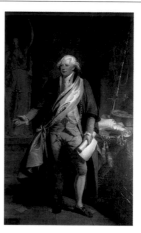

Beechey, William 1753–1839
Robert Partridge (1746/1747–1817), Mayor of Norwich (1784) 1784
oil on canvas 239.5 x 154.3
NWHCM : Civic Portrait 34 : F

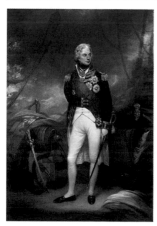

Beechey, William 1753–1839
Horatio, Viscount Nelson (1758–1805) 1801
oil on canvas 261.4 x 182.6
NWHCM : Civic Portrait 17 : F

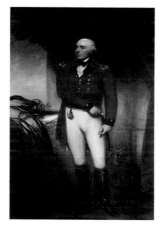

Beechey, William 1753–1839
John Patteson (1755–1833), Mayor of Norwich (1788) c.1803
oil on canvas 239.3 x 147
NWHCM : Civic Portrait 18 : F

Beechey, William 1753–1839
Elisha de Hague, Jr (1755–1826), Town Clerk of Norwich 1825
oil on canvas 240.5 x 150.2
NWHCM : Civic Portrait 94 : F

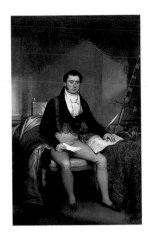

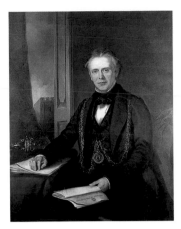

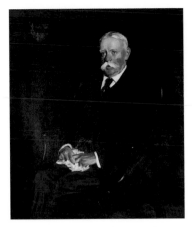

Beechey, William 1753–1839
John Staniforth Patteson (1782–1832), Mayor of Norwich (1823) 1826
oil on canvas 238.9 x 147
NWHCM : Civic Portrait 35 : F

Benson, Edward 1808–1863
John Marshall (1796 1872), Mayor of Norwich (1838 & 1841) 1850
oil on canvas 127.6 x 101.6
NWHCM : Civic Portrait 98 : F

Birley, Oswald Hornby Joseph 1880–1952
Sir William Ffoulkes, Bt (1847–1912) 1912
oil on canvas 127 x 101.6
NWHCM : Civic Portrait 120 : F

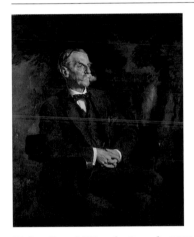

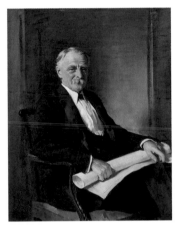

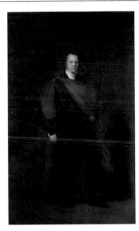

Birley, Oswald Hornby Joseph 1880–1952
The Right Honourable Ailwyn Edward Fellowes, First Baron Ailwyn of Honingham (1855–1924) 1924
oil on canvas 139.7 x 101.6
NWHCM : Civic Portrait 122 : F

Birley, Oswald Hornby Joseph 1880–1952
Russell James Colman (1861–1946), HM Lieutenant of Norfolk 1928
oil on canvas 127 x 101.6
NWHCM : Civic Portrait 123 : F

Briggs, Henry Perronet 1791/1793–1844
Charles Turner (1788–1861), Mayor of Norwich (1834) c.1835–1836
oil on canvas 239.4 x 148.2
NWHCM : Civic Portrait 22 : F

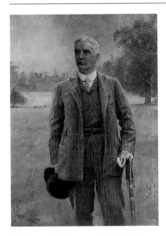

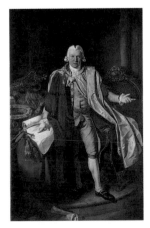

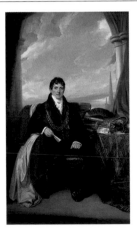

Carter, William 1863–1939
John Sancroft Holmes (1847–1920) 1921
oil on canvas 146 x 106.7
NWHCM : Civic Portrait 121 : F

Catton, Charles the younger 1756–1819
Jeremiah Ives, Jr (1728/1729–1805), Mayor of Norwich (1769 & 1795) c.1781
oil on canvas 239 x 151.8
NWHCM : Civic Portrait 58 : F

Clint, George 1770–1854
Sir John Harrison Yallop (1763–1835), Mayor of Norwich (1815 & 1831) 1815
oil on canvas 240 x 149.2
NWHCM : Civic Portrait 5 : F

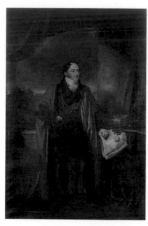

Clint, George 1770–1854
*William Hankes (1773–1860), Mayor of
Norwich (1816)* c.1816–1823
oil on canvas 237.5 x 151
NWHCM : Civic Portrait 62 : F

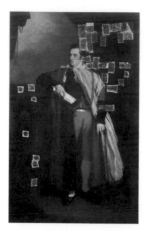

Clover, Joseph 1779–1853
*Thomas Back (1767/1768–1820), Mayor of
Norwich (1809)* c.1810
oil on canvas 239.4 x 147.3
NWHCM : Civic Portrait 20 : F

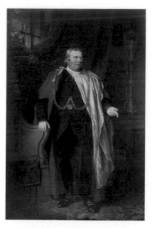

Clover, Joseph 1779–1853
*Barnabas Leman (1743–1835), Mayor of
Norwich (1813 & 1818)* 1819
oil on canvas 241.4 x 150
NWHCM : Civic Portrait 55 : F

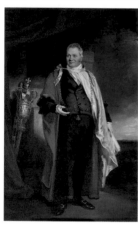

Clover, Joseph 1779–1853
Crisp Brown, Mayor of Norwich (1817)
c.1821–1822
oil on canvas 238.8 x 147
NWHCM : Civic Portrait 14 : F

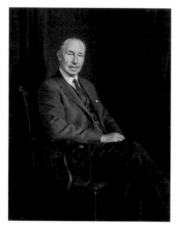

Corfield, Colin 1910–1991
*Lieutenant Colonel Sir Bartle Edwards
(1891–1977)* 1966
oil on canvas 134.6 x 104.2
NWHCM : Civic Portrait 125 : F

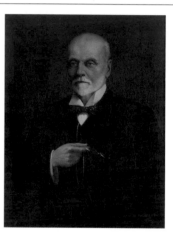

Crick, Montague active 1898–1917
*Edward Wild (1832–1929), Mayor of Norwich
(1890)* 1910
oil on canvas 89 x 64.8
NWHCM : Civic Portrait 114 : F

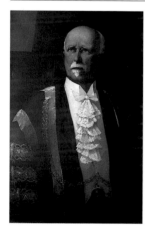

Crick, Montague active 1898–1917
*Sir George Chamberlin (1846–1928), Mayor of
Norwich (1891), Lord Mayor (1916 & 1918)*
1917
oil on canvas 127.7 x 89.6
NWHCM : Civic Portrait 117 : F

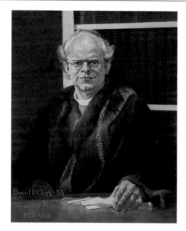

Dalton, Anthony b.1929
*The Reverend David H. Clark, Sheriff of
Norwich (1981–1982)* 1982
oil on canvas 77 x 61
NWHCM : Civic Portrait 131 : F

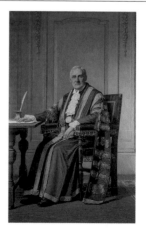

Dodd, Francis 1874–1949
*Sir Henry N. Holmes (1868–1940), Lord
Mayor of Norwich (1921 & 1932)* 1934
oil on canvas 233.5 x 140.5
NWHCM : Civic Portrait 115 : F

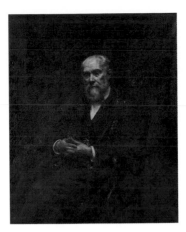

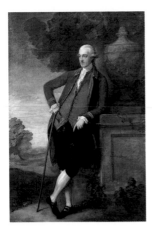

Forbes, Stanhope Alexander 1857–1947
Sir Peter Eade (1825–1915), Mayor of Norwich
(1883, 1893 & 1895) 1895
oil on canvas 137.8 x 111.9
NWHCM : Civic Portrait 110 : F ✻

Gainsborough, Thomas 1727–1788
Sir Harbord Harbord, Bt (1734–1810), MP for
Norwich 1783
oil on canvas 238.5 x 156.6
NWHCM : Civic Portrait 19 : F

Grant, Francis 1803–1878
Henry Dover (d.1855) 1847
oil on canvas 239.4 x 147.4
NWHCM : Civic Portrait 102 : F

Haydon, Benjamin Robert 1786–1846
Robert Hawkes (1773/1774–1836), Mayor of
Norwich (1822) c.1822
oil on canvas 297 x 211
NWHCM : Civic Portrait 38 : F

Heins, John Theodore Sr 1697–1756
Francis Arnam (1673/1674–1741), Mayor of
Norwich (1732) 1732
oil on canvas 242 x 150
NWHCM : Civic Portrait 47 : F

Heins, John Theodore Sr 1697–1756
Robert Marsh (1679/1680–1771), Mayor of
Norwich (1731) 1732
oil on canvas 242.5 x 150
NWHCM : Civic Portrait 8 : F

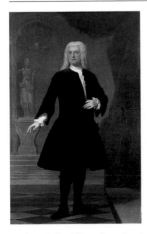

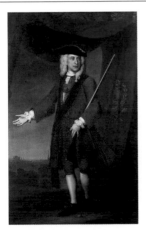

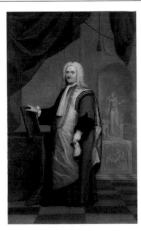

Heins, John Theodore Sr 1697–1756
Thomas Vere (1680/1681–1766), Mayor of
Norwich (1735) 1736
oil on canvas 239 x 150
NWHCM : Civic Portrait 11 : F

Heins, John Theodore Sr 1697–1756
Timothy Balderston (1682–1764), Mayor of
Norwich (1736 & 1751) 1736
oil on canvas 236 x 147.5
NWHCM : Civic Portrait 51 : F

Heins, John Theodore Sr 1697–1756
Thomas Harwood (b.1664/1665), Mayor of
Norwich (1728) 1737
oil on canvas 244.8 x 153.3
NWHCM : Civic Portrait 45 : F

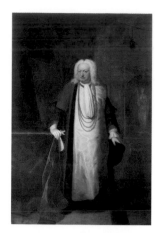

Heins, John Theodore Sr 1697–1756
Benjamin Nuthall (d.1752), Mayor of Norwich (1721 & 1749) 1738
oil on canvas 242.8 x 151.5
NWHCM : Civic Portrait 24 : F

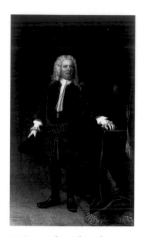

Heins, John Theodore Sr 1697–1756
The Honourable Horatio Walpole (1678–1757) 1740
oil on canvas 236.2 x 147.3
NWHCM : Civic Portrait 49 : F

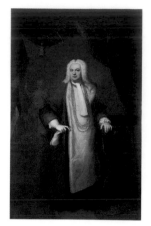

Heins, John Theodore Sr 1697–1756
William Clarke (d.1752), Mayor of Norwich (1739) 1740
oil on canvas 242.8 x 151.6
NWHCM : Civic Portrait 52 : F

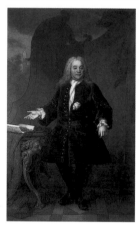

Heins, John Theodore Sr 1697–1756
Thomas Emerson (d.1785), Sheriff of Norwich (1785) 1741
oil on canvas 238.7 x 147.3
NWHCM : Civic Portrait 92 : F

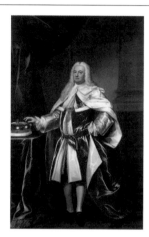

Heins, John Theodore Sr 1697–1756
John, Lord Hobart (1694–1756), 1st Earl of Buckinghamshire 1743
oil on canvas 241.3 x 151.2
NWHCM : Civic Portrait 12 : F

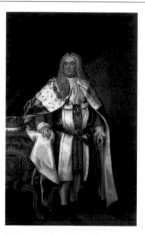

Heins, John Theodore Sr 1697–1756
Robert Walpole, Earl of Orford (1676–1745) 1743
oil on canvas 243.2 x 153.7
NWHCM : Civic Portrait 7 : F

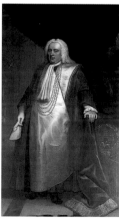

Heins, John Theodore Sr 1697–1756
William Wiggett (1693/1694–1768), Mayor of Norwich (1742) 1743
oil on canvas 240 x 147.5
NWHCM : Civic Portrait 43 : F

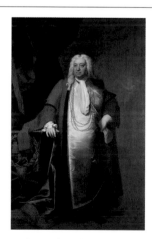

Heins, John Theodore Sr 1697–1756
Simeon Waller, Mayor of Norwich (1745) 1745–1746
oil on canvas 236.2 x 157.5
NWHCM : Civic Portrait 54 : F

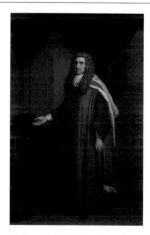

Heins, John Theodore Sr 1697–1756
Sir Benjamin Wrench, MD (1665–1747) 1746
oil on canvas 237.5 x 153
NWHCM : Civic Portrait 61 : F

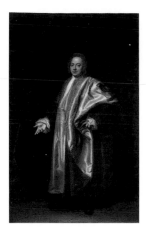

Heins, John Theodore Sr 1697–1756
Thomas Harvey (1711–1772), Mayor of
Norwich (1748) 1748–1749
oil on canvas 241.3 x 148.5
NWHCM : Civic Portrait 50 : F

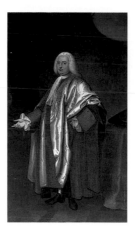

Heins, John Theodore Sr 1697–1756
Thomas Hurnard (1711/1712–1753), Mayor of
Norwich (1752) 1754
oil on canvas 238.5 x 147.5
NWHCM : Civic Portrait 28 : F

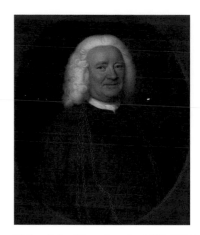

Heins, John Theodore Sr 1697–1756
Matthew Goss (b.1680/1681) 1756
oil on canvas 76.2 x 63.5
NWHCM : Civic Portrait 116 : F

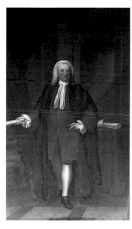

Heins, John Theodore Sr 1697–1756
Nockold Tompson (d.1777), Mayor of Norwich
(1759), and Speaker of the Common Council
(1744–1753) 1756
oil on canvas 240.5 x 149.9
NWHCM : Civic Portrait 93 : F

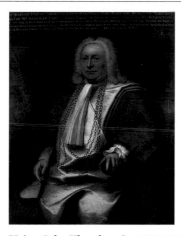

Heins, John Theodore Sr 1697–1756
John Harvey (1666–1742), Mayor of Norwich
(1727)
oil on canvas 127.3 x 101.9
NWHCM : Civic Portrait 126 : F

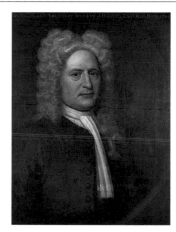

Heins, John Theodore Sr 1697–1756
John Kirkpatrick (1686–1728)
oil on canvas 72 x 61.2
NWHCM : Civic Portrait 118 : F

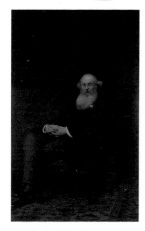

Herkomer, Hubert von 1849–1914
Jeremiah James Colman (1830–1898), Mayor
of Norwich (1867) 1899
oil on canvas 241 x 150
NWHCM : Civic Portrait 25 : F

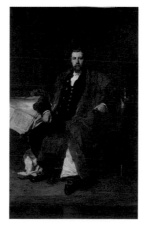

Holl, Frank 1845–1888
Sir Harry Bullard (1841–1903), Mayor of
Norwich (1878, 1879 & 1886) 1882
oil on canvas 239 x 145
NWHCM : Civic Portrait 27 : F

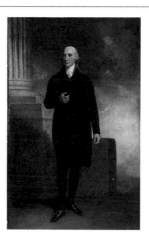

Hoppner, John 1758–1810
The Right Honourable William Windham
(1750–1810), MP for Norwich 1804
oil on canvas 242.5 x 149
NWHCM : Civic Portrait 15 : F

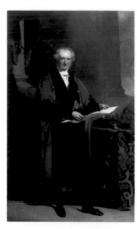

Knight, John Prescott 1803–1881
Sir Samuel Bignold (1791–1875), Mayor of
Norwich (1833, 1848, 1853 & 1872) 1850
oil on canvas 239 x 148
NWHCM : Civic Portrait 2 : F

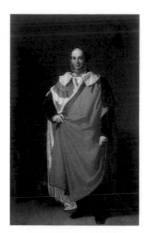

Knight, John Prescott 1803–1881
Lord Stafford (Sir Henry Valentine Stafford
Jerningham) (1802–1884) 1868
oil on canvas 239 x 147.5
NWHCM : Civic Portrait 21 : F

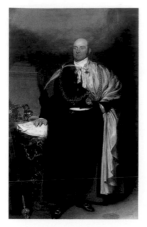

Lane, Samuel 1780–1859
Henry Francis, Mayor of Norwich (1824) 1827
oil on canvas 239.5 x 146.5
NWHCM : Civic Portrait 30 : F

Lawrence, Thomas 1769–1830
Charles Harvey (1757–1843) 1804
oil on canvas 238.8 x 144.8
NWHCM : Civic Portrait 3 : F

Lawrence, Thomas 1769–1830
Thomas William Coke (1752–1842) 1814
oil on canvas 238.8 x 142.2
NWHCM : Civic Portrait 99 : F

Mason, Arnold 1885–1963
Sir Henry Upcher (1870–1954), Chairman of
Norfolk County Council (1941–1950) c.1950
oil on canvas 119.4 x 94
NWHCM : Civic Portrait 124 : F

Mortimer, Geoffrey active 1881–1930
Walter Robert Smith (1872–1942), Norwich
City Councillor 1928
oil on canvas 53.1 x 43.2
NWHCM : Civic Portrait 127 : F

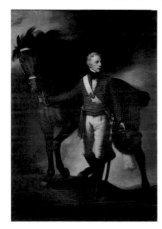

Opie, John 1761–1807
John Harvey (1755–1842), Mayor of Norwich
(1792) 1792
oil on canvas 260.6 x 184.2
NWHCM : Civic Portrait 33 : F

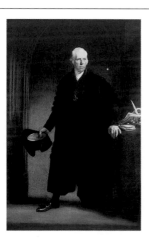

Opie, John 1761–1807
Samuel Harmer (1721/1722–1808), Speaker of
the Common Council of Norwich 1798
oil on canvas 237.5 x 151.1
NWHCM : Civic Portrait 96 : F

Facing page: Giacometti, Alberto, 1901–1966, *Diego Seated* (detail), 1948, Sainsbury Centre for Visual Arts,
University of East Anglia, (p.256)

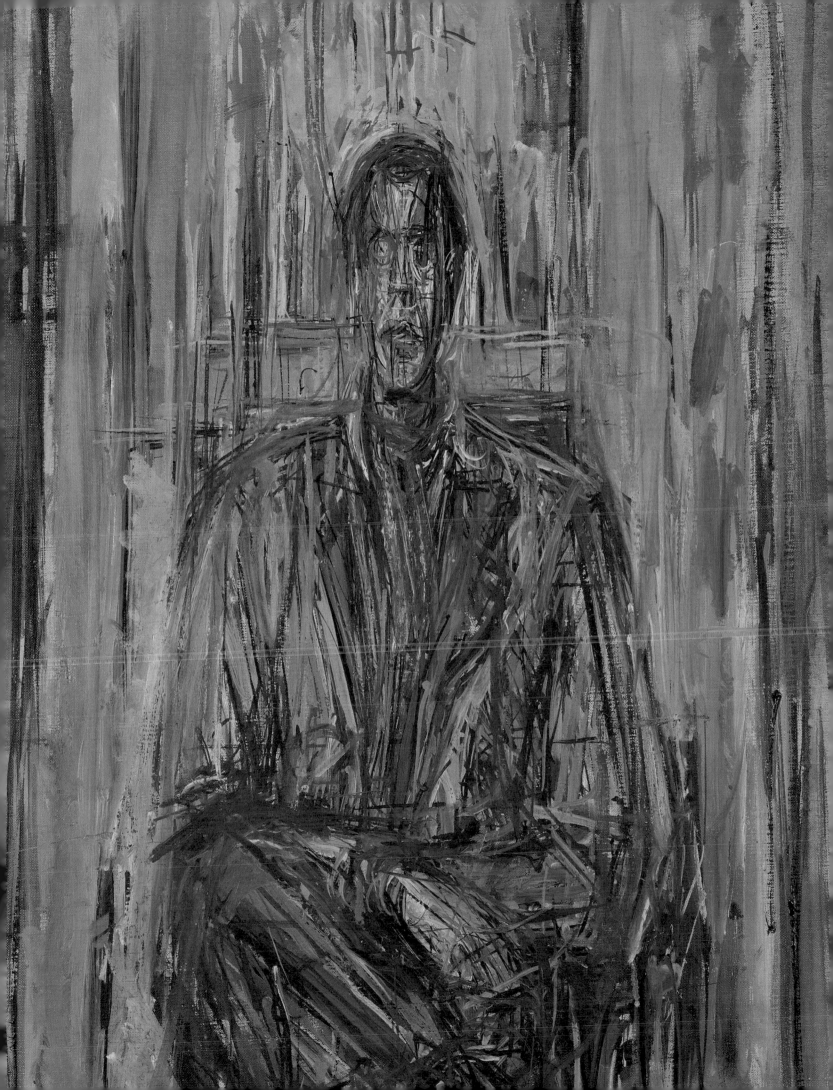

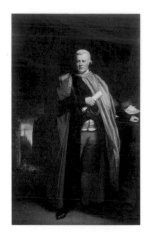

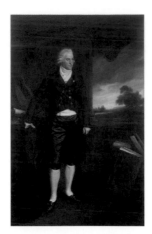

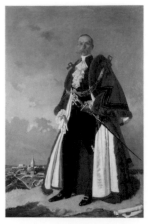

Opie, John 1761–1807
*John Herring (1748/1749–1810), Mayor of
Norwich (1799)* 1800–1801
oil on canvas 240 x 148.3
NWHCM : Civic Portrait 31 : F

Opie, John 1761–1807
*The Honourable Henry Hobart (1738–1799),
MP for Norwich* 1802
oil on canvas 238.5 x 152
NWHCM : Civic Portrait 13 : F

Orpen, William 1878–1931
*Ernest Egbert Blyth (1857–1934), Last Mayor
& First Lord Mayor of Norwich (1910)* 1911
oil on canvas 211 x 137.4
NWHCM : Civic Portrait 112 : F

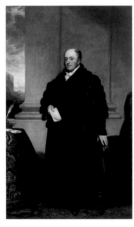

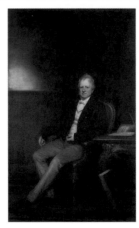

Phillips, Thomas 1770–1845
*William Simpson (1768/1769–1834), Town
Clerk of Norwich* 1826
oil on canvas 238.8 x 148.3
NWHCM : Civic Portrait 95 : F

Phillips, Thomas 1770–1845
*The Honourable John Wodehouse (1771–
1846), Lord Lieutenant of Norfolk (1821–
1846)* 1832
oil on canvas 239.4 x 147.5
NWHCM : Civic Portrait 104 : F

Richmond, George 1809–1896
*Sir Samuel Hoare (1841–1915), MP for
Norwich* 1880
oil on canvas 94 x 61
NWHCM : Civic Portrait 111 : F

Sandys, Frederick 1829–1904
*Jacob Henry Tillett (1818–1892), Mayor of
Norwich (1859 & 1875)* 1871
oil on canvas 235.5 x 150
NWHCM : Civic Portrait 23 : F

Sandys, Frederick 1829–1904
Edward Howes (1813–1871) 1872
oil on canvas 113 x 89
NWHCM : Civic Portrait 100 : F

Shannon, James Jebusa 1862–1923
Clare Sewell Read (1826–1905) 1897
oil on canvas 141 x 109.8
NWHCM : Civic Portrait 107 : F

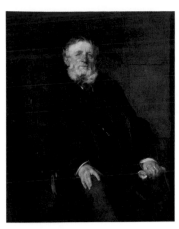

Shannon, James Jebusa 1862–1923
Lord Cranworth (Robert Thornhagh Gurdon)
(1829–1902), First Chairman of Norfolk
County Council 1899
oil on canvas 127 x 101.6
NWHCM : Civic Portrait 101 : F

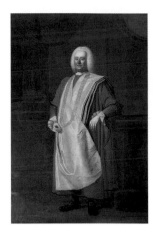

Smith, William 1707–1764
John Spurrell (1681/1682–1763), Mayor of
Norwich (1737) 1758
oil on canvas 241.1 x 151.2
NWHCM : Civic Portrait 48 : F

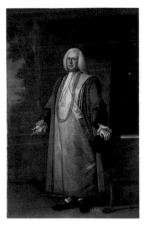

Smith, William 1707–1764
Robert Harvey (1697–1773), Mayor of
Norwich (1738) 1758
oil on canvas 244 x 154.9
NWHCM : Civic Portrait 16 : F

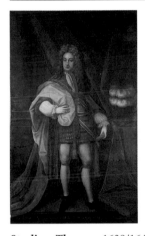

Starling, Thomas 1639/1640–1718
Prince George (1653–1708) 1705
oil on canvas 263 x 156.2
NWHCM : Civic Portrait 46 : F

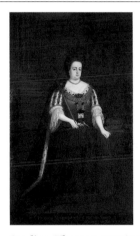

Starling, Thomas 1639/1640–1718
Queen Anne (1665–1714) 1705
oil on canvas 260.7 x 154
NWHCM : Civic Portrait 42 : F

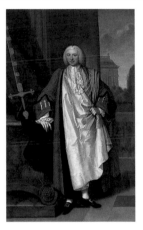

Stoppelaer, Charles active 1703–1757
Jeremiah Ives (1723/1724–1787), Mayor of
Norwich (1756) 1756
oil on canvas 244.2 x 151
NWHCM : Civic Portrait 57 : F

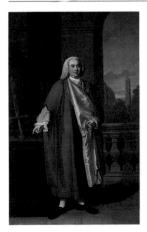

Stoppelaer, Charles active 1703–1757
Peter Colombine (1697–1770), Mayor of
Norwich (1755) 1757
oil on canvas 240.5 x 151.1
NWHCM : Civic Portrait 36 : F

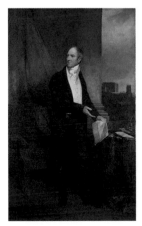

Thomson, Henry 1773–1843
William Smith (1756–1835), MP for Norwich
1814
oil on canvas 241 x 149.5
NWHCM : Civic Portrait 6 : F

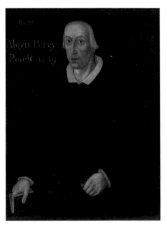

unknown artist
Alan Percy (d.1560) 1549
oil on panel 90.2 x 66
NWHCM : Civic Portrait 89 : F

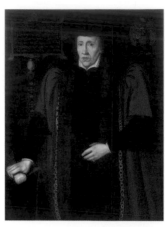

unknown artist
Sir Thomas White (1495?–1567) 1553?
oil on panel 113 x 92.7
NWHCM : Civic Portrait 74 : F

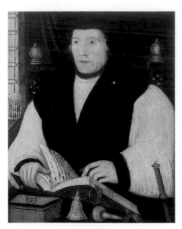

unknown artist
Archbishop Matthew Parker (1504–1575)
1573
oil on panel 61 x 49.5
NWHCM : Civic Portrait 83 : F

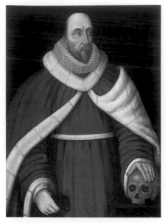

unknown artist
*Sir Edward Coke (1552–1634), Recorder of
Norwich (1586–1591)* 1587
oil on panel 91.5 x 68.5
NWHCM : Civic Portrait 81 : F

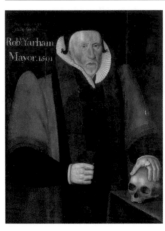

unknown artist
*Robert Yarham (1519/1520–1595), Mayor of
Norwich (1591)* 1591
oil on panel 92 x 67.3
NWHCM : Civic Portrait 84 : F

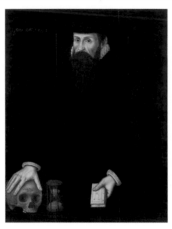

unknown artist
*Francis Windham (d.1592), Recorder of
Norwich (1575–1579)* 1592
oil on panel 91.5 x 68.5
NWHCM : Civic Portrait 60 : F

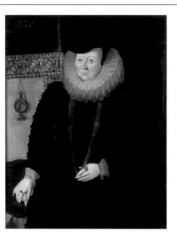

unknown artist
Mrs Joanna Smith (b.1533/1534) 1594
oil on panel 109.2 x 90.2
NWHCM : Civic Portrait 69 : F

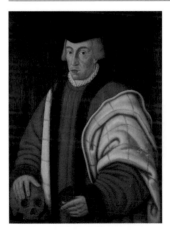

unknown artist late 16th C
*Augustine Steward (1491–1571), Mayor of
Norwich (1534, 1546 & 1556)*
oil on panel 91.5 x 67.5
NWHCM : Civic Portrait 75 : F

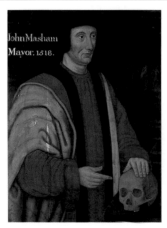

unknown artist late 16th C
*John Marsham (d.1525), Mayor of Norwich
(1518)*
oil on panel 91 x 66.7
NWHCM : Civic Portrait 70 : F

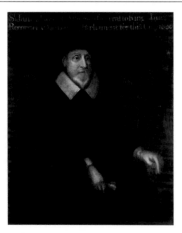

unknown artist
*Sir Henry Hobart (c.1554–1625), Steward of
Norwich (1592–1606)* 1606
oil on canvas 100.3 x 78.8
NWHCM : Civic Portrait 91 : F

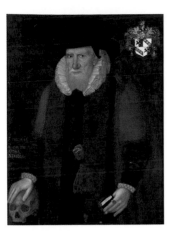

unknown artist
Thomas Layer (1528–1614), Mayor of Norwich (1576, 1585 & 1595) 1606
oil on panel 90.2 x 66.7
NWHCM : Civic Portrait 63 : F

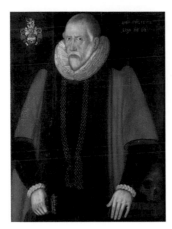

unknown artist
Sir John Pettus (1549/1550–1614), Mayor of Norwich (1608) 1612
oil on panel 90.2 x 67.3
NWHCM : Civic Portrait 71 : F

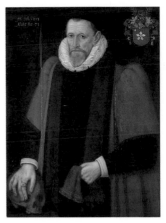

unknown artist
Thomas Anguish (1538/1539–1617), Mayor of Norwich (1611) 1612
oil on panel 90.8 x 66
NWHCM : Civic Portrait 108 : F

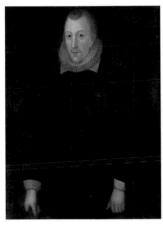

unknown artist
Robert Hernsey, Mayor of Norwich (1632)? 1634
oil on panel 90.8 x 67.3
NWHCM : Civic Portrait 86 : F

unknown artist
Pendant to Portrait of Sir Peter Rede 1646
oil on panel 81.2 x 60.3
NWHCM : Civic Portrait 76A : F

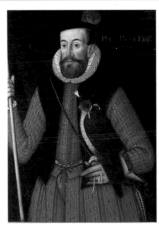

unknown artist
Sir Peter Rede (d.1568) 1646
oil on panel 91.5 x 67.3
NWHCM : Civic Portrait 76 : F

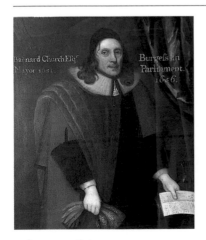

unknown artist
Barnard Church (1604–1686), Mayor of Norwich (1651) 1654
oil on canvas 103.5 x 87.7
NWHCM : Civic Portrait 64 : F

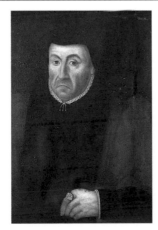

unknown artist
Robert Holmes, Sheriff of Norwich (1646) c.1655
oil on panel 67.3 x 45.1
NWHCM : Civic Portrait 82A : F

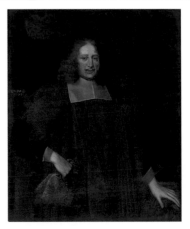

unknown artist
Sir Joseph Paine (1599/1600–1668), Mayor of Norwich (1660) 1663
oil on canvas 119.4 x 97.8
NWHCM : Civic Portrait 88 : F

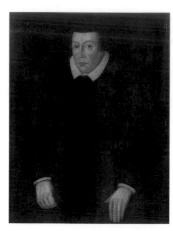

unknown artist
Francis Southwell (b.1601/1602), Recorder of Norwich 1667
oil on panel 91.5 x 68
NWHCM : Civic Portrait 73 : F

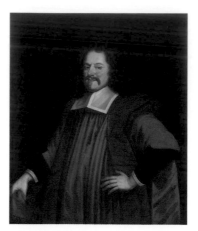

unknown artist
Augustine Briggs (1617–1684), Mayor of Norwich (1670) c.1670
oil on canvas 113 x 94
NWHCM : Civic Portrait 66 : F

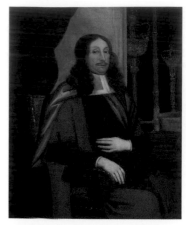

unknown artist
Unknown Mayor of Norwich c.1680
oil on canvas 117 x 96.5
NWHCM : Civic Portrait 65 : F

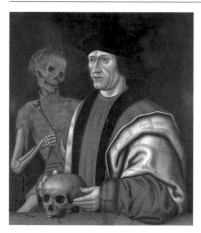

unknown artist early 17th C
Robert Jannys (c.1480–1530), Mayor of Norwich (1517 & 1524)
oil on panel 77.5 x 61
NWHCM : Civic Portrait 68 : F

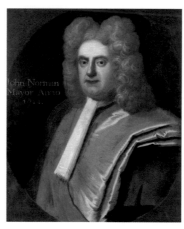

unknown artist
John Norman (1675/1676–1724), Mayor of Norwich (1714) 1714
oil on canvas 76.2 x 63.5
NWHCM : Civic Portrait 77 : F

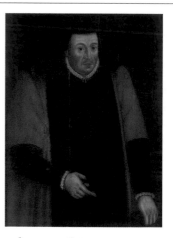

unknown artist
Francis Moundford (d.1536), Recorder of Norwich
oil on panel 90.9 x 68
NWHCM : Civic Portrait 82 : F

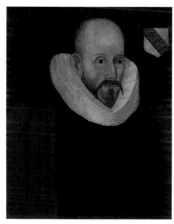

unknown artist
Henry Fawcett (d.1619), Sheriff of Norwich (1608)
oil on panel 57.2 x 45.7
NWHCM : Civic Portrait 87 : F

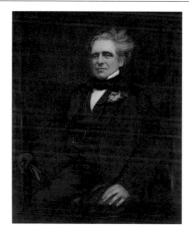

unknown artist
John Marshall (1796–1872), Mayor of Norwich (1838 & 1841)
oil on canvas 112.1 x 87
NWHCM : Civic Portrait 128 : F

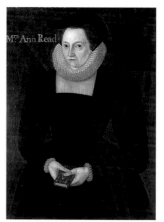

unknown artist
Mrs Anne Rede (d.1577)
oil on panel 91 x 66.5
NWHCM : Civic Portrait 78 : F

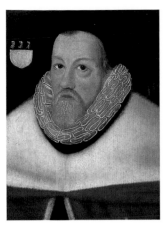

unknown artist
Sir Thomas Richardson (1569–1635)
oil on panel 58.5 x 45.7
NWHCM : Civic Portrait 109 : F

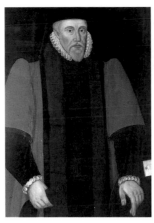

unknown artist
Thomas Carver (d.1641), Mayor Elect (1641)
oil on panel 91.5 x 68.5
NWHCM : Civic Portrait 79 : F

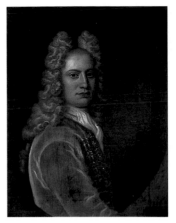

unknown artist
Thomas Hall (1681–1715)
oil on canvas 76.2 x 62.9
NWHCM : Civic Portrait 72 : F

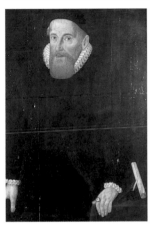

unknown artist
*Thomas King, Town Clerk of Norwich
(1615–1638)*
oil on panel 90 x 68
NWHCM : Civic Portrait 67 : F

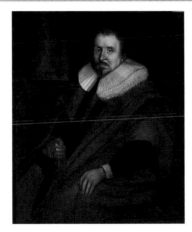

unknown artist
*William Barnham (d.c.1674), Mayor of
Norwich (1652)*
oil on canvas 111.8 x 94
NWHCM : Civic Portrait 80 : F

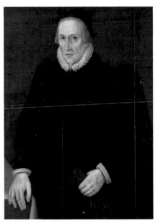

unknown artist
*William Denny (d.1642), Recorder of Norwich
(1629–1641)?*
oil on panel 89.5 x 67.3
NWHCM : Civic Portrait 85 : F

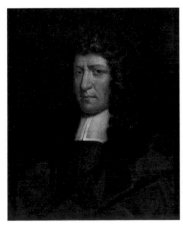

unknown artist
William Doughty (d.1687)
oil on canvas 72.4 x 59.7
NWHCM : Civic Portrait 90 : F

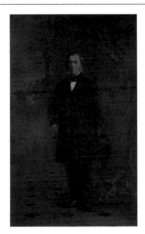

Ventnor, Arthur Dale 1829–1884
*John Oddin Taylor (1805–1874), Mayor of
Norwich (1861)*
oil on canvas 238 x 147.4
NWHCM : Civic Portrait 113 : F

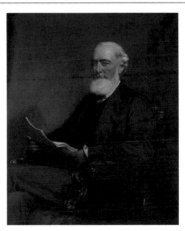

Wells, Henry Tanworth 1828–1903
*Sir Willoughby Jones (1820–1884), Chairman
of Norfolk Quarter Sessions (1856–1884) 1886*
oil on canvas 118 x 96
NWHCM : Civic Portrait 103 : F

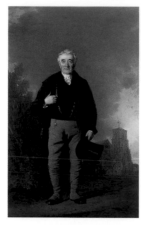

Westcott, Philip 1815–1878
Thomas Osborn Springfield (1782–1858),
Mayor of Norwich (1829 & 1836) 1852
oil on canvas 238.8 x 148
NWHCM : Civic Portrait 37 : F

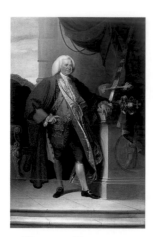

Williams, William 1727–1791
Thomas Starling (1706–1788), Mayor of
Norwich (1767) 1770
oil on canvas 241.6 x 151.7
NWHCM : Civic Portrait 4 : F

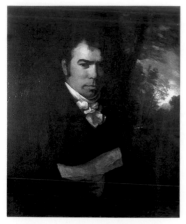

Woodhouse, John Thomas 1780–1845
John Crome (1768–1821) 1813
oil on canvas 76.2 x 64.1
NWHCM : Civic Portrait 59 : F

Norwich Magistrates Courts

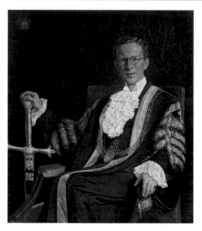

Pan, Arthur active 1920–1960
Alderman Eric John Sidney Hinde, MA 1951
oil on canvas 137 x 107 (E)
1

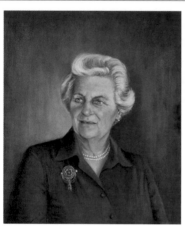

Strickland, Betty
Lady Ralphs, CBE, JP, DC, BA 1975
oil on canvas 76 x 61 (E)
2

Royal Norfolk Regimental Museum

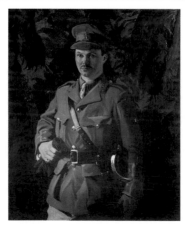

Bates, Les
Lieutenant W. M. Palmer 1917
oil on canvas 130 x 102 (E)
NWHRM : 3016

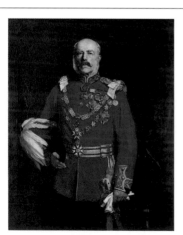

Herkomer, Herman 1863–1935
General Sir Arthur Borton, GCB, GCMG 1887
oil on canvas 141 x 111 (E)
NWHRM : 3202

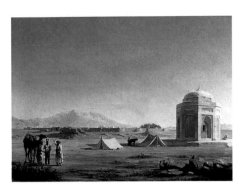

Powell, W. W. (Captain)
Scene at Jellalabad, 1842
oil on canvas 27 x 35 (E)
NWHRM : 2653

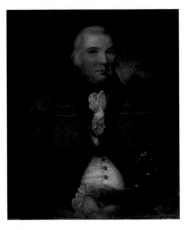

unknown artist
An Officer of the Norfolk Militia
oil on canvas?
NWHRM : 3312

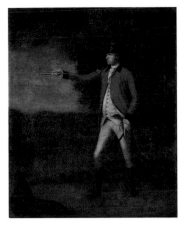

unknown artist
Major Money (d.1817) and the Norfolk Militia
oil on canvas 73.7 x 61
NWHRM : 5132

Sainsbury Centre for Visual Arts, University of East Anglia

Robert (1906–2000) and Lady Lisa Sainsbury (b.1912) donated their collection of world art to the University of East Anglia in 1973 and the Sainsbury Centre first opened its doors to visitors in 1978. It was the Sainsburys' hope that students, academic staff and the general public would enjoy the works on display in much the same way as the Sainsburys' themselves had done, by being able to look frequently and closely at them without the distraction of too much museum-style text and labelling.

As a young man, Robert Sainsbury collected private press books and only later began to acquire the objects around which he and his wife built the collection. His first significant purchase was Jacob Epstein's *Baby Asleep*, bought in 1931 or 1932. Over the next 60 years, he and Lady Sainsbury added works by both established and, perhaps more interestingly, emerging European artists. With the advice and encouragement of a handful of dealers, the collection also grew to include objects from cultures around the world spanning more than 5,000 years. The Sainsburys particularly enjoyed the friendships which they built with individual artists, among them Henry Moore, Alberto Giacometti, Francis Bacon and, more recently, John Davies, all of whom are well represented in the Collection.

Robert and Lisa Sainsbury's purchases were guided by an instinctive response to sculptural form – particularly that of the human figure. They also shared an interest in contemporary painting which is evidenced by works in the Collection by Chaïm Soutine, Alberto Giacometti, Zoran Music, Yuri Kuper and Charles Maussion. Guided by Lisa Sainsbury's passion for painting, they amassed a body of work in the Collection that is more gestural, abstract and colourful than the largely monochromatic sculptures for which it is best known. Works by Francis Bacon and Antonio Saura are examples of the early inclusion of paintings with remarkable expressive force.

The Robert and Lisa Sainsbury Collection is primarily shown in a gallery known as the *Living Area*, where modern European art is interspersed with works from across the globe, grouped by geographical region. In 1978, the presentation of ancient world art alongside modern masters was greeted as a

revelation – today it continues to provide juxtapositions across time and culture that can inspire and surprise.

When the Collection was offered to the University in 1973 it numbered around 300 works. The Sainsburys approached Norman Foster to design an appropriate building to house both the collection and the School of Fine Art (now the School of World Art Studies and Museology). Designed between 1974 and 1976 and opened in 1978, the Sainsbury Centre for Visual Arts was Norman Foster's first major public building. By the time the Centre opened the Collection had doubled in size. Now, the Robert and Lisa Sainsbury Collection contains more that 1,700 objects. Almost all of the works are on permanent display and are used extensively for teaching by various University of East Anglia (UEA) departments and many local schools and colleges. The Sainsbury Centre is one of around 100 university museums in the UK which are regularly open to the public.

By the late 1980s the Collection and the staff had outgrown the original building and the Crescent Wing was added, with new office, exhibition and technical spaces. A further extension to the gallery will open in 2006, linking the two parts of the building and providing new public, commercial, education and studio spaces.

In addition to the Robert and Lisa Sainsbury Collection, the Centre houses the University of East Anglia Collection of Abstract and Constructivist Art, Architecture and Design and the Anderson Collection of Art Nouveau. It also holds and documents those artworks given to the Vice Chancellor and to the University.[1]

The UEA Collection of Abstract and Constructivist Art, Architecture and Design was founded in 1968 with a modest capital grant from the University Council. It contains sculpture, paintings and graphics architectural models and furniture. Peter Lasko and Alastair Grieve, of the School of Fine Arts and Music, became the founding honorary curators and worked together to identify works for the Collection. Beginning from the perspective of 1960s kinetic art and multiples, they developed an interest in the non-objective and constructive art movements of the twentieth century, such as the English Vorticists, the Russian Suprematists and Constructivists, the Dutch De Stijl Group and the German Bauhaus School.

The first works acquired included Bomberg's drawing *Study for Ju Jitsu*, chairs by Gerrit Reitveld and Le Corbusier, as well as prints by Richard Lohse, Joseph Albers and Victor Vasarely. Since then, the Collection has grown to include over 400 works by artists who engage with basic geometric shapes and bold primary colours. Today there are paintings in the Collection by Richard Bell, Adrian Heath, Richard Lohse, Winifred Nicholson, Trevor Sutton and Paule Vézelay.

A selection of works from the UEA Collection is shown on the West Mezzanine of the Sainsbury Centre.

Sir Colin and Lady Anderson were among the first British collectors of Art Nouveau. Their first pieces were bought in 1960, the last in 1971. During this decade they acquired according to style rather than value, forming a collection that includes not only pieces by leading exponents of Art Nouveau such as the American Louis Comfort Tiffany and the Frenchmen Emile Gallé and René Lalique, but also inexpensive commercially produced items by unknown designers.

Amanda Geitner, Head of Collections and Exhibitions

[1] Due to the format of the current catalogue, all paintings have been listed under one collection heading. Please refer to the Further Information section should you wish to know to which particular collection a specific painting belongs.

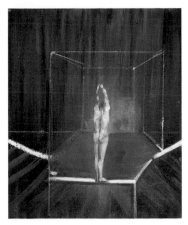

Bacon, Francis 1909–1992
Study of a Nude 1952–1953
oil on canvas 59.7 x 49.5
UEA 29

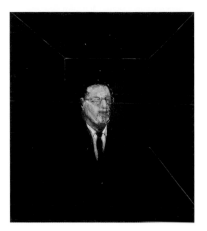

Bacon, Francis 1909–1992
Robert J. Sainsbury 1955
oil on canvas 114.7 x 99.3
RLS 3

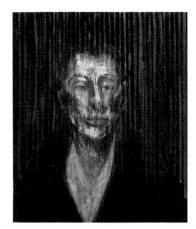

Bacon, Francis 1909–1992
Sketch for 'Lisa' 1955
oil on canvas 61 x 54.9
RLS 4 (P)

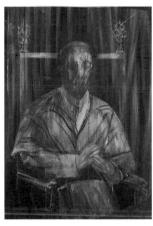

Bacon, Francis 1909–1992
Study (Imaginary Portrait of Pope Pius XII)
1955
oil on canvas, mounted on hardboard
108.6 x 75.6
UEA 30

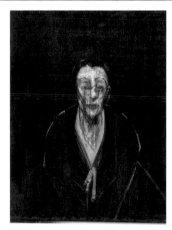

Bacon, Francis 1909–1992
Lisa 1956
oil on canvas 100.6 x 72.7
RLS 5

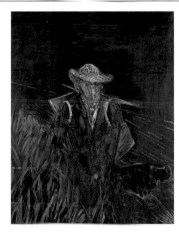

Bacon, Francis 1909–1992
Study for a Portrait of Van Gogh I 1956
oil on canvas 154.1 x 115.6
UEA 31

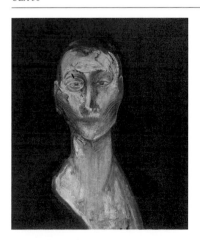

Bacon, Francis 1909–1992
Lisa 1957
oil on canvas 59.7 x 49.5
RLS 6

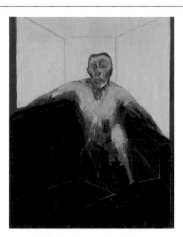

Bacon, Francis 1909–1992
Study for a Portrait of P. L., No.2 1957
oil on canvas 151.8 x 118.5
UEA 32

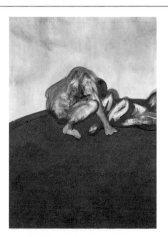

Bacon, Francis 1909–1992
Two Figures in a Room 1959
oil on canvas 197 x 141
UEA 33

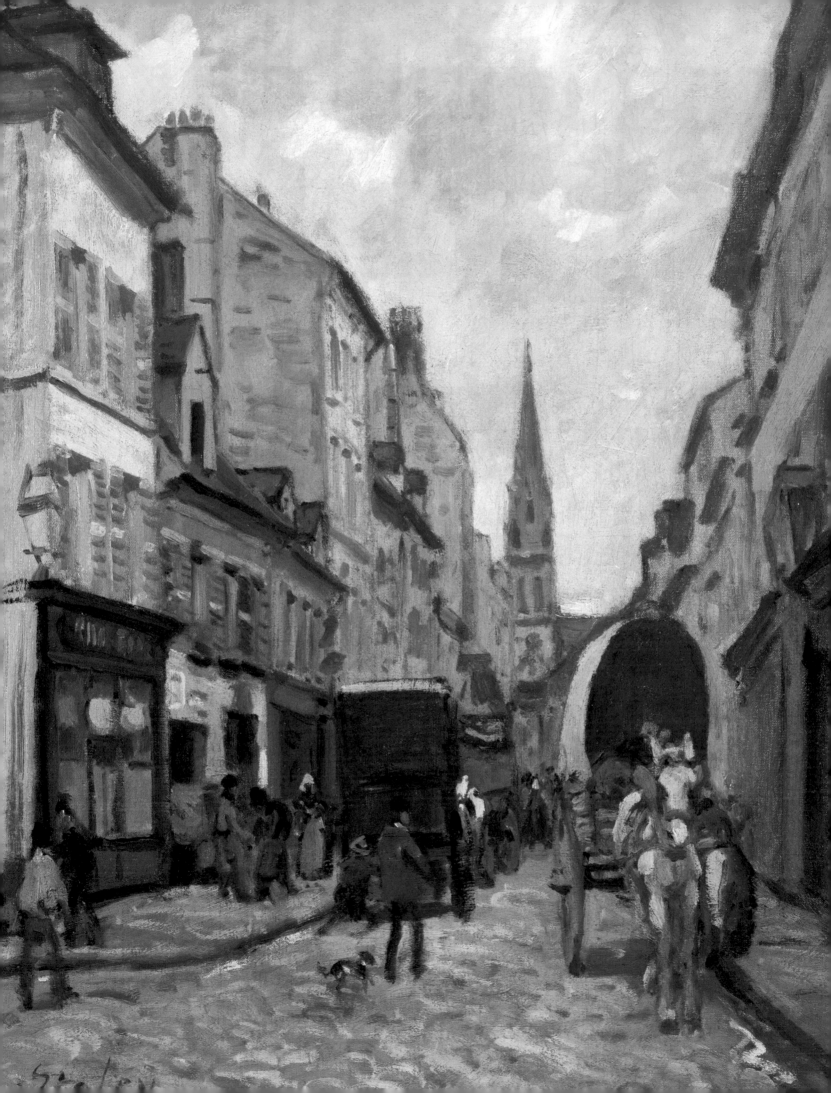

Bacon, Francis 1909–1992
Head of a Man, No.1 1960
oil on canvas 36.5 x 30.5
UEA 34

Bacon, Francis 1909–1992
Head of a Man 1960
oil on canvas 85.2 x 85.2
UEA 35

Bacon, Francis 1909–1992
Head of a Woman 1960
oil on canvas 85.2 x 85.2
UEA 36

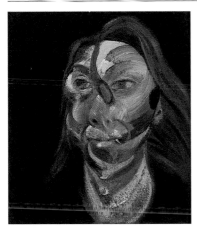

Bacon, Francis 1909–1992
*Three Studies for a Portrait of Isabel
Rawsthorne (panel 1 of 3)* 1965
oil on canvas 35.6 x 30.5
UEA 37

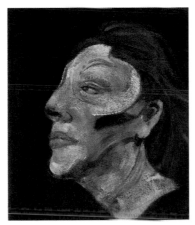

Bacon, Francis 1909–1992
*Three Studies for a Portrait of Isabel
Rawsthorne (panel 2 of 3)* 1965
oil on canvas 35.6 x 30.5
UEA 37

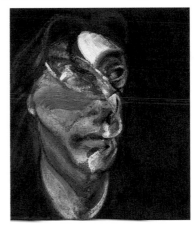

Bacon, Francis 1909–1992
*Three Studies for a Portrait of Isabel
Rawsthorne (panel 3 of 3)* 1965
oil on canvas 35.6 x 30.5
UEA 37

Bell, Richard b.1955
Eight Colour Parts and Surrounds 1986
oil on canvas 82 x 82
UEA 31313a

Bell, Richard b.1955
Eight Colour Parts and Surrounds 1986
oil on canvas 82 x 82
UEA 31313b

Bell, Richard b.1955
Eight Colour Parts and Surrounds 1986
oil on canvas 82 x 82
UEA 31313c

Facing page: Sisley, Alfred, 1839–1899, *A Street Scene (La grande rue à Argenteuil)* (detail), 1872,
Norwich Castle Museum and Art Gallery, (p.192)

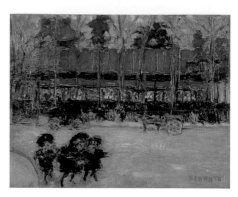

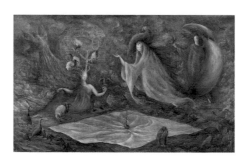

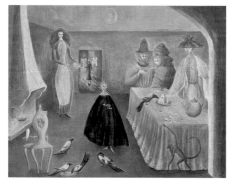

Bell, Richard b.1955
Eight Colour Parts and Surrounds 1986
oil on canvas 82 x 82
UEA 31313d

Bomberg, David 1890–1957
Self Portrait 1930
oil on canvas 40 x 30
UEA 437

Bonnard, Pierre 1867–1947
Paris: Les grands boulevards 1898
oil on canvas 22 x 24.2
RLS 21 (P)

Calliyannis, Manolis b.1923
The Black Sun 1957
oil on canvas 100 x 81.2
SAC 4 (P)

Calmettes, Jean-Marie b.1918
Still Life
oil on wood 73 x 90
SAC 5 (P)

Cameron, Eric b.1935
Painting Type 1d 1968
oil on linen & wood 154.9 x 152.4
UEA 31166

Carrington, Leonora b.1917
The Old Maids 1947
oil on board 58.2 x 73.8
UEA 27

Carrington, Leonora b.1917
The Pomps of the Subsoil 1947
oil on canvas 58.5 x 93
UEA 28

Caughlin, Ian b.1948
Covered Forecourt with People, London Bridge Station 1985
oil on canvas 184.3 x 280.5
UEA 962

Charlett, Nicole b.1957
(Dis) Placements: Corner Locus, No.1 1989
oil on linen & board 40 x 60 (E)
UEA 31310a

Charlett, Nicole b.1957
(Dis) Placements: Corner Locus, No.1 1989
oil on linen & board 60 x 40 (E)
UEA 31310b

Charlett, Nicole b.1957
(Dis) Placements: Corner Locus, No.1 1989
oil on linen & board 60 x 40 (E)
UEA 31310c

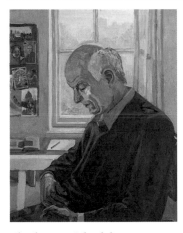

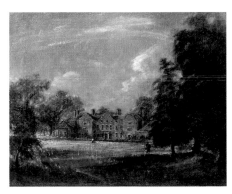

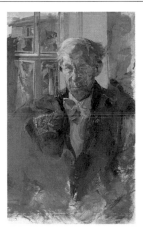

Checketts, Michael b.1960
Willie Guttsman (Founding Librarian at UEA)
1993
oil on canvas 75 x 60
UEA 41387

Davies, Arthur Edward 1893–1967
Earlham Hall 1975
oil on canvas 68 x 81
UEA 41395

Dobson, Cowan 1894–1980
Viscount Mackintosh of Halifax
oil on canvas 85 x 70 (E)
UEA 41355

Dufour, Bernard b.1922
Composition 1957
oil on canvas 92 x 72
SAC 9 (P)

Fautrier, Jean 1898–1964
Small Construction 1957
oil on canvas & paper 50 x 61
SAC 11 (P)

Fautrier, Jean 1898–1964
Coloured Lines 1958
oil on canvas 46 x 55
SAC 10 (P)

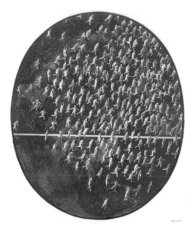

Genovés, Juan b.1930
Untitled 1966
oil on canvas 72.7 x 59.9
UEA 25

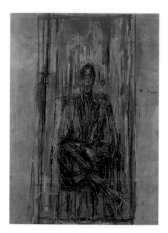

Giacometti, Alberto 1901–1966
Diego Seated 1948
oil on canvas 80.6 x 50.2
UEA 51

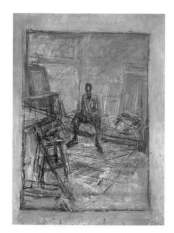

Giacometti, Alberto 1901–1966
Diego 1950
oil on canvas 80 x 58.5
UEA 52

Giacometti, Alberto 1901–1966
The Tree 1950
oil on canvas 80 x 36.5
UEA 53

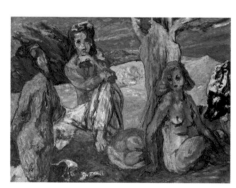

Gotlib, Henryk 1890–1966
Three Nudes in a Landscape 1953
oil on canvas 142.2 x 180
UEA 41389

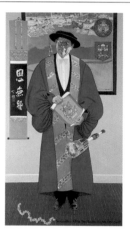

Grant, Keith b.1930
Sir Geoffrey Allen, Chancellor
acrylic on canvas
UEA 41380

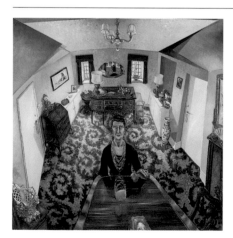

Green, Anthony b.1939
My Mother Alone in Her Dining Room
1975–1976
oil on board 181.5 x 181.5
UEA 753

Green, Anthony b.1939
The Bathroom at Number 29 1979
oil on board 215.5 x 139.5
UEA 754

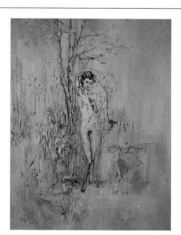

Gruber, Francis 1912–1948
Nude Woman in Landscape 1948
oil on canvas 115.4 x 88.2
UEA 905

Heath, Adrian 1920–1992
Growth of Forms 1951
oil on canvas 112.5 x 50.9
UEA 31337

Heath, Adrian 1920–1992
Composition: Red and Black 1954–1955
oil on canvas 86 x 61
UEA 31188

Hill, Anthony b.1930
Catenary Rhythms (reconstruction of original by Richard Plank) 1982
paper, enamel paint & ink on wood
61.6 x 122.7
UEA 31301

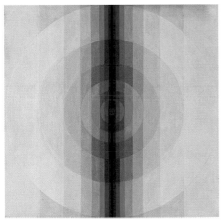

Infante, Francisco b.1943
Interpenetration 1962
tempera on card 24 x 24
L.06 (P)

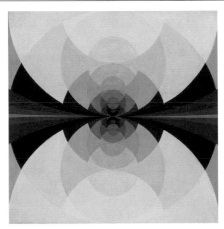

Infante, Francisco b.1943
Medieval Spain 1963
tempera on card 24 x 24
L.08 (P)

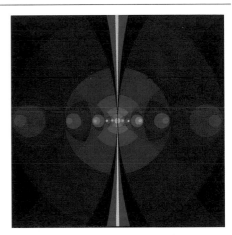

Infante, Francisco b.1943
The Reconquest 1963
tempera on card 24 x 24
L.07 (P)

Jaray, Tess b.1937
Tamlin 1971–1972
acrylic on canvas 213 x 152.5
UEA 31416

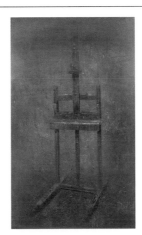

Kuper, Yuri b.1940
The Easel 1982
oil on canvas 247.5 x 147.5
UEA 882

Kuper, Yuri b.1940
Base of a Column 1985
oil on wood 69.7 x 46
UEA 923

Kuper, Yuri b.1940
Box 1985
oil on metal 50
UEA 907

Kuper, Yuri b.1940
Untitled 1986
oil on canvas, wood & perspex 101.6 x 101.6
UEA 966

Kuper, Yuri b.1940
Table with Paint Can 1988
oil on canvas 150 x 150
UEA 970

Kuper, Yuri b.1940
Palette Knife 1990
oil on paper 120 x 120
UEA 1006

Kuper, Yuri b.1940
Three Windows 1990
gesso, tempera & oil on cardboard
41.9 x 53.3
UEA 1007

Kuper, Yuri b.1940
The Window 1991
gesso, tempera & oil on cardboard 50 x 40
UEA 1041

Kuper, Yuri b.1940
Garlics 1998
acrylic on canvas 70 x 90
UEA 1166

Kuper, Yuri b.1940
Tall Grass 1998
acrylic on canvas 50 x 60
UEA 1168

Kuper, Yuri b.1940
Untitled (Large Tulip Flower) 2002
oil on paper on canvas 97 x 130
UEA 1222

Lanskoy, André 1902–1976
Composition 1958
oil on canvas 93.5 x 142
SAC 14 (P)

Latter, Jim b.1945
Triptych 1980
acrylic on paper 90.1 x 64.6
UEA 31272a

Latter, Jim b.1945
Triptych 1980
acrylic on paper 90.1 x 64.6
UEA 31272b

Latter, Jim b.1945
Triptych 1980
acrylic on paper 90.1 x 64.6
UEA 31272c

Lohse, Richard Paul 1902–1988
*Six Systematic Colour Movements from Yellow
to Yellow* 1955–1956
oil on canvas 180 x 30
UEA 31202

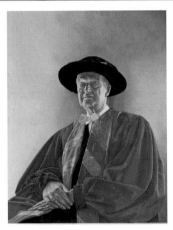

Malin, Suzi b.1950
*The Right Honourable Lord Franks of
Headington* 1984
tempera on board 107 x 84.6
UEA 41287

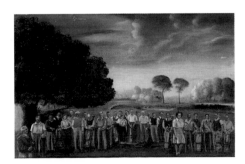

Mann, Stephen John
Earlham Golf Course, 1946 1946
oil on board 63 x 94
UEA 41390

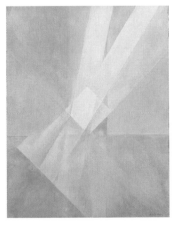

Marq, Charles
Faisceaux 1977
acrylic on paper 69.5 x 54.5
S.66 (P)

Martin, Kenneth 1905–1984
Black Sixes 1967–1968
oil on canvas 14 x 15.3
UEA 31207

Martin, Mary 1907–1969
Tidal Movements 1960
paint on wood 81.2 x 111.8
L.17 A (P)

Martin, Mary 1907–1969
Tidal Movements 1960
paint on wood 81.2 x 111.8 (E)
L.17 B (P)

Martin, Mary 1907–1969
Tidal Movements 1960
paint on wood 81.2 x 111.8
L.17 C (P)

Martin, Mary 1907–1969
Tidal Movements 1960
paint on wood 81.2 x 111.8 (E)
L.17 D (P)

Martin, Mary 1907–1969
Tidal Movements 1960
paint on wood 81.2 x 111.8
L.17 E (P)

Martin, Mary 1907–1969
Tidal Movements 1960
paint on wood 81.2 x 111.8
L.17 F (P)

Maussion, Charles b.1923
Walking Man, No.3 1950
oil & crayon on canvas 203 x 137
UEA 1015

Maussion, Charles b.1923
Untitled 1959
oil on canvas 130.2 x 96.6
SAC 22 (P)

Maussion, Charles b.1923
Untitled 1960
acrylic on canvas 80.5 x 64.4
SAC 18 (P)

Facing page: Frost, Terry, 1915–2003, *October Red Wedge* (detail), 1957, Norwich Castle Museum and Art Gallery, (p.140)

Maussion, Charles b.1923
Untitled 1960
oil on canvas 145.5 x 113
SAC 27 (P)

Maussion, Charles b.1923
The Red Spot 1961
acrylic on canvas 80 x 64
SAC 20 (P)

Maussion, Charles b.1923
Untitled 1961
acrylic on paper 64 x 48.7
SAC 17 (P)

Maussion, Charles b.1923
Untitled 1961
acrylic on canvas 99.4 x 80.2
SAC 21 (P)

Maussion, Charles b.1923
Untitled 1963
oil on canvas 80.1 x 64
SAC 19 (P)

Maussion, Charles b.1923
Head and Shoulders 1974
acrylic on paper 64.5 x 44
UEA 681

Maussion, Charles b.1923
Portrait 1974
acrylic on paper 71 x 53
UEA 750

Maussion, Charles b.1923
Head and Shoulders 1977
acrylic on paper 44.5 x 70.5
UEA 699

Maussion, Charles b.1923
Family Portrait 1978
acrylic on paper 74 x 45
UEA 751

Maussion, Charles b.1923
Four Figures 1978
acrylic on paper 23 x 35
UEA 700

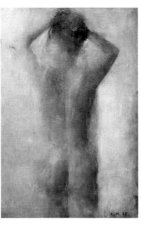

Maussion, Charles b.1923
Back of a Nude 1985
oil on board 22 x 15
S.61 (P)

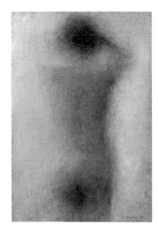

Maussion, Charles b.1923
Back of a Nude 1985
oil on canvas 36.8 x 24.5
UEA 441

Maussion, Charles b.1923
21 Studies of Seagulls 1986
acrylic on paper & board 140 x 100
S.96 (P)

Maussion, Charles b.1923
Seagull 1986
acrylic & pencil on canvas 150 x 150
UEA 1005

Maussion, Charles b.1923
Interior Courtyard 1987
oil on canvas 81 x 130
UEA 967

Maussion, Charles b.1923
Untitled (Two Studies of a Seagull) 1987
acrylic on canvas 12 x 12
P.008 (P)

Maussion, Charles b.1923
Untitled (Two Studies of a Seagull) 1987
acrylic on canvas 12 x 12
P.008 (P)

Maussion, Charles b.1923
Back of a Nude 1990
acrylic & crayon on paper 108 x 72
UEA 1040

Maussion, Charles b.1923
The Large Oak 1991
acrylic & pencil on paper 127 x 100 (E)
UEA 1054

Michaux, Henri 1899–1984
Untitled 1972
indian ink & acrylic on paper 31.7 x 54
UEA 452

Millares, Manolo 1926–1972
Neanderthalio 1970
oil & cloth on canvas 160 x 160
UEA 21

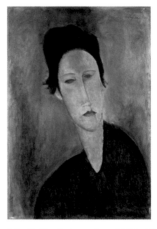

Modigliani, Amedeo 1884–1920
Head of a Woman (Anna Zborowska)
1918–1919
oil on canvas 53.7 x 36.8
UEA 13

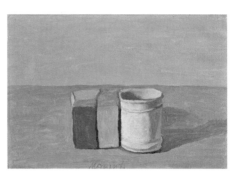

Morandi, Giorgio 1890–1964
Still Life 1954
oil on canvas 26.5 x 41
RLS 22 (P)

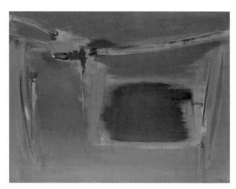

Mübin, Orhon 1924–1981
Paris Gueuse 1959
acrylic on canvas 113.2 x 145.3
SAC 53 (P)

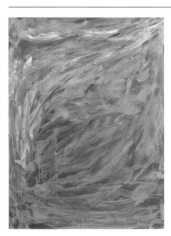

Mübin, Orhon 1924–1981
Untitled 1959
acrylic on canvas 115 x 89
SAC 48 (P)

Mübin, Orhon 1924–1981
Untitled 1959–1960
acrylic on canvas 78.8 x 97.8
SAC 47 (P)

Mübin, Orhon 1924–1981
Untitled 1960
oil on canvas 128.7 x 95.6
SAC 50 (P)

Mübin, Orhon 1924–1981
Untitled 1960
acrylic on canvas 128.6 x 161
SAC 55 (P)

Mübin, Orhon 1924–1981
Untitled 1961
oil on canvas 89.8 x 114.5
SAC 51 (P)

Mübin, Orhon 1924–1981
Untitled 1961
oil on canvas 189 x 199.4 (E)
SAC 59 (P)

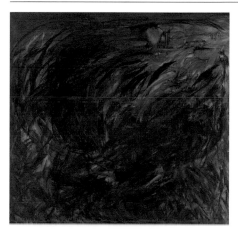

Mübin, Orhon 1924–1981
Triumph of Death III 1962
acrylic on canvas 188 x 199 (E)
SAC 58 (P)

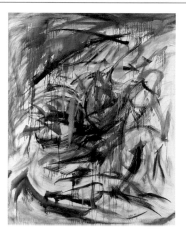

Mübin, Orhon 1924–1981
Homage to Delacroix 1963
acrylic on canvas 160.5 x 129
SAC 56 (P)

Mübin, Orhon 1924–1981
Untitled 1965
oil on canvas 99.5 x 80.5
SAC 46 (P)

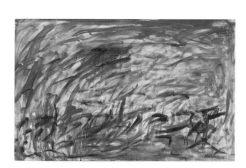

Mübin, Orhon 1924–1981
Untitled 1966
oil on canvas 65.3 x 100.5
SAC 38 (P)

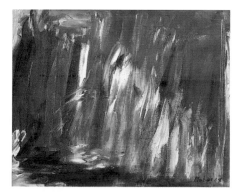

Mübin, Orhon 1924–1981
Untitled 1968
oil on canvas 33 x 41
SAC 32 (P)

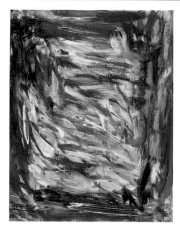

Mübin, Orhon 1924–1981
Untitled 1968
acrylic on canvas 64.8 x 50
SAC 36 (P)

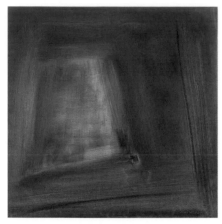

Mübin, Orhon 1924–1981
A Happy Circumstance 1973
acrylic on canvas 80 x 80
SAC 4 (P)

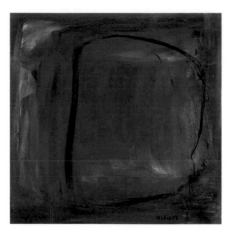

Mübin, Orhon 1924–1981
Pastoral Green 1973
oil on canvas 101 x 100.5
SAC 42 (P)

Mübin, Orhon 1924–1981
Persecuted 1973
acrylic on canvas 100 x 100
SAC 49 (P)

Mübin, Orhon 1924–1981
Untitled 1973
oil on canvas 100.2 x 100.8
SAC 41 (P)

Mübin, Orhon 1924–1981
Untitled 1973
oil on canvas 54.9 x 45.8
SAC 60 (P)

Mübin, Orhon 1924–1981
Untitled
oil on canvas 66 x 54.8
SAC 37 (P)

Mübin, Orhon 1924–1981
Untitled
acrylic on canvas 144.5 x 112.3
SAC 54 (P)

Mübin, Orhon 1924–1981
Untitled
oil on canvas 72.7 x 54
SAC 93 (P)

Music, Zoran 1909–2005
Ida 1988
oil on canvas 73 x 60
UEA 1070

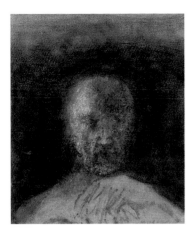

Music, Zoran 1909–2005
Self Portrait 1990
oil on canvas 48 x 38
UEA 1056

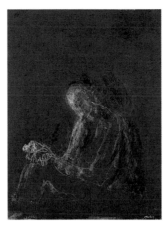

Music, Zoran 1909–2005
Luminous Figure on a Dark Ground 1999
acrylic & pastel on paper 116 x 89
UEA 1194

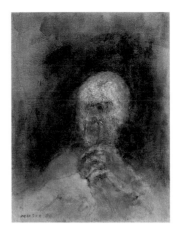

Music, Zoran 1909–2005
Self Portrait
oil on canvas 61 x 46
UEA 1071

Newcomb, Mary b.1922
Woman with Cabbages 1965
oil on board 75.8 x 75.5
UEA 41291

Newcomb, Mary b.1922
Picnic on Gaiety Day before 1981
oil on board 78.7 x 58.5
UEA 41266

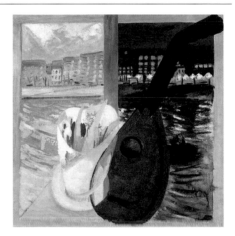

Nicholson, Winifred 1893–1981
Paris Day and Night 1933–1936
oil on board 80 x 80
UEA 31216

Noakes, Michael b.1933
Frank Thistlewaite 1980
oil on canvas
UEA 41357

Ocean, Humphrey b.1951
Professor Owen Chadwick
oil on canvas 99 x 61.5
UEA 41356

Pascin, Jules 1885–1930
The Two Sisters 1926
oil on canvas 61 x 51.2
UEA 17

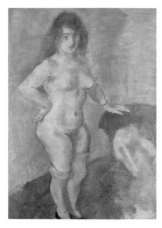

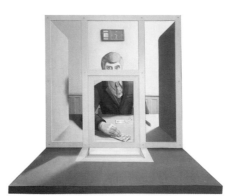

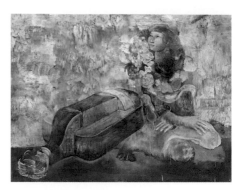

Pascin, Jules 1885–1930
Standing Woman 1928
oil on canvas 101 x 73.5
UEA 16

Redfern, David b.1947
The Bank Clerk
oil on canvas, hardboard & perspex 61 x 81.3
UEA 41264

Risse, Ernest b.1921
Girl, Glass and Flowers
oil on canvas 116 x 148
UEA 41261

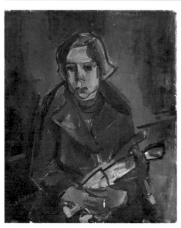

Salvendy, Frieda 1887–1965
Young Girl with a Doll
oil on canvas 62 x 51
UEA 41396

Saura, Antonio 1930–1988
Hiroshima, Mon Amour 1963
oil on canvas 133.4 x 165.1
UEA 23

Saura, Antonio 1930–1988
Shroud 1963
oil on canvas 130.2 x 97.4
UEA 22

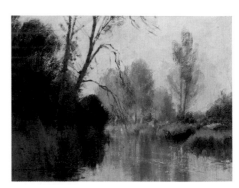

Saura, Antonio 1930–1988
Self Portrait III 1966
oil on canvas 60 x 72
UEA 443

Saura, Antonio 1930–1988
Imaginary Portrait of Philip II 1969
oil on paper 70.2 x 50
UEA 24

Seago, Edward Brian 1910–1974
The River at Earlham
oil on board 66 x 82
UEA 41279

Selim
6 M 1974
oil on wood 41.3 x 27
SAC 88 (P)

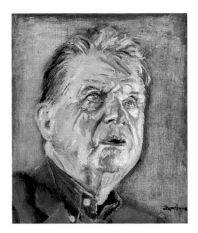

Shenstone, Clare b.1948
Francis Looking up 1980
oil on canvas 26.5 x 23
UEA 1213

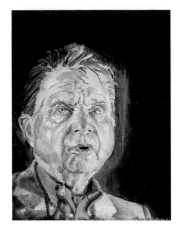

Shenstone, Clare b.1948
Francis with Blue Eyes 1980
oil on canvas 33.5 x 25
UEA 1214

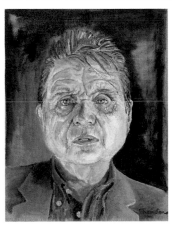

Shenstone, Clare b.1948
Head of Francis 1980
oil on canvas 35.5 x 27
UEA 1215

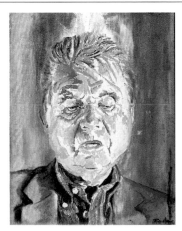

Shenstone, Clare b.1948
Francis Looking down 1982
oil on canvas 35.5 x 27.5
UEA 1216

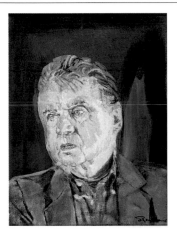

Shenstone, Clare b.1948
Francis Looking Left 1982
oil on canvas 33 x 24.5
UEA 1217

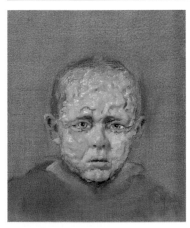

Shenstone, Clare b.1948
Wax Baby 1984
oil & beeswax on canvas 25 x 22
UEA 1224

Shenstone, Clare b.1948
Lady Sainsbury 2003
oil on cotton 101.6 x 116.8
AN 3 (P)

Shenstone, Clare b.1948
Lady Sainsbury 2003
oil on canvas 46 x 33
UEA 1253

Soutine, Chäim 1893–1943
Lady in Blue 1931
oil on canvas 78 x 63
UEA 19

Stevens, Philip b.1953
Dartmoor VI (Clearbrook) 1993
oil on canvas 167.7 x 127
UEA 1104

Stevens, Philip b.1953
Dartmoor Oak 1994
oil on canvas 87.5 x 119.5
S.102 (P)

Stevens, Philip b.1953
Standing Stones I (Avebury) 1994
oil on canvas 152.5 x 127
UEA 1101

Stevens, Philip b.1953
Posthridge 1998
oil on canvas 99 x 167.5
UEA 1155

Stevens, Philip b.1953
Across the Water (study) 2000
acrylic on canvas 107 x 102
S.104 (P)

Stevens, Philip b.1953
Burrator Beeches 2001
acrylic on canvas
S.101 (P)

Stevens, Philip b.1953
Henbury 2001
acrylic on canvas
S.100 (P)

Sutton, Trevor b.1948
Painting A 1980
oil & acrylic on canvas 95 x 171
UEA 31274

Facing page: Shannon, James Jebusa, 1862–1923, *Clare Sewell Read (1826–1905)* (detail), 1897, Norwich Civic Portrait Collection, (p.242)

Tancredi 1927–1964
Untitled
oil on wood 124.6 x 169.6
SAC 89 (P)

Thupinier, Gérald b.1950
Painting No.1 1988
paint on wood & iron 120 x 200
UEA 981

unknown artist 17th C
Triptych
tempera & gold on wood & gesso 19.5 x 23.8
UEA 400

unknown artist
Portrait of a Woman
oil on board 63.5 x 48.5
P 0.24/D.09 (P)

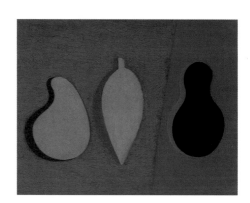

Vézelay, Paule 1893–1984
Three Forms on Pink and Brown 1936
oil on canvas 27 x 35
UEA 31298

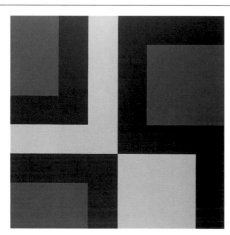

Webb, Mary b.1939
Untitled Painting 1967
oil on canvas 198 x 198
UEA 31242

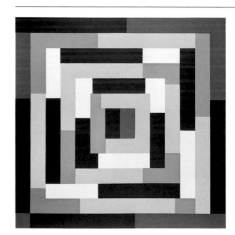

Webb, Mary b.1939
Fritton 1971
oil on canvas 152.5 x 152.5
UEA 31417

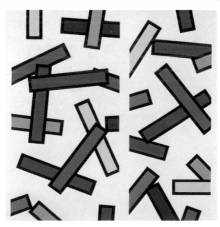

Webb, Mary b.1939
Spring Colour Study No.11 1993
oil on canvas 91.3 x 91.4
UEA 31325

Webb, Mary b.1939
Red, White and Black
acrylic on paper 20.6 x 20.8
UEA 31340A

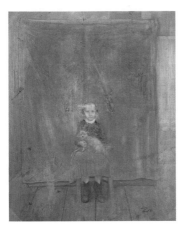

Zaborov, Boris b.1937
Girl with a Dog 1981
acrylic on canvas 147.3 x 114.3
UEA 836

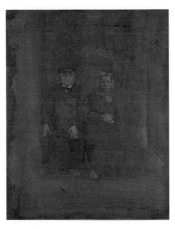

Zaborov, Boris b.1937
Old Man and Old Woman 1981
acrylic on canvas 145.4 x 113.7
UEA 837

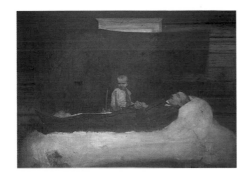

Zaborov, Boris b.1937
The Death of the Father 1982
acrylic on canvas 160.6 x 218.3
UEA 835

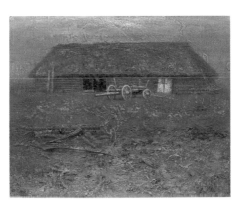

Zaborov, Boris b.1937
Landscape with Cart 1983
acrylic on wood 45.7 x 54.6
UEA 935

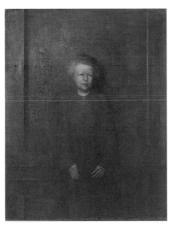

Zaborov, Boris b.1937
Lisa Sainsbury (b.1912) 1985
acrylic on canvas 146 x 111.8
RLS 19 (P)

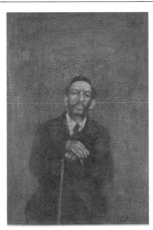

Zaborov, Boris b.1937
The Old Jew 1985
acrylic on paper 78.7 x 53.3
UEA 934

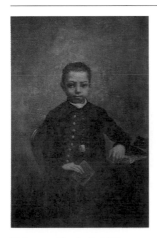

Zaborov, Boris b.1937
Boy with a Book 1985–1986
acrylic on paper 81.5 x 53.3
UEA 938

Zaborov, Boris b.1937
The Little Landscape 1987
oil on canvas 44.1 x 49.2
RLS 34 (P)

Zaborov, Boris b.1937
Japanese Girl 1988
acrylic on canvas 146 x 113.9
UEA 982

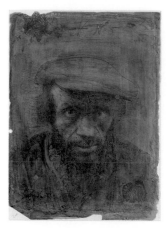

Zaborov, Boris b.1937
Nude with a Chair 1989
acrylic on paper 126.4 x 192
UEA 983

Zaborov, Boris b.1937
Une fille dans l'espace (detail) 1993–1994
acrylic on canvas 220 x 200
UEA 1110

Zaborov, Boris b.1937
Documents No.2 (detail) 1997–1998
acrylic, crayon & collage on paper 60 x 42
UEA 1176

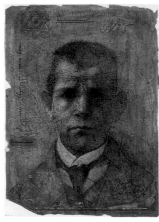

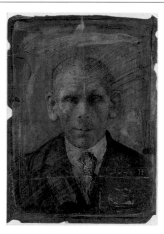

Zaborov, Boris b.1937
Documents No.3 1997–1998
acrylic, crayon & collage on paper 42 x 91
UEA 1182

Zaborov, Boris b.1937
Documents No.5 (detail) 1997–1998
acrylic, crayon & collage on paper 60 x 42
UEA 1178

Zaborov, Boris b.1937
Documents No.7 (detail) 1997–1998
acrylic, crayon & collage on paper 60 x 42
UEA 1177

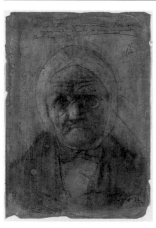

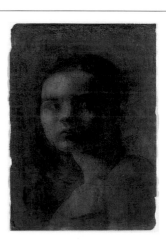

Zaborov, Boris b.1937
Documents No.9 (detail) 1997–1998
acrylic, crayon & collage on paper 60 x 42
UEA 1180

Zaborov, Boris b.1937
Documents No.10 (detail) 1997–1998
acrylic, crayon & collage on paper 60 x 42
UEA 1179

Zaborov, Boris b.1937
Documents No.11 (detail) 1997–1998
acrylic, crayon & collage on paper 60 x 42
UEA 1181

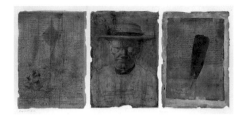

Zaborov, Boris b.1937
Documents No.12 1997–1998
acrylic, crayon & collage on paper 42 x 91
UEA 1183

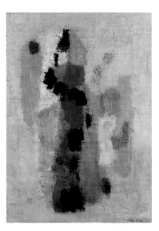

Zack, Léon 1892–1980
Composition 1955
acrylic on canvas 161 x 112
SAC 95 (P)

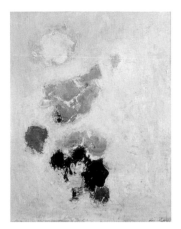

Zack, Léon 1892–1980
Composition 1956
acrylic on canvas 145 x 113
SAC 94 (P)

Zheng Gang, Lou b.1967
Calligraphic Painting
oil on canvas 177.5 x 89
AN 10 (P)

South Norfolk Council

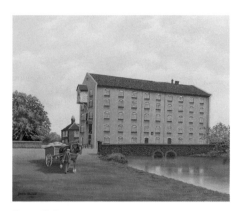

Burrell, James
Costessey Watermill 1994
oil on canvas 48 x 60 (E)
SNC1

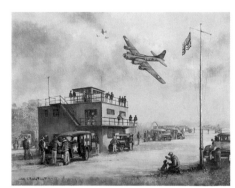

Crowfoot, Joe b.1946
Flak Happy 1993
oil on canvas 46 x 58.5 (E)
SNC2

Sheringham Museum

Sheringham Museum is best known for its collection of photographic oil paintings by the internationally known photographer Olive Edis (1876–1955). Sadly these lie outside of the remit of this catalogue. However, other works of interest in the Museum Collection include paintings by Tom Armes (1894–1963), and Bosworth W. Harcourt (1836–1919) depicting scenes from Sheringham's past. The former settled in Sheringham in 1949 and received commissions from British Railways and Sheringham Urban District Council, both wanting to promote the town as a premier holiday resort.

Armes was interested in 'producing work with a purely local flavour and making records of life about me so that the public can understand what I paint.' Sheringham Museum holds, in addition to the two pictures listed in this catalogue, several of Armes's pen and ink sketches plus two large original railway posters aimed at attracting visitors to the town.

Harcourt's painting of Sheringham Gap recalls an area of the town long lost to the sea and is a timely reminder of the ever rapacious North Sea on our doorstep.

Peter Brooks, Trustee

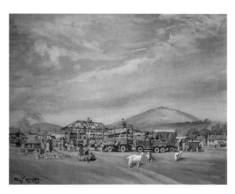

Armes, Thomas William 1894–1963
Fair on Beeston Common
oil on board 47 x 68
SHMMT 1998.29

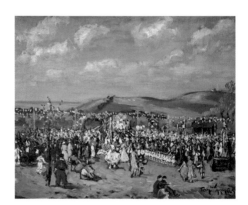

Armes, Thomas William 1894–1963
Sheringham May Fayre
oil on board 49 x 58
SHMMT 1998.30

Cooper, Rosamund active early 1930s–1949
Unknown Fisherman 1949
oil on board 44 x 35
SHMMT 2001.223

Craske, John 1881–1943
Fishing Boat 'Gannet'
oil on old bait box 29.4 x 39.2
SHMMT 1999.38

Harcourt, Bosworth 1836–1914
Sheringham Gap c. 1870
oil on canvas 32 x 48
SHMMT 2005.136

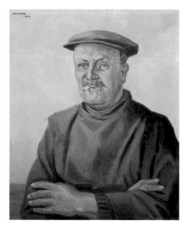

Hudson
James Dumble 1942
oil on canvas 59 x 50
SHMMT 1997.47

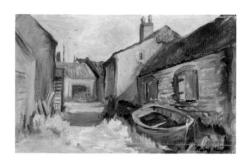

Hunt, Ruby 1903–1993
Cottages: West Slipway
oil on board 29 x 46
SHMMT 2004.8

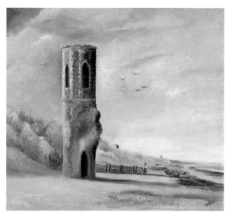

Rump, Charles Frederick active 1893–1921
Eccles Church Tower on Beach
oil on canvas 40 x 45 (F.)
SHMMT 1998.77

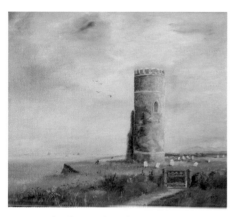

Rump, Charles Frederick active 1893–1921
Sidestrand Church
oil on canvas 40 x 45 (E)
SHMMT 1998.76

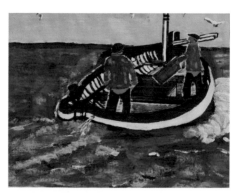

Stacey, Chris
Fishermen in Boat 1994
oil on board 22 x 27
SHMMT 1998.172

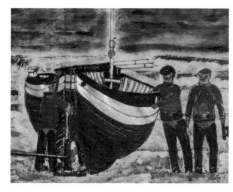

Stacey, Chris
Fishing Boat on Beach with Three Fishermen
1994
oil on board 20 x 25
SHMMT 1998.173

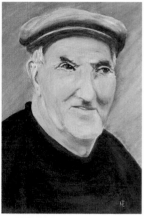

Trigg, Mary
Fisherman Teddy Craske
oil on board 34 x 24
SHMMT 2003.235

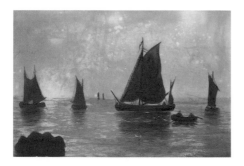

unknown artist 19th C
Seascape
oil on porcelain 19.6 x 29.4
SHMMT 1998.62

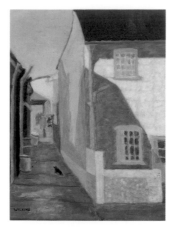

Wilkins, Audrey
Cottages: Lifeboat Plain
oil on board 40 x 30
SHMMT 2005.154

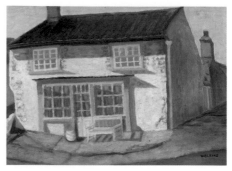

Wilkins, Audrey
Shop on Lifeboat Plain
oil on board
SHMMT 2005.155

William Marriott Museum

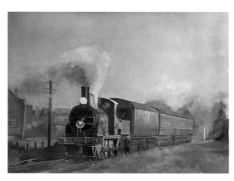

Lilley (Reverend), Ivan active 1979–1980
Recommissioning of the J15 at Sheringham, 1977 c.1979
77 x 103
SHMRM1737

Swaffham Museum

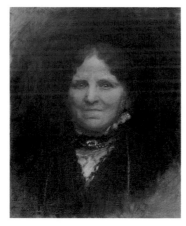

Carter, William 1863–1939
Emma Carter, 1910
oil on canvas 51 x 41
2.5

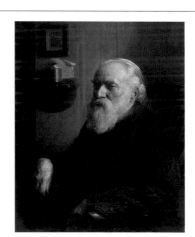

Carter, William 1863–1939
Henry Carter, 1926
oil on canvas 84 x 66 (E)
2.6

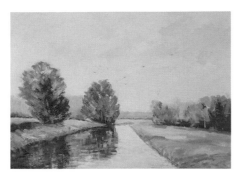

Müller, Max b.1871
Swanton Downham
oil on canvas 41 x 54 (E)
1531

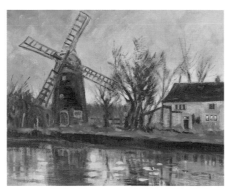

Müller, Max b.1871
Windmill on River Bank
oil on canvas 30 x 37 (E)
1184 (P)

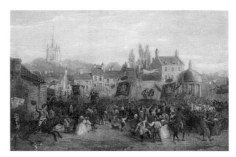

unknown artist
Chairing the Members
oil on board 25.7 x 35.7
1742

Swaffham Town Council

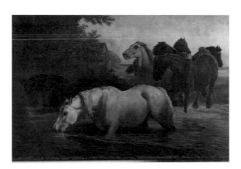

Carter, Samuel John 1835–1892
Snailspit Farm, Cley Road, Swaffham?
oil on canvas
STC 1

Ancient House, Museum of Thetford Life

The Thetford painting collection owes most to Prince Frederick Duleep Singh (1868–1926). It comprises largely portraits and reflects Prince Frederick's own interests in portraiture, heraldry and the story of East Anglia's families and their genealogy.

Prince Frederick's own family history is of particular interest – he was the second son of the Maharajah Duleep Singh who lived at Elveden Hall in Suffolk a few miles from Thetford. Prince Frederick's father had been a child king and was the last Maharajah of the Punjab. His defeat by the British following the Second Sikh wars led him to give up his rights to his kingdom and many of his possessions including the famous Koh-I-Noor diamond. The Punjab became part of the British Empire in India and Duleep Singh was adopted by the British. He moved to England and set up home in East Anglia. On the walls of

Elveden Hall, and later Prince Frederick's home at Blo Norton Hall, were hung the glittering portraits of the Sikh royal family from the Court of Lahore[1]. These portraits are now at the Red Fort in Lahore, Pakistan.

Prince Frederick had been building up his portrait collection, dating from the sixeenth to the nineteenth centuries, for over 20 years when in 1926 he agreed to give 90 of his finest paintings to the Borough of Thetford, an historic market town on the Norfolk-Suffolk border. The portraits were proudly displayed on the walls of Thetford's Guildhall. Such was the excitement in the town that a three-day public holiday was announced for people to come and see the collection. The culmination of Prince Frederick's researches and travels around the region's historic houses was the publication in 1927, just after his death, of *Portraits in Norfolk Houses* edited by Prince Frederick's friend the Reverend Edward Farrer. The Ancient House Museum holds an original copy of this comprehensive catalogue in two edited volumes; an important early record of portraiture in the county.

Prince Frederick's sisters, the Princesses Bamba and Catherine Duleep Singh, gave the remaining paintings from his collection to the town following his death.

For decades the paintings hung on the Guildhall's walls. In the 1950s, perhaps due to changing fashion or taste, it was decided to change the display. The custodians of the Guildhall chose to hang only a few of the portraits and put the others into storage. Eventually they were all taken off display.

The collection was transferred on permanent loan to the then Committee of the Norfolk Museums Service from Thetford Town Council in 1976. Since then, the curatorial care and management of the collection has been undertaken by Norfolk Museums and Archaeology Service with an active conservation programme since the 1980s. Today a selection of the paintings is displayed at the Ancient House Museum (Prince Frederick's other gift to the town) and King's House, Thetford. Opportunities are being sought for other suitable public venues in the locality where more of the collection can be made visible.

As well as the paintings given by Prince Frederick, the Thetford painting Collection includes a few other civic paintings. A striking example is the figure of *Justice* by John Theodorick (1792), given to Thetford by its mayor in the same year. There is also a nineteenth century portrait of Cornell Fison, a radical mayor of Thetford and Victorian entrepreneur of the famous Fison Fertilizer family.

The Collection is considered to be of regional importance and includes work by Thomas Bardwell, Robert Byng, Robert Cardinall, Robert Mendham, Anthony Sandys, and Joseph Clover. A few examples are of national significance whilst others are of more routine quality.

The early portraits include an oil on panel painting of the young *Queen Elizabeth I* by an unknown artist (c.1560). The Queen is shown shortly after her accession and the painting is almost identical to an example in the collection of the National Portrait Gallery, London. It is thought that the Thetford and London paintings might both be studio versions of an original by Hans Ewouts (active 1540–1573).

The British School portrait of *Mr Symonds of Norfolk*, (c.1595–1600), is an important example of an early English equestrian portrait. Set against a view of Norwich, with the Castle and Cathedral clearly depicted, Symonds is shown out

[1] Aijazuddin, F. S., 'Sikh Portraits by European Artists', Sotheby Parke Bernet, London, 1979

hawking with his dogs. It is possible that the sitter may be John Symonds who was buried in St George's, Tombland in Norwich in February 1609. However, 'Symonds' was a common name in Norfolk and Norwich. This portrait has been recognised nationally and was borrowed by the Tate Gallery in 1995/1996 for the exhibition *Dynasties: Painting in Tudor and Jacobean England 1530–1630*. It is described in the accompanying catalogue, edited by Karen Hearn, as 'a remarkable portrait'. The catalogue also notes, 'it is unusual to find such an extensive representation of landscape, particularly a specifically identified one, in a provincial work of this date.'

Also of note is a portrait of *Edward Lewkenor (1614–1634)*, by an unknown imitator of Daniel Mytens (c.1590–1642), from c.1630. The Lewkenor family lived at Denham near Bury St Edmunds, a short distance from Thetford. A Puritan country gentleman, Lewkenor is nevertheless depicted as a rather snappy dresser with breeches and matching cape, a small ruff and ribbon points at his waist. This is significant as the much plainer puritan costume did not become common for another ten years[2].

From the eighteenth century, there is a 1748 portrait by Thomas Bardwell (1704–1767) of Thomas Martin (1697–1771), author of *A History of Thetford*. The self-styled 'Honest Tom Martin of Palgrave' is shown holding an ancient pot symbolising his antiquarian interests. Also by Bardwell is a self portrait of 1765, the only known image of this local artist. Thomas Bardwell lived and worked mainly in East Anglia and wrote a book on painting technique.

A notable painting from the early nineteenth century is the portrait of *Anne, Lady Beechey (b.1764)* by Joseph Clover (1779–1853). Anne Phyllis Jessop, was the second wife of the painter Sir William Beechey (1753–1839) and was herself a painter of miniatures. Joseph Clover was a member of the Norwich School of Artists, specialising in portraiture.

The Collection includes some charming naïve paintings including the portraits of *Isaac Strutt* by John Robert Hobart (1829) and *Joshua Grigby* (c.1760–1829) attributed to the subject's wife, Jane.

In addition to the Bardwell self portrait is one by the artist Robert Mendham (1792–1875) of about 1840. Mendham was born and died at Eye, Suffolk. After serving an apprenticeship in the family coach-making business, he studied at the Royal Academy for several years. He exhibited at the RA and in various shows in Norwich between 1823 and 1860.

From the 1860s is a portrait attributed to Anthony Sandys, a textile dyer and father of the artist Frederick Sandys. The unidentified sitter depicted with parasol and hat on Yarmouth beach could be his daughter Emma (1843–1877), also an artist.

Although predominantly portraits, there are a few other subjects including two paintings of classical landscapes with foreground animals, one with goats and the other with game birds. The game birds are interesting: a great bustard (formerly resident in the Thetford area), a ptarmigan and two partridges are all shown together with a stripy lizard.

An exhibition about the history and conservation of the collection, *Saving Faces*, was held at the Ancient House in 1995 and toured to three further venues.

Oliver Bone, Curator

[2] Moore, Andrew with Crawley, Charlotte, *Family and Friends A Regional Survey of British Portraiture*, Norfolk Museums Service, London, 1992

Arrowsmith, Thomas (attributed to)
1772–c.1829
Self Portrait?
oil on canvas 36 x 31
THEHM : DS.198

Bardwell, Thomas 1704–1767
Thomas Martin of Palgrave 1748
oil on canvas 76.5 x 63.5
THEHM : DS.178

Bardwell, Thomas 1704–1767
Self Portrait 1765
oil on canvas 74 x 61.5
THEHM : DS.2

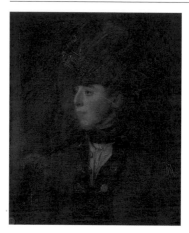

Beechey, William (attributed to) 1753–1839
William Crofts
oil on canvas 73.5 x 61
THEHM : DS.14

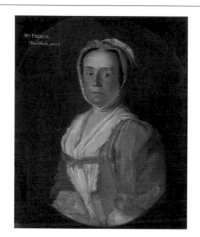

Black, Thomas
Mrs French 1670
oil on canvas 76.5 x 63
THEHM : DS.74

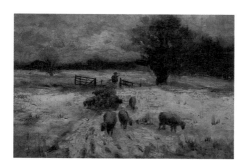

Brooks, H. active 1816–1836
Landscape
oil on canvas 31 x 46
THEHM : 1978.260.11

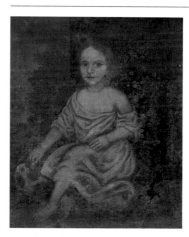

Brooks, J. (attributed to)
Portrait of a Child 1709
oil on canvas 77 x 65
THEHM : DS.79

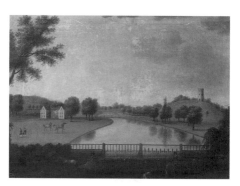

Browne, Joseph 1720–1800
Costessey Hall
oil on canvas 50.3 x 65.7
THEHM : DS.X.100

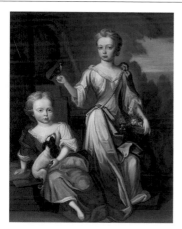

Byng, Robert 1666–1720
The Misses Jacob 1716
oil on canvas 128.5 x 104
THEHM : DS.36

Facing page: Western, Charles, active 1884–1900, *View of Cromer from the Beach* (detail), 1899, Cromer Town Council, (p.5)

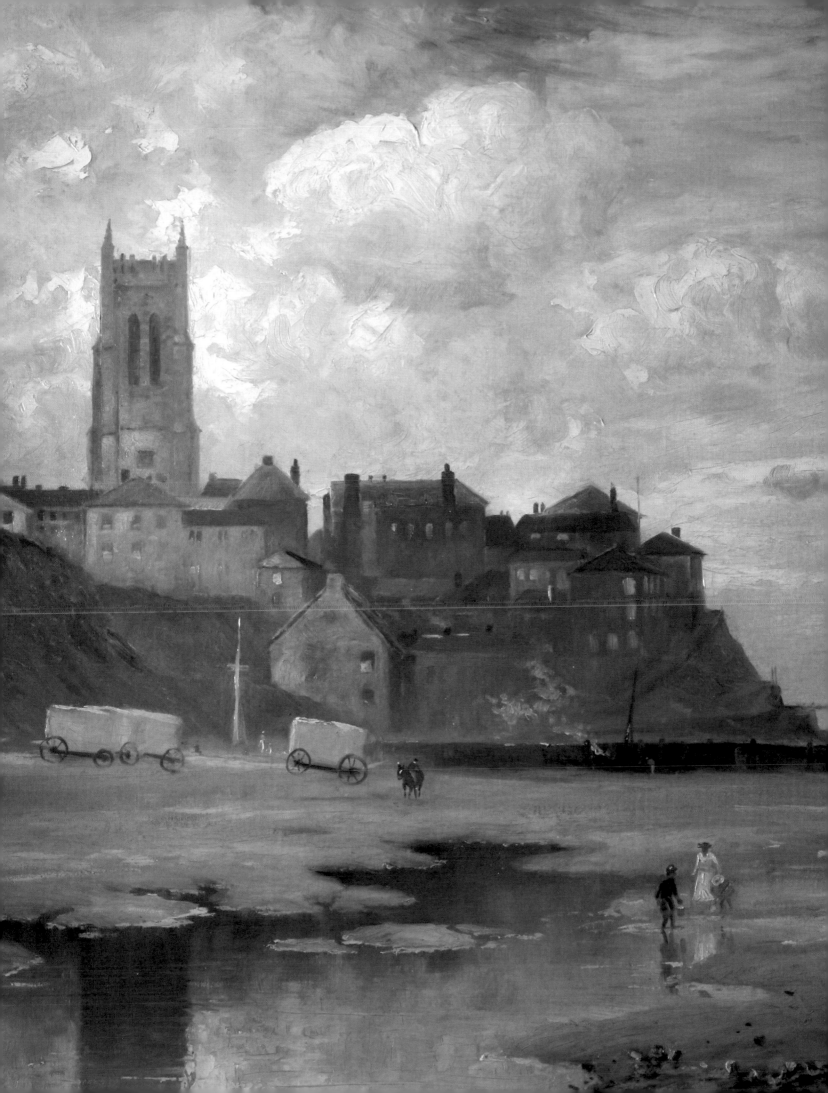

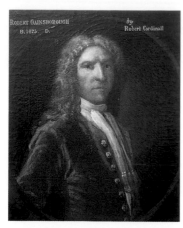

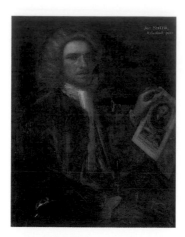

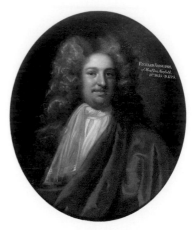

Cardinall, Robert active 1729–1730
Robert Gainsborough (b.1673) 1729
oil on canvas 32.7 x 27
THEHM : DS.21

Cardinall, Robert active 1729–1730
Joseph Smith
oil on canvas 88 x 67
THEHM : DS.97

Cardinall, Robert (attributed to)
active 1729–1730
Richard Anguish of Moulton (1655–1725)
oil on canvas 76 x 63
THEHM : DS.1

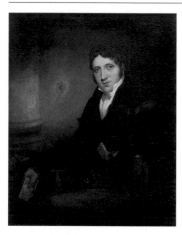

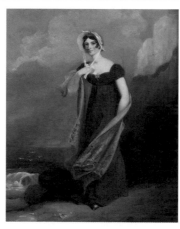

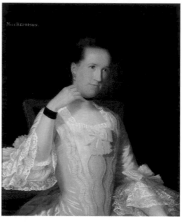

Clint, Alfred (attributed to) 1807–1883
John Sell Cotman (1782–1842) 1820–1850
oil on millboard 38 x 30
THEHM : DS.12

Clover, Joseph 1779–1853
Anne, Lady Beechey (b.1764) 1800–1840
oil on canvas 54 x 43
THEHM : DS.102

Dupont, Gainsborough 1754–1797
Miss Kerrison 1790
oil on canvas 73 x 60
THEHM : DS.39

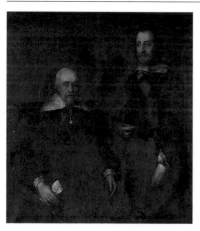

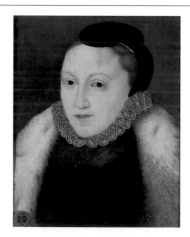

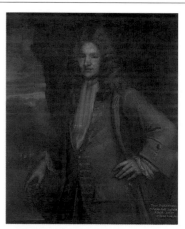

Dyck, Anthony van (circle of) 1599–1641
*Sir Ralph Hopton and His Father Robert
Hopton* 1600–1641
oil on canvas 146 x 129.2
THEHM : DS.96

Ewouts, Hans c.1525–after 1578
Queen Elizabeth I (1533–1603) 1560
oil on wood 35.5 x 27.6
THEHM : DS.22

Gage, Henry
*Thomas Rookwood of Coldham Hall, Suffolk
(1658–1728)* 1713
oil on canvas 125 x 100
THEHM : DS.55

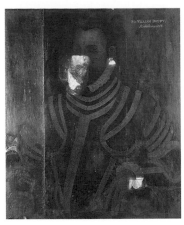

Gower, George (copy of) c.1540–1596
Sir William Drury (1527–1579) c.1575
oil on panel 81.5 x 65
THEHM : DS.18

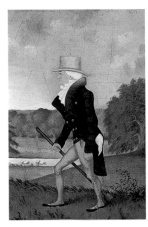

Grigby, Jane (attributed to) active 1800–
1829
Joshua Grigby (c.1760–1829)
oil on wood 22 x 15.5
THEHM : DS.23

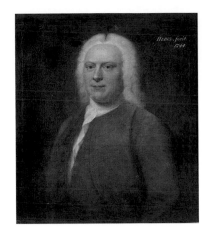

Heins, John Theodore Sr 1697–1756
Portrait of a Man 1744
oil on canvas 72 x 61
THEHM : DS.87

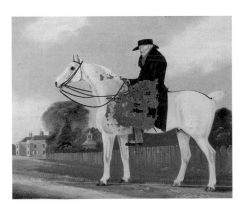

Hobart, John R. 1788–1863
Isaac Strutt 1829
oil on canvas 38 x 46
THEHM : DS.62

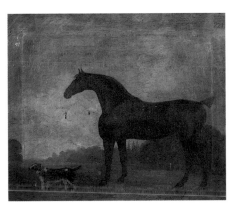

Hobart, John R. 1788–1863
Horse and Dog
oil on canvas 43 x 50
THEHM : 1976.513

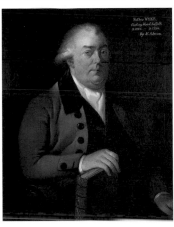

Johnson, William active 1780–1810
Father Wyke (1729–1799)
oil on canvas 76.2 x 63.5
THEHM : DS.69

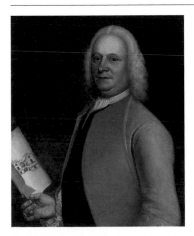

Keddington, Elizabeth active 18th C
John Howes of Morningthorpe
oil on canvas 75 x 61
THEHM : DS.30

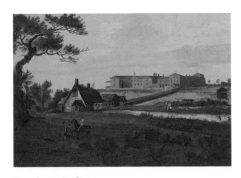

Kerrison, Robert
View of Gressenhall Union 1810
oil on canvas 32.7 x 46.7
THEHM : 1976.178

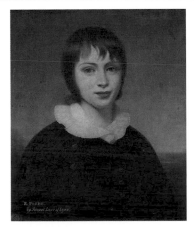

Lane, Samuel 1780–1859
Edward Frere 1820–1835
oil on canvas 62 x 51
THEHM : DS.20

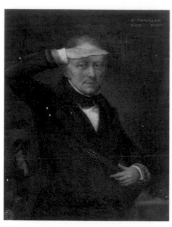

Mendham, Robert 1792–1875
Self Portrait c.1850
oil on canvas 44.5 x 35
THEHM : DS.51

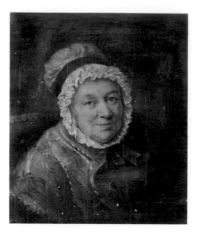

Mendham, Robert 1792–1875
Mrs Mendham, the Artist's Mother
oil on canvas 78.7 x 68.5
THEHM : DS.52

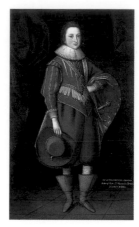

Mytens, Daniel (imitator of) c.1590–before
1648
Edward Lewkenor of Denham Hall, Suffolk
c.1630
oil on canvas 163 x 98.5
THEHM : DS.41

Os, Jan van (attributed to) 1744–1808
Still Life
oil on canvas 66 x 56
THEHM : 1978.260.19

Otway, Edward (Captain)
Martha Otway, Sister of the Artist
oil on board 23 x 18
THEHM : 1979.214

Paul, Joseph (attributed to) 1804–1887
Landscape
oil on canvas 17 x 30
THEHM : 1978.260.7

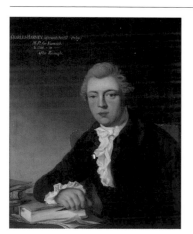

Reinagle, Philip (after) 1749–1833
Charles Harvey, MP for Norwich (b.1756)
oil on canvas 75 x 64
THEHM : DS.25

Roe, Robert Ernest 1852–1921
Sea Scene
oil on canvas 31 x 61
THEHM : 1978.260.18

Romney, George 1734–1802
Thomas Paine (1737–1809)
oil on wood 23 x 19.5
THEHM : DS.144

Roods, Thomas active 1833–1867
Miss Georgina (Bessie) Bale (d.1905) 1865
oil on canvas 49 x 38.5
THEHM : 1979.210a

Roods, Thomas active 1833–1867
Miss Louisa Ellen Bale (d.1925) 1865
oil on canvas 46.5 x 36
THEHM : 1979.210b

Sandys, Anthony (attributed to) 1806–1883
Yarmouth Beach 1860–1865
oil on canvas 36 x 46
THEHM : DS.110

Theodorick, John
Justice 1792
oil on canvas 164 x 102
THEHM : Civic; Justice

unknown artist
Dr John Caius (1510–1573) 1540–1559
oil on canvas 70 x 59
THEHM : DS.9

unknown artist
*Thomas Howard, 4th Duke of Norfolk, KG
(d.1572)* c.1560
oil on wood 106 x 74
THEHM : DS.32

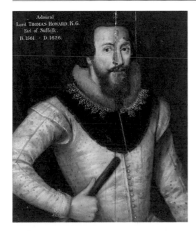

unknown artist
*Admiral Lord Thomas Howard, KG, 1st Earl of
Suffolk (1561–1626)* 1580–1610
oil on canvas 71.5 x 60.5
THEHM : DS.34

unknown artist
Mr Symonds 1590–1600
oil on wood panel 76 x 97
THEHM : DS.63

unknown artist 16th C
Portrait of a Man with a Lace Collar
oil on wood 44 x 25
THEHM : 1979.202

unknown artist 16th C
Portrait of an Elizabethan Lady
oil on wood 49.5 x 36
THEHM : DS.193

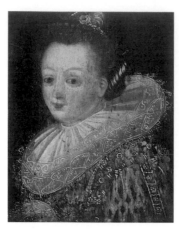

unknown artist 16th C
Possibly Lady Marchant
oil on wood 25.5 x 20
THEHM : 1979.208

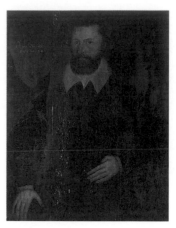

unknown artist
Man of the Shelton Family 1601
oil on wood 95 x 73.5
THEHM : DS.59

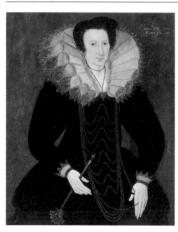

unknown artist
Portrait of a Lady of the Shelton Family 1601
oil on wood 93.5 x 74
THEHM : DS.60

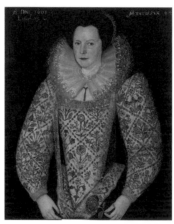

unknown artist
Lady Littlebury c.1601
oil on wood 90.5 x 73.5
THEHM : DS.184

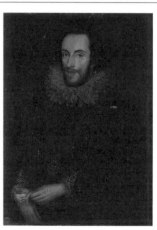

unknown artist
Thomas Howard, Earl of Arundel (1586–1686)
c.1612
oil on canvas 89.3 x 68
THEHM : DS.33

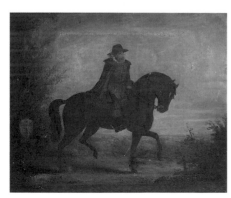

unknown artist
Mr Hobson 1620
oil on canvas 50 x 60.5
THEHM : DS.91

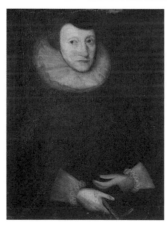

unknown artist
Mrs Redmayne 1624
oil on canvas 74 x 56
THEHM : DS.54

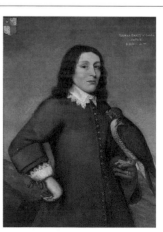

unknown artist
Thomas Dandy of Combs, Suffolk 1650–1655
oil on canvas 95 x 71
THEHM : DS.16

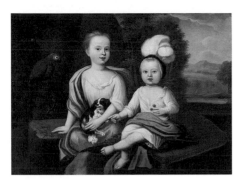

unknown artist
Young Children with Spaniel and Parrot
1650–1699
oil on canvas 88.5 x 118
THEHM : DS.70

unknown artist
Mrs Henry Shelton 1650–1700
oil on canvas 76 x 62.5
THEHM : DS.58

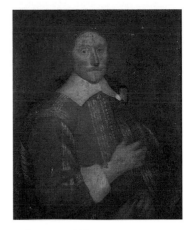

unknown artist
Portrait of a Man c.1655
oil on canvas 79.5 x 64.5
THEHM : DS.72

unknown artist
Portrait of a Man c.1655
oil on canvas 71 x 54
THEHM : DS.73

unknown artist
Portrait of a Man 1660–1740
oil on canvas 74 x 61.5
THEHM : 1979.200

unknown artist
Portrait of a Child of the Wenyeve Family
c.1680
oil on canvas 76.3 x 63.2
THEHM : DS.68

unknown artist
Mrs Edward Colman (d.1691) 1695
oil on canvas 110 x 84.5
THEHM : DS.10

unknown artist 17th C
Group of Men with Children and Cherubs
oil on wood 44 x 33
THEHM : 1978.336b

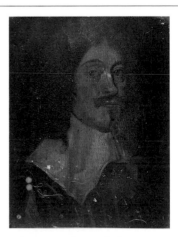

unknown artist 17th C
Head of a Cavalier
oil on wood 31.5 x 25
THEHM : 1979.198

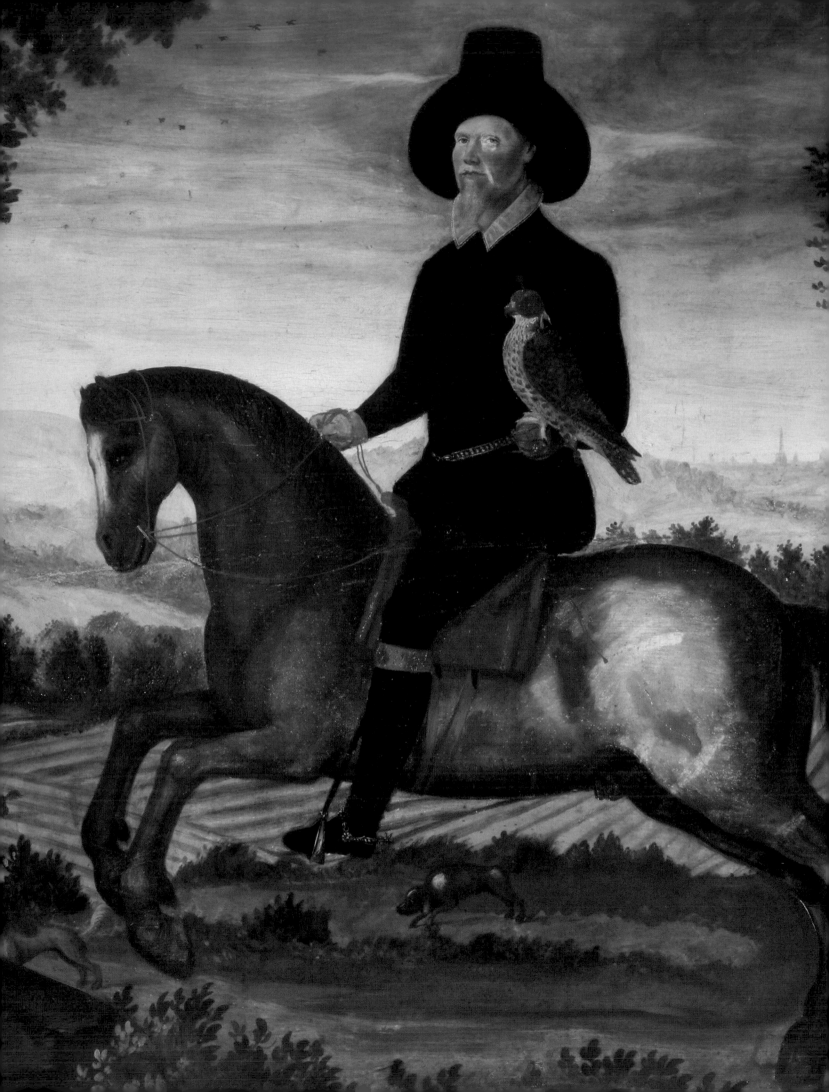

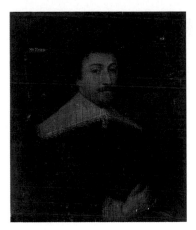

unknown artist 17th C
Mr Reed
oil on canvas 72.5 x 61
THEHM : 1976.515

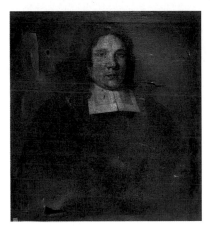

unknown artist 17th C
Portrait of a Man
oil on canvas 66.5 x 59.5
THEHM : 1979.197

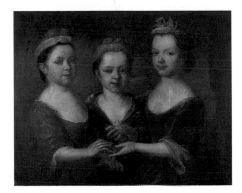

unknown artist
The Misses Decker (Catherine, Henrietta &
Mary) 1700–1737
oil on canvas 69 x 85
THEHM : DS.17

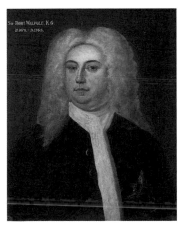

unknown artist
Sir Robert Walpole (1676–1745) 1700–1745
oil on canvas 69 x 54.7
THEHM : DS.94

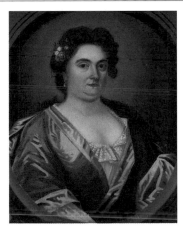

unknown artist
Miss Elizabeth Blomfield (b.1674) c.1700
oil on canvas 76.5 x 63.5
THEHM : DS.5

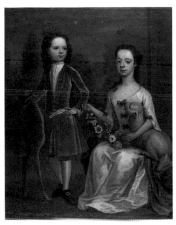

unknown artist
The Jacob Children, John and Elizabeth Jacob
c.1700
oil on canvas 137 x 107
THEHM : DS.35

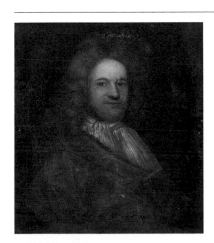

unknown artist
Portrait of a Man c.1707
oil on canvas 75 x 64
THEHM : DS.80

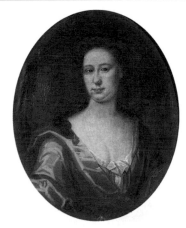

unknown artist
Portrait of a Lady 1710
oil on canvas 76 x 63
THEHM : DS.83

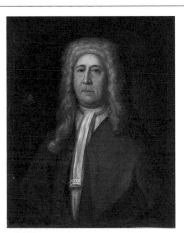

unknown artist
John Howes of Morningthorpe c.1710
oil on canvas 75 x 62.5
THEHM : DS.29

Facing page: unknown artist, *Mr Symonds* (detail), 1590–1600, Ancient House, Museum of Thetford Life, (p.287)

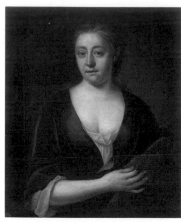

unknown artist
Portrait of a Lady c.1710
oil on canvas 76.3 x 63
THEHM : DS.81

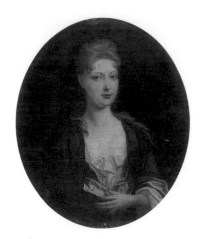

unknown artist
Portrait of a Lady c.1710
oil on canvas 76.5 x 63
THEHM : DS.82

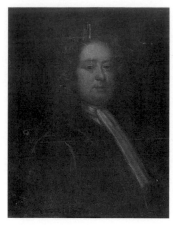

unknown artist
Robert Harvey of Old Buckenham c.1710
oil on canvas 74 x 57
THEHM : DS.27

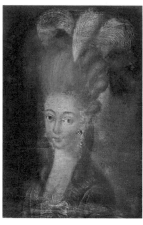

unknown artist
Portrait of a Lady 1714–1727
oil on canvas 25 x 17.5
THEHM : 1979.205

unknown artist
Sir Robert Walpole and Hounds 1715
oil on canvas 105.5 x 162
THEHM : DS.65

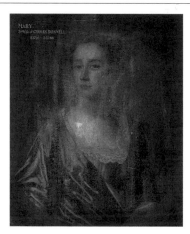

unknown artist
Mary Barnwell (1700–1786) c.1725
oil on canvas 76.5 x 63.8
THEHM : DS.4

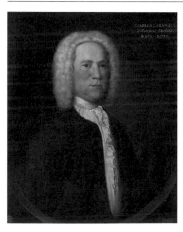

unknown artist
Charles Barnwell of Mileham (1679–1750)
1730
oil on canvas 75.7 x 62.7
THEHM : DS.3

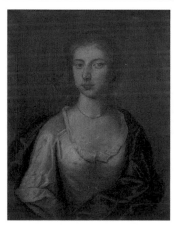

unknown artist
Mrs Robert Harvey c.1730
oil on canvas 74 x 57
THEHM : DS.28

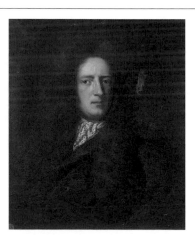

unknown artist
Portrait of a Man c.1740
oil on canvas 74.5 x 62.5
THEHM : DS.93

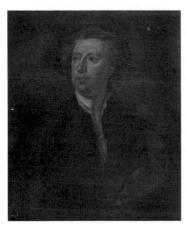

unknown artist
Portrait of a Man c.1750–1760
oil on canvas 76 x 63.5
THEHM : DS.88

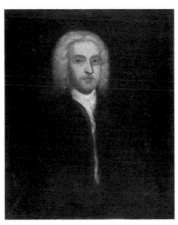

unknown artist
Portrait of a Man c.1760
oil on canvas 76 x 63
THEHM : DS.89

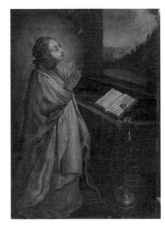

unknown artist early 18th C
Female Saint
oil on wood 36 x 26
THEHM : 1978.336a

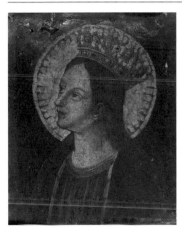

unknown artist early 18th C
Female Saint
oil on canvas 54 x 41.5
THEHM : 1978.336c

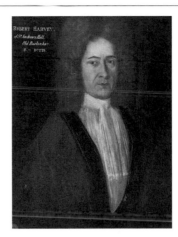

unknown artist early 18th C
*Robert Harvey of St Andrew's Hall, Old
Buckenham (d.1718)*
oil on canvas 70 x 56
THEHM : DS.26

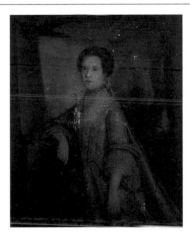

unknown artist 18th C
A Lady of the Keppel Family
oil on canvas 124 x 97.2
THEHM : DS.37

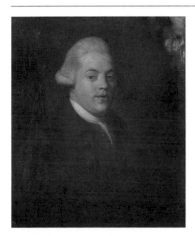

unknown artist 18th C
Charles Crofts
oil on canvas 75 x 62.5
THEHM : DS.13

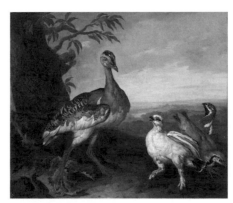

unknown artist 18th C
Game Birds
oil on canvas 74.5 x 89
THEHM : DS.95

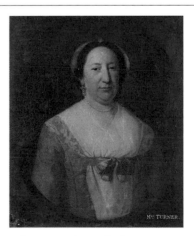

unknown artist 18th C
Mrs Turner
oil on canvas 76 x 64
THEHM · DS.64

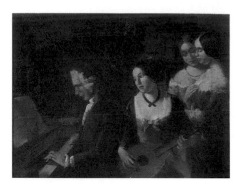

unknown artist 18th C
Musicians
oil on canvas 30.5 x 41
THEHM : 1978.260.17

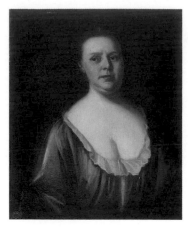

unknown artist 18th C
Portrait of a Lady
oil on canvas 73.5 x 61
THEHM : DS.77

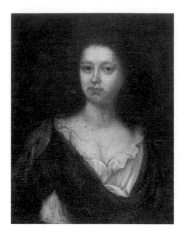

unknown artist 18th C
Portrait of a Lady
oil on canvas 66.5 x 52.7
THEHM : DS.78

unknown artist 18th C
Portrait of a Lady
oil on canvas 76 x 63
THEHM : DS.182

unknown artist 18th C
Portrait of a Lady
oil on canvas 72 x 59.5
THEHM : 1979.199

unknown artist 18th C
Portrait of a Lady of the Wenyeve Family of Brettenham
oil on canvas 76.5 x 62.5
THEHM : DS.66

unknown artist 18th C
Portrait of a Lady of the Wenyeve Family of Brettenham
oil on canvas 76.3 x 62.5
THEHM : DS.67

unknown artist 18th C
Portrait of a Man
oil on canvas 47 x 39
THEHM : DS.75

unknown artist 18th C
Portrait of a Man
oil on canvas 74 x 64
THEHM : DS.76

unknown artist 18th C
Portrait of a Man
oil on canvas 87 x 68
THEHM : DS.98

unknown artist 18th C
Portrait of a Man
oil on canvas 95 x 73
THEHM : DS.179

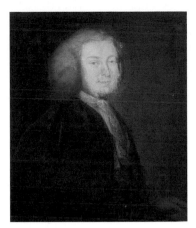

unknown artist 18th C
Portrait of a Man
oil on canvas 75.5 x 64.5
THEHM : DS.192

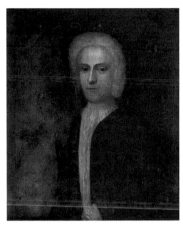

unknown artist 18th C
Portrait of a Man
oil on canvas 74 x 61
THEHM : DS.200

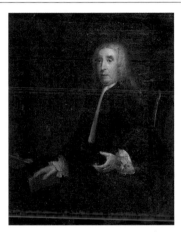

unknown artist 18th C
Portrait of a Man
oil on canvas 35.5 x 28.5
THEHM : 1979.224

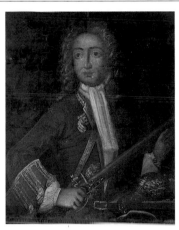

unknown artist 18th C
Portrait of a Man with a Pheasant
oil on canvas 76 x 65
THEHM : DS.181

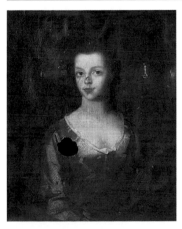

unknown artist 18th C
Portrait of a Woman
oil on canvas 75 x 62
THEHM : DS.194

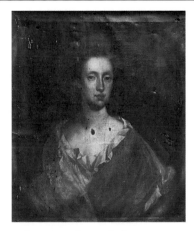

unknown artist 18th C
Portrait of a Woman
oil on canvas 76 x 62.5
THEHM : DS.195

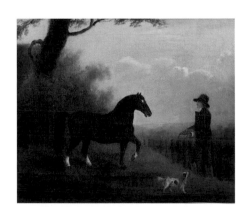

unknown artist late 18th C
Man and Horse
oil on canvas 51 x 61
THEHM : DS.99

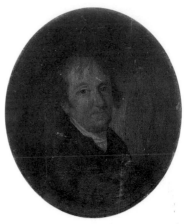

unknown artist late 18th C
Portrait of a Man
oil on wood 32 x 27
THEHM : 1979.201

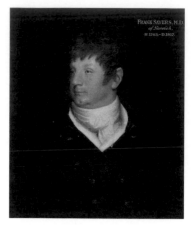

unknown artist
Frank Sayers, MD of Norwich (1763–1817)
c.1800
oil on canvas 76.5 x 63.5
THEHM : DS.56

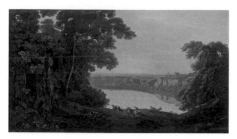

unknown artist
Landscape with Lake and Goats c.1800
oil on canvas 84 x 147
THEHM : DS.189

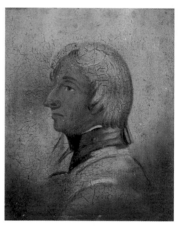

unknown artist
Lord Nelson (1758–1805) c.1800
oil on wood 14 x 10
THEHM : 1998.3.3

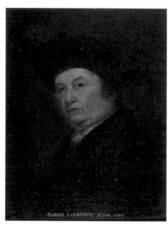

unknown artist
Robert Ladbrooke (1768–1842) c.1810
oil on canvas 51 x 41
THEHM : DS.40

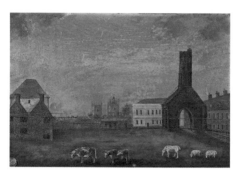

unknown artist early 19th C
Greyfriars Tower, King's Lynn
oil on wood 49.5 x 65.3
THEHM : DS.118

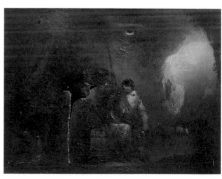

unknown artist early 19th C
Men in a Cave
oil on canvas 40.5 x 51
THEHM : 1978.260.12

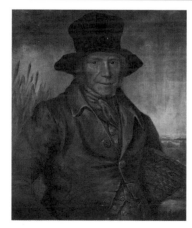

unknown artist early 19th C
Portrait of a Country Man
oil on canvas 76 x 63.5
THEHM : DS.191

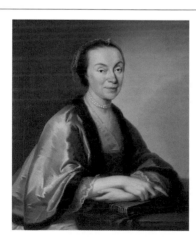

unknown artist early 19th C
Portrait of a Lady
oil on canvas 76 x 63.5
THEHM : DS.183

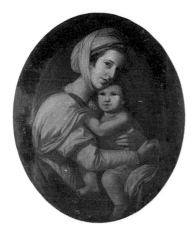

unknown artist early 19th C
Possibly Madonna and Child
oil on canvas 90 x 75
THEHM : 1979.196

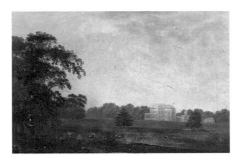

unknown artist early 19th C
Stately Home
oil on canvas 28.8 x 45.2
THEHM : DS.117

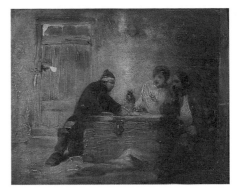

unknown artist 19th C
Interior with Figures
oil on canvas 23 x 27
THEHM : 1978.260.16

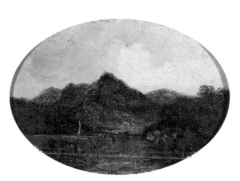

unknown artist 19th C
Landscape
oil on canvas 25 x 34.5
THEHM : 1978.260.6

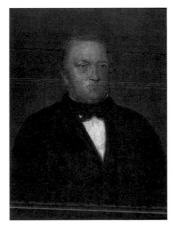

unknown artist 19th C
Portrait of a Man
oil on wood 36 x 27
THEHM : 1979.215

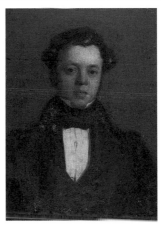

unknown artist 19th C
Portrait of a Young Victorian Man
oil on board 40.5 x 30.5
THEHM : 1979.216

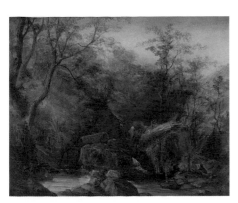

unknown artist mid-19th C
Mountain Stream
oil on canvas 30 x 36
THEHM : 1978.260.9

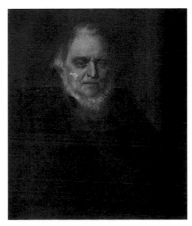

unknown artist late 19th C
Cornell Fison
oil on canvas 76.2 x 63.5 (E)
THEHM : Civic; Cornell Fison

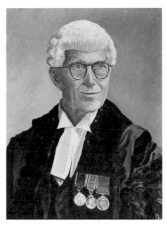

unknown artist
George Richard Blaydon 1950
oil on canvas 61 x 45.7
THEHM : Civic; Blaydon

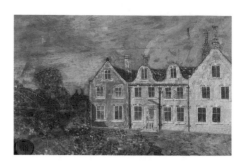

unknown artist 20th C
Norfolk House
oil on wood 24.5 x 36
THEHM : DS.119

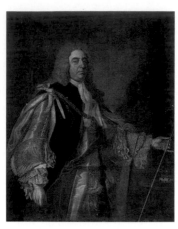

unknown artist
Charles Fitzroy, 2nd Duke of Grafton
oil on canvas 172.7 x 142.2
THEHM : Civic; Grafton

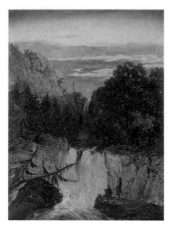

unknown artist
Landscape
oil on canvas 31 x 22.5
THEHM : 1978.260.4

unknown artist
Landscape
oil on canvas 18 x 32
THEHM : 1978.260.5

unknown artist
Landscape
oil on oak panel 58.5 x 46.5
THEHM : 1978.260.13

unknown artist
Landscape
oil on canvas 15 x 33
THEHM : 1978.260.14

unknown artist
Portrait of a Victorian Man
oil on board 28.5 x 23.5
THEHM : 1979.207a

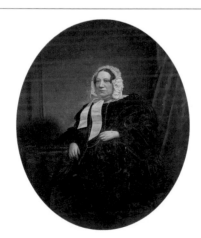

unknown artist
Portrait of a Victorian Woman
oil on board 28.5 x 23.5
THEHM : 1979.207b

unknown artist
Possibly Christ
oil on wood 19.5 x 26
THEHM : 1976.516

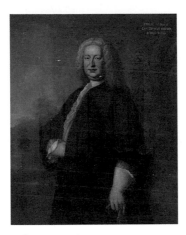

unknown artist
*The Honourable Philip Howard, 5th Son of
Lord Thomas Howard (1688–1750)*
oil on canvas 126 x 98.5
THEHM : DS.31

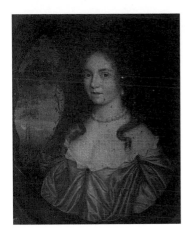

White, George (attributed to) c.1684–1732
Portrait of a Lady 1700–1730
oil on canvas 72.5 x 57
THEHM : DS.84

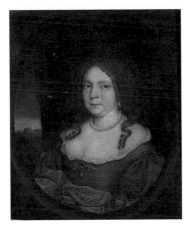

White, George (attributed to) c.1684–1732
Portrait of a Lady
oil on canvas 76.5 x 63.5
THEHM : DS.85

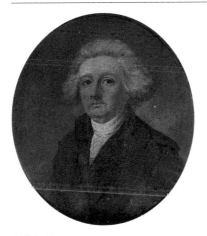

Wilde, D.
Gabriel Lepipre 1787
oil on canvas 21 x 18.5
THEHM : DS.101

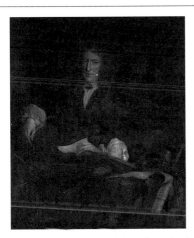

Wright, John Michael (attributed to)
1617–1694
Sir Robert Le Strange
oil on canvas 123 x 103
THEHM : DS.92

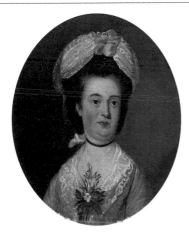

Wright, Joseph 1756–1793
Mrs Oliver of Sudbury 1771–1793
oil on canvas 30.5 x 25.5
THEHM : DS.53

Thetford Town Council

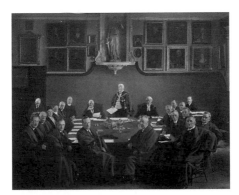

Kehoe, Chris J.
Thetford Town Council, 1 August 1934 1934
oil on canvas 61 x 78.8 (E)
TC1

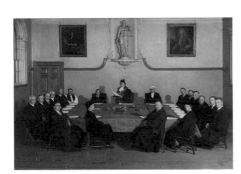

unknown artist
Thetford Town Council, 1961 1961
oil on canvas 56 x 78.8
TC2

Norfolk
Constabulary

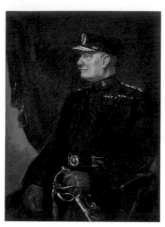

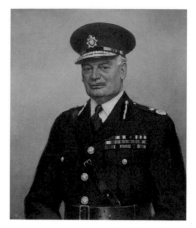

Davies, Arthur Edward 1893–1967
*John Henry Dain OBE, Chief Constable, NCH
City Police (1917–1943)* 1929
oil on canvas 103 x 72.5
NCH624

Davidson-Houston, Aubrey 1906–1995
*Captain Stephen Hugh Van Neck, CVO, MC,
Chief Constable, Norfolk (1928–1956)* 1956
oil on canvas 75 x 62.5 (E)
NCH1101

Wymondham
Heritage Museum

Elliott, Edward 1851–1916
Ketteringham Hall 1880
oil on canvas 50 x 75
WYMH913

Facing page: Crome, John, 1768–1821, *Norwich River: Afternoon* (detail), c.1812–1819, Norwich Castle Museum and Art Gallery, (p.124)

Paintings Without Reproductions

This section lists all the paintings that have not been included in the main pages of the catalogue. They were excluded as it was not possible to photograph them for this project. Additional information relating to acquisition credit lines or loan details is also included. For this reason the information below is not repeated in the Further Information section.

Great Yarmouth Museums

Amies, Anthony 1945–2000, *Seascape and Cliffs*, 71 x 61, oil on hessian, GRYEH : 2001.15.10, bequeathed, 2001, not available at the time of photography

Batchelder, Stephen John 1849–1932 *Towing in a Topsail Schooner*, 50 x 50, oil on canvas, GRYEH : 1958.38, gift, not available at the time of photography

Beaty, Charles, active 1878–1956, *Yarmouth Beach*, 1889, 20.5 x 38, oil on board, GRYEH : 1959.84, untraced find, not available at the time of photography

Fisher, Rowland 1885–1969, *St Peter's Road, Great Yarmouth*, 1960?, 30.5 x 36.5, oil on plywood, GRYEH : 1961.69, purchased, not available at the time of photography

Howes, V., *Launching the Lifeboat from Gorleston Beach*, 1884, 33 x 67.8, oil on canvas, GRYEH : 1964.45, untraced find, not available at the time of photography

Laird, S. R., *Robina*, c.1940, 27.9 x 37.9, oil on board, GRYEH : 1956.318, untraced find, not available at the time of photography

unknown artist, *Mrs Dowson*, 77 x 63.8, oil on canvas, GRYEH : 1970.120, gift from the General Hospital, 1970, not available at the time of photography

unknown artist, *Steam Drifter, 'SN43'*, oil, GRYEH : 1968.702, untraced find, not available at the time of photography

Wilson, Geoffrey b.1920, *Yarmouth River*, 1963, 25.5 x 30.5, oil on canvas board, GRYEH : 1991.40, gift, 1992, not available at the time of photography

King's Lynn Museums

unknown artist, *Portrait of a Woman*, 124 x 97, oil on canvas, KILLM : 1994.1175, not available at the time of photography

Norfolk and Norwich University Hospital

Chalon, Alfred (copy of) 1780–1860, *Dr John Yelloly (1774–1842), Physician (1820–1832)*, 60 x 50, oil on canvas, NWHHA : 1995.30.1, gift, 1871, not available at the time of photography

Norwich Assembly House

Munnings, Alfred James 1878–1959, *Boy Riding a Pony*, 1906, 61 x 74, oil on canvas, NAH 10, acquired, before 1995, not available at the time of photography

Munnings, Alfred James 1878–1959, *Boy Leading a Pony*, 63.5 x 76, oil on canvas, NAH 11, acquired, before 1995, not available at the time of photography

Munnings, Alfred James 1878–1959, *Mare and Foal*, 51 x 66, oil on canvas, NAH 12, acquired, before 1995, not available at the time of photography

Norwich Castle Museum and Art Gallery

Bagge-Scott, Robert 1849–1925, *On the Merwede, South Holland, Tjalk and Aak Coming to an Anchor*, 1885, 25.4 x 38, oil on canvas, NWHCM : 1951.235.1227 : F, bequeathed, 1946, not available at the time of photography

Nursey, Claude Lorraine Richard Wilson 1816–1873, *Woman Preparing Vegetables, Seated in Doorway*, 1849, 16.9 x 14.4, oil on paper laid on panel, NWHCM : 1977.368 : F, purchased, 1977, not available at the time of photography

Oakes, John Wright 1820–1887, *Sandy Beach near Poole, Dorset*, 34.3 x 44.4, oil on canvas, NWHCM : 1896.25.408 : F, gift, 1896, not available at the time of photography

Norwich Civic Portrait Collection

Martin, William 1753–1836 or after, *Edward I and Queen Eleanora (from James Thomson's 'Edward and Eleanora', 1739)*, 1787, 274.5 x 312.5, oil on canvas, NWHCM : Civic Portrait 9 : F, gift from the artist, 1787, unfortunately it was not possible to arrange for photography of this painting

Martin, William 1753–1836 or after, *The Death of Lady Jane Grey*, 1787, 274.5 x 314, oil on canvas, NWHCM : Civic Portrait 10 : F, gift from the artist, 1787, unfortunately it was not possible to arrange for photography of this painting

Sainsbury Centre for Visual Arts, University of East Anglia

Nicholson, Simon b.1934, *6303*, 1963, 14 x 98, acrylic on paper, L55, on loan from Lady Sainsbury, not available at the time of photography

Wragg, John b.1937, *Lilith I*, 1993, 91.2 x 13.7, acrylic on wood, UEA 1100, gift from Robert and Lisa Sainsbury, not available at the time of photography

Ancient House, Museum of Thetford Life

unknown artist 18th C, *Portrait of a Man*, 18.5 x 16, oil on canvas, THEHM : 1978.309, gift from Prince Frederick Duleep Singh, not available at the time of photography

unknown artist 18th C, *Portrait of a Woman*, 76 x 63, oil on canvas, THEHM : DS.196, gift from Prince Frederick Duleep Singh, not available at the time of photography

unknown artist, *Portrait of a Woman*, 76 x 63.5, oil on canvas, THEHM : DS.197, gift from Prince Frederick Duleep Singh, not available at the time of photography

Further Information

The paintings listed in this section have additional information relating to one or more of the five categories outlined below. This extra information is only provided where it is applicable and where it exists. Paintings listed in this section follow the same order as in the illustrated pages of the catalogue.

I The full name of the artist if this was too long to display in the illustrated pages of the catalogue. Such cases are marked in the catalogue with a (…).

II The full title of the painting if this was too long to display in the illustrated pages of the catalogue. Such cases are marked in the catalogue with a (…).

III Acquisition information or acquisition credit lines as well as information about loans, copied from the records of the owner collection.

IV Artist copyright credit lines where the copyright owner has been traced. Exhaustive efforts have been made to locate the copyright owners of all the images included within this catalogue and to meet their requirements. Any omissions or mistakes brought to our attention will be duly attended to and corrected in future publications.

V The credit line of the lender of the transparency if the transparency has been borrowed. Bridgeman images are available subject to any relevant copyright approvals from the Bridgeman Art Library at www.bridgeman.co.uk

Aylsham Town Council

Little, Ida (attributed to) b.1873, *B. B. Sapwell*
Little, Ida (attributed to) b.1873, *Frederick Little*

Bressingham Steam Museum

Weston, David b.1935, *Narrow Gauge Locomotive No.1643, 'Bronllwyd', under Restoration at Bressingham*, bequeathed by Alan Bloom, 2005, © David Weston
Weston, David b.1935, *Britannia Class Locomotive No.70013, 'Oliver Cromwell'*, gift from Alan Bloom, 1982, © David Weston
Weston, David b.1935, *Narrow Gauge Locomotive No.1643, 'Bronllwyd', Being Driven by Alan Bloom*, gift from Alan Bloom, 1982, © David Weston
Weston, David b.1935, *Sketches of Engineering Detail on Britannia Class Locomotive No.70013, 'Oliver Cromwell'*, gift from Alan Bloom, 1982, © David Weston
Weston, David b.1935, *LNER Gresley K3 Class Locomotive No.164*, bequeathed by Alan Bloom, 2005, © David Weston

Costessey Parish Council

Beaty, Charles active 1878–1956, *Costessey Stick Bridge*, purchased, 1998
Beaty, Charles active 1878–1956, *Costessey Stick Bridge*, donated by Mrs C. Larkin, 2001
Beaty, Charles active 1878–1956,

The Weir and Costessey Hall, donated by Mrs C. Larkin, 2001
Freeman, William Philip Barnes 1813–1897, *Costessey Stick Bridge (a pair)*, purchased, 1998
Freeman, William Philip Barnes 1813–1897, *Costessey Stick Bridge, Longloather Lane (a pair)*, purchased, 1998
Freeman, William Philip Barnes 1813–1897, *Costessey Weir with View of Costessey Hall*, purchased, 1998
Littlewood, Edward active 1863–1898, *Costessey Stick Bridge and Ford with Pony and Trap Crossing*, purchased, 1998
Newman, William A. active 1885–1895, *The Street, Old Costessey*, purchased, 1998
Turner, Cyril Boyland *One of the Costessey Lodges*, purchased, 1998

Cromer Museum

Church, Herbert S. d. after 1912, *Lord Battersea (1843–1907)*, gift, 2002
Rogers, Ellis *Cromer*, gift from the Crawford Holden Trustees, 1981

Cromer Town Council

Dugdale, Thomas Cantrell (copy of) 1880–1952, *Henry Blogg (1876–1954), Coxswain of the Cromer Lifeboat*, © the artist's estate
Western, Charles active 1884–1900, *View of Cromer from the Beach*, presented by the artist's brother, Henry Western

North Norfolk District Council

Baldwin, Peter b.1941, *Beeston Hill*, gift from the artist, © the artist

The RNLI Henry Blogg Museum

Childs, Ernest Alfred b.1947, *Rescue of the 'François Tixier'*, on loan from Great Yarmouth Pottery, © the artist
Childs, Ernest Alfred b.1947, *RNLB 'Henry Blogg' Attending a Steamer in Distress*, © the artist
Childs, Ernest Alfred b.1947, *Rescue of the Barge 'Sepoy'*, on loan from Great Yarmouth Pottery, © the artist
Cole, C. L. *The Coxswain Henry Blogg Driving the Cromer Lifeboat onto the Deck of the Barge 'Sepoy', December 1933 (copy of Charles Dixon)*, acquired, after 1967
Dixon, Charles 1872–1934, *The Coxswain Henry Blogg Driving the Cromer Lifeboat onto the Deck of the Barge 'Sepoy', December 1933*, gift from the artist, 1934
Dixon, Charles 1872–1934, *The Cromer Lifeboat alongside the Italian Steamer 'Monte Nevoso', October 1932*, unknown provenance (possibly given by the artist, 1933)
Dugdale, Thomas Cantrell 1880–1952, *Henry Blogg (1876–1954), Coxswain of the Cromer Lifeboat*, purchased, 1942, © the artist's estate
Gladden, I. *Cromer Lifeboat Receiving Two Men from the 'Sepoy'*

(after Charles Dixon), acquired, after 1933
Hodgson, Margaret L. active 1912–1941, *Head and Shoulders of Henry Blogg (1876–1954)*, gift from the artist, 1950
Hunt, Kenny *'Good holiday, but on the big dipper with junior and I'm sick as a dawg!!'*, unknown provenance
Hunt, Kenny *SOS let her go, and not one of em' noticed the tides out'*, unknown provenance
Hunt, Kenny *'They win the institution award for prompt launching'*, unknown provenance
Johnson, Philip M. *Answering an SOS*, unknown provenance
Mann, John b.1903, *Sea Rescue**, unknown provenance
Tyrell, A. W. *Henry Blogg (1876–1954) and Dog*, unknown provenance
unknown artist *Sea Rescue**, unknown provenance

Dereham Town Council

Ramsay, Allan 1713–1784, *George III (1738–1820)*, presented to town of Dereham by George, 4th Viscount, 1766
unknown artist *Lord Kitchener (1850–1916)*, unknown provenance

Gressenhall Farm and Workhouse: The Museum of Norfolk Life

Bowles *Father's Daub*, gift from Miss Phyllis S. Bowles, 1993
Cocks, Fred *Hobbies Saw Mill*, gift

from Mr and Miss Cocks, 1978
Cooper, J. *This House to Let*, gift from Mrs V. R. Lattaway
Locke, J. active 1870–1900, *Horses Pulling a Plough*, gift from Mrs V. R. Lattaway
Nursey, Perry 1799–1867, *Norfolk Sheep (recto)*, on loan from Norwich Castle Museum
Nursey, Perry 1799–1867, *Norfolk Sheep (verso)*, on loan from Norwich Castle Museum
unknown artist *Scragg's Cow*
unknown artist 19th C, *Delivery Cart of William Buckenham*, gift from Mr G. E. Cross, 1968
unknown artist *Jeremiah William King*, gift from Mrs J. Frost

Diss Town Council

Boxall, William 1800–1879, *Thomas Lombe Taylor*, presented by a large body of his friends who admired his philanthropy in erecting this public building of Diss Town Council in his native town, 1857
Bunbury, Harry *Rear Admiral A. H. Taylor*, presented to Diss District Council by Diss Antiquarian Society

100th Bomb Group Memorial Museum

Catchpole, Glyn b.1932, *B17 Flying Fortress 398945*, gift, 1983, © the artist
Crowfoot, Joe b.1946, *Thorpe Abbots' Control Tower, World War Two*, gift from the artist, 1994, © the artist

303

Howlett, Dennis *Storm Clouds over the Old USAAF Control Tower*, gift from Homer Young, 1986
Leigh, Ronald b.1961, *B17s x 4 (230062) Flying Fortress, 100th Bomb Group*, gift, 1994, © the artist
Powers *John Bennett*, gift, 1982
unknown artist *Female Figure*, gift from Pearl Noble (Brockdish), 1979
unknown artist *Female Figure*, gift from the Old Rectory, Thorpe Abbotts, 1979

Fakenham Town Council

Riviere, J. S. *Sir Lawrence Jones, Bt*

Great Yarmouth Magistrates Court

Hastings, Keith William b.1948, *Ferry Inn at Horning*, © the artist
Hastings, Keith William b.1948, *Wherry Hathor near Ranworth*, © the artist
Leckie, Brian *Horsey Mill*

Great Yarmouth Museums

Abbott, Edwin active 1879–1899, *John William Budds Johnson, Mayor of Yarmouth (1899), Founder of Johnson's Overalls Ltd*, gift, 1972
Allen, Elsie active 19th C, *Country Scene*, untraced find
Allen, H. L. *Countryside Scene*, untraced find
Amies, Anthony 1945–2000, *Burnt Stubble*, bequeathed, 2001, © courtesy of Franki Austin & Angela Ruecker
Amies, Anthony 1945–2000, *Burnt Stubble*, bequeathed, 2001, © courtesy of Franki Austin & Angela Ruecker
Amies, Anthony 1945–2000, *Cliff Top and Seascape*, bequeathed, 2001, © courtesy of Franki Austin & Angela Ruecker
Amies, Anthony 1945–2000, *Cliffs*, bequeathed, 2001, © courtesy of Franki Austin & Angela Ruecker
Amies, Anthony 1945–2000, *Hill Trees Sussex*, bequeathed, 2001, © courtesy of Franki Austin & Angela Ruecker
Amies, Anthony 1945–2000, *Landscape*, bequeathed, 2001, © courtesy of Franki Austin & Angela Ruecker
Amies, Anthony 1945–2000, *Landscape*, bequeathed, 2001, © courtesy of Franki Austin & Angela Ruecker
Amies, Anthony 1945–2000, *Landscape*, bequeathed, 2001, ©

courtesy of Franki Austin & Angela Ruecker
Amies, Anthony 1945–2000, *Landscape*, bequeathed, 2001, © courtesy of Franki Austin & Angela Ruecker
Amies, Anthony 1945–2000, *Landscape*, bequeathed, 2001, © courtesy of Franki Austin & Angela Ruecker
Amies, Anthony 1945–2000, *Landscape*, bequeathed, 2001, © courtesy of Franki Austin & Angela Ruecker
Amies, Anthony 1945–2000, *Landscape*, bequeathed, 2001, © courtesy of Franki Austin & Angela Ruecker
Amies, Anthony 1945–2000, *Landscape*, bequeathed, 2001, © courtesy of Franki Austin & Angela Ruecker
Amies, Anthony 1945–2000, *Landscape*, bequeathed, 2001, © courtesy of Franki Austin & Angela Ruecker
Amies, Anthony 1945–2000, *Landscape*, bequeathed, 2001, © courtesy of Franki Austin & Angela Ruecker
Amies, Anthony 1945–2000, *Landscape*, bequeathed, 2001, © courtesy of Franki Austin & Angela Ruecker
Amies, Anthony 1945–2000, *Northants*, bequeathed, 2001, © courtesy of Franki Austin & Angela Ruecker
Amies, Anthony 1945–2000, *Seascape*, bequeathed, 2001, © courtesy of Franki Austin & Angela Ruecker
Amies, Anthony 1945–2000, *Seascape*, bequeathed, 2001, © courtesy of Franki Austin & Angela Ruecker
Amies, Anthony 1945–2000, *Seascape*, bequeathed, 2001, © courtesy of Franki Austin & Angela Ruecker
Amies, Anthony 1945–2000, *Seascape*, bequeathed, 2001, © courtesy of Franki Austin & Angela Ruecker
Amies, Anthony 1945–2000, *Seascape*, bequeathed, 2001, © courtesy of Franki Austin & Angela Ruecker
Amies, Anthony 1945–2000, *Seascape*, bequeathed, 2001, © courtesy of Franki Austin & Angela Ruecker
Amies, Anthony 1945–2000, *Seascape with Cliffs*, bequeathed, 2001
Amies, Anthony 1945–2000, *Seascape with Cliffs*, bequeathed, 2001, © courtesy of Franki Austin & Angela Ruecker
Amies, Anthony 1945–2000,

Shadow of a Tree, bequeathed, 2001, © courtesy of Franki Austin & Angela Ruecker
Amies, Anthony 1945–2000, *Suffolk Landscape*, bequeathed, 2001, © courtesy of Franki Austin & Angela Ruecker
Amies, Anthony 1945–2000, *Sussex Landscape*, bequeathed, 2001, © courtesy of Franki Austin & Angela Ruecker
Anthony, Philip *Cutty Sark*, gift, 1971
Austin, William Frederick 1833–1899, *View from Thorpe Gardens*, untraced find
Bacon, Marjorie May b.1902, *Racehorses Parading*, untraced find
Baines, Henry 1823–1894, *Yarmouth North Beach*, gift, 1960
Baldry, George W. active c.1865–1917, *Portrait of Unknown Sitter*, untraced find
Barkway, Arthur active 1964–1970, *Portrait of a Yarmouth Skipper*, gift, 1979
Batchelder, Stephen John 1849–1932, *South Walsham Broad by Moonlight (The Long Ripple Washing in the Reeds)*, bequeathed
Batchelder, Stephen John 1849–1932, *A Slack Day at the Quay*, gift
Batchelder, Stephen John 1849–1932, *The Temporary Bridge*, purchased, 1958
Batchelder, Stephen John 1849–1932, *Hush'd is the Voice of Labour*, untraced find
Beadle, James Prinsep 1863–1947, *The Captive Eagle*
Beaty, Charles active 1878–1956, *Steam Vessels at Sea*, untraced find
Beaty, Charles active 1878–1956, *Fishing Boat with Net at Sea*, gift
Beaty, Charles active 1878–1956, *Sailing Smacks at Sea*, gift
Beaty, Charles active 1878–1956, *Broadland Scene*, gift
Beaty, Charles active 1878–1956, *Yarmouth Fishing Boat Coming into Harbour*, untraced find
Beaty, Charles active 1878–1956, *Three Yachts and a Wherry on a Broad*, gift, 1965
Beaty, Charles active 1878–1956, *Wherry and Yacht on a Broad*, gift
Beckett, E. J. *YH 627*, purchased, 1976
Beechey, William 1753–1839, *Elizabeth Taylor (née Barnby) (1746–1827)*, gift
Beechey, William (attributed to) 1753–1839, *Miss Elizabeth Taylor (d.1816), Daughter of William Taylor*, gift
Bennett, M. G. active 1914–1918, *'HMS Sir John Moore'*, gift, 1979
Bennett, M. G. active 1914–1918, *'HMS Alecto'*, gift, 1979
Bourne, J. *Man o'War and Ship Flying the Flag of the United States of America*, untraced find
Breanski, Gustave de c.1856–1898, *Sailing Vessel Entering Harbour*, gift from the General Hospital, 1970
British (English) School 18th C, *Sir Robert Walpole (1676–1745)*,

untraced find
British (English) School *Edward William Worlledge*
British (English) School *Great Yarmouth Harbour Scene*, untraced find
British (English) School *Sir Edmund Lacon*
Brown, Agnes Augusta 1847–1932, *Broadland Sunset*, gift
Brown, Agnes Augusta 1847–1932, *The Sentinel*, gift
Brown, John Alfred Arnesby 1866–1955, *Haddiscoe Church*, gift
Brown, John Alfred Arnesby 1866–1955, *Hay-Cutting on the Norfolk Marshes*, gift
Brown, John Alfred Arnesby 1866–1955, *Marshes at Bramerton*, gift
Brown, John Alfred Arnesby 1866–1955, *Panoramic View of Nottingham*, gift
Browne, F. J. active 1884–1894, *Sailing Drifter YH 1063 'Lewis and Katie'*, gift from the Sailors' Home, 1964
Bundy, Edgar 1862–1922, *Boys Bathing at Sandy Hook, Great Yarmouth*, untraced find
Burgess, Arthur James Wetherall 1879–1957, *'HMS Yarmouth'*, gift, 1962
Burgess, John Bagnold 1830–1897, *Charles Cory Aldred, Mayor of Great Yarmouth*
Bussey, E. J. *Fishing Trawlers Going to Sea, Gorleston, Suffolk*, gift, 1960
Butcher, John 1736–1806, *Yarmouth Jetty*, presented to the Great Yarmouth Corporation, 1796
Butcher, John 1736–1806, *Yarmouth Market*, presented to the Great Yarmouth Corporation, 1796
Butcher, John 1736–1806, *Yarmouth Quay*, presented to the Great Yarmouth Corporation, 1796
Chappell, Reuben 1870–1940, *Barges Racing*, acquired, 1956, © the artist's estate
Chatten, Geoffrey b.1952, *YH 89 'Lydia Eva'*, gift from Lydia Eva and the Mincarlo Trust, 2004
Chevalier, Thomas *Hospital Schoolboy, Great Yarmouth, 1840*, on loan
Clifford, John *Rescue by 'The Kharmi'*, gift, 1973
Collins, William (attributed to) 1788–1847, *Girl Mending Nets*, bequeathed
Combes *Self Portrait*, gift, 1970
Crane, H. b.1922, *'SS Ionian'*, gift, 1977
Crane, H. b.1922, *'SS Sicilian'*, gift, 1977
Crowfoot, Reginald active 1970–1995, *Sea Area Dogger*
Daniel, T. B. F. *Lord Nelson's Victory over the Combined Fleets of France and Spain off Cape Trafalgar, 21 October 1805*
Dobson *Sailing Drifter 'Gorleston YH 840'*, untraced find
Filbee, N. *Scots Fisher Girls at Yarmouth*, untraced find
Fisher, Rowland 1885–1969, *Fishing Smacks*, © the artist's estate

untraced find
British (English) School *Edward William Worlledge*
Fisher, Rowland 1885–1969, *Scots Fishing Boats*, untraced find, © the artist's estate
Fisher, Rowland 1885–1969, *Trawlers*, untraced find, © the artist's estate
Fisher, Rowland 1885–1969, *Cargo Vessel Entering Yarmouth Haven*, gift, © the artist's estate
Fisher, Rowland 1885–1969, *Drifters*, untraced find, © the artist's estate
Fisher, Rowland 1885–1969, *Fish Market*, © the artist's estate
Fisher, Rowland 1885–1969, *Haven Bridge, Great Yarmouth*, untraced find, © the artist's estate
Fisher, Rowland 1885–1969, *Hay Wagon*, untraced find, © the artist's estate
Fisher, Rowland 1885–1969, *Lowestoft Harbour*, gift from Great Yarmouth and District Society of Artists, © the artist's estate
Fisher, Rowland 1885–1969, *Market in Brittany*, purchased, © the artist's estate
Fisher, Rowland 1885–1969, *Sailing Barge Passing through Haven Bridge*, untraced find, © the artist's estate
Fisher, Rowland 1885–1969, *Steam Drifters Heading out in Rough Sea*, untraced find, © the artist's estate
Fisher, Rowland 1885–1969, *Trawlers*, untraced find, © the artist's estate
Fisher, Rowland 1885–1969, *Trawlers*, purchased, © the artist's estate
Fisher, Rowland 1885–1969, *Yarmouth River*, untraced find, © the artist's estate
Gouge, Mark 1869–1955, *Dutch Pier at Gorleston with Sailing Vessels Entering Harbour*, gift, 1978
Gouge, Mark 1869–1955, *Dutch Pier at Gorleston with Steam Drifter 'Eight YH 500' Entering Harbour*, gift, 1978
Gregory, John 1841–1917, *'LT 457'*, gift
Gregory, John 1841–1917, *Steam Drifter 'Sweet Pea YH 924'*, gift, 1977
Gregory, John 1841–1917, *Sailing Drifter, 'Renown LT 706'*, untraced find
R. R. H. active 19th C, *'Guiding Star YH 470'*, gift, 1972
Hambling, Maggi b.1945, *Big Sea, May*, donated, 2006, © the artist
Harrison, Charles Harmony 1842–1902, *Country Lane*, untraced find
Harrison, Charles Harmony (attributed to) 1842–1902, *Riverside Scene with Cattle*, untraced find
Heins, John Theodore Sr 1697–1756, *John Ives Senior as a Boy (1718/1719–1793)*, bequeathed, 1960
Hodds, Dennis Roy 1933–1987, *Maldon from the Estuary*, gift, 1993
Holzer, Henry active 1958–1973, *Mounting Clouds over the Marshes*, purchased from an exhibition at

the Central Library, 1973

Jarvis, William Howard *Approaching Smith's Knoll*, untraced find

Jensen, Alfred 1859–1935, *'SS Norwich'*, untraced find

Joy, William 1803–1867, *Dutch Schuyts on the Beach*, untraced find

Joy, William 1803–1867, *Shipwreck*, untraced find

Joy, William 1803–1867, *Vessels Stranded on Yarmouth Beach*, on loan from Norfolk Museums and Archaeology Service

Kennedy, Cedric J. 1898–1968, *Woman with a Bowl of Cyclamen*, untraced find

Ladbrooke, Robert 1770–1842, *The Mackerel Market on Yarmouth Beach*, untraced find

Ladbrooke, Robert 1770–1842, *Yarmouth Beach*, purchased, 1956

Lewis, Tobias c.1888–1916, *A Breezy Day*, gift, 1998

Lewis, Tobias c.1888–1916, *Reverend Forbes Phillips, Vicar of Gorleston*, untraced find

Longsdale, W. *Edward Pitt Yovell*

Luck, Kenneth 1874–1936 & **Mowle, Claude** 1871–1950 *'SS Adriatico'*, gift, 1976

Luck, Kenneth 1874–1936 & **Mowle, Claude** 1871–1950 *Steam Drifter 'Girl Winifred YH 997'*, gift, 1972

Luck, Kenneth 1874–1936 & **Mowle, Claude** 1871–1950 *Steam Tug 'United Service' Towing the Caister Lifeboat 'Covent Garden'*, gift, 1976

Luck, Kenneth 1874–1936 & **Mowle, Claude** 1871–1950 *Steam Drifter 'Archimedes YH 720'*, bequeathed, 2005

Luck, Kenneth 1874–1936 & **Mowle, Claude** 1871–1950 *Steam Drifter 'YH 246'*, gift, 1972

Luck, Kenneth 1874–1936 & **Mowle, Claude** 1871–1950 *'Piscator YH 403'*, untraced find

Luck, Kenneth 1874–1936 & **Mowle, Claude** 1871–1950 *Rescue of the Crew, Schooner 'Falke'*, untraced find

W. M. *Billy Mann*, untraced find

Marjoram, William 1859–1928, *Harbour Mouth, Gorleston*, on loan

Marjoram, William 1859–1928, *Great Yarmouth Lifeboat 'Mark Lane'*, gift, 2004

Marjoram, William 1859–1928, *Fire at Jewsons' Timber Yard, Great Yarmouth*, gift, 2004

Mason, Frank Henry 1876–1965, *'Acclivity' on the Yare*, untraced find

Mason, Frank Henry 1876–1965, *'Georgina V. Everard' Passing Beachy Head*, untraced find

Mason, Frank Henry 1876–1965, *'Saga City'*, untraced find

Matthews *Harry Andrews, Yarmouth Violin Maker*, untraced find

Mellon, Campbell A. 1876–1955, *Late Afternoon, June 1927*, purchased, 1961

Mellon, Campbell A. 1876–1955, *Late Afternoon, August 1926*,

purchased, 1961

Mellon, Campbell A. 1876–1955, *The Holiday Season*, purchased, 1961

Mellon, Campbell A. 1876–1955, *The South Wind, Gorleston*, untraced find

Mellon, Campbell A. 1876–1955, *Willows, Burgh Castle*, purchased, 1948

Miller, A. active 1880–1900, *Fishing Vessels Being Towed out of Yarmouth Harbour by Steam Vessel*, untraced find

Miller-Marshall, T. active 1878–1925, *Fish Wharf, Great Yarmouth*, untraced find

Moody, N. *House Boat*, gift, 1981

Moore, John of Ipswich 1820–1902, *'Yarmouth Wolder' Leaving the Harbour*, gift

Moore, John of Ipswich 1820–1902, *Boats on the Shore*, acquired, 1956

Moore, John of Ipswich 1820–1902, *Rough Sea*, untraced find

Nash, Joseph the younger 1835–1922, *Lifeboat 'James Pearce' Rescuing Crew from a Shipwreck*, untraced find

Nash, Joseph the younger 1835–1922, *Casualty at Sea*, gift

Nash, Joseph the younger 1835–1922, *Lifeboat Being Towed out of Yarmouth Harbour*, untraced find

Nash, Joseph the younger 1835–1922, *Sea Rescue*, untraced find

Nash, Joseph the younger 1835–1922, *Sunday Afternoon at Sea*, untraced find

Nash, Joseph the younger 1835–1922, *Yarmouth Beach*, untraced find

Palmer, Guy active 1900–1901, *South Quay, Great Yarmouth, Looking North*, untraced find

Palmer, Guy active 1900–1901, *Towing out*, untraced find

Palmer, Guy active 1900–1901, *Goodes Hotel Fire*, untraced find

Palmer, Guy active 1900–1901, *Potter Heigham Bridge*, gift

Palmer, Guy active 1900–1901, *Two Men in a Dinghy*, untraced find

Race, George 1872–1957, *'SS Never Can Tell'*, on loan

Ramsey, G. active 1856–1888, *The Tolhouse*, gift

Ramsey, G. active 1856–1888, *'Nell Morgan YH 1048'*, purchased, 1986

Ramsey, G. active 1856–1888, *The Tolhouse*

Ramsey, G. active 1856–1888, *The Fishermen's Hospital*, gift

Ramsey, G. active 1856–1888, *The Tolhouse*, gift

Ramsey, G. active 1856–1888, *The Tolhouse*

Redmore, Henry 1820–1887, *Great Yarmouth Shipping Scene*, untraced find

Redmore, Henry 1820–1887, *Vessels at Sea*, untraced find

Reed, William Sidney *Darby's Hard*, purchased, 1971

Reed, William Sidney *Power on the River*, on loan from the artist

Reed, William Sidney *Storm over Beccles*, on loan from the artist

Reed, William Sidney *The Return of the Prodigal Son*, gift, 1978

Ruggles, William Henry active 1833–1846, *A Distinguished Member of the Humane Society*, gift from the Sailors' Home, 1963

Saunders, John *'Kindred Star LT 177'*, purchased, 1976

Seago, Edward Brian 1910–1974, *Swing Bridge over Breydon*, purchased, 1956, © by kind permission of the Trustees of the estate of Edward Seago, courtesy of Thomas Gibson Fine Art Limited

Spencer, Noël 1900–1986, *Row Demolition, Yarmouth*, gift from the Norwich Twenty Group, 1963

Stannard, Alfred 1806–1889, *Caister Castle*, untraced find

Stannard, Alfred 1806–1889, *Burgh Castle*, purchased, 1945

Stannard, Alfred 1806–1889, *Yarmouth Beach*, acquired, 1956

Stannard, Alfred 1806–1889, *Yarmouth Beach*, untraced find

Stannard, Joseph 1797–1830, *Yarmouth Jetty*, on loan

Stannard, Joseph 1797–1830, *Tetley Water*, untraced find

Stannard, Joseph (attributed to) 1797–1830, *Beach Scene*, untraced find

Stannard, Joseph (attributed to) 1797–1830, *Shipping off Gorleston*, gift, 1959

Swanborough *Josiah Curtis, Bellman of Great Yarmouth*, gift, 1956

Syer, John 1815–1885, *Yarmouth Jetty*, untraced find

Tench, Ernest George 1885–1942, *'Clara and Alice LT 456'*, purchased, 1982

unknown artist *Reverend William Bridge, First Minister of the Unitarian Church in Great Yarmouth (copy of 17th C original by unknown artist)*, gift from the Old Meeting Unitarian Church

unknown artist *William North Burroughs*, untraced find

unknown artist *Great Yarmouth Suspension Bridge*, untraced find

unknown artist late 19th C, *Coastal Scene*, gift, 2002

unknown artist late 19th C, *Jetty at Great Yarmouth*, gift, 2002

unknown artist *Lynn Well Lightship*, on loan

unknown artist *Sailing Luggers*, untraced find

unknown artist *Arthur Victor Buck's Accommodation in Australia*, gift, 1987

unknown artist *Steamer in Rough Sea*

unknown artist *Abstract*, untraced find

unknown artist *Alderman T. Burton Steward*, untraced find

unknown artist *Anthony Taylor (1722–1795), Mayor of Yarmouth (1771)*, gift, 1956

unknown artist *Battle of Trafalgar, 21st October 1805*, untraced find

unknown artist *Bowl of Apples*,

untraced find

unknown artist *Burgh Castle Water Frolic*, gift, 1973

unknown artist *Burgh Castle Water Frolic, Sunset Scene*, gift, 1973

unknown artist *Caister Castle*, untraced find

unknown artist *Captain Benjamin West*, presented by Miss L. E. Moore, 1945

unknown artist *Character*, untraced find

unknown artist *George England Esq., a Member of Parliament in Great Yarmouth*, untraced find

unknown artist *'Internos YH 973'*, gift, 1977

unknown artist *Isaac Preston*, untraced find

unknown artist *John Ives*, gift, 1956

unknown artist *John Worship (1744–1805)*, gift, 1956

unknown artist *Joseph Grout, Founder of Grout and Co., Partner (1807–1852)*, untraced find

unknown artist *Portrait of a Clergyman Wearing a Wig*, untraced find

unknown artist *Portrait of a Gentleman*, untraced find

unknown artist *Portrait of a Gentleman*, untraced find

unknown artist *Portrait of a Man in a Black Bow Tie*, untraced find

unknown artist *Portrait of a Mayor*, untraced find

unknown artist *Portrait of a Woman*, untraced find

unknown artist *Racing Scene*, untraced find

unknown artist *Religious Scene*, gift

unknown artist *Robert Warmington*, untraced find

unknown artist *Samuel Tolver, Town Clerk (1822–1848)*, gift, 1970

unknown artist *Shipping at Yarmouth Jetty*, acquired, 1956

unknown artist *Sir James Paget*, untraced find

unknown artist *'SN 208'*, untraced find

unknown artist *'SS Argus'*, gift, 1970

unknown artist *The Barque 'Frederica' of Yarmouth*, untraced find

unknown artist *The Harbour's Mouth (Beach by Moonlight)*, gift, 1965

unknown artist *The 'Rich'*, untraced find

unknown artist *The Tolhouse*, untraced find

unknown artist *Town Hall and Haven Bridge, Great Yarmouth*, untraced find

unknown artist *Vessels at Sea*, gift, 1981

unknown artist *William Steward*, gift from the General Hospital, 1970

unknown artist *William Taylor (1755–1816)*, gift, 1956

unknown artist *Woodland Scene with Swans*, untraced find

unknown artist *Yachts at Sea*, gift, 1981

unknown artist *Yarmouth Front from the Jetty*, gift, 1971

unknown artist *Yarmouth Jetty*, untraced find

unknown artist *'YH 11 Leaving North Quay'*, untraced find

Verbruggen, Gaspar Peeter de II 1664–1730, *Flower Piece*, gift, 1966

Verey, Arthur 1840–1915, *Shrimpers on the Bure*, untraced find

Vincent, George 1796–1831, *Dutch Fair on Yarmouth Beach*, untraced find

Watling, M. *Fullers Hill*, untraced find

Webb, James c.1825–1895, *River Scene*, untraced find

Westgate, W. H. *Dairymaid 'YH 181'*, purchased, 1986

Wilson, Frederick Francis b.1901, *Lady Jane Grey*, gift, 1960

Wilson, Geoffrey b.1920, *Country Lane*, purchased, 1994

Worsdale, James c.1692–1767, *George I (1660–1727)*, presented to the Corporation of Great Yarmouth, 1728

Great Yarmouth Port Authority

Applegate, John Stephen b.1935, *Tug 'Hector Read'*, © the artist

Chatten, Geoffrey b.1952, *Great Yarmouth South Pier*

Fisher, Rowland 1885–1969, *The Harbour Entrance*, presented by J. Eldred Dewhurst, 1967, © the artist's estate

Goodall, Thomas Frederick 1856/1857–1944, *View of Great Yarmouth*

Lionel, Percy active 1890–1904, *Fishing Smacks*

Mason, Frank Henry 1876–1965, *'M. V. Speciality' Dry Docking at Great Yarmouth*, presented by Messrs. F. T. Everard & Sons Ltd, 1955

The Norfolk Nelson Museum

Drummond, Samuel 1765–1844, *The Death of Nelson*, purchased at auction, 1980s

Keymer, Matthew 1764–1816, *Lord Horatio Nelson (1758–1805)*, on loan from Great Yarmouth Borough Council

Royal Air Force Air Defence Radar Museum

Davis *Squadron Leader H. G. Donald RAFVR*, donated by Squadron Leader H. G. Donald

Rawlinson, William Thomas 1912–1993, *A 'CHL' (Chain Home Low) Radar Station*, on loan from the Imperial War Museum, © crown copyright

Rawlinson, William Thomas 1912–1993, *A 'Final' GCI (Grand-*

Controlled Interception) Radar Station, on loan from the Imperial War Museum, © crown copyright
Rawlinson, William Thomas 1912–1993, *A 'Type CH' (Chain Home) Radar Station on the West Coast*, on loan from the Imperial War Museum, © crown copyright
Rawlinson, William Thomas 1912–1993, *A 'Type 11' Radar Station*, on loan from the Imperial War Museum, © crown copyright
Thompson, Charles John b.1931, *Radar Station, Bawdsey, Suffolk*, donated by the World War Two Radar Association, © the artist

King's Lynn Arts Centre

British (English) School *Regatta*
Devas, Anthony 1911–1958, *Ruth, Lady Fermoy (1908–1993)*, presented to the Guildhall of St George by admirers of Lady Fermoy's great contribution to the cultural life of the community, 1954, © courtesy of the artist's estate/www.bridgeman.co.uk

King's Lynn Corn Exchange

McComb, Leonard b.1930, *View of King's Lynn from across the Great Ouse*, commissioned for the King's Lynn Festival Exhibition of Lynn Paintings, 2000, on loan from Andrew and Frances Schumann, © the artist

King's Lynn Custom House

Baines, Henry 1823–1894, *Sunset, Low Tide in the Wash*, gift, 1945
Bell, Henry 1647–1711, *Prospect of Lynn from the West*

King's Lynn Museums

Ayre, John *The Pilot Office*, untraced find
Baines, Henry 1823–1894, *Old Oil Mill, King's Lynn*, gift, 1965
Baines, Henry 1823–1894, *Gateway in the Walks*, gift
Baines, Henry 1823–1894, *Inside the High Bridge, Purfleet, King's Lynn*, purchased, 2004
Baines, Henry 1823–1894, *Kettle Mill, King's Lynn*, purchased, 2004
Baines, Henry 1823–1894, *Quayside with St Margaret's*
Baines, Henry 1823–1894, *Greenland Fishery Yard from the Rear*, presented, 1958
Baines, Henry 1823–1894, *Union Baptist Chapel, King's Lynn*, purchased, 2003
Baines, Henry 1823–1894, *Wreck of 'The Glory'*, gift, 1922
Baines, Henry 1823–1894, *St James' Workhouse*
Baines, Henry 1823–1894, *Sunset, North End*, purchased
Baines, Henry 1823–1894, *'The*

colours of old England he nail'd to the mast', untraced find
Baines, Henry 1823–1894, *Hut at Gray's Coal Yard on the Sea Bank*, gift
Baines, Henry 1823–1894, *Dragging the Net*
Baines, Henry 1823–1894, *The 'Margaret of Christiana' (wrecked at Hunstanton, 1886)*, gift, 1903
Baines, Henry 1823–1894, *Clifton House Tower*
Baines, Henry 1823–1894, *Common Staithe Quay*
Baines, Henry 1823–1894, *Country Scene*
Baines, Henry 1823–1894, *Fisher Fleet Looking East*, bequeathed
Baines, Henry 1823–1894, *Friar's Gate (Carmelite Arch)*, untraced find
Baines, Henry 1823–1894, *Gaywood Mill*
Baines, Henry 1823–1894, *High Bridge, Purfleet*
Baines, Henry 1823–1894, *King's Lynn from West Lynn, 1892*
Baines, Henry 1823–1894, *Millfleet with Greyfriars Tower and Tar Office*
Baines, Henry 1823–1894, *Nude Man*
Baines, Henry 1823–1894, *Nude Woman*
Baines, Henry 1823–1894, *Rainbow over Ely*
Baines, Henry 1823–1894, *Rainbow over Ely*
Baines, Henry 1823–1894, *Ship on Seascape*
Baines, Henry 1823–1894, *The Old Cut Bridge*, gift, 1903
Baines, Thomas 1820–1875, *Hogsback*
Baines, Thomas 1820–1875, *Bloemfontein*, gift, 1947
Baines, Thomas 1820–1875, *Scenery and Events in South Africa*
Baines, Thomas 1820–1875, *Forces under the Command of Lieutenant General Robert Cathcart Crossing the Orange River to Attack Moshesh, 1852*, gift, 1947
Baines, Thomas 1820–1875, *Greyfriars Tower*, gift
Baines, Thomas 1820–1875, *Greyfriars Tower*, gift, 1932
Baines, Thomas 1820–1875, *Kaffirs and Rebel Hottentots Attacking a Wagon Train*
Baines, Thomas 1820–1875, *South Gates, Lynn*
Baines, Thomas 1820–1875, *Elephant Hunting with the Sword, Abyssinia*, purchased, 1960
Baines, Thomas 1820–1875, *Red Mount*
Bocking, William *King's Lynn and River Great Ouse Facing South*, gift, 2002
Borrmann, Thomas active 1900–1910, *Greyfriars Tower*
Borrmann, Thomas active 1900–1910, *South Gates*
Borrmann, Thomas active 1900–1910, *South Gates*
Borrmann, Thomas active 1900–1910, *Gateway in the Walks*,

gift, 2003
Borrmann, Thomas active 1900–1910, *Greyfriars Tower*, gift, 2003
Borrmann, Thomas active 1900–1910, *South Gates*, gift, 2003
Borrmann, Thomas active 1900–1910, *Lynn Scene, Fisher Fleet*
Brett, John 1830–1902, *Castle Cornet, Guernsey*
Brett, John 1830–1902, *'HMS Northumberland'*
Brown, John Alfred Arnesby 1866–1955, *The Hayfield*
Camp, Jeffery b.1923, *Black North Sea*, © the artist
Canaletto (school of) 1697–1768, *St Mark's, Venice*, bequeathed, 1919
Closterman, John (after) 1660–1711, *Charles Turner, Mayor of Lynn (1694–1706)*, purchased, 1980
Closterman, John (after) 1660–1711, *Charles Turner, Mayor of Lynn (1694–1706)* purchased, 1980
Closterman, John (after) 1660–1711, *Sir John Turner*, purchased, 1980
Cotman, John Sell 1782–1842, *Town Hall, King's Lynn*, untraced find
Dante, M. *Frederick Savage*, gift
Dexter, Walter 1876–1958, *Gaywood Mill*, purchased, 1958
Dexter, Walter 1876–1958, *A Winter Afternoon*, purchased, 1958
Dexter, Walter 1876–1958, *Helen Dexter, the Artist's Wife*, gift
Dexter, Walter 1876–1958, *Lynn from the South West*, purchased, 1951
Dexter, Walter 1876–1958, *Ely from Middle Fen*, gift, 1969
Dexter, Walter 1876–1958, *Boston Stump*, purchased
Dexter, Walter 1876–1958, *Helen Dexter, the Artist's Wife*, purchased
Dexter, Walter 1876–1958, *Interior of St Margaret's Church*, gift
Dexter, Walter 1876–1958, *Landscape Near King's Lynn (possibly East Winch)*, bequeathed, 1970
Dexter, Walter 1876–1958, *Landscape Studies*
Dexter, Walter 1876–1958, *Marsh Landscapes, St Margaret's Church, King's Lynn*, untraced find
Dexter, Walter 1876–1958, *Moonlit Landscape*, untraced find
Dexter, Walter 1876–1958, *Moonrise*
Dexter, Walter 1876–1958, *Mrs Chadwick*, purchased, 1967
Dexter, Walter 1876–1958, *Norwich from Mousehold*
Dexter, Walter 1876–1958, *Pentney Priory*, purchased, 1972
Dexter, Walter 1876–1958, *Portrait of a Lynn Fishergirl*, purchased, 1958
Dexter, Walter 1876–1958, *Portrait of a Woman*
Dexter, Walter 1876–1958, *Purfleet Street, King's Lynn*, untraced find
Dexter, Walter 1876–1958, *River Great Ouse*, untraced find

Dexter, Walter 1876–1958, *Still Life*
Dexter, Walter 1876–1958, *Theatre Scene*, purchased, 1966
Dexter, Walter 1876–1958, *Windmill by Moonlight*, untraced find
Dexter, Walter 1876–1958, *Wisbech*, purchased, 1966
Dexter, Walter 1876–1958, *York Minster and Walls*, untraced find
Gemmath, Mary *The Sunday School, Heacham*, gift, 1973
Gosling, Edward *Ruskin School, Heacham*
Green, George Colman b.1877, *Downham Market*
Hinton, Brian active 1955–c.1970, *Mr Johnson at the Lathe, Savages*, gift
Jones, Charles 1836–1892, *Sheep on a Hillside*, gift
Joy, William 1803–1867, *'HMS Victory' Entering Portsmouth, 1844*, purchased, 1957
Ladbrooke, John Berney 1803–1879, *A Bridge*
Ladbrooke, John Berney 1803–1879, *Cottage and Trees*, bequeathed
Lane, Samuel 1780–1859, *William Swatman*
Lane, Samuel 1780–1859, *Frederick Lane*, gift, 1958
Lane, Samuel 1780–1859, *Henry Self*, gift
Lane, Samuel 1780–1859, *Horatio Nelson (1758–1805)*
Lefevre, Geoffrey *South Quay No.2*, presented, 1969
Lefevre, Geoffrey *Evening on the Marsh*, gift, 1985
Lilley (Reverend), Ivan active 1979–1980, *Gazelle*, purchased
Macbeth, Robert Walker 1848–1910, *Too Late for the Ferry*
Nurse, Charles Baxter active 1895–1915, *H. J. Hillen*
Oldmeadow, William H. *Ressley Spring*
Pickford, William *Kettle Mills*
Pickford, William *Kettle Mills*
Rosa, Salvator (after) 1615–1673, *Wood of the Philosophers*, gift, 1928
Schmitt, Guido Philipp 1834–1922, *Sarah Ingleby*
Serjeant, G. *The Quay, Wells*, gift
Sillett, James 1764–1840, *Norwich Stagecoach at King's Lynn*, purchased, 2000
Somer, Paulus van I 1576–1621, *James I (1566–1625)*
Southgate, Frank 1872–1916, *Elaine Auger*
Southgate, Frank 1872–1916, *Gordon Lowerison*
Tamlin, J. H. P. active 1903–1911, *Greenland Fishery*, gift, 1911
unknown artist 17th C, *Mother and Child*
unknown artist *Castle Rising*, gift, 1949
unknown artist *St Margaret's and Saturday Market Place*
unknown artist *The Purfleet*, purchased, 1977
unknown artist *A View of the Procession on the Opening of the New Eaubrink Cut in the County*

of Norfolk
unknown artist *The Friar's Fleet Boatyard and South Gates*
unknown artist *Reverend Edward Edwards*
unknown artist *Captain Manby (1765–1854)*
unknown artist *An Enormous Sheep*, bequeathed, 1967
unknown artist *A Market Square (possibly Wymondham)*
unknown artist *Burnham Thorpe Church*
unknown artist *Captain Manby (1765–1854)*
unknown artist *Clipper*
unknown artist *Elizabeth Cooper (1718–1739)*
unknown artist *Francis John Lake*, gift
unknown artist *Greyfriars*
unknown artist *Greyfriars Tower*
unknown artist *Horatio Nelson (1758–1805)*
unknown artist *Horatio Nelson (1758–1805) (copy of Matthew Keymer)*
unknown artist *John Pinn, Local Character*
unknown artist *Kettle Mills*
unknown artist *King John (1167–1216)*
unknown artist *Landscape with Windmill*, bequeathed
unknown artist *Landscape, Cottage and Chapel*, bequeathed
unknown artist *Mr Weston Jarvis*, gift, 1928
unknown artist *Lady Weston Jarvis*, gift, 1928
unknown artist *Portrait of a Man*
unknown artist *Portrait of a Man*
unknown artist *Portrait of an Old Woman*, gift
unknown artist *Red Mount*
unknown artist *Red Mount*
unknown artist *Roger Le Strange*, gift
unknown artist *Tuesday Market*
Weiler, Lina van b.1857, *Mrs Laurence Oliphant*, gift
White, J. T. *Greenland Fishery Yard from the Rear*
Winearls, S. *Fisher Fleet Looking East*, gift
Winearls, S. *Fisher Fleet Looking West*, gift
Winter, Alexander Charles b.1887, *Fisher Fleet*

King's Lynn Town Hall

American School *Pocahontas and Her Son Thomas Rolfe*, presented by a descendant of the Rolfe family, 1990
Baines, Henry 1823–1894, *Fishing Smack on the Shore*, on loan from King's Lynn Museums
Beresford, Frank Ernest 1881–1967, *King George VI (1895–1952)*, presented by HM the Queen Mother, 1960
Beresford, Frank Ernest 1881–1967, *Queen Elizabeth (1900–2002)*, presented by HM the Queen Mother, 1960

British (English) School *William Atkins, Mayor (1619–1620)*
British (English) School *Thomas Snelling, Mayor (1622–1623)*
British (English) School *Joshua Green, Mayor (1627 & 1637)*
British (English) School early 18th C, *A Cleric Holding the King John Sword*
British (English) School late 18th C, *Henry IV (1367–1413)*
British (English) School *Tuesday Market Place, King's Lynn*, presented by Miss Cruso, 1897
British (English) School late 19th C, *Robert Whincop*
British (English) School *Portrait of a Gentleman*
British (English) School *Sir Lewis Jarvis*
Cotes, Francis (circle of) 1726–1770, *Portrait of a Gentleman*
Devis, Arthur (circle of) 1712–1787, *Two Men Playing Chess*, presented by E. M. Beloe and Miss E. Cox, 1918
Dexter, Walter 1876–1958, *Sketch of King's Lynn over the Harbour*, acquired, 1986
Dexter, Walter 1876–1958, *View of King's Lynn over the Harbour*, purchased by public subscription, 1931
Ferrour, John b.1654 or earlier, *Sir Thomas White (1492–1567), Lord Mayor of London and Founder of St John's College, Oxford*, purchased, 1681
Ferrour, John b.1654 or earlier, *King Charles I (1600–1649)*, purchased, 1690
Ferrour, John b.1654 or earlier, *King William III (1650–1702)*, purchased, 1690
Ferrour, John b.1654 or earlier, *Queen Mary II (1662–1694)*, purchased, 1690
Ginnett, Louis 1875–1946, *Sir William H. B. Ffolkes, Bt (1847–1912) (after Oswald Hornby Joseph Birley)*, © the artist's estate
Hoare, William c.1707–1792, *Thomas Somersby, Mayor (1743–1744)*
Hodgson, David 1798–1864, *A View of the Guildhall, King's Lynn*, presented by Sir William Lancaster, 1913
Hoskins, John I c.1595–1665, *Sir Hamon Le Strange of Hunstanton (1583–1654)*, on loan from the Le Strange estate
Hudson, Benjamin active 1850–1894, *William S. V. Miles, Mayor*
Lane, Samuel 1780–1859, *King George III (1738–1820) (after Joshua Reynolds)*, presented by the artist, 1804
Lane, Samuel 1780–1859, *Horatio, Lord Nelson (1758–1805) (after John Hoppner)*, commissioned by King's Lynn Council, 1805
Lane, Samuel 1780–1859, *Thomas William Coke, 1st Earl of Leicester*, on loan from King's Lynn Museums
Lane, Samuel 1780–1859, *Lord George Bentinck (1802–1848), MP*

for King's Lynn *(1828)*, presented by local merchants and land owners, 1834
Lane, Samuel 1780–1859, *Elizabeth Swatman*, presented by Mrs E. A. Bevis, 1932
Lane, Samuel 1780–1859, *John Prescott Blencowe, Mayor (1825)*, bequeathed by Margaret Blencowe, 1898
Lane, Samuel 1780–1859, *The Reverend Robert E. Hankinson*
Lane, Samuel 1780–1859, *William Swatman, Mayor (1813)*, presented by Mrs E. A. Bevis, 1931
Lely, Peter (attributed to) 1618–1680, *Horatio, 1st Viscount Townshend (1630–1657)*, purchased, 1926
Loo, Louis Michel van (after) 1707–1771, *Sir Benjamin Keene (1697–1757), British Minister to Spain*, acquired, before 1810
Morris, William Bright 1844–1912, *Captain George Vancouver, RN (1757–1798)*, presented by subscription, 1914
Nurse, Charles Baxter active 1895–1915, *Christopher Thomas Page*, presented by descendants, 1984
Nurse, Charles Baxter active 1895–1915, *Thomas Edward Bagge (1838–1908)*
Pearce, Stephen 1819–1904, *William Seppings, Mayor (1848)*, bequeathed, 1925
Pickering, Henry active 1740–c.1771, *Portrait of a Lady*
Richardson, Jonathan the elder 1665–1745, *Sir Robert Walpole, KG (1676–1745)*, acquired, before 1810
Richardson, Jonathan the elder 1665–1745, *Roger Le Strange*, on loan from the Le Strange estate
Riviere, Hugh Goldwin 1869–1956, *Sir Somerville Gurney*
Roe, Fred 1864–1947, *Florence Ada Coxon, First Woman Mayor (1925)*, gift, 1926, © the artist's estate
Roestraten, Pieter Gerritsz. van 1629/1630–1700, *Still Life with King John Cup*, on loan from King's Lynn Museums
Shewring, Colin 1924–1995, *Saturday Market Place, King's Lynn*, presented by the artist, 1993, © the artist's estate
Vanderbank, John (circle of) c.1694–1739, *Portrait of a Gentleman (said to be Horace Walpole)*, acquired, before 1810
Veresmith, Emil active 1891–1924, *Fanny Burney (1752–1840)*, presented by Holcombe Ingleby, 1921
Watson, George Spencer 1869–1934, *Thomas Gibson Bowles, MP (1841–1922)*
Whitmore, Robert 1908–1993, *King John of France Presenting His Cup to the Mayor of Lynn, Robert Braunche, 1349*, gift from the artist, © the artist's estate
Wilson, John James II (attributed to) 1818–1875, *Fishing Smacks on a Rough Sea*, on loan from King's Lynn Museums

Broadland District Council

Applegate, John Stephen b.1935, *Norwich Cathedral*, presented by Councillor David W. Thompson, Chairman, 2000–2004, © the artist
Moss, Brian *A Broadland Scene*, presented to Gordon Godfrey, Vice Chairman of the Council, 1986–1987
unknown artist *Landscape with Boat*
E. W. *Thorpe Lodge, Yarmouth Road, Thorpe St Andrew's*

City of Norwich Aviation Museum

Barrington, Peter b.1928, *Avro Vulcan B, Mk 2 XM612 Arriving at Norwich Airport on Its Last Flight, Being Delivered to the City of Norwich Aviation Museum, January 1983*, gift, 1990, © the artist
Best, Edward *De Havilland Mosquito AS-H of 515 Squadron Flying over Little Snoring*, gift, 2005
Frost, David active 1980–1981, *De Havilland Tiger Moth, G-AHHM*, gift, 2003
Frost, David active 1980–1981, *De Havilland Tiger Moth, G-AHHM*, gift, 2003
Frost, David active 1980–1981, *De Havilland Dragon Rapide in Flight*, gift, 2003
Frost, David active 1980–1981, *World War One Dogfight, Nieuport 17*, gift, 2003
Godfrey, C. *Dresden, 1945*, gift
Matthews, Leslie 1926–2004, *100 Group Sets out to Confound*, donated by Leslie Matthews of 223 Squadron, Royal Air Force
Smith, Ray *Avro Lancaster Tanker with 3 Gloster Meteor Fighters, 1950, 245 Squadron Royal Air Force, Based at Horsham St Faith*
unknown artist *Boeing B-17 Fortress, 214 Squadron, 100 Group, Peter Knights*, gift, 2001

City of Norwich Collection

Chedgey, David b.1940, *Private View at the Alibi (panel 1 of 4)*, © the artist
Chedgey, David b.1940, *Private View at the Alibi (panel 2 of 4)*, © the artist
Chedgey, David b.1940, *Private View at the Alibi (panel 3 of 4)*, © the artist
Chedgey, David b.1940, *Private View at the Alibi (panel 4 of 4)*, © the artist
Italian School 17th C, *King Ahasuerus and Queen Esther*
Ladbrooke, Henry 1800–1869, *View of Norwich from Mousehold Heath*, gift from Nestlé UK, 1998
Mutch, Gil b.1955, *Seeing Norwich*, commissioned by the Advice Arcade Group, presented to the City Council, 1992, © the artist
Pellegrini, Giovanni Antonio

1675–1741, *Nymph and Satyrs (Galatea)*
Pellegrini, Giovanni Antonio 1675–1741, *Venus Seated with Winged Cupid and a Young Faun*
unknown artist *Landscape by a Canal*, donated by British Telecom, 1998
unknown artist *Travellers Resting*, donated by British Telecom, 1998
unknown artist *Herbert Edward Whitard*
unknown artist *Classical Scene*
unknown artist *Mountain Landscape*
unknown artist *Norwich from Mousehold*
Wimhurst, Juliet b.1940, *Strange Event in Chapelfield*, commissioned by the Advice Arcade Group, presented to the City Council, 1998, © the artist

Norfolk and Norwich University Hospital

Bardwell, Thomas (copy of) 1704–1767, *Benjamin Gooch (1708–1776)*, acquired, c.1900
Beechey, William 1753–1839, *Philip Meadows Martineau (1752–1829), Assistant Surgeon & Surgeon (1778–1828)*, gift from Helen Higginson, before 1890
Benski (copy of) *Arthur Tawke (1817–1884), Consultant Physician (1847–1851)*, acquired, c.1890
Brewer, Julian Cedric c.1830–1903, *Edward Colman (d.1812), Assistant Surgeon (1790–1812) (copy of original miniature by unknown artist)*, gift, 1871
Brewer, Julian Cedric c.1830–1903, *William Donne (1746–1804)*, gift, 1890
Bush-Brown, Margaret Lesley 1857–1944, *John Murray (1720–1792), Physician (1771–1790) (copy of a portrait by an unknown artist)*, gift, 1970
Bush-Brown, Margaret Lesley 1857–1944, *Mary Boyles*, unknown provenance
Clover, Joseph 1779–1853, *Edward Rigby (1747–1821)*, gift, 1895
Clover, Joseph (copy of) 1779–1853, *Robert Fellowes*, purchased, c.1890
Frere, Amy Hanbury active 1902–1958, *Sir Thomas Browne (1605–1682) (copy of an original by an unknown artist)*, commissioned by Norfolk and Norwich Hospital Board of Management, 1905
Heins, John Theodore Jr (copy after) 1732–1771, *John Manning (1730–1806)*, gift, c.1871
Herkomer, Hubert von 1849–1914, *William Cadge (1822–1903)*, commissioned, 1890
Highmore, Joseph (copy of) 1692–1780, *William Fellowes of Shotesham (1706–1775)*, gift, c.1800
Mann, John J. b.1903, *Mr McKee*, gift, c.1990
Opie, John 1761–1807, *James*

Alderson (1742–1825), Surgeon (1772–1793), Physician (1793–1821), gift, 1871
Sage, Faith K. active 1918–c.1950, *Athelstan Jasper Blaxland (1880–1963), Consultant Surgeon (1909–1946)*, acquired, c.1950
Smith, Henry active 1828–1844, *William Dalrymple (1772–1847), Assistant Surgeon & Surgeon (1812–1839)*, gift
Strutt, Jacob George 1790–1864, *Warner Wright (1775–1845)*, acquired, c.1890
unknown artist *Jonathan Matchett, Physician (1773–1777)*, gift, 1871
unknown artist *John Murray (1720–1792), Physician*, gift, 1871
unknown artist *John Beevor, MD (1726–1815), Physician (1771–1793)*, gift, 1871
unknown artist *John Beevor, MD (1726–1815), Physician (1771–1793)*, gift, c.1890
Ventnor, Arthur Dale 1829–1884, *John Green Crosse (1790–1850)*, gift, c.1871

Norfolk and Waveney Mental Health Partnership

unknown artist late 19th C, *Mary Chapman (1647–1724)*

Norfolk County Council

Baldwin, Peter b.1941, *St Benet's Abbey with Cow*, presented to the County Council by the artist (former chairman of the County Council)?, © the artist
unknown artist *Charles Denny*, on loan to Diss Town Council
unknown artist *Henry Denny*, on loan to Diss Town Council

Norfolk Record Office

unknown artist *Possibly Alderman Herbert Edward Witard, JP (1874–1954), Chairman of Norwich Mental Hospital (now Hellesden Hospital) Visiting Committee (1919–1948), Lord Mayor of Norwich (1927–1928)*, deposited by the Director, Estates and Facilities, Norfolk Mental Health Care NHS Trust (now Norfolk and Waveney Mental Health Partnership NHS Trust), Hellesdon Hospital, Norwich, 2003
unknown artist early 20th C, *A View of Tombland Alley from Tombland, Norwich*, deposited by Trustees of the Great Hospital and Church List Charities, Norwich

Norwich Assembly House

Clover, Joseph 1779–1853, *Augustin Noverre (1729–1805)*, presented by Miss Josephine Diver
Crome, John 1768–1821, *Woman in a Turban*

Gotch, Thomas Cooper 1854–1931, *Golden Youth*, private loan
Lamb, Henry 1883–1960, *H. J. Sexton*, donated by Eric Sexton, 1950, © estate of Henry Lamb
Messel, Oliver 1904–1978, *Lilies*, gift from Sir Edmund Bacon, 1997, © the artist's estate
unknown artist 19th C, *A Member of the Noverre Family*, on loan from Norfolk Museums and Archaeology Service
unknown artist *Mary Noverre (wife of Augustin Noverre)*, on loan from Norfolk Museums and Archaeology Service
unknown artist *Augustin Noverre (1729–1805)*, on loan from Norfolk Museums and Archaeology Service
unknown artist *Frank Noverre (1806–1878)*, on loan from Norfolk Museums and Archaeology Service

Norwich Castle Museum and Art Gallery

Adolphe, Joseph Anton 1729–c.1765, *Philip Meadows (1679–1752)*, purchased with grants from the Victoria & Albert Museum Purchase Grant Fund and Friends of the Norwich Museums, 1990
Andrews, Michael 1928–1995, *Lowestoft Promenade*, on loan from the Norfolk Contemporary Art Society, © June & Melanie Andrews
Andrews, Michael 1928–1995, *The Lord Mayor's Reception in Norwich Castle Keep on the Eve of the Installation of the First Chancellor of the University of East Anglia*, purchased with grants from the Victoria & Albert Museum Purchase Grant Fund and the Gulbenkian Foundation, 1968, © June & Melanie Andrews
Arrowsmith, Thomas 1772–c.1829, *Mrs Derry*, gift, 1940
Backhuysen, Ludolf I 1630–1708, *The Coming Squall*, gift, 1894
Bagge-Scott, Robert 1849–1925, *On the River Yare*, bequeathed, 1946
Bagge-Scott, Robert 1849–1925, *Goin' a' Milking, South Holland*, bequeathed, 1946
Bagge-Scott, Robert 1849–1925, *The Wind and the Willows*, bequeathed, 1946
Bagge-Scott, Robert 1849–1925, *Keulsche Aaks, Dordt*, bequeathed, 1928
Bagge-Scott, Robert 1849–1925, *Wroxham Bridge*, purchased, 1926
Bagge-Scott, Robert 1849–1925, *On a Dutch Dyke*, bequeathed, 1946
Bagge-Scott, Robert 1849–1925, *By the Riverside*, gift, 1901
Bagge-Scott, Robert 1849–1925, *'Twas Calm at Dordt*, purchased with the Walker Bequest Fund, 1924
Bagge-Scott, Robert 1849–1925, *Dutch Boat*, purchased, 1926
Bagge-Scott, Robert 1849–1925,

The Merwede at Dordrecht, purchased by public subscription, 1914
Baines, Henry 1823–1894, *Ballast Boats at King's Lynn*, gift, 1947
Baines, Henry 1823–1894, *Mrs Henry Baines*, gift, 1947
Baldwin, Peter b.1941, *Havergate Island*, gift, 1995, © the artist
Bardwell, Thomas 1704–1767, *John Buxton of Channonz (1717–1782)*, bequeathed, 1949
Bardwell, Thomas 1704–1767, *John Buxton of Channonz (1717–1782)*, bequeathed, 1949
Bardwell, Thomas 1704–1767, *Anne Buxton (1721–1771)*, bequeathed, 1949
Bardwell, Thomas 1704–1767, *Isabella Buxton*, bequeathed, 1949
Bardwell, Thomas 1704–1767, *Leonard Buxton (1719–1788)*, bequeathed, 1949
Bardwell, Thomas 1704–1767, *Robert Buxton (1710–1750)*, bequeathed, 1949
Bardwell, Thomas 1704–1767, *Sarah Buxton*, bequeathed, 1949
Bardwell, Thomas 1704–1767, *John Buxton of Channonz (1717–1782)*, bequeathed, 1949
Bardwell, Thomas 1704–1767, *Robert Buxton (1710–1750)*, bequeathed, 1949
Barker, Ruth b.1925, *Still Life with Ivy and Lemon*, bequeathed, 1990, © the artist
Barret, George 1728/1732–1784, *The Drive, Norbury Park*, purchased with a grant from the Victoria & Albert Museum Purchase Grant Fund, 1976
Barwell, Frederick Bacon 1831–1922, *The Hill at Norwich on Market Day*, bequeathed, 1921
Barwell, John 1798–1876, *Study of a Head*, gift from East Anglian Art Society, 1894
Barwell, John 1798–1876, *Miss Julia Smith*, bequeathed, 1918
Beattie, A. active 1850–1856, *Cantley Dyke, River Yare*, bequeathed, 1971
Beechey, William 1753–1839, *Mr and Mrs John Custance of Norwich and Their Daughter Frances*, purchased with grants from the Victoria & Albert Museum Purchase Grant Fund, the National Art Collections Fund and a family charitable trust, 1990
Beechey, William 1753–1839, *Joseph Stannard (1797–1830)*, bequeathed, 1946
Beechey, William 1753–1839, *Elizabeth, Lady Buxton, née Cholmeley (d.1884)*, bequeathed, 1949
Beechey, William 1753–1839, *Alfred Stannard (1806–1889), Aged 19*, bequeathed, 1946
Begeyn, Abraham 1637/1638–1697, *Plant Study with Goat*, purchased with a grant from the Friends of the Norwich Museums, 1957
Birley, Oswald Hornby Joseph 1880–1952, *Russell James Colman*

(1861–1946), bequeathed, 1946, © the artist's estate
Bisschop, Cornelis 1630–1674, *The Listening Maid*, gift, 1894
Blazeby, William (attributed to) active 1833–1848, *Portrait of an Unknown Man*, on deposit from Norfolk and Norwich Record Office, 1972
Bloemen, Jan Frans van 1662–1749, *Southern Landscape with Figures*, purchased under the 'acceptance in lieu of tax' scheme with grants from the Museums and Galleries Commission, the National Heritage Memorial Fund and the National Art Collections Fund, 1991
Bloemen, Jan Frans van 1662–1749, *Southern Landscape with Figures*, purchased under the 'acceptance in lieu of tax' scheme with grants from the Museums and Galleries Commission, the National Heritage Memorial Fund and the National Art Collections Fund, 1991
Blow, Sandra b.1925, *Painting: Black, White and Brown, Concrete and Sawdust*, gift from the Contemporary Art Society, 1965, © the artist
Bomberg, David 1890–1957, *Flowers*, gift in memory of David Bomberg through the Contemporary Art Society, 1981, © the artist's family
Bomberg, David 1890–1957, *Ronda, Summer*, gift in memory of David Bomberg through the Contemporary Art Society, 1981, © the artist's family
Bonington, Richard Parkes 1802–1828, *Sea Coast, the Dunes*, bequeathed, 1951
Both, Jan (attributed to) c.1618–1652, *A Southern Landscape with Muleteers on a Roadway*, purchased under the 'acceptance in lieu of tax' scheme with grants from the Museums and Galleries Commission, the National Heritage Memorial Fund and the National Art Collections Fund, 1991
Bourdon, Sébastien (copy of) 1616–1671, *Moses Striking the Rock*, gift, 1894
Bradley, John 1786–1843, *Sir Robert Seppings (1767–1840)*, gift, 1985
Bratby, John Randall 1928–1992, *The Purple Globe Artichoke Flower*, purchased with a grant from the Gulbenkian Foundation, 1966, © courtesy of the artist's estate/www.bridgeman.co.uk
Briggs, Henry Perronet 1791/1793–1844, *Sir John Jacob Buxton, 2nd Bt (1788–1842)*, bequeathed, 1949
Bright, Henry 1814–1873, *Grove Scene*, bequeathed, 1946
Bright, Henry 1814–1873, *Marsh Mill*, bequeathed, 1946
Bright, Henry 1814–1873, *Old Barn, Suffolk*, bequeathed, 1946
Bright, Henry 1814–1873, *Remains*

of St Benedict's Abbey on the Norfolk Marshes, Thunderstorm Clearing Off, gift, 1947
Bright, Henry 1814–1873, *The Mill*, gift through the National Art Collections Fund, 1948
Bright, Henry 1814–1873, *Shore Scene near Leyden, Holland*, bequeathed, 1976
Bright, Henry 1814–1873, *Orford Castle, Suffolk*, purchased with the Beecheno Bequest Fund, 1935
Bright, Henry 1814–1873, *Effect after Rain*, gift from East Anglian Art Society, 1894
Bright, Henry 1814–1873, *Marsh Mill*, bequeathed, 1976
Bright, Henry 1814–1873, *Mills on the Fens*, gift, 1947
Bright, Henry 1814–1873, *North Beach, Great Yarmouth*, bequeathed, 1929
Bright, Henry 1814–1873, *Seascape (Dunstanburgh Castle)*, gift, 1949
Bright, Henry 1814–1873, *Trees by River with Cattle*, bequeathed, 1982
Bright, Henry 1814–1873, *Windmill at Sheringham*, bequeathed, 1903
Brown, John Alfred Arnesby 1866–1955, *Myra Plater, Sister of the Artist*, gift, 1989
Brown, John Alfred Arnesby 1866–1955, *The Marshes from Burgh Castle*, bequeathed, 1956
Brown, John Alfred Arnesby 1866–1955, *Cattle on the Marshes*, purchased with the Doyle Bequest Fund, 1948
Brown, John Alfred Arnesby 1866–1955, *The Cloud (September)*, bequeathed, 1949
Brown, John Alfred Arnesby 1866–1955, *Sketch for 'The Estuary, Gathering Clouds'*, bequeathed, 1949
Brown, John Alfred Arnesby 1866–1955, *View of Norwich from the Bungay Road*, gift from the Norfolk News Company, 1945
Brown, John Alfred Arnesby 1866–1955, *Blythsburgh (Beccles across the Marshes)*, bequeathed, 1949
Brown, John Alfred Arnesby 1866–1955, *Calves*, bequeathed, 1949
Brown, John Alfred Arnesby 1866–1955, *Haddiscoe Church, Norfolk*, bequeathed, 1949
Brown, John Alfred Arnesby 1866–1955, *Morston Church, Norfolk*, bequeathed, 1949
Brown, John Alfred Arnesby 1866–1955, *Seascape with Yacht*, gift, 1989
Brown, John Alfred Arnesby 1866–1955, *The Coming Day*, purchased with the Doyle Bequest Fund, 1947
Brown, Mia Arnesby 1865–1931, *Girl Fishing*, gift, 1989
Brown, Mia Arnesby 1865–1931, *Sleeping Girl*, gift, 1989
Brown, Mia Arnesby 1865–1931, *Thomas South Mack as a Small Boy*, bequeathed, 1981
Browne, Joseph 1720–1800, *St*

Peter's Denial, on loan from the Diocese of Norwich
Brueghel, Pieter the younger 1564/1565–1637/1638, *The Rent Collectors*, bequeathed, 1975
Brundrit, Reginald Grange 1883–1960, *Trees*, bequeathed, 1949
Butler, Thomas (after) c.1730–c.1760, *The Godolphin Arabian (inn sign from 86 Magdalen Street, Norwich)*, gift from Mr C. J. Clarke, 1921
Callcott, Augustus Wall 1779–1844, *Cottage Scene*, purchased with the Beecheno Bequest Fund, 1943
Camp, Jeffery b.1923, *Golden Cliff Top*, on loan from the Norfolk Contemporary Art Society, © the artist
Carpenter, Margaret Sarah 1793–1872, *James Stark (1794–1859)*, bequeathed, 1949
Carr, David 1915–1968, *Machine Drawing*, on loan from the Norfolk Contemporary Art Society
Carter, William 1863–1939, *Juliet Dudley Edenborough (1916–1937)*, gift, 1950
Catton, Charles the younger 1756–1819, *Charles Catton, RA (1728–1798)*, gift, 1920
Chalkley, Brian b.1948, *Con-Cast 2/84*, purchased, 1985, © the artist
Chance, Ian b.1940, *Landscape Device*, gift, 1973
Chaudhuri, Jayanta b.1958, *Study for 'Night Portrait'*, 1980–1981, purchased, 1981, © the artist
Churchyard, Thomas 1798–1865, *Landscape with Trees by a Pool*, purchased, 1943
Churchyard, William John d.1930, *Copy of a Portrait of Sir John Pettus, Bt, 1670*, purchased, 1948
Clausen, George 1852–1944, *Children and Roses*, on loan from a private charitable trust, © Clausen estate
Clint, George 1770–1854, *John Berney Crome (1794–1842)*, bequeathed, 1946
Clint, George 1770–1854, *Joseph Stannard (1797–1830)*, bequeathed, 1894
Clint, George 1770–1854, *William Henry Crome (1806–1867)*, bequeathed, 1946
Clough, Prunella 1919–1999, *Man Entering a Boiler House*, on loan from the Norfolk Contemporary Art Society, © estate of Prunella Clough 2006. All rights reserved, DACS
Clover, Joseph 1779–1853, *Anna Mann (née Wade) (1751–1830)*, gift, 1965
Clover, Joseph 1779–1853, *William Mann (1738–1812)*, gift, 1965
Clover, Joseph 1779–1853, *The Harvesters*, purchased, 1976
Clover, Joseph 1779–1853, *Barnabas Leman, Mayor of Norwich (1813 & 1818)*, purchased, 1970
Clover, Joseph 1779–1853, *The Harvey Family of Norwich*, purchased with a grant from

the Victoria & Albert Museum Purchase Grant Fund and the Friends of the Norwich Museums, 1985

Clover, Joseph 1779–1853, *Whitlingham Church, Norwich*, gift, 1939

Clover, Joseph 1779–1853, *Mrs Withington*, gift, 1961

Clover, Joseph 1779–1853, *Interior with Figures*, gift, 1939

Clover, Joseph 1779–1853, *Landscape with Village in a Dale*, gift, 1939

Clover, Joseph 1779–1853, *Alderman John Browne*, gift from the East Anglian Art Society, 1894

Clover, Joseph 1779–1853, *An Interior (after Gerrit Dou)*, gift, 1939

Clover, Joseph 1779–1853, *Beach and Fishing Boats, Rugged Cliffs Beyond*, gift, 1939

Clover, Joseph 1779–1853, *Corner of a Walled Garden with Washing on Line*, gift, 1939

Clover, Joseph 1779–1853, *Couple in a Garden*, gift, 1939

Clover, Joseph 1779–1853, *Couple with a Child in a Garden*, gift, 1939

Clover, Joseph 1779–1853, *Diana*, gift, 1939

Clover, Joseph 1779–1853, *Diana and Actaeon (after Titian)*, gift, 1939

Clover, Joseph 1779–1853, *Drive of Country House, with Trees and Figures*, gift, 1939

Clover, Joseph 1779–1853, *Landscape with Farm Buildings (recto)*, gift, 1939

Clover, Joseph 1779–1853, *Family Group (verso)*, gift, 1939

Clover, Joseph 1779–1853, *Farm Buildings*, gift, 1939

Clover, Joseph 1779–1853, *Figure in Mayoral Robes*, gift, 1939

Clover, Joseph 1779–1853, *Figures in an Interior*, gift, 1939

Clover, Joseph 1779–1853, *George Vincent (1796–1832)*, bequeathed, 1898

Clover, Joseph 1779–1853, *Hilly Wooded Landscape (recto)*, gift, 1939

Clover, Joseph 1779–1853, *Wooded Landscape with Farm Buildings (verso)*, gift, 1939

Clover, Joseph 1779–1853, *Horatio Bolingbroke (1798–1879)*, gift, 1961

Clover, Joseph 1779–1853, *Interior with Couple and Children Playing*, gift, 1939

Clover, Joseph 1779–1853, *Interior with Figures*, gift, 1939

Clover, Joseph 1779–1853, *Interior with Women and Children at a Table*, gift, 1939

Clover, Joseph 1779–1853, *James Stark (1794–1859)*, gift, 1921

Clover, Joseph 1779–1853, *John Herring, Mayor of Norwich, 1799 (after John Opie)*, gift, 1939

Clover, Joseph 1779–1853, *Joseph Clover, Farrier (1725–1811), Grandfather of the Artist*, gift, 1939

Clover, Joseph 1779–1853, *Landscape with Birches and Pond*, gift, 1939

Clover, Joseph 1779–1853, *Landscape with Bridge and Cottage*, gift, 1939

Clover, Joseph 1779–1853, *Landscape with Castle*, gift, 1939

Clover, Joseph 1779–1853, *Landscape with Church and Houses, Pines in Foreground*, gift, 1939

Clover, Joseph 1779–1853, *Landscape with Cottage (recto)*, gift, 1939

Clover, Joseph 1779–1853, *Two Studies of Women (verso)*, gift, 1939

Clover, Joseph 1779–1853, *Landscape with River in Hilly Country*, gift, 1939

Clover, Joseph 1779–1853, *Man, Woman and Baby in a Bedroom*, gift, 1939

Clover, Joseph 1779–1853, *Man and Woman in an Interior Playing Music*, gift, 1939

Clover, Joseph 1779–1853, *Mother and Child*, gift, 1939

Clover, Joseph 1779–1853, *Mrs Martha Farrow (née Suckling)*, gift, 1978

Clover, Joseph 1779–1853, *Mrs Nathaniel Bolingbroke (née Mary Yallop) (1760–1833)*, gift, 1970

Clover, Joseph 1779–1853, *Portrait of a Lady with Ostrich Plume Hat*, gift, 1939

Clover, Joseph 1779–1853, *Richard Cumberland, the Poet (1732–1811)*, gift, 1939

Clover, Joseph 1779–1853, *River Landscape with Rocks in the Foreground*, gift, 1939

Clover, Joseph 1779–1853, *Sir John Harrison Yallop, Kt (1763–1835)*, gift, 1970

Clover, Joseph 1779–1853, *Three Figures Seated in a Landscape*, gift, 1939

Clover, Joseph 1779–1853, *Three Interiors with Figures*, gift, 1939

Clover, Joseph 1779–1853, *Wooded Landscape*, gift, 1939

Clover, Joseph 1779–1853, *Wooded Landscape (recto)*, gift, 1939

Clover, Joseph 1779–1853, *Sketch of Girls in a Landscape (verso)*, gift, 1939

Clover, Joseph (attributed to) 1779–1853, *Landscape*, bequeathed, 1946

Coates, M. L. *Stoke Mill near Norwich*, gift, 1940

Coker, Peter 1926–2004, *Pig's Head*, purchased, 1984, © Peter Coker, RA

Colkett, Samuel David 1806–1863, *Landscape*, purchased with the Walker Bequest Fund, 1924

Colkett, Samuel David 1806–1863, *River Scene*, gift, 1944

Colkett, Samuel David 1806–1863, *River Scene near Norwich*, gift, 1973

Colkett, Samuel David 1806–1863, *On the River Yare*, bequeathed, 1946

Colkett, Samuel David 1806–1863, *Landscape*, purchased with the Beecheno Bequest Fund, 1939

Colkett, Samuel David 1806–1863, *River Scene near Norwich*, gift, 1973

Colkett, Samuel David 1806–1863, *River Scene near Cambridge*, bequeathed, 1971

Colkett, Samuel David 1806–1863, *Queen's College Grove, Cambridge*, gift, 1900

Colkett, Samuel David 1806–1863, *Landscape with Church in Distance and Figure in a Red Shawl*, bequeathed, 1940

Colkett, Samuel David 1806–1863, *Landscape with Cottage*, bequeathed, 1946

Colkett, Samuel David 1806–1863, *Landscape with Cows in a Pool by a Clump of Trees*, bequeathed, 1940

Colkett, Samuel David 1806–1863, *Landscape with River and Mill, Sheep in Foreground*, bequeathed, 1946

Colkett, Samuel David 1806–1863, *Lane Scene*, gift, 1933

Collins, Cecil 1908–1989, *Landscape: Autumn*, bequeathed by Mrs Elisabeth Collins through the National Art Collections Fund, 2001, © TATE, London 2006

Collins, Cecil 1908–1989, *Landscape: Dawn*, bequeathed by Mrs Elisabeth Collins through the National Art Collections Fund, 2001, © TATE, London 2006

Constable, John (after) 1776–1837, *At East Bergholt*, bequeathed, 1940

Constable, John (after) 1776–1837, *Brighton*, bequeathed, 1940

Constable, John (after) 1776–1837, *Cloudy Landscape*, bequeathed, 1940

Constable, John (after) 1776–1837, *The Glebe Farm*, purchased, 1948

Coopse, Pieter d. after 1677, *A Dutch Man of War and Vessels in a Breeze*, bequeathed by Jean Alexander through the National Art Collections Fund, 1972

Coppin, Mrs Daniel c.1768–1812, *The Cottage Door (after Thomas Gainsborough)*, bequeathed, 1894

Corden, William II c.1820–1900, *James Stark (1794–1859)*, gift, 1906

Cotman, Frederick George 1850–1920, *From Shade to Sunshine*, bequeathed, 1946

Cotman, Frederick George 1850–1920, *A Flood Tide at Cley-next-the-Sea, Norfolk*, bequeathed, 1942

Cotman, Frederick George 1850–1920, *Moonlight River Scene*, gift, 1974

Cotman, John Joseph 1814–1878, *Station Road, Brundall*, gift, 1970

Cotman, John Joseph 1814–1878, *Road on the Trowse Meadows, Norfolk*, bequeathed, 1946

Cotman, John Joseph 1814–1878, *Lane near Carrow, Norwich*, bequeathed, 1946

Cotman, John Joseph 1814–1878, *Postwick Grove, Norwich*, purchased with the Beecheno Bequest Fund, 1940

Cotman, John Joseph 1814–1878, *River at Postwick near Norwich*, purchased with the Beecheno

Bequest Fund, 1940

Cotman, John Joseph 1814–1878, *Roughton Heath, Cromer*, gift, 1907

Cotman, John Joseph 1814–1878, *Whitlingham Lane, Norwich*, bequeathed, 1946

Cotman, John Joseph 1814–1878, *Whitlingham Woods near Norwich*, bequeathed, 1946

Cotman, John Sell 1782–1842, *Moreton Hall, Cheshire*, bequeathed, 1946

Cotman, John Sell 1782–1842, *The Waterfall*, bequeathed, 1946

Cotman, John Sell 1782–1842, *Portrait of a Young Man*, bequeathed, 1946

Cotman, John Sell 1782–1842, *Boy at Marbles (Henry Cotman)*, on loan from the Cotman Family

Cotman, John Sell 1782–1842, *St James of Compostela*, bequeathed, 1946

Cotman, John Sell 1782–1842, *The Beggar Boy*, bequeathed, 1946

Cotman, John Sell 1782–1842, *Mrs John Sell Cotman*, bequeathed, 1952

Cotman, John Sell 1782–1842, *The Judgement of Midas*, bequeathed, 1946

Cotman, John Sell 1782–1842, *Boats on Cromer Beach*, bequeathed, 1946

Cotman, John Sell 1782–1842, *Old Houses at Gorleston*, bequeathed, 1898

Cotman, John Sell 1782–1842, *Sea View (Fishing Boats)*, bequeathed, 1898

Cotman, John Sell 1782–1842, *After a Storm*, bequeathed, 1946

Cotman, John Sell 1782–1842, *Dutch Boats off Yarmouth, Prizes during the War*, bequeathed, 1946

Cotman, John Sell 1782–1842, *View from Yarmouth Bridge, Looking towards Breydon, Just after Sunset*, bequeathed, 1946

Cotman, John Sell 1782–1842, *In the Bishop's Garden*, bequeathed, 1946

Cotman, John Sell 1782–1842, *Silver Birches*, bequeathed, 1946

Cotman, John Sell 1782–1842, *The Baggage Wagon*, bequeathed, 1898

Cotman, John Sell 1782–1842, *The Mishap*, bequeathed, 1898

Cotman, John Sell 1782–1842, *The Silent Stream, Normandy*, bequeathed, 1946

Cotman, John Sell 1782–1842, *Palace of Prince Beauharnais*, bequeathed, 1946

Cotman, John Sell 1782–1842, *Cader Idris*, purchased with the Beecheno Bequest Fund, 1941

Cotman, John Sell 1782–1842, *Alder Carr, Norwich*, bequeathed, 1946

Cotman, John Sell 1782–1842, *An Ecclesiastic*, bequeathed, 1946

Cotman, John Sell 1782–1842, *The Monk*, bequeathed, 1946

Cotman, John Sell 1782–1842, *Henley-on-Thames, Boys Fishing*, bequeathed, 1946

Cotman, John Sell 1782–1842, *Alder Carr, Norwich*, bequeathed, 1946

Cotman, John Sell 1782–1842, *From My Father's House at Thorpe*, gift from the East Anglian Art Society, 1894

Cotman, John Sell 1782–1842, *Boat House and Trees*, bequeathed, 1946

Cotman, John Sell 1782–1842, *Capel Curig, Cader Idris*, bequeathed, 1946

Cotman, John Sell 1782–1842, *Ecclesiastics in a Vestry (Interior of Church in Normandy)*, bequeathed, 1946

Cotman, John Sell 1782–1842, *Gable End of Old Houses, St Albans (after Francis Stevens)*, bequeathed, 1946

Cotman, John Sell 1782–1842, *St Benet's Abbey, Norfolk*, bequeathed, 1946

Cotman, John Sell (attributed to) 1782–1842, *Sketch of Church Interior*, purchased with the Beecheno Bequest Fund, 1949

Cotman, John Sell (attributed to) 1782–1842, *Lincolnshire Draining Mill*, bequeathed, 1946

Cotman, John Sell (attributed to) 1782–1842, *River Scene (A Norfolk Wherry)*, bequeathed, 1946

Cotman, John Sell (attributed to) 1782–1842, *Seascape*, bequeathed, 1946

Cotman, John Sell (attributed to) 1782–1842, *The Mills*, purchased with the Beecheno Bequest Fund, 1945

Cotman, John Sell (attributed to) 1782–1842, *Unfinished Landscape*, anonymous gift, 1937

Cotman, Miles Edmund 1810–1858, *Boats on the Medway, a Calm*, bequeathed, 1898

Cotman, Miles Edmund 1810–1858, *Dutch Shipping in Stormy Weather*, bequeathed, 1946

Cotman, Miles Edmund 1810–1858, *Gorleston Harbour*, bequeathed, 1946

Cotman, Miles Edmund 1810–1858, *Hay Barge off Yarmouth*, bequeathed, 1946

Cotman, Miles Edmund 1810–1858, *Mapledurham Mill*, bequeathed, 1946

Cotman, Miles Edmund 1810–1858, *Near the Coast (The Wave)*, bequeathed, 1946

Cotman, Miles Edmund 1810–1858, *The Mouth of the Yare*, gift from the East Anglian Art Society, 1894

Cotman, Miles Edmund 1810–1858, *The Whitlingham Road*, bequeathed, 1978

Cotman, Miles Edmund 1810–1858, *Unloading Timber*, bequeathed, 1946

Cotman, Miles Edmund 1810–1858, *Whitlingham, Lane Scene with River on Left*, bequeathed, 1946

Cotman, Miles Edmund 1810–1858, *Whitlingham Looking towards Thorpe*, bequeathed, 1946

Cotman, Miles Edmund
1810–1858, *Whitlingham, Norfolk*,
bequeathed, 1946
Cotman, Miles Edmund
1810–1858, *Wooded Landscape
with Cattle*, bequeathed, 1946
Cotman, Miles Edmund
1810–1858, *Woodland and Water
(The Weir)*, bequeathed, 1946
Cotman, Miles Edmund
1810–1858, *Yarmouth Beach and
Jetty*, bequeathed, 1934
Cotman, Miles Edmund
1810–1858, *Yarmouth Beach with
the Nelson Monument in Distance*,
bequeathed, 1946
**Cotman, Miles Edmund
(attributed to)** 1810–1858,
Breydon, bequeathed, 1942
**Cotman, Miles Edmund
(attributed to)** 1810–1858, *Farm
Buildings and Pond*, bequeathed,
1952
Creffield, Dennis b.1931, *Within
a Budding Grove I*, gift from East
England Arts, 2002, © the artist
Crome, Emily 1801–1840, *Dead
Birds*, purchased, 1972
Crome, Emily 1801–1840, *An
Interior*, bequeathed, 1946
Crome, John 1768–1821, *Carrow
Abbey, Norwich*, bequeathed, 1946
Crome, John 1768–1821, *The Yare
at Thorpe, Norwich*, bequeathed,
1946
Crome, John 1768–1821, *Yarmouth
Jetty*, bequeathed, 1898
Crome, John 1768–1821, *Yarmouth
Jetty*, purchased with the Beecheno
Bequest Fund, 1945
Crome, John 1768–1821, *Study of
Flints*, bequeathed, 1946
Crome, John 1768–1821, *New
Mills: Men Wading*, purchased with
grants from the Victoria & Albert
Museum Purchase Grant Fund, the
Friends of the Norwich Museums
and the National Art Collections
Fund, 1970
Crome, John 1768–1821,
St Martin's Gate, Norwich,
bequeathed by Ernest E. Cook
through the National Art
Collections Fund, 1955
Crome, John 1768–1821, *Norwich
River: Afternoon*, purchased with
grants from the National Heritage
Memorial Fund, the Museums
and Galleries Commission, the
National Art Collections Fund,
a private family trust, the Hilda
Bacon Bequest Fund, the Friends
of the Norwich Museums and
Norwich City Bequest Funds, 1994
Crome, John 1768–1821, *Dock
Leaves*, bequeathed, 1946
Crome, John 1768–1821, *Study of a
Burdock*, bequeathed, 1898
Crome, John 1768–1821, *Back of
the New Mills*, bequeathed, 1898
Crome, John 1768–1821, *Postwick
Grove*, bequeathed, 1946
Crome, John 1768–1821,
Boulevard des Italiens, Paris, on
loan from a private owner
Crome, John 1768–1821, *Road
with Pollards*, bequeathed, 1946
Crome, John 1768–1821, *The*

Fish Market, Boulogne, accepted
in lieu of tax by HM Government
through the Council for Museums,
Archives and Libraries (Re:source),
2001
Crome, John 1768–1821, *Grove
Scene*, bequeathed, 1946
Crome, John 1768–1821, *A View
on the Wensum*, gift from the East
Anglian Art Society, 1894
Crome, John 1768–1821, *At
Honingham, Norfolk*, bequeathed,
1946
Crome, John 1768–1821, *Bruges
River, Ostend in the Distance -
Moonlight*, bequeathed, 1898
Crome, John 1768–1821, *View
of Kirstead Church, Norfolk*,
bequeathed, 1946
Crome, John (after) 1768–1821,
*On the Wensum, above New Mills,
Norwich*, bequeathed, 1940
Crome, John (after) 1768–1821,
Study of a Burdock, purchased,
1976
Crome, John (after) 1768–1821,
The Old Lazar House, Norwich,
bequeathed, 1946
Crome, John (attributed to)
1768–1821, *A Castle in Ruins,
Morning*, purchased with grants
from the National Art Collections
Fund and the Friends of the
Norwich Museums, 1930
Crome, John (attributed to)
1768–1821, *A River Scene, Welsh
Hills*, bequeathed, 1946
Crome, John (attributed to)
1768–1821, *Dutch Boats off
Yarmouth*, bequeathed, 1940
**Crome, John (attributed
to)** 1768–1821, *Early Dawn*,
bequeathed, 1946
Crome, John (attributed to)
1768–1821, *Farmyard near Trowse*,
bequeathed, 1946
Crome, John (attributed to)
1768–1821, *Heath Scene*, purchased
with the Beecheno Bequest Fund,
1939
Crome, John (attributed to)
1768–1821, *Horse Watering*,
bequeathed, 1946
Crome, John (attributed to)
1768–1821, *Landscape with Cottage
and Trees with Cattle and Figure*,
bequeathed, 1946
Crome, John (attributed to)
1768–1821, *Marlingford Grove*,
bequeathed, 1940
Crome, John (attributed to)
1768–1821, *Seascape*, bequeathed,
1946
Crome, John (attributed to)
1768–1821, *Sprowston Mill,
Norwich*, bequeathed, 1946
Crome, John (attributed to)
1768–1821, *Study of Foliage*,
bequeathed, 1946
Crome, John (attributed to)
1768–1821, *Study of Foliage*,
bequeathed, 1946
Crome, John (attributed to)
1768–1821, *The Cow Tower,
Norwich*, bequeathed, 1946
Crome, John (attributed to)
1768–1821, *The Mill*, gift, 1949
Crome, John (attributed to) 1768–

1821, *The Mill (after Rembrandt
van Rijn)*, bequeathed, 1946
Crome, John (attributed to)
1768–1821, *The Temple of Venus,
Baiae*, bequeathed, 1946
Crome, John (attributed to)
1768–1821, *The Three Cranes' Inn
Sign*, purchased with the Beecheno
Bequest Fund, 1936
Crome, John (attributed to)
1768–1821, *View of Norwich*,
purchased with the Beecheno
Bequest Fund, 1941
Crome, John (imitator of)
1768–1821, *Mill on Mousehold*,
gift, 1949
Crome, John Berney 1794–1842,
Rouen, purchased with the
Beecheno Bequest Fund, 1935
Crome, John Berney 1794–1842,
Moonlight Scene, bequeathed, 1942
Crome, John Berney 1794–1842,
Amsterdam, gift in memory of Dr
Basil K. Nutman (1882–1976),
1982
Crome, John Berney 1794–1842,
*View near Bury St Edmunds,
Suffolk*, gift, 1895
Crome, John Berney 1794–1842,
River Scene by Moonlight,
bequeathed, 1946
Crome, John Berney 1794–1842,
*Great Gale at Yarmouth on Ash
Wednesday*, bequeathed, 1946
Crome, John Berney 1794–1842,
*The Removal of Old Yarmouth
Bridge*, gift in memory of four
generations of the Eaton family,
namely Thomas Eaton, Thomas
Damant Eaton, the Reverend
William Ray Eaton, George
Clayton Eaton and Frederic Ray
Eaton (all Freemen of the city
of Norwich) and the Reverend
Thomas Ray Eaton, who in their
various ways contributed to the
cultural life of Norwich and
Norfolk, 2002
Crome, John Berney 1794–1842,
Breydon, Moonlight, bequeathed,
1969
Crome, John Berney 1794–1842,
Burgh Castle near Yarmouth,
bequeathed, 1898
Crome, John Berney 1794–1842,
Burgh Castle near Yarmouth, gift,
1973
Crome, John Berney 1794–1842,
Caister Castle, Moonlight, gift, 1973
Crome, John Berney 1794–1842,
Fishing Boats on the Scheldt,
bequeathed, 1940
Crome, John Berney 1794–1842,
Landscape, bequeathed, 1946
Crome, John Berney 1794–1842,
*Landscape with Trees and Cottage at
Felbrigg*, bequeathed, 1946
Crome, John Berney 1794–1842,
Moonlight, bequeathed, 1934
Crome, John Berney 1794–1842,
Moonlight on the Yare, gift, 1941
Crome, John Berney 1794–1842,
Moonlight Scene, Carrow,
bequeathed, 1946
Crome, John Berney 1794–1842,
Moonlight Scene near Dereham,
bequeathed, 1946
Crome, John Berney 1794–1842,

River Scene in Holland, gift, 1934
Crome, John Berney 1794–1842,
Yarmouth Jetty, Moonlight Scene,
bequeathed, 1946
**Crome, John Berney (attributed
to)** 1794–1842, *Holl's Lane,
Heigham, Norwich*, bequeathed,
1946
Crome, Vivian 1842–c.1926, *The
White Dog*, purchased with a
grant from the Victoria & Albert
Museum Purchase Grant Fund,
1970
Crome, William Henry 1806–
1873, *Landscape with Bridge and
Man Fishing*, bequeathed, 1946
Crome, William Henry
1806–1873, *Landscape with
Norwich Castle and Cathedral in
the Distance*, bequeathed, 1946
Crome, William Henry
1806–1873, *Lewisham Church and
Village*, bequeathed, 1946
Crome, William Henry 1806–
1873, *Scene with Mill*, gift, 1942
Crome, William Henry
1806–1873, *A Grove of Trees near a
Stream with a Man Fishing from a
Boat*, bequeathed, 1946
Crome, William Henry
1806–1873, *Landscape with Cattle*,
bequeathed, 1969
Crome, William Henry 1806–
1873, *Landscape with Farmhouse
and Mill*, gift, 1970
Crome, William Henry 1806–
1873, *The Old Watermill, Ivybridge,
South Devon*, purchased with the
Beecheno Bequest Fund, 1938
Crome, William Henry
1806–1873, *Wooded Stream with
Anglers and Man on a White Horse*,
bequeathed, 1946
Crotch, William 1775–1847,
Windsor Castle, on loan from
Norfolk Library and Information
Services
Crotch, William 1775–1847, *Lane
near Budleigh Salterton, Devon*,
on loan from the Norfolk and
Norwich Joint Records Committee
Crotch, William 1775–1847,
Landscape, on loan from Ipswich
Borough Council Museums &
Galleries
Crotch, William 1775–1847,
Landscape (after Jacques d'Arthois),
on loan from the Norfolk and
Norwich Joint Records Committee
Crotch, William 1775–1847,
Landscape with Ruins, on loan
from the Norfolk and Norwich
Joint Records Committee
Crotch, William 1775–1847, *Sheep
and Cows (after Augustus Wall
Callcott)*, on loan from the Norfolk
and Norwich Joint Records
Committee
Crowe, Eyre 1824–1910, *Nelson's
Last Farewell to England*, purchased
by public subscription, 1905
Culbert, Bill b.1935, *Transcend*,
purchased with a grant from the
Gulbenkian Foundation, 1965, ©
the artist
Dahl, Michael I 1656/1659–1743,
Elizabeth Buxton, bequeathed, 1949
Dahl, Michael I 1656/1659–1743,

*Ann Gooch, Mrs John Buxton
(1691–1749)*, bequeathed, 1949
Dahl, Michael I (attributed to)
1656/1659–1743, *Ann Gooch,
Mrs John Buxton (1691–1749)*,
bequeathed, 1949
Dahl, Michael I (attributed to)
1656/1659–1743, *John Buxton
(1684–1731)*, bequeathed, 1949
Daniell, (Miss) *Yarmouth Old Jetty*,
gift, 1964
Daniell, Edward Thomas 1804–
1842, *Ruins in Rome*, bequeathed,
1946
Daniell, Edward Thomas
1804–1842, *A View of St Malo*, gift
from the East Anglian Art Society,
1894
Daniell, Edward Thomas
1804–1842, *Sketch for a Picture
of the Mountains of Savoy from
Geneva*, gift from the East Anglian
Art Society, 1894
Daniell, Edward Thomas 1804–
1842, *Back River, Norwich (View at
Hellesdon)*, bequeathed, 1946
Daniell, Edward Thomas
1804–1842, *Mount Edgecombe,
Devonshire*, bequeathed, 1946
Daniell, Edward Thomas
1804–1842, *Ruins of a Claudian
Aqueduct in the Campagna di
Roma*, bequeathed, 1946
Danielsz., Andries (attributed to)
c.1580–c.1640, *Floral Study with
Insects in the Foreground*, accepted
in lieu of tax by HM Government
through the Museums and
Galleries Commission, 1987
Darby, Alfred William active
1875–1902, *Cavalier*, gift
Daubigny, Charles-François
1817–1878, *Cattle at a Stream,
Evening*, purchased with the
Beecheno and Doyle Bequest
Funds, 1949
Davis, John Philip 1784–1862,
*Captain George William Manby
(1765–1854)*, gift, 1831
De Wint, Peter 1784–1849, *Bray-
on-Thames*, bequeathed, 1949
Decker, Cornelis Gerritsz. d.1678,
*A Sluice, Wooded Landscape with
Figures on a Path*, purchased
with grants from the Museums
and Galleries Commission, the
National Heritage Memorial Fund
and the National Art Collections
Fund, 1991
Dexter, Walter 1876–1958, *A
Workshop*, purchased, 1901
Dexter, Walter 1876–1958, *An Arch
in a Wood*
Dexter, Walter 1876–1958, *Sketch
of Seated Woman in a Blue Hat*
**Diest, Willem van (attributed
to)** 1610–1673, *Estuary Scene
with Shipping, Figures in the
Foreground*, purchased with grants
from the Museums and Galleries
Commission, the National
Heritage Memorial Fund and the
National Art Collections Fund,
1991
Dixon, Robert 1780–1815, *River
Scene with Sailing Boat and
Cottage*, gift, 1945
Dobson, William (attributed

to) 1611–1646, *Robert Buxton (1633–1662)*, bequeathed, 1949

Donthorne, William John 1799–1859, *Norwich Cathedral (South Aisle)*, gift, 1938

Donthorne, William John 1799–1859, *St Andrew's Hall, Norwich*, gift, 1938

Doyle, Honor Camilla 1888–1944, *Lock 75, Cassiobury Canal*, bequeathed, 1944

Droochsloot, Joost Cornelisz. 1586–1666, *Village Scene*, gift from the National Art Collections Fund, 1967

Drummond, Samuel 1765–1844, *The Death of Nelson*, purchased with a grant from the Victoria & Albert Museum Purchase Grant Fund, 1973

Ducq, Johan le (school of) 1629–1676/1677, *The Tippler*, unknown provenance

Duguid, John 1906–1961, *Happisburgh Beach*, gift, 2002

Dupré, Jules 1811–1889, *Landscape with Cattle Watering*, purchased with the Beecheno and Doyle Bequest Funds, 1949

Durrant, Roy Turner 1925–1998, *Inscape: Autumn at Alderworth*, gift, 1973

Dutch School *The Yarmouth Collection*, gift, 1947

Dutch School, 17th C *Group of Men and a Horse near a Frozen River*, bequeathed by Jean Alexander through the National Art Collections Fund, 1973

Dutch School *View of Norwich*, purchased with a grant from the Victoria & Albert Museum Purchase Grant Fund, 1967

Dutch School *Shipping Scene*, bequeathed by Ernest E. Cook through the National Art Collections Fund, 1955

Edwards, Edwin 1823–1879, *Westleton Common, Suffolk*, gift, 1925

Elliott, Edward 1851–1916, *Miss Catherine Maud Nichols (1847–1923)*, gift, 1923

Elliott, Edward 1851–1916, *George Clayton Eaton (1834–1900) (painted from a photograph)*, gift in memory of four generations of the Eaton family, namely Thomas Eaton, Thomas Damant Eaton, the Reverend William Ray Eaton, George Clayton Eaton and Frederic Ray Eaton (all Freemen of the City of Norwich) and the Reverend Thomas Ray Eaton, who in their various ways contributed to the cultural life of Norwich and Norfolk, 2002

Engelsz., Cornelis 1574/1575–1650, *The Supper at Emmaus*, purchased with grants from the National Art Collections Fund, the Headley Trust, MLA/Victoria & Albert Museum Purchase Grant Fund, a private family trust (through the East Anglia Art Foundation), the Friends of the Norwich Museums, the Paul Bassham Trust, East Anglia Art Foundation, Kip Bertram (through the East Anglia Art Foundation), Town Close Estate Charity and the Mercers Company, 2004

Ernst, Max 1891–1976, *A Sunny Afternoon in 1913*, on loan from the East Anglia Art Foundation, © ADAGP, Paris and DACS, London 2006

Ernst, Max 1891–1976, *The Bird School Sign*, on loan from the East Anglia Art Foundation, © ADAGP, Paris and DACS, London 2006

Fidler, Martin b.1950, *Norwich Market in the Rain*, gift from the artist, 1985, © the artist

Fidler, Martin b.1950, *Norwich Market in the Sun*, gift from the artist, 1985, © the artist

Fielding, Anthony V. C. (attributed to) 1787–1855, *Sailing Boat in a Storm*, purchased with the Beecheno Bequest Fund, 1943

Finnie, John 1829–1907, *A Member of the Naval Reserve*, gift, 1896

Fitzpatrick, (Colour Sergeant) *Windmill*, gift, 1926

Flemish School *Triptych: The Adoration with St Peter and St Barbara and Donors*, gift, 1948

Flemish School mid-16th C, *Head of Christ*, gift, 1945

Flemish School early 17th C, *Vanity*, gift, 1925

Flemish School 17th C, *The Virgin and Child with St Catherine*, unknown provenance

Flemish School late 17th/early 18th C, *Landscape with Figures*, bequeathed, 1969

Fletcher, Alexandrina *St Andrew's Church, Burlingham, 7th June 1894*, gift, 1971

Foley, Henry John 1818–1874, *Anne Hathaway's Cottage, Stratford-on-Avon*, bequeathed, 1933

Fouqueray, Dominique Charles 1871–1956, *Norwich Castle with Cattle Market*, purchased with the assistance of a private charitable trust, 1991, © ADAGP, Paris and DACS, London 2006

Francia, François-Thomas-Louis 1772–1839, *Saving the Crew and Passengers from the Brig 'Providence', Wrecked off Winterton, on 15th April 1815*, gift, 1841

Francia, François-Thomas-Louis 1772–1839, *Saving the Crew of the Brig 'Leipzig', Wrecked on Yarmouth Bar, on 7th December 1815*, gift, 1841

Freeman, William Philip Barnes 1813–1897, *The River at Thorpe Reach, Norwich*, bequeathed, 1969

Freeman, William Philip Barnes 1813–1897, *Cromer from the East, Evening*, gift, 1963

Freeman, William Philip Barnes 1813–1897, *Landscape*, gift, 1933

Freeman, William Philip Barnes 1813–1897, *Landscape at Costessey*, bequeathed, 1948

Frere, Amy Hanbury active 1902–1958, *The Late J. H. Gurney (after William Carter)*, gift, 1923

Frost, Terry 1915–2003, *October Red Wedge*, gift from the Contemporary Art Society, 1962, © the artist's estate

Gainsborough, Thomas 1727–1788, *Autumn Landscape*, purchased with the Beecheno and Doyle Bequest Funds, 1951

Gainsborough, Thomas 1727–1788, *Farmyard with Milkmaid, Cows and Donkeys*, on loan from a private owner

Gallon, Robert Samuel Ennis active 1830–1868, *John Ayris (1830–1902)*, on loan from a private owner

Garstin, Norman 1847–1926, *Burford, Oxfordshire*, gift from the Contemporary Art Society, 1980

Geldart, Joseph 1808–1882, *Old Trowse Bridge, Norwich*, bequeathed, 1946

George, Patrick b.1923, *Natalie Dower*, on loan from the Norfolk Contemporary Art Society, © the artist

Gill, William 1826–1869, *Bridge over a Stream*, gift, 1946

Gill, William 1826–1869, *Rocky Stream with Small Waterfall*, gift, 1946

Ginner, Charles 1878–1952, *Norwich Cathedral from Pull's Ferry*, gift, 2004

Glasgow, Alexander c.1840–1894, *The Reverend T. J. Batcheler (1794–1874)*, gift, 1946

Goodall, Thomas Frederick 1856/1857–1944, *Rockland Broad, Norfolk*, gift, 1948

Goyen, Jan van 1596–1656, *A River Estuary*, purchased with grants from the National Art Collections Fund and the Friends of the Norwich Museums, 1958

Graham, George 1881–1949, *Shipping Scene*, bequeathed, 1949

Graham, J. active 1853, *The Philosopher's Breakfast*, on loan from a private collection

Grant, Francis 1803–1878, *John Henry Gurney (1819–1890)*, purchased by public subscription, 1861

Greaves, Derrick b.1927, *Entering a Room with Difficulty*, purchased with grants from the Norfolk Contemporary Art Society and the Victoria & Albert Museum Purchase Grant Fund, 1984, © the artist

Green, George Colman b.1877, *Heydon's House, King Street, Norwich*, unknown provenance

Greiffenhagen, Maurice 1862–1931, *Sir Henry Rider Haggard (1856–1925)*, bequeathed, 1925

Griffiths, Tom 1901–1990, *St Gregory's Alley, Norwich*, gift, 1986

Gross, Anthony 1905–1984, *Undulating Valley*, gift from the Contemporary Art Society, 1959, © Anthony Gross, RA, CBE - painter/etcher

Hambling, Maggi b.1945, *Sleepwalker*, gift from East England Arts, 2002, © the artist

Hambling, Maggi b.1945,

Preparatory Study for 'The Head of a Warder at the National Gallery', anonymous gift through the National Art Collections Fund, 2003, © the artist

Harcourt, Bosworth 1836–1914, *At Costessey, Norfolk*, bequeathed, 1914

Harcourt, Bosworth 1836–1914, *St Swithin's Alley, Norwich*, bequeathed, 1914

Harding, George Perfect (style of) 1781–1853, *Portrait of a Lady*, purchased with grants from the Museums and Galleries Commission, the National Heritage Memorial Fund and the National Art Collections Fund, 1991

Harding, James Duffield 1798–1863, *In the Welch Hills*, purchased with a grant from the Victoria & Albert Museum Purchase Grant Fund, 1973

Havers, Alice 1850–1890, *'But Mary kept all these things and pondered them in her heart'*, gift, 1895

Hawkins, M. A. (attributed to) *Portrait of a Young Girl*, on loan from Norfolk Library and Information Services

Hayman, Francis c.1708–1776, *A Hound, a Spaniel and a Pug (A Portrait of a Mastiff)*, purchased with grants from the Museums and Galleries Commission, the National Heritage Memorial Fund and the National Art Collections Fund, 1991

Heda, Willem Claesz. 1594–1680, *Still Life with an Upturned Roemer*, accepted in lieu of tax by HM Government, 1998

Heins, John Theodore Sr 1697–1756, *Self Portrait*, purchased with a grant from the Victoria & Albert Museum Purchase Grant Fund, 1974

Heins, John Theodore Sr 1697–1756, *Thomas Harwood, Mayor of Norwich (1728)*, gift, 1924

Heins, John Theodore Sr 1697–1756, *The Death of Thomas Guy*, purchased with a grant from the Victoria & Albert Museum Purchase Grant Fund, 1981

Heins, John Theodore Sr 1697–1756, *Thomas Guy Counting His Money*, purchased with a grant from the Victoria & Albert Museum Purchase Grant Fund, 1981

Heins, John Theodore Sr 1697–1756, *Christopher Amiraut*, gift, 1924

Heins, John Theodore Sr 1697–1756, *The Reverend Thomas Roger Duquesne*, on loan from East Tuddenham Parish Council

Heins, John Theodore Sr 1697–1756, *Thomas Hurnard, Mayor of Norwich (1752)*, purchased, 1974

Henderson, Nigel 1917–1985, *Willy Call-Up*, purchased with grants from the Norfolk Contemporary Art Society and the Victoria & Albert Museum

Purchase Grant Fund, 1984, © the Henderson estate

Herkomer, Hubert von 1849–1914, *Jeremiah James Colman, MP*, bequeathed, 1946

Heyligers, Hendrik 1877–1967, *Three Children Playing with a Toy Farm*, gift, 1938

Highmore, Joseph (attributed to) 1692–1780, *Portrait of Three Children*, gift, 1953

Hilder, Richard 1813–1852, *Landscape with Figures*, purchased with the Beecheno Bequest Fund, 1943

Hilton, William I 1752–1822, *Nathaniel Bolingbroke (1757–1840), Mayor of Norwich (1819–1820)*, gift, 1939

Hines, Edward Sidney 1906–1975, *Toward Stratford St Mary*, gift from the Norfolk and Norwich Art Circle, 1980, © the artist's estate

Hitchens, Ivon 1893–1979, *Red Spring*, gift from the Contemporary Art Society, 1956, © Ivon Hitchens' estate/ Jonathan Clark & Co

Hoare, William (attributed to) c.1707–1792, *John Plampin, Aged 11*, gift, 1944

Hobbema, Meindert 1638–1709, *The Anglers*, bequeathed by Ernest E. Cook through the National Art Collections Fund, 1955

Hodgson, Charles (attributed to) 1769–1856, *The Old Fish Market, Norwich*, purchased with the Beecheno Bequest Fund, 1937

Hodgson, David 1798–1864, *The Old Fish Market, Norwich*, bequeathed, 1900

Hodgson, David 1798–1864, *Market Place, Norwich*, gift

Hodgson, David 1798–1864, *Norwich Fish Market*, bequeathed, 1923

Hodgson, David 1798–1864, *Old Post Office Court, Norwich*, bequeathed, 1946

Hodgson, David 1798–1864, *Sir Benjamin Wrench's Court, Norwich*, bequeathed, 1946

Hodgson, David 1798–1864, *Cowgate, Norwich*, bequeathed, 1938

Hodgson, David 1798–1864, *Norwich Castle*, bequeathed, 1923

Hodgson, David 1798–1864, *Sandling's Ferry, Norwich*, gift from the East Anglian Art Society, 1894

Hodgson, David 1798–1864, *A View from Whitefriars Bridge, Norwich*, bequeathed, 1900

Hodgson, David 1798–1864, *St Laurence Church, Norwich*, gift, 1946

Hodgson, David 1798–1864, *Interior of a Church near Ely*, bequeathed, 1923

Hodgson, David 1798–1864, *King Street Gates, Norwich*, bequeathed, 1946

Hodgson, David 1798–1864, *Norwich Castle*, bequeathed, 1938

Hodgson, David 1798–1864, *Norwich Cathedral from Cowgate*, bequeathed, 1940

East Anglian Art Society, 1894
Middleton, John 1827–1856, *A Fine Day in February (Hellesdon)*, bequeathed, 1946
Middleton, John 1827–1856, *A Fine Day in February (Hellesdon)*, bequeathed, 1946
Middleton, John 1827–1856, *Landscape with Pollards*, purchased with the Beecheno Bequest Fund, 1938
Middleton, John 1827–1856, *Near Ivybridge, South Devon*, bequeathed, 1946
Middleton, John 1827–1856, *Road Scene*, bequeathed, 1946
Middleton, John 1827–1856, *Stepping Stones*, bequeathed, 1946
Middleton, John 1827–1856, *The Avenue, Gunton Park, Norfolk*, bequeathed, 1963
Middleton, John (attributed to) 1827–1856, *View of Mousehold*, purchased with the Beecheno Bequest Fund, 1941
Mieris, Frans van the younger (attributed to) 1689–1763, *The Reverend Dr Cox Macro (1683–1767)*, purchased with grants from the Museums and Galleries Commission, the National Heritage Memorial Fund and the National Art Collections Fund, 1991
Millais, John Everett 1829–1896, *The Conjuror*, gift, 1938
Minns, Edwin 1852–1915, *Beccles*, gift, 1929
Mommers, Hendrick (attributed to) 1623–1693, *Cowherd with Cattle on a Path beneath a Cliff*, purchased with grants from the Museums and Galleries Commission, the National Heritage Memorial Fund and the National Art Collections Fund, 1991
Morris, Cedric Lockwood 1889–1982, *Solva*, bequeathed, 1990, © trustees of the Cedric Lockwood Morris estate/ foundation
Mortimer, John Hamilton 1740–1779, *A Shooting Party at Cavenham Park, Bury St Edmunds, Sir Simon le Blanc and Nephews*, gift, 1950
Moucheron, Frederick de (attributed to) 1633–1686, *Extensive Southern Landscape*, purchased with grants from the Museums and Galleries Commission, the National Heritage Memorial Fund and the National Art Collections Fund, 1991
Munnings, Alfred James 1878–1959, *The Farmyard*, bequeathed in memory of F. S. Deyns Page, 1985, © the artist's estate
Munnings, Alfred James 1878–1959, *Study of a Pony*, gift, 1961, © the artist's estate
Munnings, Alfred James 1878–1959, *The Painting Room, Norwich School of Art*, on loan from the Norwich School of Art and Design, © the artist's estate
Munnings, Alfred James

1878–1959, *Still Life*, on loan from the Norwich School of Art and Design, © the artist's estate
Munnings, Alfred James 1878–1959, *Sunny June*, gift, 1902, © the artist's estate
Munnings, Alfred James 1878–1959, *First Study in Oils from Life at Julien's Atelier*, on loan from the Norwich School of Art and Design, © the artist's estate
Munnings, Alfred James 1878–1959, *Crostwick Common*, bequeathed, 1932, © the artist's estate
Munnings, Alfred James 1878–1959, *The Horse Fair (A Suffolk Fair)*, bequeathed, 1937, © the artist's estate
Munnings, Alfred James 1878–1959, *Sketch of Cows*, gift, 1925, © the artist's estate
Munnings, Alfred James 1878–1959, *Mendham, the Mill Pool near the Artist's Home*, purchased, 1951, © the artist's estate
Munnings, Alfred James 1878–1959, *Gravel Pit in Suffolk*, gift, 1928, © the artist's estate
Munnings, Alfred James 1878–1959, *'Mendham Ensign', Suffolk Stallion*, gift, 1961, © the artist's estate
Munnings, Alfred James 1878–1959, *Watering Horses, Canadian Troops in France, 1917*, gift, 1928, © the artist's estate
Munnings, Alfred James 1878–1959, *Study for 'In the Paddock, Cheltenham'*, purchased with the Doyle Bequest Fund, 1951, © the artist's estate
Munnings, Alfred James 1878–1959, *Laura Knight Painting*, gift from a family charitable trust, 1985, © the artist's estate
Munnings, Alfred James 1878–1959, *The Huntsman and Hounds*, gift, 1971, © the artist's estate
Muzin, C. P. *John Hasfeld*
Neer, Aert van der 1603–1677, *Moonlit Landscape with a River*, purchased with grants from the Friends of the Norwich Museums and the Victoria & Albert Museum Purchase Grant Fund, 1967
Newcomb, Mary b.1922, *Moths and Men with Hay, August*, gift, 2000, © the artist
Newcomb, Mary b.1922, *Mendham Marsh*, gift, 2000, © the artist
Newcomb, Mary b.1922, *Burdock and Us with Burrs*, gift, 2002, © the artist
Newcomb, Mary b.1922, *The Fête*, purchased with a grant from the Victoria & Albert Museum Purchase Grant Fund, 1978, © the artist
Newcomb, Mary b.1922, *Suffolk Clun-Cross Ewe with Two Lambs*, on loan from the artist, © the artist
Newcomb, Mary b.1922, *Suffolk Ewe Sitting down*, on loan from the artist, © the artist
Neyn, Pieter de (attributed to) 1597–1639, *River Landscape with Ferry Boat and Cottage*, purchased

with grants from the Museums and Galleries Commission, the National Heritage Memorial Fund and the National Art Collections Fund, 1991
Nicholls, Guy b.1926, *Dylan Thomas (1914–1953)*, gift, 1966
Nichols, Catherine Maude 1847–1923, *Bethel Hospital, Norwich*, gift, 1940
Nichols, Catherine Maude 1847–1923, *Earlham, Norwich*, gift, 1903
Nichols, Catherine Maude 1847–1923, *Early in the Year*, bequeathed, 1934
Nichols, Catherine Maude 1847–1923, *George Borrow (after John Thomas Borrow)*, gift, 1921
Nichols, Catherine Maude 1847–1923, *Lime Pit Cottages, Ipswich Road, Norwich*, gift, 1917
Nichols, Catherine Maude 1847–1923, *On Norwich River*, bequeathed, 1952
Nichols, Catherine Maude 1847–1923, *River and Trees*, gift, 1940
Nichols, Catherine Maude 1847–1923, *River Scene*, gift, 1940
Nichols, Catherine Maude 1847–1923, *Somerleyton, Evening*, gift, 1940
Nichols, Catherine Maude 1847–1923, *The Roadside*, gift, 1934
Nichols, Catherine Maude 1847–1923, *Trees in Meadow*, gift, 1940
Nichols, Catherine Maude 1847–1923, *Trees in Spring*, gift, 1940
Nichols, Catherine Maude 1847–1923, *Waterloo Bridge, London*, gift, 1940
Ninham, Henry 1793–1874, *Jesus Chapel, Norwich Cathedral*, bequeathed, 1946
Ninham, Henry 1793–1874, *The Devil's Tower, Carrow, Norwich*, bequeathed, 1946
Ninham, Henry 1793–1874, *View through the Archway of the Cow Tower, Norwich, Showing the Dean Meadow*, bequeathed, 1946
Ninham, Henry 1793–1874, *Whitefriars, Norwich*, bequeathed, 1946
Ninham, Henry 1793–1874, *St Stephen's Back Street, Norwich*, bequeathed, 1946
Ninham, Henry 1793–1874, *Market Cross, Wymondham*, bequeathed, 1971
Ninham, Henry 1793–1874, *Cromer Church*, bequeathed, 1969
Ninham, Henry 1793–1874, *Fuller's House, St Martin's, Norwich*, bequeathed, 1946
Ninham, Henry 1793–1874, *Gateway and Cattle*, gift from the East Anglian Art Society, 1894
Ninham, Henry 1793–1874, *Gateway, Norwich (Entrance to the Bishop's Palace)*, bequeathed, 1946
Ninham, Henry 1793–1874, *Interior of Strangers' Hall, Norwich*, purchased with the Beecheno Bequest Fund, 1946
Ninham, Henry 1793–1874, *Near Mousehold, Norwich (Sheds behind

Cavalry Barracks)*, bequeathed, 1946
Ninham, Henry 1793–1874, *Norwich Scene with Whitefriars Bridge*, gift, 1961
Ninham, Henry 1793–1874, *Old Houses, Elm Hill, Norwich*, purchased with the Beecheno Bequest Fund, 1937
Ninham, Henry 1793–1874, *Old Houses near St Benedict's Church, Norwich*, purchased with the Beecheno Bequest Fund, 1937
Ninham, Henry 1793–1874, *The River Wensum, Norwich*, bequeathed, 1946
Ninham, Henry (attributed to) 1793–1874, *Farm at Great Ormesby, Norfolk*, gift, 1945
Ninham, John 1754–1817, *Beach Scene*, bequeathed, 1946
Noiles, Arthur Philip Barnes *(1792?–1874), Secretary, Vice-President and President of the Norwich Society of Artists*, gift, 1973
Nursey, Claude Lorraine Richard Wilson 1816–1873, *Officers of the 1st City of Norwich Rifle Volunteers, with Their Captain Henry Staniforth Patteson, on the Rifle Range, Mousehold Heath*, purchased with grants from the Friends of the Norwich Museums and the Victoria & Albert Museum Purchase Grant Fund, 1988
Nursey, Perry 1799–1867, *The Norfolk Sheep: A Portrait*, purchased, 1976
Oakes, John Wright 1820–1887, *Moonlight, Near Cemmaes, Anglesea*, gift, 1896
Oakes, John Wright 1820–1887, *Glen Sannox (Arran)*, gift, 1896
Offord, Gertrude Elizabeth 1860–1903, *Still Life with Water Lilies*, gift, 1934
Offord, Gertrude Elizabeth 1860–1903, *The Art Class*, purchased with a grant from the Friends of the Norwich Museums and the MLA/Victoria & Albert Purchase Grant Fund, 2002
Opie, John 1761–1807, *John Crome (1768–1821)*, bequeathed, 1898
Opie, John 1761–1807, *Mary Gay (the future Mrs Girdlestone) (c.1780–1853)*, bequeathed, 1935
Opie, John 1761–1807, *Self Portrait*, purchased with the Walker Bequest Fund, 1910
Opie, John 1761–1807, *The Noverre Children*, gift, 1958
Opie, John 1761–1807, *Master William Buckle Frost (1798–1875)*, gift, 1963
Opie, John 1761–1807, *Crisp Molineux (1730–1792)*, bequeathed, 1979
Opie, John (after) 1761–1807, *Dr Frank Sayers (1763–1817), at the Age of 37*, purchased, 1945
Opie, John (after) 1761–1807, *Thomas Harvey of Catton*, gift, 1959
Pacheco, Ana Maria b.1943, *A Little Spell in Six Lessons (lid of box containing a series of six drypoint etchings)*, gift from the

Contemporary Art Society, 1992, ©Ana Maria Pacheco, courtesy of Pratt Contemporary Art
Paul, Joseph 1804–1887, *Cottage and Mill*, bequeathed, 1929
Paul, Joseph 1804–1887, *Cottage Landscape with Figures and Horses by a Pond*, bequeathed, 1988
Paul, Joseph 1804–1887, *Farm Buildings*, bequeathed, 1946
Paul, Joseph 1804–1887, *Landscape*, bequeathed, 1940
Paul, Joseph 1804–1887, *Landscape with Cottage*, bequeathed, 1929
Paul, Joseph 1804–1887, *Landscape with Farm Buildings*, bequeathed, 1946
Paul, Joseph 1804–1887, *Moonlight Scene*, gift, 1948
Paul, Joseph 1804–1887, *Moonlight with Shipping and Mill*, gift, 1948
Paul, Joseph 1804–1887, *Poringland Oak (after John Crome)*, purchased with the Beecheno Bequest Fund, 1943
Paul, Joseph 1804–1887, *Pull's Ferry, Norwich*, purchased with the Beecheno Bequest Fund, 1943
Paul, Joseph 1804–1887, *Trees and Pool*, purchased with the Beecheno Bequest Fund, 1943
Peacock, Ralph 1868–1946, *Mrs Maud Isobel Buxton*, bequeathed, 1949
Peake, Robert I c.1551–1619, *Elizabeth D'Oyley, Aged 16*, bequeathed, 1949
Peake, Robert I (attributed to) c.1551–1619, *Elizabeth Buxton, née Kemp*, bequeathed, 1949
Penny, Edward 1714–1791, *Captain Matthew Pepper Manby*, gift, 1831
Penrose, Roland 1900–1984, *Cryptic Coincidence II*, on loan from the Norfolk Contemporary Art Society, © Roland Penrose Estate, England 2006. All rights reserved. www.rolandpenrose. co.uk
Péri, Lucien 1880–1948, *Mont Notre Dame, 15 April 1916 (Wartime Scene)*, gift, 1925, © the artist's estate
Phillips, Tom b.1937, *The Castle, Norwich… the Splendour Falls*, gift from the Norfolk Contemporary Art Society in memory of Mrs Geoffrey Colman, 1972, © DACS 2006
Picabia, Francis 1879–1953, *Le colibri*, on loan from the East Anglia Art Foundation, © ADAGP, Paris and DACS, London 2006
Pigg, James Woolmer 1850–1910, *Back River, Heigham, Norwich*, gift from the East Anglian Art Society, 1894
Piper, John 1903–1992, *Castle Howard: Temple and Mausoleum*, purchased, 1950, © the artist's estate
Pocock, Nicholas 1740–1821, *Saving a Crew at Corton, Norfolk*, gift, 1841
Pocock, Nicholas 1740–1821, *Vessel in Distress, Yarmouth*, gift, 1841

Poelenburgh, Cornelis van 1594/1595–1667, *Landscape with Roman Ruins*, purchased with the Doyle Bequest Fund, 1957

Poelenburgh, Cornelis van 1594/1595–1667, *Nymphs Bathing in a Southern Landscape*, purchased with grants from the Museums and Galleries Commission, the National Heritage Memorial Fund and the National Art Collections Fund, 1991

Potter, Mary 1900–1981, *The Mere*, on loan from the Norfolk Contemporary Art Society, © DACS 2006

Potter, Mary 1900–1981, *Orchard*, gift, 2002, © DACS 2006

Preston, Thomas (attributed to) active 1826–1850, *Wymondham Abbey from the West*, gift, 1957

Priest, Alfred 1810–1850, *Road by the Churchyard*, bequeathed, 1940

Priest, Alfred 1810–1850, *Scene at Taverham, Norfolk (Taverham Paper Mill)*, bequeathed, 1969

Priest, Alfred 1810–1850, *Godstowe Bridge, Oxford*, bequeathed, 1946

Priest, Alfred 1810–1850, *Iffley Mill, Oxford*, gift from the East Anglian Art Society, 1894

Priest, Alfred 1810–1850, *Owlegarchy*, gift from the East Anglian Art Society, 1894

Priest, Alfred 1810–1850, *Beach Scene*, bequeathed, 1971

Priest, Alfred 1810–1850, *Beach Scene with Fishermen and Fishing Baskets in the Foreground*, bequeathed, 1946

Priest, Alfred 1810–1850, *Norwich from the South-East*, gift, 1950

Priest, Alfred 1810–1850, *Beech Trees, Grazing Cattle to Right*, bequeathed, 1946

Priest, Alfred 1810–1850, *Fishing Boats in a Storm*, bequeathed, 1946

Priest, Alfred 1810–1850, *Landscape with Stream Passing through Trees, Pond in Foreground*, bequeathed, 1946

Priest, Alfred 1810–1850, *River Scene with Overhanging Trees*, bequeathed, 1946

Priest, Alfred 1810–1850, *River Scene with Tree to the Right and Wooden Palings on the Left*, bequeathed, 1946

Priest, Alfred 1810–1850, *River Scene with Trees and House with Red Roof and Felled Trunk*, bequeathed, 1946

Priest, Alfred 1810–1850, *Rough Sea with Rowing Boat and Two Figures, Sailing Vessels in the Background*, bequeathed, 1946

Priest, Alfred 1810–1850, *Thorpe River, Norwich (View through an Arch of Whitlingham Church)*, bequeathed, 1946

Priest, Alfred (attributed to) 1810–1850, *Fishing Boat in a Storm*, bequeathed, 1952

Redpath, Anne 1895–1965, *Spanish Village*, on loan from the Norfolk Contemporary Art Society, © courtesy of the artist's estate/www.bridgeman.co.uk

Reeve, James 1833–1920, *Ruins at Whitlingham*, bequeathed, 1946

Reeve, James 1833–1920, *Trowse Old Hall*, bequeathed, 1946

Reinagle, Philip 1749–1833, *Elizabeth Patteson, née Staniforth (1760–1838)*, on loan from a private owner

Reinagle, Philip 1749–1833, *John Patteson (1755–1833)*, on loan from a private owner

Reinagle, Philip 1749–1833, *Mrs John Patteson, née Elizabeth Staniforth (1760–1838)*, purchased with grants from the Museums and Galleries Commission, the National Heritage Memorial Fund and the National Art Collections Fund, 1991

Reinagle, Ramsay Richard 1775–1862, *A View of London with St Paul's*, purchased with grants from the Friends of the Norwich Museums and the Victoria & Albert Museum Purchase Grant Fund, 1978

Richmond, William Blake 1842–1921, *Lieutenant Colonel Charles Edward Bignold*, bequeathed, 1951

Richmond, William Blake 1842–1921, *Phaeton and the Horses of the Sun*, gift, 1924

Riley, Bridget b.1931, *Edge of Day*, purchased with the assistance of grants from the Victoria & Albert Museum Purchase Grant Fund, Henley Curl through the Norfolk Contemporary Art Society, Eastern Arts Association, Friends of the Norwich Museums, Contemporary Art Society, the Robert and Lisa Sainsbury Charitable Fund and anonymous donors, 1985, © the artist

Riley, John 1646–1691, *Thomas Marsham of Stratton Strawless*, bequeathed, 1949

Riley, John 1646–1691, *Joseph Cox*, purchased with grants from the Museums and Galleries Commission, the National Heritage Memorial Fund and the National Art Collections Fund, 1991

Riley, John 1646–1691, *Mrs Joseph Cox, née Elizabeth Macro (d.1682)*, purchased with grants from the Museums and Galleries Commission, the National Heritage Memorial Fund and the National Art Collections Fund, 1991

Riviere, Briton 1840–1920, *Childe Roland to the Dark Tower Came*, gift, 1932

Riviere, Briton 1840–1920, *Two Boys with a Birdcage*, bequeathed, 1976

Riviere, Hugh Goldwin 1869–1956, *Canon Sydney Pelham*, bequeathed, 1941

Roberts, David 1796–1864, *Jerusalem from the Mount of Olives with Pilgrims Entering from the River Jordan*, presented by subscribers to commemorate the part taken by Norfolk units in the capture of Jerusalem by troops under General Allenby, 9 December 1917

Roberts, Herbert Harrington 1837–after 1920, *The Reverend John Gunn, FGS (1801–1890)*, gift, 1870

Roe, Fred 1864–1947, *The Return of the Hero (Lord Nelson)*, bequeathed, 1928, © the artist's estate

Rombouts, Salomon c.1652–c.1702, *A Village Fair with a Mummer in the Foreground*, purchased with grants from the Museums and Galleries Commission, the National Heritage Memorial Fund and the National Art Collections Fund, 1991

Romeyn, Willem (attributed to) c.1624–1694, *A Shepherdess with Sheep beneath the Walls of Rome, Other Figures and Buildings Beyond*, purchased with grants from the Museums and Galleries Commission, the National Heritage Memorial Fund and the National Art Collections Fund, 1991

Romney, George 1734–1802, *Sir Robert John Buxton, 1st Bt*, bequeathed, 1949

Roscoe, Theodora active 1929–1962, *Camilla Doyle*, gift, 1951

Rose, William S. 1810–1873, *Morning in the Highlands*, bequeathed, 1946

Rosoman, Leonard Henry b.1913, *Figures in a Square*, on loan from the East Anglia Art Foundation, © the artist

Rossetti, Dante Gabriel 1828–1882, *Tobias in the House of His Father and Mother*, gift, 1938

Rothwell, Richard 1800–1868, *Mrs Barwell*, bequeathed, 1918

Rousseau, Théodore 1812–1867, *Landscape*, purchased with the Beecheno and Doyle Bequest Funds, 1949

Russel, Anthony (attributed to) c.1660–1743, *Mrs Soame*, purchased with grants from the Museums and Galleries Commission, the National Heritage Memorial Fund and the National Art Collections Fund, 1991

Ruysdael, Jacob Salomonsz. van 1629/1630–1681, *Landscape*, bequeathed, 1984

Saftleven, Herman the younger (circle of) 1609–1685, *An Extensive River Landscape with Figures on a Road, a Wood to the Left*, purchased with grants from the Museums and Galleries Commission, the National Heritage Memorial Fund and the National Art Collections Fund, 1991

Sanders, John 1750–1825/1826, *Joseph Browne (1720–1800)*, on loan from the Diocese of Norwich

Sanders, John 1750–1825/1826, *The Reverend John Walker and His Wife*, purchased with a grant from the Victoria & Albert Museum Purchase Grant Fund, 1982

Sandys, Anthony 1806–1883, *Three Portraits of the Artist*, bequeathed, 1946

Sandys, Anthony 1806–1883, *Self Portrait*, gift, 1909

Sandys, Anthony 1806–1883, *Whitlingham Reach, near Norwich*, bequeathed, 1946

Sandys, Anthony 1806–1883, *Henry Ninham (1796–1874)*, gift, 1947

Sandys, Anthony 1806–1883, *Meditation*, bequeathed, 1931

Sandys, Anthony 1806–1883, *On the River Yare*, bequeathed, 1946

Sandys, Anthony 1806–1883, *Portrait of a Man*, gift, 1939

Sandys, Anthony 1806–1883, *Richard Roper Boardman (Underchamberlain to Norwich Corporation, 1834)*, gift from the East Anglian Art Society, 1894

Sandys, Anthony 1806–1883, *The Girl in the Hat*, gift, 1968

Sandys, Anthony 1806–1883, *The Mill*, gift, 1911

Sandys, Anthony (attributed to) 1806–1883, *The Sand Pit*, gift, 1950

Sandys, Emma 1843–1877, *Portrait Study of a Lady in a Yellow Dress*, bequeathed, 1946

Sandys, Emma 1843–1877, *Study of a Head*, gift from the East Anglian Art Society, 1894

Sandys, Frederick 1829–1904, *Self Portrait, When 19 Years of Age*, gift, 1909

Sandys, Frederick 1829–1904, *Adelaide Mary, Mrs Philip Bedingfeld*, purchased with the Walker Bequest Fund, 1942

Sandys, Frederick 1829–1904, *Autumn*, bequeathed, 1946

Sandys, Frederick 1829–1904, *Hannah Louisa, Mrs William Clabburn*, bequeathed, 1946

Sandys, Frederick 1829–1904, *Philip Bedingfeld, LLD, JP*, purchased with the Walker Bequest Fund, 1942

Sandys, Frederick 1829–1904, *Mary Magdalene (Tears, Idle Tears)*, bequeathed, 1946

Sandys, Frederick 1829–1904, *Breydon Water*, bequeathed, 1946

Sartorius, Francis II c.1777–c.1808, *A Stranded Vessel: The Snipe Gun-Brig Grounded at Great Yarmouth in 1807 with the Loss of 67 Lives*, gift, 1841

Sartorius, Francis II c.1777–c.1808, *Saving a Crew at Anholt*, gift, 1841

Schetky, John Christian 1778–1874, *'HMS Amelia' and the French Frigate 'Arethuse' in Action, 1813*, bequeathed, 1902

Schetky, John Christian 1778–1874, *'HMS Amelia' Chasing the French Frigate 'Arethuse', 1813*, bequeathed, 1902

Schofield, Zara b.1981, *Veiled (Orange and Green)*, gift from the Norfolk Contemporary Art Society, 2005, © the artist

Schott, Cecil (attributed to) active 1887, *John Gurney (after George Frederick Watts)*, gift, 1894

Scully, Sean b.1945, *26.7.74, No.3/4*, gift from East England Arts, 2002

Seago, Edward Brian 1910–1974, *The Dark Canal, Venice*, bequeathed, 1975, © by kind permission of the Trustees of the estate of Edward Seago, courtesy of Thomas Gibson Fine Art Limited

Seago, Edward Brian 1910–1974, *Miss Rosamund Le Hunte-Cooper*, bequeathed, 1975, © by kind permission of the Trustees of the estate of Edward Seago, courtesy of Thomas Gibson Fine Art Limited

Seago, Edward Brian 1910–1974, *Sunset, Yarmouth*, bequeathed, 1975, © by kind permission of the Trustees of the estate of Edward Seago, courtesy of Thomas Gibson Fine Art Limited

Seago, Edward Brian 1910–1974, *A Stubble Field near Ludham*, bequeathed, 1978, © by kind permission of the Trustees of the estate of Edward Seago, courtesy of Thomas Gibson Fine Art Limited

Seago, Edward Brian 1910–1974, *La Vena Canal, Chioggia*, bequeathed, 1975, © by kind permission of the Trustees of the estate of Edward Seago, courtesy of Thomas Gibson Fine Art Limited

Seago, Edward Brian 1910–1974, *A Norfolk Village, Aldeby*, bequeathed, 1975, © by kind permission of the Trustees of the estate of Edward Seago, courtesy of Thomas Gibson Fine Art Limited

Seago, Edward Brian 1910–1974, *Drainage Mill on the Bure*, bequeathed, 1975, © by kind permission of the Trustees of the estate of Edward Seago, courtesy of Thomas Gibson Fine Art Limited

Seago, Edward Brian 1910–1974, *Evening Haze, Thurne Dyke*, bequeathed, 1975, © by kind permission of the Trustees of the estate of Edward Seago, courtesy of Thomas Gibson Fine Art Limited

Seago, Edward Brian 1910–1974, *Fishing Boats on the Mud, Honfleur*, bequeathed, 1975, © by kind permission of the Trustees of the estate of Edward Seago, courtesy of Thomas Gibson Fine Art Limited

Seago, Edward Brian 1910–1974, *The Anvil Cloud*, gift, 1944, © by kind permission of the Trustees of the estate of Edward Seago, courtesy of Thomas Gibson Fine Art Limited

Seago, Edward Brian 1910–1974, *The East Window*, gift, 1944, © by kind permission of the Trustees of the estate of Edward Seago, courtesy of Thomas Gibson Fine Art Limited

Seago, Edward Brian 1910–1974, *The Haystack*, gift, 1976, © by kind permission of the Trustees of the estate of Edward Seago, courtesy of Thomas Gibson Fine Art Limited

Seago, Edward Brian 1910–1974, *The White Kitchen*, gift, 1956, © by kind permission of the Trustees

of the estate of Edward Seago, courtesy of Thomas Gibson Fine Art Limited

Seago, Edward Brian 1910–1974, *Winter Landscape, Norfolk*, gift, 1963, © by kind permission of the Trustees of the estate of Edward Seago, courtesy of Thomas Gibson Fine Art Limited

Sebire, Gaston 1920–2001, *Environs de Madrid*, gift from the Mayor of Rouen (twin city of Norwich), 1964, © ADAGP, Paris and DACS, London 2006

Self, Colin b.1941, *Large Harvest Field with Two Hay Bales at Happisburgh, Norfolk*, purchased with the Kenneth Spelman Bequest Fund, 1998, © DACS 2006

Self, Colin b.1941, *Norfolk Landscape with Cow, 14th September*, purchased with the Kenneth Spelman Bequest Fund, 1998, © DACS 2006

Sewell, Benjamin 1774–1849, *Norwich Castle*, gift, 1923

Sewell, Benjamin 1774–1849, *Norwich Cathedral*, gift, 1891

Sewell, Benjamin 1774–1849, *Norwich Cathedral*, gift, 1891

Sharp, Michael William 1777–1840, *Man Eating*, gift, 1969

Sharp, Michael William 1777–1840, *Mrs John Crome Seated at a Table by an Open Work Box*, purchased with the Beecheno Bequest Fund, 1935

Sharp, Michael William 1777–1840, *John Crome (1768–1821)*, bequeathed, 1946

Sharp, Michael William 1777–1840, *Samuel Marsh*, bequeathed, 1946

Sherrington, James Norton d.1848, *Road with Pollards (after John Crome)*, gift in memory of Mrs Dorothy Rose Thornycroft by her children, 1974

Shiels, William 1785–1857, *Possibly William Loades Rix (c.1777–1855)*, gift, 1977

Short, Obadiah 1803–1886, *Footbridge with Woman Crossing*, gift from the East Anglian Art Society, 1894

Short, Obadiah 1803–1886, *Road Scene*, bequeathed, 1927

Short, Obadiah 1803–1886, *Wooded Landscape with Cottage and Woman*, purchased with a grant from the Friends of the Norwich Museums, 1932

Short, Obadiah 1803–1886, *Landscape with Tree-Lined Road, River and Barge*, purchased with a grant from the Friends of the Norwich Museums, 1932

Short, Obadiah 1803–1886, *At the Farm Gate*, bequeathed, 1983

Short, Obadiah 1803–1886, *River Scene with Cottage and Trees*, bequeathed, 1946

Short, Obadiah 1803–1886, *Road Scene*, gift from the East Anglian Art Society, 1894

Short, Obadiah 1803–1886, *Road Scene with Cottage*, bequeathed, 1946

Short, Obadiah 1803–1886, *View of Norwich*, gift, 1940

Short, Obadiah (attributed to) 1803–1886, *Landscape*, bequeathed, 1940

Siberechts, Jan 1627–c.1703, *Landscape with Road, Cart and Figures*, purchased with the Doyle Bequest Fund, 1949

Sickert, Walter Richard 1860–1942, *The Red Shop (The October Sun)*, bequeathed, 1949, © estate of Walter R. Sickert/DACS 2006

Sickert, Walter Richard 1860–1942, *Auberville*, purchased with grants from the Friends of the Norwich Museums and the Gulbenkian Foundation, 1961, © estate of Walter R. Sickert/DACS 2006

Sillett, James 1764–1840, *Self Portrait*, unknown provenance

Sillett, James 1764–1840, *The Winfarthing Oak*, purchased with the Beecheno Bequest Fund, 1947

Sillett, James 1764–1840, *Thorpe Gardens Public House, Norwich*, purchased with the Beecheno Bequest Fund, 1941

Sillett, James 1764–1840, *Flowers and Fruit*, gift from the East Anglian Art Society, 1894

Sillett, James 1764–1840, *Norwich Cathedral*, bequeathed, 1946

Sillett, James 1764–1840, *Interior of St Andrew's Hall, Norwich*, gift, 1934

Sillett, James 1764–1840, *Three-Panel Screen with Six Flower Pieces (recto)*, purchased with grants from the Victoria & Albert Museum Purchase Grant Fund, Friends of the Norwich Museums and a private family trust, 1994

Sillett, James 1764–1840, *Three-Panel Screen with a View of Norwich Castle (verso)*, purchased with grants from the Victoria & Albert Museum Purchase Grant Fund, Friends of the Norwich Museums and a private family trust, 1993

Sillett, James 1764–1840, *Henry Bathurst DD, Bishop of Norwich (1744–1837)*, gift from the Norwich Central Library, Colman and Rye Library of Local Studies, 1983

Sillett, James 1764–1840, *Seascape in Moonlight*, purchased with the Doyle Bequest Fund, 1955

Sillett, James 1764–1840, *St Michael Coslany Church, Norwich*, bequeathed, 1946

Sillett, James 1764–1840, *Still Life of Lobsters, etc.*, purchased with the Beecheno Bequest Fund, 1944

Sisley, Alfred 1839–1899, *A Street Scene (La grande rue à Argenteuil)*, bequeathed through the National Art Collections Fund, 1945

Slaughter, Stephen 1697–1765, *Sir Robert Walpole, 1st Lord Orford (1676–1745)*, purchased with grants from the Victoria & Albert Museum Purchase Grant Fund and the Friends of the Norwich Museums, 1996

Smith, Ivy b.1945, *Gladioli in a Glass (preparatory study for 'The Smith Family Golden Wedding')*, gift, 1986

Smith, Ivy b.1945, *The Smith Family Golden Wedding*, purchased with grants from the Victoria & Albert Museum Purchase Grant Fund and the Friends of the Norwich Museums, 1986, © the artist

Smith, Miller c.1854–1937, *St Helen's Hospital, Norwich*, gift, 1956

Smith, Miller c.1854–1937, *Costessey, Norfolk*, gift, 1956

Smythe, Thomas 1825–1907, *Carriers Cart, Winter*, bequeathed, 1971

Smythe, Thomas 1825–1907, *Carting Timber, Winter*, bequeathed, 1969

Smythe, Thomas 1825–1907, *Crossing the Brook, Scene near Ipswich*, bequeathed, 1969

Smythe, Thomas 1825–1907, *Crossing the Common, Scene near Ipswich*, bequeathed, 1969

Smythe, Thomas 1825–1907, *The Rabbit Catcher and His Horse, Winter*, bequeathed, 1971

Solomon, Abraham 1824–1862, *Portrait of Lady with a Letter*, gift, 1938

Somerville, Margaret active c.1927–1929, *Happys Days by the Sea*, gift, 1985, © reproduced by kind permission of Rosemary Somerville c/o Messum Gallery

Somerville, Peggy 1918–1975, *Spring Time*, gift, 1985, © reproduced by kind permission of Rosemary Somerville c/o Messum Gallery

Somerville, Peggy 1918–1975, *Gipsies, Tring*, gift, 1985, © reproduced by kind permission of Rosemary Somerville c/o Messum Gallery

Somerville, Peggy 1918–1975, *Wiggington, Near Tring*, gift, 1985, © reproduced by kind permission of Rosemary Somerville c/o Messum Gallery

Somerville, Peggy 1918–1975, *Beside the Deben*, gift, 1985, © reproduced by kind permission of Rosemary Somerville c/o Messum Gallery

Somerville, Peggy 1918–1975, *Newbourne Hall*, gift, 1985, © reproduced by kind permission of Rosemary Somerville c/o Messum Gallery

Somerville, Peggy 1918–1975, *John and Charlotte*, gift, 1985, © reproduced by kind permission of Rosemary Somerville c/o Messum Gallery

Somerville, Peggy 1918–1975, *Winter, Newbourne*, gift, 1985, © reproduced by kind permission of Rosemary Somerville c/o Messum Gallery

Somerville, Peggy 1918–1975, *Summer, Aldeburgh*, gift, 1985, © reproduced by kind permission of Rosemary Somerville c/o Messum Gallery

Somerville, Peggy 1918–1975, *Aldeburgh, Coast Scene*, gift, 1985, © reproduced by kind permission of Rosemary Somerville c/o Messum Gallery

Somerville, Peggy 1918–1975, *Spring, The Orchard, Newbourne*, gift, 1985, © reproduced by kind permission of Rosemary Somerville c/o Messum Gallery

Somerville, Peggy 1918–1975, *Still Life with Flowers and Mirror*, gift, 1985, © reproduced by kind permission of Rosemary Somerville c/o Messum Gallery

Somerville, Peggy 1918–1975, *Strawberries*, gift, 1985, © reproduced by kind permission of Rosemary Somerville c/o Messum Gallery

Somerville, Peggy 1918–1975, *Summer*, gift, 1985, © reproduced by kind permission of Rosemary Somerville c/o Messum Gallery

Sothern, Arthur active 1893–1900, *Aldborough, Norfolk*, gift, 1937

Spencer, Vera 1901–1989, *Jock*, gift from the Norfolk and Norwich Art Circle, 1987

Stannard, Alfred 1806–1889, *Moonlight Scene near Carrow*, bequeathed, 1946

Stannard, Alfred 1806–1889, *Scene in Crown Point Wood with Woodcutters*, purchased with a grant from the Friends of the Norwich Museums, 1926

Stannard, Alfred 1806–1889, *Vessels in Full Sail*, bequeathed, 1946

Stannard, Alfred 1806–1889, *Yarmouth Jetty*, bequeathed, 1946

Stannard, Alfred 1806–1889, *Seascape*, bequeathed, 1940

Stannard, Alfred 1806–1889, *On the River Yare*, bequeathed, 1946

Stannard, Alfred 1806–1889, *Gorleston Harbour*, bequeathed, 1946

Stannard, Alfred 1806–1889, *On the River Deben*, gift, 1983

Stannard, Alfred 1806–1889, *Caister Castle, near Great Yarmouth*, bequeathed, 1946

Stannard, Alfred 1806–1889, *River Scene with Mill*, gift from the East Anglian Art Society, 1894

Stannard, Alfred 1806–1889, *Yarmouth Beach*, bequeathed, 1946

Stannard, Alfred 1806–1889, *Seascape*, bequeathed, 1928

Stannard, Alfred 1806–1889, *Seascape*, bequeathed, 1940

Stannard, Alfred 1806–1889, *Trowse Hall near Norwich*, gift, 1943

Stannard, Alfred 1806–1889, *River Scene with Lock*, bequeathed, 1946

Stannard, Alfred 1806–1889, *Trowse Old Hall, near Norwich*, bequeathed, 1946

Stannard, Alfred 1806–1889, *Barges on the Thames*, bequeathed, 1946

Stannard, Alfred 1806–1889, *Sea Piece*, bequeathed, 1946

Stannard, Alfred George 1828–

1885, *A Road Scene*, gift, 1895

Stannard, Alfred George 1828–1885, *A View of Gresham near Cromer*, bequeathed, 1946

Stannard, Alfred George 1828–1885, *Meadows near Norwich*, bequeathed, 1946

Stannard, Alfred George 1828–1885, *On the Yare at Whitlingham*, bequeathed, 1946

Stannard, Alfred George 1828–1885, *River Scene with Peterborough Cathedral in the Distance*, bequeathed, 1946

Stannard, Anna Maria active 1852–1869, *Winter Scene*, bequeathed, 1946

Stannard, Eloise Harriet 1829–1915, *Fruit: Grapes, Peaches, Plums and Pineapple with a Carafe of Red Wine*, bequeathed, 1946

Stannard, Eloise Harriet 1829–1915, *Dying Birds, Illustration for a Poem*, gift, 1962

Stannard, Eloise Harriet 1829–1915, *Still Life, Black Grapes*, gift from the East Anglian Art Society, 1894

Stannard, Eloise Harriet 1829–1915, *Still Life, Pelargoniums*, gift from the East Anglian Art Society, 1894

Stannard, Eloise Harriet 1829–1915, *Strawberries in a Cabbage Leaf on a Table with a Flower Pot Behind*, bequeathed, 1946

Stannard, Eloise Harriet 1829–1915, *Overturned Basket with Raspberries, White Currants and Roses*, bequeathed, 1946

Stannard, Eloise Harriet 1829–1915, *Still Life of Raspberries in a Willow Pattern Bowl, with Cherries and Bindweed*, bequeathed in memory of Canon Edward Copeman, Canon of Norwich Cathedral, 1989

Stannard, Eloise Harriet 1829–1915, *Still Life of Yellow Roses in an Upturned Basket*, bequeathed in memory of Canon Edward Copeman, Canon of Norwich Cathedral, 1989

Stannard, Eloise Harriet 1829–1915, *Still Life of Strawberries on a Cabbage Leaf in a Basket*, bequeathed in memory of Canon Edward Copeman, Canon of Norwich Cathedral, 1989

Stannard, Eloise Harriet 1829–1915, *Duchess Pears with Black Grapes in a Basket*, bequeathed, 1933

Stannard, Eloise Harriet 1829–1915, *Ribston Pippins in a Rush Basket with Mistletoe Sprig*, bequeathed, 1933

Stannard, Eloise Harriet 1829–1915, *Strawberries and Raspberries in a Glass Bowl*, bequeathed, 1946

Stannard, Eloise Harriet 1829–1915, *Apples in an Overturned Basket*, bequeathed, 1997

Stannard, Emily 1803–1885, *Dead Game and a Gun*, bequeathed, 1946

Stannard, Emily 1803–1885, *Dead Game*, bequeathed, 1946

Stannard, Emily 1803–1885,

Flowers, bequeathed, 1894

Stannard, Emily 1803–1885, *Group of Dead Game Birds*, gift, 1894

Stannard, Emily 1803–1885, *Still Life of Dead Game with a Flagon and a String of Onions*, bequeathed, 1946

Stannard, Emily 1803–1885, *Still Life of Dead Ducks, a Hare with a Basket and a Sprig of Holly*, bequeathed, 1946

Stannard, Emily 1803–1885, *Still Life of Hamper with Dead Wood Pigeon and Leveret*, bequeathed, 1946

Stannard, Emily 1803–1885, *Study of Wild Duck*, bequeathed, 1940

Stannard, Joseph 1797–1830, *Thorpe Water Frolic, Afternoon*, gift, 1894

Stannard, Joseph 1797–1830, *Yarmouth Beach and Jetty*, bequeathed, 1946

Stannard, Joseph 1797–1830, *Yarmouth Sands*, gift, 1935

Stannard, Joseph 1797–1830, *A Fresh Breeze*, gift from the East Anglian Art Society, 1894

Stannard, Joseph 1797–1830, *Fishing Boats*, bequeathed, 1946

Stannard, Joseph 1797–1830, *Landscape*, bequeathed, 1946

Stannard, Joseph 1797–1830, *Still Life with a Group of Eight Mackerel in a Broken Basket: A Study on Yarmouth Beach*, bequeathed, 1946

Stannard, Joseph 1797–1830, *The Apotheosis of Dr Beckwith*, on loan from St Peter Mancroft Church

Stannard, Joseph 1797–1830, *The River at Thorpe*, bequeathed, 1946

Stannard, Joseph 1797–1830, *Thorpe, near Norwich*, bequeathed, 1946

Stannard, Joseph (attributed to) 1797–1830, *Nelson's Column at Great Yarmouth*, gift, 1963

Stark, Arthur James 1831–1902, *Dartmoor Ponies*, gift, 1902

Stark, Arthur James 1831–1902, *James Stark*, gift, 1968

Stark, Arthur James 1831–1902, *Near Bettws-y-Coed, North Wales*, gift, 1927

Stark, James 1794–1859, *View on the Yare near Thorpe Church*, bequeathed by Ernest E. Cook through the National Art Collections Fund, 1955

Stark, James 1794–1859, *Landscape (after Claude Lorrain)*, bequeathed, 1946

Stark, James 1794–1859, *An Interior of an Old Bakehouse, Bank Street, Norwich*, bequeathed, 1946

Stark, James 1794–1859, *Whitlingham from Old Thorpe Grove*, bequeathed, 1946

Stark, James 1794–1859, *Carrow Bridge, Norwich*, bequeathed, 1946

Stark, James 1794–1859, *Cromer*, purchased with grants from the National Art Collections Fund, Watney Mann (East Anglia) Ltd and the Victoria & Albert Museum Purchase Grant Fund, 1975

Stark, James 1794–1859, *The Forest Oak*, bequeathed, 1898

Stark, James 1794–1859, *Whitlingham from Old Thorpe Grove*, bequeathed, 1946

Stark, James 1794–1859, *A Dyke Head*, bequeathed, 1946

Stark, James 1794–1859, *A View through Trees with a Horseman and Other Figures, Cattle and Sheep*, bequeathed, 1946

Stark, James 1794–1859, *Buckenham Common, Norfolk*, bequeathed, 1946

Stark, James 1794–1859, *Footbridge over a Stream, with Woman, Child and Dog*, bequeathed, 1946

Stark, James 1794–1859, *Gable End of Cottage*, bequeathed, 1946

Stark, James 1794–1859, *Lake Scene, with Two Men Fishing*, bequeathed, 1946

Stark, James 1794–1859, *Landscape with Road Winding through Trees with Figures*, bequeathed, 1946

Stark, James 1794–1859, *Lane Scene, with Horseman Talking to Woman*, bequeathed, 1946

Stark, James 1794–1859, *Marlborough Forest*, bequeathed, 1946

Stark, James 1794–1859, *Penning the Flock*, gift, 1933

Stark, James 1794–1859, *River Scene, Cattle in Foreground*, bequeathed, 1946

Stark, James 1794–1859, *River Scene with Men Fishing from a Boat*, gift, 1977

Stark, James 1794–1859, *Road Scene at Intwood*, bequeathed, 1900

Stark, James 1794–1859, *Road Scene at Intwood*, bequeathed, 1940

Stark, James 1794–1859, *Rustic Scene*, bequeathed, 1944

Stark, James 1794–1859, *Sheep Washing*, bequeathed, 1957

Stark, James 1794–1859, *Sheep Washing*, bequeathed, 1946

Stark, James 1794–1859, *The Bathers*, bequeathed, 1898

Stark, James 1794–1859, *The Edge of a Wood*, bequeathed, 1946

Stark, James 1794–1859, *The Forest Gate*, bequeathed, 1898

Stark, James 1794–1859, *The Strid, Bolton Abbey*, gift, 1921

Stark, James 1794–1859, *Windsor Castle*, gift from the East Anglian Art Society, 1894

Stark, James 1794–1859, *Wood Scene*, purchased with the Beecheno Bequest Fund, 1939

Storck, Abraham (circle of) 1644–1708, *Shipping in an Estuary with a Jetty to the Left*, purchased with grants from the Museums and Galleries Commission, the National Heritage Memorial Fund and the National Art Collections Fund, 1991

Stubbs, Joseph Woodhouse 1862–1953, *Dahlias and Rosebuds*, gift, 1985

Sutherland, Graham Vivian 1903–1980, *A Path in the Woods*, on loan from the Norfolk Contemporary Art Society, © estate of Graham Sutherland

Swarbreck, Samuel Dukinfield c.1799–1863, *Interior of Strangers' Hall, Norwich*, purchased with a grant from the Friends of the Norwich Museums, 1983

Tait, Robert Scott c.1816–1897, *Edward Taylor (1784–1863), Founder of the Norwich Festival*, gift, 1990

Tidman, Brüer b.1939, *The Dressing Room*, gift, 1994, © the artist

Tillemans, Peter 1684–1734, *The Artist's Studio*, accepted in lieu of tax by HM Government, 1989

Tillemans, Peter 1684–1734, *Master Edward and Miss Mary Macro, the Children of the Reverend Dr Cox Macro*, purchased with grants from the Museums and Galleries Commission, the National Heritage Memorial Fund and the National Art Collections Fund, 1991

Tillemans, Peter 1684–1734, *Four Hounds with Gentlemen Shooting*, purchased with grants from the Museums and Galleries Commission, the National Heritage Memorial Fund and the National Art Collections Fund, 1991

Tillemans, Peter 1684–1734, *Four Hounds with Huntsmen to the Right*, purchased with grants from the Museums and Galleries Commission, the National Heritage Memorial Fund and the National Art Collections Fund, 1991

Tillemans, Peter 1684–1734, *Horse with Groom and Hounds*, purchased with grants from the Museums and Galleries Commission, the National Heritage Memorial Fund and the National Art Collections Fund, 1991

Tillemans, Peter 1684–1734, *Three Hounds with Sportsman, a Hunt to the Left*, purchased with grants from the Museums and Galleries Commission, the National Heritage Memorial Fund and the National Art Collections Fund, 1991

Tillemans, Peter 1684–1734, *A Hunting Piece: Going-a-Hunting with Lord Biron's Pack of Hounds*, purchased with grants from the Museums and Galleries Commission, the National Heritage Memorial Fund and the National Art Collections Fund, 1991

Tillemans, Peter 1684–1734, *Battle Scene*, purchased with grants from the Museums and Galleries Commission, the National Heritage Memorial Fund and the National Art Collections Fund, 1991

Tillemans, Peter 1684–1734, *Little Haugh Hall, Suffolk*, purchased with grants from the Museums and Galleries Commission, the National Heritage Memorial Fund and the National Art Collections

Fund, 1991

Tuck, Horace Walter 1876–1951, *Landscape near Sheringham, Norfolk*, gift, 1995, © the artist's estate

unknown artist 15th C, *Two Saints*, gift

unknown artist *St Catherine (panel 1 of 3 from a chancel screen)*, on loan from Lessingham P. C. C.

unknown artist *St Appolonia (panel 2 of 3 from a chancel screen)*, on loan from Lessingham P. C. C.

unknown artist *St Mary Magdalene (panel 3 of 3 from a chancel screen)*, on loan from Lessingham P. C. C.

unknown artist *Mr Bill, Dean of Westminster*, gift, 1831

unknown artist *Robert Buxton*, bequeathed, 1949

unknown artist *Henry Birde, Aged 60*, gift, 1935

unknown artist *Memento Mori*, gift, 1953

unknown artist *Anthony Meres of Lincoln (1539–1616)*, gift, 1946

unknown artist *The Ages of Man*, gift, 1927

unknown artist *Portrait of an Unknown Man*, bequeathed, 1949

unknown artist *Mrs Thomas Conyers*, bequeathed, 1949

unknown artist *John Buxton (1608–1660)*, bequeathed, 1949

unknown artist *Margaret Conyers (Mrs John Buxton of Tibenham) (1611–1687)*, bequeathed, 1949

unknown artist *Anne Murray, Viscountess Bayning (1619–c.1678)*, gift, 1938

unknown artist *Boy with Coral*, gift, 1949

unknown artist *Jane Palmer (1632–1701)*, gift, 1946

unknown artist *Jehosophat Davy, Sheriff of Norwich, 1667, Mayor, 1678*, bequeathed, 1959

unknown artist *William Skutt*, gift, 1944

unknown artist *Sir Neville Catelyn*, bequeathed, 1949

unknown artist 17th C, *The Wife of Bishop Sparrow (1621–1697)*, gift, 1831

unknown artist *Robert Buxton (d.1735)*, bequeathed, 1949

unknown artist *Harbour and Men Loading Cargo*

unknown artist *Thomas John Batcheler of Horstead Hall (1737–1789), Norfolk, Aged 16*, gift, 1946

unknown artist *Mrs Margaret Tryon*, bequeathed, 1950

unknown artist *Portrait of a Lady with a Broken Pitcher*, bequeathed by Miss H. B. Oddin-Taylor, 1974

unknown artist *Robert Harvey (1730?–1816), Mayor of Norwich, 1770 & 1800*, gift, 1982

unknown artist *Master William Crotch (1775–1847)*, on loan from the Norfolk and Norwich Joint Records Committee

unknown artist *A Panoramic View of Norwich*, purchased with grants from the Victoria & Albert

Museum Purchase Grant Fund and the Friends of the Norwich Museums, 1975

unknown artist *Captain Horatio Nelson, RN, 1781*, gift, 1865

unknown artist *Robert Forby (1759–1825)*, gift, 1858

unknown artist *Portrait of a Woman (formerly believed to be Elizabeth Fry)*, gift, 1944

unknown artist *Sarah Coaks, Wife of Richard Coaks*, gift, 1953

unknown artist *Paymaster Frederick Jackson (1830–1912)*, gift, 1937

unknown artist *View of Carrow Works and the River Wensum, Norwich*, gift, 1942

unknown artist *Hare and Game Birds with Gun*, bequeathed, 1982

unknown artist *Heron with Mallard and Birds*, bequeathed, 1982

unknown artist *Pheasants*, bequeathed, 1982

unknown artist *Turnshoe Maker*, gift from Mr G. W. Marshall, 1985

unknown artist *A Lady in a Satin Dress*, gift, 1949

unknown artist *Angel Playing a Guitar (painted panel of a rood screen)*

unknown artist *Angel Playing a Harp (painted panel of a rood screen)*

unknown artist *Anne Batcheler (1734–1808)*, gift, 1946

unknown artist *Arabella Baker (1793–1881)*, gift, 2000

unknown artist *Augustine Briggs (1617–1684), Mayor of Norwich, 1670*, bequeathed, 1953

unknown artist *Bishop Anthony Sparrow (1620–1685)*, gift, 1831

unknown artist *Boy with Sheep, Master Thomas John Batcheler (1737–1789)*, gift, 1946

unknown artist *Carisbrooke Castle*, gift, 1975

unknown artist *Caroline Bilham*, bequeathed, 1963

unknown artist *Catherine Jane Magnay*, gift, 1946

unknown artist *Children in Dutch Costume Crossing a Stream*

unknown artist *Country Lane*, bequeathed, 1952

unknown artist *Dame Elizabeth Pettus (d.1653)*, gift, 1946

unknown artist *Devil's Tower, Norwich*, gift, 1979

unknown artist *Elizabeth Gooch (Mrs Robert Buxton) (1664–1730)*, bequeathed, 1949

unknown artist *George and Dragon (inn sign from Norwich)*, untraced find

unknown artist *House on the Marsh*, purchased with the Beecheno Bequest Fund, 1940

unknown artist *J. Smith*, on loan from Norfolk Library and Information Services

unknown artist *James Watson, Sheriff of Norwich, (1847–1848)*, gift, 1947

unknown artist *John Bull Laden with Taxes*, gift from Sir John Peter

Boileau, Bt, Ketteringham Park
unknown artist *John Buxton (1657–1682)*, bequeathed, 1949
unknown artist *John Langley of Norwich (1679–1755)*, gift, 1926
unknown artist *John Ninham (1754–1817)*, gift, 1947
unknown artist *King of Prussia (inn sign from Ipswich Road, Norwich)*, untraced find
unknown artist *Landscape*, gift, 1946
unknown artist *Landscape*, bequeathed, 1949
unknown artist *Landscape*, gift, 1934
unknown artist *Landscape with Lake, Mountains and Ruined Castle*, bequeathed, 1954
unknown artist *Lord Nelson (1758–1805)*, gift, 1846
unknown artist *Mary Pettus (1701–1764)*, gift, 1946
unknown artist *Meriden Heath near Coventry*, gift, 1949
unknown artist *Mrs Butcher*, gift, 1956
unknown artist *Naïve Painting of a Farmhouse with Outbuildings and Farm Animals in Foreground*, bequeathed, 1985
unknown artist *Old Trowse Bridge, Norwich*, bequeathed, 1946
unknown artist *Possibly Francis Bell Rix*, gift, 1977
unknown artist *Richard Coaks, Sheriff of Norwich (1840–1841), Mayor of Norwich (1852–1853)*, gift, 1953
unknown artist *Richenda Cunningham, née Gurney (1782–1855)*, gift, 1985
unknown artist *Robert Buxton (1558–1610)*, bequeathed, 1949
unknown artist *Robert Buxton (1659–1691)*, bequeathed, 1949
unknown artist *Rocks and Waterfall*, bequeathed, 1946
unknown artist *Samson Arnold Mackey, the Self-Taught Astronomer of Norwich (1765–1843)*, gift, 1868
unknown artist *Samuel Fitch*, bequeathed, 1904
unknown artist *Sir Geoffrey Palmer (1598–1670)*, gift, 1946
unknown artist *Sir Horatio Pettus, 4th Bt of Rackheath (d.1731)*, gift, 1946
unknown artist *Sir Thomas Browne (1605–1682)*, purchased, 1995
unknown artist *Sir Thomas Pettus (d.1654)*, gift, 1946
unknown artist *The Bittern*, presented, 1949
unknown artist *The Reverend Francis Cunningham*, gift, 1982
unknown artist *The Reverend John Horne, Chaplain to Mary of Orange*, bequeathed, 1949
unknown artist *The Reverend William Kirby (1759–1850)*, gift, 1878
unknown artist *The Star Inn, Haymarket, Norwich*, gift, 1960
unknown artist *The Woodcutters*, bequeathed, 1952
unknown artist *Thomas Horatio*

Batcheler (1763–1844), gift, 1946
unknown artist *Thomas Osborn Springfield (1782–1858)*, gift, 1923
unknown artist *W. Butcher, Sheriff of Norwich, 1870*, gift, 1956
unknown artist *William Baker (d.1808)*, gift, 2000
unknown artist *William Crotch (1775–1847)*, on loan from Norfolk Library and Information Services
unknown artist *William Crotch (1775–1847)*, on loan from the Norfolk and Norwich Joint Records Committee
unknown artist *William Crotch (1775–1847)*, purchased, 1940
Vandergucht, Benjamin 1753–1794, *Sophy Coates*, gift, 1940
Vaughan, John Keith 1912–1977, *Untitled*, gift, 2002, © the estate of Keith Vaughan/DACS 2006
Vaughan, John Keith 1912–1977, *Figure in a Red Room*, on loan from the Norfolk Contemporary Art Society, © the estate of Keith Vaughan/DACS 2006
Vautier, D. *Sir Henry Bedingfeld of Oxburgh*, bequeathed, 1949
Velde, Adriaen van de (attributed to) 1636–1672, *Cattle in a Field, a Village beyond a Wood*, purchased with grants from the Museums and Galleries Commission, the National Heritage Memorial Fund and the National Art Collections Fund, 1991
Velde, Adriaen van de (attributed to) 1636–1672, *Landscape with Cattle*, purchased with grants from the Museums and Galleries Commission, the National Heritage Memorial Fund and the National Art Collections Fund, 1991
Ventnor, Arthur Dale 1829–1884, *Mr C. B. Dennes*, gift, 1977
Ventnor, Arthur Dale 1829–1884, *Mrs C. B. Dennes*, gift, 1977
Ventnor, Arthur George active 1890–1926, *A Quaint Corner*, gift, 1896
Verhaecht, Tobias c.1560–1631, *The Tower of Babel*, gift, 1949
Vickers, Alfred 1786–1868, *A Farmstead with Cattle*, purchased with the Beecheno Bequest Fund, 1943
Vickers, Alfred 1786–1868, *The Watering Place*, purchased with the Beecheno Bequest Fund, 1943
Vincent, George 1796–1831, *Rouen*, purchased with the Beecheno and Walker Bequest Funds, 1952
Vincent, George 1796–1831, *View in Glen Sharrah near Inverary*, bequeathed, 1919
Vincent, George 1796–1831, *Yarmouth Quay*, bequeathed, 1946
Vincent, George 1796–1831, *A Distant View of Pevensey Bay, the Landing Place of King William the Conqueror*, purchased, 1945
Vincent, George 1796–1831, *Pevensey Bay*, bequeathed, 1946
Vincent, George 1796–1831, *Entrance to Loch Katrine, Moonlight, Highlanders Spearing*

Salmon, bequeathed, 1946
Vincent, George 1796–1831, *Rustic Scene*, gift, 1944
Vincent, George 1796–1831, *The Travelling Pedlar*, bequeathed, 1940
Vincent, George 1796–1831, *The Fish Auction, Yarmouth*, gift, 1927
Vincent, George 1796–1831, *The Fish Auction, Yarmouth Beach*, bequeathed, 1940
Vincent, George 1796–1831, *Pastoral Scene*, bequeathed, 1946
Vincent, George 1796–1831, *Trowse Meadows, near Norwich*, bequeathed, 1898
Vincent, George 1796–1831, *Valley of the Yare, near Bramerton*, bequeathed, 1940
Vincent, George 1796–1831, *The Blasted Oak*, bequeathed, 1968
Vincent, George 1796–1831, *A Shady Pool*, gift, 1933
Vincent, George 1796–1831, *Lane Scene*, bequeathed, 1946
Vincent, George 1796–1831, *On the River Yare*, bequeathed, 1946
Vincent, George 1796–1831, *Postwick Grove*, bequeathed, 1946
Vincent, George 1796–1831, *Road Scene with Cattle*, bequeathed, 1946
Vincent, George 1796–1831, *Road Scene with Cottage*, gift from the East Anglian Art Society, 1894
Vincent, George 1796–1831, *Trowse Hythe, near Norwich*, purchased with the Beecheno Bequest Fund, 1939
Vincent, George 1796–1831, *View near Norwich*, bequeathed, 1946
Vincent, George (attributed to) 1796–1831, *Landscape with Cart*, bequeathed, 1968
Vincent, George (attributed to) 1796–1831, *Landscape with Figures and Cottage*, bequeathed, 1968
Vlaminck, Maurice de 1876–1958, *Les Andelys*, accepted in lieu of tax by HM Government, 1996, © ADAGP, Paris and DACS, London 2006
Vroom, Hendrick Cornelisz. (attributed to) 1566–1640, *Ferry Boat on a River, Trees on a Hill to the Left*, purchased with grants from the Museums and Galleries Commission, the National Heritage Memorial Fund and the National Art Collections Fund, 1991
Vuillard, Jean Edouard 1868–1940, *L'encrier bleu sur la cheminée*, purchased with grants from the Victoria & Albert Museum Purchase Grant Fund, the Friends of the Norwich Museums and Professor G. B. A. Fletcher Bequest Fund, 1997, © ADAGP, Paris and DACS, London 2006
Waite, Edward Wilkins 1854–1924, *An August Afternoon, Woolhampton*, gift, 1938
Wale, Samuel 1721–1786, *Robert Kett Receives the Earl of Warwick's Herald, 1549*, purchased with a grant from the Victoria & Albert Museum Purchase Grant Fund, 1976

Wales, Marjorie active 1979–1982, *Gulf of Corinth (from sketches made in 1979)*, gift, 1990
Walker, James William 1831–1898, *Still Life of Fruit*, gift, 1896
Walker, James William 1831–1898, *Under the Trees*, gift, 1896
Walker, James William 1831–1898, *A Sandy Lane*, gift, 1896
Walker, James William 1831–1898, *December, near Rivington, Lancashire*, gift, 1896
Walker, James William 1831–1898, *Père, mère et fils*, gift, 1896
Walton, Henry 1746–1813, *John Custance (1749–1822), of Weston House, Norfolk*, purchased with grants from the National Art Collections Fund, the Parson Woodforde Society and the Friends of the Norwich Museums, 2005
Walton, Henry 1746–1813, *Sir Robert Buxton, 1st Bt (1753–1839)*, bequeathed, 1949
Walton, Henry 1746–1813, *Sir Robert and Lady Buxton and Their Daughter Anne*, bequeathed, 1949
Walton, Henry 1746–1813, *Edmund Gillingwater (1735–1813)*, gift, 1858
Warhol, Andy 1928–1987, *Pom*, on loan from the East Anglia Art Foundation, © licensed by the Andy Warhol Foundation for the Visual Arts, Inc/ARS, New York and DACS, London 2006
Waterloo, Anthonie c.1610–1690, *Landscape with Horsemen on a Path Entering a Wood, Figures Waiting for a Ferry, Cattle and Sheep Beyond*, purchased with grants from the Museums and Galleries Commission, the National Heritage Memorial Fund and the National Art Collections Fund, 1991
Watson, Charles John 1846–1927, *Old Cottage, Trowse Hythe, Norwich*, gift from the East Anglian Art Society, 1894
Watson, Charles John 1846–1927, *Dirty Weather near the Mouth of the Yare*, gift from the East Anglian Art Society, 1894
Watson, Charles John 1846–1927, *Shades of Evening, Barton Broad, Norfolk*, gift from the East Anglian Art Society, 1894
Watson, Charles John 1846–1927, *Minna Bolingbroke, Wife of the Artist*, gift, 1972
Watts, George Frederick 1817–1904, *Study for 'The Court of Death'*, gift, 1907
Watts, George Frederick 1817–1904, *The Curse of Cain*, gift, 1907
Watts, George Frederick 1817–1904, *Study for 'Britomart'*, gift, 1907
Watts, George Frederick 1817–1904, *The Outcast: Goodwill*, gift, 1907
West, Benjamin 1738–1820, *Venus Comforting Cupid Stung by a Bee*, bequeathed, 1916
Wheatley, Francis 1747–1801, *Edward and Priscilla Wakefield with Mrs Wakefield's Sister, Catherine*

Bell, purchased with the assistance of grants from the Victoria & Albert Museum Purchase Grant Fund, the National Art Collections Fund and a private family trust, 1985
Wilkins, William the elder 1751–1815, *South-East View of Norwich Castle*
Wilkins, William the elder 1751–1815, *Norwich Castle*
Williams, Edward 1782–1855, *River Bank with Cottage*, bequeathed, 1953
Williams, Edward 1782–1855, *The Mill*, purchased with the Beecheno Bequest Fund, 1943
Wilson, Benjamin 1721–1788, *Edward Macro (d.1766)*, purchased with grants from the Museums and Galleries Commission, the National Heritage Memorial Fund and the National Art Collections Fund, 1991
Wilson, Richard 1713/1714–1782, *The Thames at Twickenham*, bequeathed by Ernest E. Cook through the National Art Collections Fund, 1955
Winter, Cornelius Jansen Walter 1817–1891, *The Butcheries, Norwich*, bequeathed, 1938
Wonnacott, John b.1940, *The Life Room*, purchased with grants from the Victoria & Albert Museum Purchase Grant Fund, the National Art Collections Fund, the Friends of the Norwich Museums and Eastern Arts Association, 1981, © the artist
Wood, Tom b.1955, *Timothy Colman*, commissioned, 1992, © the artist
Woods, Michael b.1933, *Sign*, purchased, 1968, © the artist
Wootton, John c.1682–1765, *The Beauchamp-Proctor Family and Friends at Langley Park, Norfolk*, purchased with the assistance of the National Heritage Memorial Fund, Museums and Galleries Commission, National Art Collections Fund, a private family trust and the Friends of the Norwich Museums, 1993
Wouwerman, Philips 1619–1668, *A Cavalry Skirmish in a Mountainous Landscape*, purchased with grants from the Museums and Galleries Commission, the National Heritage Memorial Fund and the National Art Collections Fund, 1991
Wouwerman, Philips 1619–1668, *The Seashore at Scheveningen*, purchased with the Doyle Bequest Fund, 1956
Wouwerman, Philips (follower of) 1619–1668, *Figures on a Shore, a Mother with a Child, a Grey Horse, a Cart Beyond*, purchased with grants from the Museums and Galleries Commission, the National Heritage Memorial Fund and the National Art Collections Fund, 1991
Wyndham, Richard 1896–1948, *A Dinka Herdsman*, on loan from the

317

East Anglia Art Foundation, © the artist's estate

Zoffany, Johan 1733–1810, **Gilpin, Sawrey** 1733–1807 & **Farington, Joseph** 1747–1821 *A Family Picture: Henry and Mary Styleman*, purchased with grants from the Heritage Lottery Fund, the National Art Collections Fund, the East Anglia Art Foundation and Friends of the Norwich Museums, 2001

Zuccaro, Federico (attributed to) c.1541–1609, *Thomas Flowerdewe, Aged 26*, gift, 1917

Norwich Civic Portrait Collection

Adolphe, Joseph Anton 1729–c.1765, *Benjamin Hancock, Mayor of Norwich (1763)*, purchased by public subscription, 1764

Adolphe, Joseph Anton 1729–c.1765, *Elisha de Hague, Sr (1717–1792), Town Clerk of Norwich*, commissioned by Norwich Corporation (Common Council), 1764

Bardwell, Thomas 1704–1767, *William Crowe (d.1778), Mayor of Norwich (1747)*, gift from the Artillery Company, 1746

Bardwell, Thomas 1704–1767, *John Gay (d.1787), Mayor of Norwich (1754)*, purchased by public subscription, 1755

Bardwell, Thomas 1704–1767, *John Goodman (d.c.1779), Mayor of Norwich (1757)*, purchased by public subscription, c.1757

Bardwell, Thomas 1704–1767, *John Press (1696/1697–1773), Mayor of Norwich (1753)*, purchased by public subscription, 1759

Bardwell, Thomas 1704–1767, *Sir Thomas Churchman (1702–1781), Mayor of Norwich (1761)*, purchased by public subscription, 1761

Bardwell, Thomas 1704–1767, *Robert Rogers, Mayor of Norwich (1758)*, purchased by public subscription, c.1762

Bardwell, Thomas 1704–1767, *Jermy Harcourt (1708/1709–1768), Mayor of Norwich (1762)*, purchased by public subscription, c.1763

Bardwell, Thomas 1704–1767, *John Dersley, Mayor of Norwich (1764)*, purchased by public subscription, 1766

Bardwell, Thomas 1704–1767, *James Poole (d.1780), Mayor of Norwich (1765)*, purchased by public subscription, c.1767

Beechey, William 1753–1839, *Robert Partridge (1746/1747–1817), Mayor of Norwich (1784)*, purchased by public subscription, c.1784

Beechey, William 1753–1839, *Horatio, Viscount Nelson (1758–1805)*, commissioned by the Corporation of Norwich, 1801

Beechey, William 1753–1839, *John Patteson (1755–1833), Mayor of Norwich (1788)*, gift from the Norwich Battalion of Volunteer Infantry, c.1803

Beechey, William 1753–1839, *Elisha de Hague, Jr (1755–1826), Town Clerk of Norwich*, purchased by public subscription, 1825

Beechey, William 1753–1839, *John Staniforth Patteson (1782–1832), Mayor of Norwich (1823)*, purchased by public subscription, 1826

Benson, Edward 1808–1863, *John Marshall (1796–1872), Mayor of Norwich (1838 & 1841)*, unknown provenance

Birley, Oswald Hornby Joseph 1880–1952, *Sir William Ffoulkes, Bt (1847–1912)*, unknown provenance, © the artist's estate

Birley, Oswald Hornby Joseph 1880–1952, *The Right Honourable Ailwyn Edward Fellowes, First Baron Ailwyn of Honingham (1855–1924)*, purchased by public subscription, 1923, © the artist's estate

Birley, Oswald Hornby Joseph 1880–1952, *Russell James Colman (1861–1946), HM Lieutenant of Norfolk*, gift from Russell James Colman, 1931, © the artist's estate

Briggs, Henry Perronet 1791/1793–1844, *Charles Turner (1788–1861), Mayor of Norwich (1834)*, purchased by public subscription, c.1836

Carter, William 1863–1939, *John Sancroft Holmes (1847–1920)*, purchased by public subscription, 1921

Catton, Charles the younger 1756–1819, *Jeremiah Ives, Jr (1728/1729–1805), Mayor of Norwich (1769 & 1795)*, purchased by public subscription, 1781

Clint, George 1770–1854, *Sir John Harrison Yallop (1763–1835), Mayor of Norwich (1815 & 1831)*, purchased by public subscription, 1815

Clint, George 1770–1854, *William Hankes (1773–1860), Mayor of Norwich (1816)*, purchased by public subscription, 1823

Clover, Joseph 1779–1853, *Thomas Back (1767/1768–1820), Mayor of Norwich (1809)*, purchased by public subscription, 1810

Clover, Joseph 1779–1853, *Barnabas Leman (1743–1835), Mayor of Norwich (1813 & 1818)*, purchased by public subscription, 1819

Clover, Joseph 1779–1853, *Crisp Brown, Mayor of Norwich (1817)*, purchased by public subscription, 1822

Corfield, Colin 1910–1991, *Lieutenant Colonel Sir Bartle Edwards (1891–1977)*, commissioned by Norfolk County Council, 1966

Crick, Montague active 1898–1917, *Edward Wild (1832–1929), Mayor of Norwich (1890)*, gift from Edward Wild, 1910

Crick, Montague active 1898–1917, *Sir George Chamberlin (1846–1928), Mayor of Norwich (1891), Lord Mayor (1916 & 1918)*, gift from the family of Sir George Chamberlin, 1928

Dalton, Anthony b.1929, *The Reverend David H. Clark, Sheriff of Norwich (1981–1982)*, gift from Reverend David H. Clark, 1998, © the artist

Dodd, Francis 1874–1949, *Sir Henry N. Holmes (1868–1940), Lord Mayor of Norwich (1921 & 1932)*, purchased by public subscription, 1934

Forbes, Stanhope Alexander 1857–1947, *Sir Peter Eade (1825–1915), Mayor of Norwich (1883, 1893 & 1895)*, purchased by public subscription, 1895, © courtesy of the artist's estate/www.bridgeman.co.uk

Gainsborough, Thomas 1727–1788, *Sir Harbord Harbord, Bt (1734–1810), MP for Norwich*, purchased by public subscription, c.1783

Grant, Francis 1803–1878, *Henry Dover (d.1855)*, gift from the magistrates of the County of Norfolk, 1847

Haydon, Benjamin Robert 1786–1846, *Robert Hawkes (1773/1774–1836), Mayor of Norwich (1822)*, purchased by public subscription, c.1822

Heins, John Theodore Sr 1697–1756, *Francis Arnam (1673/1674–1741), Mayor of Norwich (1732)*, gift from the Grocers' Company, 1732

Heins, John Theodore Sr 1697–1756, *Robert Marsh (1679/1680–1771), Mayor of Norwich (1731)*, gift from the Grocers' Company, 1732

Heins, John Theodore Sr 1697–1756, *Thomas Vere (1680/1681–1766), Mayor of Norwich (1735)*, purchased by public subscription, 1736

Heins, John Theodore Sr 1697–1756, *Timothy Balderston (1682–1764), Mayor of Norwich (1736 & 1751)*, gift from the Artillery Company, 1736

Heins, John Theodore Sr 1697–1756, *Thomas Harwood (b.1664/1665), Mayor of Norwich (1728)*, gift from the trustees of the Charity Schools, 1737

Heins, John Theodore Sr 1697–1756, *Benjamin Nuthall (d.1752), Mayor of Norwich (1721 & 1749)*, presented by a society of gentlemen, 1738

Heins, John Theodore Sr 1697–1756, *The Honourable Horatio Walpole (1678–1757)*, gift from Horatio Walpole, 1741

Heins, John Theodore Sr 1697–1756, *William Clarke (d.1752), Mayor of Norwich (1739)*, presented by a society of gentlemen, 1740

Heins, John Theodore Sr 1697–1756, *Thomas Emerson (d.1785), Sheriff of Norwich (1785)*, commissioned by Norwich City Council, 1741

Heins, John Theodore Sr 1697–1756, *John, Lord Hobart (1694–1756), 1st Earl of Buckinghamshire*, gift from John Lord Hobart, 1743

Heins, John Theodore Sr 1697–1756, *Robert Walpole, Earl of Orford (1676–1745)*, gift from Robert Walpole, Earl of Orford, 1743

Heins, John Theodore Sr 1697–1756, *William Wiggett (1693/1694–1768), Mayor of Norwich (1742)*, purchased by public subscription, 1743

Heins, John Theodore Sr 1697–1756, *Simeon Waller, Mayor of Norwich (1745)*, presented by a society of gentlemen, 1746

Heins, John Theodore Sr 1697–1756, *Sir Benjamin Wrench, MD (1665–1747)*, unknown provenance

Heins, John Theodore Sr 1697–1756, *Thomas Harvey (1711–1772), Mayor of Norwich (1748)*, presented by a society of gentlemen, 1749

Heins, John Theodore Sr 1697–1756, *Thomas Hurnard (1711/1712–1753), Mayor of Norwich (1752)*, purchased by public subscription, 1754

Heins, John Theodore Sr 1697–1756, *Matthew Goss (b.1680/1681)*, gift from Sir Henry Holmes, 1938

Heins, John Theodore Sr 1697–1756, *Nockold Tompson (d.1777), Mayor of Norwich (1759), and Speaker of the Common Council (1744–1753)*, commissioned by Norwich City Council, 1756

Heins, John Theodore Sr 1697–1756, *John Harvey (1666–1742), Mayor of Norwich (1727)*, bequeathed by Dr Robert Coke Harvey, 1981

Heins, John Theodore Sr 1697–1756, *John Kirkpatrick (1686–1728)*, gift from Major Frank Cubitt, 1927

Herkomer, Hubert von 1849–1914, *Jeremiah James Colman (1830–1898), Mayor of Norwich (1867)*, purchased by public subscription, 1899

Holl, Frank 1845–1888, *Sir Harry Bullard (1841–1903), Mayor of Norwich (1878, 1879 & 1886)*, purchased by public subscription, 1882

Hoppner, John 1758–1810, *The Right Honourable William Windham (1750–1810), MP for Norwich*, purchased by public subscription, 1804

Knight, John Prescott 1803–1881, *Sir Samuel Bignold (1791–1875), Mayor of Norwich (1833, 1848, 1853 & 1872)*, purchased by public subscription, 1850

Knight, John Prescott 1803–1881, *Lord Stafford (Sir Henry Valentine Stafford Jerningham) (1802–1884)*, purchased by public subscription, 1866

Lane, Samuel 1780–1859, *Henry Francis, Mayor of Norwich (1824)*, purchased by public subscription, 1827

Lawrence, Thomas 1769–1830, *Charles Harvey (1757–1843)*, commissioned by the Norwich Corporation, 1804

Lawrence, Thomas 1769–1830, *Thomas William Coke (1752–1842)*, gift from the magistrates of the County of Norfolk, 1814

Mason, Arnold 1885–1963, *Sir Henry Upcher (1870–1954), Chairman of Norfolk County Council (1941–1950)*, unknown provenance

Mortimer, Geoffrey active 1881–1930, *Walter Robert Smith (1872–1942), Norwich City Councillor*, gift from Mrs G. O. Smith, 1983

Opie, John 1761–1807, *John Harvey (1755–1842), Mayor of Norwich (1792)*, presented by the Norwich Light-Horse Volunteers, c.1797–1802

Opie, John 1761–1807, *Samuel Harmer (1721/1722–1808), Speaker of the Common Council of Norwich*, commissioned by Norwich Corporation (Common Council), 1798

Opie, John 1761–1807, *John Herring (1748/1749–1810), Mayor of Norwich (1799)*, purchased by public subscription, c.1800–1801

Opie, John 1761–1807, *The Honourable Henry Hobart (1738–1799), MP for Norwich*, gift, 1804

Orpen, William 1878–1931, *Ernest Egbert Blyth (1857–1934), Last Mayor & First Lord Mayor of Norwich (1910)*, purchased by public subscription, 1911

Phillips, Thomas 1770–1845, *William Simpson (1768/1769–1834), Town Clerk of Norwich*, unknown provenance

Phillips, Thomas 1770–1845, *The Honourable John Wodehouse (1771–1846), Lord Lieutenant of Norfolk (1821–1846)*, unknown provenance

Richmond, George 1809–1896, *Sir Samuel Hoare (1841–1915), MP for Norwich*, gift from the Right Honourable Sir Samuel Hoare, 1935

Sandys, Frederick 1829–1904, *Jacob Henry Tillett (1818–1892), Mayor of Norwich (1859 & 1875)*, purchased by public subscription, 1871

Sandys, Frederick 1829–1904, *Edward Howes (1813–1871)*, unknown provenance

Shannon, James Jebusa 1862–1923, *Clare Sewell Read (1826–1905)*, gift from the Norfolk Chamber of Agriculture, 1898

Shannon, James Jebusa 1862–1923, *Lord Cranworth (Robert Thornhagh Gurdon) (1829–1902), First Chairman of Norfolk County Council*, unknown provenance

Smith, William 1707–1764, *John Spurrell (1681/1682–1763), Mayor of Norwich (1737)*, purchased by public subscription, 1758

Smith, William 1707–1764, *Robert Harvey (1697–1773), Mayor of Norwich (1738)*, purchased by public subscription, 1758

Starling, Thomas 1639/1640–1718, *Prince George (1653–1708)*, gift from the St George's Company, 1705

Starling, Thomas 1639/1640–1718, *Queen Anne (1665–1714)*, gift from the St George's Company, 1705

Stoppelaer, Charles active 1703–1757, *Jeremiah Ives (1723/1724–1787), Mayor of Norwich (1756)*, gift from the Gregorians, 1756

Stoppelaer, Charles active 1703–1757, *Peter Colombine (1697–1770), Mayor of Norwich (1755)*, purchased by public subscription, 1755

Thomson, Henry 1773–1843, *William Smith (1756–1835), MP for Norwich*, purchased by public subscription, c.1814

unknown artist *Alan Percy (d.1560)*, commissioned by Norwich City Council, 1549?

unknown artist *Sir Thomas White (1495?–1567)*, commissioned by Norwich City Council, 1553?

unknown artist *Archbishop Matthew Parker (1504–1575)*, gift to the city of Norwich from the town clerk, Thomas Corie, to mark the granting of a new royal charter, 1683

unknown artist *Sir Edward Coke (1552–1634), Recorder of Norwich (1586–1591)*, commissioned by Norwich City Council

unknown artist *Robert Yarham (1519/1520–1595), Mayor of Norwich (1591)*, commissioned by Norwich City Council, 1591?

unknown artist *Francis Windham (d.1592), Recorder of Norwich (1575–1579)*, commissioned by Norwich City Council, 1592?

unknown artist *Mrs Joanna Smith (b.1533/1534)*, gift to Norwich City Council, c.1594?

unknown artist late 16th C, *Augustine Steward (1491–1571), Mayor of Norwich (1534, 1546 & 1556)*, commissioned by Norwich City Council

unknown artist late 16th C, *John Marsham (d.1525), Mayor of Norwich (1518)*, commissioned by Norwich City Council

unknown artist *Sir Henry Hobart (c.1554–1625), Steward of Norwich (1592–1606)*, commissioned by Norwich City Council, 1606?

unknown artist *Thomas Layer (1528–1614), Mayor of Norwich (1576, 1585 & 1595)*, commissioned by Norwich City Council, 1606

unknown artist *Sir John Pettus (1549/1550–1614), Mayor of Norwich (1608)*, commissioned by Norwich City Council, 1612?

unknown artist *Thomas Anguish (1538/1539–1617), Mayor of Norwich (1611)*, purchased by public subscription, 1935

unknown artist *Robert Hernsey, Mayor of Norwich (1632)?*, commissioned by Norwich City Council, 1634

unknown artist *Pendant to Portrait of Sir Peter Rede*, commissioned by Norwich City Council, 1646?

unknown artist *Sir Peter Rede (d.1568)*, commissioned by Norwich City Council, 1646?

unknown artist *Barnard Church (1604–1686), Mayor of Norwich (1651)*, commissioned by Norwich City Council, 1654?

unknown artist *Robert Holmes, Sheriff of Norwich (1646)*, gift from Thomas Wood, 1668

unknown artist *Sir Joseph Paine (1599/1600–1668), Mayor of Norwich (1660)*, commissioned by Norwich City Council, 1663?

unknown artist *Francis Southwell (b.1601/1602), Recorder of Norwich*, commissioned by Norwich City Council, 1667?

unknown artist *Augustine Briggs (1617–1684), Mayor of Norwich (1670)*, commissioned by Norwich City Council, c.1670?

unknown artist *Unknown Mayor of Norwich*, commissioned by Norwich City Council, c.1680?

unknown artist early 17th C, *Robert Jannys (c.1480–1530), Mayor of Norwich (1517 & 1524)*, commissioned by Norwich City Council

unknown artist *John Norman (1675/1676–1724), Mayor of Norwich (1714)*, commissioned by Norwich City Council, 1714

unknown artist *Francis Moundford (d.1536), Recorder of Norwich*, commissioned by Norwich City Council

unknown artist *Henry Fawcett (d.1619), Sheriff of Norwich (1608)*, commissioned by Norwich City Council, 1619?

unknown artist *John Marshall (1796–1872), Mayor of Norwich (1838 & 1841)*, gift from Michael Chapman, 1985

unknown artist *Mrs Anne Rede (d.1577)*, commissioned by Norwich City Council

unknown artist *Sir Thomas Richardson (1569–1635)*, purchased, 1950

unknown artist *Thomas Carver (d.1641), Mayor Elect (1641)*, commissioned by Norwich City Council, c.1641?

unknown artist *Thomas Hall (1681–1715)*, gift from John Taylor, 1821

unknown artist *Thomas King, Town Clerk of Norwich (1615–1638)*, commissioned by Norwich City Council, c.1638?

unknown artist *William Barnham (d.c.1671), Mayor of Norwich (1652)*, commissioned by Norwich City Council, c.1652?

unknown artist *William Denny (d.1642), Recorder of Norwich (1629–1641)?*, commissioned by Norwich City Council, 1641?

unknown artist *William Doughty (d.1687)*, commissioned by Norwich City Council, 1687?

Ventnor, Arthur Dale 1829–1884, *John Oddin Taylor (1805–1874), Mayor of Norwich (1861)*, gift from F. Oddin Taylor, 1916

Wells, Henry Tanworth 1828–1903, *Sir Willoughby Jones (1820–1884), Chairman of Norfolk Quarter Sessions (1856–1884)*, commissioned by Norfolk County Magistrates, 1886

Westcott, Philip 1815–1878, *Thomas Osborn Springfield (1782–1858), Mayor of Norwich (1829 & 1836)*, purchased by public subscription, 1852

Williams, William 1727–1791, *Thomas Starling (1706–1788), Mayor of Norwich (1767)*, purchased by public subscription, c.1770

Woodhouse, John Thomas 1780–1845, *John Crome (1768–1821)*, gift from Joseph Crome

Norwich Magistrates Courts

Pan, Arthur active 1920–1960, *Alderman Eric John Sidney Hinde, MA*

Strickland, Betty *Lady Ralphs, CBE, JP, DC, BA*

Royal Norfolk Regimental Museum

Bates, Les *Lieutenant W. M. Palmer*, gift from Captain W. M. Palmer

Herkomer, Herman 1863–1935, *General Sir Arthur Borton, GCB, GCMG*, gift from C. Borton, Air Vice Marshall, great-grandson of the sitter

Powell, W. W. (Captain) *Scene at Jellalabad, 1842*

unknown artist *An Officer of the Norfolk Militia*, purchased by the Ogilvy Trust on behalf of the museum trustees, 1978

unknown artist *Major Money (d.1817) and the Norfolk Militia*, bequeathed, 1994

Sainsbury Centre for Visual Arts, University of East Anglia

Bacon, Francis 1909–1992, *Study of a Nude*, gift from Robert and Lisa Sainsbury. Part of the Robert & Lisa Sainsbury Collection, © estate of Francis Bacon/DACS 2006, photo credit: James Austin

Bacon, Francis 1909–1992, *Robert J. Sainsbury*, gift from Robert and Lisa Sainsbury. Part of the Robert & Lisa Sainsbury Collection, © estate of Francis Bacon/DACS 2006, photo credit: James Austin

Bacon, Francis 1909–1992, *Sketch for 'Lisa'*, gift from Robert and Lisa Sainsbury. Part of the Robert & Lisa Sainsbury Collection, © estate of Francis Bacon/DACS 2006, photo credit: James Austin

Bacon, Francis 1909–1992, *Study (Imaginary Portrait of Pope Pius XII)*, gift from Robert and Lisa Sainsbury. Part of the Robert & Lisa Sainsbury Collection, © estate of Francis Bacon/DACS 2006, photo credit: James Austin

Bacon, Francis 1909–1992, *Lisa*, gift from Robert and Lisa Sainsbury. Part of the Robert & Lisa Sainsbury Collection, © estate of Francis Bacon/DACS 2006, photo credit: James Austin

Bacon, Francis 1909–1992, *Study for a Portrait of Van Gogh I*, gift from Robert and Lisa Sainsbury. Part of the Robert & Lisa Sainsbury Collection, © estate of Francis Bacon/DACS 2006, photo credit: James Austin

Bacon, Francis 1909–1992, *Lisa*, gift from Robert and Lisa Sainsbury. Part of the Robert & Lisa Sainsbury Collection, © estate of Francis Bacon/DACS 2006, photo credit: James Austin

Bacon, Francis 1909–1992, *Study for a Portrait of P. L., No.2*, gift from Robert and Lisa Sainsbury. Part of the Robert & Lisa Sainsbury Collection, © estate of Francis Bacon/DACS 2006, photo credit: James Austin

Bacon, Francis 1909–1992, *Two Figures in a Room*, gift from Robert and Lisa Sainsbury. Part of the Robert & Lisa Sainsbury Collection, © estate of Francis Bacon/DACS 2006, photo credit: James Austin

Bacon, Francis 1909–1992, *Head of a Man, No.1*, gift from Robert and Lisa Sainsbury. Part of the Robert & Lisa Sainsbury Collection, © estate of Francis Bacon/DACS 2006, photo credit: James Austin

Bacon, Francis 1909–1992, *Head of a Man*, gift from Robert and Lisa Sainsbury. Part of the Robert & Lisa Sainsbury Collection, © estate of Francis Bacon/DACS 2006, photo credit: James Austin

Bacon, Francis 1909–1992, *Head of a Woman*, gift from Robert and Lisa Sainsbury. Part of the Robert & Lisa Sainsbury Collection, © estate of Francis Bacon/DACS 2006, photo credit: James Austin

Bacon, Francis 1909–1992, *Three Studies for a Portrait of Isabel Rawsthorne (panel 1 of 3)*, gift from Robert and Lisa Sainsbury. Part of the Robert & Lisa Sainsbury Collection, © estate of Francis Bacon/DACS 2006, photo credit: James Austin

Bacon, Francis 1909–1992, *Three Studies for a Portrait of Isabel Rawsthorne (panel 2 of 3)*, gift from Robert and Lisa Sainsbury. Part of the Robert & Lisa Sainsbury Collection, © estate of Francis Bacon/DACS 2006

Bacon, Francis 1909–1992, *Three Studies for a Portrait of Isabel Rawsthorne (panel 3 of 3)*, gift from Robert and Lisa Sainsbury. Part of the Robert & Lisa Sainsbury Collection, © estate of Francis Bacon/DACS 2006

Bell, Richard b.1955, *Eight Colour Parts and Surrounds*, purchased from the artist, 1991. Part of the University of East Anglia Collection of Abstract & Constructivist Art, Architecture & Design

Bell, Richard b.1955, *Eight Colour Parts and Surrounds*, purchased from the artist, 1991. Part of the University of East Anglia Collection of Abstract & Constructivist Art, Architecture & Design

Bell, Richard b.1955, *Eight Colour Parts and Surrounds*, purchased from the artist, 1991. Part of the University of East Anglia Collection of Abstract & Constructivist Art, Architecture & Design

Bell, Richard b.1955, *Eight Colour Parts and Surrounds*, purchased from the artist, 1991. Part of the University of East Anglia Collection of Abstract & Constructivist Art, Architecture & Design

Bomberg, David 1890–1957, *Self Portrait*, gift from Robert and Lisa Sainsbury. Part of the Robert & Lisa Sainsbury Collection, © the artist's family, photo credit: James Austin

Bonnard, Pierre 1867–1947, *Paris: Les grands boulevards*, on long-term loan from Lady Sainsbury, © ADAGP, Paris and DACS, London 2006, photo credit: James Austin

Calliyannis, Manolis b.1923, *The Black Sun*, part of the Sainsbury Abstract Collection, on long-term loan from Lady Sainsbury, © ADAGP, Paris and DACS, London 2006

Calmettes, Jean-Marie b.1918, *Still Life*, part of the Sainsbury Abstract Collection, on long-term loan from Lady Sainsbury, © ADAGP, Paris and DACS, London 2006

Cameron, Eric b.1935, *Painting Type 1d*, purchased from the artist, 1969. Part of the University of East Anglia Collection of Abstract & Constructivist Art, Architecture & Design, © the artist

Carrington, Leonora b.1917, *The Old Maids*, gift from Robert and Lisa Sainsbury. Part of the Robert & Lisa Sainsbury Collection, © ARS, New York and DACS, London 2006, photo credit: James Austin

Carrington, Leonora b.1917, *The Pomps of the Subsoil*, gift from Robert and Lisa Sainsbury. Part of the Robert & Lisa Sainsbury Collection, © ARS, New York and DACS, London 2006, photo credit: James Austin

Caughlin, Ian b.1948, *Covered Forecourt with People, London*

Bridge Station, gift from Robert and Lisa Sainsbury. Part of the Robert & Lisa Sainsbury Collection, photo credit: James Austin

Charlett, Nicole b.1957, *(Dis) Placements: Corner Locus, No.1*, purchased from the artist, 1991. Part of the University of East Anglia Collection of Abstract & Constructivist Art, Architecture & Design

Charlett, Nicole b.1957, *(Dis) Placements: Corner Locus, No.1*, purchased from the artist, 1991. Part of the University of East Anglia Collection of Abstract & Constructivist Art, Architecture & Design

Charlett, Nicole b.1957, *(Dis) Placements: Corner Locus, No.1*, purchased from the artist, 1991. Part of the University of East Anglia Collection of Abstract & Constructivist Art, Architecture & Design

Checketts, Michael b.1960, *Willie Guttsman (Founding Librarian at UEA)*, commissioned by UEA Library in memory of Willie Guttsman, 1999. Part of the University & Vice Chancellor's Collection, © the artist

Davies, Arthur Edward 1893–1967, *Earlham Hall*, given in memory of Alasdair Gordon, MSc, PhD after his death in 1975 by his parents. Part of the University & Vice Chancellor's Collection

Dobson, Cowan 1894–1980, *Viscount Mackintosh of Halifax*, part of the University & Vice Chancellor's Collection

Dufour, Bernard b.1922, *Composition*, part of the Sainsbury Abstract Collection, on long-term loan from Lady Sainsbury, © DACS 2006

Fautrier, Jean 1898–1964, *Small Construction*, part of the Sainsbury Abstract Collection, on long-term loan from Lady Sainsbury, © ADAGP, Paris and DACS, London 2006

Fautrier, Jean 1898–1964, *Coloured Lines*, part of the Sainsbury Abstract Collection, on long-term loan from Lady Sainsbury, © ADAGP, Paris and DACS, London 2006

Genovés, Juan b.1930, *Untitled*, gift from Robert and Lisa Sainsbury. Part of the Robert & Lisa Sainsbury Collection, © DACS 2006, photo credit: James Austin

Giacometti, Alberto 1901–1966, *Diego Seated*, gift from Robert and Lisa Sainsbury. Part of the Robert & Lisa Sainsbury Collection, © ADAGP, Paris and DACS, London 2006, photo credit: James Austin

Giacometti, Alberto 1901–1966, *Diego*, gift from Robert and Lisa Sainsbury. Part of the Robert & Lisa Sainsbury Collection, © ADAGP, Paris and DACS, London 2006, photo credit: James Austin

Giacometti, Alberto 1901–1966,

The Tree, gift from Robert and Lisa Sainsbury. Part of the Robert & Lisa Sainsbury Collection, © ADAGP, Paris and DACS, London 2006, photo credit: James Austin

Gotlib, Henryk 1890–1966, *Three Nudes in a Landscape*, gift from Mrs Gotlib, 1992. Part of the University & Vice Chancellor's Collection, © the artist's estate

Grant, Keith b.1930, *Sir Geoffrey Allen, Chancellor*, part of the University & Vice Chancellor's Collection, © the artist

Green, Anthony b.1939, *My Mother Alone in Her Dining Room*, gift from Robert and Lisa Sainsbury. Part of the Robert & Lisa Sainsbury Collection, © the artist, photo credit: James Austin

Green, Anthony b.1939, *The Bathroom at Number 29*, gift from Robert and Lisa Sainsbury. Part of the Robert & Lisa Sainsbury Collection, © the artist, photo credit: James Austin

Gruber, Francis 1912–1948, *Nude Woman in Landscape*, gift from Robert and Lisa Sainsbury. Part of the Robert & Lisa Sainsbury Collection, © ADAGP, Paris and DACS, London 2006, photo credit: James Austin

Heath, Adrian 1920–1992, *Growth of Forms*, gift from Grace Baratt through the UEA Alumni Association, 1998. Part of the University of East Anglia Collection of Abstract & Constructivist Art, Architecture & Design, © the estate of Adrian Heath, photo credit: James Austin

Heath, Adrian 1920–1992, *Composition: Red and Black*, purchased with the assistance of the Victoria & Albert Museum Purchase Grant Fund, 1977. Part of the University of East Anglia Collection of Abstract & Constructivist Art, Architecture & Design, © the estate of Adrian Heath, photo credit: James Austin

Hill, Anthony b.1930, *Catenary Rhythms (reconstruction of original by Richard Plank)*, gift from the artist, 1983. Part of the University of East Anglia Collection of Abstract & Constructivist Art, Architecture & Design, © DACS 2006, photo credit: James Austin

Infante, Francisco b.1943, *Interpenetration*, on long-term loan

Infante, Francisco b.1943, *Medieval Spain*, on long-term loan

Infante, Francisco b.1943, *The Reconquest*, on long-term loan

Jaray, Tess b.1937, *Tamlin*, gift from East England Arts, 2002. Part of the University of East Anglia Collection of Abstract & Constructivist Art, Architecture & Design, © the artist, photo credit: James Austin

Kuper, Yuri b.1940, *The Easel*, gift from Robert and Lisa Sainsbury. Part of the Robert & Lisa Sainsbury Collection, © the artist, photo credit: James Austin

Kuper, Yuri b.1940, *Base of a Column*, gift from Robert and Lisa Sainsbury. Part of the Robert & Lisa Sainsbury Collection, © the artist, photo credit: James Austin

Kuper, Yuri b.1940, *Box*, gift from Robert and Lisa Sainsbury. Part of the Robert & Lisa Sainsbury Collection, © the artist, photo credit: James Austin

Kuper, Yuri b.1940, *Untitled*, gift from Robert and Lisa Sainsbury. Part of the Robert & Lisa Sainsbury Collection, © the artist, photo credit: James Austin

Kuper, Yuri b.1940, *Table with Paint Can*, gift from Robert and Lisa Sainsbury. Part of the Robert & Lisa Sainsbury Collection, © the artist, photo credit: James Austin

Kuper, Yuri b.1940, *Palette Knife*, gift from Robert and Lisa Sainsbury, 1990. Part of the Robert & Lisa Sainsbury Collection, © the artist, photo credit: James Austin

Kuper, Yuri b.1940, *Three Windows*, gift from Robert and Lisa Sainsbury, 1990. Part of the Robert & Lisa Sainsbury Collection, © the artist, photo credit: James Austin

Kuper, Yuri b.1940, *The Window*, gift from Robert and Lisa Sainsbury. Part of the Robert & Lisa Sainsbury Collection, © the artist, photo credit: James Austin

Kuper, Yuri b.1940, *Garlics*, gift from Robert and Lisa Sainsbury. Part of the Robert & Lisa Sainsbury Collection, © the artist

Kuper, Yuri b.1940, *Tall Grass*, gift from Robert and Lisa Sainsbury. Part of the Robert & Lisa Sainsbury Collection, © the artist

Kuper, Yuri b.1940, *Untitled (Large Tulip Flower)*, gift from Robert and Lisa Sainsbury. Part of the Robert & Lisa Sainsbury Collection, © the artist, photo credit: James Austin

Lanskoy, André 1902–1976, *Composition*, part of the Sainsbury Abstract Collection, on long-term loan from Lady Sainsbury, © ADAGP, Paris and DACS, London 2006

Latter, Jim b.1945, *Triptych*, gift from the Contemporary Art Society, 1983. Part of the University of East Anglia Collection of Abstract & Constructivist Art, Architecture & Design, © the artist

Latter, Jim b.1945, *Triptych*, gift from the Contemporary Art Society, 1983. Part of the University of East Anglia Collection of Abstract & Constructivist Art, Architecture & Design, © the artist

Latter, Jim b.1945, *Triptych*, gift from the Contemporary Art Society, 1983. Part of the University of East Anglia Collection of Abstract & Constructivist Art, Architecture & Design, © the artist

Lohse, Richard Paul 1902–1988, *Six Systematic Colour Movements from Yellow to Yellow*, purchased

from the artist, 1969. Part of the University of East Anglia Collection of Abstract & Constructivist Art, Architecture & Design, © DACS 2006, photo credit: James Austin

Malin, Suzi b.1950, *The Right Honourable Lord Franks of Headington*, part of the University & Vice Chancellor's Collection, © the artist, photo credit: James Austin

Mann, Stephen John *Earlham Golf Course, 1946*, gift from the artist, 1994. Part of the University & Vice Chancellor's Collection

Marq, Charles *Faisceaux*, on long-term loan from Lady Sainsbury

Martin, Kenneth 1905–1984, *Black Sixes*, purchased with assistance from the Victoria & Albert Museum Purchase Grant Fund, 1968. Part of the University of East Anglia Collection of Abstract & Constructivist Art, Architecture & Design, © the artist's estate

Martin, Mary 1907–1969, *Tidal Movements*, on long-term loan from the P&O Art Collection, © the artist's estate, photo credit: James Austin

Martin, Mary 1907–1969, *Tidal Movements*, on long-term loan from the P&O Art Collection, © the artist's estate, photo credit: James Austin

Martin, Mary 1907–1969, *Tidal Movements*, on long-term loan from the P&O Art Collection, © the artist's estate, photo credit: James Austin

Martin, Mary 1907–1969, *Tidal Movements*, on long-term loan from the P&O Art Collection, © the artist's estate, photo credit: James Austin

Martin, Mary 1907–1969, *Tidal Movements*, on long-term loan from the P&O Art Collection, © the artist's estate, photo credit: James Austin

Maussion, Charles b.1923, *Walking Man, No.3*, gift from Robert and Lisa Sainsbury, 1990. Part of the Robert & Lisa Sainsbury Collection, photo credit: James Austin

Maussion, Charles b.1923, *Untitled*, on long-term loan from Lady Sainsbury

Maussion, Charles b.1923, *Untitled*, part of the Sainsbury Abstract Collection, on long-term loan from Lady Sainsbury

Maussion, Charles b.1923, *Untitled*, part of the Sainsbury Abstract Collection, on long-term loan from Lady Sainsbury

Maussion, Charles b.1923, *The Red Spot*, part of the Sainsbury Abstract Collection, on long-term loan from Lady Sainsbury

Maussion, Charles b.1923,

Untitled, part of the Sainsbury Abstract Collection, on long-term loan from Lady Sainsbury

Maussion, Charles b.1923, *Untitled*, part of the Sainsbury Abstract Collection, on long-term loan from Lady Sainsbury

Maussion, Charles b.1923, *Untitled*, part of the Sainsbury Abstract Collection, on long-term loan from Lady Sainsbury

Maussion, Charles b.1923, *Head and Shoulders*, gift from Robert and Lisa Sainsbury. Part of the Robert & Lisa Sainsbury Collection

Maussion, Charles b.1923, *Portrait*, gift from Robert and Lisa Sainsbury. Part of the Robert & Lisa Sainsbury Collection

Maussion, Charles b.1923, *Head and Shoulders*, gift from Robert and Lisa Sainsbury. Part of the Robert & Lisa Sainsbury Collection, photo credit: James Austin

Maussion, Charles b.1923, *Family Portrait*, gift from Robert and Lisa Sainsbury. Part of the Robert & Lisa Sainsbury Collection

Maussion, Charles b.1923, *Four Figures*, gift from Robert and Lisa Sainsbury. Part of the Robert & Lisa Sainsbury Collection, photo credit: James Austin

Maussion, Charles b.1923, *Back of a Nude*, on long-term loan from Lady Sainsbury

Maussion, Charles b.1923, *Back of a Nude*, gift from Robert and Lisa Sainsbury. Part of the Robert & Lisa Sainsbury Collection, photo credit: James Austin

Maussion, Charles b.1923, *21 Studies of Seagulls*, on long-term loan from Lady Sainsbury, photo credit: James Austin

Maussion, Charles b.1923, *Seagull*, gift from Robert and Lisa Sainsbury. Part of the Robert & Lisa Sainsbury Collection, photo credit: James Austin

Maussion, Charles b.1923, *Interior Courtyard*, gift from Robert and Lisa Sainsbury. Part of the Robert & Lisa Sainsbury Collection, photo credit: James Austin

Maussion, Charles b.1923, *Untitled (Two Studies of a Seagull)*, on loan from Lady Sainsbury

Maussion, Charles b.1923, *Untitled (Two Studies of a Seagull)*, on loan from Lady Sainsbury

Maussion, Charles b.1923, *Back of a Nude*, gift from Robert and Lisa Sainsbury. Part of the Robert & Lisa Sainsbury Collection, photo credit: James Austin

Maussion, Charles b.1923, *The Large Oak*, gift from Robert and Lisa Sainsbury. Part of the Robert & Lisa Sainsbury Collection, photo credit: James Austin

Michaux, Henri 1899–1984, *Untitled*, gift from Robert and Lisa Sainsbury. Part of the Robert & Lisa Sainsbury Collection, © ADAGP, Paris and DACS, London 2006, photo credit: James Austin

ADAGP, Paris and DACS, London 2006, photo credit: James Austin
Zaborov, Boris b.1937, *Boy with a Book*, gift from Robert and Lisa Sainsbury. Part of the Robert & Lisa Sainsbury Collection, © ADAGP, Paris and DACS, London 2006
Zaborov, Boris b.1937, *The Little Landscape*, on long-term loan from Lady Sainsbury, © ADAGP, Paris and DACS, London 2006, photo credit: James Austin
Zaborov, Boris b.1937, *Japanese Girl*, gift from Robert and Lisa Sainsbury. Part of the Robert & Lisa Sainsbury Collection, © ADAGP, Paris and DACS, London 2006, photo credit: James Austin
Zaborov, Boris b.1937, *Nude with a Chair*, gift from Robert and Lisa Sainsbury. Part of the Robert & Lisa Sainsbury Collection, © ADAGP, Paris and DACS, London 2006, photo credit: James Austin
Zaborov, Boris b.1937, *Une fille dans l'espace (detail)*, gift from Robert and Lisa Sainsbury. Part of the Robert & Lisa Sainsbury Collection, © ADAGP, Paris and DACS, London 2006, photo credit: James Austin
Zaborov, Boris b.1937, *Documents No.2 (detail)*, gift from Robert and Lisa Sainsbury. Part of the Robert & Lisa Sainsbury Collection, © ADAGP, Paris and DACS, London 2006, photo credit: James Austin
Zaborov, Boris b.1937, *Documents No.3*, gift from Robert and Lisa Sainsbury. Part of the Robert & Lisa Sainsbury Collection, © ADAGP, Paris and DACS, London 2006, photo credit: James Austin
Zaborov, Boris b.1937, *Documents No.5 (detail)*, gift from Robert and Lisa Sainsbury. Part of the Robert & Lisa Sainsbury Collection, © ADAGP, Paris and DACS, London 2006, photo credit: James Austin
Zaborov, Boris b.1937, *Documents No.7 (detail)*, gift from Robert and Lisa Sainsbury. Part of the Robert & Lisa Sainsbury Collection, © ADAGP, Paris and DACS, London 2006, photo credit: James Austin
Zaborov, Boris b.1937, *Documents No.9 (detail)*, gift from Robert and Lisa Sainsbury. Part of the Robert & Lisa Sainsbury Collection, © ADAGP, Paris and DACS, London 2006, photo credit: James Austin
Zaborov, Boris b.1937, *Documents No.10 (detail)*, gift from Robert and Lisa Sainsbury. Part of the Robert & Lisa Sainsbury Collection, © ADAGP, Paris and DACS, London 2006, photo credit: James Austin
Zaborov, Boris b.1937, *Documents No.11 (detail)*, gift from Robert and Lisa Sainsbury. Part of the Robert & Lisa Sainsbury Collection, © ADAGP, Paris and DACS, London 2006, photo credit: James Austin
Zaborov, Boris b.1937, *Documents No.12*, gift from Robert and Lisa Sainsbury. Part of the Robert

& Lisa Sainsbury Collection, © ADAGP, Paris and DACS, London 2006, photo credit: James Austin
Zack, Léon 1892–1980, *Composition*, part of the Sainsbury Abstract Collection, on long-term loan from Lady Sainsbury, © ADAGP, Paris and DACS, London 2006
Zack, Léon 1892–1980, *Composition*, part of the Sainsbury Abstract Collection, on long-term loan from Lady Sainsbury, © ADAGP, Paris and DACS, London 2006
Zheng Gang, Lou b.1967, *Calligraphic Painting*, on long-term loan from Lady Sainsbury, photo credit: James Austin

South Norfolk Council

Burrell, James *Costessey Watermill*, presented by Councillor Tim East, Chairman of South Norfolk Council (1997–1998)
Crowfoot, Joe b.1946, *Flak Happy*, presented by Councillor E. J. (Bob) Lines, Chairman of South Norfolk Council (1992–1993), © the artist

Sheringham Museum

Armes, Thomas William 1894–1963, *Fair on Beeston Common*, purchased, 1998
Armes, Thomas William 1894–1963, *Sheringham May Fayre*, purchased, 1998
Cooper, Rosamund active early 1930s–1949, *Unknown Fisherman*, gift, 1961
Craske, John 1881–1943, *Fishing Boat 'Gannet'*, purchased by the Museum Trust, 1999
Harcourt, Bosworth 1836–1914, *Sheringham Gap*, purchased, 2005
Hudson *James Dumble*, gift, 1997
Hunt, Ruby 1903–1993, *Cottages: West Slipway*, gift, 2004
Rump, Charles Frederick active 1893–1921, *Eccles Church Tower on Beach*, gift, 1998
Rump, Charles Frederick active 1893–1921, *Sidestrand Church*, gift, 1998
Stacey, Chris *Fishermen in Boat*, gift, 1998
Stacey, Chris *Fishing Boat on Beach with Three Fishermen*, gift, 1998
Trigg, Mary *Fisherman Teddy Craske*, gift, 2003
unknown artist 19th C, *Seascape*, gift from J. Lees, 1998
Wilkins, Audrey *Cottages: Lifeboat Plain*, gift, 2005
Wilkins, Audrey *Shop on Lifeboat Plain*, gift from the artist, 2005
William Marriott Museum

Lilley (Reverend), Ivan active 1979–1980, *Recommissioning of the J15 at Sheringham, 1977*, gift, 2000

Swaffham Museum

Carter, William 1863–1939, *Emma Carter, 1910*, gift from Swaffham Town Council
Carter, William 1863–1939, *Henry Carter, 1926*, gift from Swaffham Town Council
Müller, Max b.1871, *Swanton Downham*, gift from Mrs R. Coates, York
Müller, Max b.1871, *Windmill on River Bank*, on loan from David Butters
unknown artist *Chairing the Members*, purchased from Mandells Gallery by Swaffham Town Council with the assistance of the National Art Collections Fund, the Friends of Swaffham Museum and private donors

Swaffham Town Council

Carter, Samuel John 1835–1892, *Snailspit Farm, Cley Road, Swaffham?*

Ancient House, Museum of Thetford Life

Arrowsmith, Thomas (attributed to) 1772–c.1829, *Self Portrait?*, gift from Prince Frederick Duleep Singh
Bardwell, Thomas 1704–1767, *Thomas Martin of Palgrave*, gift from Prince Frederick Duleep Singh
Bardwell, Thomas 1704–1767, *Self Portrait*, gift from Prince Frederick Duleep Singh
Beechey, William (attributed to) 1753–1839, *William Crofts*, gift from Prince Frederick Duleep Singh
Black, Thomas *Mrs French*, gift from Prince Frederick Duleep Singh
Brooks, H. active 1816–1836, *Landscape*, gift from the Staniforth Collection, 1940s
Brooks, J. (attributed to) *Portrait of a Child*, gift from Prince Frederick Duleep Singh
Browne, Joseph 1720–1800, *Costessey Hall*, gift from Prince Frederick Duleep Singh
Byng, Robert 1666–1720, *The Misses Jacob*, gift from Prince Frederick Duleep Singh
Cardinall, Robert active 1729–1730, *Robert Gainsborough (b.1673)*, gift from Prince Frederick Duleep Singh
Cardinall, Robert active 1729–1730, *Joseph Smith*, gift from Prince Frederick Duleep Singh
Cardinall, Robert (attributed to) active 1729–1730, *Richard Anguish of Moulton (1655–1725)*, gift from Prince Frederick Duleep Singh
Clint, Alfred (attributed to) 1807–1883, *John Sell Cotman (1782–1842)*, gift from Prince Frederick Duleep Singh

Clover, Joseph 1779–1853, *Anne Lady Beechey (b.1764)*, gift from Prince Frederick Duleep Singh
Dupont, Gainsborough 1754–1797, *Miss Kerrison*, gift from Prince Frederick Duleep Singh
Dyck, Anthony van (circle of) 1599–1641, *Sir Ralph Hopton and His Father Robert Hopton*, gift from Prince Frederick Duleep Singh
Ewouts, Hans c.1525–after 1578, *Queen Elizabeth I (1533–1603)*, gift from Prince Frederick Duleep Singh
Gage, Henry *Thomas Rookwood of Coldham Hall, Suffolk (1658–1728)*, gift from Prince Frederick Duleep Singh
Gower, George (copy of) c.1540–1596, *Sir William Drury (1527–1579)*, gift from Prince Frederick Duleep Singh
Grigby, Jane (attributed to) active 1800–1829, *Joshua Grigby (c.1760–1829)*, gift from Prince Frederick Duleep Singh
Heins, John Theodore Sr 1697–1756, *Portrait of a Man*, gift from Prince Frederick Duleep Singh
Hobart, John R. 1788–1863, *Isaac Strutt*, gift from Prince Frederick Duleep Singh
Hobart, John R. 1788–1863, *Horse and Dog*, gift from Prince Frederick Duleep Singh
Johnson, William active 1780–1810, *Father Wyke (1729–1799)*, gift from Prince Frederick Duleep Singh
Keddington, Elizabeth active 18th C, *John Howes of Morningthorpe*, gift from Prince Frederick Duleep Singh
Kerrison, Robert *View of Gressenhall Union*, gift from Prince Frederick Duleep Singh
Lane, Samuel 1780–1859, *Edward Frere*, gift from Prince Frederick Duleep Singh
Mendham, Robert 1792–1875, *Self Portrait*, gift from Prince Frederick Duleep Singh
Mendham, Robert 1792–1875, *Mrs Mendham, the Artist's Mother*, gift from Prince Frederick Duleep Singh
Mytens, Daniel I (imitator of) c.1590–before 1648, *Edward Lewkenor of Denham Hall, Suffolk*, gift from Prince Frederick Duleep Singh
Os, Jan van (attributed to) 1744–1808, *Still Life*, gift from the Staniforth Collection, 1940s
Otway, Edward (Captain) *Martha Otway, Sister of the Artist*, gift from Prince Frederick Duleep Singh
Paul, Joseph (attributed to) 1804–1887, *Landscape*, gift from the Staniforth Collection, 1940s
Reinagle, Philip (after) 1749–1833, *Charles Harvey, MP for Norwich (b.1756)*, gift from Prince Frederick Duleep Singh
Roe, Robert Ernest 1852–1921, *Sea Scene*, gift from the Staniforth Collection, 1940s
Romney, George 1734–1802,

Thomas Paine (1737–1809), gift from Prince Frederick Duleep Singh
Roods, Thomas active 1833–1867, *Miss Georgina (Bessie) Bale (d.1905)*, gift from Prince Frederick Duleep Singh
Roods, Thomas active 1833–1867, *Miss Louisa Ellen Bale (d.1925)*, gift from Prince Frederick Duleep Singh
Sandys, Anthony (attributed to) 1806–1883, *Yarmouth Beach*, gift from Prince Frederick Duleep Singh
Theodorick, John *Justice*, on loan from Thetford Town Council
unknown artist *Dr John Caius (1510–1573)*, gift from Prince Frederick Duleep Singh
unknown artist *Thomas Howard, 4th Duke of Norfolk, KG (d.1572)*, gift from Prince Frederick Duleep Singh
unknown artist *Admiral Lord Thomas Howard, KG, 1st Earl of Suffolk (1561–1626)*, gift from Prince Frederick Duleep Singh
unknown artist *Mr Symonds*, gift from Prince Frederick Duleep Singh
unknown artist 16th C, *Portrait of a Man with a Lace Collar*, gift from Prince Frederick Duleep Singh
unknown artist 16th C, *Portrait of an Elizabethan Lady*, gift from Prince Frederick Duleep Singh
unknown artist 16th C, *Possibly Lady Marchant*, gift from Prince Frederick Duleep Singh
unknown artist *Man of the Shelton Family*, gift from Prince Frederick Duleep Singh
unknown artist *Portrait of a Lady of the Shelton Family*, gift from Prince Frederick Duleep Singh
unknown artist *Lady Littlebury*, gift from Prince Frederick Duleep Singh
unknown artist *Thomas Howard, Earl of Arundel (1586–1686)*, gift from Prince Frederick Duleep Singh
unknown artist *Mr Hobson*, gift from Prince Frederick Duleep Singh
unknown artist *Mrs Redmayne*, gift from Prince Frederick Duleep Singh
unknown artist *Thomas Dandy of Combs, Suffolk (b.1610)*, gift from Prince Frederick Duleep Singh
unknown artist *Young Children with Spaniel and Parrot*, gift from Prince Frederick Duleep Singh
unknown artist *Mrs Henry Shelton*, gift from Prince Frederick Duleep Singh
unknown artist *Portrait of a Man*, gift from Prince Frederick Duleep Singh
unknown artist *Portrait of a Man*, gift from Prince Frederick Duleep Singh
unknown artist *Portrait of a Man*, gift from Prince Frederick Duleep Singh
unknown artist *Portrait of a Child*

of the Wenyeve Family*, gift from Prince Frederick Duleep Singh

unknown artist *Mrs Edward Colman (d.1691)*, gift from Prince Frederick Duleep Singh

unknown artist 17th C, *Group of Men with Children and Cherubs*, gift from Prince Frederick Duleep Singh

unknown artist 17th C, *Head of a Cavalier*, gift from Prince Frederick Duleep Singh

unknown artist 17th C, *Mr Reed*, gift from Prince Frederick Duleep Singh

unknown artist 17th C, *Portrait of a Man*, gift from Prince Frederick Duleep Singh

unknown artist *The Misses Decker (Catherine, Henrietta & Mary)*, gift from Prince Frederick Duleep Singh

unknown artist *Sir Robert Walpole (1676–1745)*, gift from Prince Frederick Duleep Singh

unknown artist *Miss Elizabeth Blomfield (b.1674)*, gift from Prince Frederick Duleep Singh

unknown artist *The Jacob Children, John and Elizabeth Jacob*, gift from Prince Frederick Duleep Singh

unknown artist *Portrait of a Man*, gift from Prince Frederick Duleep Singh

unknown artist *Portrait of a Lady*, gift from Prince Frederick Duleep Singh

unknown artist *John Howes of Morningthorpe*, gift from Prince Frederick Duleep Singh

unknown artist *Portrait of a Lady*, gift from Prince Frederick Duleep Singh

unknown artist *Portrait of a Lady*, gift from Prince Frederick Duleep Singh

unknown artist *Robert Harvey of Old Buckenham*, gift from Prince Frederick Duleep Singh

unknown artist *Portrait of a Lady*, gift from Prince Frederick Duleep Singh

unknown artist *Sir Robert Walpole and Hounds*, gift from Prince Frederick Duleep Singh

unknown artist *Mary Barnwell (1700–1786)*, gift from Prince Frederick Duleep Singh

unknown artist *Charles Barnwell of Mileham (1679–1750)*, gift from Prince Frederick Duleep Singh

unknown artist *Mrs Robert Harvey*, gift from Prince Frederick Duleep Singh

unknown artist *Portrait of a Man*, gift from Prince Frederick Duleep Singh

unknown artist *Portrait of a Man*, gift from Prince Frederick Duleep Singh

unknown artist *Portrait of a Man*, gift from Prince Frederick Duleep Singh

unknown artist early 18th C, *Female Saint*, gift from Prince Frederick Duleep Singh

unknown artist early 18th C, *Female Saint*, gift from Prince Frederick Duleep Singh

unknown artist early 18th C, *Robert Harvey of St Andrews' Hall, Old Buckenham (d.1718)*, gift from Prince Frederick Duleep Singh

unknown artist 18th C, *A Lady of the Keppel Family*, gift from Prince Frederick Duleep Singh

unknown artist 18th C, *Charles Crofts*, gift from Prince Frederick Duleep Singh

unknown artist 18th C, *Game Birds*, gift from Prince Frederick Duleep Singh

unknown artist 18th C, *Mrs Turner*, gift from Prince Frederick Duleep Singh

unknown artist 18th C, *Musicians*, gift from the Staniforth Collection, 1940s

unknown artist 18th C, *Portrait of a Lady*, gift from Prince Frederick Duleep Singh

unknown artist 18th C, *Portrait of a Lady*, gift from Prince Frederick Duleep Singh

unknown artist 18th C, *Portrait of a Lady*, gift from Prince Frederick Duleep Singh

unknown artist 18th C, *Portrait of a Lady*, gift from Prince Frederick Duleep Singh

unknown artist 18th C, *Portrait of a Lady of the Wenyeve Family of Brettenham*, gift from Prince Frederick Duleep Singh

unknown artist 18th C, *Portrait of a Lady of the Wenyeve Family of Brettenham*, gift from Prince Frederick Duleep Singh

unknown artist 18th C, *Portrait of a Man*, gift from Prince Frederick Duleep Singh

unknown artist 18th C, *Portrait of a Man*, gift from Prince Frederick Duleep Singh

unknown artist 18th C, *Portrait of a Man*, gift from Prince Frederick Duleep Singh

unknown artist 18th C, *Portrait of a Man*, gift from Prince Frederick Duleep Singh

unknown artist 18th C, *Portrait of a Man*, gift from Prince Frederick Duleep Singh

unknown artist 18th C, *Portrait of a Man with a Pheasant*, gift from Prince Frederick Duleep Singh

unknown artist 18th C, *Portrait of a Woman*, gift from Prince Frederick Duleep Singh

unknown artist 18th C, *Portrait of a Woman*, gift from Prince Frederick Duleep Singh

unknown artist late 18th C, *Man and Horse*, gift from Prince Frederick Duleep Singh

unknown artist late 18th C, *Portrait of a Man*, gift from Prince Frederick Duleep Singh

unknown artist *Frank Sayers,*

MD of Norwich, gift from Prince Frederick Duleep Singh

unknown artist *Landscape with Lake and Goats*, gift from Prince Frederick Duleep Singh

unknown artist *Lord Nelson (1758–1805)*, purchased, 1994

unknown artist *Robert Ladbrooke (1768–1842)*, gift from Prince Frederick Duleep Singh

unknown artist early 19th C, *Greyfriars Tower, King's Lynn*, gift from Prince Frederick Duleep Singh

unknown artist early 19th C, *Men in a Cave*, gift from the Staniforth Collection, 1940s

unknown artist early 19th C, *Portrait of a Country Man*, gift from Prince Frederick Duleep Singh

unknown artist early 19th C, *Portrait of a Lady*, gift from Prince Frederick Duleep Singh

unknown artist early 19th C, *Possibly Madonna and Child*, gift from Prince Frederick Duleep Singh

unknown artist early 19th C, *Stately Home*, gift from Prince Frederick Duleep Singh

unknown artist 19th C, *Interior with Figures*, gift from the Staniforth Collection, 1940s

unknown artist 19th C, *Landscape*, gift from the Staniforth Collection, 1940s

unknown artist 19th C, *Portrait of a Man*, gift from an unknown donor

unknown artist 19th C, *Portrait of a Young Victorian Man*, gift from an unknown donor

unknown artist mid-19th C, *Mountain Stream*, gift from the Staniforth Collection, 1940s

unknown artist late 19th C, *Cornell Fison*

unknown artist *George Richard Blaydon*

unknown artist 20th C, *Norfolk House*, gift from Prince Frederick Duleep Singh

unknown artist *Charles Fitzroy, 2nd Duke of Grafton*

unknown artist *Landscape*, gift from the Staniforth Collection, 1940s

unknown artist *Landscape*, gift from the Staniforth Collection, 1940s

unknown artist *Landscape*, gift from the Staniforth Collection, 1940s

unknown artist *Landscape*, gift from the Staniforth Collection, 1940s

unknown artist *Portrait of a Victorian Man*, gift from the Staniforth Collection, 1940s

unknown artist *Portrait of a Victorian Woman*, gift from the Staniforth Collection, 1940s

unknown artist *Possibly Christ*, gift from Prince Frederick Duleep Singh

unknown artist *The Honourable Philip Howard, 5th Son of Lord*

Thomas Howard (1688–1750), gift from Prince Frederick Duleep Singh

White, George (attributed to) c.1684–1732, *Portrait of a Lady*, gift from Prince Frederick Duleep Singh

White, George (attributed to) c.1684–1732, *Portrait of a Lady*, gift from Prince Frederick Duleep Singh

Wilde, D. *Gabriel Lepipre*, gift from Prince Frederick Duleep Singh

Wright, John Michael (attributed to) 1617–1694, *Sir Robert Le Strange*, gift from Prince Frederick Duleep Singh

Wright, Joseph 1756–1793, *Mrs Oliver of Sudbury*, gift from Prince Frederick Duleep Singh

Thetford Town Council

Kehoe, Chris J. *Thetford Town Council, 1 August 1934*, presented by Sir William Gentle

unknown artist *Thetford Town Council, 1961*

Norfolk Constabulary

Davies, Arthur Edward 1893–1967, *John Henry Dain OBE, Chief Constable, NCH City Police (1917–1943)*, donated

Davidson-Houston, Aubrey 1906–1995, *Captain Stephen Hugh Van Neck CVO, MC, Chief Constable, Norfolk (1928–1956)*, commisioned, 1956

Wymondham Heritage Museum

Elliott, Edward 1851–1916, *Ketteringham Hall*, presented by W W. E. Giles

Collection Addresses

Aylsham

Aylsham Town Council
Town Hall, Aylsham NR11 6EL
Telephone 01263 733354

Bressingham

Bressingham Steam Museum
Thetford Road, Bressingham IP22 2AB
Telephone 01379 686900

Costessey

Costessey Parish Council
Parish Rooms, Townhouse Road,
Old Costessey, Norwich NR8 5BS
Telephone 01603 742958

Cromer

Cromer Museum*
East Cottages, Tucker Street, Cromer NR27 9PE
Telephone 01263 513543

Cromer Town Council
North Lodge Park, Overstrand Road, Cromer NR27 0AH
Telephone 01263 512254

North Norfolk District Council
Council Offices, Holt Road, Cromer, NR27 9PZ
Telephone 01263 513811

The RNLI Henry Blogg Museum
The Rocket House, The Promenade, Cromer NR27 9ET
Telephone 01263 511294

Dereham

Dereham Town Council
Assembly Rooms, Quebec Street, Dereham NR19 2TX
Telephone 01362 693821

Gressenhall Farm and Workhouse: The Museum of
Norfolk Life*
Beech House, Gressenhall, Dereham, NR20 4DR
Telephone 01362 860563

Diss

Diss Town Council
Council Offices, 11–12 Market Hill, Diss IP22 4JZ
Telephone 01379 643848

100th Bomb Group Memorial Museum
Common Road, Dickleburgh, Diss IP21 4PH
Telephone 01379 740708

Fakenham

Fakenham Town Council
Fakenham Connect, Oak Street, Fakenham NR21 9DY
Telephone 01328 850104

Great Yarmouth

Great Yarmouth Magistrates Court
North Quay, Great Yarmouth NR30 1PW
Telephone 01493 849800

*Great Yarmouth Museums:**

Elizabethan House Museum
4 South Quay, Great Yarmouth NR30 2QH
Telephone 01493 855746

Great Yarmouth Borough Council Town Hall
Hall Plain, Great Yarmouth NR30 2QF
Telephone 01493 856100

Time and Tide Museum of Great Yarmouth Life
Blackfriars Road, Great Yarmouth NR30 3BX
Telephone 01493 743930

Great Yarmouth Port Authority
20–21 South Quay, Great Yarmouth NR30 2RE
Telephone 01493 335500

The Norfolk Nelson Museum
26 South Quay, Great Yarmouth NR30 2RG
Telephone 01493 850698

Horning

Royal Air Force Air Defence Radar Museum
RAF Neatishead, Norwich NR12 8YB
Telephone 01692 633309

King's Lynn

King's Lynn Arts Centre
29 King Street, King's Lynn PE30 1HA
Telephone 01553 779095

King's Lynn Corn Exchange
Tuesday Market Place, King's Lynn PE30 1JW
Telephone 01553 765565

King's Lynn Custom House
Purfleet Quay, King's Lynn PE30 1HP
Telephone 01553 763044

*King's Lynn Museums:**

> Lynn Museum
> Market Street, King's Lynn PE30 1NL
> Telephone 01553 775001

> Town House Museum
> 46 Queen Street, King's Lynn PE30 5DQ
> Telephone 01553 773450

King's Lynn Town Hall
Saturday Market Place, King's Lynn PE30 5DQ
Telephone 01553 774297

Norwich

Broadland District Council
Broadland District Council Offices, Thorpe Lodge,
1 Yarmouth Road, Thorpe St Andrew, Norwich NR7 0DU
Telephone 01603 430522

City of Norwich Aviation Museum
Old Norwich Road, Horsham St Faith, Norwich NR10 3JF
Telephone 01603 893080

*City of Norwich Collection:**

> City Hall,
> St Peter's Street, Norwich NR2 1WG
> Telephone 01603 212521

> Norwich Register Office,
> Churchman House, 71 Bethel Street,
> Norwich NR2 1NR
> Telephone 01603 767600

Norfolk and Norwich University Hospital
Hospital Arts Project, Norfolk and Norwich University
Hospital, Colney Lane, Norwich NR4 7UY
Telephone 01603 287870

Norfolk and Waveney Mental Health Partnership
Mary Chapman House, Hotblack Road,
Norwich NR2 4HN
Telephone 01603 421950

*Norfolk County Council:**

> Carrow House
> Level 5, 301 King Street, Norwich NR1 2TN
> Telephone 0844 800 8020

> Norfolk County Council,
> Chairman's Office, Martineau Lane,
> Norwich NR1 2DH
> Telephone 01603 222966

Norfolk Record Office
The Archive Centre, Martineau Lane, Norwich NR1 2DQ
Telephone 01603 222599

Norwich Assembly House
The Assembly House Trust Ltd, Theatre Street,
Norwich NR2 1RQ
Telephone 01603 626402

*Norwich Castle Museum and Art Gallery:**

> Norwich Castle Museum and Art Gallery
> Castle Meadow, Norwich NR1 3JU
> Telephone 01603 493625

> Strangers' Hall Museum
> Charing Cross, Norwich NR2 4AL
> Telephone 01603 667229

> The Bridewell Museum
> Bridewell Alley, Norwich NR2 1AQ
> Telephone 01603 615975

*Norwich Civic Portrait Collection:**

> Blackfriars' Hall
> St Andrew Plain, Norwich NR3 1AU
> Telephone 01603 628477

> St Andrew's Hall
> St Andrew Plain, Norwich NR3 1AU
> Telephone 01603 628477

> The Guildhall
> Gaol Hill, Norwich NR2 1NR
> Telephone 01603 666071

Norwich Magistrates Courts
Bishopgate, Norwich NR3 1UP
Telephone 01603 632421

Royal Norfolk Regimental Museum
The Shirehall, Market Avenue, Norwich NR1 3JQ
Telephone 01603 493649

Sainsbury Centre for Visual Arts, University of East Anglia:

Robert and Lisa Sainsbury Collection
University of East Anglia, Norwich NR4 7TJ
Telephone 01603 593199

Sainsbury Abstract Collection
University of East Anglia, Norwich NR4 7TJ
Telephone 01603 593199

University and Vice Chancellor's Collection
University of East Anglia, Norwich NR4 7TJ
Telephone 01603 593199

University of East Anglia Collection of
Abstract and Constructivist Art,
Architecture and Design,
University of East Anglia, Norwich NR4 7TJ
Telephone 01603 593199

South Norfolk Council
Leisure Services, Long Stratton, Norwich NR15 2XE
Telephone 01508 533633

Sheringham

Sheringham Museum
Sheringham Museum Trust, Station Road,
Sheringham NR26 8RE
Telephone 01263 821871

William Marriott Museum
North Norfolk Railway, Sheringham Station,
Sheringham NR26 8RA
Telephone 01263 710484

Swaffham

Swaffham Museum
Town Hall, 4 London Street, Swaffham PE37 7DQ
Telephone 01760 721230

Swaffham Town Council
Town Hall, 4 London Street, Swaffham PE37 7DQ
Telephone 01760 722922

Thetford

*Ancient House, Museum of Thetford Life:**

Ancient House Museum
White Hart Street, Thetford IP24 1AA
Telephone 01842 752599

King's House
King Street, Thetford IP24 2AP
Telephone 01842 754247

Thetford Town Council
Council Offices, King's House, King Street,
Thetford IP24 2AP
Telephone 01842 754247

Wymondham

Norfolk Constabulary
Operations and Communications Centre,
Falconers Chase, Wymondham NR18 0WW
Telephone 01953 423717

Wymondham Heritage Museum
10 The Bridewell, Norwich Road, Wymondham NR18 0NS
Telephone 01953 607494

* These museums are managed by the Norfolk Museums and Archaeology Service

Index of Artists

In this catalogue, artists' names and the spelling of their names follow the preferred presentation of the name in the Getty Union List of Artist Names (ULAN) as of February 2004, if the artist is listed in ULAN.

The page numbers next to each artist's name below direct readers to paintings that are by the artist; are attributed to the artist; or, in a few cases, are more loosely related to the artist being, for example, 'after', 'the circle of' or copies of a painting by the artist. The precise relationship between the artist and the painting is listed in the catalogue.